Germaine Krull

PHOTOGRAPHER OF MODERNITY

GERMAINE KRULL

PHOTOGRAPHER OF MODERNITY

Kim Sichel

The MIT Press Cambridge, Massachusetts London, England

Library of Congress Cataloging-in-Publication Data

Sichel, Kim.
 Germaine Krull: photographer of modernity / Kim Sichel.
 p. cm.
 Includes bibliographical references and index.
 ISBN 0-262-19401-5 (hc : alk. paper)
 1. Krull, Germaine. 2. Women photographers—Germany
 Biography. 3. Photographers—Germany Biography. I. Title.
TR140.K76S53 1999
770'.92—dc21
[B] 99-23818
 CIP

Typesetting: Typograph, Munich
Separations: Nova Concept, Berlin
Printing: Passavia, Passau
Binding: Großbuchbinderei, Monheim

Printed and bound in Germany

CONTENTS

FIGURES

Titles of these photographs are descriptive. They vary widely from print to print, and from publication to publication. When the photographer wrote a title on the back, it is in italics. Printed titles of books and portfolios are also in italics. All prints are vintage prints unless otherwise noted.

Plate 7.24 Pont Transbordeur, 1926, Collection A. Jammes, Paris

Plate 7.25 Marseille, c. 1927, Collection Thomas Walther, New York

Plate 7.26 Marseille, c. 1927, Collection Thomas Walther, New York

Plate 8.1 General de Gaulle, Algiers, 1944, Museum Folkwang, Essen

Plate 8.2 *AEF Brazzaville, Les Généraux de Gaulle et LeClerc et le Gouverneur Général Eboué sur l'Aérodrome*, 1943, Museum Folkwang, Essen

Plate 8.3 *Oubangui-Chari. Bangassou. Usine de coton Comouna*, c. 1943, Museum Folkwang, Essen

Plate 8.4 *Cameroun. Dschang. Coopérative indigène du café*, June 1943, Museum Folkwang, Essen

Plate 8.5 *M'Vouti. Exploitation minière de M. Vigoureux*, April 1943, Museum Folkwang, Essen

Plate 8.6 *M'Vouti. Exploitation minière de M. Vigoureux*, April 1943, Museum Folkwang, Essen

Plate 8.7 *Gabon. Sur la route de Mouila à l'Onoi. Pelles et pioches*, 1943, Museum Folkwang, Essen

Plate 8.8 Gabon. *Déblayage sur la route après une pluie, Mouila-Onoi*, 1943, Museum Folkwang, Essen

Plate 8.9 Gabon, Porter, 1943, Museum Folkwang, Essen

Plate 8.10 Mother and child, Brazzaville, 1943, Museum Folkwang, Essen

Plate 8.11 *Une Tchikombi déja promise, Pointe Noire*, April 1943, Museum Folkwang, Essen

Plate 8.12 *Tchad. Fort Archambault. Les négresses à plateau*, August 1943, Museum Folkwang, Essen

Plate 8.13 *Brazzaville. Poto-Poto. Séance de coiffeur*, n.d., Museum Folkwang, Essen

Plate 8.14 Man and child, n.d., Museum Folkwang, Essen

Plate 8.15 Landscape, Gabon, 1943, Museum Folkwang, Essen

Plate 8.16 *Oubangui – Chari. Bambari. Cavalier Bororo*, August 1943, Museum Folkwang, Essen

Plate 9.1 *Siam Nord Chiengmai, Doi Suthep*, late 1950s, Museum Folkwang, Essen

Plate 9.2 *Chute d'eau, Mékong Nord*, late 1950s, Museum Folkwang, Essen

Plate 9.3 *Siam Nord Kampangpet Wat Pra Ken 61*, Thailand, 1961, Museum Folkwang, Essen

Plate 9.4 *Siam Nord 58. Statue de Buddah dans la forêt (XIIen) à Chiengsen*, 1958, Museum Folkwang, Essen

Plate 9.5 *Pagan Naudama temple group (1266)*, 1959, Museum Folkwang, Essen

Plate 9.6 *Ankor*, n.d., Museum Folkwang, Essen

Plate 9.7 *Pagan Shmaniyan Pagoda, Burma*, 1959, Museum Folkwang, Essen

Plate 9.8 *Ankor*, n.d., Museum Folkwang, Essen

Plate 10.1 *His Holiness Sakya Trizin*, c. 1968, Museum Folkwang, Essen

Plate 10.2 *Tibetan religious ceremony*, n.d., Museum Folkwang, Essen

Plate 10.3 *Tibetan dance group*, n.d., Museum Folkwang, Essen

Plate 10.4 A group of Tibetan dancers, c. 1968, Museum Folkwang, Essen

Plate 10.5 During prayers in the temple, c. 1968, Museum Folkwang, Essen

Plate 10.6 Young monk, c. 1968, Museum Folkwang, Essen

ACKNOWLEDGMENTS

I met Germaine Krull only a few times, in the summer of 1984, when she was a very old woman. Her memory had failed her, but her vibrant personality remained. Even in our conversations of relatively few words, she impressed me with her vitality, and the numerous accounts I had read about her charm, her attractive qualities, and her passion for life rang true.

This project would never have been possible without the collaboration and cooperation of Krull's family and friends and of the Germaine Krull Nachlass (estate) at the Museum Folkwang in Essen, Germany. I am particularly grateful to Christel Klose for granting early and unlimited access to the Krull archives and to Berthe Krull for corresponding with me about her sister. I owe many thanks to the entire staff of the Museum Folkwang, especially Irene Heim, Robert Knodt, Hella Nocke-Schrepper, and Axel Wipperman. In particular, I would like to thank Ute Eskildsen for her sustained support of Krull's work and this project, her comments on the European section of the book, and her cooperation in selecting the plates.

For research and support, I am grateful to multiple funding sources. A National Endowment for the Humanities Fellowship for University Teachers supported the project from 1994 to 1995, as did a Bunting Fellowship at Radcliffe College. I am grateful to my Bunting colleagues, especially to Florence Ladd, director; Renny Harrigan, associate director; and fellow scholars there, particularly Dierdre Chetham, Kathleen Cleaver, Kate Cloud, Laura Harrington, Barbara Grossman, Rachel Kadish, and Helena Meyer-Knapp. Susan Pedersen, in particular, read many drafts of the manuscript, and her assistance and moral support have been invaluable. Boston University granted me a sabbatical from 1994 to 1995 and a Humanities Foundation Fellowship in the spring of 1997, which released me from teaching and allowed me time to complete this project. I thank Katherine O'Connor, director of the Boston University Humanities Foundation, and my colleagues for the 1996 to 1997 year for their support of this project. A Georges Lurcy Fellowship from 1983 to 1984 and a Kress Foundation Fellowship the following year supported the first research I conducted on Krull's Paris work, as part of my doctoral dissertation on Brassaï, André Kertész, Germaine Krull, and Man Ray at Yale University. For nurturing a rigorous model of social history, I owe a great deal to my advisors Robert L. Herbert and Donald Crafton. Robert

Herbert, in particular, has long encouraged me to return to Krull for a full investigation.

For research in French archives and museums, I thank Françoise Reynaud, Musée Carnavalet; Michelle Aubert, Eric LeRoy, and Sylvie Bourcier, Centre national de la cinématographie; Genevieve Dieuzeide, Chef du service iconographique, and Anne Zourabischvili, Documentation Française, Paris; Catherine Trouiller, archivist, Institut Charles de Gaulle; Annick Lionel-Marie and Alain Sayag, Musée national d'art moderne, Centre national d'art et de culture Georges Pompidou; and Sophie Aubernas, Cabinet d'estampes, Bibliothèque Nationale, Paris. I also thank many individuals in France: Christian Bouqueret, Françoise Denoyelle, André Jammes, Arthur Lehning, Marceline Loridan-Ivens, Toke van Helmond, and Virginia Zabriskie. In Belgium I am grateful to Hendrik Ollivier, Archive and Museum of the Socialist Labor Movement, Ghent. Dutch research has been assisted by an ongoing correspondence with Ida Boelema and by the staff of the Koninklijke Bibliotheek, The Hague. In Austria I thank Christian Brandstätter, Vienna. In Russia, I wish to acknowledge Kirill Michailowitsch Anderson, Zentrum zur Aufbewahrung und Erforschung zeitgenössischer Dokumente, Moscow; and Reinhard Krumm. In England, John Tate has generously shared his memories of Germaine Krull. In Germany, I am grateful to Marion Beckers, Berlin; Rudolf Herz, Munich; Hartwig Kopperman, Staatliche Fachakademie für Fotodesign München; Bodo Niemann, Berlin; Frank-Manuel Peter, Deutsches Tanzarchiv, Cologne; Gunzelin Schmid-Noerr, Horkheimer-Archiv, Stadt- und Universitätsbibliothek, Frankfurt; Dietmar Siegert, Munich; Thomas Weski, Sprengel Museum, Hannover; Ann and Jürgen Wilde, Zülpich; and Sabine Wolf, Walter-Benjamin-Archiv, Stiftung Archiv der Akademie der Künste, Berlin.

In the United States, I have received assistance from Peter Galassi, Museum of Modern Art; Judith Keller, J. Paul Getty Museum; Laura Muir, Metropolitan Museum of Art; Peter Nesbit, Busch-Reisinger Museum, Harvard University Art Museums; Sandra Phillips, San Francisco Museum of Modern Art; David Travis, Chicago Art Institute; and Anne W. Tucker, Museum of Fine Arts, Houston. At Boston University my many supportive colleagues and students include Peter Barr, David Ehrenpreis, Patricia Hills, Caroline A. Jones, Mary Drach McInnes, Keith N. Morgan, Jonathan Ribner, James Schmidt, John Stomberg, and Elizabeth ten Grotenhuis. A photography reading group has also been a great help during this process, including Patricia Berman, Judith Black, Deborah Bright, Eleanor Hight, Patricia Johnston, Joanne Lukitsh, and particularly Elizabeth Anne McCauley, who read the entire manuscript with painstaking care. At MIT Press, Roger Conover, Julie Grimaldi, Sandra Minkkinen, and the readers for the press have been enormously helpful. I would also like to thank Mark Antliff, Barbara Bokhour, Sherry Buckberrough, Brenda Danilowitz, Kate Edgar,

Susan Ehrens, Lucy Frucht, Robert Klein, Percy Lehning, Karen Lucic, Hattula Moholy-Nagy, Christine Poggi, Rebecca Taniguchi, Margarita Tupitsyn, and Thomas Walther.

I began examining Germaine Krull's work through my interest in the interwar international experiences of expatriate photographers and artists. Only during recent years have I realized how closely Krull's peripatetic experiences mirrored those of my own family, whose members left Germany, interrupted their educations and careers, and recreated lives in the United States, Argentina, Venezuela, Sweden, France, Great Britain, and Hong Kong. My adolescence was peppered with stories from my late father, E. Otto Sichel, about his own student years in Berlin in the late 1920s. During my work on this book, my mother, Anne M. Sichel, patiently and humorously assisted in various translations and contributed her own vivid memories of Paris in the 1930s, as did Lollo Erda and Marguerite Weinbach. My two children, David Sichel Brown and Alexandra Sichel Brown, supported travels, hours at the computer, and long discussions about Krull with grace. My greatest thanks go to my husband, Richard Leonard Brown, who has supported my life as a scholar, teacher, companion, and parent over the years and whose exacting editing, patience, and enthusiasm were essential to this project. I dedicate this book to him.

Art student in Munich in the midst of World War I. Activist in the Bavarian Revolution. Dissident in Moscow at the Third World Congress of the Communist International. Consumer and constructor of Weimar culture in Berlin. Witness to Dutch industry and the founding of the Filmliga. Introducer of the New Vision to France. Preeminent press photographer in interwar Paris. Book publisher. Wartime coordinator of de Gaulle's Free French photographic service in Africa. Entrepreneur and hotelier in Bangkok. Buddhist convert and supporter of Tibetan exiles in rural India.

Germaine Krull: Photographer of Modernity chronicles the life and work of a passionate witness to the events of the twentieth century and serves simultaneously as a model for a complex reading of modernism. Krull's adventures and accomplishments from 1915, when she entered art school, until her death in 1985 offer a compelling view of the period of history that is often called the modernist century. Through a combination of happenstance and intention, Krull witnessed many of the pivotal moments of this era, and she died just as the concept of purely modern institutions became defunct and a postmodern world emerged full of local, ethnic, and complicated events. Her photographs and writings can be used as a reference point for considering the transformations of twentieth-century art, politics, and culture.

In addition to her role as a photographer, Krull supported varied political causes and ran organizations and businesses under political regimes at many of the century's transformational moments. Krull's emergence into adulthood closely parallels not only the beginning of World War I but also the widespread demise of monarchies (czarist Russia and Wilhelmian Germany, to name only two) that were replaced by other political institutions such as communism, fascism, and democracy. She was present at the formation and evolution of communist governments in Bavaria, Russia, and Vietnam. Her eclectic beliefs eventually shifted away from support of communism in favor of capitalist democracies, although throughout her life she steadfastly opposed authoritarian regimes regardless of their labels. In this spirit, she actively battled to preserve and strengthen democracy in the face of fascist threats, notably with Charles de Gaulle's French resistance movement in Africa during World War II.

Krull was no passive spectator at these events but wrote about and photographed them critically, throwing herself passionately into her era. This passion reverberates throughout the decades. Her tools of expression included the written word and political activism, but with her most powerful tool—her camera—she turned a compelling lens on the century. Her photographic output encompassed artistic, documentary, and commercial imagery. As an artist commenting on these events, Krull not only witnessed the modern world but actively engaged in the complex discourse of modernism as a cultural language. She mastered the various formal tools of modernist art, evolving from symbolism to abstraction and onward into documentary realism.

Cultural modernism, by some accounts, began with the Enlightenment, but most scholars place its beginning in the years after 1848, and its origin is often marked in the writings of Charles Baudelaire in the 1860s. It is widely accepted that modernism transformed itself fundamentally in the years just before World War I, which was when Krull began art school. Although there is much discussion about the ending point of the modern period, the many cultural and political upheavals of the late 1960s mark a clear turning point, again oddly paralleling Krull's last disillusioned departure from Europe and her final turning to religion at the end of her life. Her despair at the failure of many of the institutions she believed in rings particularly poignantly for us as we look back on modernism.

In its simplest definition, cultural modernism signifies purity—in the medium, the role of the artist, and the supremacy of art over mass culture.[1] This book, however, presents a far more complex view of modernism than a 1950s canonical view of a solitary artist (usually male) working in isolation, concerned above all with self-referentiality, honesty to the medium, and work that stands above mass culture as high art. Instead, Krull worked in opposition to this canonical view: she was female, worked collaboratively, referred to the exterior world, and freely mixed art and commerce, high art and popular culture. In fact, interwar photographers in general made a division between avant-garde and commercial practice and not between high and low, and photography was not often seen in museum exhibitions.

Although many revisionist studies of modernist artists have begun to reinsert mass cultural and political elements into more formalist tales, Krull presented herself as an inclusionary modernist long before it was again fashionable for nonphotographic artists to do so. She viewed her modernist realm as a broad and rich field allowing the simultaneous presence of all modes of photographic communication—emphatically including and even conflating both commercial and artistic applications. In her inclusionary vision of modernism, Krull saw herself as an intellectual and as an artistic commentator on her era, although her essentially pragmatic nature led her to make the best of the events around her.

Moreover, the stories of most modern artists, particularly in the interwar years, are more complex than they appear. The public perceived a distinction between professional photographic practice and amateur art photography (international photography clubs such as the American Photo-Secession, British Linked Ring, and French Photo-Club de Paris). Only the amateur organizations engaged in the discourse of high art, while the professional businesses included studio portraiture, fashion photography, and photojournalism. The concept of photographic exhibitions, at least until 1927, was reserved for amateur photography. After that year, when they, too, began to exhibit their works, imaginative professional photographers like Krull began to occupy a much more multifaceted and fluid position.

In addition, many professional photgraphers recast their careers after World War II to fit into the purist definition of modernism, emphasizing their avant-garde over their mass production efforts. By refusing or ignoring this last pattern, Krull therefore becomes a role model for a more fully engaged modern artist. Instead of simply searching for authenticity and authorship in a pure and self-referential fashion, she engaged and influenced a series of cultural ideas throughout this century. Photography—interchangeably artistic and commercial —was simply her language for commenting on the world around her.

This photographer openly embraced seemingly contradictory elements— commercialism and the avant-garde, male and female roles, communism and democracy. Here she differed from many of her male colleagues, such as Brassaï, André Kertész, László Moholy-Nagy, Man Ray, Albert Renger-Patzsch, Alexandr Rodchenko, and others who focused on their artistic careers rather than their commercial endeavors. Although they, too, regularly crossed the borders between the avant-garde and mass culture in the 1920s, they later often downplayed their "transgressions" or justified commerce as utopian activism. Krull also chose a different path from many of her female colleagues, including Berenice Abbott, Laure Albin-Guillot, Ilse Bing, Marianne Brandt, Florence Henri, Lotte Jacobi, Lucia Moholy, and Ringl and Pit, many of whom are studied in Ute Eskildsen's groundbreaking 1994 exhibition and catalogue for the Museum Folkwang, *Fotografieren hieß teilnehmen: Fotografinnen der Weimarer Republik.*[2] Unlike most of these women, Krull operated in a man's world beyond the circumscribed women's circles of fashion or portrait photography, and her politicized position encompassed industry, street photography, and war photography. Male and female colleagues alike remained more closely tied to Europe (and America); they chose their subjects close to home, with the exception of Henri Cartier-Bresson and war photographers such as Robert Capa, who belong to a later, more documentary, postwar generation.

Among the high modernist photographers, Germaine Krull was unique for the wide geographic range of her lens. In his book on modernity and post-

modernity, David Harvey emphasizes the importance of what he calls a "complex historical geography of modernism."[3] Modernity was a localized as well as an international phenomenon, with spurts of activity in Paris, Berlin, Munich, London, Moscow, and Vienna, and it is telling that Krull found herself living and working in so many of these locales at the moments when their cultures were most actively being transformed. The geographical trajectory of modernism sent it to New York after World War II, and although she traveled widely, Krull's adventures never brought her to the United States, so that her experiences offer a case study largely uncolored by issues of Americanism both political and cultural. Instead, Krull's choices reflect a different modernism, one as linked to the international movement of capital as to culture. Her reach after World War II extended beyond the European capitals to include South America, Africa, and Asia, although she remained a European at heart, with all the strengths and biases of a Eurocentric training.

Krull also differed from her colleagues because she wrote extensive memoirs chronicling her politics, her art, and her personal life. Other photographers in her generation also wrote memoirs; for example, Brassaï later wrote erudite studies of literature and culture, Man Ray wrote a witty self-portrait at the end of his life, and Gisèle Freund wrote about the history of her period. Yet few of them shared Krull's lifelong passion for autobiography; she left behind six book-length self-portraits—autobiographical writings, both fictionalized and documentary.[4] Perhaps she was driven to write because she was surrounded throughout her life by writers, including such close friends as Max Horkheimer, Jean Cocteau, and André Malraux. Or perhaps she felt that it was essential to reinsert herself into a dialogue that was largely nonexistent for photographers; she knew her work was important, but the exterior world did not recognize individual photographic excellence in either commercial practice or the art world until well after World War II. Or perhaps she chose the memoir as a private means of self-construction because more public recognition was closed to many women photographers during her era.

In any case, Krull constructed several different sorts of tales, relating the events that catapulted her into so many different situations and her successful use of them to land on her feet and further her career. In "Chien-fou" and "Ceux de Brazzaville," unpublished memoirs written in the mid-1930s and 1940s, respectively, she placed herself into the center of the major political battles she shared ("Chien-fou" was structured as a novel set in post–World War I Germany, "Ceux de Brazzaville" was a World War II African memoir with loosely disguised names).[5] In *Bangkok: Siam's City of Angels* and *Tales from Siam*, written in Thailand in the 1960s, she presented herself as the doyenne of postwar Southeast Asian life, telling roughly verifiable sagas of the luminaries and odd characters she encountered but romanticizing Thai life to exclude political realities. "Click

entre deux guerres," a memoir of the interwar years, and "La vie mène la danse," a full autobiography encompassing her entire life, were both written during the last ten years of her life. In these two works (one published during her life, one appearing only posthumously), Krull for the first time attempted to reconstruct herself as a modern artist. Unlike Man Ray in his *Self-Portrait*, however, she conflated art, commerce, adventure, and friendships, speaking very little about the value of her photographs and much more about the importance of her contacts and friends. Krull's life and work were inseparable—in her eyes, at least. These manuscripts are invaluable but problematic sources; they present the photographer's varying myths of herself and a certain amount of information unavailable elsewhere. Their greatest value, however, is similar to that of the pictures themselves: both must be closely read and decoded for their symbolic representations of an era.

Krull's photographic archive, or the lack of it, also has played an important role in allowing us to see her multileveled career with clarity. Her oeuvre has remained elusive, largely because she lost her negatives from the period before World War II. When the war broke out, she left her early archives with a friend, and they have never been recovered. Her contributions to the photographic world, therefore, must be reassembled from periodicals, exhibition histories, and the popular press where she published so much of her work, forcing an approach that is more inclusive than one centered only around an artist's own archive of master prints (such as that of Alfred Stieglitz, to cite the most renowned example of an artist-controlled archive). Of course, recently rediscovered vintage prints, too, reveal invaluable clues about Krull's stylistic interpretations of her time, her working methods, and her relationships with patrons and press. In short, a close reading of the photographic evidence is essential, in all its manifestations.

The slow pace of Krull's rediscovery can be attributed to several potential causes. As a woman photographer, she was nearly invisible in the first reconstruction of photographic modernism that resurrected artist-photographers such as Moholy-Nagy, Man Ray, and others whose work in other media developed a wider audience for their photography. As an emigrant from Europe, she was honestly ignorant of the growing interest in her medium, although she had fleeting contacts with art dealers. As a less-than-savvy self-promoter, she also lagged behind many photographic colleagues who began to reassemble their careers sooner than she. I believe, however, that a more fundamental reason drove Krull's long dormancy within the canon of international modernism. The photographer herself contributed to the unconventional history of her artistic legacy; if we can believe her memoirs, she was more conscious than many of her contemporaries of her complex role as a photographer. By essentially ignoring the artistic content and value of her work during a large period of her life, she made it clear that exhibition images alone were never the heart and soul of her photography—not

in the 1920s and not in the 1970s. Instead, Krull consistently conflated high art images with mass cultural photographs, particularly those used in the picture press and for political reportage. In her own choices, then, she followed an unconventional path that has seemed at odds with the standard usage and purist preservation of modernist photography.

This book falls into three sections that not only mirror the broad geographical and chronological divisions of Krull's activities, but also incorporate the large issues with which she grappled as she constantly renegotiated her position regarding modernism. The narrative divides logically into three geographical and chronological sections—Germany and Russia from 1915 to 1925, Holland and France from 1925 to 1940, and Africa and Asia from 1940 until the end of her life—and these divisions signal three philosophical issues as well. Krull reacted to and shaped three of the most exciting and troubling developments of her era— the growing equality of women, the expansion of industrialization, and the decline of colonialism. Her style evolved to suit her situations within these manifestations of contemporary culture. Krull reacted intuitively to the circumstances in which she found herself, while using photography to serve her sense of adventure in a way that was typically male. In her early work, she commented on and eventually transformed representations of the interwar New Woman. As her thoughts about gender and women's roles developed, her nudes and portraits slowly evolved from academic pictorialism to empowering lesbian and playful nude imagery. In France and Holland, in her most famous machine and urban images, Krull skillfully combined abstraction, montage, and selective representation in a commentary on changing attitudes toward the Machine Age. Her images of technology and urbanism permeated high and low culture simultaneously. In her later work, she grappled with the evolving yet still enduring definitions of colonialism as European nations and the non-European world transformed themselves during and after World War II. She condensed her abstracted simplicity to serve political causes, returning to a more transparent documentary style to reinforce her vision of the non-Western world.

It is no accident that Krull learned her craft in Germany during and after World War I or that she engaged in the political battles of the late teens and the evolving sexuality struggles of the 1920s. Germany and Russia in the years from 1915 to 1925 proved a fertile breeding ground for the international photographic commentator that Krull would soon become. She may have chosen photography and been born a German citizen, by chance, but Krull seized the moment and used her various experiences to allow her a far richer training and adolescent experience than nineteenth-century young women had. Marching in Munich in 1918, attending photography school, receiving abortions, living alone, setting up an independent business, and experimenting publicly with bisexuality—all of

these experiences would have been almost impossible before World War I. There were other New Women who shared these experiences in Weimar Germany, but Krull managed to craft a unique position for herself. This was due largely to her photographic profession but also to the peculiar mix of her political experiences, artistic training, and intellectual milieu.

Krull's education during and after the war was artistic, economic, political, and personal. The first chapter in this book introduces her unconventional childhood and photographic education. In addition to a technical and academic training in pictorialist photography, Krull began to work in the commercial arena, establishing studios first in Munich and later in Berlin. Chapter 2 chronicles her induction into the passionate battles of politics, when in Munich and Moscow she marched in demonstrations, attended political events, and landed in jail on more than one occasion. Finally, after a number of lovers, she married her first husband, a young revolutionary named Samuel Levit.

As a young woman pragmatically finding an independent place in her world, Krull epitomized the complex gender issues of her decade. Chapter 3 addresses her attempts to establish herself in Berlin as a professional photographer with a voice of her own. Recent literature on the New Woman of Germany (and France) often suggests that women were typecast by politicians and that in Germany, each cultural stereotype evolved in response to threats perceived by Weimar society. In reality, the New Woman was any and all of these stereotypes, at different moments, as recent literature by Renate Bridenthal, Atina Grossmann, Patrice Petro, Mary Louise Roberts, and many others has demonstrated.[6] The boundaries between categories themselves, however, became blurred, and Krull's experiences epitomized the complexity of the issues. At various moments, Krull was a good girl, a promiscuous lover, a dutiful daughter, a respectable wife, and an independent businesswoman. Eventually, she intermittently cast aside traditional feminine roles and assumed an actively male position in society. The simultaneous existence of so many positions within one person's life and work proves that the evolution of the New Woman was as complex and unstable as recent scholars have recognized. Krull herself had no ambivalence about her multiple roles; she enjoyed them all equally, suffering when things went amiss with work or life and rejoicing in successes ranging from the political to the personal. Her essentially practical and adventurous nature allowed her to react constructively to her varied surroundings.

Krull's writings and photographs reveal that she negotiated for herself an even more compelling position of power during these years. Studies of Weimar culture generally concentrate on men's anxiety about the explosion of independent women, whether in demographic strength, financial independence, promiscuous habits, or cultural representations.[7] Most studies to date believe that the male gaze or point of view was an organizing factor in perceptions of the New

Woman.[8] Krull, however, incorporated both male and female points of view. She influenced how Weimar perceived images of the New Woman and of urban life between the wars. Not only did she occasionally dress in men's clothing, assuming an androgynous position quite common in Weimar culture,[9] but she simultaneously rejoiced in her sexuality as a woman, avoiding militant feminism and enjoying liaisons with men and women alike.

Her camera became her tool of empowerment. Wandering the streets behind the safety of its metallic bulk, she reversed the male gaze and examined her society as a maker, not only receiver, of images. These images had multiple uses—from private sexual titillation to conventional displays of fashionable women in the picture press to even military photographs. Krull did not "become a man" in a simplistic sense, however. She conflated male and female roles, aided by the liberating tool of the camera and its presence in art circles and mass culture, both private and public. As she eventually turned to making street photographs, she began to comment on that most masculine manifestation of modernity, industry itself.

If Krull left Berlin as an explosively powerful New Woman with a broader agenda than many of her colleagues, the years from 1925 to 1940 in Holland and France offered a new series of opportunities and events that she soon exploited fully as a successful professional. Krull entered the art world at the precise moment when photography, in particular, was transforming itself from pictorialism into the experimental and abstracting conception of the New Vision.[10] In the highly industrialized cultures of Holland, France, and Germany, Krull—now liberated from traditional female photographer's roles—seized the opportunity to reflect and actively shape the Machine Age. She became an international photographic eye, amassing the visual clues of her culture and reassembling them in a series of photographic essays that were sometimes poignant, sometimes sensationalist, and always impassioned. In picture stories and books, the photographs use the rhetoric of fact to craft a narrative that has a moral edge.

The great revolution in technology, beginning in the nineteenth century and peaking in the 1920s, fostered a myriad of new inventions—assembly line, steel bridge, railroad, automobile. Siegfried Giedion has defined the symptom of full mechanization as "the assembly line, wherein the entire factory is consolidated into a synchronous organism."[11] At the height of the Machine Age, an international response to mechanization and modernization allowed factories and tools to become iconic symbols of the industrial world.[12] Like many of her colleagues, Krull discovered the beauty of machines and trained her lens on their abstract and symbolic power alike.

Krull created for herself an abstracted machine style in Holland and then introduced it to France. In 1928, her exhibitions, art publications, and popular press imagery exploded onto the French scene, and her career reached its height.

Chapter 4 discusses Krull's Dutch and French industrial photographic language in reference to film montage theory. She imported the precise imagery of Dutch and German industrial photographers to France.[13] Her great gift to the medium, however, was the manner in which she vitalized her work with the experimental ideas and strategies of filmmakers and photographers such as Sergei Eisenstein and László Moholy-Nagy. She energized her subjects with the tactics of montage film theory and presented her French and Dutch audiences, in particular, with an activist critique of the machine world. Her photographic montage technique for exploding industrial imagery developed in partnership with her second husband, the Dutch filmmaker Joris Ivens. Krull's involvement in the Dutch avant-garde—in the Filmliga and in her close friendships with film theorists like Eisenstein, Ivens, and Walther Ruttmann—allowed her to create single images and suites of images that approximated the city symphony films of these colleagues. Her machine photographs and *Métal*, in particular, deconstructed the synchronous assembly line celebrated by Giedion and the politicians of the interwar years and created instead a new industrial symbol of partial, poetic, and highly charged industrial fragments.

Chapter 5 chronicles the role she played in drawing photography into the discourse of high modernist abstraction and her unapologetic use of commercial imagery to craft the pictures she presented as art. Krull's machine imagery transformed in France into a more humanist modernism that included portraiture and, in particular, urban photography. Chapter 6 explores her urban imagery and the popularity of the collage-style photographic picture story in the picture press. Some urban images framed the city in a safe and manageable package for middle-class consumption; others revealed the disruptions and inequalities inherent in the modern world. In addition to the montage structures that worked so well to energize her machine imagery, Krull engaged other formal strategies in her urban work, using structural imbalances and narrative jumps to mimic surrealist chance and the fragments of the detective story structure, both of which also reflected the mystery of the modern city. Chapter 7 examines her photographic books for the popular press, which expanded the role of photography from single images to disjunctive or mysterious groupings. Her exploration of short and long photographic essays led her to develop disjunctive narrative styles such as the detective story. Not only did these projects expand the narrative and symbolic qualities of photography in creating series, but they became cultural texts to be read over time, like films or writings.

When Krull began photographing the forms of industry and urbanism in Holland and France, she simultaneously continued with avant-garde experimentation and worked for corporate clients. Although recent discussions of the Machine Age have depicted it as the province of the avant-garde, Krull crossed into commercialism with enthusiasm, as did many of her colleagues such as

Moholy-Nagy, Herbert Bayer, and El Lissitzky. Not only did she exhibit these subjects on gallery walls, but—far more powerful and troublesome—she placed them in the popular picture press. Her corporate work paralleled that of the American photographer Margaret Bourke-White. But whereas Bourke-White placed herself firmly on the side of popular culture and the mass media and seldom concentrated on exhibiting her work, Krull engaged the industrial world in the theoretical terrain of experimental abstraction, reveling in both the nonrepresentational artistic forms of industry and its horsepower capabilities. Krull's machine and city subjects, in fact, had a larger impact in commercial and popular press imagery, if possible, than in art exhibitions. Her success in both avant-garde and commercial practice makes her an important model for a fuller understanding of how modernist photographers actually worked in the interwar years.

Krull and many of her contemporaries embraced avant-garde art and commerce with no sense of conflict, but their merging of high art and mass culture violates canonical definitions of modernism that since the 1950s have denied their equal worth. As Andreas Huyssen has clearly stated, "Modernism constituted itself through a conscious strategy of exclusion, an anxiety of contamination by its other: an increasingly consuming and engulfing mass culture."[14] Photography, embedded as it is in popular culture, violates this division, but even recent histories of photography often ignore the mass cultural aspect of photography, or, when they do engage it, refuse to address the connections between high and low. However, modernist photographers operating in the interwar years, from Man Ray to Moholy-Nagy to Kertész, *did* engage in both kinds of photography simultaneously, although some denied it later in memoirs and museum presentations, when they repositioned themselves to be marketable in the art world. Krull, on the other hand, consistently celebrated the complex nature of her photographic practice and moved easily between the mass medium and the exhibition wall with no sense of conflict. Huyssen expands his definition of the century to embrace what he calls a historical avant-garde, including German expressionism and Dada, Russian constructivism, and French surrealism, insisting that "the historical avant-garde aimed at developing an alternative relationship between high art and mass culture and thus should be distinguished from modernism, which for the most part insisted on the inherent hostility between high and low."[15] Krull's photographs fall chronologically into the category of the historical avant-garde, and she certainly employed the formal strategies of expressionism, Russian constructivist montage, and surrealism, but she went beyond an "alternative relationship" between high and low to conflate them intentionally.

By the time Krull left Europe in 1940 to work in Africa, Thailand, and India, until the late 1970s, she adopted a documentary style seemingly at odds with modernist abstraction. But although she abandoned abstraction, she re-

tained her ideals of a complex modernist project. Still an autonomous New Woman and still a famous interpreter of the Machine Age for art and commercial worlds alike, Krull ostensibly left Europe to reclaim it from fascism. Her viewpoint, however, remained staunchly European. This stance—first as a Free French military photographer, then as an Asian entrepreneur, and finally as a promulgator of Tibetan Buddhism for a European audience—found her in the throes of another crisis moment of modernism, the late stages of colonialism. Krull adapted her European modernist vocabulary to her new political causes and returned to a more documentary style, but she did not land in these three unlikely places by accident. She believed passionately in freedom and democracy, and her activities, both political and professional, aligned with her attempts to reclaim a powerful position for them. In the years of World War II and its aftermath, the cold war, pure modern democracy became an impossibility, and as another modernist myth fell by the wayside, Krull traveled to Africa and Asia in an attempt to resurrect it.

Although during this latter period of her life she stated that Europe no longer interested her, she operated as a European commentator on imperialism, or the European domination of other parts of the globe, at a pivotal moment when international capital was moving into Africa and Asia. In her businesses, her writings, and her photographs, she repackaged third world events for a European audience, participating in the wartime and postwar institutions of late colonialism. Postcolonial theorists have framed the now-familiar analysis of packaging the East for Western consumption.[16] Edward Said has defined *orientalism* based on the intrinsic difference between East and West, "a way of coming to terms with the Orient that is based on the Orient's special place in European Western experience."[17] This is a political as well as a mythical enterprise, dominated by Britain, France, and the United States, a "Western style for dominating, restructuring, and having authority over the Orient."[18] Although she was remarkably unaware about it, Krull clearly participated in various ways in European domination over other worlds.

Krull's photographic projects and her business activities cast a revealing light on this discourse. European in viewpoint and training but a willing emigrée, she personified the romance of an orientalizing view as an escape from European culture. Speaking from "there" rather than "here," Krull nonetheless remained European, a peculiar hybrid who packaged the cultures she experienced in terms still bounded by her training in interwar Europe.[19] Framed by her European experiences with modernism, her justifications differed for her viewpoints in each place. In Africa, the subject of chapter 8, the war justified colonialist acts of aggression and coercion. In Thailand, discussed in chapter 9, she became one of the most successful European businesswomen in postwar Asia; her business adventures formed an important part of the insemination of Western

capitalist aims into Southeast Asian centers. And in India, addressed in the final chapter, she framed Tibetan Buddhism for a European audience, structuring her last years in a moralistic belief in Asian religion but packaging it in strictly European terms that excluded elements potentially troubling to the mores of European viewers.

Nonetheless, Krull's experiences in the third world paralleled an important development in late colonialism. Despite the independence of many previous French, British, and other colonies, Krull participated in a kind of neo-colonialism, which Fredric Jameson succinctly terms "the replacement of the British Empire by the International Monetary Fund."[20] Her photographs for the Free French proselytized about African industrial contributions to the European war effort, and her military stance as a member of de Gaulle's resistance army led to a position of power. She operated from a similar position in Thailand, and her development of the Oriental Hotel in Bangkok (where important government representatives and multinational businesspeople stayed) contributed significantly to the rising importance of Thailand as a new center for European and global investment. Even in India she remained a wealthy European patron for the monastery she supported.

Tellingly, all three enterprises—feminism, industrialism, and colonialism—failed Krull's idealistic search in some fashion. By the last five or six years of her life, she sensed the collapse of many of the modern institutions she had been most involved in and she returned to photography as a poetic and philosophical tool for organizing her life, finally casting herself in a more conventional formalist role as an artist. She titled her last manuscript "La vie mène la danse" (Life leads the dance), and in it she continued to celebrate the century's rhythm, its multileveled richness, and the chance quality that catapulted her into so many pivotal events. Although she posed as a woman who had abandoned Europe for Asia and thought of herself as a truly international figure, Krull operated as a Eurocentric eye abroad, and she never abandoned the modernist training of her European experiences. Of course, Krull's international photographic eye shaped far more than her life alone: she reflected, filtered, and created some of the most enduring and powerful myths of the era of modernity.

GERMAINE KRULL

PHOTOGRAPHER OF MODERNITY

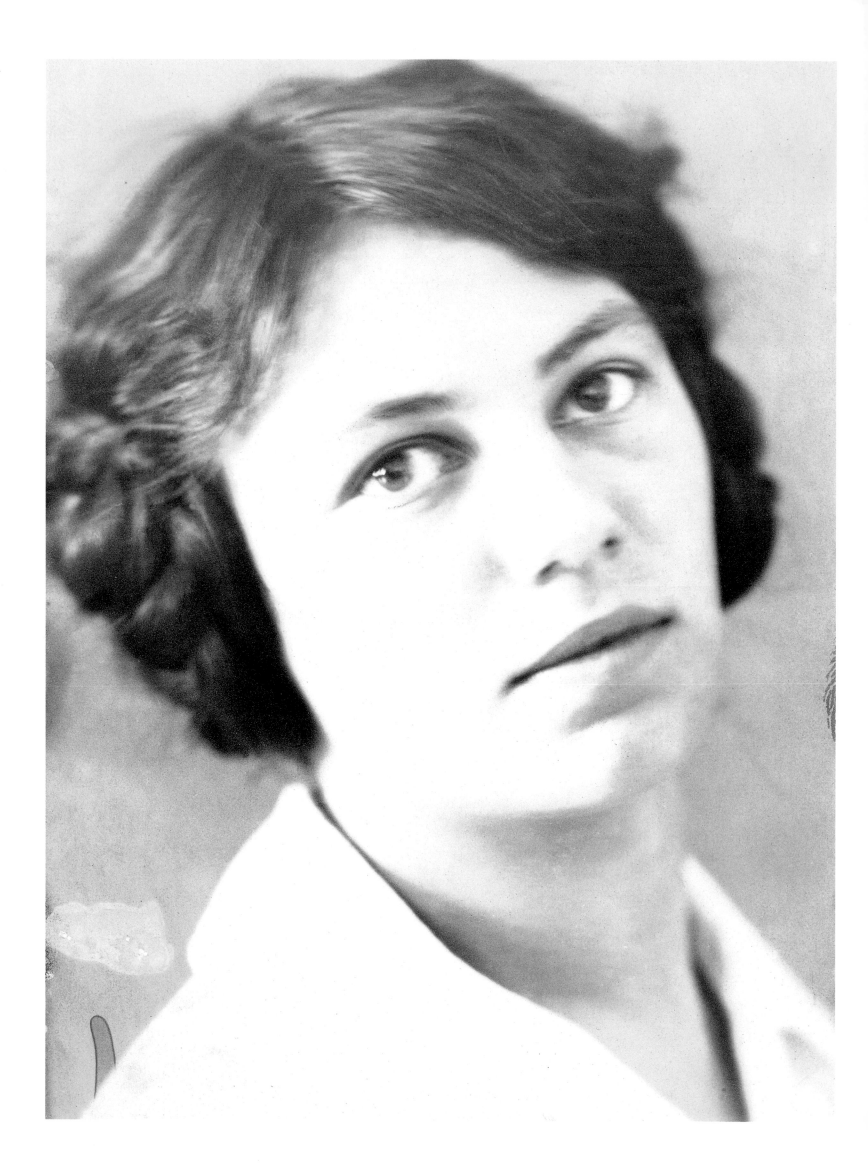

Chien-fou

CHILDHOOD AND STUDENT YEARS IN MUNICH UNTIL 1918

School was a revelation for me, something that I had never known in my life. Everything was new to me—communal working, joint ventures, and above all drawing. . . . There were also classes— chemistry and physics, for example. . . . On the other hand, the laboratory work was a game and a joy for me. My friendships with my comrades were simple and direct. I became friendly with two girls and we were called "the trio." . . . [Eyna] was the one who gave me the nickname I had for years: "Chien-fou" because of my hair which was too long and thick and hard to comb. I let it hang in two braids on either side of my face, which always made me look badly groomed. . . . Our professor, the good Professor Spörl, watched us living. He knew there was something special in the lives of these three girls.[1]

Germaine Luise Krull's 1916 self-portrait illustrates both the photographer's youth and her training as a soft-focus pictorialist (fig. 1.1). Krull made this picture during her student days at the Lehr- und Versuchsanstalt für Photographie in Munich. Framed in a bust-length view, the photographer looks quietly out and lights her face with diffused light from the side, emphasizing the soft and flattering angles of the pictorialist photography she was learning in school. Her youth is revealed by the seriousness of the pose, a gravity that she would bring both to her art and to her politics during these years. She wears a simple white shirt, avoids confrontation with the camera, and presents herself as somewhat dreamy.

Krull's hairstyle betrays her age as well, as she wears her long hair braided around her ears in the schoolgirl style. The wisps of escaping strands suggests the nickname that Krull was given by her fellow students at the Lehr- und Versuchsanstalt für Photographie. Called *Zottel* in German, Krull later translated this essentially

PRECEDING SPREAD:
FIGURE 1.1
GERMAINE KRULL, MUNICH, 1916,
GELATIN SILVER PRINT.
13.9 x 8.8 CM.,
GERMAINE KRULL NACHLASS.
MUSEUM FOLKWANG, ESSEN

untranslatable slang nickname into "Chien-fou" when she began to write about her life in French in the 1930s. The German phrase loosely means "messy," "untidy," or "disheveled." In her own French translation, she dramatized her nickname from messiness into a quality of madness, incorporating the dramatic elements of German expressionism by calling herself "mad dog."

Krull's first autobiographical manuscript—a fictionalized tale of her early years—is titled "Chien-fou." It covers the years until 1922, and in it Krull places herself and her companions in a highly colored version of the events discussed in this chapter and the following one. The passion that was still lacking in her early self-portrait is fully present in her representation of her life in the memoir, whose title emphasizes the wild quality—politically, emotionally, and sexually—of these expressionist years. Krull translated *Zottel* into the masculine *Chien-fou* rather than the feminine *Chienne-folle*.[2] Even bearing in mind the negative connotations of *bitch*, this was an empowering act that allowed Krull to lift herself out of her woman's body to experience life as she wished—male or female.

Krull chose an unconventional life, but she was given a singularly unusual childhood that provided her with unique experiences. The vagaries and adventures that marked her childhood offered important models for the choices that the photographer made later in her life, and many of them revolved around her father. Krull's father, Johann Friedrich Krull (fig. 1.2), was a significant, if not always positive figure in her youth. A brilliant but peripatetic engineer, he adopted a distinctly unorthodox life for himself and his family. Rejecting the idea of formal schooling, he preferred to teach Germaine himself, imparting to his older daughter his own views of religion, revolution, and independence. Not until the eighteen-year-old entered the Lehr-und Versuchsanstalt für Photographie in the autumn of 1915 did she encounter conventional schooling or traditions. Her close friendships there and the support of her professor were particularly significant because she had never before experienced communal school life. The unlikely combination of a wildly unstructured childhood and a strong pictorialist training in the photography program laid the foundation for an early adulthood that was to be both politically radical and artistically conventional.

An Unconventional Childhood

Many of the beliefs and moral values that Krull retained throughout her life stemmed from her childhood experiences. Krull's father, a free-thinker and engineer, schooled her at home and taught her to distrust most conventional bourgeois beliefs, from religion to capitalism. Her revolutionary political career owed its passion and its independence of thought to her father, although she had personal conflicts with him. Krull's mother, a more nurturing figure, also influenced her daughter, both in her unconcerned parenting and in her idiosyncratic sexual mores. The patterns they demonstrated to her—trusting in new causes and then feeling betrayed by their lack of purity—would be repeated often in Krull's life.

The Krull family moved so frequently during Germaine's early childhood that the two memoirs that address it can give only a broad picture; what they do achieve, however, is a picture of turbulence caused largely by her father's idiosyncrasies.[3] Germaine Krull was born on 29 November 1897 in Wilda in the urban district of Poznan. Poznan was then on the German-Polish border, in East Prussia, but became part of Poland after World War I. Her father, a Hamburg citizen, had married Albertine Kunigunde Engelbrecht, a young woman from Nuremberg (fig. 1.3). Albertine's wealthy family tried to set Friedrich Krull up as the chief engineer in Bosnia, but after Germaine was born, the family traveled widely from job to job, and from place to place. Frequent moves rendered continuity in education or friendships close to impossible. Throughout Germaine's childhood, the Krulls moved erratically from country to country in the wake of her parents' monetary difficulties and her father's interests. (Krull herself followed this pattern throughout her life. In many ways, she was a woman without a country.) In her memoirs, the photographer recalls early sojourns in such varied places as Bosnia, Rome, Paris, Montreux (Switzerland), La Mounia (near Graz, Austria), Bad Aibling (Bavaria), and finally Munich. She recounts periodic trips to Nuremberg to visit her maternal grandparents and numerous battles over Albertine's inheritance. In Paris, they lived first in the city and then in the suburb of Asnières (1906), where her mother ran a *pension* or boarding house. At

this time her only sister, Berthe, was born.[4] Albertine's mother died in 1906, freeing up more funds. With the inheritance, the family seems to have purchased a farm not far from Graz, which Krull describes in her memoirs as a virulently anti-Prussian and anti-German area. "Chien-fou" follows their path after the farm adventure failed—first to Switzerland but soon again to Bad Aibling, Bavaria, where Krull recounts that her mother ran a *pension* for four years. After Germaine's parents separated in 1912, Albertine seems to have opened another *pension* in Munich, near the university.

Partially due to their travels but also because of her father's unconventional beliefs, Germaine never attended school as a child; her father taught her at home. Krull writes that in Paris she had a governess for a short time,[5] but the woman was fired. The memoirs suggest that the family moved to Montreux, Switzerland, at least in part because Germaine would have had to take school exams in France.[6] She writes of briefly attending a convent school in Bad Aibling, in Bavaria,[7] but recalls that the nuns could not understand this young girl who knew natural history and philosophy but not history or spelling: "I read like a child of four years old, and I had terrible handwriting. On the other hand, I knew the Prologue of *Faust* by heart."[8] All in all, although the exact details remain unclear, it is evident that Friedrich Krull taught his older daughter brilliantly but sporadically during these years, concentrating on the issues that were important to him.

In "Chien-fou," Germaine describes her father's educational ideas in political terms that she appears to have agreed with, more or less: "Hans Karol [Friedrich Krull] is the enemy of school just as he is against all that calls itself education. For him, all of this is stuffing the brain with bourgeois ideas. 'My daughter should form herself all alone.'"[9] As a result, she recalls learning Schopenhauer, Nietzsche, and Hegel but not the standard schoolbook histories of Napoleon and Charlemagne. Although Friedrich Krull's influence waned by 1912, when her parents separated, the memoirs relate that financial needs kept the fifteen-year-old Germaine home from school after that. (Germaine's younger sister Berthe, born in 1906, had a more conventional schooling, largely because her parents had separated by the time Berthe reached school age.) In many ways, Krull's lack of formal education made her self-conscious throughout her life. She wrote prolifically but never grammatically; she spoke many languages but none perfectly; and photography was the only language

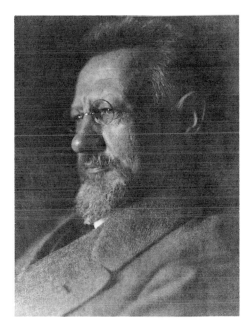

that she learned in an academic setting and that she could then transform from a base of conventional information rather than vernacular knowledge. It became not only her eye onto the world but her own voice to the world.

Despite her lack of schoolroom learning, Krull achieved an idiosyncratic grasp of moral issues in early childhood. Her father was a determined free-thinker, and he vociferously expressed his ideas about religion and morality. In fact, the photographer opens her memoirs with a memory of her father's individualistic religious training, recounting his explanation of Christ's meaning to his small daughter:

> *"What does that mean, that man nailed onto a cross?" Papa caressed me and told me softly that it was a sad story. We sat down and he told me the story. He told me that there was a man long ago, long before Mother and Papa were born, and that this man was good and wanted to help the poor. Mean men killed him and now people make a god of him. . . . For Papa, Christ was the first revolutionary, and that consoled me, because revolutionaries were good men, said Papa. . . . Papa comforted me. He told me that I should not believe in it, but that in order to do that I must be stronger than society. He hugged me in telling me that I shouldn't talk of such things in the house. The maid would be shocked because she is a believing Christian.*[10]

In telling his five-year-old daughter that Christ was a good man but not a god, Friedrich Krull was embarking

FIGURE 1.2
FRIEDRICH KRULL, MUNICH, 1915.
GELATIN SILVER PRINT, 14.4 x 10.5 CM.,
GERMAINE KRULL NACHLASS, MUSEUM FOLKWANG, ESSEN

on an education that would shape hers, intentionally and unintentionally, throughout her life, and by opening her memoirs with the tale she proves that his ideas made a decided impact. Yet he also taught her certain tools for surviving as an unconventional thinker; when he told her bluntly not to believe, he also counseled her to avoid controversy by not discussing his interpretation of Jesus with the traditionally minded maid. Clearly, in Friedrich Krull's eyes, revolutionaries were the true heroes: "There are good men, like Christ, who want to help the workers. These are the revolutionaries. But mean men always kill them or hurt them."[11] Krull adopted her father's almost religious belief in workers and adhered to it through disillusionment, changes of allegiance, and the repudiation of whole political creeds. She also credited her father with a lack of fear about taking an uncommon path and seems to have followed this pattern as well.

In one of the more bizarre aspects of an unusual childhood, which she relates with relish in her memoirs, Krull was dressed as a boy for several years beginning in 1906 when she was nine years old and the family was living in Paris. The photographer recalls that her father found this a good solution, telling Albertine Krull, "You always wanted a boy," but that her mother was less convinced, until she realized that Germaine's dresses were uniformly ruined by tree climbing.[12] The photographer remembers that she reveled in the freedom: "I was proud; no more ribbons, no more white dresses, and above all no more curtsies when saying hello."[13] She seems to have kept the boys' garb throughout the family's stay in France, during their 1907 farm experiment in La Mounia, in Paris, and until their short stay in Switzerland. In her memoirs, she recounts that she resumed wearing dresses only when she fell and injured her head after a fight with some boys. Friedrich Krull's idea of dressing a girl as a boy allowed his daughter both the freedom and the trauma of experiencing childhood from a variety of viewpoints. Even if this experience did not shape her adult life markedly, it offered a model for ignoring standard gender roles, and she certainly transcended conventional women's activities in her later life.

Switches from boys' to girls' clothing were only one of the mixed messages about gender issues that had roots in Krull's childhood and that occupied her throughout her life. The troubled relationship between her parents had an impact on her as well. Although her memoirs recount Friedrich Krull's influence on his

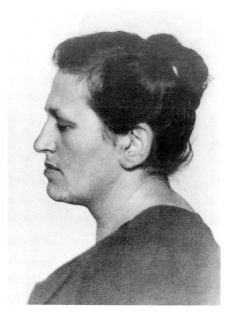

daughter's thinking, the allegiances had turned by her early teens. The frequent fights between her parents and almost constant financial arguments soon led her to side with her mother against her father: "After long arguments and disagreeable scenes, the parents decided to separate. Papa left, and the household sighed with relief."[14] Krull's father no longer lived with them permanently after 1912, and Albertine Krull opened yet another *pension* in Munich, where Krull recounted that she rented rooms to a handful of university students for an income. From this point onward, Friedrich Krull's anticlerical and anticapitalist viewpoint was countered by the more nurturing views of her mother.

During their troubled marriage, her mother and father alike seem to have had many other sexual partners, and Krull followed this pattern in her adult life as well. The two memoirs recount Albertine's admirers, including "l'oncle Joyce" in Paris whom Krull represented as Berthe's father, the Marquis de Tattara in Bavaria, and many others. Oddly, Krull related that these admirers seem to have befriended her father as well as her mother. More surprisingly, at least in the version that Krull gives us, both parents seem to have looked leniently on Germaine's early liaisons with her mother's boarders, beginning when she was barely fifteen years old. "La vie mène la danse" represents her mother's only comment on her first lover, a student boarder named Harbeck in the memoirs: "Do what you want, but a child would be the death of me. Never. You understand, you must pay attention."[15] The force of this unconventional comment is amplified in "Chien-fou," and clearly Albertine's horror at the prospect of a pregnant daughter carried much weight in Germaine's mind. The memoirs

FIGURE 1.3

GERMAINE KRULL. ALBERTINE KUNIGUNDE ENGELBRECHT KRULL. 1945. GELATIN SILVER PRINT. 11.7 x 8.5 CM..

GERMAINE KRULL NACHLASS. MUSEUM FOLKWANG. ESSEN

recount that her first pregnancy miscarried naturally, but a second pregnancy, with a second boarder named Emil Peters (a music student) created greater problems. As she reconstructs the events in her memoirs, Krull became engaged to Peters, followed him to Berlin after the beginning of World War I in 1914, but soon broke off relations and received an illegal abortion in the winter of 1915.[16]

Her relations with her mother, which had been relatively good until then, broke down completely after Albertine told her that they would have raised the baby; Germaine never forgave her mother for, in her view, forcing her to have the abortion. As she dramatically writes in "Chien-fou": "Alice [Albertine], who Maria [Germaine] adores, for whom she had just sacrificed her baby, disappeared. . . . Nothing remained but a single phrase which hammered into her head: 'We would have raised it.' . . . A bitterness without end rose in her mind."[17] The image of the lost fetus haunted her for months, and she refers to it sporadically throughout her memoirs for the next few years.[18] By the time of these events, both parents had left an indelible mark on her future, both positive and negative. Her father had promoted her independent free-thinking values but abandoned the family; her mother had loved and supported her but betrayed her emotionally.

Photography School in Munich

After this abrupt initiation into adulthood, Germaine decided in the autumn of 1915 to escape from parental control and to become independent by studying a trade. She wished to enter the university but was ejected for lack of a degree. Krull recalls that her father "left her a strong heritage of liberty, but no knowledge."[19] With no formal schooling, her choices of trade schools in Munich were limited to bookbinding and photography.[20] Krull chose photography as a likely trade because of the strong reputation of the photography school in Munich, but the almost accidental nature of her career choice contrasts strongly with the fame it later brought her. The years she spent at the Lehr- und Versuchs-anstalt für Photographie from the 1915–1916 academic year to the summer of 1917 or 1918 were her first sustained classroom experiences.[21] This period marked a distancing from her family. Krull relates that she lived at home and remained close to her younger sister Berthe, but she rarely spoke with her mother during

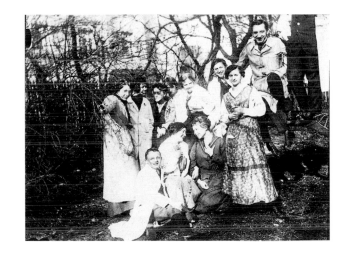

these years. Albertine was now separated from Friedrich[22] and, according to the memoirs, living on an allowance from her brother, Max. Krull represents Albertine as having a new set of friends and working sporadically with the wartime black market:

> I did not return often to the house, but its
> atmosphere was always just as cold, and my
> mother was never there. Mother took her path,
> and I should say that we never lacked anything
> from the point of view of food, but for the rest,
> she was very far away from me.[23]

To take the place of her family, she began to develop close friendships with her peers, as can be seen in a group portrait of her fellow students at the Lehr- und Versuchsanstalt für Photographie (fig. 1.4). Her closest friends at the photography school were dark-haired Käthi Lux, a half-Russian whom Krull called Katja, and frail, blond Erna Messerschmidt, whom Krull called Eyna or Moritz.[24] The three were inseparable, except that Germaine confided in no one about her recent abortion. These were the friends who gave Germaine the nickname of *Zottel*.[25] In later years, Krull's wide circle of lifelong friends—from Munich and later—would serve as her family.

During her years in school and immediately after, Krull began to develop her mastery of the photographic language. For the first time, she received a rigorous academic training. For a student whose background included only private tutoring, this was a transformative experience. Even though she later moved away from the pictorialist training of the school, she formed a strong

FIGURE 1.4

GROUP PORTRAIT, PHOTOGRAPHY SCHOOL, MUNICH [KRULL STANDING SECOND FROM LEFT WITH BRAIDS], 1916. GELATIN SILVER PRINT, 8.8 x 14 CM., GERMAINE KRULL NACHLASS, MUSEUM FOLKWANG, ESSEN

belief in the power of art photography. A strong practical streak, however, led her to open a commercial art photography studio immediately after graduating, proving that she was comfortable with both the exhibition and the commercial facets of her new trade. Krull embraced these dual uses of photography, which were sometimes congruent and sometimes contradictory, throughout her life. The school also gave her a professional diploma and allowed her to begin an independent career—a tool she valued (whether she was successful or bankrupt) from then onward. Finally, several of the subjects she continued to explore began as early as 1918, particularly her fascination with portraiture and nude photography.

Krull's intellectual, political, and creative life began during her photography schooling. Her pattern, in fact, was not markedly different from other women of her generation who did not—and were not expected to—attend university; they studied trades such as ceramics, photography, hairdressing, dressmaking, or cosmetology, gaining diplomas or certificates in these trades and usually practicing them until their marriages. By the time her career was established, several years after the end of the war, she was one of many working women. Photography was a popular women's profession, and many women in the 1920s echoed the sentiments of photographer Ilse Siebert: "Being a housewife didn't interest me."[26] In the recent 1994 Museum Folkwang exhibition of Weimar women, the list of photographers included fifty-three women working between the wars in Germany, and a 1931 yearbook of Berlin photographers lists an astonishing one hundred women among the enormous number of six hundred photographers active that year in the city.[27]

Krull and her female classmates at the photography school outnumbered the men in her class because she studied during World War I, when most men were in active service at the front. Her school contacts, at first enthusiastic about and later disgusted with Germany's involvement in the war, would offer her an entrée to intellectual circles that led directly to her political involvement in 1918 and after. In the meantime, however, her wartime studies placed her at the forefront of the profession that opened to women after the war's end. Photographers were a relatively privileged group among the working women of Weimar Germany. In 1925, 11.48 million of the 24.28 million women in Germany worked.[28]

Tim Mason cites only one and a half million women working in nonmanual fields in 1925—mostly as clerks, typists, and saleswomen. Far fewer women entered the professions, and as late as 1931 only 19,000 women studied in universities.[29] Krull's profession was not as prestigious as medicine: most women trained in photographic techniques were no more than retouchers and technicians. Her education and her independent studio, however, put her above the vast mass of family assistants and manual workers who might have shared her lack of formal secondary education. Despite her unconventional childhood, Krull had found a way to learn a workable trade and to position herself among the Weimar culture's professional classes.

Working women, blue-collar and white-collar alike, formed 35.8 percent of the labor force, and they were universally referred to as the New Woman. Krull not only photographed the New Woman, but she was one herself. Krull and her few photographer colleagues who established their own studios clearly formed part of the urban half of the female working force and exerted more power than their sisters in the manual workforce and than colleagues confined to studio technical assistance and printing. However, their position as independent entrepreneurs was even more unusual, for even teachers were salaried and lacked the independence of owning their own businesses. Moreover, photographers were tastemakers as well as consumers of Weimar culture; they became vicarious participants in social, cultural, and political events through their camera lenses. They embodied not only the lifestyle of the New Woman but, as intellectuals and entrepreneurs, became her conscience.

Women (and men) who desired to become professional photographers could follow two paths—apprenticeship in a studio or attendance at one of the few photographic schools in Germany. As Ute Eskildsen explains, the generation of women who were born around 1900 began in the 1920s to consider photography not only a handicraft but an avocation.[30] In Germany, two schools offered the best photographic training available to women—Krull's program in Munich and the Photographische Lehranstalt des Lette-Vereins in Berlin. A third—the Photographische Lehranstalt für Damen des Breslauer Frauenbildungs Verein—opened in Breslau in 1891.[31]

The Lette-Verein stemmed directly from the late-nineteenth-century changes that allowed women to study and to work. Originally, women could study photography only privately in studios. Change occurred first through Wilhelm Adolf Lette, the founder in 1865 of the Verein zur Förderung der Erwerbstätigkeit des Weiblichen Geschlechts.[32] Lette, however, had been teaching a few students privately since 1866 and taught women at the Gründung der Handels- und Gewerbeschule (1872) and the Haushaltsschule (1886). He opened his Photographische Lehranstalt on 15 October 1890, offering photographic handwork, lithography, and graphic technical training to a select group of thirteen students.[33] By 1919, with men admitted from 1910 onward as well, 337 students were enrolled at the Berlin school. The Lette-Verein offered such varied fields as photomechanical reproduction, portrait photography, and technical photography. Krull's program, the Lehr- und Versuchsanstalt für Photographie in Munich, began admitting women in 1905.[34]

The Munich Lehr- und Versuchsanstalt für Photographie was founded on 15 October 1900 by the journalist and photographic dealer Georg Heinrich Emmerich. It differed from the Lette-Verein's emphasis on technical and handicraft skills and concentrated also on the traditions of pictorialist photography. Renamed the Höhere Fachschule für Phototechnik in 1921 and the Bayerische Staatslehranstalt für Lichtbildwesen in 1928, it still operates today under the name Staatliche Fachakademie für Fotodesign München. Although Hamburg was more famous, the city of Munich had been a center for pictorialist photography since the 1898 International Elite Exhibition of Art Photographs in the Secession, and the school included a large library of more than a thousand volumes from Germany, England, France, and the United States, as well as a teaching collection of photographs by such art photography luminaries as Hugo Henneberg, Heinrich Kühn, and Alfred Stieglitz.[35] Krull may have stumbled onto a professional trade, but the particular character of this photography school was ideally suited to give her a comprehensive background in art history, photography, and commerce.

Like most women's photography programs, the Munich school was geared to daughters of bourgeois families like Krull's. The first women students were Sophie Reynier and Wanda von Debschitz-Kunowski (wife of the founder of the art school of Wilhelm von Debschitz),[36] and women formed one-third of the student body by the onset of the war. Although Krull attended without a primary school certificate, she was one of the only students listed as being solely privately tutored. Men were admitted above age fifteen, women above the age of seventeen (Krull was eighteen when she entered).[37] When she passed examinations in the summer of 1917 in drawing, chemistry, physics, book arts, and optics, her class of twenty-seven consisted of twenty-one women and only six men. By the 1920s, the ratio had balanced, with roughly equal numbers of men and women.

The two-year photography program was taught by Rudolf Lähnemann and Hans Spörl (who was named director in 1919) and included elementary drawing from models, physics, photochemistry, practical photography, and bookkeeping. Gum bichromate processes, combination processes, photogravure and collotype processes, and retouching were taught. Students also received lectures in art history. The course ended with an exam (Gehilfenprüfung). Some women students attended for a supplemental third year, and the third year became standard by the 1920s.[38]

In addition to technical training for professional photographers, the school concentrated heavily on the pictorialist photography ethos developed around 1900, and classes were taught from 1907 until 1913 by the American photographer Frank Eugene, among others. Eugene, born Frank Eugene Smith in New York in 1886, brought international pictorialism to Munich. Although Krull entered the school in 1915, two years after Eugene's departure, his strong teaching style marked his students and colleagues alike and thus affected her early development. A member of two seminal pictorialist photography groups, the American Photo-Secession and the British Linked Ring, Eugene's friends included Francis Brugière, F. Holland Day, Heinrich Kühn, Edward Steichen, and Alfred Stieglitz.[39] He also provided a direct link with his friend Alfred Stieglitz, a visitor to Munich who in 1911 donated two hundred Photo-Secession photographs to the school for the opening of a new building to form the core of a "model collection."[40] Students clearly were shaped by their exposure to this world, and Eugene noted that fourteen of his students purchased the issues of *Camera Work* in which his own work was reproduced.[41] In addition to his role as a

contact with the world of international pictorialism, Eugene's power as a teacher was appreciated: one critic lauded his "original and unusual compositions" and his ability to "communicate his ideas on pictorial composition to his students."[42] This article in the *Deutscher Camera-Almanach* was illustrated by student work, including photographs by Wanda von Debschitz-Kunowski and Josef Pécsi, two Eugene students who would later collaborate with Krull on her first portfolio of nudes.[43]

Krull's training in the midst of World War I, therefore, was in classically pictorialist photography. After the war, the pictorialist slant of the school's program continued through the exacting teachings of Franz Grainer from 1916 to 1921 but shifted toward sharp-focus imagery in the 1920s with the appointment of younger staff like former students Hanna Seewald and Willy Zielke.[44]

Hence Krull's training was not only as a technical craftsperson but also as a professional photographer skilled in the same pictorialist style so popular before World War I throughout Europe and America. Like Edward Weston in the United States, she soon moved away from her early training, but it is important to note that her professional training covered aesthetic as well as technical issues. By attending school in the pictorialist-centered teens rather than during the sharp-focus-dominated 1920s, she learned techniques and aesthetics associated with the turn of the century.

When Krull emerged with her master certificate in photography from the Lehr- und Versuchsanstalt für Photographie, the course had provided her first intellectual and practical tools outside her family structure. She writes fondly of her teacher Hans Spörl, who seems to have supported her in several ways—finding her scholarship money, encouraging her work, and watching over Krull and her two friends with a kindly eye. Her graduation portfolio included a 1916 or 1917 portrait (now lost) of her little sister Berthe. According to her memoirs, this image was accepted as one of the best student projects of the year. Krull writes of her effort to capture the impression of an angel:

> One day Berthe, who had just had her first communion, came to pose in the studio. She was such a beautiful child and so angelic that I wanted to express this in a photograph. I made a lot of exposures, and it was truly the image of an angel and not of a girl.[45]

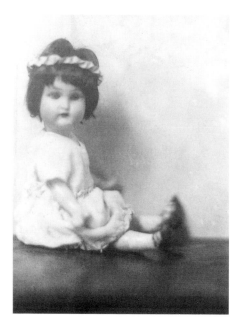

This statement also highlights the difference between Germaine and Berthe Krull's upbringing by casually noting the first communion of her younger sister while she herself had been taught not to believe in Christ by her father.[46] More important, it also illustrates her affection for her little sister, whose doll she also photographed at this time (fig. 1.5).

Krull began early to experiment with the photographic medium. Berthe Krull describes the communion picture as follows: "I wore a lovely white silk dress with very small white pearls made out of a dress of my mother's and a crown of white silk roses on my head."[47] She remembers the prize-winning picture as a half-length view, with Berthe looking demurely downward. According to the memoirs, Germaine's professor tried to discourage her from including this image in her final portfolio, fearing that it was too radical for the judging professors, although with no image surviving, we cannot know how different it was from nineteenth-century art photography like that of Julia Margaret Cameron or from other accepted pictorialist portraits. But Krull relates that the school's panel of judges, after questioning her on the image and its meaning, passed her and kept the picture.

Studio Portraits and Nudes

Despite her training in the pictorialist techniques internationally popular among amateur art photographers, Krull's training was to be a professional photographer, and she always viewed herself as a commercial photographer, not as an adherent of the credos of amateurism

FIGURE 1.5
GERMAINE KRULL. THE DOLL ERNA. BERTHE'S FAVORITE DOLL. C. 1916. GELATIN SILVER PRINT. 10.2 x 7.3 CM..
GERMAINE KRULL NACHLASS. MUSEUM FOLKWANG. ESSEN

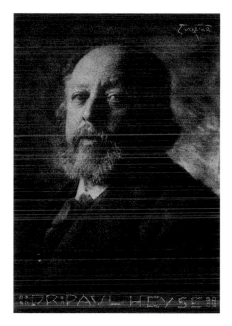

and art for art's sake. Krull probably opened her first photography studio in 1918 in Schwabing, the arts district, and there she presumably hoped to earn a living as a portrait photographer.[48] Although the date cannot be verified precisely, she must have opened for business in that year because the Munich city address book first listed her in 1919 as "Germaine Luise Krull, Werkstatt für mod. Künstlerische Photographie, Hohenzollernstraße 5, Gartengebäude."[49] The book repeated the listing in 1920 but no longer listed her in 1921. She usually made portraits and nudes during these first years, in a style that reflected few departures from her pictorialist training. Most of this work is lost, and our knowledge of her early work is limited, but it conformed to the pictorialist practice of traditional subjects borrowed from painting.

Portraits

A surviving portrait of Krull's father from her school years (fig. 1.2) suggests that the photographer was making conventional portraits but allowing the sitter's strong personality to emerge through his piercing glance. Since Friedrich Krull died in the spring of 1917, this image must have been executed while she was still a student. Its dark background and dramatically lit profile recalls the pictorialist portraits of Frank Eugene, particularly his famous 1899 image of Alfred Stieglitz as a young man. Clearly, Eugene's style still dominated the Munich school even though he had departed from Munich in 1913, two years before Krull enrolled. In fact, Eugene made many of his portraits of friends in the studios of the Lehr- und Versuchsanstalt, so that it is possible that the settings of both photographers' portraits are similar.[50] For example, Krull's series of dramatically lit heads, silhouetted against a dark background, strongly resemble Frank Eugene's 1910 portraits of the neoclassicist poet and Nobel Prize-winner Paul Heyse (fig. 1.6).

The Independent Socialist leader Kurt Eisner, who would create the Bavarian Republic in November 1918, was one of Krull's first professional portrait clients (plate 1.1). Krull met Eisner through family friends and became interested in political activities through her student circles. The dramatic effect of this connection is fully discussed in the next chapter, which concentrates on Krull's political experiences during and after World War I. However, Krull knew the political leader well enough before February 1918 to take an early portrait of him in her new studio. This photograph respects Krull's

traditional photographic training and resembles the similarly dark portrait of her father. With its dark tones and dramatic formal lighting, a conventional rather than a daring composition, it signals the beginning of her political awakening rather than her journey into photographic modernism. In this photograph, Eisner still looks like the journalist and drama critic he was before 1918. He returned for a second sitting in November 1918 (plate 1.2). As in the portrait of Krull's father, Eisner's head in the November portrait is dramatically lit from a limited light and silhouetted against a dark background. The lighting creates the effect of a Rembrandt etching, and the illuminated balding head symbolizes drama and intellectual thought in a style widely accepted among art photographers and studio portraitists ranging from Julia Margaret Cameron to Edward Steichen. In the later photographs, Eisner, with longer beard and hair, appears much older and more tired than the first portrait. The chiaroscuro effect gives him the appearance of a serious thinker, a philosopher. Krull also made Eisner's death portrait (fig. 1.7) after his February 1919 assassination.

The young photographer attempted to attract other clients and writes in her memoir of her plan to invite local actors for free photos. To her surprise, she recounts, they came: "I set to work writing to the famous artists, with no expectations of response. But human vanity knows no bounds: they all came."[51] None of these images survive, although three portraits of the dancer Hilde Brumof in the Deutsches Tanzarchiv may well be from this period (see plate 1.3).[52] In a style very similar to the Munich school's training, Brumof, who studied ballet at the Staatstheater in Munich, appears

FIGURE 1.6

FRANK EUGENE. PAUL HEYSE.

C. 1910. PHOTOGRAVURE. 17.0 x 12.0 CM..

COLLECTION DR. CHRISTIAN BRANDSTÄTTER, VIENNA

demurely framed, with the winsome beauty and soft fo-
cus characteristic of Eugene and his followers.

Although Krull was just beginning her business por-
trait practice, she was following accepted patterns of
photographic behavior in concentrating on portraiture.
In 1907, Frank Eugene compiled and exhibited a similar
series of portraits of Munich artists, including Franz
Defregger, Franz von Stuck, and Fritz von Uhde.[53]
Pictorialist portraits of artists were popular subjects
among other studio portrait photographers in Munich,
as well. Krull's better-known Munich colleagues during
her first years in practice included Franz Grainer,
Elisabeth Hecker (Atelier Elisabeth), Stephanie Ludwig-
Held (Atelier Veritas), the brothers Lützel, Elias von
Bommel, Wanda von Debschitz-Kunowski, and Eduard
Wasow.[54]

Nudes

During these years, Krull was also working on nude
photographs—a second established subject for pic-
torialist photographers. Her first publication was a
self-published portfolio of nudes in collaboration with
two better-known and older photographers, *Der Akt:
Zwanzig photographische Aufnahmen weiblicher Körper nach
der Natur*. This volume of twenty images was published
in 1918; it included seven of Krull's photographs as well
as four by Josef Pécsi, a well-known Hungarian pictorial-
ist photographer, and nine by Wanda von Debschitz-
Kunowski.[55] Both Josef Pécsi and Wanda von Debschitz-
Kunowski had studied with Frank Eugene at the Lehr-
und Versuchsanstalt für Photographie in Munich, and
from 1905 to 1914 Debschitz-Kunowski taught at her
husband's newly established reform art school, the
Debschitz-Schule.[56] Like Krull, she would open a studio
in Berlin in the early 1920s. These twenty photographs
are bound together into a beautifully produced book,
with hand wood-block-pressed lettering. The pho-
tographs are photogravures, like some images in Alfred
Stieglitz's magazine *Camera Work*, and they are tipped
into the book in the same fashion. Krull recalled that
she, Pécsi, and Debschitz-Kunowski hand-tipped the
photographs into the books themselves, since they had
no funds to have it done professionally.[57] The portfolio,
in fact, bears a resemblance to Frank Eugene's *HAWE*
portfolio, a 1914 compilation of twelve photogravures
of classically posed male nudes, published by Hans
Wittmann.[58]

In these photographs, Krull's impeccable pictorialist
training is evident. The soft shadows, artistic backdrops,

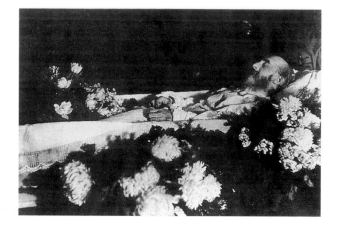

and manipulated imagery are on a par with the nudes of
Clarence White and Robert Demachy, two of the best
nude photographers of the parallel American and
French pictorialist movements. They also bear a distinct
relation to Frank Eugene's nude studies of women. The
three photographers in this portfolio—all students of
Eugene—display distinct styles. Pécsi's images are more
frankly theatrical, with demure girls holding props like
cups, garlands, and teapots; one of these graces the
portfolio's cover, presumably because Pécsi was the old-
est and at the time the best known of the photographers
(fig. 1.8). Debschitz-Kunowski's nudes are simpler than
Pécsi's but slightly more artificially posed than Krull's.
Krull's photographs are the most natural and the sim-
plest of the group, displaying a comfort with pictorial
poses and compositional effects while already experi-
menting with lighting, drama, and humor. Some of
these photographs, with their dramatically posed forms
against dark or patterned backgrounds, resemble Robert
Demachy's French pictorialist nudes.[59] One example,
the fifteenth image in the portfolio, shows a seated
young woman whose back is dramatically lit from a
window (plate 1.4). This model, a light-haired woman
who is also the subject of plates 13 and 20 in *Der Akt*,
sits on a patterned blanket in a peaceful scene. The
contrast between flesh and patterned bedspreads would
recur in many of Krull's later nudes in Berlin and
Paris. But the images still fall squarely within the
pictorialist tradition, like an image of a dark-haired
girl's back (plate 1.5), stretching upward into the dark-
ness, which seems very close to the dramatic stretching
pose of Robert Demachy's *Struggle*. Like Demachy, Krull
posed her models in dramatic or classical poses. The

FIGURE 1.7

GERMAINE KRULL. KURT EISNER DEATH PORTRAIT, FEBRUARY 1919.
GELATIN SILVER PRINT. COLLECTION WALTER KRÖPELIN. MUNICH

young photographer, however, generally eschewed the scratching on the print and the hand manipulation of imagery at which Demachy excelled. Her nudes assumed conventional academic poses but remained uncluttered.

The models for Krull's early portfolio of nudes were probably school comrades. We cannot positively identify the dark and blond models as Krull's close friends Eyna and Katja, although this seems a possibility. Clearly, Krull experimented with serious pictorialist nude imagery in this first published project, mastered its technical and formal rules, and was accepted by two senior colleagues who agreed to publish her work alongside theirs. She would return to the subject, with different approaches, in Berlin and Paris.

Social and Intellectual Circles in Schwabing

Krull's two closest friends from school formed the core of her social world in Munich. Krull, in her memoirs, has firm opinions of both: she recalls that Erna Messerschmidt (Eyna) was the more personal friend and eventually became Germaine's studio assistant. Krull generally acted as Eyna's protector, even going so far as to print photos for Eyna's final review portfolio in school. After several years, their relationship eventually waned due to political differences. Käthi Lux (Katja), however, introduced Krull to a broad world of intellectual and political contacts in Munich.

Many of these were based in Schwabing, Munich's historically lively arts district that welcomed students, satirists, political activists, and artists in a Bohemian melting pot. This sector of Munich housed writers such as Thomas Mann, artists such as Vassily Kandinsky, and musicians such as Richard Strauss and Bruno Walter. The many Russian students and visitors included Lenin, who had written *What Is to Be Done* in Munich after the turn of the century.[60] Krull writes of the influence of Mary Wigman's eurythmic dances, Rudolf Steiner's lectures, and new music that the young photographer found difficult to comprehend.[61] She also discusses Lotte Pritzel, a famous puppeteer whom she would later photograph in Berlin, and the writers Stefan Zweig and Rainer Maria Rilke. Of the latter, she writes that "Rilke is the conscience of Schwabing, and a great poet. . . . His judgment has weight; when Rilke speaks of the war, he calmly says what he thinks. The word he uses is simple and quiet: 'a non-sense.'"[62]

Through casual contact with figures like Rilke, who in her memoirs, at least, seems to have visited her studio fairly regularly, Krull began to understand the intellectual aspects of modernism that she would adopt and transform throughout the next decade. The traditional studio training from the photography program was now supplemented by the discussions of the artists in Schwabing. All Germany was engulfed in the final years of World War I, however, and the disillusionment of many of her friends was omnipresent. In the next year or two politics would overwhelm the art circles of Schwabing; even the relatively apolitical Rilke had his flat searched twice by troops during the White terror of 1919.[63]

Rilke was not her only prominent friend.[64] Katja arrived one day with a student, Max Horkheimer, who became a lifelong friend of Krull's, and they shared personal and political discussions for the next half century:

> *One morning, Katja arrived with Max Horkheimer. He seemed all nervous and agitated. He was handsome, tall, thin, and above all a young man of good background. Max Horkheimer came to see me regularly and little by little, this nervous, jumpy spirit became a spirit who was singularly ironic and precise, and also very keen.*[65]

Her description of Horkheimer's close friend and colleague Friedrich Pollock, whom Max brought to see her in the fall of 1918, reveals the instantaneous and enduring nature of their friendship: "I was attracted by Fritz, and he remained my big brother for the rest of his

14.15

FIGURE 1.8
JOSEF PÉCSI. *DER AKT: ZWANZIG PHOTOGRAPHISCHE AUFNAHMEN WEIBLICHER KÖRPER NACH DER NATUR.* DACHAU BEI MÜNCHEN: EINHORN VERLAG. 1920. COVER IMAGE AND PLATE 14. PHOTOGRAVURE. COLLECTION FRANÇOISE DENOYELLE. PARIS

life."[66] Horkheimer and Pollock later became founding members of the Institut für Sozialforschung (Frankfurt School for Social Research), established in 1923.[67] Their circle of friends continued to grow. According to Krull's memoirs, Katja fell in love with a poet and political activist, Ernst Toller, and introduced Germaine, Max, and Friedrich to him. Another friend of Krull's family, Ernst Joske, would draw the photographer into Kurt Eisner's circle.[68]

Even with these student friends introducing her to left-wing intellectual and political circles, Krull had conservative friends as well, including an older, more conservative painter whom she calls Rudi in her memoirs:[69]

> He was a painter, but he was, as we said, completely "pompier." He painted marine views that sold very well. . . . People are crazy, he said. They are fixated on my nasty marine paintings, they want them. And that brings in so much money, so what should I do?[70]

Krull relates in her memoirs that her student friends were disgusted and amazed when Rudi became her lover. Yet despite his conservative paintings, she insists that he taught her much about cubism and modern art. In addition, she continues, his Austrian hatred for the Prussians and the kaiser who allowed the war to continue reinforced the antiwar sentiment in her more liberal circle. If we are to believe her memoirs, Rudi provided the funding for Krull's first studio, paid the first six months' rent, and departed for the war again.

Krull's studio was in Schwabing. With friends like Toller and Rilke, she certainly participated in the broad expressionist movements of poetry, drama, art, and culture that surrounded her. Writers, political activists, poets and others came to visit Krull's studio regularly. Although she never met Thomas Mann or Kandinsky, this was the milieu where she furthered her friendships with Max Horkheimer, Friedrich Pollock, and Rainer Maria Rilke, and undoubtedly others whom she did not list in her memoirs. Schwabing, and the Munich art circles in general, welcomed a contradictory mix of avant-garde and traditional forces. As Franz Blei writes, "Everyone visits everyone else. Everyone is a member of all the circles or of none."[71] Krull openly aspired to be the leader of one of these circles, but at twenty-one it remained a dream. With typical hubris and humor, she describes her hopes in her memoirs:

> At this time, my studio was in a way the meeting place of all of Schwabing, and I dreamed of becoming the Queen of Schwabing. But the most famous people did not yet come to my studio, although some did: Rainer Maria Rilke and Stefan Zweig, but it was not yet really established. The little fairy was not yet the queen! I wanted so much to become the Queen.[72]

Her wish to become the Queen of Schwabing, however, was soon to be interrupted by the political events that swept Munich in November 1918 and carried Krull along with them.

Passion and Politics

MUNICH, 1918–1920, AND MOSCOW, 1921

On this day, the Independent Socialist party of Kurt Eisner and the Bavarian Socialist party asked their members to attend a rally to demand an immediate armistice. When we arrived at the large piazza outside town where the demonstration was to take place, we saw a veritable sea of people waiting. We were surprised. There were women, children, soldiers, intellectuals, and workers, all together. Then Eisner spoke about the war. There was not even a whisper, and when he ended his speech by demanding the end of the war, there was a single outcry: "Armistice, armistice!" The crowd began to march slowly toward the city. We could hear, quietly at first, then more loudly: "Long live the republic!" We went toward the center of town. We reached the Residence, the [royal family's] general quarters, and as if by magic, the doors were open. The crowd gathered and demanded a republic.

I marched just behind Kurt Eisner, next to his wife and Ernst. We had not expected this. The doors of the palace were open. No resistance. The procession slowly moved through the rooms of the empty palace and retired into the night.[1]
—7 November 1918

The demonstration of 7 November 1918 helped end the Bavarian monarchy and ushered in a dramatic change in Krull's activities over the next three years in her life. As the young photographer shared the euphoria of the 7 November demonstration outside and then inside the palace, the last days of the war swept the Bavarian and German monarchies out of power, and she continued the indoctrination into leftist politics Friedrich Krull had begun. Her adventures also followed shortly after her father's death in Hamburg in the spring of 1917, marking Krull's first independence from the shadow present or absent—of Friedrich's

convictions. When she later writes about the exhilarating presence of "women, children, soldiers, intellectuals, and workers, all together"[2] at the demonstration that ended the Bavarian monarchy, Krull cites elements that would continue to be important to her throughout her life—an intellectual revolution, a commitment to workers, and a political activism in which she, as a woman, could participate. Her Schwabing circle already included intellectuals (Rainer Maria Rilke, Max Horkheimer, and Friedrich Pollock), and now she added politicians (Kurt Eisner and Ernst Toller) to her world, which for the next three years centered on politics rather than art.

The end of World War I and the battle for the new German republics, both democratic and communist, were inextricably intertwined. Hunger, famine, and disillusionment with the German government were rampant during the last months of the war, creating a chaotic situation in Germany that would take years to resolve itself.[3] Bavaria led the way, forming the Bavarian Independent Socialist Republic on 7 November 1918. Kaiser Wilhelm II abdicated and established the German Republic on 9 November, and World War I fighting ceased on 11 November 1918. The new Bavarian Independent Socialist Republic (November 1918 to February 1919) was followed in April by two idealistic but short-lived communist governments—the Bavarian Räterepubliks (soviet council republics). They were speedily crushed by right-wing forces by early May 1919.[4]

During the months between November 1918 and the signing of the Treaty of Versailles on 18 June 1919, Germany was painfully attempting to redefine itself, and the soviet revolutions in Berlin and Bavaria formed an integral if ultimately unsuccessful part of the process. Bavaria, a conservative and predominantly Roman Catholic state, seems an unlikely site for a communist revolution, and as historian Allan Mitchell states, "It is virtually impossible, in fact, to locate anything which might properly be considered a radical movement in Bavaria before 1918."[5] Mitchell sees several tensions as underlying causes for the Bavarian Revolution, including the incomplete transition to parliamentary government, changing social conditions, the popular dislike of Prussian hegemony, and the demand for peace.[6] Nevertheless, Bavaria was the first German state to create a republic with a parliamentary system, and the parliamentary system survived even if its early radical governments did not.

Krull's political activism after World War I fell into three distinct periods, all involved with socialist and communist events in Bavaria. It started with an enthusiastic but relatively moderate Independent Socialist Party (USPD) position in the shadow of Kurt Eisner, who had become prime minister of the newly formed Bavarian Independent Socialist Republic in November 1918. After his death she moved in a second direction, becoming allied with the German Communist Party (KPD) when the two short-lived soviet council republics (Räterepubliks) were established in Bavaria in April 1919. In the "White terror" that marked the eradication of the Bavarian soviet council republic in May 1919, she aided the escape of a Russian Soviet revolutionary named Tobias Axelrod.

The last stage began after she met her husband-to-be, a Russian student activist named Samuel Levit. At this time her politics shifted sharply leftward to a position that remained communist but decried the increasingly centralized control of Moscow. Although the specific details of her oppositional stance are unclear, she spent from January 1921 to January 1922 in Russia and attended the Third World Congress of the Communist International in Moscow in June 1921. By the time she returned from Moscow in January 1922, she had been expelled from the Communist Party, tried for treason in Germany, and first jailed and then deported from both Bavaria and the Soviet Union.

These three phases marked Krull's growing political education and increasing disillusionment with the power of government to effect change. A reluctant radical, the photographer labored for the three political causes she found herself involved with, but her ultimate allegiance seems to have been to people (first Kurt Eisner, then Tobias Axelrod, then Samuel Levit) and not to party politics (whether the USPD, the KPD, or the far-left position she and Levit took outside the party). Unlike her associates in intellectual and artistic circles, these politically committed figures did not remain close to her for long: Eisner died, Axelrod returned to the Soviet Union, and Levit abandoned her. Once she was betrayed—inadvertently or intentionally—by these friends, Krull abandoned activist politics for a more distanced intellectual commentary, at least until the onset of World War II.

Her more permanent alliances and lifelong friendships from this period were with the intellectual Marxists Max Horkheimer and Friedrich Pollock. Although she did not participate in the philosophical discussions of the intellectual writers who formed the Frankfurt School for Social Research in that city, her political position after January 1922 resembled their belief in a Marxism of thought rather than of revolution, which Max Horkheimer termed a "critical approach to existing society."[7] Her photographs, like their philosophy, would critique capitalist culture but not torpedo it.

The Bavarian Independent Socialist Republic

The first, specifically socialist portion of Krull's tale stemmed from the splintering of the German Social Democratic Party (SPD) into two parties in April 1917 and directly followed her personal involvement with Kurt Eisner, the leader of the newly formed Independent Socialist Party of Germany (USPD).[8] The USPD included pacifists, revolutionaries, and others appalled by the war. Eisner, a Jewish journalist from Berlin, had arrived in Bavaria in 1907 to work on Social Democratic journals in Nuremberg and Munich.[9] He founded an antiwar discussion group in Munich at the Golden Anchor tavern in 1917, and his growing audiences eventually included Krull.

A well-known critic, writer, and editor of the SPD journal *Vorwaerts*, Eisner had become politically active largely out of disgust with the war. An abortive strike in favor of peace in January 1918 was only one sign of the revolt. He was jailed for eight and a half months for helping to organize that January strike, and after his amnesty on 14 October, he continued to move strongly against the government. The events of the next few weeks led to the declaration of the Bavarian Republic on 7 November 1918. Eisner was an unlikely hero for this effort. As A. J. Ryder remarks in his study of the 1918 German revolution, "That such a man, a Berlin Jew and the leader of a small extremist party, should be able with little effort to depose the Wittelsbach dynasty which had ruled Bavaria for nearly a thousand years was one of the least predictable episodes in the German revolution."[10]

Eisner spoke outdoors on the Thereselenwiese on 3 November, advocating peace through revolution, as he did on 7 November at another enormous meeting there. As Krull describes vividly in her memoir, the USPD leader led the crowd of fifty thousand through the city to take over the barracks and other public buildings, only to finish at the Diet building. There he announced the establishment of a Bavarian Republic.[11] Eisner created the new republic in two days, effectively leading the march, proclaiming the republic, forming the government and the workers' councils, and becoming Ministerpräsident.

Krull's involvement with the socialist uprising in Munich probably began well before the November declaration of the Bavarian Republic. Students at the Munich photography school were unanimous in despising the kaiser and hating the Prussian reich that kept them in a state of war. Krull's Munich friends also included a startling roster of soon-to-be-prominent political thinkers—Friedrich Pollock, Max Horkheimer, and Ernst Toller, a writer who would be elected deputy president of the new republic's workmen's, peasants', and soldiers' councils and who would lead the second Bavarian soviet council republic in April of 1919.[12]

Krull's own accounts of her first months in contact with Eisner's circle maintain a tone of youthful adventure, even in the face of violence. According to "La vie mène la danse," her friend Ernst Joske,[13] the son of one of her mother's friends, first took the photographer to Kurt Eisner's lectures, probably at the Golden Anchor. Eisner's lectures filled the audience with enthusiasm, and the photographer's memoirs reflect the power of the impression he made. Although she recorded the events long after they took place, Krull essentially retained the impressions of her almost romantic reaction to these political events. It is not difficult to imagine the group of students overresponding to these stirring speeches, as Krull and Joske did. She writes:

> *Kurt Eisner was not handsome. He was very small, but when he spoke, he became big and strong. He told us that all the problems stemmed from the Prussians and from the kaiser and that blood would have to flow. We came out of this meeting full with enthusiasm. The kaiser must be gotten rid of; he must disappear and we decided to kill him.*[14]

Neither personal danger nor political violence seemed tragic to her, as they would in later years. In an

18.19

extraordinary and unverifiable saga that Krull relates in both of her memoirs, Joske seems to have convinced Krull to go to the train station and fire at the kaiser.[15] According to "Chien-fou," Joske's father, an official who was Albertine Krull's lover, discovered the plot before the pair even left the house, stormed into her studio, and took the gun. Krull reports—in an oddly matter-of-fact tone—that as a final touch, he then raped her. Rather than traumatizing her as her recent abortion had done, this rape seems to have struck her as another of the inexplicably violent acts of these years.[16] Instead of relating it as a purely physical violation, she seems to classify it as an inexcusable and inappropriate act by an older male in a position of power. She repeats the tale both in "Chien-fou" (where she writes that she found his combined rage and sexual act more astonishing than disgusting) and in "La vie mène la danse," (where she recounts that "he threw me on the couch and forced me to submit to the most horrible act—my mother's old lover").[17] The details of the photographer's abortive assassination attempt and her alleged rape remain unverified, but Krull certainly became actively involved in Eisner's Independent Socialist Party.

As his portraitist, Krull clearly had a direct connection with Eisner. In January 1918, eleven months before the formation of the Bavarian Republic, she made her first portrait of the politician (plate 1.1), shortly before he was jailed for his involvement in the strikes at the end of that month. Krull may well have had contact with him during his months in prison, as historical sources confirm that Joske acted as a secretary or messenger for the jailed politician.[18] On a personal level, she writes that she enlisted Eisner's aid in extricating her mother from prison, where, at least according to the photographer's memoirs, she had landed as a result of her black-market activities (Albertine Krull had apparently been smuggling farm goods from the country into food-starved Munich). She also seems to have been friendly with Else Eisner.

Krull photographed Kurt Eisner again on 18 November 1918 (plate 1.2), eleven days after he declared the creation of the Bavarian Republic. This portrait emphasizes the eccentric persona that Eisner had cultivated after his release from prison. In contrast to the trim goatee of the previous photograph, Eisner's beard in this image is long and unkempt. Toller describes him well, painting a word picture comparable to the photographic portrait: "small and slight; gray hair that had once been fair fell in a confused tangle to his coat-collar, and an untidy beard straggled over his chest; short-sighted eyes looked out calmly from the deeply lined face."[19] Krull's photograph highlights the leader's idiosyncrasies and entered the public political heritage in several forms. The *Leipziger Illustrierte Zeitung*, for instance, published Krull's portrait of Eisner as Bavarian president on 12 December 1918, with the caption and credit line "Ministerpräsident des Volksstaates Bayern, Phot. Krull, München."[20] Furthermore, Eisner's book *Die neue Zeit*, published in 1919, carried a reproduction of this very portrait glued onto the outside cover of the book.[21]

On 21 February 1919, Eisner was assassinated as he walked from the Promenadenplatz toward the opening meeting of the Provincial Assembly. He was on his way to resign as prime minister, although he planned to remain at the head of the revolutionary councils he so believed in.[22] The murder provoked outrage and general panic. Eisner's funeral became an enormous demonstration, and many made pilgrimages to the Promenadenplatz where he had been shot.

Unlike Heinrich Hoffmann, the photographer who documented most of the events of these years in Munich,[23] Krull made no photographs of the tumultuous politics swirling around her or at least none that survive. Her pictorialist studio portraits of Eisner are quite different from many of Heinrich Hoffmann's less academic photographic portraits of functionaries in the 1918 and 1919 governments. Those functionaries appear much more neat and conventional, with short haircuts in marked contrast to Eisner's long beard. As a recent graduate, Krull's work at this time was limited to portraits and nudes, and she did not, as far as we know, take her camera with her when she ventured into the streets—although thousands of street photographs of the events of 1918 and 1919 in Munich survive and are published in the excellent study of revolution and photography in Munich by Rudolf Herz and Dirk Halfbrodt.[24] Krull did make a funeral portrait of Eisner lying in his coffin (fig. 1.7), but it remained in family archives and was not released for public use. The November 1918 portrait (plate 1.2), however, was reproduced in print form in the massive press coverage of Eisner after his death and appeared in Munich's *Neue Zeitung* on 22 February 1919 and with a black border as a memorial postcard.[25] Despite the prominence of this

image in the national press, however, Krull's own memoirs suggest a personal rather than a political reaction to the assassination; she writes rather naively of an all-encompassing confusion and of her attempts to comfort Eisner's widow Else.[26]

The Bavarian Soviet Council Republics

Within a few weeks both the political environment and Krull's own participation in it changed markedly, and she began the second phase of her political involvement. On 6 April 1919, the first Bavarian Räterepublik, or soviet council republic, was declared in Munich and stated its solidarity with Hungary and Russia.[27] A military coup to crush it on 13 April failed. The second soviet council republic, more in line with the party line of the German Communist Party (KPD), began that day, and Krull's friend, Ernst Toller, as one it its leaders, beat back a second attempt to crush the republic. The second soviet council republic lasted barely three weeks, until right-wing troops from Prussia and Württemberg were called in from Berlin to try to crush it. By 2 May these protofascist Freikorps troops had demolished all resistance. As Sebastian Haffner writes, "A 'White terror' ensued such as no German city, not even Berlin in March, had yet experienced."[28] For about a week, Prussian Freikorps troops roamed the streets, burning red soviet flags and replacing them with blue and white Bavarian flags, shooting at will, and continuing a rampage of killing, neighborhood by neighborhood. The final toll left nearly a thousand dead.[29]

During the early weeks of the Bavarian soviet council republic that spring, some of Krull's friends occupied important political positions. The Bavarian soviet government remained the creation of intellectuals, and thus its attraction for Krull must have been twofold. It formed solely within Germany and outside of the sphere of influence of Moscow's central Communist Party, which unsympathetically declared that it had been the creation of "romantic fools."[30] After its rapid collapse, most of its members would be arrested.[31] In this environment, she became involved in supporting her Communist friends, literally to save their lives. Krull's reaction to these events was far more complicated than her more passive admiration of Eisner's leadership the previous November, although she clung to his more moderate position for a period. In a passage in "Chien-fou," she reconstructs her sense of bewilderment: "Eisner always said that the Communists were too violent . . . Chien-fou was confused."[32] Krull would soon go on to fight actively, but she remained uncertain about the soviet revolution she witnessed.

Max Horkheimer and Friedrich Pollock

Krull's closest friends were as ambivalent as she. Friedrich Pollock and Max Horkheimer, Munich university students at this time, were equally cautious about the soviet council republic, and although neither wrote much about their involvement in these events, they were intellectuals first and street fighters almost never. Horkheimer had spent the critical days of November 1918 in a Munich sanitarium, and he and Pollock deeply distrusted Toller and the aims of the soviet council republic.

Martin Jay, in his overview of the Frankfurt school, clarifies the school's alternative view toward Marxism. He outlines three choices of most left-wing intellectuals after World War I—adherence to the moderate socialists of the new Weimar republic, support for the new German Communist Party and its Moscow leadership, or a more theoretical "reexamination of the very foundations of Marxist theory, with the dual hope of explaining past errors and preparing for future action."[33] Pollock and Horkheimer seem to have preferred theoretical scholarship to revolutionary activity, even during these turbulent months in Munich. Jay writes that they witnessed but did not participate in the revolutionary activities and that they hid victims of the White terror but thought the revolution "premature and inevitably doomed by the lack of objective conditions favoring true social change."[34]

Krull's memoirs, too, relate that Pollock's reaction to the soviet council republic was that it was "completely idiotic and that Toller should be arrested at once."[35] At this moment, Krull seemed to share their skepticism; she herself describes the May 1919 events as follows: "They were hunting, at any cost, the organizers of this madness of Toller's."[36] As she later frames the narrative of these turbulent months, Max and Fritz, as she called them, provide the cautious note in their circle, such as warning the photographer to wear her Sunday clothes[37] to avoid attracting attention from the police. Krull's memoirs relate that she abandoned her studio in

Schwabing, which was too much a target for the White troops, and stayed with "Max and Fritz" in their more middle-class neighborhood. Yet Horkheimer and Pollock would remain at a distance from direct political involvement—their few documented activities seem to have been at the photographer's behest—but Krull was moving dramatically leftward at a time when Germany, after the middle of 1919, was about to veer sharply toward the right.

Tobias Axelrod

The White terror of May 1919 marked the beginning of Krull's active political engagement. Krull recounts in her memoir that she was asked to hide two men from the soldiers.[38] Tobias Axelrod and Willi Budich, whom she had never met, were representatives of the second Räterepublik: Axelrod was a Russian Bolshevik emissary who had been installed as "political commissar at the finance ministry" of the Bavarian Soviet Republic,[39] and Budich also belonged to the German Communist Party (KPD).[40]

Rudolf Herz and Dirk Halfbrodt's thorough research in the Munich archives, as well as Krull's own 1921 deposition to the Russian authorities, verify the details of these events.[41] Krull assisted in Axelrod's escape, and during his abortive flight the Russian diplomat was carrying papers belonging to Pollock—obtained by Krull.[42] Both Krull and Axelrod were apprehended. Axelrod was arrested in early May, sentenced to fifteen years in prison, and soon repatriated to Moscow in exchange for the release of an arrested German diplomat.[43] Krull made sustained efforts to secure Axelrod's release, although she eventually stood trial for treason for her assistance to him.

In her memoirs and in her depositions, Krull reveals the spontaneous nature of her first involvement in this event and then her dogged efforts to support Axelrod thereafter, although she reported that she had never met him before she was asked to shelter him. The fact that the Spartakists (members of the KPD) would have approached her for a hiding place for such a prominent figure suggests that she was closer to the events of April than she reveals in her autobiographies. After discovering that the men were wanted Spartakists, she writes, she obtained false papers for them and determined to help them escape to Austria. Budich, who had a badly injured leg, used papers obtained through Krull's mother, belonging to a Dr. Willi Mathiesen. After walking across Munich to the train station past posters displaying

Axelrod's name and offense, they took the train, were forced to get off because soldiers were checking papers, and crossed on foot into Austria. The trio was caught on 12 May 1919 in Schwaz in the Tyrol. Her memoirs romanticize her first imprisonment in Innsbruck, as the precise moment when she shifted from lighthearted participation in an adventure to a more politicized opposition to the authorities: "Here I was in prison for the first time, and it seemed to me to be an enormous step. It really does something to you, when the door is locked with a key behind you."[44] They were shipped back over the Bavarian border to Garmisch to be imprisoned.

Unlike Axelrod, Krull was not yet a known revolutionary but merely a suspected accessory to the escape. She was released under slightly unclear circumstances.[45] She recounts that Horkheimer had brought her a package of food at Garmisch, but his involvement in the release is also unclear. According to the Soviet deposition, at Garmisch Horkheimer was momentarily mistaken for Toller and arrested for a short period of time.[46] When Krull arrived back in Munich, she relates, Horkheimer arranged to hide her in the Sanitarium Neuwittelsbach until things cooled down.[47]

Krull's memoirs chronicle the wistful friendship between Horkheimer and the photographer, which continued throughout their lives. They also highlight the wide difference between their intellectual pursuits and the extent to which Horkheimer—and by extension, Pollock as well—felt responsible for Krull, assuming a protective and advisory role although they were close in age. Throughout their many years together, he often assumed a tutelary role, either attempting to instruct her on political theory or physically and fiscally rescuing her from the scrapes in which her impetuous actions landed her—not always a pleasant task for the philosopher. In a revealing passage in her memoirs, which demonstrates the photographer's lack of sophisticated knowledge about the causes she was supporting, Krull describes Horkheimer's attempts to teach her about the two kinds of revolution and to warn her that the time for street fighting may have passed. She certainly never grasped the complexities of the philosopher's position:

> *You see, there are two types of revolution, not only one type. Listen, Chien-fou, let me explain.*

Don't interrupt me right at the beginning! Good! You had the revolution in the street and it was beautiful, but the street means death. All the great leaders are dead—Rosa Luxemburg, Karl Liebknecht, Kurt Eisner, etc. Now the reaction is strong, tied to the socialist government. The reaction is always well organized because it has money and weapons. The second way of having a revolution is to enter into the government and to sabotage it. This kind of revolution isn't bad and in the long run can be better. Karl Marx says that if the revolution in the street is finished, it is necessary to participate in the government and to sabotage it. So there are two methods, but there can be a conflict because some may say that the street revolution has ended and others may say that it is still alive. You are right to like the first formula, but I fear that Lenin, as a good Marxist, thinks that the street revolution has ended.[48]

Yet Krull was moving away from Pollock's and Horkheimer's moderate stance and was about to cast her vote with the street revolutionaries. Horkheimer, in this springtime of 1919, already recognized Lenin's distaste for the German version of council communism and his preference for strict party discipline, although he engaged in neither form of active politics himself. Krull, conversely, solidified her belief in the street revolution during these months, as several comments in her memoirs confirm: "Bit by bit, the conversation with Max grew inside my head, and I realized that one thing was sure: our side was right."[49] Krull departed on her political adventure, and it was left to Horkheimer to reluctantly rescue her and put the photographer's life back together again when her illusions were crushed in early 1922.

During the summer months of 1919, Krull traveled to Berlin, Vienna, and Budapest, trying to arrange for Axelrod to be traded back to the Soviet Union in exchange for a German prisoner. She got no satisfaction from Paul Levi, the head of the KPD in Berlin, who considered Axelrod foolish for involving himself in the Munich revolution.[50] She reports that in Budapest she saw a deputy of Bela Kun's, named in the Moscow deposition as Comrade Alpari.[51] Krull must have eventually succeeded, for Axelrod was in fact exchanged for a German diplomat.[52]

Samuel Levit

On her trip to Berlin early that summer, Krull met Samuel Levit, also known as Kurt Adler or Mila. The two promptly became both lovers and fellow revolutionaries, and Krull's sister has corroborated that he was the great love of her youth. Tantalizingly elusive archival sources suggest that she married Levit sometime between the summer of 1919 and November of 1920.[53] Rudolf Herz writes that as early as the autumn of 1919, police depositions from Levit refer to Krull as his fiancée.[54] Krull's sister recalls a Russian marriage.[55] Krull presumably divorced Levit in Moscow, although she was still married in March of 1920.[56] Berthe Krull recalls the photographer's story of appearing before a magistrate to end the marriage. This cannot have been a public marriage; Max Horkheimer, for one, was surprised at the status of their relationship.[57] Krull suggested to her sister that they could say they were not married "because it all seemed stupid for German ways . . . in relation to Western ideas."[58] With no written records of the marriage, it seems plausible that this was a "free love" union in the spirit of the bohemian tradition—the kind of informal marriage without paperwork that was popular in Germany and Russia at that time.[59]

In the autumn of 1919 Levit arrived in Munich. With hindsight, Krull would assert that during her turbulent two-and-a-half-year relationship with Levit she had the ideas and that Levit, a powerful orator and writer, relied on her for inspiration. However, it seems equally possible, if not more probable, that Krull's politics echoed those of her lover. After meeting Levit, Krull clearly became more activist, which concerned Pollock and Horkheimer.[60]

In their attempts to organize the left wing branch of the Munich Communist Party, the couple became embroiled in the disorganization and infighting in the various Communist factions in Munich, which were in considerable disarray after the crushing of the soviet council republics. Accusations of embezzlement, treason, countertreason, and dishonesty peppered the relations between Levit and other members of the party, eventually resulting in a break between the factions. As a left-wing splinter Communist, Levit soon fought violently with Karl Römer, the Munich party secretary. Levit and Krull attended several party congresses, and in

Frankfurt or Stuttgart they were voted out of the German Communist Party for their radical views.[61] After a brief flurry of activity, both Römer and Levit were arrested in October 1919.[62] Police records show that Levit was in Krull's apartment at the time of his arrest. For one already waiting to stand trial for her involvement in Axelrod's escape, this new association brought the photographer under even greater suspicion. According to her memoirs, she was arrested as well and may have spent about a month in jail before her release pending trial.[63] Levit received a jail sentence of one year and three months and was transferred to a Nuremberg prison.[64]

At the end of February 1920, Krull eventually stood trial for assisting in Axelrod's escape, but she was freed for lack of evidence. In her written accounts of the trial, she relates that she followed the advice of her lawyer, Dr. Stepacher, and refused to explain why she was climbing the Alps with Axelrod and Budich.[65] By steadfastly refusing to admit any political connections with Axelrod, she was acquitted. The *Bayerische Kurier* reported the trial, writing, "She denied having known of the warrant for Axelrod's arrest, and she believed that she was helping with a harmless excursion. With no further evidence known, she must be acquitted."[66] Such close associations with communist agitators such as Axelrod and Levit must have been a danger sign for the government: one month later, Krull was banned from Bavaria by order of Staatskommissar Pöhner.[67] In "Chien-fou," the photographer paraphrases this police order, fabricating a few picturesque details and inserting her nickname into the purported police document: "Miss Louise Germaine Krull, called *Chien-fou (Zottel)*, is forbidden to remain on Bavarian territory. She must leave the city within twenty-four hours."[68]

Krull's ideals became, if anything, purer through her trial and expulsion. She seemed conscious that her politics now reflected her father's, and her memoirs contain a revealing parallel in her own mind between their beliefs. She reminisces about Friedrich Krull:

> *More than ever, the morality that my father taught me when I was a little girl—barely eight years old—seemed true to me. He told me: "My little girl, you have a conscience. It is the only thing that will guide you: listen to it. Never do anything that seems wrong to it. Follow your path, even against the others, if your conscience*

> *tells you to." It was the light of my conscience that I found in my heart, in these black and hidden corners of my soul, and I found my ideal of reconstructing society on a more dignified base. I knew I had to fight for those who suffered.[69]*

Throughout the months and years that followed, Krull continued to follow "the light of my conscience," doggedly and passionately maintaining her own personal morals even in the face of massive hardship.

Moscow and the Third World Congress

Krull began as a supporter of Eisner and the Bavarian Independent Socialist Republic and then moved leftward to the German Communist Party (KPD). The third period of her political birth by fire was the period (from March 1920 until January of 1922) she spent with Levit after being expelled from Bavaria. During this time, the couple operated outside of the support and structure of any political party; Pollock's characterization of them as anarchists was not far off. Krull's comments to the Russian authorities in March of 1921 make it clear that they were seen as highly troublesome even in the Soviet Union, and Moscow documents state that both Levit and Krull were under deep suspicion of espionage and "political adventurism."[70] Although relatively little concrete information about these years can be found, it seems clear that Krull and Levit were enmeshed in the growing struggles between the German and Soviet Communist Parties. They argued strongly and unsuccessfully for local Communist autonomy and revolutionary activity in a complex series of developments that culminated in centralization of power and control in the Russian Communist Party, to the detriment of other international movements.

As the photographer recounts in her memoirs and deposition, she left Munich at the end of March 1920, traveled to Düsseldorf where she worked briefly in a studio, and met up again with Levit in Berlin. Her memoirs recall that the antipathy of his parents, Russian Jews who owned a Berlin pharmacy, toward non-Jewish Germaine was palpable.[71] Krull writes that his mother

declared that she would rather see him dead than involved with a Christian. She repeats Levit's explanation that the Cossacks had looted his mother's Russian village when he was an infant and that Frau Levit's hatred of gentiles stemmed from that event.[72] It was war between mother and photographer from beginning to end, and Krull was equally vicious. Despite her friendships with German Jewish friends like Horkheimer and Pollock, Krull describes Frau Levit in unflattering and even anti-Semitic terms: "She was a woman of about forty years, fat and totally round; she was the typical oriental Jew."[73] Their dislike for each other was such that even after Krull left Russia, she feared Levit's parents, and she blamed them for much of her political trouble in Moscow.[74]

In fact, from their first arrival in Berlin, the couple planned to travel to the Soviet Union. In her efforts to support her far-left position, Krull spent from January 1921 until January 1922 in the Soviet Union.[75] Few documents corroborate her remembered accounts of this year, and our only source is "La vie mène la danse" ("Chien-fou" ends in Berlin and records no Russian events). Until more is gleaned from Moscow archives, we must thus use Krull's memoir as a first-hand, if biased and skewed, account.

Krull recounts that she traveled to Russia via Stettin, a now-Polish port on the Baltic Sea, with a group of repatriated Russian prisoners of war. On the journey, she reverted to a childhood practice and dressed as a man to avoid travel hassles. According to "La vie mène la danse," the couple arrived in St. Petersburg at a time when the Russian economy had almost completely collapsed. They spoke to delegates of the Communist Party but were referred to Moscow, since, as they termed themselves, they were "members of the opposition."[76] With almost four months to wait before the Third World Congress of the Communist International, they seemed to have stayed briefly in St. Petersburg, although the exact dates of their stays in either Russian city cannot be corroborated. Tobias Axelrod was now a prominent member of the Soviet Comintern, and he headed the Comintern press in 1920 and 1921. At the Third World Congress he directed the publication of the Comintern's daily bulletin.[77] Axelrod may or may not have had a connection with their jobs: Krull's memoirs mention only that the Soviet government's photographic service was ready to use her talents and that Levit would translate articles for the party.[78]

Russian documents reveal only that Krull worked for a photographic press service, named in the Russian documents as the Photokino Committee,[79] but her memoirs supply the missing details. She writes that all the water pipes in the building had burst and so her only job was to file existing negatives rather than create or print pictures. She admits that language was also an insurmountable barrier: "I patiently started to classify the negatives by group. Since I could not read, it was useless, but so what. Men with men, women with women, and groups with groups, because I had to do something."[80] She remembers little of her fellow workers, stating merely, "They had been told to work so they worked. They knew nothing and wanted nothing. I could not talk to them and they were suspicious of me."[81] True to her expressionist background in Munich, even in her most radical moments she remained an individualist aesthetic and intellectual leftist and seemed to resist becoming a disciplined party worker.

During the weeks of waiting, Krull writes of walking incessantly, sometimes onto the ice of the Kronstadtsee and sometimes in St. Petersburg's streets, and she paints a bleak picture of the almost nonfunctioning city. Levit seemed to have been a sour companion as well. She writes of hearing Trotsky speak inspiringly, although she admits that she understood none of his Russian, and of witnessing the sailors' mutiny at Kronstadt in February 1921. She clearly sympathized with these opposition groups who were fighting against central party control.[82] Krull movingly describes the Kronstadt massacres of that March and vividly depicts the soldiers firing on the sailors and the sailors falling through the ice of the Kronstadtsee.[83] Her sympathy for the workers and their attempts to affect change from below ran directly contrary to Lenin's new policies, about to be articulated that summer. Trotsky summarizes the situation succinctly: "The slogan of the Third International did not simply read: 'To the masses!' but: 'To power through a previous conquest of the masses!'"[84]

The photographer's memoirs relate that she arrived in Moscow for the Third World Congress of the Communist International. The Congress opened on 22 June 1921 and lasted until 12 July. Of the 509 delegates from forty-eight countries who attended, 291 could vote.[85] Krull recounts that they were representatives of

the dissident left wing of the party. The official documents of the Third World Congress list two unnamed opposition delegates of the German Communist Party, but it is far from certain that these two were Levit and Krull. Documents show that neither of them spoke officially or were recorded in the Congress minutes.

At the Third World Congress, Lenin explained that the "Comintern had passed from the tactics of assault to the tactics of siege, infiltration taking the place of open armed struggle."[86] The Congress furthered the position of the Second World Congress, which already stated a desire to create a single world Communist Party rather than an association of independent parties.[87] In the resolution "On Party Unity," written in March 1921, he threatened severe punishment for anyone who attempted to create a separate group.[88] Krull recounts her awe at hearing Lenin speak for five hours during the opening of the Congress. But her joy was short-lived as she heard his message, which she relates and paraphrases in her memoirs:

> He concluded that the revolution had arrived at a time when it was necessary to fight with the weapons of reaction or, in other words, to enter into the governments. He explained how and why the revolution was finished, and he concluded that now the time had come for the opposition to reflect if it was better so. If not, they would have time to reflect in prison with the anarchists. Mila [Levit] was not allowed to speak, and the next day, we were arrested and transferred to the Cheka.[89]

It seems that Krull and Levit were quickly labeled as troublemakers and jailed in the KGB prison in Lubyanka Square as antiparty agitators. She recounts that there she shared a room with four other women, and even her appeal to Tobias Axelrod, whom she had saved in Munich, was of no help as she was now seen as the partner of Levit, a seditious antirevolutionary.[90] During this incarceration, Krull recounts that she became very ill with an undefined stomach illness, and she was eventually transferred to a prison hospital.

As she recreates her story, she received a package of food from a friend, the Austrian consul, and was freed once the Congress was over. Returning to the Hotel Metropole, she was told that Levit had left. She looked for him at the Hotel Lux but was denied access, despite her pleas that he was her husband.[91] At their reunion,

she learned that Levit was planning to leave in two days with the last delegates. Despite his explanation that this was his only chance to leave Russia, since he was a Russian citizen, she felt completely betrayed: "I couldn't say a thing, the shock was huge. It seemed that once more in my life there had been a betrayal."[92] Her relationship with Levit seems to have ended with this disloyalty, which also heightened her disillusionment with the Soviet system. As in the first betrayal by her mother, Levit's ultimate treachery was a refusal to hold to his word. In Krull's eyes, he had abandoned her. The fact that, as a Russian citizen, Levit might only have been able to depart with the other Congress delegates seems to have had no impact on her thinking.

After Levit's departure, presumably in the summer or early autumn of 1921, Krull probably remained alone in Moscow, taking over her husband's job as a reader and sorter of foreign newspapers. Here she met a German named Hans Basler, who brought her news from Berlin. Basler would again befriend her in Berlin as well. Krull seems to have been jailed a second time on 19 October, as a letter to Horkheimer related a further eleven and a half weeks in prison, "as a publicly declared anti-Bolshevik."[93] Part of this time she probably spent in the prison hospital, for reasons that remain unclear. At some point during her prison time in Moscow, guards apparently took her from her cell, as if she were about to be executed. Although she does not mention this specifically in her memoirs, both her sister Berthe and Joris Ivens recalled her terror of this moment.[94] Eventually she was thrown out of the Soviet Union and given transport by the German consulate as a former German citizen. Another letter to Horkheimer recounts the details—but a different jail period. Here she suggests that her jailing in Moscow was linked to Mila's parents:

> Through the intrigues of Mila's mother etc. I sat in jail for half a year as a counterrevolutionary and was forcibly escorted out of Russia at the end. The German consulate gave me the possibility as a former German to travel home with a transport, and now I am in a jam. The papers read "Levit-Krull," and I want nothing to do with being Rumanian or Russian with Mila.

I beg of you, Hork, come. I'm so tired, and need help. . . . When Mila learns that I am here, I fear further persecution from his parents.[95]

This was Krull's second political expulsion in two years. In "La vie mène la danse," she recreates the wording of her deportation order:

You are deported from the Russian territory for leftist counterrevolutionary activities, and you must leave the country as soon as possible. There is a convoy from the famine areas; we will put you with them. They leave tomorrow. Go to this address.[96]

She wrote that she insisted on departing despite the onset of typhus fever. Arriving in Riga, in the newly independent nation of Latvia,[97] Krull refused to go to the hospital and continued her journey. With her physical deportation, her belief in political activism, especially of the Soviet order, also died. According to her sister Berthe, "Communism was 'out' for her when she came with 'dysenterie' out of Russia."[98] The American activist Emma Goldman, who had also witnessed the events at Kronstadt and had left Russia in December 1921, published a book about her own experiences during her two years in the Soviet Union.[99] She describes her departure in terms as disillusioned as Krull's: "My dreams crushed, my faith broken, my heart like a stone. *Matushka Rossiya* bleeding from a thousand wounds, her soil strewn with the dead."[100]

Krull's letters to her friends clarify the details of her escape and her radical conversion from belief in communism to hatred for it. On 12 January 1922, she wrote to Pollock and Horkheimer from Riga, explaining that it was precisely one year since she had crossed the Russian border. In this letter she states her change of political ideology very clearly, denouncing the Soviet system:

Today I know that it would be a misfortune for the world and for all classes, if Bolshevism came to the West. . . . Forgive me and don't be angry that I write exactly what I feel, and you have a right not to call me a friend any longer. I now see that I have given two years of my life for an ideal, but it is only an ideal.[101]

She also writes in this letter that she did not want to see Levit again, "although I carry his name." Krull certainly

suffered at the hand of the Bolsheviks and survived imprisonment in Moscow, although her disgust with communism probably was tinged by her disgust for Levit. Political and personal betrayal both weighed heavily on her.

Ten days later, she wrote Pollock and Horkheimer again from Stettin, where she was in the city hospital (Städl-Krankenhaus). She relates three days of fever but not typhus. The response of her two friends, called to rescue her from yet another disaster, was heartwarmingly immediate, although Horkheimer's letters to his future wife, Rosa Riekher, reveal that Krull was a responsibility he had to bear.[102] On 24 January 1922, they wrote to *Zottel* that they were coming with money, friendship, sanctuary, and moral support. Writing that they had been unaware of the circumstances of her relationship with Levit, they promised to find her a place to go. Their response to her political comments reveal the intellectual Marxism that Krull could again share after casting off her militant activism. Horkheimer writes, "We hope to assure you that today you have a glimpse on the meaning of our life and the goals we work for. We do not participate in the party programs, as generally politics cannot be the last word."[103] The two young scholars found Krull a sanitarium, brought her mother to visit her, and provided a reintroduction to Else Eisner, at whose quiet rural home she would recuperate.

Until this point, Krull's two most committed activities—politics and photography—had found no common ground. During these months, it seems plausible that little or no photographic activity was possible. In her memoirs she recalls that she was devoting all of her attention to political activities and that photography did not and could not play an active role in her goals. In 1918 and 1919, she occasionally continued her photographic activities, but by the spring of 1919, as she related in her memoirs, she was working more and more sporadically. The Schwabing studio had become too dangerous, no clients were available, and external events took over Krull's life. She lost her studio altogether by March 1920, and during the Berlin months before going to Moscow, Krull probably worked primarily for the revolutionary cause. In Moscow, as far as we know, Krull filed other photographers' negatives but made no pictures of her own, and she would not again

whatever you want. Buy what you wish." "I want only one thing, to work." "Give me fifteen more days and I'll find work."[16]

An early Berlin portrait of Krull (fig. 3.2), probably taken by Basler, may have been taken in this room. It suggests the allure of the exotic polyglot culture that drew Basler and proves that Krull was not an unwilling participant. In marked contrast to her demure early self-portrait as a Munich student, she crouches here amid vases, Asian blankets, and embroidered cloths. She looks at the camera with an amused half-smile and tips her cigarette into an ashtray tucked among the pillows.

Interestingly, while Krull objected to Basler's appearance, his politics did not seem to bother her. She felt no hesitation at eating with him in the expensive restaurants in Berlin that only foreigners could afford. This, like her dismay at the workers she was forced to meet in Moscow, highlights her essentially theoretical embrace of socialism. She writes of her indignation at his initial offer to pay for her company with such favors. She justifies her acceptance of an apartment and a business partnership from him by noting, "I need work. I do not want to be a kept woman."[17] Basler seems to have been genuinely attached to her, and when she became pregnant, he was willing to keep the baby. But Krull writes that she could not countenance a child with this man and that therefore she obtained a legal abortion. Some abortions were allowed for medical reasons, and her recent typhus and the damage it had done to her lungs were reason enough, although her ability to navigate the red tape to obtain the legal procedure is further evidence of her access to financial support when necessary.[18] This abortion ended Krull's third and last accidental pregnancy[19] and marked the end of her physical involvement with Basler, who seems to have bowed out gracefully.

Nudes: Freikörperkultur
The cult of the body expressed itself in another, more innocent way, which also intrigued Krull. *Freikörperkultur,* or the "free body culture" movement, gained much popularity in Berlin in the 1920s under Adolf Koch, who conducted gymnastics classes in the nude.[20] The nude classes promoted nudism in the open air, and the swimming pool at Luna Park hosted weekly "Naked Day" for German families.[21] Nudity was popular and widespread during this decade in many German towns, and in fact the culture of the nude body had

been a popular part of a reform movement dating back to the turn of the century. It included a cult of fresh air, the building of public swimming pools, and the general perception that life must be experienced as a whole— mind and body in a totality.[22] Adherents believed that in a culture of nature and bodily exposure to the elements, such societal evils as pornography, sexually transmitted diseases, and prudery would die a natural death. Nude dance and gymnastics were a popular part of the movement, and many photographers, such as Trude Fleischmann and Madame d'Ora, recorded the nude dancers and exercising bodies in the 1920s and the two preceding decades.[23] Archive photographs of *Freikörperkultur* practiced by members of the *wandervögel* youth movement exhibit a campy quality; and in the popular press, the pleasure in nude exercise was treated as a form of play and a path to good health rather than as an aberration.

During her Berlin years, Krull seems to have actively participated in and photographed the *Freikörperkultur.* Several groups of images show Krull's facility with the nude figure, an interest she had begun to explore in Munich and would pursue throughout her career in Europe. First is an unpublished series of stereographic views of women in nature. One view, of a woman named Freia reaching out her arms silhouetted against the sky in an open field, is a conventional example of *Freikörperkultur* imagery (plate 3.1) similar in its celebration of fresh air and the freedom of nudity to many others of the decade. We know little about Freia herself, other than that she was a friend of Krull's. The only explanation for these images lies in the caption that Freia herself wrote on the back of the pictures, explaining

FIGURE 3.2

HANS BASLER, PORTRAIT OF GERMAINE KRULL, BERLIN, 1922.

GELATIN SILVER PRINT, 15.8 x 21.9 CM.,

GERMAINE KRULL NACHLASS, MUSEUM FOLKWANG, ESSEN

that because Krull had needed a model but couldn't afford to pay, she modeled for free.[24]

Krull's stereographs, however, contain a hint of sexuality. She photographed Freia and another unknown woman cavorting through the meadows in a series of stereoscopic views that are simultaneously playful and humorous (plate 3.2). The two figures bend down, knee deep among some reeds, so that their bent heads and rounded backs create mirror images of each other. With the startling depth of field of the stereograph format, one seems to be leaping backward out of the frame. We have no explanation of Krull's use of the stereoscopic format, and no other examples survive. She seems to have glued these together herself, using identical negatives, rather than the dual-exposure stereoscopic camera that gives slightly differing views. The optical effect, therefore, is a joke and a pun rather than a serious stereograph. The format mirrors the ubiquitous pornographic stereographs that were sold in Paris and Germany throughout the late nineteenth century.[25]

With no further information, we cannot know if Krull meant these photographs to be playful snapshots, marketable images, or personal explorations of bisexual and lesbian relationships. As she writes in her memoirs, she did have an intermittent lesbian relationship with a woman whom she called "Elsa," which spanned her years in Berlin and Amsterdam. Krull writes wistfully of Elsa that she was the only woman she ever loved or had an affair with. Unfortunately, their love affair was complicated by three men in their lives—Krull's new companion Joris Ivens, Elsa's husband, and Elsa's male lover. As far as we know, Elsa was indeed Krull's only female lover. Krull relates her affection for Elsa but is careful in her later memoirs not to call herself a lesbian:

> I never loved another woman. . . . We would have laughed if someone had labeled us lesbians. She was so much mine that the physical question did not count or had so little importance. She had a lover and a husband but had never had an orgasm. I was the one who could make her come. Everything was so simple, and we were happy to have a secret between us.[26]

Although Krull was certainly interested in lesbianism, the dominant theme in the Freia images, as in her other pairings of nude women during these years, seems to be playfulness rather than sexuality. Like many of her colleagues, Krull was fascinated with female nude subjects

throughout her life, and they recurred in Paris and in Africa, although never again with such overt lesbian suggestions.

Nudes: Berthe

Krull also photographed her little sister Berthe in another series of nudes, when Berthe visited her sister in Berlin shortly before her eighteenth birthday. Ironically, Krull was far more protective of Berthe, who was six years younger, than she was of her own body. Berthe and her friend Elsie Leitz, both dance students, came to Berlin in 1923, with the blessing of Krull's mother. According to Krull's memoirs, the two young dancers had an engagement in a cabaret on the Alexanderplatz, a neighborhood well known for its gangs and nightclubs. In a highly dramatized account that subtracts almost two years from their ages, Krull recounts her anger at seeing them there.

> A dark, small room, men smoking cigars were seated in armchairs. A tiny stage with hardly any light . . . suddenly there were my little doves! They were fresh and pretty, both of them hardly sixteen years old. They danced as if they were dancing for a God and put everything they had into their dancing, as if it were a sacred ritual. The fat men stared at them with their eyes popping out of their heads. Joris could not contain his rage. We took the two girls by the arms and pulled them to the exit. "You are completely crazy; you might as well go into a brothel! Never set foot in here again!" Cries of protest. I was furious. This was typical of my mother once again. Elsie was more reasonable. At the end, Berthe was also amused, but she left again for Munich.[27]

In rescuing her sister from this embarrassing situation, Krull once again voiced her fury at her mother's lax sense of responsibility, this time for Berthe.

Krull saw no moral dilemma, however, in photographing her sister in a series of nude studies, executed in the privacy of her studio (plates 3.3, 3.4) and now housed in the collection of the Deutsches Tanzarchiv in Cologne. One bears the date 1923, and the inscription,

in Germaine Krull's hand, reads "To my dear sister Berthe on her eighteenth birthday"; another in the series bears a note in Berthe's hand, "Berthe Krull as a seventeen-year-old." Krull and her sister seem to have had fun with the nude photographs, which follow the more extreme conventions of early twentieth-century German nude studies. These photographs recall the 1906 pictorialist nudes of Heinrich Kühn, for example, some of which were similarly posed in overly dramatic positions, with props and draped backdrops.[28] In a departure from the more classically academic studies of Krull's earlier nude portfolio, the two sisters set deliberately campy poses. Berthe lounges on oriental shawls and blankets like models in the Kühn photographs. Krull stages a series of humorously adoring poses toward a grimacing mask hung on the curtained wall, mimicking the "sacred ritual" of the nightclub dance. This series suggests that some of Basler's oriental room had remained in Krull's mind; these pictures of Berthe poke fun both at the oriental motif and at the figures themselves.

The general conception of these photographs continued to adhere to the dramatic poses of the German nude tradition, seen in similar images by Franz Grainer, a teacher at the Lehr- und Versuchsanstalt für Photographie, and others who also presented nudes in dramatic poses.[29] In one photograph (plate 3.3), Berthe gestures toward the mask as if she is praying to it or making an offering. She crouches or sways as if in supplication, casting a black shadow against the wall beneath the mask. In another image (plate 3.4), she kneels with her head tipped backward, her feet trapped in the shawl, and her hands fashioned into terrorizing claws. These photographs evoke the modern dance world led by Mary Wigman and also the images of nude gymnasts that were so popular. But by making the poses more extreme, Krull displays a sense of humor about her subject as well.

Nudes: Gretel Hübschmann
Between 1922 and 1924, Krull and Gretel Hübschmann, the wife of Krull's studio partner, decided to embark on yet another series of playful half-nudes, which Krull describes briefly in her memoirs:

> *I wanted to do something unusual, photographs without modesty, maybe some "photos galantes." Gretel Hübschmann thought that was a good idea, and we made a series of half-nude pictures,*

> *which were not erotic enough and yet more than simply beautiful nudes. But nothing was exactly to my taste.[30]*

In fact, in 1924 Krull and Kurt Hübschmann published a portfolio of these nudes.[31] A sense of lighthearted humor pervades this series, too, and illustrates that the photographer was familiar with the playful tone of pornographic imagery during these years, which occasionally depicted paired women for a titillating effect on its male viewers. In these pairs, Gretel Hübschmann and an unnamed companion wrap themselves in the paisley shawl that Berthe Krull used. They lounge or crouch on a bed and whisper to each other as they disrobe. Instead of titillating the viewer, Krull allows a playfulness between the sitters rather than for the benefit of the viewer alone. In one view (plate 3.6) high heels are added to the shawls for costumes, and in another (plate 3.5), the half-clad women seem to be enjoying a good gossip rather than a sexual interlude. These pictures occupy a middle ground that could have been seen in an academic art setting, despite their playfulness.

In yet another portfolio, grouped together in a cardboard cover hand-marked "Les amies," Krull ventured beyond playful poses of paired women to frankly sexual lesbian lovemaking.[32] In this series of eleven photographs, two women cavort in a variety of positions on the same bed and with the same paisley shawl as in the previous series. These may well be the same models, as both have short dark hair, but their faces are often obscured, so that a direct identification cannot be definitively made. Instead, in two of the images, one of the women wears a masculine white shirt and tie and embraces her lover who is clad in more conventional and sober feminine clothing. In most of the other views, the women wear nothing but black stockings and shoes. Despite their directly sexual content, these images lack the frilly drawers or off-the-shoulder undergarments common to popular pornographic imagery. The hosiery and high heels remind us of the campy quality of the Hübschmann nudes, but these pictures directly demonstrate sexual poses and embraces.

In making this series of photographs, Krull clearly condoned lesbianism. We know that she had one woman lover herself, but we know nothing about the in-

tended use of the images. They may have been sold as pornography, or they may represent the completion of her lighthearted private studio experiment with Gretel Hübschmann and the second unknown model. The format of the portfolio mimicked the art portfolios of Krull's studio photography training, but the content of the photographs looked different. In plate 3.7, Krull has aimed her camera directly between one woman's legs but maintained a slight distance by framing the scene so that the bed, table, and length of the second woman's kneeling embrace create a stage set, although she must have been no more than three feet away. Comparable pornographic views exaggerated the thrusting view of the camera into unmistakable crotch shots, but Krull has chosen a more distanced version.[33] Nonetheless, a stockinged foot waves in the air, and there is a direct quality about the point of view and awkward pose that moves the photograph from camp to a quality uncomfortably close to cinema verité. Plates 3.9 and 3.10 depict similar passionate moments of mutual embrace. In these views, Krull has repeated her slightly formal point of view, aiming her camera from a distance of several feet from the couch and slightly below it. The effect is to recall the closed shallow space and chaise longue of Manet's *Olympia*, while exposing the intercourse and intimacy of a very different sexual transaction. Unlike the *Olympia*, however, the faces of these women are hidden, preserving their privacy while exposing their nudity in a much more shocking manner. Plate 3.8 returns to the directness of plate 3.7, in a pose where one woman kneels on the floor as she embraces her lover. Krull must have almost touched her shoe in making this exposure.

Although all of Krull's Berlin nudes—of Freia, Berthe, Gretel Hübschmann, and the lesbian couple—share a knowledge of the traditions of nude and pornographic photography and painting, Krull increasingly allowed for a humorous disrespect for its conventions. Krull had been classically trained as a pictorialist studio photographer, and her Munich portfolio demonstrates that she was able to compose and print the soft-focus, idealized, and romantic nudes that were the norm in the first years of the twentieth century. Her work in that portfolio is comparable to that of that of her colleagues Pécsi and Debschitz-Kunowski. By the time she made her Berlin nudes, however, she had both grown older and become more experienced. As an antidote to her virtual prostitution to Basler, the photographs represent an empowered position in which Krull controls the en-

vironment as well as responds to it. No longer was she the kept woman in the oriental room, but now she was the mistress of ceremonies herself, especially in the last portfolio. Krull could easily have created angry images in response to Basler's earlier control of her body and imagery, but she seems oddly free of anger, suggesting that she first accepted and then rejected Basler quite lightheartedly. If these images are a commentary on male control, they reflect the humor of the Grosz caricature that Krull depicts in her memoirs rather than a real sense of abuse. Her appetite for adventure and experimentation and her independence from any ongoing rules are typical of her conduct throughout her life.

The playful quality of all four groups of images creates a comment on nude imagery while adapting to its conventions. By lightheartedly inserting elements of pornographic imagery, Krull subverts the safely distant purity of the classical portrait style of the pictorialists. Her pairs of women also encourage multiple interpretations about the sexuality of the posers, or even frank lesbianism, another note outside the conventions of pictorialist nudes. Finally, the campy and dramatic quality of the photographs demonstrates that Krull and her sitters were playing with the genre, in effect substituting an activist collaboration for the conventional male gaze controlling a docile nude. It might be tempting to suggest that Krull turned to the lesbian world as a reaction to her various negative sexual experiences, but while she made these photographs, she was simultaneously involved in heterosexual relationships. Her position as a sexualized New Woman, therefore, must be read as a complex one, which embraced a powerful rejection of the male gaze of Weimar culture in favor of a female gaze, but not to the exclusion of male participation in her own photographic or personal life.

In these Berlin nudes, Krull began to move outside the male-dominated conventions of academic studio photography and slowly to formulate her own photographic view of the world. Her nudes represent women gazing on women, sometimes to mock male conventions and sometimes to touch on forbidden lesbian sexuality. The subjects (friends and relations) are not passive victims but collaborators in the irony. The nudes do not dispense with convention entirely, but they insert a playful note into the conventions to create a subtle commentary on Berlin life.

34.35

The New Woman and Professional Independence

Krull's nude studies comment on events around her, making her not only a participant in Weimar culture but a producer of the images that created the stereotypes of the New Woman. In her study of Hannah Höch, Maud Lavin highlights the disparities between the lives of Weimar women and the myth of the New Woman that are often discussed by scholars.[34] She concludes that "in considering the representation of the New Woman, it may not be so easy to differentiate between the experience of material life and its cultural myths."[35] Höch reappropriated existing press photographs into her collages in order to comment on this conflation, but Krull, who experienced Berlin while creating some of its popular press myths, was implicated in an even more complex—though less introspective—way. Published in the mainstream popular press, Krull's photographs, in fact, helped to market the public's image of women in postwar Germany.

Krull pushed the idea of the New Woman in another direction as well, setting up a professional practice as a woman. In many respects, she epitomized the bobbed, clean-cut, cigarette-toting working woman of uncertain sexuality highlighted, for better and for worse, in the popular press (fig. 3.1). But she went further than the popular perception of the office girl, becoming an entrepreneur—not a standard feminine role in Berlin. Against great odds, Krull began and sustained a photographic career that would increasingly bring her income, satisfaction, and professional identity throughout much of her life. This commercial work included portraits, fashion, and theater photographs for the exploding popular press. In fact, Krull proved, and would repeatedly prove over the next decades, that she was an entrepreneur at heart.

Women Photographers in Berlin
During these early years, Krull established a studio to attempt to make her own living, with limited success. Krull was not the only woman opening a studio in the early 1920s in Berlin, although she did so very early in her generation; many others would follow in the late 1920s, by which time she would have been long established in Paris. She differed from them in departing from fashion and traditional women's subjects by the mid-1920s, turning instead to the traditionally male industrial and street views that many of her colleagues avoided.

Most of the major women photographers in Germany had studios in Berlin, and many of them followed a path similar to Krull's by beginning with portrait and studio work and then breaking into the illustrated press by the later 1920s. The vast publishing machinery of the Berlin-based Ullstein Company produced an enormous number of newspapers and magazines during these years and provided a livelihood for many photographers.[36] Many women whose names would pepper the pages of *Die Dame, Das Illustrierte Blatt, Der Berliner Illustrirte, UHU*, and other weekly photographically illustrated magazines in the late 1920s worked in Berlin. Most remained closely tied to the women's fashion and society portrait supplements of the press even then.

Krull's pioneering Berlin colleagues during the early 1920s included her earlier cohort from Munich, Wanda von Debschitz-Kunowski, who opened a studio in Berlin in 1921.[37] Erna Lendvai-Dircksen, who studied at the Lette-Verein from 1910 to 1911, had a portrait studio in Berlin from 1916 to 1943. Elli Marcus also opened her photography studio there in 1918 and specialized in theater photography from 1924 onward. Cami Stone probably moved to Berlin in 1922. Yva (born Else Neuländer) named her Berlin studio Yva in 1925. Many of this first generation of German women set up shop near Krull's address on or near the Kurfürstendamm. For instance, Suse Byk's studio operated on the Kurfürstendamm from 1913 to 1938, and Hanna Riess had her studio at 14/15 Kurfürstendamm from 1925 to 1930. By the late 1920s, when the work of these women was most prominent in Germany, Krull's photographs were all over the Paris magazines, although some were sold to the German illustrated press as well.

Atina Grossmann suggests certain factors that facilitated the involvement of women with the professions during these years. She suggests that the double pulls of American consumerism and Bolshevik communism competed in complicated ways to define modernity in Weimar culture.[38] These competing economic and political systems had a particularly poignant meaning for Krull. As a woman who had devoted four years of her life to the leftist cause and who, like Emma Goldman and others, had felt betrayed by it, she had to reinvent her attitude toward political engagement. Krull's first-

hand knowledge of the problems of communism freed her from blindly adhering either to its rules or to those of the capitalist marketplace; she consistently explored her own personal path. For example, she was not an employee of the vast Ullstein-inspired marketing machinery of the Berlin newspaper and portraiture industry, like her colleagues Elli Marcus, Yva, and Cami Stone. Nor was she a committed cultural commentator in the manner of artists such as Hannah Höch, whose photomontages viciously mocked Berlin culture, or Alice Lex-Nerlinger, who made overtly political montages. She was fortunate enough to combine occasional commercial work with her own projects, such as her uncommissioned explorations of art subjects like nudes during these years.

Gender issues would be critical for Krull's later work, although her Berlin pictures fall more comfortably into the mainstream of women's photography. Patrice Petro has brilliantly discussed the gendered issues of mass media production and spectatorship in her book *Joyless Streets: Women and Melodramatic Representation in Weimar Germany*.[39] Petro disagrees with historians ranging from Siegfried Kracauer to Peter Gay who analyze Weimar culture through reference to male Oedipal narratives.[40] Instead, she suggests that the cinema and the illustrated press addressed a female rather than a male spectator.[41] Women's photographs and illustrated magazines aimed primarily at women (which included not only *Die Dame* but mainstream papers like the *Berliner Illustrirte Zeitung*) used the androgynous image of the New Woman in masculine clothes. As Petro writes, "the representation of gender identity in *Die Dame* may be said to encourage a vision of sexuality as shifting between masculinity and femininity."[42] Krull's Berlin work of the early to mid-1920s fits into this model, but she would not be content with the traditional female subjects of fashion photography, nudes, and portraiture for long.

Kurt Hübschmann

Not only did a man finance her Berlin studio, but Krull began her professional career in Berlin in partnership with a male photographer; both were short-lived alliances. As noted, she was not ashamed to accept financial help from Basler, but her aim was to sustain her business independently. Basler's purchase of a partnership with Kurt Hübschmann in 1922 or 1923 allowed the two young photographers to test the waters of the professional Berlin photography world together.[43] Krull

describes her first visit to the studio in "La vie mène la danse":

> *The atmosphere was good and a little confusing. I said that I would return the next day, alone. The next day the ice was broken, and I saw that Hübschmann was of my own world and that all would go well. It was Basler who hit the false note in the scene.*[44]

Although little is known about Hübschmann's early career, he figures prominently in Tim Gidal's book on early photojournalism in Germany. Gidal quotes Felix H. Man, a fellow photojournalist from the late 1920s, who noted that while Hübschmann was "first a studio and advertising photographer, he subsequently became a photojournalist."[45] This career move parallels Krull's; both moved from studio work in the early 1920s to street photography by the late 1920s. In 1929, Hübschmann joined the German photo service Dephot, which was founded in 1928 by Simon Gutmann and Alfred Marx. After leaving Dephot, Hübschmann joined another agency, Weltrundschau, using a small Ermanox camera as of 1929 and a Leica after 1930. Gidal describes his later work: "His pictures radiate a sympathy for the human beings whom he described by means of photography" and are also characterized by "sympathy and joy of life."[46] In the mid–1930s, Kurt Hübschmann, who was half-Jewish, emigrated to London and changed his name to Kurt Hutton. There he collaborated with Stefan Lorant, the émigré editor of *Picture Post*.[47]

During their first months, Hübschmann and Krull worked happily together. According to the memoirs, Krull enjoyed making portraits of their clients. Hübschmann was shyer and preferred laboratory work, and his wife Gretel Hübschmann handled the fashion work, which Krull disliked.[48] They had few clients, despite the photographs they displayed in a vitrine on the sidewalk of the Kurfürstendamm. When Lenin died on 21 January 1924, Hans Basler appeared in their studio with a series of photographs of the Soviet leader, amassed through his Moscow business contacts. They rephotographed these and assembled several hundred small books, which, according to the memoirs, sold very

successfully both in Russia and Berlin and provided a cash influx to stabilize their business.

Little remains of the work on which Krull and Hübschmann collaborated between 1922 and about 1924, at which point Hübschmann moved on and left his portion of the studio to Krull. Their fledgling business seems not to have been very successful, and little of this work found its way into the press. From her memoirs, we know that she and Hübschmann attempted fashion photographs, portraits, and a few photographs for the illustrated press, but the surviving materials include no images by her partner alone, and few collaborations. Krull's portrait of Friedrich Pollock (plate 5.11), dated 1923, suggests the beginnings of a dramatic portrait style, with its sharp shadows, informal pose, and geometric framing; it is signed by Krull alone. This Berlin portrait shows Pollock, in shirtsleeves instead of dark coat, posed informally against a light background. The looming shadow behind his body doubles the image in a manner reminiscent of cubist interpretations of photography, a strong contrast to the pictorialist effect of Krull's Eisner portraits just five years earlier. No fashion photographs or other portraits from this period have yet emerged, suggesting that the studio was not commercially very successful.

The young partners clearly attempted to initiate publishing and portfolio schemes as marketing tools, but the fledgling nature of their business is highlighted by the fact that their main models were family members. The nude photographs of Berthe Krull, for example, bear a circular sticker on the back that reads "Kara-Kunstdruck-Verlag GMBH Berlin," with a freehand drawing of a nude in its center.[49] Berthe Krull explains that Krull and Hübschmann founded the "Kara-Kunstdruck-Verlag" together and that Germaine alone made the photographs in the series, despite the double signature.[50] The double nudes of Gretel Hübschmann and her friend were also organized into a portfolio entitled "Akte."[51]

Theater Portraits

In addition to her nudes, Krull's work from 1922 until 1925 followed the gendered pattern of the vast number of her colleagues, concentrating on portraiture and studio work. Some of her photographs, however, moved outside the studio to record the cultural life of Berlin—not a traditional subject for a woman photographer. Moreover, while she wrote detailed accounts of her later Paris life, she left little written record of the plays she saw in Berlin, the books she read, or the music she heard during these years. We can glean some sense of Krull's interests, however, from her theater photographs, which provide visual evidence that she was, in fact, intimately involved with the city's cultural avant-garde. Theater subjects were among the most popular themes in the popular press. Dance operated as a twin reflection of the modern and the eternal world, and Siegfried Kracauer's 1925 essay "Reise und Tanz" stresses the theological implications of dance as an escape from rationalization.[52] Her interest in modern dance was a way to begin to move beyond the academic studio training of her youth, although it is unclear whether the dance inspiration came from her own observations or the interests of her sister Berthe, a dancer. At any rate, dance evolved from expressionism to a starker form much as photography did, and Krull observed the transition with her photographs.

Among the few Krull press photographs that survive from Berlin are a series of theatrical and dance photographs in the Deutsches Tanzarchiv. A portrait of Max Terpis (plate 3.11) depicts the half-nude figure in a dancer's pose, framed as a tall, thin image and printed in a soft sepia tone that harkens back to Krull's earlier pictorialist training. Unlike the Eisner portrait, however, the subject is clearly a key member of the Weimar avant-garde. Max Terpis (1880–1958) was a famous dancer, both in classical ballet and as a student of the modern dance master Mary Wigman, a renowned eurythmics dancer. Wigman's credo read in part as follows:

> *Dance is the language of the living, moving body.*
> *Dance expresses invisible movement by means of*
> *visible movement.*
> *Dance is an avowal of human existence.*
> *Dance is the unity of force, time, and space,*
> *bound and unbound by inborn rhythm.*[53]

Terpis studied with Wigman in 1921 in Dresden and then made his debut in about 1923.[54] Among his early Wigman performances was the *Josephslegende*, with music by Richard Strauss. Krull's portrait of Terpis may depict him in this role, draped with a waistcloth and standing with arms crossed above his head in an expres-

sionist pose reminiscent of either Saint Sebastian or the Joseph legends.

If the study of Terpis is a serious dance study, another half-nude carries on the humorous tradition Krull explored in her Berlin nude portfolio with Gretel Hübschmann. A photograph of Daretha Albu (plate 3.12) depicts a tousled woman, holding a feather boa to her chest and loins, with her eyes shut as if mocking sleep or sensuality. The costume was designed by Lotte Pritzel, a famous German designer of costumes and satirical puppets, whom Krull first mentions in her memoirs about Munich. Although it is unclear whether she and Pritzel met first in Munich or in Berlin, they clearly continued their connection in Berlin.

Another photograph depicts Lotte Pritzel herself, with classical dancer Daisy Spies and modern dancer Harald Kreutzberg, all in costume for the Kroll-Redoute, a famous masked ball in the third Berlin opera house, the Kroll Oper (fig. 3.3). Either in her studio or in the theater, Krull framed the three famous Berlin characters in dramatic lighting and deliberately exaggerated poses and costumes for the ball. Several other photographs in this series are similarly overposed and humorous. Krull's photographs appeared in several Berlin papers and probably helped to establish Krull's reputation, although the press clippings that survive are unlabeled.[55] The magazine publication of an unidentified 1925 caricature of these three in costume, in the Deutsches Tanzarchiv, allows us to date this photograph.[56]

Pritzel, on the left, designed all three costumes, which were manufactured by the firm of Becker in Berlin. On the right side of the photograph, Kreutzberg poses in a shaggy wig, as "the Ape." Kreutzberg (1902–1968) was probably the greatest male modern dancer in Berlin at that time. Like Terpis, Kreutzberg studied in Dresden with Mary Wigman and arrived at the Berlin Stadt Opera House in 1924. His career took off from there with his role in *Die Nächtlichen*, with music by E. Wellesz. Spies's costume, complete with ears, represents the Fledermaus, after the mouse in the Richard Strauss opera.

Krull writes in her memoirs, very briefly, that she began to be more successful during these years, although little evidence survives to substantiate this. Her theater work, possibly through her photography contacts and probably also through her younger sister's interest in modern dance, began to evolve slowly. A final portfolio of dancers reveals that although Krull continued to mount her groups of photographs in port-

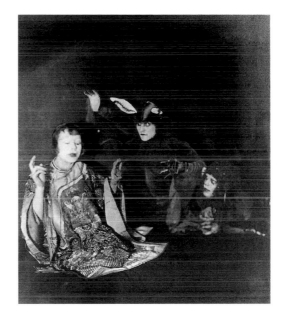

folios reflecting her art school training, the compositions began to shift subtly. In this group of modern dancers, the soft focus and allegorical subject of the Terpis photograph have sharpened to more graphic and dramatic views. In one view (plate 3.13), a dancer in black leggings and turtle neck allows his head and hands to fall limply in the manner of modern dancers at that time, and Krull captures the informality of the pose by silhouetting him against a dark background so that only the dancer's white head, hands, and feet emerge. In plate 3.14 another dancer strikes a more dramatic pose, with fists clenched and black-rimmed eyes staring upward, but Krull has framed her subject in a more graphic composition than she had for Terpis.

Street Photographs

During these years, we can discern the tentative beginnings of a shift in Krull's photography away from women's subjects, such as theater and fashion, toward a less typically feminine image—the street. This shift signaled the sea change in Krull's style and intellectual focus that would bring her international fame in the popular press and the art world alike by the late 1920s. Very few of Krull's surviving photographs document Berlin's streets. Simultaneously, the industrial and metallic elements of the modern city tentatively begin to enter into her compositions. Her Berlin photographs do not yet display the kaleidoscopic effect of urban fragments that the writer Alfred Döblin would incorporate in his 1929 book, *Berliner Alexanderplatz*. Nonetheless, she was absorbing its energy like many other intellectuals and would soon put it to good use in Amsterdam and Paris, where her photographs would reflect the montage effect of modern life.

FIGURE 3.3

GERMAINE KRULL. KROLL-REDOUTE [WITH LOTTE PRITZEL. DAISY SPIES. AND HARALD KREUTZBERG]. 1925. GELATIN SILVER PRINT. 18.5 x 16 CM.. DEUTSCHES TANZARCHIV. COLOGNE

Krull's Berlin street photographs chronicle well-known spots. Her studio was in the new shopping and entertainment section of the Kurfürstendamm, surrounded by cafés and glittering with lights at night. She also explored the Alexanderplatz, "the center of the Berliner's Berlin,"[57] and the dark underworld of the city centered there. She certainly knew enough to rescue her sister from her seedy Alexanderplatz nightclub engagement. Yet her Berlin street photographs chronicle the city's popular centers, such as the crowded government and newspaper center, Potsdamer Platz (site of the world's first traffic light). Among the few street photographs that survive from Krull's Berlin years are two photographs of a populist cultural phenomenon, the grouping of travel-theme restaurants on the Potsdamer Platz called Haus Vaterland (plate 3.16). A contemporary account describes the Platz:

> What a jolly place! What a youthful, carefree, won't-go-home-till-morning, romantic, wonderful place! The merry illuminated bonnet it wears for a roof whirls round and round like the rings of Saturn. It has orchestras to pipe and fiddle all the different sorts of music people play from Seville to Stamboul. It has cowboys and Turks, Spanish dancing girls and buxom maidens from Bavaria. It has silver walls, and marble staircases, fountains—and even mountains and trains. It is the jolliest place in Berlin.[58]

Krull's photograph of the Potsdamer Platz highlights the gleaming trolley tracks in the foreground and the overhead trolley and electric lines above, and silhouettes the domed building against the sky. This photograph signals her imminent departure from the accepted women's professional subjects of fashion and portraiture. Instead of photographing the shopping and entertainment complex at night, she frames it in the rain, focusing on glistening streets and umbrella-covered pedestrians traversing the road in a manner resembling the paintings of Caillebotte. Although she acknowledges modern subjects like tracks and trolleys, her style does not yet abstract them into fragments as she would do in Amsterdam.

Several other street photographs suggest that Krull was beginning to venture into the streets, although their dating remains unclear, and they may have been made on later trips back to Berlin. Another photograph documents the Romanisches Café, the artistic and in-

tellectual center of Krull's circle (plate 3.15). Although lacking the touches of avant-garde style of the Haus Vaterland image, Krull clearly documented the centers of Berlin where ideas were evolving.

The Berlin illustrated press supported many photographers in this decade, although it used photographic illustrations most heavily after 1928. Even in the mid-1920s, the cultural center of the publishing world was Berlin, which produced hundreds of newspapers. Although Krull mentions briefly in her memoirs that she sold a photo to a magazine soon after she began working in Berlin, her first documented photograph in the press appeared in 1925.[59] But during these early years, her own contacts with the newspaper world were not yet developed. When Krull later became famous in the picture press, it was for industrial and street photography; by contrast, the vast majority of the women photographers working in Berlin gained their reputations in fashion photography, portraiture, or cultural records such as theater photography.[60] By the late 1920s Krull, like Hübschmann, actively published her photographs in Berlin and throughout Europe. She began more active participation in the press in Amsterdam in 1925 and 1926 and exploded into print once she moved to Paris. These later photographs were placed not only in Holland and France but also in Germany—through the Mauritius Agency, founded by Ernst Mayer, a book publisher who began selling photographs to magazines in 1928 or 1929.[61] For the moment, Krull was beginning to forge the connections that would soon lead her into the avant-garde.

Berlin's Intellectual World

In her wanderings around Berlin, Krull frequented the Romanisches Café across from the Emperor William Memorial Church at the beginning of the Kurfürstendamm. This was the center of Berlin's intellectual world and the place where George Grosz's dada circle, Bertolt Brecht's theater world, and others gathered.

Arthur Lehning

Kurt Hübschmann was Krull's conduit to the intellectual world of Berlin, and he introduced her into his

circle of friends. Through him Krull met three Dutch-men—the anarchist and writer Arthur Lehning (or Müller-Lehning), the poet Hendrik Marsman, and Joris Ivens. Krull writes relatively little about her cultural contacts until she broke into this circle of Dutch intellectuals studying and working in Berlin, centered at the home of Lehning and Annie Grimmer:

> When friends of Hübschmann asked me to accompany them to visit some Dutch friends, I accepted with pleasure. Müller-Lehning had an elegant studio. He was an intellectual. . . . The welcome was warm. He showed us his paintings and read us his poems.[62]

Both Arthur Lehning and Joris Ivens had been students at Rotterdam's Economische Handelshoogeschool in 1919.[63] Lehning first became involved with avant-garde art publications then and also was a member of various pacifist organizations, combining political and artistic avant-garde interests that would influence Krull deeply. Ivens later describes Lehning as a "student more engaged than I was in the social reality. He was a committed anarchist who began to open my eyes."[64] Lehning had published political articles in Holland and also learned about the de Stijl and expressionist art worlds. He first visited Berlin in 1921 and moved there in September to work for the publishing house Die Schmiede.[65] During 1922 and 1923, Lehning attended the meetings of the Internationale Arbeiter-Assoziation, and there he met Alexander Berkman, Emma Goldman, Gregory Maximoff, and Alexander Schapiro all, like Krull herself, recently returned from Russia. His first political brochure Die Sozialdemokratie und der Krieg was published in 1924, and by the end of that year he moved to Paris.[66]

In discussing her meeting with Lehning in her memoirs, Krull makes no mention of Lehning's political contacts, but she does discuss her encounter with the Dutchman's childhood friend, the poet Hendrik Marsman (1899–1940). Born in Zeist, Marsman studied with Lehning in 1914, and the two remained friends thereafter. One of Lehning's first projects at the publishing house in Berlin was to hand set Marsman's early collection of expressionist poetry, Verzen.[67] Marsman became one of the most important interwar Dutch poets and a good friend to Krull. In fact, he long planned to write a book about Krull's political adventures in Munich and Moscow, only stopping his project in 1933

when Krull admitted that the memories were too painful for her to revisit.[68]

Joris Ivens
On her first visit to Lehning's apartment in 1923, Germaine Krull noticed another young Dutchman and student friend of Lehning, Joris Ivens (plate 5.13):

> There was also a young Dutch man, who worked for Zeiss. "He makes photographs, too," someone told me. He was the son of one of the biggest photography merchants in Amsterdam. His father wanted him to do an internship in the Zeiss factories to understand what he sold. He had a quiet air, and just sat and looked around him. His eyes had a way of seeing things in a different manner. . . . I saw Joris Ivens again. I found myself strangely attracted to him. His simple way of seeing things gave me confidence. I told him everything. . . . Joris listened to me and put me back on my path. When I became his mistress, everything was simple, as everything was always simple and clean with him.[69]

Together Ivens and Krull would navigate the waters of Berlin's world in 1923 and 1924—as passionate lovers, as friends leading each other intellectually and emotionally, as jointly naive observers of the inflation gripping the city, and as growing political thinkers. Ivens would be Krull's companion during the crucial years when she formulated a sophisticated aesthetic and political world view.

Ivens had arrived in Berlin in September 1923 after a first short stay there in 1922.[70] His father owned Capi, one of the largest chains of photographic stores in Holland, and had sent his son to study and train for the family business in Germany.[71] Ivens had grown up in the town of Nijmegen and spent two years studying in Rotterdam in the Economische Handelshoogeschool. There he had met Arthur Lehning.[72] Once settled in Berlin, Ivens began absorbing the world around him with the older and more experienced Krull as a guide.

In his memoirs, Ivens writes movingly about his years with Krull, for whom he clearly cared deeply:

At the time when we met, Germaine K. was passing through a difficult period in her life. She was in an unstable state and fluctuated ceaselessly between excessive gaiety and sudden despair. Anarchist, revolutionary, and artist with an exquisitely honed sensibility, Germaine K. was obsessed with death and suicide. I became her lover, her friend, and her traveling companion in life. Through her I penetrated into a world I had only imagined. It was my encounter with revolution, with art, with life.[73]

Krull was certainly depressed during these years and still haunted by memories of her near execution in Russia. She may not have been actively suicidal, however, for Ivens's prose is often as exaggerated as Krull's.

Ivens describes more fully than Krull the passionate nature of their affair, writing that he discovered love with Germaine, remembering "that extraordinary relationship between two beings, erotic and sexual, but also the deeper relationship of a shared and recognized sensibility, with the rare and moving sensation of discovering the world together and recreating it together."[74] He also describes their relationship as one of equals: "Germaine was two years older than I, but we formed a couple very man-woman, equal-equal. That, also, was new to me. In practical matters, we split everything half and half."[75] The equality between these two artists was the key to their lifelong friendship and marked a change for Krull, who had never before been in a relationship of equals. She would never again be under the control of a male authority figure.

Krull, on her part, writes very eloquently of their mutual education. She taught him about politics; he taught her about the bourgeoisie:

For my part, Joris introduced me into an unknown world, that of the bourgeoisie, the Dutch bourgeoisie. I introduced him to the struggle for the workers. Each of us was encountering a new world. But for him, it was stronger and more vibrant than for me. He lived seven days of the week with workers, saw them living and working; whereas I could only imagine Joris's parents and their world.[76]

During their three years in Berlin, Ivens simultaneously experienced the workers' strikes of 1923 in Dresden and Berlin, the whirling Berlin cultural scene, and the uni-

versity and manufacturing worlds where he was studying. When he writes, in his memoirs, that Krull introduced him to a new world, his words suggest that she did not break as completely with her political beliefs as her own writings would suggest.

Nevertheless, as intellectuals, their involvement in the working class was indirect; they sympathized with the cause but suffered none of the privations of most workers. In fact, during the years of enormous inflation around 1923, Ivens, with his Dutch florins, suddenly found himself wildly wealthy, and they spent money on books, meals, and other luxuries in the city. For example, Krull's memoir describes their collection of rare books.[77] Ivens, despite his dabbling in the revolutionary world and his contacts with factory workers, freely admits in his memoirs that he was a middle-class citizen at heart and had at this point in his life not yet engaged completely with the worker's world. This was his first taste of it, and Lehning's ideas and Krull's together created a crossroads for him.[78] Neither Ivens nor Krull were strikers or activist political workers during these years; they confined their actions to intellectual discussion and observation from the sidelines, unlike Krull's earlier experiences. Together with Krull, Ivens marched in sympathy with workers' strikes in the streets of Berlin. But unlike Krull, whom the filmmaker-to-be calls an anarchist in his memoirs, he soon came down on the side of organized communism:[79]

In these repeated and violent hours, I saw the communists prove their method and efficiency. They attacked the police forces head on and sometimes pushed them back. The anarchists, on the other hand, had a disorderly violence; they advanced with no order, they were hit, arrested, sometimes killed.[80]

There is no proof of Krull's serious involvement in anarchism in Berlin.

Their intellectual sympathies did not prevent them from continuing their respective business educations. Ivens marched in the street demonstrations and yet continued to prepare to take over his father's business; Krull observed the workers from afar. In this joint position, they were comparable to Horkheimer and Pollock,

both of whom fought Marxist battles in the university rather than the street, and to Lehning, who also wrote rather than fought.[81] Their activities until 1925 do not suggest a reasoned synthesis of the two opposing worlds of art and politics; that, too, would arrive, for both of them, when they moved permanently to Amsterdam in the autumn of 1925.

During the first twenty-seven years of her life, therefore, Krull was learning to exist as an independent woman in the twentieth century. Molded by her unconventional upbringing and tested by her first experiments with political involvement, she also began to interact with the international avant-garde. She had begun to forge a more self-assured position for herself by the time she left Berlin. From a young woman exploited by circumstance and by the more powerful men in her life (whether benevolent role models like Kurt Eisner or tempestuous lovers like Samuel Levit), Krull emerged as a New Woman who emphatically assumed control of her own destiny. In Berlin, Krull both recorded and enacted the stereotype of this postwar female role, but she also began to comment on it critically.

In her fascinating study of gender roles in France between 1917 and 1927, historian Mary Louise Roberts paints two opposing cultural images of women—the traditional role of the mother and the new role of the modern woman, who is culturally perceived as being "fast, loose," and as following the new fashions of bobbed hair and fast cars.[82] Roberts's symbol of that modern woman is the heroine of *La Garçonne*, an enormously popular 1922 novel by Victor Margueritte featuring a "modern woman who denounces her bourgeois family in order to lead an independent and promiscuous life in Paris."[83] Krull certainly played out the role of the modern woman or New Woman in Berlin. Roberts sees these two roles as achieving a kind of progression in a third role—that of the "single woman," an autonomous working woman.[84] This term was coined to designate the 1.5 to 3 million who would remain unmarried and childless because of the war's demographic devastation. They had to enter the workforce and somehow exist as single women without male support; their huge numbers precluded the possibility of labeling all of them immoral modern women and hence the new category. When Krull arrived in Amsterdam, she was about to obtain professional, personal, and political independence as a respectable single woman.

PLATE 1.1
KURT EISNER.
BEFORE FEBRUARY 1918.
GELATIN SILVER PRINT, 18 x 13 CM.,
GRAPHISCHE SAMMLUNG IM
MÜNCHNER STADTMUSEUM,
MUNICH

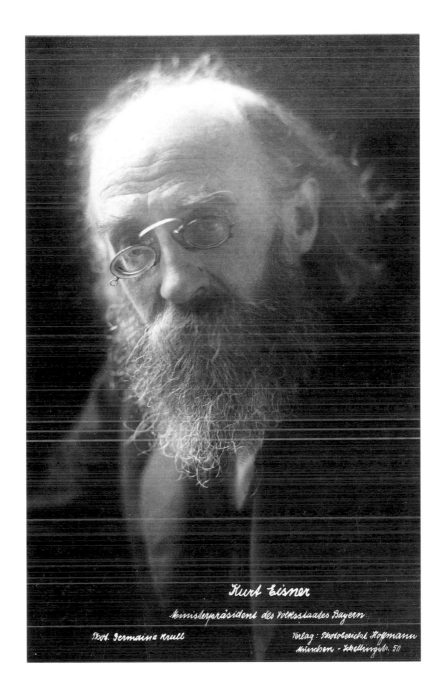

44.45

PLATE 1.2
KURT EISNER, OCTOBER/NOVEMBER 1918,
GELATIN SILVER PRINT, 13.9 x 8.9 CM.,
FOTOMUSEUM IM MÜNCHNER
STADTMUSEUM, MUNICH

46.47

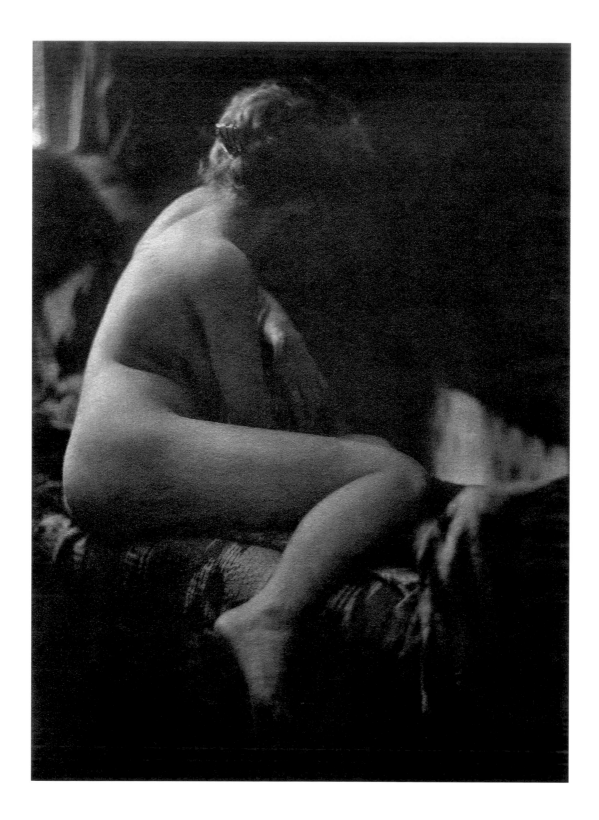

PLATE 1.4

FROM *DER AKT: ZWANZIG
PHOTOGRAPHISCHE AUFNAHMEN
WEIBLICHER KÖRPER NACH DER
NATUR*. DACHAU BEI MÜNCHEN:
EINHORN VERLAG. 1920. (PLATE 15).
PHOTOGRAVURE. COLLECTION
FRANÇOISE DENOYELLE. PARIS

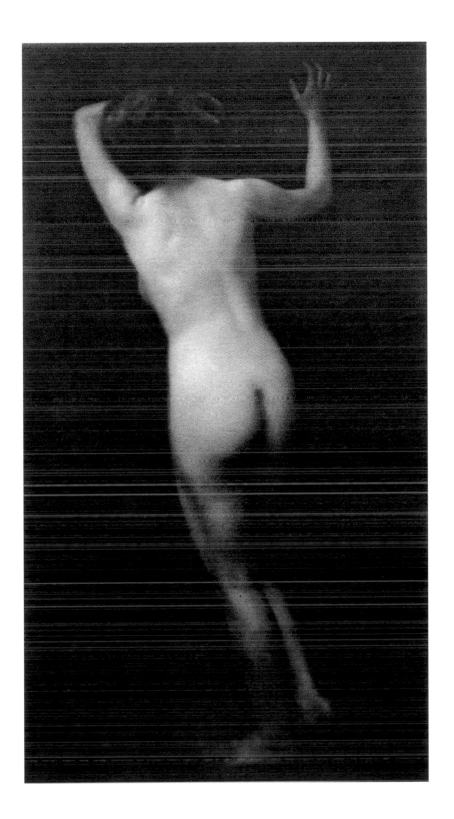

48.49

PLATE 1.5
FROM *DER AKT: ZWANZIG
PHOTOGRAPHISCHE AUFNAHMEN
WEIBLICHER KÖRPER NACH DER
NATUR, DACHAU BEI MÜNCHEN:*
EINHORN VERLAG, 1920. (PLATE 16).
PHOTOGRAVURE. COLLECTION
FRANÇOISE DENOYELLE, PARIS

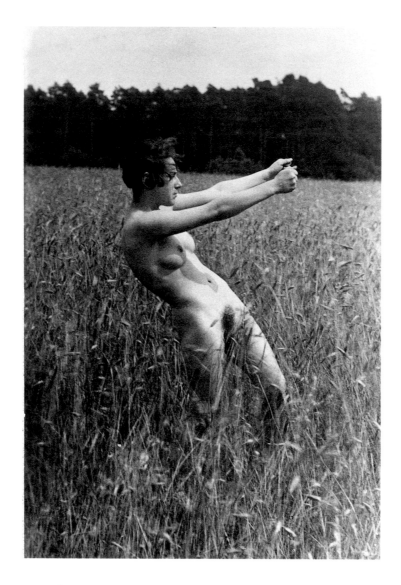

PLATE 3.1
FREIA. 1924.
GELATIN SILVER PRINT, 6.9 x 5.1 CM.,
PRIVATE COLLECTION, NEW YORK

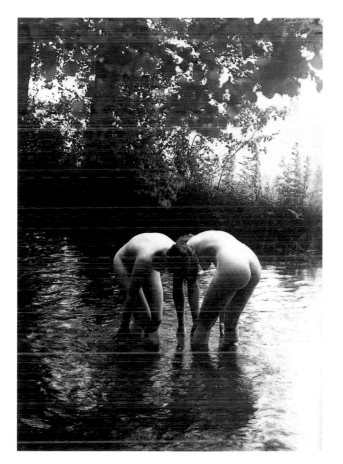 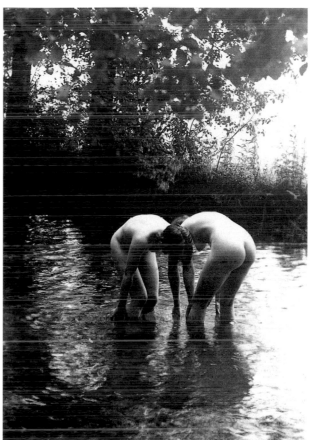

50.51

PLATE 3.2
FREIA. 1924.
STEREOSCOPIC VIEW.
GELATIN SILVER PRINTS.
RIGHT 6.9 x 5.2 CM.,
LEFT 7.0 x 5.1 CM.,
TOTAL WIDTH 10.7 CM.,
PRIVATE COLLECTION, NEW YORK

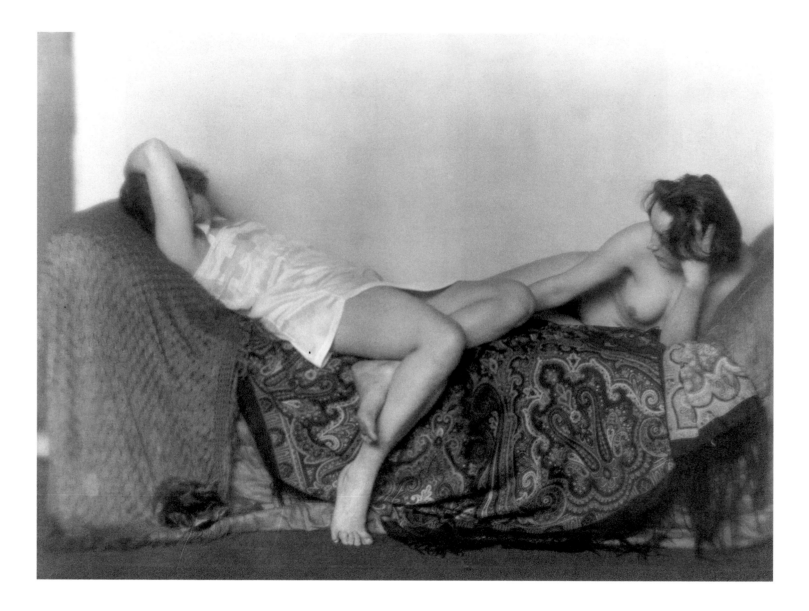

PLATE 3.5
FROM *AKTE*, 1924.
GELATIN SILVER PRINT, 16.5 x 22.1 CM.,
COLLECTION DIETMAR SIEGERT,
MUNICH

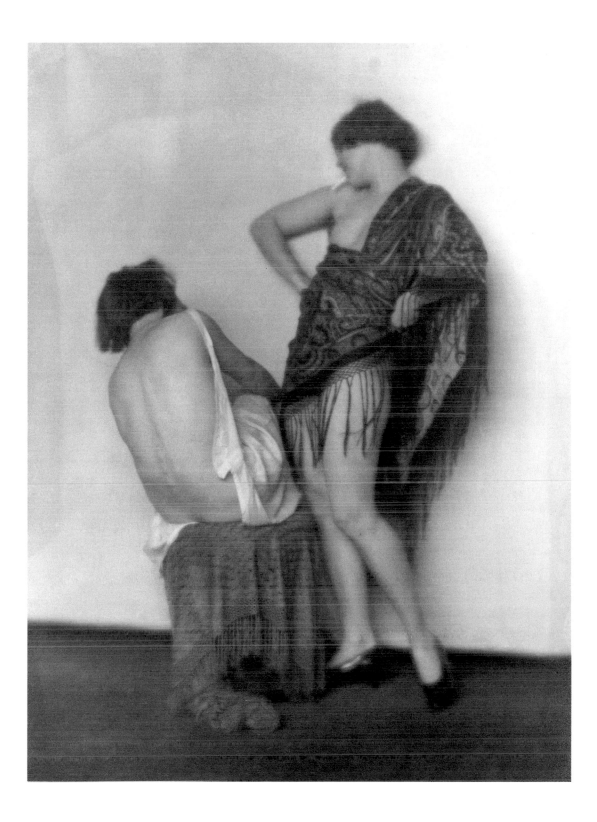

54.55

PLATE 3.6
FROM *AKTE*, 1924,
GELATIN SILVER PRINT, 22.2 x 16.3 CM.,
COLLECTION DIETMAR SIEGERT,
MUNICH

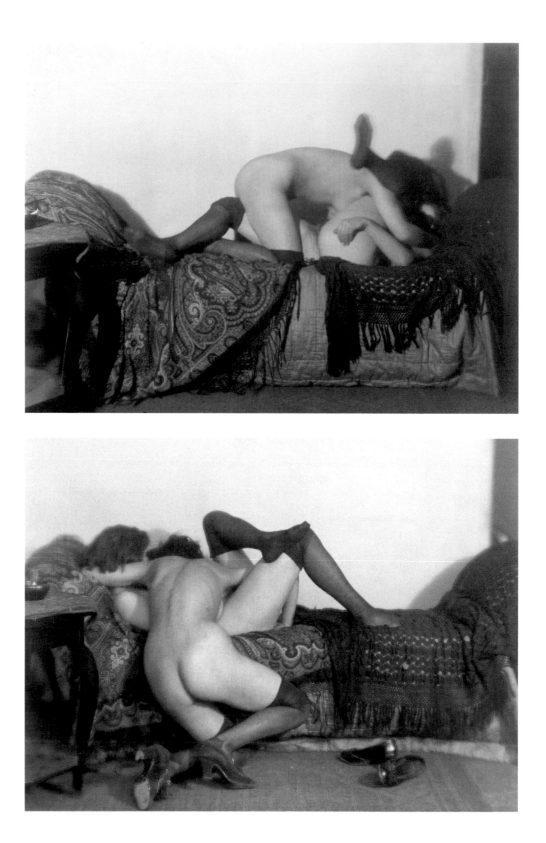

PLATE 3.7
FROM *LES AMIES*, C. 1924,
GELATIN SILVER PRINT, 15.9 x 21 CM.,
COLLECTION SUSAN EHRENS,
BERKELEY

PLATE 3.8
FROM *LES AMIES*, C. 1924,
GELATIN SILVER PRINT, 16.1 x 30.9 CM.,
COLLECTION SUSAN EHRENS,
BERKELEY

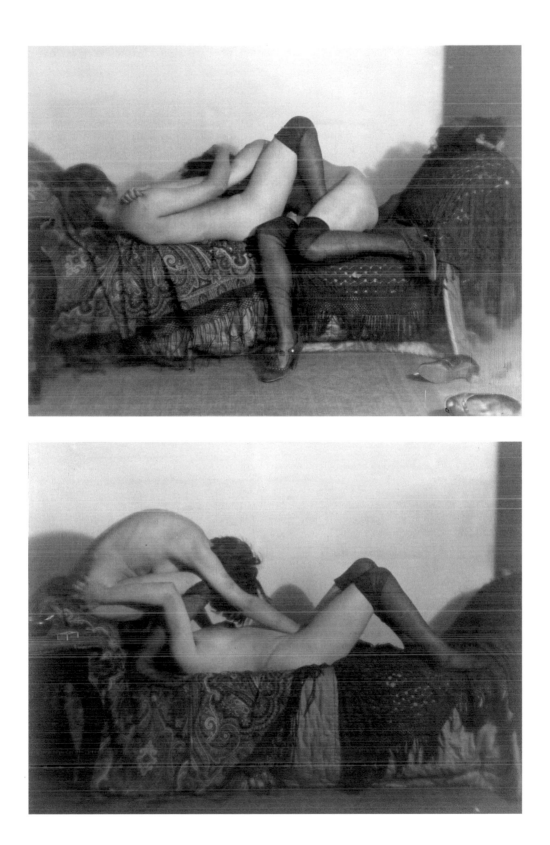

56.57

PLATE 3.9
FROM *LES AMIES*, C. 1924.
GELATIN SILVER PRINT, 15.8 x 21.6 CM.,
COLLECTION SUSAN EHRENS,
BERKELEY

PLATE 3.10
FROM *LES AMIES*, C. 1924.
GELATIN SILVER PRINT, 15.5 x 21.2 CM.,
COLLECTION SUSAN EHRENS,
BERKELEY

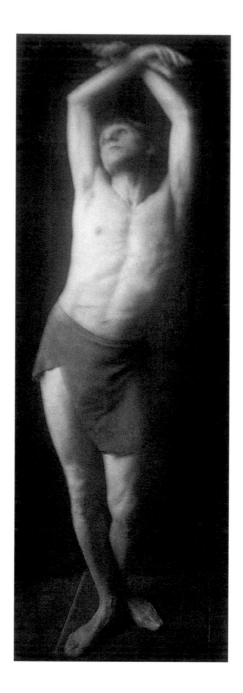

PLATE 3.11
MAX TERPIS, N.D.,
GELATIN SILVER PRINT, 16.9 x 6.1 CM.,
DEUTSCHES TANZARCHIV, COLOGNE

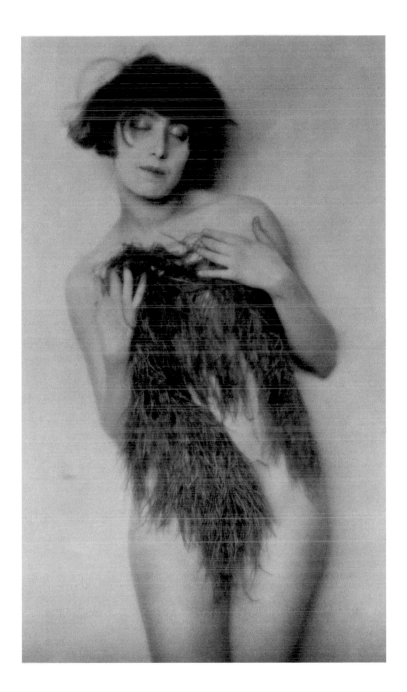

58.59

PLATE 3.12
DARETHA ALBU [COSTUME AND
DESIGN BY LOTTE PRITZEL], N.D.,
GELATIN SILVER PRINT, 19.6 x 11.7 CM.,
COURTESY HOUK FRIEDMAN NEW YORK
AND ROBERT KLEIN GALLERY, BOSTON

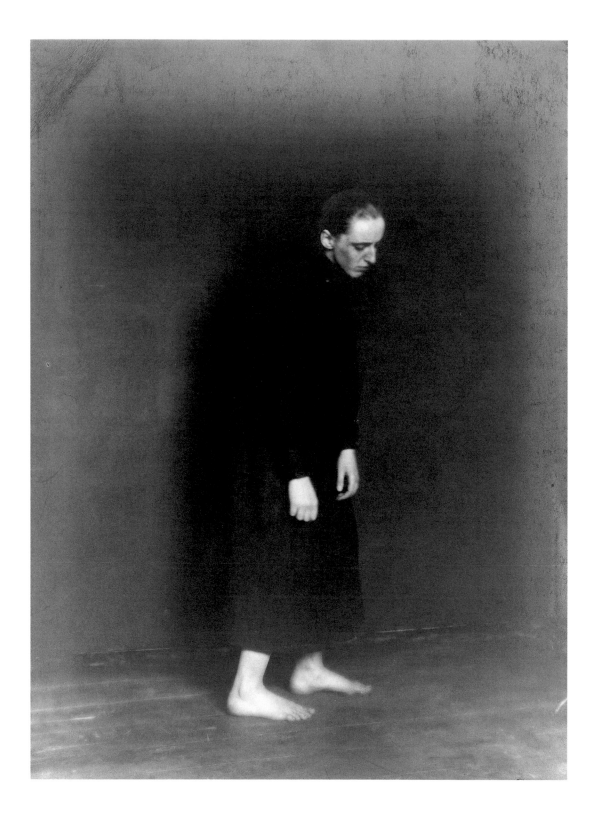

PLATE 3.13
JO MIHALY, TANZ, 1925,
GELATIN SILVER PRINT, 22 x 16 CM.,
MUSEUM FOLKWANG, ESSEN

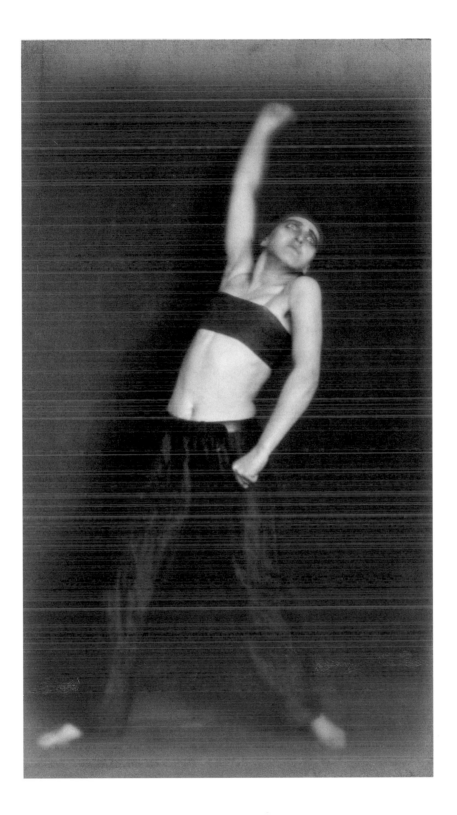

60.61

PLATE 3.14
JO MIHALY, IN 'REVOLUTION,'
TANZ, 1925.
GELATIN SILVER PRINT, 21.4 x 12.4 CM.,
MUSEUM FOLKWANG, ESSEN

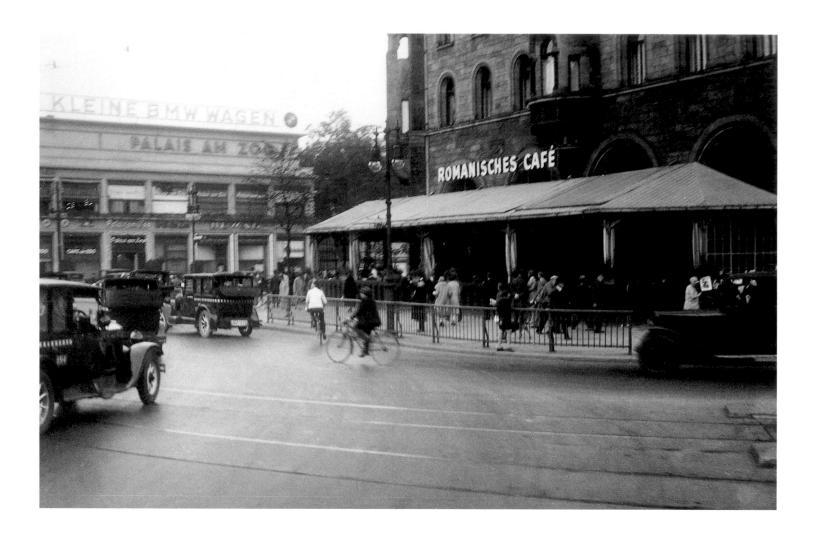

PLATE 3.15
ROMANISCHES CAFÉ, BERLIN, C. 1929,
GELATIN SILVER PRINT, 14.5 x 22.7 CM.,
ARCHIVE AND MUSEUM OF THE
SOCIALIST LABOUR MOVEMENT
(AMSAB), GHENT

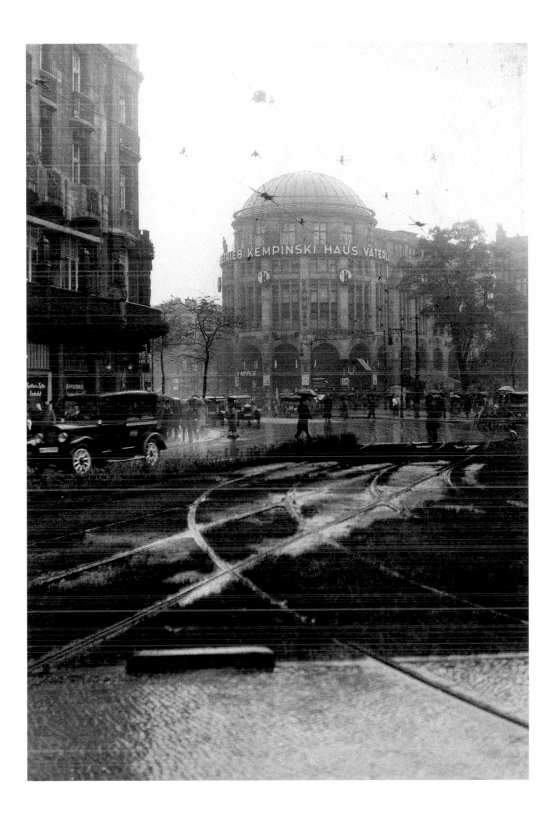

62.63

PLATE 3.16
HAUS VATERLAND, BERLIN, C. 1924,
GELATIN SILVER PRINT, 22.1 x 15.7 CM.,
COLLECTION KLAUS BEHNKEN,
BERLIN

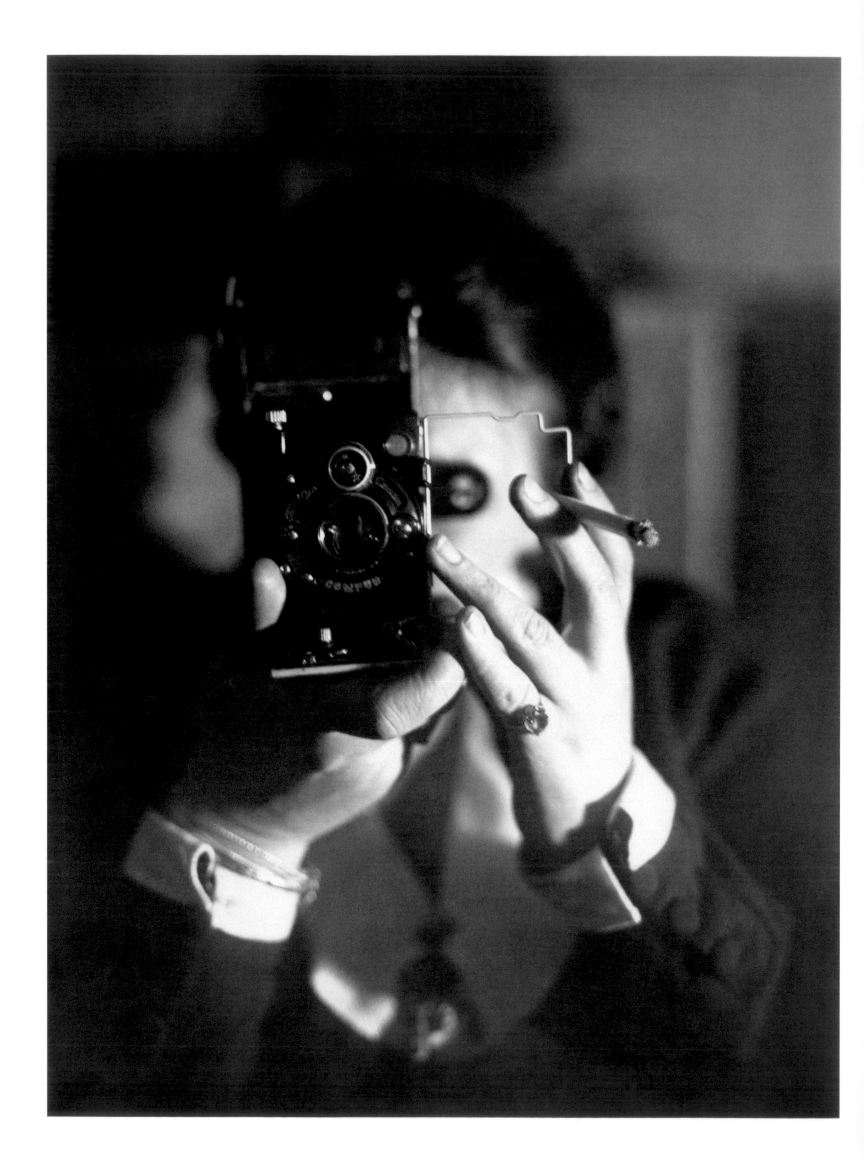

Chapter 4

Métal

THE DEVELOPMENT OF AN INDUSTRIAL AESTHETIC. 1925 TO 1928

*But the greatest joy was our walks in the
port of Rotterdam. Everything was steel; I loved
to walk along the quays to see the boats loading
and unloading; seeing how that worked
was a new idea for me. I wanted to see them,
to show their force; I wanted to capture them
on film. But how to photograph them?
They were so big and strong, and so impressive
To see them one had to move back a long way
and then they lost their impact. I was haunted
by them for days and days; I dreamed of them.
I photographed them and could never express
what I wanted. It took weeks to come up with
new ideas.[1]*

In 1925, Germaine Krull made a self-portrait, either in Holland or France (fig. 4.1). This photograph represents a multiplicity of views, and Krull's development was so complex at this period that it seems a fitting metaphor for her career during the ten years the photographer spent in Amsterdam and Paris.[2] Krull shoots from behind a hand-held camera, her features indistinct but her hands prominently displayed. The rectangular camera, an Ikarette, dominates the photograph. Contrasting with the soft clothing tones, it bisects the picture—splitting light from dark, woman from machine, human eye from mechanical one, past from future. It fully blocks the right side of her face, and its metal film slide frames the other half of her face as well. An attachment protrudes from one side, effectively blocking both her eyes. We see, therefore, an image of a woman with no face, whose vision, brain, and thinking mechanism are a machine, and a camera at that, and yet whose hands comfortably and calmly control her world. In her self-portrait, Krull actively chooses to conflate her photographic eye with her natural eye and transforms the machine blocking her face from an act of obliteration to an intentional collaboration, an act of power. During her years in

PRECEDING PAGE:
FIGURE 4.1
GERMAINE KRULL. SELF-PORTRAIT. 1925.
GELATIN SILVER PRINT. 20.5 x 15.1 CM..
COLLECTION ANN AND JÜRGEN WILDE.
ZÜLPICH

Holland and France, Germaine Krull underwent just such a transformation in her professional life.

Krull's geometric framing of white face and black machine demonstrates the formal advances she was making as well. The soft background contrasted to the hard-edged foreground shows her skillfully creating a dialogue between two photographic genres—prewar pictorialism and the abstracted constructivist photographic style that today is widely termed the New Vision. The phrase derives from the English title of László Moholy-Nagy's 1929 Bauhaus book.[3] In this 1925 image, Krull presents herself as poised on the cusp of the two genres, and the photographer behind the camera depicts herself as the creator of her own style in front of the apparatus. As she left academic photography behind for a new and rigorous geometry during the next years, she would effectively introduce the New Vision to French audiences.

The portrait suggests the changes to come in her life as well. Despite the prominence of the mechanical camera, the photograph is subtly feminine, and the rest of her body reveals many clues about Krull's embrace of both male and female elements in her world. In a masculine note, Krull holds a lit cigarette in her hand, surely a statement of liberation at a time when a woman lighting a cigarette at the 1924 Berlin Press Ball created a media scandal.[4] Yet the hand, finely shaped, sports a pinkie ring, an androgynous touch. The slightly blurred hairline and background add a clearly feminine touch and refer backward in time from the emancipated cigarette-wielding hand to the earlier era of the photographer's youthful student training as a pictorialist photographer. Clothing adds subtle clues as well. Krull wears a dress but a subdued, tailored one. It is buttoned to the wrist and bordered with white cuffs, far from the more frivolous flapper style. A demure white collar, peter pan style, shines through the shadows at her neck. In her self-portrait, Krull allows demure, tousled, soft-focus "female" elements—rings, wisps of hair, shadows—to coexist with the masculinity of the new machine. And the camera provides a striking contrast with the woman behind it. Who rules whom? Is she a handmaiden to the machine or its mistress? Is there an unseen boss? Krull is both subject and object. By aiming the camera at herself, and ultimately at us, the viewers, she definitively restructures the photographic image.

The duality of this portrait foreshadows the multiplicity of views that Krull would incorporate into her new work. Her method for this sophisticated expression was montage, in a variety of forms. During these years

Krull dynamically and abstractly reframed single images to create double exposures or dramatically angled views that reinvented their subjects. She adopted these strategies through her contacts with the art and film world in Holland and then introduced them to France. In 1928, in Paris, when her work would gain public recognition, three important events catapulted her into the public eye. These events form the centerpieces of the next three chapters—this chapter on the industrial photographs in Holland and France that led to the 1928 publication of *Métal*, chapter 5 on her Paris reception, which centered on the 1928 Salon de l'Escalier exhibition, and chapter 6 on her widely acclaimed journalistic photographs for *Vu*, the weekly picture magazine that began publishing in 1928.

Germaine Krull first visited Holland in August of 1924, at the invitation of the Ivens family. She moved there in the autumn of 1925 and probably stayed less than a year until mid-1926. Yet even after her permanent move to Paris, she and Ivens stayed in close touch, and although their physical affair ended by early 1927, they often traveled back and forth between the two cities. The psychological relationship and artistic collaboration of Ivens and Krull in Berlin, Amsterdam, and Paris spans a period from 1923 until 1927 and beyond. Even though Krull lived only for a relatively brief time in Amsterdam itself, her intellectual and formal development during these four years owes a great deal to the Dutch avant-garde.

Her intellectual exposure in Holland to film theorists from the Soviet Union, Holland, and Germany led to her greatest montage work—the series of industrial photographs that she began in Holland and continued in France. By 1927, Krull had made most of the body of Dutch and French industrial images that became *Métal*, and this propelled her into the forefront of the international avant-garde. With this album, her abstracted and formal experiments with urban and industrial forms moved definitively away from women's magazine work to an avant-garde photographic experimentation as radical as any being developed in the Bauhaus. She eventually published *Métal* in Paris in 1928. Although the ideas that led to *Métal* emerged from her Dutch contacts, many of the images themselves and the album's huge critical reception are French. Another essential

element is the simultaneous existence of these images in the art world and the commercial arena. Her politics were reflected in her work; the metal images present a cool but subtly biting critique of both the power and the disorientation of industry.

With Ivens at her side, Krull explored a wide range of intellectual contacts. Her intellectual loyalties switched definitively away from the German ideas of her photography training; she now included French, Russian, and Dutch avant-garde concepts. Although her work embraced both a pure abstraction similar to Dutch and German avant-garde experimentation and the photographic adaptation of French cubism, she never later referred to the German work that must have inspired her in these early years. On the one hand was the New Vision of László Moholy-Nagy, which Eleanor Hight describes as a "method of visual analysis, based on a variety of photographic devices (such as close-ups, cropping, unusual viewpoints, high contrast)."[5] In addition, she probably responded to the Dutch avant-garde, especially to the work of designers and photographers such as Paul Schuitema and Piet Zwart. Her contacts with Arthur Lehning's Dutch avant-garde journal *i10* put her in the company of Moholy-Nagy and Schuitema alike.

She also incorporated into her conception of the New Vision a dynamism that owed a great deal to another source—film montage, ranging from Joris Ivens's experiments with formal montage to Sergei Eisenstein's theoretic coupling of montage and rupture. Her comprehension of montage also included the politicized ideas of collage described by the Frankfurt school critic Walter Benjamin. Krull met Eisenstein through Ivens, and Benjamin through Max Horkheimer and Friedrich Pollock; their collective ideas allowed her to develop a uniquely dynamic and powerful photographic style.

Krull and Ivens

During her years with Ivens, several issues resolved themselves for Krull, and filmmaker and photographer matured together. Her relationship with Ivens, a young, developing artist like herself, allowed her to grow both intellectually and artistically. During the four or five years of their relationship, Krull and Ivens were often in different places. Even after he returned to Holland in 1924 to work for his father's photographic equipment firm Capi, Ivens traveled back and forth to Berlin, spending as much time as possible with Krull.[6] Ivens

had clearly looked after Krull as she recovered her balance and her health in the time soon after Moscow. Ivens, too, was very ill at one point in Berlin, and Krull reported that she nursed him, for which Ivens's staid father was duly grateful. Ivens's parents, for the most part, seem to have found Krull an odd character, as the filmmaker relates in his memoirs.[7] Yet they invited her to the family home in Nijmegen in August 1924, swallowing their discomfort at the fact that the couple was not planning to marry, and let them stay in one of their summer bungalows. Krull and Ivens traveled back and forth between Berlin and Amsterdam from 1924 to 1925, before Krull permanently left Berlin for Amsterdam in the course of 1925.

During the years up until 1927, the relationship between filmmaker and photographer was at its height. This period marks one of the few times when Krull stayed with one partner for a number of years, although she had occasional sexual adventures. One of the oddest involves Krull's first trip to Paris, probably in 1925, for a short visit from Amsterdam in order to explore the great city that had attracted her for so long. Krull recounts these events in her memoirs, and their accuracy cannot be verified completely. As she tells it, she met her Berlin lesbian lover Elsa, and they spent ten days together in a hotel at Montmartre. Ivens, who was probably ignorant of their sexual relationship, financed this trip, and the two women explored Paris, more or less as tourists. After the ten days, Elsa's husband and Joris arrived. They stayed another week on their own, then Elsa left and Krull became briefly but obsessively involved with a mysterious man she calls Jo in her memoirs. After several weeks, Ivens's brother ostensibly came to collect her to return to Amsterdam. Krull became gravely ill and had major abdominal surgery on her return to Holland. Then began another peaceful period with Ivens and a rich time of discovery in Holland. Their relationship seems to have survived detours of this sort undamaged.

It is clear, however, that from 1925 onward Krull traveled often to Paris, where she rented an apartment around mid-1926. Krull's letters to Hendrik Marsman from early 1926 and the summer of 1926 list both 190 Amstel in Amsterdam and 78 bis Rue de Maistre in Paris.[8] As her dual addresses indicate, Krull's stay in

Amsterdam lasted less than a year, so that her affiliations with Holland were intellectual rather than strictly geographical. Her spiritual ties to Ivens and to the ideas of the Dutch avant-garde, however, lasted from 1925 to 1927. An exact dating of her movements is difficult, but she clearly continued to travel often to Amsterdam well after 1927.

Her brief exposure to the stable business family of Joris Ivens and to the comfortable environment in which they lived was the only time in her life when Krull entered the world of a moneyed industrial family. Yet the young couple plunged into the art world of Amsterdam very quickly, leaving behind the family home for more exotic territories in both their lives and their work.

The year 1927 marked the end of Ivens's and Krull's romantic relationship but not the end of their close friendship. In fact, Ivens traveled to Paris on 2 April 1927 to marry Krull, a *mariage blanc* that gave her the stability of a Dutch passport, and allowed her to register legally with the Prefecture de Police on 2 May 1927 as a Dutch journalist.[9] Although Krull departed from her marriage ceremony without Ivens, they continued to work together and visit for several years.

Krull's marriage is enormously important for both symbolic and practical purposes. From this point onward, she was no longer a woman without a country, expelled from Bavaria and the Soviet Union, but a married Dutchwoman, a status that would make possible many professional and personal acts of independence over the next twenty years. Indeed, Krull would carry a Dutch passport for the rest of her life, even after her divorce was made final in August of 1943.[10] Marriage removed from Krull the stigma of being a New Woman or even Mary Louise Roberts's more respectable category of "a single woman." Krull discovered her own path, gaining the veneer of married respectability without sacrificing her autonomy, and she took full advantage of it both personally and professionally. From 1927 onward she could present herself, if not as a mother, at least as Madame Krull-Ivens.[11] A *mariage blanc* made perfect sense for Krull as a brutally practical measure, and the photographer appreciated the value of Ivens's gesture of friendship. She writes of Ivens during this period, "We stayed good friends. I could not forget a certain sense of guilt about him. I knew how he suffered."[12] The two maintained their friendship for the rest of their lives.

George Henri Anton Ivens married Germaine Louise Krull on 2 April 1927, in the Mairie of the eighteenth arrondissement of Paris. Their marriage certificate lists Ivens as a merchant and Krull as a photographer.[13] A marriage contract translated into French on 10 March 1927 by an Amsterdam notary spells out the conditions of the marriage.[14] In the contract, Ivens is listed as an Amsterdam resident, and Krull as a Paris resident. There would be no common property or goods, Krull would have her own home and income, and any eventual children would be supported financially by both parties equally. It is unclear whether the mention of children supposes that the partners envisioned a renewal of the sexual union or whether this was standard language supplied by an official. The contract does contain details unique to the two partners. Ivens declared that he brought to the marriage a library of books (probably his Berlin collection) about technical matters, literature, and photographic and cinematographic art, whereas Krull brought her photographic apparatus. Each had goods of roughly equal value (500 florins).

The Dutch Avant-Garde

Krull's relationship with Ivens fed her search for intellectual roots. She often had felt lonely, uncertain, and uncomfortable in the Germanic culture of Berlin when Ivens was not there to keep her company. In their Amsterdam loft, she found a much more comfortable circle. She and Ivens often saw the expressionist poet Hendrik Marsman, who befriended Krull as well as Ivens and who had been in Berlin with them. They met Mannus Franken (who would be a member of the Filmliga and collaborate on films with Ivens), sculptor Jan Havermans, writer Jan Slauerhoff, painter Charley Toorop, and other artists and writers.[15] Although not there in person, Arthur Lehning remained present in spirit. In 1927, he founded his international avant-garde journal *i10*, bringing Marsman, Ivens, and Krull together in print with such figures as Hans Arp, Walter Benjamin, Naum Gabo, El Lissitzky, László Moholy-Nagy, Piet Mondrian, Paul Schuitema, and Menno ter Braak. Krull's participation in this circle must have broadened her horizens dramatically. She continued to photograph during this time, although she temporarily stopped making fashion and theater photographs and

seems not to have documented much for the popular press in Amsterdam or Berlin. Instead, she photographed her circle of avant-garde friends and their activities and even published ghostly views of Havermans's looming, white, skull-like masks in the German literary publication *Der Querschnitt* in 1926 (plate 4.4).[16]

Ivens recounts their 1925 installation in the loft at 190 Amstel (a canal) and their mutual discovery of Amsterdam, which Ivens knew little better than Krull: "With Germaine, I discovered this aquatic city. . . . The place was strange and not without beauty."[17] Hendrik Marsman continued to be a close friend, forming a third member of what Arthur Lehning called "the triumvirate." While Krull was in Amsterdam, these three friends explored the ports and the sailors' bars, especially in the Zeedyk area, and she writes eloquently of the Amsterdam landscape in her memoirs.[18]

For poet, photographer, and filmmaker alike, the streets and urban life proved an important inspiration. For instance, correspondence with Marsman relates anecdotes of an encounter Marsman, Ivens, and Krull had with a colorful drunken sailor. The sailor, whom they met while on vacation together in August 1924 in a Rotterdam bar, supposedly fell in love with Krull. This episode became the subject of a short sketch written by Marsman, "The King of Canada."[19] The visits to these bars also formed the first subject of Ivens's attempts at filmmaking. In this film, now lost, Ivens describes the bar and the drunken sailor, "who regularly became the King of Canada after his second bottle of gin."[20] The young filmmaker recorded his antics and described this film as his departure from pure experimental abstraction such as that of German filmmaker Walther Ruttmann: "I had tested my talent and the test had been conducted in a real setting and not in the abstract angles and curves of Ruttmann."[21] Krull, too, photographed these sailors' bars, although she writes in her memoirs that the sailors discouraged cameras.[22] These are some of her earliest urban photographs and mark a growing interest in urban photography. The only surviving Krull photograph from this series is an image of a Dutch sailors' bar (plate 4.1) (an undated image with a Paris stamp on the verso), which may depict Amsterdam or Rotterdam. Depicting a varied group (with few sailors) around a stove, it carries the caption, "Amsterdam in the sailors' bar; just like a family. The children serve during the night."[23] As a journalistic photograph, it is remarkable for its lack of drama and its posing of subjects in naturalistic poses—a far cry from

the exaggerated poses of Pritzel and Spies in their Berlin carnival costumes. Even if this is not one of Krull's first unposed urban portraits, it represents the shift from posed studio work to more urban photography.

Krull's experience of the Dutch urban landscape in 1925 and 1926 reawakened her own passion for photography and served as the catalyst for the greatest photographs of Krull's career. During her first months in Holland, she went on bicycle rides with Ivens and her friends. Her physical experience of Amsterdam, Rotterdam, and other Dutch places moved her deeply, and the formal patterns she saw became more and more abstract. She recounts her first reactions: "We walked often in the ports. . . . The large ships, the sailors' bars, and the *bals musettes* were for me a joy, and I began to take my first metalwork photographs."[24] These early views, often taken with her small Ikarette/Agfa 6 x 9 cm. camera, include bird's-eye or worm's-eye views of towns like Anvers (fig. 4.2). In this view, a tower and a metalwork grid float at opposite corners of the frame, grounded neither by a horizon line nor by rational perspective. The viewer is reduced to the position of a trapeze artist flying through the air, and the objects swing freely across the picture's surface with no visual anchor. Krull photographed from high or low angles, framed her views to highlight geometric forms, and intentionally confused the perceptions of normal perspectival space.

During these trips around Holland, Krull developed her own photographic vision and merged these ideas with a revolutionary way of seeing both form and industry. During her convalescence from abdominal surgery, she wandered through Amsterdam on long walks. Industry was to become her particular obsession.

FIGURE 4.2

GERMAINE KRULL. *ANVERS.* C. 1925. GELATIN SILVER PRINT. 21 x 14.1 CM.. PRIVATE COLLECTION, NEW YORK

Above all, the ports of Rotterdam and Amsterdam fascinated her. In one view, which became plate 9 of *Métal* (plate 4.14), Krull created a composition of dancing cranes and boat masts in Amsterdam's port, so that they seem to rise vertically, intersect horizontally, and create a lyrical geometry with only minimal reference to a ground plane.[25] On close inspection, a boat's flag is visible along the lower edge of the photograph, and one can glimpse a steel hull in the corner, but the photograph concentrates on metal trusses that seem to dance in the sky. She also photographed the ports and bridges in Rotterdam. As early as October 1926, she published an aerial view of the Amsterdam port, in the literary magazine *Maandschrift voor Katholieke Reconstructie De Gemeenschap*, with the help of Hendrik Marsman.[26] The inclusion of scaffolding and a bird's-eye view of the boats below would be often repeated in later industrial images in Rotterdam, Paris, Hamburg, and Marseilles. In a few images, like plate 4.10, black smoke belching from Amsterdam smokestacks intersects with metallic boat forms and masts to create a romantic view, although the atmospheric effect does not detract from the strong graphic quality of the composition. In a view made in Hamburg (plate 4.9), cranes, enormous scoops suspended from cranes, and masts of boats merge into a collection of geometric patterns.[27] Krull still grounds this view with a horizon line, but the forms interpenetrate to such an extent that their specific uses are lost in a medley of industrial patterns. She was quite conscious of her efforts to see them anew and recalls her ideas in her memoirs:

> Perhaps these walks, where I felt so small next to the great metallic giants, frightened me. An irresistible wish to fix them, to approach and perhaps to render them more human, forced me to photograph them. I went for more and more frequent walks in the port, always with my little Ikarette/Agfa 6 x 9. Did I find these metal forms beautiful? I don't know. I liked photography, but these steel giants revealed something to me that made me love photography again. From this moment onward, I began to SEE things as the eye sees them, and it is at this moment that photography was born for me.[28]

These enormous metallic forms have an energetic quality that inspired Krull. Instead of representing inert iron as a still life form, she presents vitalized and some-times anthropomorphized forms representing power and life—both positive and negative (plate 4.14). She does not present "hymns to industry" but instead frames the shapes in more complex commentaries on their vibrant shapes and enormous size. The ideas developed here form the core of her first major body of work, which she soon called *Métal*.

During these years, Krull was inarticulate about her political beliefs and equally reticent about her formal development. The astonishing changes that occurred in this work itself owe a great deal to her Dutch contacts. Various friendships and contacts contributed to the evolution of this body of industrial work, and it marks the moment when her art and politics merge. Old friends and new would contribute to these events.

Arthur Lehning and i10
Arthur Lehning, who had introduced Ivens to Krull in Berlin, was an important intellectual influence during this time, although he was temporarily living in Vienna in 1924 and then (from late 1924 until mid-1926) in Paris.[29] During these years, Lehning was becoming interested in Bakunin and slowly gathering ideas for a review he wished to publish based on the revolutionary German weekly, *Die Aktion*. More important, he was beginning to engage with avant-garde artists in Germany, Holland, and Paris. Lehning met de Stijl artists Piet Mondrian and J. J. P. Oud and traveled in October 1926 to Dessau to visit the Bauhaus, where he met Moholy-Nagy. (Krull was already in Holland, and had left Berlin in same year the Hungarian arrived—1925.)

When *i10* first appeared in January 1927—after Krull had been photographing the ports of Rotterdam for several years—Oud was the architecture editor, Moholy-Nagy the film and photography editor, philosopher Ernst Bloch wrote the music reviews, and Alexander Berkman and Alexander Schapiro commented on the Russian Revolution. Other contributors to *i10* included Walter Benjamin, Joris Ivens, Hendrik Marsman, Piet Mondrian, Paul Schuitema, Kurt Schwitters, and architect Sybold van Ravesteyn.[30] The journal combined avant-garde art and leftist politics in a mixture that was very familiar to Krull, and Lehning's editorial policy must have seemed very comfortable to her. In fact, its exploration of avant-garde form while celebrating leftist

politics was a common formula among the art press and quasi-popular press in the 1920s; this particular combination, published in many European journals, would continue to suit Krull well into the early 1930s, when a more conservative press began to take over.

Although no evidence exists that Lehning physically introduced Krull or Ivens to these artists, either he or Moholy-Nagy, as his photography editor, published work by both of them in his journal *i10* in 1927. Krull published photographs of Ivens's film *De Brug (The Bridge)* in the magazine.[31] Although personal links cannot be documented beyond their presence in the same publication, intellectual affinities can be. Her work in Amsterdam, unlike her Berlin photographs, clearly demonstrates not only her knowledge of abstraction and collage but her reformulation of constructivist ideas. Krull, along with Anton Bruehl, Albert Renger-Patzsch, Sasha Stone, and Americans like Margaret Bourke-White and Charles Sheeler, participated in an international phenomenon of machine commentary.[32]

Because she had left Berlin as early as 1925, Krull's exposure to the constructivist style of photography probably came during her years in Holland. Graphic designers and photographers such as Piet Zwart and Paul Schuitema were experimenting with photography as a montage tool during these years. Schuitema, a graphic designer, began photographic experiments in 1926, and Zwart included photographic montages in his posters and advertisements for Dutch industry as early as 1924.[33] Both included photographs of industrial machinery in their poster designs and made overlapping images of lettering and photography, as well as photomontages of machine parts. All were meant to create an effect of oscillation in their designs. Although Schuitema exhibited his poster and photographic designs and Zwart became a member of the de Stijl movement, both developed their montage conceptions within their commercial work for Dutch industries such as the post office, NKF, and De Vries Robbé and Co. Although there is no direct evidence that Krull saw these projects, she, too, explored industry in her commercial work and then exhibited and published her machine images as fine art as well.

Moholy-Nagy may also have been a model for a photographer who combined commercial and avant-garde projects, but he worked more conventionally within an art school. He had been teaching the preliminary course at the Weimar Bauhaus since 1923 and continued at the new Dessau Bauhaus, but he described

himself as a painter and not a photographer throughout his life.[34] Photography appeared in this curriculum, and artists such as Marianne Brandt took photographs in the course, but there was no formal photography training at the Bauhaus until Walter Peterhans began teaching the subject in 1929. Moholy-Nagy's 1925 book *Painting Photography and Film* (Bauhaus Book No. 8) catapulted photography into the forefront of artistic expression. As Andreas Haus writes, "Photography was never really a formal means of art via 'design' but primarily a pedagogical means of 'expression' and 'experience' for Moholy at the Bauhaus."[35] For Krull, on the other hand, it was a bone-deep means of discourse and a commercial means of survival in a way that it was not for the Hungarian-born painter, sculptor, photographer, and teacher.

In the first issue of *i10* in January of 1927, Moholy-Nagy published an important essay on photography as a modernist medium, defining it as a medium unlike any other, one that must develop its own original methods of representation. Moholy-Nagy called for the "conscious use of light-dark relationships. Activity of brightness, passivity of darkness. Inversions of the relationships between positive and negative values," and suggested pointing the camera up or down, experimenting with lenses, and avoiding perspectival foreshortening.[36] Krull's photographs from 1926 onward exhibit these qualities, although she never mentions Moholy-Nagy directly, and some of her more arresting work predates this essay by a year or more. Instead of following the Hungarian's lead, Krull clearly developed a similar set of formal tools independently or at least concurrently in 1925 and 1926.

Krull's industrial photographic experiments in Holland and France, in fact, bear more resemblance to Soviet filmic montage than to the single poster compositions of Schuitema or Zwart or to the more purely abstract films of Moholy-Nagy. The Dutch group Filmliga, which Ivens helped to found in 1927, had a direct impact on her thinking and her work. Krull's many visits to Amsterdam during its formation and her friendship with its members introduced her to the world of the German and Dutch avant-garde and to Russian film theory. Krull had observed many of these movements in Berlin, but now, through Ivens, she became more close-

ly involved with them, befriending, among others, the Soviet filmmaker Sergei Eisenstein and cultural critic Walter Benjamin in Paris in 1926.[37] She contributed to the journal *Filmliga* and published portraits of the filmmakers Walther Ruttmann, Eisenstein, and others, as well as photographs related to Ivens's films, and her own abstractions.

Filmliga

In the development of these ideas, Krull did not act alone. Joris Ivens, following quite a similar path in his evolution into a committed documentary filmmaker, experienced many of the same events. Therefore, the story of Krull's industrial photographs is best told as a collaborative tale of the photographer and filmmaker together, culminating in 1928 with the Paris publication of Krull's album *Métal* and Ivens's film *De Brug*, which was screened in Amsterdam and Paris. Krull learned an enormous amount from her collaboration with Joris Ivens during the years when he first began to make films, to experiment with montage techniques, and to organize the Filmliga, an organization that included more members of their immediate circle of friends than did the *i10* writers. The Filmliga's embrace of avant-garde films, particularly the Soviet montage theories of Eisenstein and V. I. Pudovkin, would affect Krull as strongly as they did Ivens. In their various memoirs, both Krull and Ivens repeatedly emphasize that this was a journey they made together.

Although Ivens was employed from 1925 onward as technical director of his father's firm, his interests turned more and more to film. He and Krull developed their visual identities in tandem, sharing ideas, images, and contacts as they came along; rather than one influencing another, theirs was a more symbiotic relationship. The continuing contacts between Krull and Ivens, and between Paris and Amsterdam, are further shown by the fact that one of Ivens's first great films, an almost abstract montage study of four minutes entitled *Etude de mouvements*, was shot in 1928 in the streets of Paris on a visit with Krull. Krull's passion for the Paris streets, developed from her Berlin and Rotterdam pictures, probably inspired Ivens in this early project.

In 1927, the Dutch government censored public screenings of Pudovkin's film *The Mother*, and Ivens and his friends Menno ter Braak and Leo Jordaan formed the Filmliga in protest after privately screening the film. While Ivens analyzed the film frame by frame, he also participated in writing the Filmliga manifesto. The first

issue of the journal *Filmliga* was published in September of 1927, with its manifesto on the first pages.[38] Signers included Henrik Scholte (president), Menno ter Braak (secretary and treasurer), J. H. G. Ivens, Charley Toorop, L. J. Jordaan, Cees Laseur, Hans van Meerten, Joris Ivens, and Ed Pelster (the last two are listed as technical advisors). Ivens wrote about film technique, and his friend Mannus Franken wrote about the French avant-garde, citing Cavalcanti, Réné Clair, and Fernand Léger, with mentions of particular films like *Ballet mécanique*, *Entr'acte*, and other new films. Simon Koster contributed a discussion of the Russian film avant-garde. The interest of these international filmmakers in abstract form would be important for Krull as well as for Ivens.

Thus, from the first issue of *Filmliga* in 1927, Ivens and his film collaborators determinedly embraced the international avant-garde.[39] Screenings included films by Cavalcanti, Dulac, Eisenstein, Pudovkin, Richter, Ruttmann, and others. Although Krull was already based in Paris by 1927, she actively contributed to the journal, supplying photographs like a beautiful abstracted spiral view of a staircase to demonstrate light and dark effects in the picture plane (plate 4.3).[40] In aiming her camera up at the stairwell, she achieved an elegant and disembodied effect; this stair stands as an example of lyrical form, and not as a climbable structure. She also contributed a close-up photograph of hands that are editing a strip of film for one issue's cover and a portrait of S. M. Eisenstein (plate 5.16), who with Ivens visited her in Paris.[41]

De Brug

In addition to portraits and experimental work, Krull also supplied the still photographs for the studies of Ivens's groundbreaking 1928 film *De Brug (The Bridge)*, which was discussed in depth in several issues of the journal. She photographed Ivens as he filmed *De Brug* and recorded a meeting of Ivens and his cronies at a table toasting an issue of *Filmliga* (plate. 4.2). She has dramatically lit the scene from above so that bright light falls on the heads of the collaborators and the page proofs of the magazine, surrounded by a cavelike darkness. Although Krull made her first machine images in

1925 and 1926, two or three years before Ivens completed *De Brug*, the projects have many links. Some of Ivens's shots create a filmic version of still shots in Krull's book *Métal*, and Krull returned often to the Rotterdam bridge that Ivens recorded in 1928. The two projects, both completed in 1928 when Krull already lived in Paris, are best understood together, and since they present the cornerstone of Krull's critical fame, their reception in France is also discussed here.

Ivens's *De Brug* documents the railroad bridge over Rotterdam's Meuse River.[42] The film premiered on 5 May 1928 in Amsterdam's Centraaltheater. The film begins with a traditional distant shot of the entire bridge (fig. 4.3). Seen from afar, this bridge is a moveable truss bridge, which lifts and lowers its central span between two towers: its lower position allows trains to pass; when lifted, boats can sail underneath. Apart from this brief glimpse, Ivens never allows the bridge to appear in its totality. He intersperses the bridge with sequences of airplanes, trains, and automobiles, using the ruptured montage composition sthen being developed by the Soviet filmmakers Eisenstein, Pudovkin, and Vertov, whom Ivens was presenting at the Filmliga. Ivens then immediately signals a more active way of looking at his subject by a series of overlapping shots of the hand-held Kinamo camera; the shots frame the apparatus in multiple exposures of its front and side. Ivens had studied Pudovkin's films by analyzing every shot and applied this knowledge to the construction of his own film by drawing a card of each shot before editing, to ensure maximum effect (fig. 4.4). For each frame of the film, he draws a diagram indicating the direction of the camera angle—up, down, diagonal—and he edits the film accordingly. He thus uses montage to transform his subject from a static record to an energized collection of fragments, actively juxtaposing the individual elements of the bridge and its multiple transportation uses rather than telling a linear story. Pudovkin at times defines montage as linkage, in contrast to Eisenstein's concept of montage as collision.[43] Ivens retains a sense of linkage, in contrast to Krull's more radical collisions of abstract forms in *Métal*. In *De Brug*, water, shadows, and steam formally tie the disparate elements together to create a lyrical story.

Ivens's film is a classic "city symphony" film. Avant-garde filmmakers like Réné Clair (*Paris qui dort*, 1924), Walther Ruttmann (*Berlin: Die Symphonie einer Großstadt*, 1927), and Dziga Vertov (*Kino-Eye*, 1924) were making lyrical "city symphony" films during these

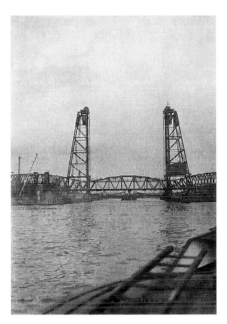

years.[44] Familiar with these filmmakers from the Filmliga, Ivens adhered to their essentially narrative structure. In fact, he had visited Ruttmann in early 1927 and seen the Berlin film then.[45] City symphony films often follow the progression of a day, from dawn to dusk to night, and Ivens followed a similar narrative path in documenting the raising of the bridge, the passage of boats beneath, the lowering of the bridge, and the train's path across it. Yet there are important distinctions. Ivens's overtly industrial subject is new, and so is the film's montage structure, relating the workings of the bridge from above and below, at raking angles and in detail. The film quickly became a hit among international avant-garde circles and continues to be a prominent icon of Dutch interwar modernism.

The film presents the speeding train brought to a halt by a barge about to pass under the bridge and then the slow raising of the various metal parts of the bridge itself—cogs, rivets, tracks, electric equipment, interlocking beams. Each fragment retains just enough information for its function to be clear. Preindustrial horses, carts, and pedestrians are present as well. In his film of the Rotterdam bridge, Ivens chose many views that Krull had been photographing as well, and *Métal* has several shots of the bridge that resemble the framing of *De Brug*. For example, several Krull photographs of the top of the Rotterdam bridge display a composition almost identical to Ivens's shots (plates 4.5 and 4.6).[46] In plate 4.6, we see only a soaring view of curving bands of steel and round rivets filling the frame in a vast rising form; this could be virtually any industrial span.

In the film itself, figures are merely glimpsed briefly behind the bridge, and then visually and dramatically

74.75

crushed by the descending machinery. The bridge seems to operate independently, and there are only intermittent shots of the operator turning the mechanisms. Ivens, in fact, clambered about on the bridge every day for weeks until the operator finally told him, "You don't have to *eat* the bridge. You look like some sort of tiger sneaking and creeping around that wheel."[47] On the surface, the film praises the bridge; it is only on a second look that we realize the disturbingly small role of humans or the omnipotence of all those cogs and rails and engines. Thus it displays not only the power but also the inhumanity of industry.

Ivens employs his energetic montage language to create an active view of the bridge and a sense of the conflicts between old and new. But he does not directly promote a course of social action. Nonetheless, his film impressed the Soviet filmmakers who were merging montage with political action. In 1929, Pudovkin visited Holland for forty-eight hours. Impressed by *De Brug* and the unfinished portions of Ivens's new film *Regen (Rain),* he invited Ivens to Russia. The Dutchman departed in January 1930 for a visit of three months and toured the country lecturing and screening his films. The response of the workers viewing the films had an enormous impact on him. He recalls, "The workers in Moscow asked me, 'Where is the man who sets this bridge in motion? Who travels in the train? Who crosses the bridge on the road from Rotterdam to Paris? Can a worker pay the fare in this train?'"[48] Ivens never again ignored the workers involved in industrial projects, but he used the formal montage tools learned in this project for the rest of his life. Montage became an aid to documentary, and the human scale of Ivens's later works reflected his early experimentation. The same progression occurred with Krull, whose dramatic compositions in Holland remained a vital part of her later photojournalism.

Krull and Ivens were not unique in exploring machine imagery during the second half of the 1920s, particularly in the photographic medium. In Germany, Moholy-Nagy wrote about the industrial metaphor as early as 1922: "The reality of our century is *technology*— the invention, construction, and maintenance of the machine. To be a user of machines is to be of the spirit of this century. It has replaced the transcendental spiritualism of past eras."[49] Outside the Bauhaus, *Neue Sachlichkeit* (New Objectivity) photographers like Albert Renger-Patzsch and Karl Blossfeldt developed a more clearly realist style that celebrated the subject rather than the formal experimentation made possible by the

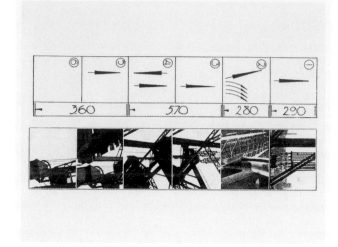

machine. Journalist Kurt Tucholsky admired Renger-Patzsch's "pure visual joy in the concrete thing, in material."[50] In the often acrimonious debate between the two German artists, critics and artist exchanged heated articles about the power of machine imagery.[51] Germaine Krull belonged to no one camp, and her work epitomizes the international quality of the technological age. Her *Métal* photographs of industrial factories sometimes resembled the clarity and beauty of Renger-Patzsch's gleaming images, as in a photograph of smokestacks (plate 4.16), where the stacks rise high and serene into the sky, marching backward into space in a perspectival recession that recalls the most serene views of Charles Sheeler as well as Renger-Patzsch. Other images in the album, however, offer a more mixed view, such as a view of a crane almost obscuring a rail yard, with an older factory rising in the background behind the strong shapes of the metal scaffolding in the foreground (plate 4.8). Both the more static work and the fragmentary images could also be found in the commercial Dutch work of Zwart and Schuitema.

Métal

Krull's industrial fragments made in Holland, France, and Germany found a public audience in 1928, when she published her portfolio of images called *Métal* in Paris.[52] She began receiving major critical attention for her other work in this year, but this publication prompted an outpouring of response.[53] *Métal* would assure Krull's place as one of the foremost European photographers of the decade. This book of sixty-four

FIGURE 4.4

JORIS IVENS. SKETCH CARDS. *DE BRUG.* 1928.

FROM *FILMLIGA* 5 (FEBRUARY 1929): 362

unbound collotype plates was published by the Librarie des arts décoratifs, edited by A. Calavas in Paris, with a foreword by the French editor and critic Florent Fels, who was a steadfast supporter of the photographer. The cover, with Krull's name superimposed over a photograph of the elevator wheels of the Eiffel Tower in Paris, was designed by M. Tchimoukow (plate 4.7). (This photograph also appeared in *Vu.*) *Métal* was first advertised internationally in *Variétés* in June of 1929.[54] This notice, advertising "An album of 64 collotype plates" for 150 French francs, also promotes *Métal* as "the dance of the metal nudes."

Thus, even in its promotion, it was seen as a lyrical suite and not merely a collection of machine parts. *Métal*, in fact, is a "city symphony" quite comparable to its sister film, *De Brug. Métal* also evokes an album of human nudes, as the promotional subtitle "métaux nus" indicates. By isolating the forms with no identification, fetishizing their beauty, and concentrating on details rather than functioning portions, Krull dehumanizes the industrial forms in a manner more radical than she would have considered for her earlier portfolios of female nudes in Munich and Berlin. (A 1930 album later applied this fragmentation to nudes.) Here she reorganized the photographs from various commercial and personal interactions with machines into a series with no lingering subject or geographical meaning.

Some of these images bear affinities to Moholy-Nagy's experimental abstractions, and others are quite lyrical industrial still lifes comparable to the clearly detailed works of Albert Renger-Patzsch. Renger-Patzsch's images are more in line with the *Neue Sachlichkeit*; his work has a classical beauty and calm clarity that he felt the camera could deliver better than any other medium. Renger-Patzsch's book *Die Welt ist schön* (*The World Is Beautiful*) appeared the same year as *Métal*, although the structure of Krull's book bears a greater affinity to Renger-Patzsch's 1931 book *Eisen und Stahl*.[55] A comparison of Renger-Patzsch's descriptive views and Krull's more realist ones demonstrates their common fascination with industry. But in general Krull represents the side allied more closely with Schuitema or Moholy-Nagy; her photos celebrate the confusion, speed, and simultaneity of the industrial world. Like Moholy-Nagy, she sometimes used the new techniques of multiple exposure to explore her impressions of machine forms. Although certain images of Krull's echo Renger-Patzsch's clarity, many are closer to Moholy's deliberate dysfunctional compositions.

What sets Krull apart from Moholy-Nagy and Renger-Patzsch alike is the filmlike structure of her book. *Die Welt ist schön* presented one hundred single images grouped in eight thematic sections such as plants, technology, and architecture.[56] Krull's suite is more abstract, less easily identifiable, and more cinematic in its conception. Although plates were culled from Krull's work in Rotterdam, Amsterdam, Paris, and Marseilles, individual structures cannot be identified by place or purpose and remain more dynamic and full of movement.

Krull's sixty-four industrial photographs in *Métal* are untitled and often unidentifiable—both more formally abstract and more disruptive than Ivens's images—and in their power they seem to embody more than simple lyricism. She includes fragments of cranes, bridges, ports, factory machinery, and the Eiffel Tower. Krull may have shot the Rotterdam bridge in the company of Ivens or before he made the film; the record remains unclear, although she certainly made some of Ivens's film stills. However, when she frames the Dutch bridge (plates 4.5 and 4.6),[57] the horizon is often obliterated, and the viewer sees no top or bottom. The effect is dizzying. By eliminating the viewer's grounding, she achieves in a single image the equivalent of the disorienting effect of montage. Krull discusses the industrial ports she photographed on her long walks in Holland by saying: "I had to pretend I was looking at a part, and the whole was there. . . . A portion of a crane turns, and it is entirely present."[58] Yet, at the same time, these mere details are functionally useless, incapable of fulfilling their industrial purpose, and thus they become another kind of Brechtian interruption. This is the quality that Walter Benjamin admired in her work.

In her multiple exposures, Krull creates another effect—a sense of unfamiliarity even within single images. Renger-Patzsch's blast furnace stands polished and still. Some of Krull's photographs, like a view of a gleaming factory interior (plate 4.12), are static like Renger-Patzsch's. But many are not; Krull's machines often literally dance within the frame, as in the multiple exposure shown in plate 4.13. In this image, bicycle wheels are superimposed over other industrial fragments, creating a round pattern of swirling metal,

shadows, and dark machine details that literally rotate around the edge of the photograph.

Krull's portfolio assembles industrial and metallic imagery from Holland and France (including the Rotterdam bridge) and praises the machine while creating an active role for the viewer. Is her album more radically abstract and more politically active than Ivens's film? Her machines certainly appear more abstract and nonfunctional than *De Brug.* She assembles disorienting images of metal parts one after the other, thus reproducing in the progression of the book's pages the intervals of filmic montage footage. Several distinct forms of montage operate here, perceptible as one turns the pages. First, Krull expands on Ivens's narrative structure for an even more kaleidoscopic montage effect, closer to Eisenstein's ideas than to Pudovkin's strategy of linkage, which intrigued Ivens. Second, in the multiple exposures and rotations of certain images and in the changes of scale from very small to enormous, she invokes montage theory in specific images in the whole album.

The photographs in the portfolio are arranged in a pattern that is more radically full of interruptions and formal jumps than anything in Ivens's film. Static images are followed by vertiginous ones. There is no respite between any two images, as can be seen in the progression from swirling bicycle wheel to quiet factory interior in plates 22 and 23 (plates 4.13 and 4.12). With each turn of a page, we must turn our heads from vertical to horizontal, move from close-up to distant view, or travel unknowingly from Holland to Paris to Marseilles and back again. We cannot identify the purpose or the locale of any of these machines. Krull's erratic narrative pattern in this album and her geometric experimentation bear a strong resemblance to contemporary film structure as well as to Walter Benjamin's conception of montage. Sergei Eisenstein defines film montage, in fact, as a language of "visual counterpoint," involving conflicts that can be graphic, planar, volumetric, spatial, and so on—all formal tools used by Krull.[59] Furthermore, the Soviet theorist writes that *"Emotional* effect begins only with the reconstruction of the event in montage fragments . . . an all-embracing complex of emotional feeling."[60] Eisenstein would have approved of Krull's symbolic use of montage effect in her *Métal* images. There is no story line but a series of images erratically illuminating a single subject—the power and disorienting effect of the machine.

Ivens's film and Krull's album have until now been regarded as purely formal studies. On the surface, both projects might seem to laud industry in a manner closer to the static admiration of Albert Renger-Patzsch's German New Objectivity than Alexandr Rodchenko's Soviet activist compositions, which were destined to change society. Yet they are not mere beautiful objects or simple hymns to industry. For Eisenstein, "montage as a collision"[61] implied "the collision of independent shots—shots even opposite to one another."[62] Krull's album juxtaposes completely unrelated industrial fragments from one page to the next and occasionally within a single image. And it is precisely the formal interruptions created by her montage process that allow an energized yet not overtly revolutionary reading of these supposedly capitalist hymns. When Krull photographed the Rotterdam bridge that Ivens would later film, she framed its tower at an angle, so that it seems to tilt backward with a diagonal force that is not entirely comfortable to observe (plate 4.5). The tower of the bridge fills the frame but floats with no fixed anchor, forcing us to read rivets and wires against the bare sky—an abstract pattern. The power of the bridge is manifest; it seems more in control than do we, the observers. The roadbed is not visible at all, nor is any ground line.

Montage theory formed the basis for Krull's album construction and offers clues to its reading. Her use of montage goes beyond Eisenstein's film theory to incorporate the montage of Brechtian theater to a photographic activism. One of Krull's friends, in fact, wrote about photographic montage theory while using Krull as an example. Krull met Walter Benjamin either through Friedrich Pollock or Arthur Lehning and knew him well enough to photograph him by 1926 (plate 5.14).[63] She had a protracted correspondence with him and wrote to him about her own publishing projects. In his essay, "The Author as Producer," while describing Bertolt Brecht's new kind of epic theater, Walter Benjamin offers a useful political definition of montage:

> *I am speaking of the procedure of montage: the superimposed element disrupts the context in which it is inserted. . . . Epic theater, therefore, does not reproduce situations; rather, it discovers them. This discovery is accomplished by means of*

the interruption of sequences. Only interruption here has not the character of a stimulant but an organizing function.[64]

The idea of interruption, according to Benjamin, differentiates truly revolutionary work from the mere aping of the modern world, a quality that he scornfully attributes to the New Objectivity and to Albert Renger-Patzsch's photography. In a sarcastic reference to Renger-Patzsch's book *Die Welt ist Schön*, Benjamin writes:

> *[Photography] can no longer depict a tenement block or a refuse heap without transfiguring it. It goes without saying that photography is unable to say anything about a power station or a cable factory other than this: what a beautiful world! A Beautiful World—that is the title of the well-known picture anthology by Renger-Patzsch, in which we see New Matter-of-Fact photography at its peak. For it has succeeded in transforming even abject poverty, by recording it in a fashionably perfected manner, into an object of enjoyment.*[65]

Although he never wrote a review of *Métal*, Benjamin chose Krull to represent a more activist and engaged photography of the industrial and modern urban world. He believed that only the addition of words, or the sequencing of images to allow the sharp contrasts of montage, could transcend the reifying function of photography. And in "A Small History of Photography" (1931) he cites Krull, along with August Sander and Karl Blossfeldt, as the few photographers who could correct the fashionable creativity that he loathed in Renger-Patzsch in order to create activist photography:

> *Where photography takes itself out of context, severing the connections illustrated by Sander, Blossfeldt or Germaine Krull, where it frees itself from physiognomic, political and scientific interest, then it becomes* creative. . . . *The creative in photography is its capitulation to fashion. The world is beautiful—that is its watchword. Therein is unmasked the posture of a photography that can endow any soup can with cosmic significance but cannot grasp a single one of the human connections in which it exists, even*

where most far-fetched subjects are more concerned with saleability than with insight. But because the true face of this kind of photographic creativity is the advertisement or association, its logical counterpart is the act of unmasking or construction.[66]

By these strategies, Benjamin believes the artist can become an active engineer of a new world, and he sees Krull as unmasking or constructing, rather than being a passive observer like Renger-Patzsch. Instead, Krull exemplifies "a supplier of the productive apparatus into an engineer who sees it as his task to adapt this apparatus to the purposes of the proletarian revolution."[67] Interruption, or the fracturing operation of the montage technique, is an important tool in the works being discussed here, and it ostensibly allows Krull and Ivens to change from observer to active participant. Both Ivens's film and Krull's album employ the techniques of montage to avoid Renger-Patzsch's elegant fetishized objects and to energize and politicize their imagery.

Industry and Commerce

The film theorists and Ivens himself helped Krull to resolve another important issue—the presence of politics in her work. Until now, Krull had alternated between periods of relatively apolitical photographic activity, including her nude photography and portraiture in Munich and Berlin, and intensely political moments in her life when she made no pictures, particularly her involvement in the Munich revolution and voyage to Russia. Although she had participated in Lehning's circles in Berlin, and Lehning himself was involved with Russian Communist émigrés in Berlin and with political writing and action, Krull made no mention of this side of the Berlin world. She was similarly reticent in Holland. But in Amsterdam, where she was not active in political circles, she became a much more radical artist, moving away from the pictorialist work or portraiture of her early years to an abstract vision that redefined the visual world around her. Her evolution places her in the philosophical company of artists whose abstract compositions claimed to change the world.

At first glance, both Germaine Krull's *Métal* images and Joris Ivens's film *De Brug* seem to pay homage to the capitalist industrial complex of 1920s Europe. In fact, various members of the French press framed the book as a lyrical hymn to the beauty of machines and a formal grouping of beautiful machine abstractions. Yet, in contrast to the popular critical response, Krull's active representation of these machine forms suggests that this seemingly formal album may have a subtle social purpose. Benjamin, of course, was one discerning critic who read the social dimension in works like these. By juxtaposing so many industrial details without allowing them to function, Krull removes the machines from their immediate functions, creating instead a dance of activated industrial shapes. The images hover between engagement and distance in their political stance. In their compositions, some of the machines are useless and elegant objects, on the one hand, becoming the kind of fetishized descriptive objects for which Renger-Patzsch was both praised and reviled. Others, in their collaged multiple exposures and alienating angles, approximate the New Vision, which could be read either as praise or criticism of the machine. In the layout of the book *Métal*, usage patterns disintegrate and leave only a collection of fascinating but alienating metal parts. Although they never commented specifically on *Métal*, Benjamin and Eisenstein praised this formal effect as an actively political commentary against capitalism, although its effectiveness as a political tool might be questioned.

It is tempting to read *Métal* as a subtle indictment of capitalist industry. But industry was the metaphor of progress for Soviet communism as much as for Western capitalism. The Soviet government was busy building industrial factories simultaneously with the Western European economic efforts: the machine was a Soviet as well as a capitalist icon in the 1920s. These projects lean toward the West rather than the East in their commentary but are not inconsistent with the artists' leftist intellectual sympathies. Both she and Ivens used the effects of montage interruption, or fracturing, to enliven their series of industrial images. Their emotional response to industry seemed generally positive. However, they often formally frame these machines as fragments despite the humanizing fact that Krull, at least, calls her machine parts nudes. This suggests a more complex response. In their eyes, the industrial world becomes both exciting and, in its lack of humanity, threatening. Krull and Ivens present industrial forms for admiring middle-class enjoyment, yet they simultaneously manage to create subtle political criticism. The uneasy tensions between industrial celebration and its political critique coexist, defying simplistic categories. Both capitalists and communists extolled industry during these years, and the critique could apply to any industrial forms, not just Western ones.

This seeming dichotomy between artists' leftist beliefs and their industrial imagery is in fact quite common to the early and mid-1920s. Our understanding of montage as a political artform stems largely from the study of figures like John Heartfield, Hannah Höch, and Alice Lex-Nerlinger who used the formal ruptures of montage compositions to criticize capitalism. Montage, however, straddled both sides of the political spectrum. In the catalogue of the recent exhibition "Montage and Modern Life" at the Institute of Contemporary Art in Boston, Christopher Phillips begins to clarify the more varied political roles of montage when he suggests that between 1919 and 1942, "Montage served . . . as a kind of symbolic form, providing a shared visual idiom that more than any other expressed the tumultuous arrival of a fully urbanized, industrialized culture."[68] During these few years industry—whether capitalist or communist—symbolized modernity and progress; montage was the exciting formal language most suited to its celebration. The survey quality of the Boston show precluded specific examination of individuals within the contexts of their production. But here it is possible to explore the complexity of political positions that two closely linked artists expressed through their montage projects.

The issue of industry cannot be easily resolved in these artists' work. *Métal* and *De Brug*, usually seen as early formalist projects by otherwise politically active artists, can now be read as commentaries on industry as well as appreciations. Krull and Ivens celebrated the industrial complex while commenting on its inhumanity—a stance that could be a celebration or critique of capitalist industry and Soviet machinery alike. Simultaneously, they embraced anarchism and communist ideology. All seemed exciting paths to a new world. The complex dance between praising industry and critiquing it would continue, for Krull in particular, when she moved to Paris.

Both Krull and Ivens remained political activists in their lives and their work as well. By World War II, Krull would photograph for Charles de Gaulle and the Free French in Africa. By 1930, Ivens's first documentary film, *Zuiderzee*, prompted Pudovkin to praise "the union between an artist and the organization of the revolutionary workers' movement in Holland."[69] From this film developed socially activist documentary films like *Spanish Earth* (1937), for which Ivens is best known. The photographic language for political activism was often commercial photography, and here too Krull and Ivens shared a point of view. Both operated freely in both the art world and the most pragmatic commercial worlds.

The coexistence of commercial and avant-garde loyalties has, until the postmodern era, seemed an uncomfortable mix to viewers, steeped as we are in the autonomy of the artwork as a modernist credo. However, as she did in Berlin, Krull fully embraced both kinds of photography in Holland and then in Paris. In this she was not alone; despite the narrowly formalist profiles of many photographers to date, most prewar photographers enjoyed a similar dual career. But Krull also occupied an even more complicated position than some artists in that she actually worked for the companies most involved in capitalist industrialism while simultaneously commenting on them.

A final layer of complexity lies in the commercial contacts of both Krull and Ivens. We may take note of their leftist politics, their deliberate disavowal of commerce in these early projects, and the implicit formal critique of the industrial world made possible by the montage structures. But these artists simultaneously applauded the industrial complex and worked on commission for numerous big business patrons, like their Dutch colleagues Schuitema and Zwart. The formal experiments Krull conducted in Holland translated easily into commercial work for French industrial clients, for whom the abstracted language of machine fragments symbolized modern business rather than modern culture in the broader sense. Krull—like her contemporaries—felt no contradiction in applying the same strategies to her personal artistic adventures as to her commercial work. In fact, in *Métal*, Krull includes certain images made on commission and directly credits her industrial clients for certain images, including André Citroën[70] and an electrical company, the Compagnie Parisienne de Distribution d'Electricité of the Centrale Eléctrique (CPDE) de Saint Ouen. Some of

her photographs in *Métal*, in fact, derive from her commercial work, like an unidentified still life composed of small cogs and wheels (plate 4.11) and an image for a company named Sandoz (plate 4.15). These images isolate shining cogs and machine parts with little information about their actual usage, although "Gve. Sandoz/Paris" appears embossed on the metal of plate 4.15. Ivens also continued to accept occasional commercial film projects for industrial companies, including *Philips Radio* in 1931 and *Creosote* the same year.

Once she established herself in Paris, Krull had many industrial clients over the years, based on the success of the experimental images that formed *Métal*. Her commissioned work from 1927 to 1936 also included projects for Citroën, the Fonderies de Pont à Mousson, Laboratoires Debat, Ocel Paris, Union Electrique d'Ivry, Union Electrique Vitry, and others.[71] In fact, one of Krull's most striking industrial projects is the series of photographs she supplied for the Compagnie Parisienne de Distribution d'Electricité of the Centrale Eléctrique, in a book called *Les Nouvelles Installations de la Centrale d'Issy-les-Moulineaux*.[72] Published in 1929, this sumptuously produced volume was clearly meant as a marketing tool for the electricity company, and Krull's seven photographs, along with those of many other photographers, uncompromisingly celebrate the machinery they depict.

Finally, Krull photographed for various automobile companies like Citroën and Peugeot and happily received first a Peugeot *cinq-chevaux* car and later a Peugeot 202 as partial payment for her work. One image of an automobile assembly line (plate 4.17) presents ranks of cars in a glass-enclosed shed, gleaming and polished as they are prepared to enter the marketplace. This photograph has the same aesthetic and virtually the same purpose as the series of photographs Charles Sheeler made for Ford at River Rouge—a beautifully composed, lit, and constructed commercial endorsement of capitalist endeavor. The photographer reused images like these in other contexts, and the commercially produced photographs in *Métal* often create different meanings from their original use for their industrial clients. The multiple existence of both commissioned and more personal images in *Métal* demonstrates that when she moved to Paris, Krull put

her formal experiments in Amsterdam to good, solid commercial use. This bothered neither the clients nor Krull; they saw no conflicts in shooting an electric company on commission and then mounting the same images in art exhibitions.

The pattern set by *Métal* demonstrates that a portfolio like this—in the wake of Zwart's and Schuitema's advertising campaigns—could be read as a good advertising technique. Krull made advertising shots, too, such as an advertisement for Shell Oil with a diagonally placed oilcan and shining wrench (plate 4.18). They were commissioned and used by industrialists at the forefront of efforts to rationalize production, such as André Citroën, whose anti-union sentiments could hardly have been further removed from those of Benjamin.[73] In the absence of Krull's own political commentary on this album, we must assume that she saw no conflict in her decade's multiple readings of her work as both pro- and anti-industry, as both capitalist and anticapitalist, and as both commercial and artistic. Her pattern of mixing artistic and commercial aims would reach its height in Paris, as would her international reputation. Although the theoretical ideas underpinning their development lay in the Filmliga and film theory, Krull's metalwork pictures and her other photographs gained widespread public recognition only in Paris.

"The Valkyrie of Photographic Film"

*The first science of the photographer is to know
how to look. One looks with one's eyes. The same
world, seen through different eyes, is not exactly
the same. It is the world seen through a
personality. With one snap of the shutter, the
lens registers the world from the outside, and the
photographer from the inside.[1]*

From 1926 until 1935 Krull achieved the height of suc-
cess in her personal life, her forms of artistic expres-
sion, and her economic life. During this ten year
period, Krull produced her best work and freely moved
between exhibition and commercial venues. With her
background in film montage theory, she entered the
center of the Parisian avant-garde in Saint-Germain-
des-Prés, Montmartre, and Montparnasse, quickly
establishing contacts that would position her at the fo-
refront of the newly developing photographic avant-
garde. The same background also secured her success as
a commercial photographer. Her arrival in Paris with a
portfolio of industrial images under her arm established
the constructivist tone of her work, which she then ex-
panded successfully in France. In addition to her indu-
strial work, Krull adapted this style to fashion photo-
graphs and to portraits. During the late 1920s, she also
began to exhibit all her work widely in international
exhibitions, and critics across Europe wrote about her
photography.

Parisian Circles

In the same way that Joris Ivens and his film circle had
provided a personal and intellectual centerpoint for
Krull's Amsterdam photography, friends in the world of
literature and painting shaped her experience in Paris.
She had been yearning for a chance to move to Paris
and establish a studio, and in 1926 she was settled in
France. She soon joined the circle of intellectuals who

They were also inseparable companions in the Paris wandering that yielded their best portrait, industrial, and street photography. They worked for various industries, exhibited in many exhibitions, and published their work both in popular journals such as *Vu* and in art journals such as *Variétés*.

Commercial Studio Work in Paris

During her early years in Paris, from 1926 to 1928, Krull continued to make studio photographs to earn a living, concentrating on fashion and portrait photography. Her fashion work with Luigi Diaz marked her first Parisian success, but once she began working more closely with Lotar, she also made portraits, street photographs, and further industrial images.

Fashion Photography

These early years in Paris mark the time when Krull first became financially successful as a photographer. Not only was she becoming famous in art circles, but her studio was finally beginning to make money for the first time. Her first Parisian success was in the fashion photography world, which she disliked but which brought a certain financial stability. Krull entered the fashion market with Luigi Diaz. Together, they printed a first letterhead with a business address, 6, Avenue Daubigny, in the seventeenth arrondissement. But by 31 October 1926 their studio had moved to Krull's new home at 11 Avenue Junot.[18] Then for about six months, until early 1927, they published a number of fashion photographs under the name Photos Presse Paris. On their letterhead, Luigi Diaz is listed as commercial director and Germaine Krull, in the center of the page in big letters, as artistic director. The partnership of Photos Presse Paris regularly supplied photographs for the *Frankfurter Zeitung's* monthly women's supplement, *Für die Frau*, which had begun publication in January 1926. Krull scornfully wrote that Luigi's flirtations with the German newspaper correspondent were the main cause for their commissions.[19] By May 1927, just after her *mariage blanc* with Ivens, when she lived on rue Becquerel, her business relationship with Luigi Diaz had deteriorated.[20] She wrote Marsman that she was no longer involved in Photos Presse Paris, that Diaz had not been very nice, but that she considered herself almost a regular correspondent for the Frankfurt paper.[21] Krull continued to publish her fashion photographs under her own name

in *Für die Frau*.[22] Diaz also continued his work as a fashion photographer and published photographs in *Die Dame* and other magazines.[23]

Krull made a variety of fashion photographs during her Paris years. She uniformly disliked this kind of work, later writing, "If there is one thing in this world that has never attracted my photographic eye, and that never interested me, it is fashion photography."[24] For example, she photographed for a French and Belgian fashion designer called Norine and made various views of models and actresses like Davia in different designers' clothes.[25] In 1930, she photographed ties for J. D. D'Ahetze, a store on the Champs-Elysées,[26] and she photographed a series of dress designing sessions and models for the Parisian designer Jacques Heim in the winter of 1933.[27] Her real contribution to fashion photography, however, and the work that financially supported her so that she could also photograph the city, was her collaboration with Sonia Delaunay.[28]

Sonia Delaunay hired Krull from November 1925 onward to photograph her fabric designs, although there is no way to know whether she began working for Delaunay before or after she was permanently installed in Paris. Even these projects held little appeal for her. She describes Sonia Delaunay's clothes as "big zig-zag designs and contrasting colors. The women dressed by [Delaunay] seemed to resemble billboard panels."[29] The photographs themselves, however, are among her best fashion photographs.

Sonia Delaunay had begun commercial production of fabrics in 1924.[30] She had exhibited these fashions and textiles in the decorative arts section of the Paris Salon d'Automne and opened a Boutique Simultanée with the fashion designer Jacques Heim on the Pont Alexandre III during the 1925 Exposition des Arts Décoratifs. Her designs decorated scarves, clothing, and even cars, and Krull photographed both the clothing and Delaunay herself in her studio at 19, Boulevard Malesherbes. A spectacular Krull portrait of Delaunay surrounded by her fabric designs is the centerpiece of an article in the *Illustrierte Beilage zum Berlin Börsen Courier* in March 1926.[31] Uncredited Krull photographs of Delaunay's designs were reproduced in the *Illustrierte Beilage zum Berlin Börsen Courier* as early as 25 November 1925 and in *The Home* as early as 1 April 1926.[32] Sonia

Delaunay's archives at the Bibliothèque Nationale in Paris and in the Delaunay estate contain dozens of her photographs. In the Bibliothèque Nationale, half a dozen from 1925 and 1926 bear Krull's signature, while more than twenty-one others carry the Photos Presse Paris stamp.[33] A receipt for payment dating from 21 September 1927, from Sonia Delaunay's studio, demonstrates that she was for Krull a major client.[34] The total bill was for 875 francs, and Krull wrote Hendrik Marsman that the partial payment of this bill had made her life much easier.

Krull's portraits of models such as the Russian dancer Violette Napierska in Sonia Delaunay's creations demonstrate that although she may have made fun of the large patterns in her late memoir, her contemporary record of the designs is sympathetic and full of contrasts and shadows that highlight the strong patterns of the Delaunay clothes (plate 5.1). In her recent article on Sonia Delaunay's designs, Sherry Buckberrough equates the dynamic patterns and shadows created by the body's movement in these clothes with the collisions and dynamic structure of postwar life.[35] Krull was clearly participating in the same celebration of international cultures and simultaneity. The majority of the fashion photographs are simple views of standing or seated models posed against walls to allow the geometric pattern of the dress designs to dominate the compositions. In some images, clearly taken by Krull, her signature shadow is evident (plate 5.2).

Some of the Delaunay fashion photographs move beyond straightforward advertising to become more personal statements by Krull. These portraits often depict dancers so that Krull could combine her interest in theater photography with the commissions (she later photographed many of the productions of Louis Jouvet in Paris). A portrait of Lizica Codriano, a Romanian artist who danced in the P'tit Parigot, transcends commercial documentation (plate 5.4). One of Krull's most beautiful portraits, this image frames Codriano, seated and wrapped in one of Delaunay's shawls, dancing with the movements of her hands. Her face is painted in a geometric pattern to match the fabric.[36] The Russian dancer Violette Napierska returns in various other images, as well, suggesting that she was a favorite model for Sonia Delaunay and for Krull alike, and Krull documented many other dancers, such as the Javanese prince Mas Madja-Djava, who danced in Paris in 1930 (plate 5.3).[37]

In her fashion work, Krull continued to experiment as often as the clients permitted. One striking photograph (plate 5.9) presents a surrealist multiple exposure of a model's head and the silky folds of a flowing dress, so that the face literally peers through the folds of the cloth. Other works present unusual viewpoints, such as an unidentified image of people dancing, cropped so that only legs and elegantly clad feet are visible (plate 5.7). Several photographs illustrate unclothed mannequins, revealing the mechanical robotlike underpinnings for the marketing of the flowing clothes of the 1920s (plate 5.8). Not all clients were so flexible, however, and many of Krull's bread-and-butter fashion photographs resemble the industry standard of smiling models in beautiful clothes. Lacking the long and elegant lines of Man Ray's most successful surrealistic fashion images, they fall closer to the mainstream of photographs by d'Ora, Baron de Meyer, and Steichen.

Nudes

Krull's best photographs for Sonia Delaunay echoed the compositions and effects of her long-running experiments with nude photography. Krull's last portfolio of nudes was published in 1930 in Paris.[38] Paradoxically, these are the most straightforward nude photographs she made, consisting of simple forms lounging on couches with less formal innovation than her German work. More similar to the unmanipulated American modernist nudes of the 1920s by Edward Weston and Imogen Cunningham than to the surrealist distortions of André Kertész or Herbert Bayer, they were widely reproduced in various magazines as well.

The 1930 album presents an elegant but cool view of the human body, quite different both from the erotic Berlin nudes and from the "métaux nus" of the *Métal* album. It is interesting that in her most conventional publishing project, Krull wrote an introduction that could be the credo for her street photography and industrial photography rather than for her nudes. Her text seems less suited to the nude images than to her other bodies of work: "The photographer is a witness. A witness of his era. The true photographer, the witness of each day's events, a reporter."[39] These words betray her true love—the world around her.

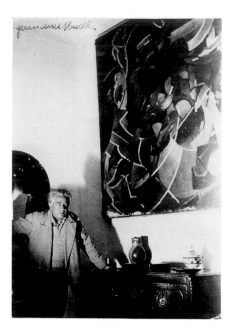

Portraits

Being a reporter also involved making portraits of the luminaries of the Parisian scene. Krull had been photographing the friends in her circle for years, and she continued to photograph the intellectual world of Paris, sometimes out of friendship and sometimes on commission. She had made portraits of Friedrich Pollock in Berlin (plate 5.13) and Joris Ivens when they first met (plate 5.15).[40] In her personal portraits we can see the progression from a traditional, though dramatically shadowed, view of Pollock to the close-up, New Vision ideas inspired by Benjamin and Eisenstein. Krull photographed Walter Benjamin in 1926 in her early days in Paris (plate 5.14).[41] She framed Benjamin in a very close-up view, emphasizing his pensive expression against the velvety black background. By cropping out all references to exterior setting or even to costume and by highlighting only the author's cigarette, glasses, and pose with his chin on his hand, she concentrated on the life of the mind that so obsessed Benjamin. The psychological quality of this portrait echoes that of Lotar (fig. 5.2). Both have cigarettes, symbols of a more casual depiction, and both signal a new kind of portraiture less formulaic than earlier portraits such as that of Pollock—a style of portraiture that Krull developed at length in France. She also photographed S. M. Eisenstein, when she drove him, together with Ivens and Lotar, around the environs of Paris (plate 5.16).[42] By cropping Eisenstein's body in a view from below and between his legs, so that he seems to press against all four edges of the photograph, Krull approximated the estrangement effect of Soviet montage composition in his portrait. Another portrait of Eisenstein (plate 5.17) frames only his face, eliminating hair, chin, and ears, so that his features fill the entire picture frame, creating a disturbing effect even closer to the estrangement effect that these filmmakers attempted to create with filmic montage.

The images of Krull's French avant-garde friends were often used for publication in magazines. Her close contacts with the art world are documented in her portraits of Robert Delaunay working on an Eiffel Tower painting (fig. 5.1) and Francis Picabia in front of his 1912 painting *Udnie* (fig. 5.3). She also made portraits of many prominent figures in the literary world, including Jean Cocteau (plates 5.19, 5.20), Colette (plate 5.23), André Malraux, (plate 5.21), Eugène Dabit, André Gide, Paul Valéry, Paul Morand, and many others who were connected with the review *Nouvelle revue française.*

Founded by André Gide in 1908, this monthly journal was the main vehicle of the French literary world, and Krull would, in different ways, become close to many members of its circle. Her *Nouvelle revue française* contacts included Jean Cocteau, Eugène Dabit, André Gide, Joseph Kessel, André Malraux, Paul Morand, Jean Prévost, and Paul Valéry. Malraux and Cocteau became lifelong supporters and friends.

These literary portraits are among her most compelling images. The photographs span the personal and the commercial, and, even more than the work of the other major portraitists in Paris, Berenice Abbott and Man Ray, offer glimpses into the sitters' souls. Man Ray's portraits remained slick and elegant, whereas Abbott knew her sitters less well and treated them less personally. By contrast, Carlo Rim, who later edited *Jazz* and worked at *Vu*, remembers in an 1988 interview how vibrant Krull was in portrait sessions with her sitters: "She was very ugly, but she was so passionate about photography that when she photographed you, she became beautiful. It is puzzling, but the fact of being photographed by Germaine Krull gave her a charm."[43]

Krull's best Parisian portraits are of the people to whom she felt closest intellectually, like Jean Cocteau and André Malraux. Krull made an extraordinary series of portraits of Cocteau's sensitive hands and face (plates 5.19, 5.20), whose stark contrasts and intense statuesque quality resemble the formal compositions in Cocteau's film *Blood of a Poet*. The two portraits that survive prominently display his long fingers, and their gestures are the most mysterious element in the somber and dreamy portraits. The harsh light on Cocteau's high forehead accentuates his youth, and the fingers that frame his

FIGURE 5.3

GERMAINE KRULL. PICABIA DEVANT 1ER ÉTAT DU TABLEAU "UDNIE" (1912). C. 1925–1930. GELATIN SILVER PRINT. 21.3 × 14.8 CM., ACHAT DIRECT DU DIRECTEUR. 1991. MUSÉE NATIONAL D'ART MODERNE. 1991.307. CENTRE GEORGES POMPIDOU. PARIS. © C. G. POMPIDOU. 1986

body and head are prominently lighted and positioned to be the major actors in the image. Krull's own description of Cocteau's hands begins to sound like the writer's own fanciful prose: "his hands like seaweed, fine and long, where each finger seemed to move individually. I could not drag my eyes away from his hands and they were the first thing I photographed."[44] Cocteau's reaction to the photographs of his own hands was equally dramatic: "I have to admit that I did not recognize my own hands. . . . I could hardly identify these long nervous things. Then, I saw that these animals, these dead plants, were actually attached to a sleeve, to my suit, and I understood how much they resemble me more than a face."[45] Krull was fascinated by hands and made many studies of them, commenting on their allure for her in her memoirs. A suite of these images is published in *Variétés* and runs the range from the deliberately mysterious to the self-consciously posed.[46]

Krull sometimes photographed subjects whom she had not met previously. For instance, Lucien Vogel commissioned Krull, Abbott, and Kertész to photograph some of the most fashionable writers in Paris. Krull recounts her first portrait assignments—to photograph the novelists Colette and André Gide.[47] Colette was living at the Hotel Claridge on the Champs-Elysées. Krull describes in detail the portrait session and the fact that their common love for cats helped them to break the ice; they rapidly became very friendly. That friendship is evident in Krull's portrait, which appeared in *Marianne* (plate 5.23). The photographer has closely framed the author's face, so that her arms cushioning her face fill the frame and she seems very near to photographer and viewer, almost close enough to whisper intimate secrets. Her strikingly lit face, seemingly caught in the midst of a daydream, contrasts with the dark borders of the photograph, increasing the focus on Colette's extraordinary eyes.[48]

During the period when Krull met André Malraux, he was a young and moody star of the Parisian literary scene. Malraux (1901–1976) wrote novels, essays, and art criticism. Krull's first portrait of him (plate 5.21) captures his youthful intensity, as he holds a cigarette in nicotine-stained fingers and looks broodingly at us out of a dark background. The checked pattern of his sweater and the dramatic shadows cast by his head create a psychological portrait that conveys the strength of his personality. Krull's verbal description in her memoirs fits the portrait well: "My first impression of Malraux is that he was very young, svelte, tall, with a

thin face and always a certain tic, where he moved his hand to arrange a strand of hair that fell forwards."[49] Although the lock of hair is in place in this portrait, the slightly disheveled air and unwavering intensity come through.

This first contact would establish Malraux as a kindred spirit and a patron for her photographic career, but their lifelong friendship reached much deeper than that. The mutual interests of Krull and Malraux spanned photography, leftist and republican politics, a passion for memoir writing, mutual work for the Free French during the World War II, and a love for Asia and other exotic archaeological sites.[50] Like Krull, Malraux was an early advocate of communism and wrote three famous novels, including *Man's Fate*, on the subject. He renounced communism once he saw its totalitarian character, as did Krull, and then worked long and hard for republican and antifascist causes during the 1930s and 1940s. He would meet Krull again on the battlefields of World War II, when both worked for the Free French, and both returned to France for the Battle of Alsace in 1944. After the war, his powerful position in de Gaulle's postwar government and again at de Gaulle's return to power in 1958 did not cause him to forget his old friend, and their correspondence continued throughout their lives. He enlisted her help in a survey of Southeast Asian Buddhist sculpture in the early 1960s, and he would sponsor her first one-woman show, at the Cinémathèque Française, in 1967.

In the late 1920s, however, Krull's exhibition career was just beginning, and Malraux was an early supporter of her work. When he was asked to edit a series of books on new photographers, Krull and Man Ray were his first choices, and he convinced Pierre Mac Orlan to write the text.[51]

The New Vision Comes to France

Krull wrote little about her artistic development during these years, but her statements reprinted in Pierre Mac Orlan's 1931 monograph on the photographer demonstrate an essential shift from the conceptual investigations and purely formalist experiments of some avant-garde photographers. The photographer explains:

The camera cannot invent, combine, or trick.
It is neither painting, nor imagination.
The photographer is a witness. The witness
of her era.

 The true photographer is the witness of each
day's events, a reporter. It is natural that she
does not always keep her eye at one-and-a-half
meters off the ground. But she must always think
of the ground, of the grounding of today, of this
morning, of this Thursday morning.[52]

With these words, Krull rejects the pure formalism of the New Vision and grounds her formal experimentation in the real world.[53] Her insistence on the external world reshapes the New Vision into what would become its French form for many photographers. Krull's insistence on the photographer's role as witness, reporter, and mediator of the contemporary world around her forms the foundation for the special mark that she would make in the world of French and European photography.

The emergence of modernist avant-garde photography has usually been credited to Germany and to Russia, with France largely ignored in the discussion. Critics sometimes acknowledge that surrealism contributed a French flavor to the discourse but usually place French photography in a secondary position. This portrayal is not accurate, for several reasons. To begin with, one of the first exhibitions of modernist photography, the Salon de l'Escalier, took place in Paris in May 1928.[54] Although it was held in a theater staircase and not in a formal museum like comparable German shows, it predates by a full year the German Film and Foto (FIFO) exhibition, which is usually held up as the high point of modernist photography exhibitions. Krull was a prominent exhibitor in both.

Although the Dutch journal *i10* included French, German, and English synopses of its articles, Moholy-Nagy's writings would not appear prominently in France until 1929,[55] so many French critics probably saw Krull's work before they saw or read either New Vision or New Objectivity photography and writings. More than Moholy-Nagy, Krull stressed the importance of existing within history, and her more grounded approach may have shaped the French response to the New Vision. Even during these years when politics almost never enters her verbal discourse, she comments on concrete places and plumbs their symbolism. If presenting the French public with a constructivism in the form of her industrial imagery was her first gift to French photography, this grounding within history—a social constructivism—was her second.

Furthermore, Krull articulated a position that is commonplace today but that was largely disclaimed during the 1920s. She remained firmly wedded to the exterior world, but on her own terms, rejecting the commonplace idea that the photographic medium is transparent. In the essay for Mac Orlan's monograph, she writes: "With one snap of the shutter, the lens registers the world from the outside and the photographer from the inside."[56] Here she assumes that the reporter is not objective but views her world through her own personality. Thus she acknowledges the importance of her personal vision as a historical lens; belying the concept that history can be objective and recognizing the importance of her own point of view. This, too, would become a hallmark of French photography, reaching its best-known imagery in the "decisive moment" photography of Henri Cartier-Bresson the following decade.[57]

Krull, like most of her colleagues in Berlin, Holland, and Paris, did not separate commercial from avant-garde photography. Her industrial photographs were frequently commissioned, her abstractions appeared in the popular press, and her street photographs were exhibited alongside her metal imagery. Krull was one of the first photographers in France to combine avant-garde style with journalistic street photography and to participate in French illustrated magazines. Thus, she helped to form the discourse both in exhibitions and in the popular press, and her theoretical position acknowledged the simultaneous importance of popular information and avant-garde experimentation.

Exhibitions
From 1927 until 1930, Krull was included in every major photography exhibition in Paris, Brussels, and Germany, and the press regularly praised her work. In 1927 and 1928, she chose to submit her industrial abstractions, with the occasional portrait, to exhibitions in Paris. During the next two years, she gradually began to choose to exhibit her street photographs made for the popular press, and these gained equal footing with the metalwork photographs in the international exhibi-

tions that abounded in Europe in 1929 and 1930. The critics recognized the power of both bodies of work and also appreciated the amalgam of geometry and journalism that Krull made uniquely her own.

Krull reached the zenith of her career in 1928. By the time of the 1928 Salon de l'Escalier, Krull was seen by critics to be among the top three photographers in Paris; the other two usually named were André Kertész and Man Ray. The Salon de l'Escalier, or the First Independent Salon of Photography, was held in the stairwell of the Comédie des Champs-Elysées from 24 May to 7 June 1928. Its organizers included *Vu's* editor Lucien Vogel, filmmaker René Clair,[58] critics Florent Fels and Georges Charensol, and writer Jean Prévost. Krull knew the first three well, and although conventional histories of the exhibition's organization ignore her participation, she may have had some limited involvement. Krull writes in her memoirs that she and Lotar often met Kertész, Man Ray, and Berenice Abbott at the Café des Deux Magots and that they wanted a place to exhibit their photographs. She writes that her friend Louis Jouvet, director of the Comédie des Champs-Elysées, gave them the staircase of the theater.[59] Therefore, in addition to her prominent exhibition in the show, it remains unclear whether she was in fact involved with the organization of the show or whether she has been fanciful in her memoirs.[60]

As the first postpictorialist exhibition devoted to modernism, the show's goal was to show that photography was becoming a medium with its own rules—neither painterly nor realist but strictly aesthetic.[61] With this exhibition, photography broke definitively with the amateur-based, soft-focused, and painterly art photography of the previous thirty years.[62] Reflecting the paucity of interesting French photography in the previous decades, the organizers included a multitude of foreigners—Berenice Abbott, d'Ora, Georges Hoyningen-Huené, André Kertész, Germaine Krull-Ivens, Paul Outerbridge, and Man Ray. French representatives included Laurie Albin-Guillot, Nadar (deceased), and a retrospective of the work of Eugène Atget (misspelled Adget), who had died the previous year. Lotar did not participate. Photographers like Abbott, Kertész, Krull, and Man Ray represented the movement away from pictorialism to abstraction and hard-edged geometry, and the inclusion of the historical figures Nadar and Atget claimed a patrimony of realism, not pictorialism, for French photography. All of these photographers worked as commercial photographers.

Krull's importance in the exhibition is undisputed. The exhibition catalogue reveals that she exhibited thirteen photographs, including ten that were industrial in nature—three views of the Eiffel Tower, three views of the port or bridges in Rotterdam, one view of the port at Saint-Malo, a Breton fishing port, a view of the Seine, and another of a barge. These industrial photographs stood out as radically different from anything else in the exhibition; similar photographs were being produced in Germany, but none had yet been seen in France. The three remaining images were a nude study, the hands of Mariette Lidys, and a portrait of Joris Ivens. Unfortunately, none of these images have yet been definitively identified; Krull made many such pictures for *Métal*, *Vu*, and elsewhere. Yet the choice of works in this exhibition demonstrates that she saw herself mainly as an industrial photographer.

André Kertész, in contrast, exhibited a different and far less abstract mix among his fifteen photographs, including six portraits, two Paris views, and seven still life or studio studies. Other participants exhibited portraits and studio views.[63] Aside from Atget's street views, a visitor to the exhibition would have recognized only Kertész and Krull as photographers who ventured outside of the studio and only Krull's images as industrial or constructivist photographs. These must have made a remarkable impression, and their impact is reflected in the critical response to the exhibition.

Krull's photography was clearly the most adventurous work in the Salon de l'Escalier exhibition. The organizers of the exhibition had not included photographers from outside of France whose work might have paralleled Krull's. The new generation of German photographers was not included in this exhibition, nor were any Russian or Dutch photographers, so that Krull's work took center stage as the model to follow for industrial abstractions and modernist cityscapes in France. During the following decade, dozens of photographers in Paris would record the city and the French countryside with similar angles and abstractions, but their first model in France was Germaine Krull.[64] Berenice Abbott later recalled Krull's position in the Parisian art world, stating that "Germaine Krull was doing some remarkable work and she was sort of the Bourke-White of France."[65] (Margaret Bourke-White, in

fact, made no industrial photographs before 1927.) Brassaï, who began photographing several years after Krull, wrote, "For many years now, Germaine Krull has figured as one of the pathfinders of the new work of photography. I especially remember her Eiffel Tower images, which had a muscular and undeniable newness."[66]

Several months later, in October 1928, another international exhibition of modern photography opened at the Galerie l'Epoque in Brussels. This grouping included a more international vision of modern photography than the French (or adoptive French) construction given at the Salon de l'Escalier; New Vision and surrealist imagery appeared alongside the photographers of the Paris exhibition. These photographers included Krull, Lotar, and Man Ray, in addition to Abbott, Atget, Anne Biermann, Robert Desmet, E. Gobert, E. L. T. Mesens, Moholy-Nagy, and Robertson. Krull exhibited ten images, again heavily weighted toward industrial imagery from *Métal*, with two Eiffel Tower photographs, five photographs from Marseilles, a nonspecific metalwork image, a photograph of hands, and a portrait of the German critic Walter Benjamin (plate 5.14). A critic for *Variétés* groups Kertész, Krull, and Lotar together as photographers who "can suggest power, peace or mystery by the use of an essential fragment of a view."[67] Interestingly, Moholy-Nagy is not discussed along with them as a photographer of fragments. The Brussels exhibition also excluded the more retrograde French photographers of the earlier show, such as d'Ora and Laure Albin-Guillot.

Krull's photographs were entering the international arena of modern photography. She was rapidly becoming a major force in the field. By 1929, Krull was helping other, younger photographers as well as promoting her own work. In January 1929 Krull's work was included in the important Internationale Ausstellung Fotografie der Gegenwart at the Museum Folkwang in Essen, Germany, that traveled to nine other cities in Germany, England, and Austria.[68] Lotar was also included, as he had been in the exhibition at the Galerie l'Epoque in October 1928. In this first appearance in a major German museum show, Krull had reinvented herself as an industrial and urban photographer, a force to be reckoned with in the highest circles of the international avant-garde. She had become so prominent that she was referring other photographers from France to the exhibition's organizers. Krull's involvement in the choices for this exhibition appears in a letter from

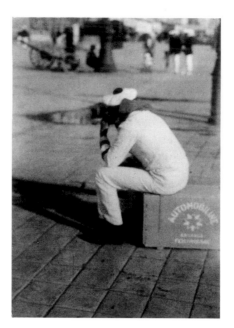

Berenice Abbott to the Museum Folkwang, stating that "Mme. Germaine Krull has kindly informed me of your intention of holding an exhibition at Essen and that my contribution would be welcome."[69]

In May of 1929 Krull's work took center stage in the biggest German international exhibition of modern photography, the Internationale Ausstellung des Deutschen Werkbunds. Popularly called the Film und Foto exhibition, it began in Stuttgart and then traveled to Zurich, Berlin, Danzig, Vienna, and Agram. The Parisian representatives included only photographers who had achieved an international status in the avant-garde, rejected were pictorial work and mere journalistic work alike. Krull exhibited twenty images, alongside Berenice Abbott, Eugène Atget, Florence Henri, George Hoyningen-Huené, André Kertész, Eli Lotar, and Man Ray.[70] The catalogue presents only general descriptive titles, and few photographs can be positively identified, although the general grouping is clear. With a dozen metalwork photographs, probably from *Métal*, there is no shortage of ironwork, industrial, and dock imagery. But now Krull had been photographing for Lucien Vogel at *Vu* for more than a year, and her reputation had expanded to include street photography as well as industrial abstractions. In a significant shift from June 1928 to June 1929, this exhibition thus included—for the first time—street photographs. Two surviving images of sailors from the Schostal agency archives are the only surviving images with a Film und Foto stamp (fig. 5.4, plate 6.1). Yet if we can learn about photographers' presentations of themselves from the images they send to major exhibitions at this time, Film und Foto marks a change in Krull's view of her own best work. These

FIGURE 5.4

SAILOR. C. 1929. GELATIN SILVER PRINT. 21.9 x 14.2 CM..

COLLECTION DR. CHRISTIAN BRANDSTÄTTER. VIENNA

sailors, casually posed in the open air, are a new kind of exhibition image for Krull, neither portrait nor abstraction. In addition to the sailors, she also showed several pictures taken in Paris streets, including two views of gypsies and four of *clochards* or street vagrants. For the first time, moreover, a clearly identified commercial commission was included (*Elektrizitätswerk Paris*). After the Film und Foto show, Krull's abstractions and street photographs were regularly included together in the large international exhibitions across Europe.[71]

Criticism

The critical reception of Krull's work, and of photography in general, can teach us much about the position of photography in the interwar avant-garde. Like the pictures Krull chose to exhibit, the criticism followed the general pattern of her development from industrial views to urban imagery. The critical responses valued Krull's abstractions but equally valued her commitment to honest reporting; the combination would engender a unique contribution to the medium. The intellectual height of the response to her work, of course, is her inclusion by Walter Benjamin in his "Small History of Photography," published in *Literarische Welt* in 1931, when Benjamin placed her at the forefront of photographers who combine formal innovation and political activism.[72] Benjamin valued both aspects of Krull's work in reaching this conclusion, and both street photographs and abstractions attracted the attention of intellectuals across Europe. Krull published images in European avant-garde magazines like *i10* and *Bifur*. However, her work—like that of most photographers in the avantgarde—elicited its most vociferous written responses and reproductions in more mainstream art journals such as *L'Art vivant*, *Variétés*, and *Cahiers d'art*. Like the magazines they wrote for, the critics for these journals were neither surrealists nor Bauhaus theorists; they occupied a middle ground. As art historian Romy Golan recognizes, what she labels as "the mediocrity of the art-critical discourse of such middle-of-the-road magazines" is instructive about art's power to reflect society.[73]

Although it developed out of her contacts in the Filmliga film world, Krull's work evoked several distinct but sometimes overlapping kinds of critical interpretations in France that were not directly related to her exposure to Dutch, German, and Soviet film and theory. Few of the Parisian writers had Benjamin's insight to overtly recognize the political power of photography. Instead, the Parisian art critics valued three disparate

elements of Krull's work, appropriating it into a specifically French cultural commentary. Some French viewers (with Florent Fels at their lead) were quick to recognize her work as constructivist and to celebrate the arrival of an industrial photographic vision (few called it a German vision) to Paris. For these writers, Krull was the industrial imagery specialist among modernist photographers, and her geometric machines served as a metaphor for the maelstrom of modern life. While praising her abstraction, some other critics, spearheaded by Jean Gallotti, perceived a poetic quality in Krull's work. This second conception, even more pro-French and traditionalist than the first position, tempered discussions of simultaneity with comments on romanticism and modern mystery. A final body of criticism celebrated Krull not for her abstraction but for her realism, her ability to ground vision in the daily world. The pioneering third group of writers, with Pierre Mac Orlan prominent among them, recognized her poetry yet framed Krull as a "honest reporter" who saw the possibilities of marrying realism with abstraction for a new cultural language that could reflect the excitement and instability of modern life. This complex response earns her place, along with André Kertész, as the originator of the uniquely French blend of abstraction, humanism, and journalism that has marked international photojournalism from then until now.

Florent Fels was both the most powerful of Krull's critics and the one who most clearly recognized the metalwork photographs for the seminal constructivism that they represented for France (although he also appreciated her lyricism and her reporting abilities). An important figure in the literary and art world for many years, he wrote art criticism for *Les Nouvelles littéraires* and then became editor-in-chief (from 1925 to 1930) of the new journal *L'Art vivant*, an offshoot of *Les Nouvelles littéraires*. During this time he often wrote for other journals as well.[74] Later, he entered the popular press world as director of *Voilà*, a picture magazine in the style of *Vu*. Fels's literary and artistic friends included Jean Cocteau, Juan Gris, Max Jacob, André Malraux, and many more.[75] Fels was one of the major photography critics of the decade, and his loyal championing of Krull's work would continue for years. Not only did he include her in the Salon de l'Escalier and praise her

work in his review of the show, but Fels wrote the introductions to two of her best-known books, *Métal* (1928) and *100 x Paris* (1929). He also collaborated with Krull in *Vu* articles, repeated published images and reviews of her work in his journal, and befriended her at various times until she left France in 1940. Krull was on very friendly terms with Fels, remembering that "[he] did a great deal for us. He was a good friend and an enthusiast of photography."[76]

Fels was generally supportive of the abstraction and energetic strength of Krull's work. His seminal review of the Salon de l'Escalier in *L'Art vivant* honors the retrospectives of Nadar and Atget, discusses the participants, and then devotes full paragraphs only to Krull, Man Ray, and Kertész. He calls Krull a "sort of Valkyrie of photographic film," and the Wagnerian name remained with her during her Paris years.[77]

Fels continues his praise in the introduction to *Métal*. Here he equates Krull's industrial forms with the new landscape, writing: "Steel is transforming our landscapes. Forests of pylons replace ancient trees. Tall furnaces substitute for the hills. . . . Germaine Krull is the Desbordes-Valmore of this lyricism, and her photographs are sonnets with sharp and luminous rhymes."[78] In this essay he adds to his admiration of her power a lyrical note that would become the norm among French critics. In this and similar texts for Krull's work in the magazine *Vu*, Fels romanticizes the abstract machine compositions, perhaps more than Krull herself intended.[79]

The critic did not shy away from her most difficult and abstract images, however, whether in his writing or in the portfolios of images that he published in *L'Art vivant*. In *Métal*, there are several multiple exposures. In plate 22 (plate 4.13), for example, the overlapping layers of wheels create a sense of movement within the frame. The critic specifically discusses such multiple exposures in his introduction to the album, commenting that "superimpressions give a fantastic look to the most precise mechanisms, . . . radiating in luminous vibrations."[80] We could interpret this vibration as the ultimate homage to the power of the machine, but the dizzying effect could also be seen as threatening, with a life of its own. Fels, in fact, saw the dark side as well as the celebration, writing, "We observe this paradoxical fact: large industry serves all sorts of progress except for one that improves the human condition."[81] Krull also glued photographic images together, sometimes with Lotar and sometimes alone. One such view (plate 6.4), formed part

of a series that Fels presented in *L'Art vivant* and comprises three photographs cut out and collaged together—one of the Palais Royal facade, a second of the gates of the Louvre courtyard, and a third unidentified image of a modern industrial building with a double stack.[82] The crude collage is deliberately unbalanced, and the double stack of the modern building has an anthropomorphic identity with a birdlike head and the clock of the facade peering through like a nose. Although this is the only example of a montage photograph where Krull physically glued three cut-out images on top of one another for a disorienting effect, it follows the same estrangement conception of her work for *Métal*. More and more, Krull would use the city as inspiration, even for her collages, and Fels was quick to appreciate this new work.

Although Fels was the first to highlight what he saw as a mixture of industrial abstraction and lyrical romanticism, other critics followed suit. Some clearly understood Krull's use of the city as a metaphor for modernity, partially geometric and partially realist. Charles Saunier wrote a long article on *Métal* for *L'Art vivant*, in which he credits Krull with discovering a poetic photographic language to reveal the contemporary world, in contrast to the cubists, futurists, and expressionists whose attempts he finds too static. Like Fels, he celebrates the variety of superimpressions and odd angles used in the book and echoes Krull's own sentiments that the camera is a tool directed by the human eye: "This revelation is the work of the lens! The lens, of course, is disciplined by an expert hand, controlled by an intelligent eye."[83] A second, anonymous reviewer of the Salon de l'Escalier in *L'Art vivant* writes that Krull "borders on mechanical lyricism, that of industrial landscapes, boats, and metallic constructions."[84]

Many critics outside of the circle of *L'Art vivant* also note this combination of vertiginous points of abstraction and poetry. For example, a critic for the regional newspaper *La Petite Gironde* writes of the brutal beauty of the machines and the secret radiance of a motor or a wheel.[85] Reviews of the Salon de l'Escalier were published as far afield as the *New York Herald* and the *Chicago Tribune*. The lengthy review for *La Revue hebdomadaire* judges Krull's Eiffel Tower, river, and Rotterdam bridge photographs the best in the entire show.[86]

Fels and Saunier admired the brute power as well as the poetry of Krull's machinery, but a second group of critics found the images softer and more purely lyrical, creating a more conservative framework for their interpretation. Jean Gallotti, one of the most important photography critics of the decade, shared the nostalgia of many post–World War I critics in an essentially romantic view of culture. In his series of articles for *L'Art vivant*, Gallotti highlights Krull, along with Alban, Laure Albin-Guillot, Atget, André Kertész, Eli Lotar, Man Ray, and Maurice Tabard. Gallotti treats them as artists, not technicians, and historian Dominique Baqué suggests that he shies away from extreme experimental modernism.[87] Krull was the fifth photographer to be discussed in Gallotti's series. He casts Krull's work, and *Métal* in particular, in a romantic vein, writing, "Is it not the immoderate love that Madame Krull has for iron and steel that places her apart from the artists of her time? . . . She gives charm to the coldest, driest, and deadest subjects."[88] Gallotti's less than complete enthusiasm for modern industrial forms surfaces often in his article. He makes repeated comments to the effect that these photographs are more beautiful than the objects they depict. His closing paragraphs refer to those viewers who "feel themselves swept away in vertiginous reflections; those who will object that the photographs of Madame Krull make one think." Gallotti felt a glimmer of the discomfort that *Métal* instills in its viewers but preferred to praise the formal shapes and what he called their almost romantic mystery. He remained firmly committed to Krull the art photographer but shied away from her broader role as a commercial figure.

The third approach to Krull's work valued what Fels only touched on—the reporting quality of her photography. The influential critic and novelist Pierre Mac Orlan looked toward a kind of popularized surrealism in Krull's work and was thus able to appreciate all facets of her work, street photography as well as industrial abstractions. The writer was well known for popular gangster tales and urban sagas that combined the enigmatic and the realistic.[89] He was also one of the first critics to recognize that photography is a kind of *writing* uniquely suited to the modern era.[90] The novelist lauded mystery and even mysticism as an important element in the emerging photographic styles. During the late 1920s and early 1930s, he wrote a series of articles discussing the special role of photography in what he called the "social fantastic" of contemporary life.[91] In these essays, he praises Krull in particular, seeing in her work (along

with that of Berenice Abbott, Kertész, and Man Ray) that powerful element of mystery lurking in everyday events. Despite the romanticism of his "social fantastic," Mac Orlan was observant enough to celebrate the note of uneasiness that Krull instilled into her images.

By 1931, Editions Gallimard, one of the most prestigious French publishers, had published a book on Krull's work. It formed part of a series edited by Malraux, Les photographes nouveaux, that produced only two books—on Krull and on Man Ray. She had come a long way from the circumscribed commercial photography world. Mac Orlan's essay for the monograph, entitled "Les sentiments de la rue et les accessoires de la rue," also appeared in *L'Art vivant*.[92] In it, Mac Orlan places Krull at the head of the photographers who act as "lyrical and meticulous witnesses of the social picturesque," praising not only her industrial imagery but her Paris street photography as well, which he equates with the world of the writer Francis Carco. He highlights her Dutch, Nordic identity, obliquely referring to the constructivist tradition, while praising her for inserting her "personality into all the elements of steel and flesh that form and serve the picturesque and social fantastic of the contemporary epoque."[93] He had enormous respect for her eye:

> *Whether Germaine Krull transposes a machine landscape into a sort of stupefying symphony or whether she plays literally with the lights of Paris between the Place Pigalle and the Bastille, she does not create simple anecdotes. Instead, she uncovers evidence of the secret details that people do not always perceive but that the light of her lens uncovers wherever it is hiding.[94]*

If Mac Orlan read mystery and realism in the photographs, Krull's friend Jean Cocteau saw facts more clearly, concentrating on the realist liaisons between external and internal worlds. Cocteau, who had emerged in the last years of World War I as a major force in the Paris art world, was one of Krull's most powerful friends and advocates. He writes, "I understood that there existed in Paris an artistic Right and an artistic Left, which were ignorant or disdainful of each other for no valid reasons and which it was perfectly possible to

bring together."[95] Krull's photographs during the mid-1920s would tread a similar path between the various artistic and literary elites of Paris, including figures as disparate as Walter Benjamin and André Gide.

Cocteau became a close friend of Krull's in Paris in the late 1920s. She accompanied him to opium dens and elsewhere, although she had no interest in opium herself. They had long arguments about the role of photography. Cocteau insisted that photos created a mirage rather than a transparent view, where Krull saw personalities revealed in her ground glass.[96] Nevertheless, the playwright recognized the importance of her reportorial vision, writing, "Isn't that your method? You are a reforming mirror. You and the camera obscura obtain a new world, a world that has bridged both mechanisms and the soul."[97] Krull's reforming mirror would be at its most eloquent in the journalistic photographic essays she did for Lucien Vogel and his magazine *Vu*.

Krull's own view of herself—in writing that "with one snap of the shutter, the lens registers the world from the outside and the photographer from the inside"—was characteristically pragmatic.[98] She recognized that photography involved both a camera and a personality and shaped the external world through the interior view. Her memoirs ignore her own critical reception by writers such as Fels or Mac Orlan, and she refers only to Jean Cocteau's label of herself as a "reforming mirror." Instead, she highlights her commercial and journalistic work, valuing its contribution as highly as any exhibition review. The force of commercial work was essential to her reception in Paris, but she regularly exhibited these pictures as art. Krull did not ignore the importance of paid work, nor should we.

Krull's photographs for hire were treated as seriously, both by the photographer and by the press, as were her autonomous experiments. As was shown in chapter 4, the industrial work clearly bridged the gap between exhibition and commerce, as her photographs for various industrial companies in Holland and France demonstrate. Krull began working for *Vu* in 1928, and this would prove to be her most prolific commercial work and to foster her involvement with street photography. By 1929, she would exhibit *Vu* pictures internationally alongside her abstractions.

Chapter 6

"A Reforming Mirror"

VU AND THE PARIS PICTURE PRESS, 1928–1933

The Eiffel Tower—all that enormous, lifeless, black iron—had never interested me. Full of discouragement, I climbed from floor to floor by elevator, trying to photograph. I found an angle here, an angle there, but it was not exciting. How was I to make photographs that resembled my Métal *pictures out of this old black and inert thing? Finally, I found a small door at the very top to a staircase that no one uses and no one knows. I climbed and descended, and suddenly there was the magic of iron, those great wheels that turned the elevators, those crowns of iron, the lace work of small ironwork that served as decoration, seen against the sky like huge spiders. When I brought my harvest of pictures back to Lucien Vogel, he embraced me and said: "Our first issue is set."*[1]

This chapter examines Krull's magazine work in the late 1920s and early 1930s, when her photographs for the picture press accomplished several important goals. As the above interchange with an editor proves, magazine and illustrated press clients provided Krull with a successful career as a photojournalist, and her work from 1928 onward would encompass far more journalism than studio work. Her urban and industrial subjects, already important in Holland, were now regularly published across Europe. Popular press demands for images of Paris street life—ranging from the Eiffel Tower to the daily events of the city's back alleys— would prove to be a major inspiration for the artist. In addition, the inclusion of urban vagrants and industrial abstractions in the Film und Foto and other exhibitions illustrates that much of her best work derived primarily from her commercial projects for the picture press. The distinction between commercial and avant-garde imagery, therefore, was all but nonexistent. Her street photographs set a stylistic standard for others to follow. In clear distinction from the photographic styles of the

German magazines, Krull, along with her Hungarian colleague André Kertész and the American-born Man Ray, created a particularly French view of the modern world. Few German photographers contributed to the French magazines, and these three foreigners framed the pictorial discourse for the dozens of younger French photographers who would illustrate *Vu*, *Voilà*, *Détéctive*, and other magazines.[2] Finally, through its enormous exposure to large numbers of magazine readers, Krull's published work attained a larger goal—participating in a cultural construction of French society. As part of a magazine essay, encompassing pictures, texts, and captions, the images worked within a larger system of discourse than the gallery wall.[3] These photographs, and the journals they appeared in, redirected the intellectual perceptions of French culture, mapping a complex path—from a nostalgic look at the nineteenth century, to an energized postwar examination of the new world, and then back again to a more traditional view in the mid-1930s.

French magazines and novels in the years up to 1928 looked backward to the nineteenth century with a certain amount of nostalgia, even while artists engaged with the New Vision and Machine Age. Historians like Jean-Jacques Becker and Serge Berstein have framed this nostalgia as a "visceral desire to return to the past in order to forget the war, and the practical impossibility of such a return due to the war's upheaval."[4] Romy Golan and Kenneth Silver have cast painting and sculpture during and after World War I in a similarly nostalgic role.[5]

Beginning in 1928, the popular press allowed Krull to contribute actively to the cultural construction of the late 1920s. Krull's interpretation of the world around her both stemmed from popular perceptions about life in the late 1920s and helped to reshape them. If the images in *Métal* allowed Krull to reshape the industrial fabric of the modern world into its exciting collection of fragments, both titillating and threatening, these new subjects addressed life beyond the mechanical. Through the street subjects, Krull and her colleagues would help to reconcile the alienation of postwar Paris life and poverty with a nostalgic longing for a traditional past. Krull's most exciting and unsettling work would appear in the late 1920s, in the brief moment when war issues had been resolved and before the Depression struck France. By the mid-1930s, her use of energizing ideas and styles would fit back into a more conservative mold that

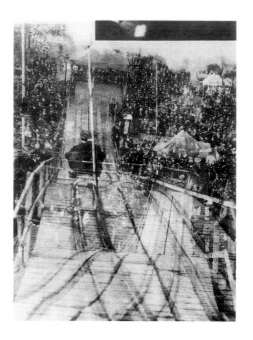

mirrored the economic and political seriousness of that decade.

Lucien Vogel and *Vu*

Creators of photographs for the popular press cannot work alone. In the editor Lucien Vogel, Krull found a viewer who recognized the power of her imagery and who supplied an essential ingredient, a market for it. On seeing her *Métal* images, he told her that he needed pictures like these for his new journal and sent her to the Eiffel Tower to create them—understanding, no doubt, that the structure of the tower itself was an architectural form of montage and that her photographs could best capture its active quality. In applying her New Vision compositions to the Parisian cityscape and the street subjects acceptable to the commercial picture press, Krull succeeded in transforming an elitist pictorial language into a much more universal and widely accessible form of communication. When she published her pictures in the new weekly illustrated magazine *Vu*, they established her reputation.

Krull met Vogel in late 1927 or early 1928, while he was preparing for his new publication. The editor included one of Krull's pictures, a street image of the *Chariot des Alfredistes*, in the first issue of the magazine in a section called "Vu cette semaine."[6] Her first photographic essay for *Vu*, "Fêtes foraines," appeared three weeks later and included six images.[7] This series on popular street fairs includes a vertiginous multiple exposure of a boy standing at the top of an enormous slide or roller coaster, ample proof that the close

FIGURE 6.1

GERMAINE KRULL. STREET FAIR. SLIDE. FROM EDMOND GREVILLE. "FÊTES FORAINES." *VU* 4 (4 APRIL 1928): 92

cropping, montage techniques, and the dizzying angles of her metalwork images had entered the popular press (fig. 6.1). In this photograph, the abstracted industrial forms of the chute's rails are made frankly fantastical by the presence of the youth, who seems to float above the wooden structure, about to descend its rails without a barrel or a car under him. Adding to the vertiginous quality is a second set of overlapping rails montaged over the first negative that create a grid pattern in the foreground. A similar view of the chute without the double exposure contains the dramatic sweep of the rails and the crowd below, but in a single image that reveals Krull's record of the crowds and the boys climbing to the top of the slide (plate 6.2). In her published picture in *Vu* (fig. 6.1), Krull has overlapped the background of the slide with her second view, to create a tighter, more disorienting and dramatic view. This multiple exposure is one of the first published indications of Krull's interest in the street life of Paris and in a certain kind of whimsical visual fantasy—both new subjects absent in the earlier machine images. Over the next several years, Krull would publish at least once a month in *Vu* on a wide variety of subjects, illustrating several covers (plate 6.1) and hundreds of articles.[8]

Lucien Vogel occupies a special place in the history of the photographically illustrated press. The editor was a firm supporter of his photographers, and his style differed visibly from that of his German colleagues. He used more photo-essays and developed a collage-style format with images that overlapped each other on each page. He made major changes as an editor, as a patron of important photographers, and as a political figure himself. After studying architecture at the École des Beaux-Arts, he had begun his editing career at Hachette and had worked at *La Vie heureuse* and, with Emile Levy, at *Art et décoration*. From 1910 until after 1919, he worked with his brother-in-law Michel de Brunhoff at *La Gazette du bon ton* and then started a new magazine, *Jardin des modes*, with him. Most recently, he had been art director at *Vogue* before founding *Vu*.[9]

Vogel crossed easily from the popular press to the art world and back again, demonstrating again that neither critics nor commercial photographic clients drew clear distinctions between themselves in the way that is commonplace now. Krull herself saw no difference between the two worlds. Editors commonly worked with both fine arts and commercial publications, and Vogel even served that same spring of 1928 on the organizing committee for the Salon de l'Escalier.

Similar dualities exist for Florent Fels, the art critic and editor at *L'Art vivant* who most consistently supported Krull. In addition to his art world role, he wrote the texts for *Vu*'s popular articles and later became director at *Voilà*, a popular magazine modeled on *Vu*.[10]

Vogel's presence in Paris galvanized a particular form of avant-garde reporting photography spearheaded by Krull and André Kertész. The *Berliner Illustrirte Zeitung*, edited by Kurt Korff, had been publishing single reportage photographs such as those of Martin Munckacsi as early as 1923, and the *Münchner Illustrierte Presse*, whose picture editor was Stefan Lorant, began photographic essay publication only in 1929.[11] Photo-essays were thus first developed by Vogel and by Lorant.[12] Even though Kertész's series on Trappist monks in the January 1929 *Berliner Illustrirte Presse* is usually cited as one of the earliest photo-essays, *Vu* began publishing photo stories by Krull, Kertész, and others in its first issues in March 1928. In fact, contrary to much of the published literature, French magazines matched or surpassed the innovations of their German counterparts in 1928.

The first issue introduced the combination of a geometric Art Deco logo, slightly geometric design, and sepia-toned reproductions that would characterize *Vu*'s look—a clever blend of the avant-garde and the nostalgic. The overlapping montage effect of the photographic layout appears more constructivist than the *Berliner Illustrirte Zeitung*'s, and the magazine has a more modern look to match Vogel's philosophy. *Vu* was not a political magazine; it remained a popular journal devoted to the leisure world to a large extent, but Vogel paid more attention to leftist political issues like Soviet Russia and Republican Spain than did his German contemporaries.

When Vogel published the first number of *Vu*, he immediately commissioned series of photographs from Kertész, Krull, Lotar, and others.[13] He encouraged them to make daring compositions and then published them in innovative montage layouts in his journal, printing pictures that overlapped each other or created a cubist patchwork effect. The magazine resembled the German journals but produced a better print quality and more innovative graphic design. Cassandre designed the logo and the typeface, and art director Irène Lidova and,

later, Alexandre Liberman created an exciting new look for *Vu*.[14] *Vu*'s new format interacted with the multifaceted presentation of the contemporary world that fascinated Vogel. The opening number of *Vu* proclaimed the arrival of a new world—"pages overflowing with photographs to translate events of French and foreign political life through images . . . sensational illustrated reportages."[15]

When the first issue of *Vu* appeared on 21 March 1928, Vogel's "Remarques sur un nouvel journal illustré" clarified the particular position he would take in the popular press. The editor specifically wanted to translate the speed of modern life into an exciting magazine, an aim Krull shared:

> *We do not yet have an illustrated magazine that, when read, will translate the precipitous rhythm of contemporary life, a magazine that teaches and documents all the manifestations of contemporary life: political events, scientific discoveries, cataclysms, explorations, sports events, theater, cinema, art, fashion. Vu's task is to fill this void. Conceived in a new spirit and realized by new methods,* Vu *brings a new formula to France: illustrated reporting on world events.[16]*

The cast of characters in *Vu* appears familiar; most writers and photographers operated in the fine arts arena as well. For example, *Vu*'s first issue included night photographs taken by Eli Lotar during the filming of Francis Carco's novel *Paname*, an article titled "La Féerie du progrès" by Florent Fels with X rays and machinery in uncredited photographs, James Abbé's photographic reportage from the Soviet Union, fashion images, an unpublished novel excerpt by Maurice De Kobra called "Le Fou de Bassan," photographs of apes by the German *Neue Sachlichkeit* photographer Albert Renger-Patzsch, an article on modern "Apaches" by art critic Jean Gallotti with anonymous photographs, and photographs by Germaine Krull in the section "*Vu* cette semaine."

The particular mix of modernity and mystery in this first issue heralded the general tone that Vogel would adopt during the next five or six years and that paralleled Krull's own interests. His description of the journal's structure includes pages of political and historical events loaded with photographs ("l'Histoire"), sensational illustrated reportages (such as "*Vu* en Russie"),

pages filled with documents ("*Vu* dans le monde"), unpublished novels, travel tales ("la Vie dangereuse"), "causes célèbres," recent discoveries ("*Vu* dans l'avenir"), the latest literary fantasies ("*Vu* à Paris"), film stills, sports snapshots ("Tout le Sport *Vu*"), the sickness of the month, ("la Maladie du mois"), and comic pages ("*Vu* pour rire").[17]

Vogel had definite tastes, which he demonstrated over and over again. He commissioned many industrial stories and photographic reportages, celebrating the role of the machine in the 1920s. He also published a variety of nostalgic subjects and "types" (*fêtes foraines, flâneurs, clochards*), updating many of the nineteenth-century figural types into new role models for the 1920s. Not only did the concentration of filmic and collage compositions in the layout popularize a new style, but the magazine's subjects inspired many of the great photographers of the decade. For example, the photographic books of Krull, Kertész, and Brassaï which constructed fragmented urban photographic narratives based on image sequencing and disjunctures between pictures, would have been impossible without the pattern of *Vu*.[18] Vogel's emphasis shifted between the years directly after 1928 and the next decade. Like many popular journals of the late 1920s and 1930s, *Vu* changed with the Depression, the political tumult of the mid-1930s, and the threat of fascism. The magazine's photographs and style became more sober and less experimental by about 1934, as did Krull's contributions. Deemed too leftist by *Vu*'s Swiss owners, Vogel was forced to resign in 1937, although the journal briefly resumed publication—without Vogel—as *Vu et Lu*.[19]

Vogel's control of Krull's career cannot be overestimated. Editors wielded great power in the 1920s, both in Germany and in France, as important commercial patrons for photographers and as their artistic mentors. In a 1970 interview, Stefan Lorant explains that the various illustrated weekly magazines all had different styles, due to their different editors:

> *At that time editing was quite different than it is now. Editors were individualists; they were prima donnas. An editor had the function of a good conductor. As the good conductor knows what kind of sounds he wants to produce, so the editor*

*of a picture magazine must have in his
imagination the issue he wants to create. To do
that effectively he needs good players, good
photographers. A conductor must have rapport
with his concertmaster and with members of his
orchestra. . . . Likewise the editor and his
photographer.*[20]

Krull's exposure through Vogel's magazine solidified
her reputation, and her work was soon demanded across
Europe. After the success of *Vu*, other French magazines
soon followed. *Voilà*, published by Florent Fels, began
publication in 1931. Its format was slightly more sensa-
tionalist than that of *Vu* but was conceived along the
same lines of collaged images and text. Less elegant
illustrated weeklies also flourished, including *Détective*,
edited by Georges Kessel. Krull contributed many pho-
tographs to all these journals, as well as to the literary
journal *Marianne*. *Marianne* was run by Emmanuel Berl
and André Malraux, among others, and began publish-
ing photographic pages in 1932 under the sponsorship
of Carlo Rim. Krull was also a major source of pictures
for more avant-garde art magazines like *Jazz*,[21] *Variétés*,
and *Bifur*. A quick view of these latter journals shows
that Krull photographs outnumber almost any other
photographer's and that her city photographs entered
the art world with a full range of subjects from abstract-
ed cityscapes to city "types."[22]

For foreign photography sales after 1928, the pho-
tographer sometimes used picture agencies, which ad-
vertised Krull's specialty in modern Parisian subjects.
Although she writes that she had little contact with
agencies, many of her photographs from this period
bear the stamps of Mauritius and Schostal. Krull began
working with Mauritius in about June 1928. The
Mauritius agency was owned by Ernst Mayer, a book
salesman in Berlin who later became one of the co-
founders of the Black Star photo agency in 1936 in New
York.[23] Mayer founded Mauritius in 1928 and sold pho-
tographs to the *Münchner Illustrierte Presse*, *UHU*, *Die
Dame*, *Die Wochenschau*, and the *Berliner Illustrirte
Zeitung*, among others. After Hitler became chancellor
in 1933, Mayer emigrated to the United States, selling
his business to a Swiss picture agent. As early as 14
December 1928, a letter from Ernst Mayer to Berenice
Abbott, whom Krull recruited for Mauritius, sheds
valuable light on Krull's dealings with the agency.
Mayer wrote that "Frau Krull will have already told you
of her experience during the half-year's relationship

that we have had with her. We are the sole distributors
for a large number of well-known photographers, and
solely represent the English photographer E. O. Hoppé
in Germany."[24] Although the full extent of Krull's sales
through Mauritius is not yet known, "Mauritius/Krull"
credits appear in *Die Dame* in 1930,[25] for two extra-
ordinary portraits of Javanese dancers (plate 5.3).

Krull also worked with the A. G. Schostal agency,
which was based in Vienna and had offices in Paris and
Milan, although the dates of this collaboration are un-
clear.[26] Schostal also represented d'Ora, Lotte Jacobi,
Yva, Dr. Paul Wolff, and other photographers. The
Schostal archives give a clear indication of the types of
French and Parisian images that Krull would have sent
to them. Groupings of photographs still in the agency
holdings include hand studies, Marseilles, images, work-
ers of Paris, *bals musettes*, Les Halles, *clochards*, *fêtes for-
aines*, a *Faschisten Surrealisten Ausstellung*, fashion pho-
tos for the Paris couturier Jacques Heim, sailors, the
Eiffel Tower, and Paris at night.[27] The archive includes
two photographs that bear a stamp from the Film und
Foto exhibition (fig. 5.4, plate 6.1), but Krull probably
gave these to Schostal long after the show, as available
prints of particular images. She sent her own pictures to
the Gegenwart exhibition, and her correspondence with
Berenice Abbott reveals that she certainly did the same
with the Film und Foto show.

Picture Press Subjects

Krull's commercial work for the picture press spans the
years from 1928 to 1936, although her most prolific pe-
riod and best essays stem from 1928 to 1930. This work
divides roughly into several categories, which continue
in the photographs in the many books she published
from 1929 onward. First, a small number of photoessays
cover political events like the Kellogg-Briand Pact (sign-
ed 27 August 1928) (plate 6.2).[28] Next, not surprisingly,
are the cityscapes and industrial abstractions that she
had begun in Holland and that, following the Eiffel
Tower essay, would become her trademark.[29] These
often resemble the Paris imagery in *Métal*, such as the
album's close cropping of a Paris Métro rail track (plate
6.5). Third are a variety of views of Parisian street

scenes, ranging from vagrants to street markets to *fêtes foraines*,[30] which became her second great specialty. Two other popular magazine topics spilled over into the book trade (the topic of the next chapter), and Krull made book-length studies as well as magazine articles. These included travel essays: Krull traveled widely for Vogel, submitting photo-essays to *Vu* on Carcassonne, Anvers, Brittany, Marseilles, and Terre Neuve, among other places.[31] In addition, Krull contributed several photo-essays on superstitions and quasi-religious or fantastical subjects, and she would illustrate detective stories for other journals and produce book-length works as well.[32]

Krull did little straight news reporting or political work. She worked seldom for straight news-oriented papers like *Paris-Soir* or *L'Intransigeant* and wrote frankly of her disinterest in news photography. She explained: "My soul, which was so centered on the visual side of things, adapted poorly to the task of topical news reporting."[33] Her reportorial work is represented in her Kellogg-Briand Pact project, a series commissioned for *Vu* in August 1928. The Pact of Paris, also known as the Kellogg-Briand Pact, was signed by the international powers in Paris on 27 August 1928. Formulated by Frank B. Kellogg, American secretary of state, and Aristide Briand, of France, this agreement was a general statement renouncing war and providing for conciliation and arbitration. Krull photographed the ceremony and arrangements surrounding its signing. Krull's typed captions for this series survive and provide a rare glimpse into her working methods.[34] These captions are in German, suggesting that the images may have also been intended for a foreign journal or that she still wrote most comfortably in German at this point. Krull took thirteen pictures, of which eight survive. She records heads of state and diplomats like Raymond Poincaré and Myron T. Herrick in a few photographs but reserves much more attention for the film operators' setup and the bystanders in the street. In one image (plate 6.2), a film cameraman stands among an eerie assortment of geometric shapes—candelabras, empty chairs, and tripods in the empty hall. Krull's caption to this photograph reads "Preparation of the film operators before the signing."[35] She was more interested in the media reaction to this pivotal event than in the dignitaries who implemented it. However, what actually appeared in print was more conventional. Three different views were published in *Vu* 24 (30 August 1928). These pictures depict the speech of Aristide Briand, the banquet

table, and observers of the signing. This populist and anecdotal point of view is typical of *Vu* and demonstrates the comfortable fit between Vogel's ideas and Krull's. In contrast to Krull's relatively apolitical subjects, during these first years of the magazine, Lotar published more political photo-essays than Krull did, including series on M. Herriot's home in Lyon, Cardinal Dubois, and the funeral of Maréchal Foch.[36]

The Eiffel Tower

Krull's most famous project for Vogel was her Eiffel Tower essay, published in *Vu* 11 (30 May 1928) (plate 6.6). She photographed the Eiffel Tower on commission for the magazine and permanently changed the public's photographic vision of the tower by highlighting isolated yet recognizable details of its ironwork instead of its total shape.[37] These images, and the cityscape articles that followed them, created a modern metaphor for the rapidly changing city. The article also featured a text by Florent Fels. Their collaboration serves as a case study for the photographic and textual representation of the new Paris in the popular press and proves that not only photographers, but art critics, too, crossed over from the fine art world to the popular arts world with hardly a tremor. Krull's later cityscape photographs for *Vu* accompany texts by other well-known popular novelists and essayists such as Emmanuel Berl, Henri Danjou, and Jean Gallotti.

Lucien Vogel, by commissioning projects such as Krull's, pioneered a new magazine subject and design. The layout and construction of the article was innovative and, like *Métal*, bore a resemblance to film montage. In order to understand the significance of these photographs of ironwork fragments, and their publication for a large audience in *Vu*, both the tower's cultural significance and Krull's individual photographs must be studied in some detail. The full production details of the *Vu* article have been lost. A few statements, however, clarify the planning and layout of popular magazine commissions like these, illuminating the role city imagery then played in the popular press. In several anecdotes, Krull's memoirs reveal that Vogel asked her to photograph the Eiffel Tower after seeing the *Métal*

photographs she brought from Holland to Paris.[38] Krull describes meeting Vogel in his offices at *Vogue* before *Vu* began publication.[39] She stresses his fundamental dynamism and his enthusiasm for her *Métal* photographs. According to her recollections, Vogel told her: "This is what I want for my first issue. Go and photograph the Eiffel Tower, Germaine. Photograph it as you really see it, and make sure that you don't bring me a postcard view."[40]

Despite the fame of these Eiffel Tower photographs for *Vu*, and despite her memoirs, which present them solely as commissions for Vogel, Krull published four tower views several months before *Vu*'s issue, to accompany an article on the tower in the German illustrated magazine *UHU* in December 1927.[41] Vogel was probably the inspiration for the project, but many photographers sold similar photographic sets of imagery to different journals during these years. The *UHU* text is straightforwardly historical, and a portion of the text is even in Gothic print, despite the abstract beauty of the views. However, after *Vu* published them in May 1928, the tower pictures became part of her most famous work: they were reproduced in many popular and art journals and shown in most of her exhibitions.

In reinterpreting the tower, Krull was not working in a vacuum. The tower's position as a symbol of modern Paris was expressed not only in photography but in painting, film and literature as well, and many of the artists who used it as a symbol were Krull's friends. The closest link was to Robert Delaunay, who first painted the Eiffel Tower in 1911–1912 and returned to the subject in the 1920s. Jean Prévost, who was listed as a co-organizer of the Salon de l'Escalier, published a monograph on Gustav Eiffel in 1929 in a series entitled "Les Maîtres de l'Art Moderne" and included Krull photographs in his book.[42] Réné Clair, another organizer of the Salon, made the tower into the central character of his 1924 protosurrealist film *Paris qui dort*.[43] Contemporary art critics recognized the links between popular press images and artistic interpretations. A 1928 article on the Eiffel Tower specifically compares Krull's and Clair's interpretations of the tower: the author emphasizes that both grasp its essential detail and structure rather than the anecdotal reproduction of a tourist icon. Contemporary interpretations of the tower were not limited to any one political party. In his journal *Grand'route*, Philippe Lamour enlisted Krull's Eiffel Tower and other photographs as part of a fascist position derived from Georges Sorel.[44]

Germaine Krull shattered the Eiffel Tower into fragments. Her fragments, however, are not randomly chosen abstractions. Specific, not accidental, details represent the tower. The concept of honest witnessing of the visual world is central to Krull's work, despite the partially abstract quality of her compositions. Eli Lotar accompanied Krull on her first excursion to the Eiffel Tower in late 1927. As Krull's memoirs (reproduced as the epigraph for this chapter) recount, they wandered up and down aimlessly until they found a hidden door to the stairs, and a panoply of metal forms unfolded before them.[45] Lotar was at this time Krull's assistant and was not yet a practicing photographer. Yet his eye for details, combined with Krull's fascination with abstract forms, resulted in a powerful series of images. By the end of her day at the tower, the photographs were made, and her reputation was fixed.[46]

Of the three photographs in the *Vu* article, the largest (plate 6.6) forms a vast, flattened pyramid, creating a tilted view of the upper portion of the tower. With no base visible and only one side shown, Krull's photograph flattens the tower and denies it its three-dimensional structural form. She permits us to see no foreground or background, no bottom or top, and no sense of a three-dimensional monument in space. The sole naturalistic details are a group of clouds in the sky behind the top of the tower. Some rods protrude from the top for radio or electrical transmissions. Furthermore, we see none of the familiar and iconic attributes of the tower—its distinctive shape, its Art Nouveau scroll-like details, or its tourist platforms. The interlocking patterns of the rivets and iron girders create a flat and formal pattern. A vertical girder in the center of the image leads the eye upward, although the only access would seem to be a fly's path up the face of the tower. Another diagonal girder splayed across the surface of the picture suggests the formal patterns of contemporary images of German Bauhaus or New Vision photographers.

Fels's caption to the photograph in *Vu* reads:

> *Beams, girders, and rivets act here like verse,*
> *words, and rhymes. We no longer think of the*
> *marvelous mechanisms, of the labor, of the forge,*
> *of the mines. We forget the engineer, the worker,*

*the workmanship, and think only of the
unparalleled and incomparable poet: EIFFEL.[47]*

In equating Eiffel's metal joists with words and verse,
Fels suggests that Krull manipulates these beams and
rivets to make a poetic statement in photographic
terms. The elements depart from standard represen-
tation to re-present the tower in abstract and personal
terms. The two-dimensional play of dark and light re-
inforces the autonomy and abstraction of the view.

The second photograph (plate 6.7), another aerial
view, also manipulates shadow and light but in a more
literal style. Shooting from the top of the tower, Krull
represents the tower's shadow, complete with visible
girders and beams. Like the first view, this shadow of
the tower succeeds in flattening a very vertical monu-
ment. We see its plan rather than its elevation, although
Krull does not depict the entire tower here. This is not a
logical plan, however, as it would be in an architectural
rendering. Instead, like Robert Delaunay who painted
the tower in a similar composition, Krull uses an unu-
sual angle. Moreover, she superimposes the tower's
shadow—not the tower itself—over the terrain of Paris
surrounding it and mocks the traditional mapping of
Paris.

Fels comments in the caption, "In our thoughts, we
slide along the length of the tower, to the point of her
sister shadow, which moves like the pointer of a sun-
dial."[48] Since shadows follow the sun, we are indeed re-
minded of the shadow of a sundial, moving in a circle
to pin down the time. This pointer, a huge shadowy
finger, reads the time of day in Paris and also points to
or overshadows certain streets and buildings. It exudes
an eerie anthropomorphism, moving across the land-
scape like a living thing. The tip of the shadow lands in
the central courtyard of an apartment building, and the
shaft overlaps the park land and pond of the Champs de
Mars.

Krull clearly rejects earlier modes of photographic
documentation and consciously compares her work
with that of Robert Delaunay. In its abstraction and for-
mal strength, the second photograph closely resembles
Delaunay's representations of the tower. Like Delaunay's
painting *Les Jardins du Champs de Mars* (1922) (see fig.
5.1), Krull's anthropomorphic repetition of the struc-
ture's form appears to have a life that has little to do
with iron, bending in independent directions instead of
soaring straight into the sky. Like Delaunay's simplified
shapes of the tower, only the general outline of the

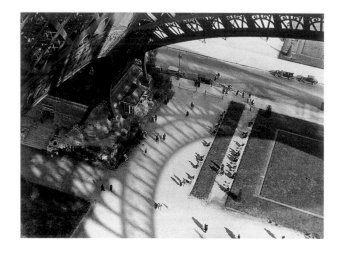

iconic monument is visible. Delaunay also presents the
shadow as a positive element.[49] The vital compositions
of both painting and photograph evoke an optimistic
attitude toward the city and modern life and bring Krull
into the community of city poets like Blaise Cendrars
and Guillaume Apollinaire as well as painters like
Delaunay and Fernand Léger, who celebrated the life
and movement of the modern city.

The third photograph in Krull's *Vu* article (plate 6.8)
attains a greater abstraction, retaining none of the
familiar shape of the Eiffel Tower at all. This flat pattern
of lines and curves, filling the entire frame, in fact
forms part of the elevator mechanism, but Krull's
photograph offers no explanation about its workings. If
it were not labeled we could easily mistake this for a
number of other iron constructions—bridges, girders,
and so on. In addition, although it was published this
way in *Vu*, its reproductions are inverted in Krull's *Métal*
and in Pierre Mac Orlan's 1931 monograph.[50] It reads
well both ways; no horizon line orients us, as in a
traditional landscape. Shadows and sunlight pierce the
large horizontal beam much as pockets of air punctuate
the solids, leaving no formal distinction between the
solids and voids of girders and sun and shade patches.
The photograph becomes merely a flat, and very
beautiful, pattern of horizontal, vertical, and diagonal
lines, articulated by a few circles. Again, an affinity with
Delaunay, Léger, and the cubist aesthetic is apparent.
This third view is more modernist in its formal at-
tributes than the first two.[51] Yet, despite her abstrac-
tions, in general Krull includes the identifying features
of the tower, as does André Kertész, whose most famous
tower view (fig. 6.2) includes miniaturized visitors. Like

FIGURE 6.2

Krull, Kertész presents only fragments of the tower and highlights the shadow instead of the object itself. However, he includes a section of the ironwork in the upper left corner, so that the shadow's subject is to some extent visible in the image. Both photographers exhibit more interest in the specific subject than Moholy-Nagy, whose single Eiffel Tower photograph from 1925 is a pure pattern of receding geometric shapes and whose image, moreover, is a single picture and not part of a narrative series as is Krull's (fig. 6.3).[52]

The caption to Krull's third *Vu* photograph, commenting on the analogy between birds flying and elevators rising, contributes little to an understanding of Krull's intentions. Fels uses poetic phrases, writing, "The elevator, the wheel that sweeps some humans to the kingdom of the birds, suddenly becomes our natural habitat."[53] Yet in both the captions and his text for the article, Fels's narrative style and his choppy and nonsequential phrases used as poetic elements parallel the photographic compositions themselves and link Krull strongly to cubist pictorial structure.

Even the arrangement of these three photographs on the page defies conventional narration. Instead of following a linear progression or plot, they are arranged in a montage (plate 6.6) similar to contemporary avant-garde film techniques. Vogel commonly used this montage technique in the general layout of *Vu*'s individual pages. Furthermore, the whole narrative of the magazine forms a disjunctive collage. This issue of *Vu* contains illustrated articles about pygmies and gorillas, Cardinal Dubois, the Ku Klux Klan and secret societies, and a serialized novel, *La Spéctatrice*, by Henri Duvernois. None of these articles relates to another; each is autonomous within the magazine. They are juxtaposed in a patchwork narrative similar to the nonsequential arrangement of these three photographs on the page.

The text accompanying Krull's photographs is merely two paragraphs long. Fels recounts the initial dislike of the tower by Parisians in the 1880s, with the celebrated artists' statement condemning it. He then goes on to describe it as "The ultimate symbol of the new era."[54] He draws on a long line of precedents from Apollinaire to Jean Cocteau. Fels puts into words what Krull's first large photograph in *Vu* visually suggests: the tower has a distinct anthropomorphic quality. "It has its feet in the Seine," he writes. Referring to the tower's electrification, he continues, "This giant was missing a headdress of stars; now it has one. Industry now writes its luminous history on the nocturnal spine of the tower."[55]

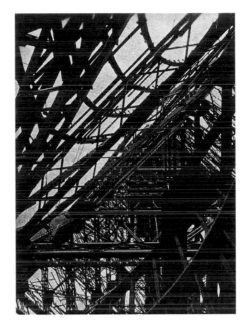

The last sentence of Fels's article in *Vu* draws attention to the electrification of the tower, which was an important issue in its depiction. Krull emphasized this in an image in *Métal* that highlights the hundreds of light bulbs on the iron structure.[56] André Citroën's advertisements in light on its four sides began in 1925, engineered by the Jacopozzi Brothers and arranged anew each year.[57] One almost unrecognizable view of the very top of the tower clearly highlights the strings of bulbs as they climb up to the platform (plate 6.12). Another photograph, similar to the first of the *Vu* series in format, depicts the tower as a sea of interlocking geometric forms and round bulbs and suggests analogies to Robert Delaunay's and Réné Clair's views of the Eiffel Tower (plate 6.9).[58] All three artists comment on the interaction of nature and this most symbolic of all industrial structures.

Métal, too, included several additional photographs of the tower (plates 6.10, 6.11, 6.13).[59] Some, like plate 6.13, are as abstract as the most extreme *Vu* image and celebrate the wheels of elevator shafts and iron girders, although the structure is marginally more recognizable than that of Moholy-Nagy. Another image (plate 6.11) reproduces the lower girders in a series of diagonal patterns, with the natural foliage trees and rectangular ground-level structures intertwined with the triangles of metal strutwork. Only one (plate 6.10), refers to the Art Nouveau scrollwork decorating the tower, but even this image focuses more on the vast upward sweep of the central ironwork than on the decorative elements.

As she had been in Holland, Krull was drawn in Paris to iron and industrial forms. These appear at first to be purely abstract patterns, but the force of the

FIGURE 6.3

LÁSZLÓ MOHOLY-NAGY. *PARIS*. 1925.

VINTAGE GELATIN SILVER PHOTOGRAPH. 8 x 6 3.4 IN. (20.3 x 7.1 CM.).

THE MUSEUM OF FINE ARTS. HOUSTON: MUSEUM PURCHASE WITH

FUNDS PROVIDED BY THE PROSPERO FOUNDATION.

REPRODUCTION COURTESY HATTULA HUG-MOHOLY-NAGY

industrial metal structures and her insistence on "reporting" forbids pure abstraction and allows an alternative reading. For instance, by a denial of the tower's traditional views, Krull creates a powerful portrait concentrating on the symbolism of its details, yet we see a recognizable tower and not a disembodied collection of fragments. Frédéric Lefèbvre commented on this quality: "Germaine Krull battles against *conventional photography*, which lets no fantasy into its angles or lighting. But *she never cheats.*"[60]

Krull's use of significant details to capture the whole was extended to her representation of Paris in general. If a piece of iron girder could symbolize the tower, which in turn symbolized Paris, then any significant detail of it could capture the essence of Paris. These details, however, were not randomly chosen. Whether they were industrial forms or city workers, Krull's grouping of individual forms and workers demonstrates a commitment to the buildings and people who would symbolize Paris in the popular imagination.

Clochards

If Germaine Krull's Eiffel Tower photographs symbolized the reordering of Paris monuments into disjunctive and fragmentary experiences during the 1920s, she soon published numerous other essays on street life in Paris such as street fairs, flea markets, gypsies, and workers. The monograph by Pierre Mac Orlan published in 1931 bore one of her images of a gypsy on its cover (plate 6.14). Her fragmented treatment of the Eiffel Tower could not be adapted to individual representations of people. Instead, Krull and her contemporaries at *Vu* chose a type of Paris citizen and a style of portraiture that effectively destroyed the static figural representations of the previous century. They portrayed gypsies, street sellers, vagrants, and other marginal members of the Parisian underclass, employing the same alienating angles and collage techniques that were popular in their architectural photographs. The result was a series of street people who were exciting to look at, relatively unthreatening to encounter in prose, and ultimately titillating rather than threatening—a fitting symbol of the turbulent but optimistic few years before the Depression hit hard in France in 1933. Magazines like *Variétés* combined Krull's pictures with Atget's celebrated 1900 photograph of a lampshade vendor, among others, in portfolios of vagabonds and gypsies.

Krull's gypsy is paired with a haunting view of a shack in the "zone" or the outer regions of Paris, implying that this is the gypsy's home (plate 6.15).[61]

Krull's series of vagrant, or *clochard*, photographs provided another kind of Paris imagery. Krull's *clochards* received almost as much critical attention as her Eiffel Tower pictures and established her as one of the preeminent street photographers in Paris.[62] Two series of Germaine Krull's *clochards* were published in 1928, in wildly varying contexts. Ten of her photographs accompanied a *Vu* article by Henri Danjou entitled "Les Clochards dans les bas fonds de Paris—ceux de la Maubert" (plates 6.16, 6.17, 6.18).[63] Henri Danjou was a popular writer whose book on *clochards*[64] appeared the same year. Like most of the successful magazine work of the decade, the text, captions, and photographs were a collaboration. In *Vu*, the interaction between editor Vogel, writer Danjou, and photographer Krull produced an essay whose images, layout, and interrelation of text and pictures epitomized the 1920s' view of the *clochard*. Another group, with a slightly different focus, was published in the Belgian surrealist journal *Variétés*. Without the humanizing words of the *clochards* themselves, which pepper the *Vu* essay, this art magazine coopts Krull's bums as surrealist "found objects." Both magazines, however, presented the *clochard* as a symbol of aggressive independence and hatred of conventional and totalitarian rules—and in that sense Krull found not only a sympathetic subject but a kindred spirit in the homeless inhabitants of Paris.

Krull was not the only intellectual to adopt the outsider as an urban symbol for freedom during these years; in the 1920s the *clochard* became the quintessential representative of the city.[65] As the most charismatic marginal figure, the *clochard* was widely depicted as independent, insouciant, and idiosyncratic, a symbol of nonconformism and freedom for the general population. For instance, authors with such varying political positions as André Breton, Francis Carco, Pierre Mac Orlan, Georges Simenon, Philippe Soupault, and scores of less well known writers concentrated on vagrants as well as the "apache," the killer, the prostitute, and the penniless wanderer in the city of Paris. Photographers such as Germaine Krull, André Kertész, Brassaï, and Eli Lotar represented vagabonds, prostitutes, and gypsies,

creating romantic figures who suggested "Paris as it was." By concentrating on the margins of society, these writers and photographers attempted to grasp the changing elements of urban existence and to redefine them for the public—in a safely disengaged format. Krull's distance from her political stance of ten years earlier appears in the fact that the *clochards* represent no street revolution—nor does she suggest one.

Most illustrated magazines, whether art journals, popular weekly magazines, or pornographic rag sheets, included the vagabond in at least some articles. Often, the same photographs appeared in different contexts, allowing for a diverse definition of vagrancy and indigent leisure. Krull, Brassaï, and Kertèsz, as well as the big photographic agencies, recorded a veritable "rogues gallery" of photographs of vagabonds and published them widely. Photographs by Krull and many others accompanied articles not only in *Vu* but also in its sister magazine *Voilà*. These ranged from exposés of the Salvation Army shelters, descriptions of the daily routine of a typical *clochard*, and portrait galleries of notable vagabonds of the streets of Paris. Napoléon, a vagrant named *le clochard-philosophe* by the press, represents only one example of the wide variety of personae that were adopted.[66] Even pornographic magazines such as *Paris-Magazine* juxtaposed sunbathing beauties with *clochards* basking on a bench.

Photographs of marginal figures often suggested links with the political left. They appeared both in popular journals such as *Vu* and in surrealist magazines like *Variétés* and *Bifur*.[67] Even more, though, these figures refuted capitalism and presaged the socialist years of the Front Populaire and the antifascist movement during the late 1930s and World War II.[68] Despite their simplistic romanticization for the popular press, they represented a denial of authority and a fundamental antitotalitarianism that Krull deeply shared. In the popular imagination, they rejected government support, preferring to sleep at privately run flophouses like La Grappe d'Or and to spend their days on the quais and bridges near Notre Dame and the Place Maubert, the vagrant's haven on the Left Bank near Notre Dame. Krull's photographs reinforce the popular myth of the *clochard* as philosopher and sometimes as a rag picker with a similar scorn for societal conventions.

Krull relates her encounters with the *clochards* in "La vie mène la danse." Her memoirs correspond closely enough to the popular opinions of the 1920s to bear quoting at length. Neither the photographer nor the

popular magazines attempted social reform. Instead, the growing hunger for travel articles about unknown parts of the world made even local color a subject for new interpretation; *clochards* were the "other" of Paris:

> People wanted to see Paris as it had never been seen, as if they did not know it. There was also La Cloche, *the kings of the beggars who were not beggars at heart. They had a special view of liberty, and they wished to organize their lives according to their ideas. I did a reportage with my friend Henri Danjou, a very intelligent journalist who loved street life as I did. We went down below, on the quais of the Seine, near the Quai Montebello, across from Notre Dame. There, the lords of the* cloche *were at home. I arrived in the morning and I left at night. They did not receive us happily, but little by little they became accustomed to our presence. My camera bothered them greatly. . . . [T]hey wished nothing from life but a liter of red wine and a loaf of bread. They worked a few hours in Les Halles early in the morning as vegetable or meat porters. Then they set up on the banks of the Seine with their meal of wine and bread. If by chance they found no work, or in winter, they went to the Salvation Army for a bowl of hot soup. Each had a story, not always a pretty one. One had been director of a circus, another a banker. There were heads of families who left everything to live freely, à la* cloche.[69]

An autobiography need not reinforce a clearly mythical definition of the homeless population of Paris; Krull could easily have photographed a subject she did not support. But Krull, like the readers of *Vu*, clearly felt that the *clochards* were special. She described them as *seigneurs*, not beggars. They were free; they liked their bread, wine, and river views; and they worked only long enough to earn the bare minimum for these necessities. Krull even believed the popular myth that they all had some "history" that rendered them special and that they had freely chosen their lifestyle. Furthermore, she envied their liberty, wondering if it was not, in fact, better than middle-class constraints. Echoing the

sentiments of Charles Chaplin's film "tramps," she writes, "I quite liked the company of these men. Sometimes I understood them. Perhaps they were not as crazy as all that?"[70] If we look at her entire life, Krull's peripatetic habits may not be so far removed from the myth of the *clochards*. She cherished her independence above all, valued no permanent home as much as her freedom, and regularly eschewed middle-class comfort for adventure, sometimes out of necessity but sometimes out of choice. Like these bums, Krull steadfastly denies her misfortunes in her memoirs, preferring to fabricate a facade of adventure.

Critics and photographers in the 1920s and 1930s often cited Krull's work as model urban pictures.[71] Yet generally, except for the work of Kertész, their compositions were less daring than hers, and they relied more explicitly on the formal conventions of the centuries-old print tradition of the *petits métiers*. Krull's photographs did take poses and attributes from the compositions of the *petits métiers*, tapping the nostalgic feelings of the Paris population, yet her views of *clochards* also utilized elements of modernist composition derived from cubism and constructivism.

The first photograph, occupying center stage on the first page of the *Vu* article, clearly symbolizes the image of an independent Paris citizen who is, nonetheless, unthreatening to the magazines' audience (see plate 6.16). Its composition only superficially resembles the nineteenth-century type of the mendicant. In its central position of importance on the page, this picture sets the general modernist tone of the article. Krull crops the image to a three-quarter length view and cuts off the top of his hat, so that we confront the vagabond very directly. He regards us piercingly and unflinchingly, with his head tilted slightly to his right, and he leans heavily on his stick only as an afterthought. His left hand holds a basket perched on his hip, but not like an medieval "attribute" or a rag picker's bag. Instead, his cocky stance and the insouciance with which he wears his oddly buttoned coat suggest nonconformist independence. His compellingly raised eyebrow and half-smile suggest a humorous and intelligent individual who sized up the photographer even as she photographed him. Henri Danjou's caption, "A philosopher of the Place Maubert, who judges his fellows with civility," reinforces our impression of self-assurance and independence.[72] Far from a stylized figure like Atget's, the author describes him as a philosopher with a specific home, the Place Maubert. We are immediately told, in the caption, that this individual can judge his fellow men. *Clochards*, like the rag pickers before them, were often described as philosophers. The role of street philosopher was especially popular in magazine articles.[73] According to the literature, photography, and press of the time, all *clochards* were odd characters— philosophers, famous figures, or fallen millionaires.[74]

Danjou's text for the article opens with a strong statement of *clochard* self-will and individuality, and its first line lies directly next to the *clochard*-philosophe in plate 6.16. As he had done in the Eiffel Tower layout, Vogel and his art editors manipulated the interrelationship of texts and images for the strongest graphic effect. The first line reads: "There certainly are characters at Maubert!"[75] Pride, snobbery, and individuality were the prime attributes of the figures whom Danjou chose to interview, and he discloses middle-class taste in choosing for public consumption a population of *clochards* who lived completely independently.

In one of her pictures, a man descends the steps to the quai in a shot comparable to André Kertész's bird's-eye river views (plate 6.23). The steep and disorienting angle contrasts with the figure firmly planted in the center of the steps, arresting and stabilizing the vertiginous composition of street fragments. The *clochard* inhabits that street, and his firm stance on the stairs stills the dizzying impression of their descent into the river. He carries a *chiffonnier*'s bag, and the caption labels him "Down and Out Daddy" (Le père 'La Purée'). Like the first *clochard*, this man has a specific home; he lives at the Place Maubert.

A third photograph (plate 6.19), of a lone woman slumped on a street bench, also suggests the democratic and voluntary nature of *la cloche*. The caption tells us that this is a countess who has chosen to live among the vagabonds.[76] In another image a "minister's niece" fills the role of a celebrated figure who has voluntarily joined the ranks of *la cloche* (plate 6.22). She drinks from a shared bottle with her comrades, and the caption strongly emphasizes the qualities of independence and equality. By the *clochard* code, all men and women are equal, even former countesses and nieces of ministers. The convivial attitude of this group, tightly packed on one side of their bench, cannot be mistaken. Their group, interacting among themselves, holds the center

of the urban stage, and we are left to look enviously at the "club."

Another popular spot for the *clochard* was the river-bank, which Krull documents in a striking photograph of three men watching from the quais as the Seine passes by. Another view shows sleeping figures in the doorways, waiting for the vegetable trucks to arrive for unloading (see plate 6.18). Even in repose on a dirty street corner, these *clochards* evoke pity neither in the caption nor in the formal composition. Curled up in a niche, each body humanizes the geometry of closed iron grilles and pillars surrounding him. Despite the trash she included in her scene, Krull photographed her subjects straight on, from a slight distance, so that they look less miserable. Krull never photographed *clochards* at work, venturing only as close as this nap before the opening of Les Halles. A working *clochard*, immortalized in a photograph, would have posed a contradiction in terms for the readers of *Vu*, who identified *clochard* existence with leisure. Of course, the meaning of the photographs changed radically as they were sold to picture magazines outside Paris, given different texts and captions, and seen by different people.

Henri Danjou's article for *Vu* condenses the physical terrain of the *clochard* into its most typical Parisian form. And not only do Krull's photographs strengthen the myth of the leisurely *clochard*, but they reconstruct the topographic progression of the *clochard*. In his text, Danjou, like Krull, uses specific individuals to suggest general behavior, rejecting the typologies of the nineteenth century. Danjou's guide, Jean l'Américain, leads him on the standard route of the *clochard*. This particular path reappears in every contemporary chronicle of vagrant life in Paris, and *clochards* are still to be found in many of the same spots today. Krull's photographs illuminate the high points of Danjou's itinerary—Place Maubert, Les Halles, the Seine, Notre Dame, the quais, and the Quartier St. Merri, home of the Grappe d'Or. This was a very circumscribed world, covering no more than ten or twelve square blocks, on both sides of the river near Notre Dame. We see no tourists, however, but only the underside of the Paris population. Although beggars and vagrants undoubtedly lived in all parts of Paris, as they do now, photographers and press returned repeatedly to this one area.[77]

Other groups of Krull's *clochard* photographs appeared in magazines more related to art and literature than to magazine journalism. These photographs did not follow the topographical path of the *clochard* and

had a different urban symbolism from that of *Vu*. A portfolio of clochards was published in *Variétés*.[78] This magazine provides a good example of the ambiguous ties between the photographer and the surrealist movement. Krull almost certainly did not consider herself a surrealist, yet she utilized specific surrealist concepts. Furthermore, the journal treats her work as a surrealist *trouvaille*, a group of images discovered out of context while reading the magazine. In *Variétés*, the series of eight views comments on the vagrant state in more purely graphic terms than do the *Vu* pictures.[79] Each page is titled "*Clochards* par Germaine Krull," departing from journalistic photo credits on the edge of the photograph and granting equal importance to the photographer and the subjects. Krull's *clochards* are framed like objects on a gallery wall in this essay, yet they have little overt connection to surrealism, which dominates much of the rest of the journal. In the art journals, photographs could also stand alone, like scientific evidence or precious objects. This portfolio, corresponding to its art context, emphasizes the diagonal, modernist orientation of the compositions more than do the *Vu* photographs. The images, expanding on the *Vu* picture of Père la Purée, are photographed from above at dramatic angles.

The photographic essay in *Variétés* begins with a view of a man sitting on the curb with his feet in a littered gutter (plate 6.24). Since we stumble across him on the curb, he can be seen as an urban found object similar to the street finds of the surrealists. He leans on a lamppost that also supports a series of advertisements. We read the words "Metropole . . . Attraction" at the top; beneath that are "Le Jou . . . d'echecs," and "Yvette . . . BERT." The *clochard* is, in a sense, the lowest metropolitan attraction on the list, the pawn in the urban chess game. The background affords glimpses of a busy street, cafés, and passersby, including a man who walks toward us, the side of his body edged by the billboard. All this movement contrasts with the sitting man, who is equated with the refuse in the gutter. A lamppost, which points directly to the sitting man, formally splits the single, static street portrait in two.

Another image in *Variétés* suggests more communal or domestic activities. In this picture, we see a woman crouched on the bare cobblestones (plate 6.20). She

leans over the food in her hand, and the wine bottle and discarded paper wrappings are prominently displayed in front of her. Here Krull frames a more alienating composition by leaning over her subject from above. This woman bends over her food and avoids our eye, creating a minuscule amount of privacy in the curve of her lap as she leans over her lunch. Repeating the motif of the photograph on the previous page, Krull here frames daily events in the street in a beautifully composed but somewhat alienating arrangement of stones, brick wall, and cobblestones, each with a different texture. The stone may be an uncomfortable bed, but Krull's composition and the activities of this *clochard* domesticate the city streets, making them habitable. Another photograph in the series depicts a young man throwing dice on the cobblestones, and yet another image presents a companionable group of five drinkers, one of whom looks directly out at the photographer. In these photographs Krull reinforces the popular French attitude that *la cloche* is not so bad after all. Overall, this series has stronger geometric compositions than the group in *Vu*, perhaps partly due to the more aesthetic interests of the journal. Yet despite the angles and textures of the photographs, Krull portrays a world that is inviting, not miserable, except for the first and third images. Wine, river, camaraderie, lodging, entertainment—all appear in a moderately positive, although not sanitized, manner.

Germaine Krull's vagabond photographs were widely published in other contexts as well and are a good example of the multiple uses of one corpus of images. Schostal Agency, for instance, still holds seven vagrant photographs today. Although these are the same images, their meaning changes according to their context. For instance, Krull's *clochards*, flea markets, and street fairs illustrate André Warnod's gloomy and nostalgic look backward toward the lost charms of prewar Paris, *Visages de Paris* (1930).[80] Here, the very same images hold the opposite meaning to Vogel's optimistic look at 1920s society. Other *clochards* appeared in Krull's own Paris book, *100 x Paris* (1929), which otherwise adheres to a more conventional series of monuments and streets. As one of the images of *100 x Paris*, the *clochard* is an exception to the standard subjects of a topographic city album. The group of drinkers, again the same image from *Variétés*, offers a startling variation to the more distanced views of the rest of the book.

In the late 1920s, the representation of *clochards* briefly created a romantic view of freedom. This roman-

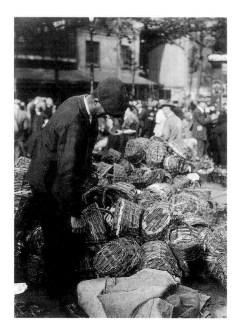

ticization may signify the political disengagement of the late 1920s or represent a general aestheticization of poverty, a middle-class attempt to excuse its existence. By imbuing marginal figures with the stylistic traits of the nineteenth-century print cycles, *Vu* and its fellow journals assigned middle-class values to the *clochards* in these photographs. Their camaraderie, set habits, and philosophic attitudes drew them close enough to the bourgeoisie to serve as a nonthreatening symbol: the street was habitable, not frightening. An unkempt, violently drunk and abusive vagrant would not symbolize the attractions of their free world as effectively as an eloquent, contented one.[81]

Les Halles

Krull made many photographs of Parisian street life, and it became one of her trademarks in the French press and for export in the international picture press. In another example, she photographed Les Halles, the central markets in Paris, in an series of extraordinary photographs. The text accompanying these images from the Viennese Schostal picture agency survives, as do other texts for the Schostal agency pictures. Although we have no way of knowing definitively who wrote the text, it is typewritten in French and remains with the photographs. The elegance and correct syntax of the French typescript suggest that Krull may not have written these words herself, but the pairing of a body of images with an explanatory narrative was extremely unusual in picture agencies, suggesting that she may have collaborated with a writer to send these pictures to the Viennese

FIGURE 6.4

GERMAINE KRULL. LES HALLES. C. 1928.

GELATIN SILVER PRINT, 22 x 15.3 CM..

COLLECTION DR. CHRISTIAN BRANDSTÄTTER, VIENNA

archive. Krull probably agreed with the popular opinions expressed in the texts, in much the same way that she remembered agreeing with the written ideas of Henri Danjou when they roamed Paris together looking for *clochards*. The romance of the text has the same euphemistic tone as the captions in the French picture press, emphasizing tradition, history, and the beauty of the crowded market scene in the early hours of the morning: "one of the most remarkable markets in the world, 'the belly of Paris,'" where each morning "the miracle repeats itself."[82] One photograph (fig. 6.4) frames a man surrounded by a load of empty baskets, so that the baskets seem to cascade out of the photograph.[83] A second picture portrays a stout market woman hanging a bag on the iron framework of a tree in the littered market (plate 6.26). This series includes several beautiful photographs of the market's debris, in contrast to the positive tone of the caption text. In the first of these photographs (plate 6.27), straw and litter surround an empty box marked "Lobsters," and in the second (plate 6.28) the photographer has trained her camera on the ground alone to emphasize a pile of spilled apples surrounded by straw and paper debris. Little of the bounty of the market appears in these pictures, although others are more conventional views of heaping vegetables and meats.

A return to more traditional, pitiful, or dreary views of the working and destitute classes occurred in the mid-1930s, when the economic situation again made poverty a threatening subject. By the mid-1930s, political feeling in France varied from the socialist ideals of the Front Populaire to the far right of the Action Française. Many artists abandoned experimental styles of photography for a more straightforward presentation. Vogel, with his clearly leftist sympathies, reverted to a more documentary mode whose political message resembles that of American photographs of the Farm Security Administration. During these years, Vogel published whole issues of *Vu* on political subjects like the Spanish Revolution. The German photographer Ilse Bing writes of Vogel's changing orientation:

> *In the Spring, 1931, I showed Mr. Vogel the series of photographs which I had made about the Salvation Army in Frankfurt, in 1930. He told me he liked the photographs very much, but that he could not offer "such a dreary subject" to his readers. In the Fall of 1934, I got a phone call*

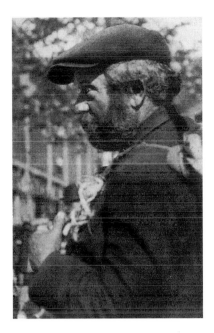

from his office. . . . Could I bring back these photographs to Mr. Vogel?[84]

Bing's photographs represent a general trend toward more serious documentary. Some photo stories published in *Vu* at this time were even more traditional than Bing's. For example, a late essay by Kertész represented the *petits métiers* as traditional types very close to the previous century's prints. Even more static than Eugène Atget's, these views are centrally organized, posed, and made into formal portraits of generalized types. Krull's own return to more traditional representations can be seen in illustrations for an article by Jean Gallotti, "Permanence du Type Populaire—les modèles des frères Le Nain" (fig. 6.5).[85] In this review for an exhibition of Le Nain paintings from the seventeenth century, Krull contributed studies of "types" who could have modeled in 1934 for those paintings.

Despite Krull's protestations about being merely a witness, her photographs of *clochards*, the Eiffel Tower, and Les Halles did not convey impartial testimony to their viewers. Instead, they molded and shaped the popular perception of the city and its inhabitants into a form that would have a huge impact on *Vu*'s readers. The city was recreated as an exciting, machine-driven, yet human place. Vogel, Krull, and other photographers idealized marginal groups, representing them as symbols of freedom and, by extension, of free thinking. Photojournalism, therefore, became a tool for shaping public perceptions of society, and editors, writers, and photographers collaborated in the messages they chose to project. By framing these citizens as individuals, and surrounding them with personal anecdotes, the picture

FIGURE 6.5

GERMAINE KRULL. "IL N'A PAS SEULEMENT ACCORD"
FROM JEAN GALLOTTI, "PERMANENCE DU TYPE POPULAIRE—LES
MODÈLES DES FRÈRES LE NAIN." *VU* 331 (18 JULY 1934): 912

press packaged and whitewashed them for middle-class consumption. Gone were the nineteenth-century depictions of "laboring classes as dangerous classes"; photographers and writers had replaced the frightening stereotype with an endearing one.[86]

The picture press encouraged another, less journalistic mode of photographic inquiry—superstition and mystery. Despite their claims to be honest witnesses, photographers and writers often blurred the lines between reportage and invention, driven as much by the competition in the expanding print media as by anything else. Krull's photographs included many views of mysterious or magical events and have strong links to literary movements of the late 1920s. Similar explorations into the mysteries of daily life appear in books such as the surrealist novels of Louis Aragon, André Breton, and Philippe Soupault, the brutal action fiction of Joseph Kessel, the detective fiction of Georges Simenon and his colleagues, and the idiosyncratic blend of mystery and fantasy in the works of Pierre Mac Orlan. Krull, too, would create tales of what Mac Orlan called the "social fantastic" of urban life. She created these narratives both in photographic picture stories and in longer, full-length photographic book projects.

An International Photographic Eye

Germaine Krull is literate. . . . I like to imagine her in her studio, a cigarette between her lips with a wisp of smoke that drifts into her eyes. She knows that the street, which is the most closed domain of human thought, will reveal the shadows of its entranceways. Behind Krull and her round object like an octopus's eye, the children of misfortune press up, knock against each other, moan, squabble, and jostle in order to place themselves before the camera."Don't move."[1]

— *Pierre Mac Orlan*

By 1930, Krull had settled into her life in Paris as a successful working photographer and a celebrated artist. Her magazine work soon led to book-length works modeled on some of the topics of her picture press work—energized compendiums of city views, travelogues, and suspense or slightly mysterious stories. After the success of the unbound art album *Métal*, Krull began to plan to make books for the larger trade. Photographic and even verbal narratives continued to interest her throughout the 1930s, in books, films, and also in her own writing, which began during this decade. For this she gained a new ally. Among her admirers was a young editor named Jacques Haumont (plate 5.22), who wanted to publish picture books of her photographs with only a small amount of text in the prefaces.

Krull found his ideas exciting and felt that her own experiments would be honored: "He entered totally into my ideas, and he had many ideas himself. I felt that something could be done, but the discussions troubled me a bit nonetheless. Had I found the man to transform my dreams into reality? And did he have the power and the money to do it?"[2] Since "La vie mène la danse" was written at the end of Krull's life, and Haumont did in fact bankrupt her in the end, her thoughts may be harsher in hindsight than they were at that moment. In fact, Haumont's publishing ven

tures allowed her to further explore some of the photographic narrative issues that had fascinated her in magazine stories. Although these were trade or tourist books, Haumont gave Krull almost free rein. In her memoirs, Krull recalls that Lucien Vogel was quite amused at the dynamic developing between the two. When Haumont left Editions Firmin-Didot and opened his own publishing house, the photographer relates that Vogel laughingly commented, "Here you are launched with Haumont. You will do great things, but you'll need strong reins. It would be better to name the publishing house after Germaine Krull."[3] It is at about this time, in 1930, that Krull moved to the Boulevard St. Michel to a studio suggested by her friend Roche and financed by Haumont, who had also become her newest lover. The apartment was renovated into a grand studio, and Marcel, her laboratory assistant, had a new lab to work in.

After Krull and Lotar parted company, she began to see many more men, and Haumont numbered among them: "I was no longer a young girl who loves only a single man. I had adopted the Paris custom of taking pleasure where I found it and forgetting it the next day—too fast, perhaps. But why not? Eli Lotar was always in the wings, but even Lotar counted no more than the others now."[4]

Originally under the auspices of Editions Firmin-Didot and then under his own imprint, Haumont published most of Krull's books during the 1930s. During these years, Firmin-Didot published photography books by Krull, including *Le Valois* (text by Gerard de Nerval, 1930) and *La Route de Paris à la Méditerranée* (text by Paul Morand, 1931) (which included photographs by Kertész, Krull, Sougez, and others). Once Haumont opened his own publishing house, Editions Jacques Haumont, he published four of Krull's projects—*La Folle d'Itteville* (text by Georges Simenon, 1931), *L'Affaire des sept* (text by Georges Simenon, 1931), *La Route Paris-Biarritz* (text by Claude Farnère, 1931), and *La Bataille d'Alsace* (Novembre–Décembre, 1944) (text by Roger Vailland, 1945). Krull occasionally worked with other publishers. In 1929, she published *100 x Paris* (text by Florent Fels, Berlin: Verlag der Reihe, 1929), and in 1935 she published *Marseille* (text by André Suarès, Paris: Plon, 1935). She also provided illustrations for a large number of books, both literary and topographical in nature. In her book illustrations, and in her films and writing during the 1930s, Krull displayed a renewed interest in continuous narrative, and she would explore narra-

tives in various ways that both continued and transformed the montage experiments of her industrial work.

These books fall into three main groupings—urban view books with direct links to the Parisian sagas of Krull's magazine work, detective tales, and more continuous narratives, especially travelogues. Each genre maintained certain conventional elements, both in style and in narrative structure, but each also explored changing popular attitudes toward French culture. They traced a path from Brechtian collections of fragments to newly moral tales and presented a kind of retreat from the New Woman to a more inclusive culture. Like so many of her colleagues, Krull was navigating the circuitous path between past history and the postwar world, and she recognized the unease that both past and present provoked. Many avant-garde artists returned to more traditional modes in their zigzag encounter with modernism, especially when the market forces of publishers and patrons intervened.

In Krull's book *100 x Paris*, published at the height of her avant-garde involvement in 1929, New Vision compositions and an interest in modern Paris merge with a more traditional topographical tour through the capital's monuments. Then, in the detective volumes beginning in 1930 and lasting for two years or so, Krull explored an entirely new, although not necessarily avant-garde, genre of photographic narrative. These photographs, although conventional by themselves, are groundbreaking fusions of texts and images in novelistic form. In reflecting a moral attitude toward contemporary behavior—clearly distinguishing good from evil—the detective stories are also an illuminating lens on both Krull's attitudes and those of the general public in the early 1930s.

Finally, the travelogues, beginning in 1930 and continuing until 1935, reflect the side of French culture that searched for stability and convention during these years. The French landscape—in its beauty, its permanence, and its historical and pictorial connotations—appeared soothing both to the French book-buying public and to Krull herself. The engagement with the landscape became modern, too, however. During these years, hordes of French families headed to the south for vacations for the first time, and car culture took over the country. In Krull's eyes and those of many of her

compatriots, the car was the great modern symbol of freedom and independence. Once Krull got her first car in 1929, she seems to have been on the road as often as possible. Many of these books are literally photographed from the road, out of the windshield of a car, and they blend tradition with the modern culture of tourism. Krull's travel urge encompassed her filmmaking as well as her book photography. Eventually, her voluntary escapes to the south of France became a financial necessity; with her Paris business bankrupt, she moved to Monte Carlo in November 1935.[5]

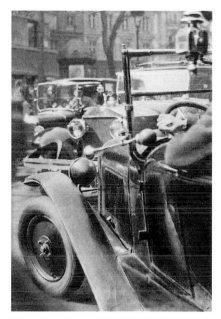

100 x Paris

Krull's first full-length book after the *Métal* portfolio was *100 x Paris*.[6] Published in Berlin by a German publisher, its sepia-toned images, one on each page, appear quite retrograde at first glance, especially in comparison with the double exposures and close-up details of *Métal*. Following in a centuries-old tradition of topographical looks at the great monuments of Paris, these illustrations appear quite conventional.[7] The pictures follow a path from Notre Dame to the Louvre, the Champs-Elysées, the Bois de Boulogne, the Eiffel Tower, and the Pantheon. Florent Fels's introduction, unlike the rest of his writing about Krull's work, is similarly historical, calling attention to the historical force of Paris: "These monuments must be seen in the light of the persons connected with them, one must be prepared to rub shoulders with the great."[8] Krull the reporter, rather than Krull the constructivist, is to be our guide, he reports. Paris is "recaptured by the intelligent lens of that hunter of images: Germaine Krull."[9]

Yet even in this conventional format Krull subverts the traditional picture. Although many images are frontal and static, some are more surprising. The July Column in the Place de la Bastille, for example, is visible only by its shadow, which reaches across the city in an image reminiscent of *Vu*'s shadow of the Eiffel Tower. The Place de l'Etoile (plate 7.5), shows only a small corner of the Arc de Triomphe, instead framing the geometric patterning of stopped cars, pedestrians, and leafless trees surrounded by metal grillwork.[10] Not all monuments were suitable candidates for this kind of disorienting treatment and modern energy, but by extending the formal language she developed in *Métal* and in the Eiffel Tower images, she allowed the viewer to experience all of Paris, even historical Paris, with a

modern eye. Deliberate juxtapositions of old and new Paris are scattered throughout the book. The first, "A block in the traffic" (fig. 7.1), presents a crowded view of honking cars and is placed across from a historical view of the Marais that looks close to Eugène Atget's views of old Paris. Krull often uses diagonal geometric forms in this book to signify modern activity in the city.

Some critics, like Georges Charensol, found this book cold, but others, like Paul Fierens, easily read the cubist and surrealist clues that Krull embedded in the pictures.[11] Fierens writes in *Variétés*, "In the album of Germaine Krull, cubism and surrealism seem to carry the day. Atget's tradition is alive and well, however."[12] Fierens labels as realist (like Atget, in his view) several scenes of Les Halles, the *clochards*, and a grocery store. He then decides that "there is cubism when the intervention of will manifests itself in the ordering, the cropping, the analysis or the synthesis of the subject." Finally, he equates the "strange apparition" of a corner of the Boulevard Bonne Nouvelle to André Breton's surrealist use of that street in *Nadja*. Fierens concludes that "Germaine Krull's lens has an affinity for poetry."[13] In *100 x Paris*, the structure of the book remains conventional, but Krull inserts modernist punctuation into it. Thus, she successfully integrates into book-length form the blend of modernism and convention that she had developed in her work for *Vu*. Other photographers later followed her lead, but André Kertész, for example, did not succeed in publishing a Paris book until 1934.[14]

Krull made hundreds of other street photographs in Paris, some destined for the picture press, some for the more traditional forum of books like these, and some for the exhibition wall. In many of her pictures, she

FIGURE 7.1

GERMAINE KRULL. A BLOCK IN THE TRAFFIC. 1929.

FROM *100 x PARIS* (BERLIN: VERLAG DER REIHE, 1929), PLATE 8

concentrates on the simultaneous existence of history and modernity. In one view (plate 7.7), cars pass in the foreground of a building plastered with posters; the poster designs and events advertised give a taste of the multiplicity of musical, journalistic, and political events in Paris. The building being almost obscured, however, is a Second Empire apartment building surrounded by scaffolding as if historical structures themselves are under attack and reinvention. A second image (plate 7.10) is so plastered with posters and industrial signage that the building almost disappears. In photographs like these, Krull's response to the city parallels that of the surrealists who gloried in the simultaneous and often contradictory visual juxtapositions seen in Paris.

Surrealism

The late 1920s and early 1930s witnessed the height of surrealist literature. Yet despite her fascination with mystery and the dream imagery of mediums and mysticism, Krull's work was not overtly surrealist. She did, however, often make oddly disjunctive street photographs, like the ones discussed above, in the tradition of Eugène Atget, and haunted the deserted quarters of Paris that fascinated such surrealist writers as Louis Aragon, André Breton, Robert Desnos, and Philippe Soupault. Nonetheless, she never collaborated with them on articles, although Soupault, for instance, did write for the popular press. Krull's photographs never appeared in Georges Bataille's journal *Documents* (although Lotar's did), in Breton's magazines, or in *Minotaure*, but she contributed to more popularized surrealist journals such as *Jazz*, *Bifur*, and *Variétés*.

Krull's contacts with surrealism were indirect, but her picture book *100 x Paris* was interpreted by critics as having a certain surrealist content. In *Jazz*, *Bifur*, and *Variétés*, Krull published portfolios of city images that more directly highlight the unease of urban life that fascinated the surrealists. One portfolio of sixteen photographs, "Melancolie des villes," appeared in *Variétés*, with works by Krull, Berenice Abbott, Herbert Bayer, Lux Feininger, and Ewald Hoinkis.[15] Spanning cities as diverse as Versailles, New York, Brest, Rostock, London, Amsterdam, and Berlin, these are deserted cityscapes, all with a forlorn or mysterious tone. The art journal deliberately excluded any explanatory prose, and the reader is left to make poetic connections between the disconnected cities. *Jazz* published a similar essay on

"Hambourg" by Pierre Mac Orlan, with two photographs by Krull and one by Lotar.[16]

In another surrealist portfolio in *Variétés*, only a few pages after Eli Lotar's famous series of slaughterhouse photographs, titled "La Viande," Krull presented "La Nourriture."[17] Instead of simply documenting meat or vegetable markets, she contributed a mysterious pile of cauliflower eerily lit in a black predawn marketplace (plate 7.18), in a view with all the poetry and mystery of Brassaï's nocturnal views in *Paris de nuit* two years later.[18] In this photograph, the dramatically lit vegetables seem to double as nightmarish floral arrangements, and their geometric organization takes on the eerie form of a bier—a vegetarian coffin.

The deserted streets and blacked out windows of these unsettling scenes recall the tradition of Eugène Atget's more surrealist work. When Krull photographed shopfronts and mannequins in windows, she allowed the commodities for sale (fur-trimmed coats, garments, and other objects), to create their own aura of estrangement.[19] In certain images, mannequins are lined up in a headless parade, sometimes on several tiers or in a stagelike shop window (plate 7.17). Atget, too, explored these disjunctures, and Krull, along with her contemporaries, clearly found his work or his kind of vision inspiring. In her pictures, Krull allowed the new Paris to mingle with the old, but the city's mysterious corners inspired both photographers. In her photographs, the city often becomes an enclosed space, sometimes literally. In fact, three of her photographs of the glass-enclosed arcades of Paris illustrate a posthumous edition of Walter Benjamin's *Passagen-Werk*.[20] One of them, of the Imprimerie de l'Horloge in the Passage des Deux Soeurs, had appeared in *Variétés* in a portfolio on Paris as early as 1928 (plate 7.11).[21] Krull's image in *Variétés*, however, was paired with another of her photographs, of an international style house on the Rue Mallet-Stevens. But unlike Krull, neither Benjamin nor Atget would have given this gleaming glass, steel, and concrete building any attention whatsoever, preferring to concentrate on old Paris. Walter Benjamin recognized Atget's fascination with the fringes of the city and described the older photographer's subjects in terms that could apply to portions of Krull's work as well:

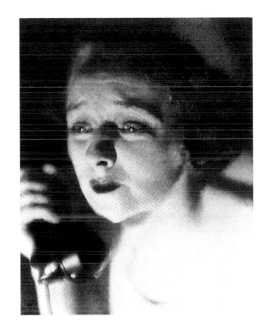

Atget always passed by the "great sights and so-called landmarks"; what he did not pass by was a long row of boot lasts; or the Paris courtyards, where from night to morning the handcarts stand in serried ranks; or the tables after people have finished eating and left, . . . or the brothel at Rue . . . No. 5, whose street number appears, gigantic, at four different places on the building's facade.[22]

During the years while he was working on his magnum opus, the *Passagen-Werk,* Benjamin was friendly with Krull and admired her photography. Although Benjamin did not commission photographs such as these, the writer and the photographer clearly shared the same fascination with Paris and its secret life (plates 7.12, 7.13, 7.14).[23]

In these photographs, Krull demonstrates her fascination with the concepts of convulsive beauty and objective chance explored by André Breton in his novels *Nadja* (1928), *Les Vases communicants* (1932), and *L'Amour fou* (1937).[24] Krull would have seen Atget's photographs in the art journals and at the Salon de l'Escalier, and her shopfronts (plates 7.15, 7.16, 7.17) refer to a similar mystery of the street, with multiple headless images and stagelike vignettes like those that Atget explored in his late work.

For Germaine Krull and her colleagues, as for Atget, even the surrealist avant-garde aesthetic was strongly conditioned by the moral obligation these photographers felt to honest reporting. Lotar, Krull, and Kertész tempered their surrealist impulses with the mystery of the world around them. Cubist and surrealist elements in Krull's work cannot be denied, but she considered herself a photographic witness and reporter above all. The reporter-photographer was a romantic figure in the illustrated popular press. An early issue of *Voilà* includes an article called "Chasseurs d'images," chronicling the trade of a news photographer.[25] The back cover sports a photographer perched at an impossible angle on an unfinished building, aiming his camera at the city below. The text follows the reporting of a bombing:

With the instinct of the hunter who shoulders his gun at the slightest movement of the leaves, he puts himself into a state of receptivity. It is only later, several seconds later, that he learns that this was a bomb thrown by a revolutionary at the cortege of the young king [26]

Significantly, this photographer's activity was couched in hunting terms.

The photographer relating this tale had not seen the event he photographed; he aimed his camera at a crowd and shot at arm's length, by instinct, as the article relates. The camera's eye records what the naked eye cannot see, and the state of active "receptivity" is what counts. Therefore, journalism involves not only honest reporting but an act of intuition. This state of readiness parallels what Henri Cartier-Bresson would later term "the decisive moment" but acknowledges its irrational quality. Krull put herself in just such a hunter's receptive state in much of her photography.

Detective Books

Receptivity was a quality that had stronger links to intuitive or mysterious ways of thinking than to reporting. Critics like Pierre Mac Orlan and Jean Cocteau, who simultaneously appreciated Krull's machine abstractions and her "honest witnessing" of the street, resolved this apparent contradiction by labeling her street photographs transformative. They also saw another quality, one harder to pinpoint. Cocteau wrote of this mysterious quality in her portraits, quoting a letter from "R. de Saint-Jean": "Have you seen the prints of Krull? The shadow of [Berthe] Bovy on the telephone? One would say a machine that suffers" (fig. 7.2).[27]

This portrait of actress Berthe Bovy's one-woman performance of Cocteau's new play, *La Voix humaine,* at the Comédie Française is ostensibly a theater reportage. In Cocteau's groundbreaking play, the sole character,

FIGURE 7.2

GERMAINE KRULL. BERTHE BOVY IN COCTEAU'S "LA VOIX HUMAINE." 1930.

FROM *VARIÉTÉS* 2 (12) (15 APRIL 1930): 872 FF.

played by Bovy, talks into a telephone on-stage during the entire performance. The play was prominently photographed and covered in *Vu* but not by Krull. Georges Marant published six photographs of Bovy in a two-page spread, but the photographs are more conventional posed images of the actress and her telephone.[28] Krull's portrait, by contrast, borders on the mystical. The photographer denies Bovy her beauty and frames her face in an unfocused, suffering expression in stark contrast to the black phone. Although it was too extreme for *Vu*, *Variétés* published this image as a single portrait.[29]

Mac Orlan described the psychological or mystical element in Krull's work somewhat differently, emphasizing the mystery with which she imbued her pictures. He defined this as a detective's task in his 1931 monograph on Krull. The novelist succinctly described her method of uncovering evidence of hidden details of urban life and praised her for using the light of her camera lens to make it visible.[30] Admiring the "children of misfortune" who seemed to loom out of the street to place themselves before her camera, he recognized a similarly unsettling trait in Krull's street photography. This particular attribute, an ability to tease out the mystery or unease behind a straightforward scene, sets Krull apart from Kertész, for instance, who generally held a sunnier view of humanity. Krull's empathy for discomfort may have arisen from her turbulent history, and even during this relatively stable and peaceful time in her life, she portrayed the modern world as slightly off balance.

Krull did not abandon montage techniques in order to capture this elusive mysterious quality. In her construction of city imagery for the popular press, Krull employed the deliberately disjunctive imagery that she began in the *Métal* images. People, architecture, and events were presented as a series of details without linear order. This structure comes from the montage effect of film theory, and also from another popular source—literature. In her popular press work, Krull's belief in honest witnessing was modified not only by her creative use of the camera angles, but by an active interest in various deliberately nonrealist ideas.

Another series of books with direct links to her magazine work allowed Krull to further explore the literary and narrative issues that fascinated her. In these literary explorations, mystery and uncertainty became creative tools for Krull. Unlike *100 x Paris*, where single images included formal experimentation but the narrative structure remained orthodox, these new

images often looked less abstract individually, but their arrangement displayed Krull's literary and storytelling imagination.

The key to Krull's narrative structure of images lies in her links to literature, but she followed no writer's path exactly. Krull was clearly influenced by the literary methods of several friends. These writers, like the photographers, comfortably straddled the commercial world and the literary worlds; they published in the popular magazines as often as they published more intellectual books. Likewise, photographers and writers struck a balance between the realist and the fantasy worlds. Krull drew on several literary traditions. It would be simple to label Krull a surrealist and to attach surrealist qualities to her images. Her work, however, was too tied to the visual world to sit comfortably in the surrealist camp, unlike that of Jacques-André Boiffard, Lotar, Roger Parry, or Man Ray, all of whom made surrealist street photographs. Some of her work was so mystical—because of its fragmentary composition—that it seems closer to the spiritualists whom she documented for the press than to any of her literary contemporaries. Krull also embraced the poetic fantasy of Mac Orlan, who wrote the extraordinary praise of her work cited above. Yet she was not simply a fantastical poet in the exact vein of Mac Orlan. Although she was closely linked to him, in most of her photographs her lens was too uncompromising for the romantic fictions that Mac Orlan created. She also admired the violence of Joseph Kessel's fiction: the *Nouvelle revue française* writer had won the Grand Prix du Roman of the Académie Française for his 1926 novel *The Captives*. Perhaps the best clue lies in detective fiction, and in Krull's ties to the enormously popular detective stories of Georges Simenon, which actively structured the modern world as a series of clues.[31]

Krull illustrated several articles in *Vu* and *Variétés* addressing superstition, a topic equally attractive to surrealist investigation. Some surrealist photographers, such as Herbert Bayer or Maurice Tabard, might have created dream fantasies in the studio or with manipulated prints, but Krull found her dream imagery in everyday occurrences. In this she was not unique; Kertész also photographed fortunetellers and talismans of good and bad luck.[32] In December 1930, they collaborated in illustrating Sylviac's article, "Superstitions,"[33] a playful

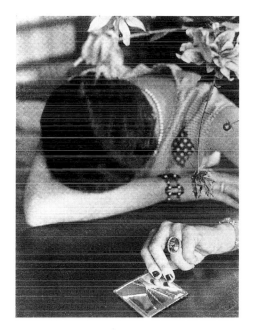

look at bad luck and good luck omens. Kertész photographed four-leaf clovers, ladders, and broken mirrors, while Krull photographed umbrellas opened indoors, horseshoes, and scissors falling point down into the floor. More sinister was her photograph of the rope of a hanged man. The close cropping and dark shadows of this picture suggest a lurid bloodthirstiness that Krull exploited in her detective work as well. These photographs appeared in the art journal *Variétés* as well, in a portfolio that included some of these same pictures and some different ones. For example, a woman sinks her head in her arms in despair, while clutching a broken mirror signaling "seven years of bad luck" (fig. 7.3).

Variétés published several other images by Krull dealing with superstition and mystery. An early and spectacular photograph is "The predictions of the voyante" (fig. 7.4).[34] Part of a series on "Ectoplasms" with Eli Lotar, this image is a multiple exposure whose dark shadows allow an eye in a white face to emerge from the void, juxtaposed with two hands palm reading an empty white glove, a magnifying glass, and other fortunetelling details. The sheen of the round magnifying glass approximates a second, all-seeing eye, trained on the brightly lit palm contrasting with the darkness. Although she seldom labeled herself a surrealist, this photograph shares all the dreamlike and disturbing qualities of pictures by Bayer, Man Ray, and Tabard.

Krull also documented various mystical and religious activities, accepting the popular press groupings—in single articles—of such widely disparate religious or quasi-religious beliefs as the Quakers, the Trappists, and the Theosophists.[35] Krull herself expressed no interest in Buddhism at this period of her life, although eastern religions and artifacts were also treated with this same mix of fascination and mystery in the popular press. For example, Titaÿna, an adventurer and world traveler who was also a founder of *Jazz*, published a two-article series on her theft of a Buddhist head from Angkor.[36] "Comment j'ai volé la tête d'un bouddha d'Angkor" appeared in the fifth and sixth numbers of *Vu*.[37] Man Ray's photograph of the Buddha and Titaÿna's helmet-clad head adorn the cover of *Vu* 5, but Krull's photographs exclusively document the latter half of the article, when Titaÿna parades through Paris with the head, posing with it at the Eiffel Tower, Place de la Concorde and elsewhere, in a blatant pastiche of cultural monuments with this illegally gotten trophy. Krull's photographs depict the adventurer with the stolen head in various spots around Paris, in a hu-

morous replay of André Malraux's 1923 notoriety for stealing Khmer antiquities.[38] One shot (plate 7.19) frames the Buddha head pilloried between two fence spikes next to the obelisk of the Place de la Concorde. The obelisk looms upward at an angle, its vertical shape as energized as Krull's metalwork images but with a phallic thrust similar to the surrealist experiments of Man Ray. In contrast, the Buddha's head, pinned by the ears between two of the sharp points of the cast-iron fence, recalls surrealist dreams of decapitation and dismemberment. Although Krull knew of the circumstances surrounding its placement there, it seems to the unsuspecting viewer to be an example of a surrealist chance encounter. In the best surrealist tradition, the photograph expertly juxtaposes two totally disconnected "found objects" to disturbing effect and adds the element of history to the mix. In the words of the caption, "the Khmer civilization and the Egyptian civilization confront each other in the center of Paris."

In addition to being the domain of the surrealists, the troubling poetry of the city was Pierre Mac Orlan's specialty. His critical discussion of photography as depicting the "social fantastic" of the city extended both to his journalism on other topics and to his fiction. Mac Orlan wrote various columns on urban life for the journals, including a column for *Vu* called "Il faut lire et entendre," one for *Variétés* called "Tragédies et divertissements populaires," and various urban essays for *Les Nouvelles littéraires*.[39] In these essays, Mac Orlan clearly defines documentary photography as a literary phenomenon, and, like Benjamin, disdains art photography, which he terms "plastic photography":

FIGURE 7.3

GERMAINE KRULL. MIROIR BRISÉ. SEPT ANS DE MALHEUR. FROM "LA SUPERSTITION." *VARIÉTÉS* 2 (6) (15 OCTOBER 1929): 428 FF.

propel her into new adventures in the next years. Her love of France was inextricably tied with her lifelong hatred of the totalitarianism that she began to see all around her in the failure of the Spanish Civil War and elsewhere.

Although Krull writes little about politics in her memoirs about France, a note of unease creeps into her discussion of her last Paris days, as she describes the appearance of the German threat among her colleagues: "Bit by bit the news in the movie theaters coming from the other side showed fanatic youths who seemed completely crazy and dangerous to us."[80] Krull reentered the street to demonstrate with the other French intellectuals of both the right and the left against Nazism. She recounts a demonstration at the Bastille where André Malraux spoke, followed by the communist Vaillant-Couturier and the leader of the right-wing Action Française, Charles Maurras. Despite her ongoing close friendship with Malraux, she seems to have had little contact with the Spanish Civil War or the causes that Malraux and other French intellectuals supported so passionately. Nonetheless, Krull was involved enough in French politics to participate in the strongly antifascist photographic exhibition Documents de la vie social at the Galérie de la Pléïade in May and June of 1936. This was organized by the Association des écrivains et artistes révolutionnaires (commonly known as AEAR), which since 1932 had been the French branch of the Soviet Union des intellectuels et des écrivains révolutionnaires.

Soon before she left Paris, Krull's Ikarette, the camera which had served her so well, was stolen. She mourned its loss, writing, "It seemed that at this moment I lost a part of myself. This camera was always before my eye; it registered things even before I did."[81] She had trouble getting used to a Rolleiflex and began using a 35 millimeter camera, a Contax. The loss of her camera paralleled the general decline of her photographic business. After the dispersement of her Paris studio, she had difficulty reestablishing herself.

The remainder of her French career was based in Monte Carlo, where she soon settled and opened a studio at 4, rue des Violettes. Her photographs during the years from 1936 to 1940 are relatively uninteresting, and her heart was clearly not in her work. The Casino of Monte Carlo asked her to direct their photographic service and to illustrate their weekly gazette. In September 1937, she was established well enough in Monte Carlo that Monaco's Commissariat Général of the upcoming

International Exposition in Paris invited her to serve on the jury for Monaco's pavilion.[82] Krull created several enormous photographic murals for the Monaco pavilion at the Paris Exposition Internationale.[83]

No traces of these murals remain, but photographic murals provided a common decoration for the various national pavilions. Photographer and scholar Gisèle Freund, in reviewing photography from the 1937 international exhibition, criticizes the large number of photographic murals.[84] Freund points out that the medium's apparent transparency—coupled with its ability to create a point of view without seeming to—made photography a powerful propagandistic tool. She notes that Russia was among the first to use oversized photographs for political effect but is astonished at how many of the national pavilions used photographic murals or photomontages in 1937; Krull's project for Monaco was not an unusual effort. Freund discusses the murals of the Russian, English, Swiss, and Belgian pavilions and writes that the large number of other lesser murals could not be discussed for lack of space and interest. Monaco is not mentioned, but since Freund discusses the few murals she liked, we can assume it was not noteworthy to her.

Little remains of Krull's work in Monaco. She produced an uninspired book for the Ballets de Monte Carlo.[85] Her archives contain a number of theatrical portraits and stage set images, like a multiple exposure of the performers "Jules and Julien" (plate 5.10). This kind of theater photography was not new for Krull, as in Paris she had photographed Cocteau's productions, and worked extensively for Louis Jouvet. Her interest in literature partially explains these connections. Krull made 215 photographs of Jouvet's productions at various times, including stage shots of La Machine infernale, Tessa, and Amphitrion. Her correspondence with Jouvet during the late 1930s in Monte Carlo reveals her business difficulties and her general feeling of depression. Jouvet asked her to make prints of all the photographs she had taken of his company, which she declined to do. Instead, she sent him the negatives and asked him to have them printed at Kodak, an indication that she was not very active in her own darkroom. She wanted to avoid financial arguments with him, since she had recently fought with two friends over the printing of various pictures.[86]

During the late 1930s, Krull tried to reestablish her business and prepared a proposal through which she tried to sell her archive of photographs to interested investors. This four-page document provides an enormous amount of information about her business practices, the work she felt to be most powerful, and her philosophy of the role of a professional photographer. Hers was, above all, an inclusive view, and the document is titled: "Project of Germaine Krull: to establish a commercial business concerning the exploitation of all branches of applied photography."[87] She described her eight years of work in Paris in the areas of press photography, publicity, industrial photography, illustrated books, cinema, decoration, color photography, portraits and fashion photographs, and other photographic applications. In her grand plan, Krull even suggests the possibility of opening a school of art photography. "All these different branches support and complement each other," she declares.[88] She attempted to sell her stock of 30,000 negatives to a larger agency and needed the financial support the sale would provide. No evidence exists to show whether Krull sold her negatives.

In the late summer of 1937, the Monte Carlo Casino, which had been paying her 1,000 francs a month, fired her, compounding her financial difficulties. Correspondence with Max Horkheimer and with Walter Benjamin reveals the details of her financial troubles, although the reasons for her termination are not clarified. On 31 August 1937, Krull wrote to Horkheimer that she now needed U.S. $50 to $80 a month to survive and begged him and Friedrich Pollock to help her.[89] She wrote that she had reestablished contact with Ernst Mayer, who had represented her at Mauritius Agency in Berlin and was now a founding member of Black Star Agency in New York, but that his 50 percent commission would leave her with little money. (Krull's business cards from Monte Carlo bear the Black Star name, although no trace of her work appears in the press with that label.)[90] Like the loyal friend that he was, Horkheimer responded immediately to her call for help, in a letter of 6 September 1937: "In the U.S. I shall certainly try the impossible for you. In the meantime, the monthly 1,000 francs continue to compensate for the loss of the Casino."[91] Krull's letters to Walter Benjamin during these years reveal that they had become closer friends than they had been in Paris in the late 1920s and that Benjamin helped Krull at the worried request of Horkheimer. Although Horkheimer had left Germany for New York and was only visiting Paris in the fall of 1937, Benjamin was still living in the French capital.

Correspondence with her friends highlights three concerns that dominated Krull's life at the end of the 1930s and that are largely absent from her memoir, "La vie mène la danse." First, as we have seen, her financial difficulties were severe, but Horkheimer was able to help her. Second, she herself had begun to write, and her correspondence with Benjamin reveals her new attitudes toward her own writing, and the sometimes misplaced self-confidence she had in comparing it to the work of other friends like Malraux. Third, the European political situation was assuming a greater prominence in her mind.

As early as 1934, Krull had turned to writing. In her last months in Paris, Krull wrote the first of her long memoirs, "Chien-fou," the novelized version of her political experiences in Munich in 1918. The tale stops before her departure for Moscow, but it is interesting that she wrote this manuscript, romanticizing and celebrating her early fling with political commitment and a kind of freedom fighting, at a time when the European political scene and the popular press were increasingly overshadowed by Italian and German fascism. The circumstances surrounding the creation of this book are somewhat unclear, but certain things can be understood. Hendrik Marsman had been wanting to write her story for years, as his correspondence related. By 1933, she wrote him that she was unable to work on this project, as it was too painful for her to remember those times.[92]

Instead, Krull cowrote "Chien-fou" with a colleague whose pen name was Gaston Cohen, and a 1937 letter to Walter Benjamin stated that the manuscript had been finished in 1934.[93] Cohen was managing editor of the left-wing paper La Flèche: Hebdomadaire politique du combat.[94] He seems to have received Krull's manuscript in Paris, and she had trouble reaching him or recovering that copy of her manuscript. Her only comment on La Flèche was to notice that Gide had begun to write for it. She worried that it would become an intellectual's paper: "I hate that like the plague. Because a workers' movement made by intellectuals is as false as the contrary."[95] She enlisted Benjamin's help in trying to find a publisher, since the NRF (Nouvelle revue française) and

Stock had already turned it down. Benjamin must have read the manuscript, since she wrote him: "It pleases me to know that you are reading it. I think that the book is good and historically exact. Tell me frankly what you think, even if it's bad." In a later letter, she wrote, "I am glad that you liked my book."[96] Gaston Cohen never answered her letters of inquiry about their publishing project, despite the intervention of Benjamin on her part. No one published this manuscript; and her failure and frustration with this were the beginning of Krull's lifelong pattern of difficulty in finding a European publisher willing to publish her books.

At this point in her life, Krull returned to the story of her first great political engagement, the Munich revolutions of 1918. In Munich and again in Moscow, Krull had battled for political causes she believed in and fought what she perceived as totalitarianism. Perhaps it is not surprising that in 1937, with Hitler and Mussolini looming large on the political horizon, her early beliefs in freedom and antitotalitarianism would be rekindled. Although in Paris she had been part of the intellectual left wing, Krull had passed a relatively nonactivist fifteen years. Her friends in the art world and literary world, with the exception of Malraux and others who went to fight in Spain, talked more than they fought. But now her letters reveal a reengagement with politics.

As early as 31 August 1937, Krull was writing to Horkheimer that she had to get her sister Berthe, now a dancer and dance instructor, out of Berlin: "I cannot let her rot in Berlin."[97] Berthe did in fact come to visit Germaine in Monte Carlo, and several beautiful dance photographs of Berthe on the beach bear testimony to their visit, but she then returned to Germany. The political split between these very different sisters would broaden drastically during their years of separation when Germaine fought for Charles de Gaulle's Free French resistance forces who were battling fascist Germany and Vichy France. Berthe, on the other hand, remained in Germany throughout the war. Krull had disliked Germany since her return from Moscow, and her comments on Hitler recognize his threat: "I think that Mr. Hitler will soon swallow a small piece of earth, and then afterward it will be a new day, and we will be able to laugh. But before that there will be thousands of deaths and so much pain. What an era we live in."[98]

Germaine Krull spent the "false war" in Monte Carlo, with her friends Maurice and Flechette Privat, dabbling in astrology.[99] When the war actually broke out in the summer of 1939, Krull immediately volunteered her services in the name of freedom. In Monaco, she was busy making identification photographs for the government, but she wrote to Louis Jouvet, asking him to help her work against the Germans with Giraudoux. In a letter of 2 October 1939, she offers her services, saying, "I am ready to do anything if I am needed. For your information: I am Dutch, I can make photographs, I have driven since 1929, I can read and write German. Those are the most important things I can do. If you see a job where I could help, tell me. I've been in France since 1926."[100]

She spent the next months trying to obtain a visa to leave France in order to join the Free French in London. Paris was evacuated on 13 June, Marshal Henri-Philippe Pétain asked the Germans for an armistice on 17 June, and the armistice was signed on 22 June. This agreement decreed that French forces be disarmed and that three-fifths of France be surrendered to Germany. Although her friends Maurice and Flechette Privat were quick to embrace this solution, Krull threw in her lot with de Gaulle from the moment of his speech of 23 June 1940 stating that "France had lost a battle but not the war."[101] With Pollock and Horkheimer waiting to help her in New York, America might have been a logical choice for Krull, but Joris Ivens had sworn on his arrival in the United States that he was not married; her entry would have resulted in his being accused of perjury. Krull was surprisingly tolerant of his position in her memoirs.[102] On the advice of Florent Fels, with whom she met up in Nice, she obtained a visa for Brazil. As she recounts in "Click entre deux guerres," Fels told her, "From Brazil you can join AEF Brazzaville, which is the capital of Free France."[103]

Krull embarked for Brazil from Marseilles in January of 1941, an action that symbolically marked her entry into active service in the war.[104] It also marked her departure from the last traces of the avant-garde world of interwar Europe and her ceremonial departure from European culture, to which she would return only sporadically from that point on. Krull returned to Europe only for a month here and there, and she never again lived in Europe until her final illness. Her photography, however, continued to be her major tool in fighting for freedom. The medium that had allowed her to make portraits of Eisner, to document the cultural life of

Berlin, to redefine the modern industrial abstraction of Holland, to become a major figure in New Vision photography in France, and to help reconstruct a French self-identity for that country's picture press would now become an overtly propagandistic war tool in the service of Charles de Gaulle and the Free French.

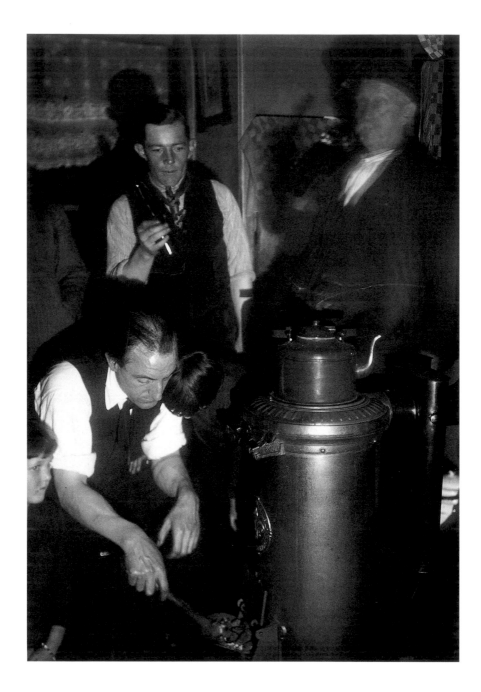

PLATE 4.1
AMSTERDAM, SAILORS' BAR, C. 1924,
GELATIN SILVER PRINT, 16.8 x 11.5 CM.,
ARCHIVE AND MUSEUM OF THE
SOCIALIST LABOUR MOVEMENT
(AMSAB), GHENT

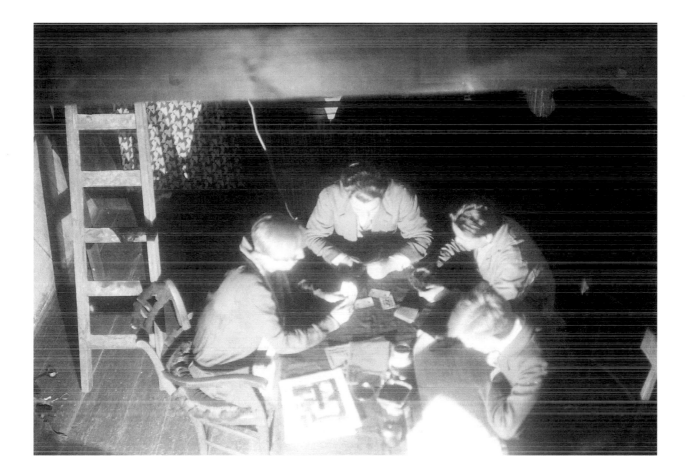

PLATE 4.2
IN JORIS IVENS'S STUDIO, C. 1927,
GELATIN SILVER PRINT, 11.7 x 16.6 CM.,
GERMAINE KRULL NACHLASS,
MUSEUM FOLKWANG, ESSEN

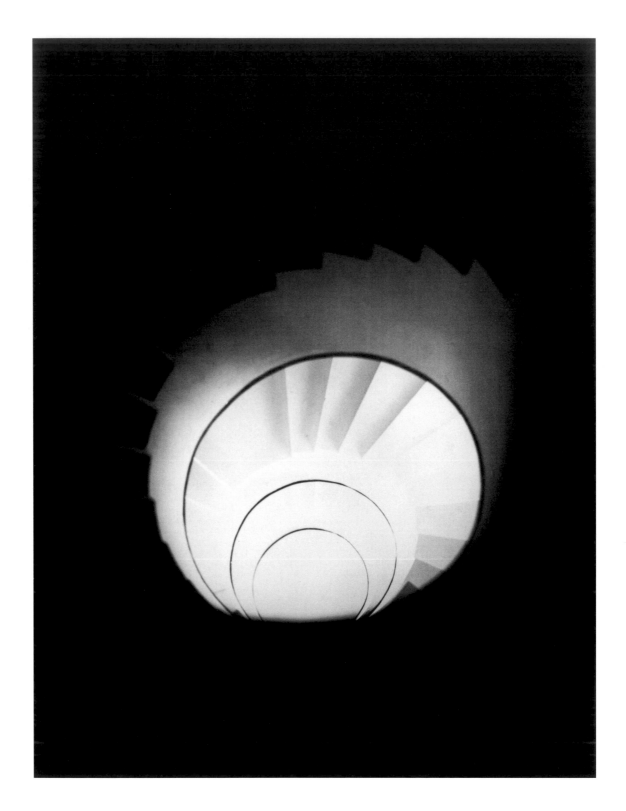

PLATE 4.3
ESCALIER, 1928,
GELATIN SILVER PRINT, 21.1 x 16.3 CM.,
COLLECTION MUSÉE NATIONAL D'ART
MODERNE, ACHAT DU CNAC GP, 1986,
1986.302, CENTRE GEORGES POMPIDOU.
© C. G. POMPIDOU, 1986

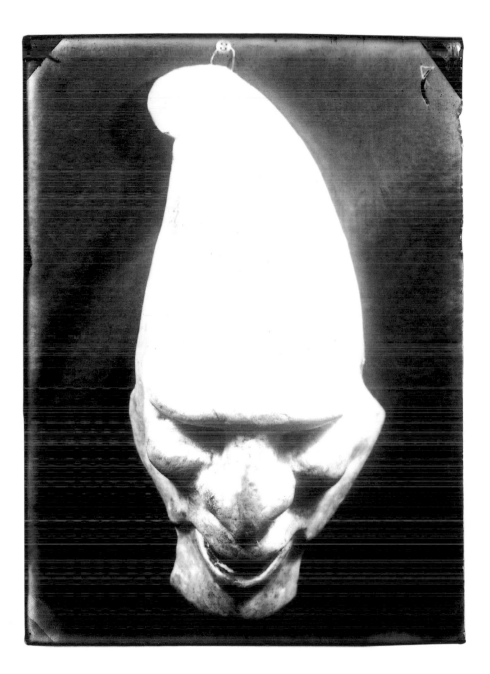

PLATE 4.4
JAN HAVERMANS'S MASK FOR
STRAVINSKY'S "STORY OF A
SOLDIER," C. 1926.
NEW GELATIN SILVER PRINT (1995)
FROM GLASS NEGATIVE, 17.6 x 13.0 CM.,
GERMAINE KRULL NACHLASS,
MUSEUM FOLKWANG, ESSEN

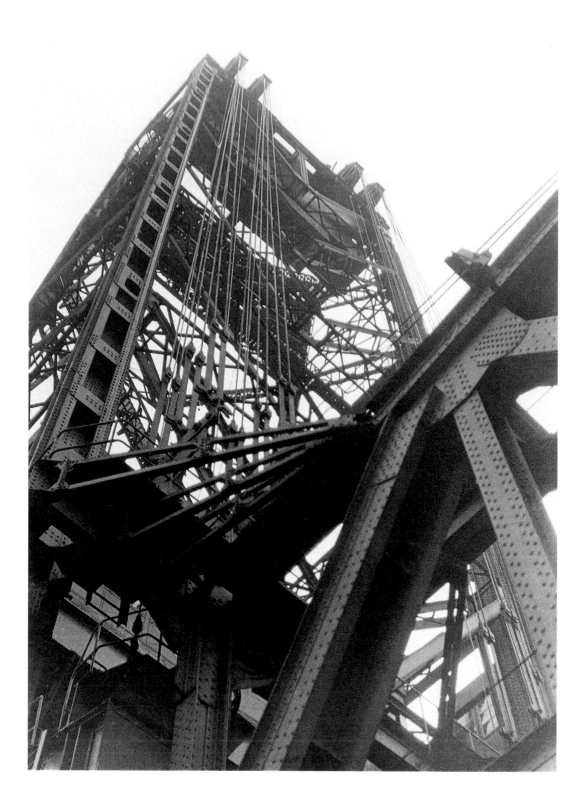

PLATE 4.5
UNTITLED, [*MÉTAL*, PLATE 6,
ROTTERDAM BRIDGE], 1926,
GELATIN SILVER PRINT, 21.3 x 15.6 CM.,
COLLECTION A. JAMMES, PARIS

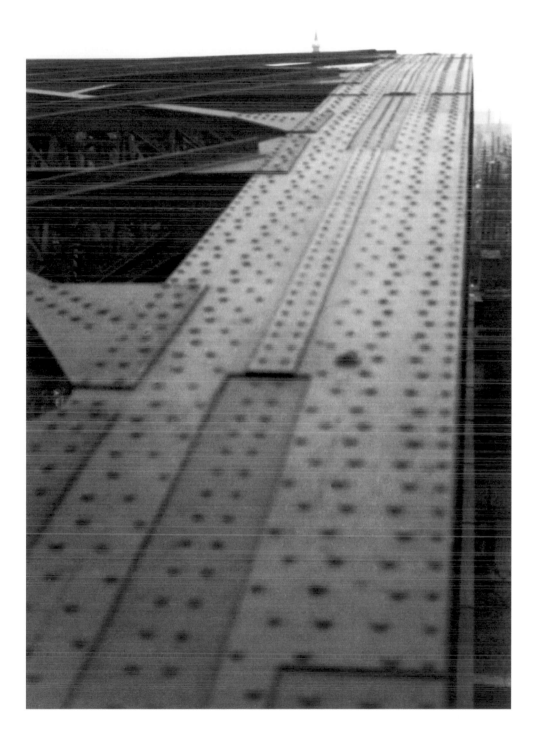

PLATE 4.6
PONT SOUSPENDU DE
ROTTERDAM [*MÉTAL*, PLATE 46], 1926,
GELATIN SILVER PRINT, 21.4 x 14.6 CM.,
MUSÉE NATIONAL D'ART MODERNE,
ACHAT DU CNAC GP 1989, 1990–1971,
CENTRE GEORGES POMPIDOU, PARIS,
© C. G. POMPIDOU, 1986

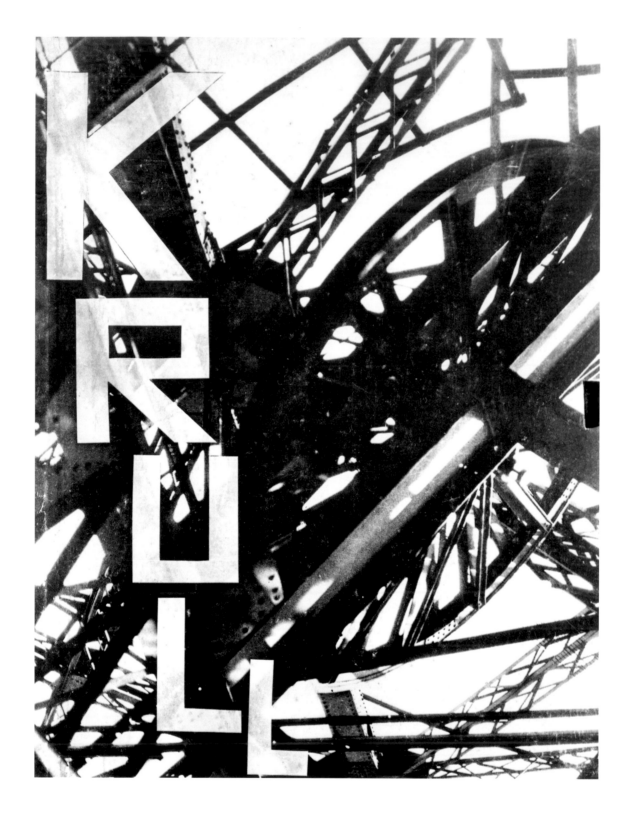

PLATE 4.7
COVER, *MÉTAL*, 1928,
COLLOTYPE, 23.5 x 17.1 CM.,
GERMAINE KRULL NACHLASS,
MUSEUM FOLKWANG, ESSEN

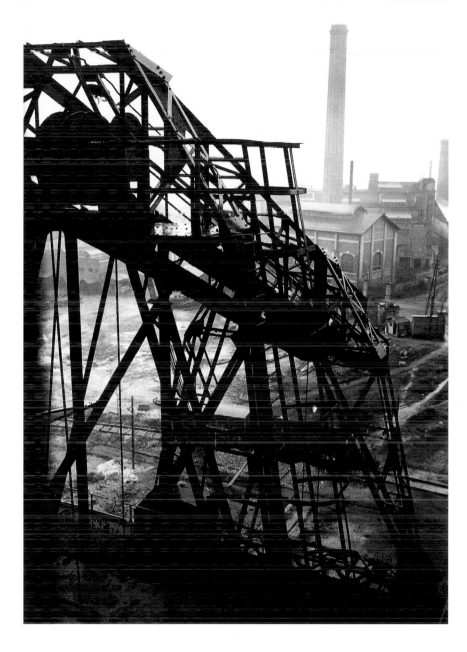

PLATE 4.8
UNTITLED [*MÉTAL*, PLATE 14],
C. 1925–1928,
GELATIN SILVER PRINT, 16.8 x 11.9 CM.,
COLLECTION A. JAMMES, PARIS

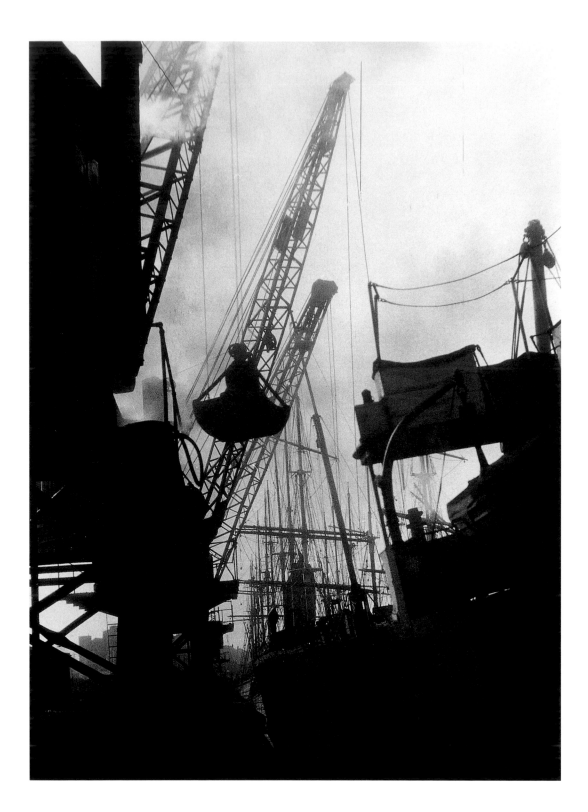

PLATE 4.9
UNTITLED. *[MÉTAL.* PLATE 30.
HAMBURG]. C. 1925–1928.
GELATIN SILVER PRINT. 20.5 x 14.7 CM..
ARCHIVE AND MUSEUM OF THE
SOCIALIST LABOUR MOVEMENT
(AMSAB). GHENT

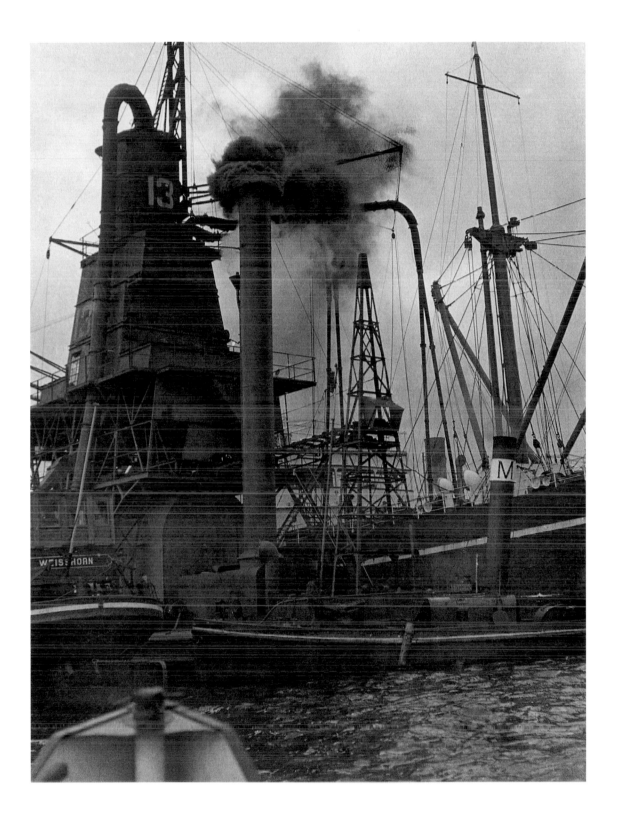

PLATE 4.10
*BUITENLANDSCH GRAAN WORDT
TE ANTWERPEN GELOST*, N.D.,
GELATIN SILVER PRINT, 22.3 x 15.4 CM.,
ARCHIVE AND MUSEUM OF
THE SOCIALIST LABOUR MOVEMENT
(AMSAB), GHENT

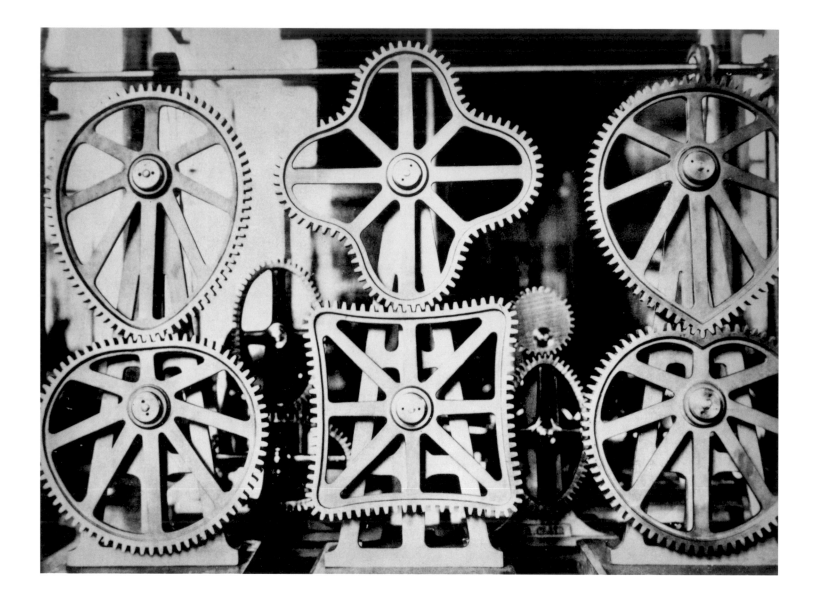

PLATE 4.11
UNTITLED. [*MÉTAL*. PLATE 16]. 1928.
COLLOTYPE. 17.2 x 23.5 CM.,
GERMAINE KRULL NACHLASS,
MUSEUM FOLKWANG, ESSEN

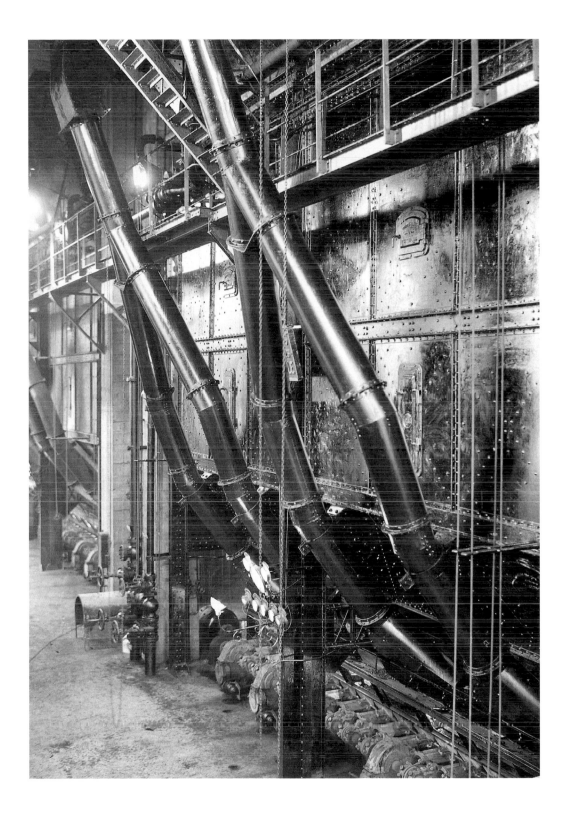

140.141

PLATE 4.12
UNTITLED, [MÉTAL, PLATE 23],
C. 1925–1928,
GELATIN SILVER PRINT, 22.3 x 15.9 CM.,
COLLECTION A. JAMMES, PARIS

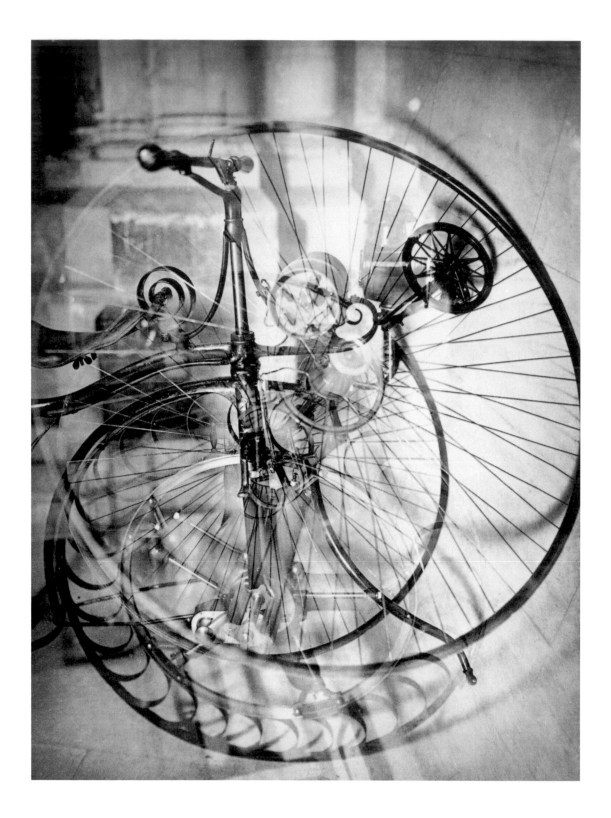

PLATE 4.13
UNTITLED. [*MÉTAL*, PLATE 22]. 1928.
COLLOTYPE. 23.2 x 17.1 CM.,
GERMAINE KRULL NACHLASS,
MUSEUM FOLKWANG, ESSEN

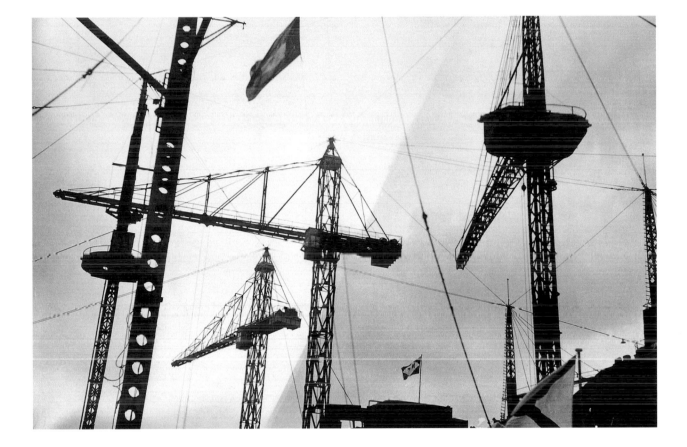

142.143

PLATE 4.14
UNTITLED, [*MÉTAL*, PLATE 9,
AMSTERDAM]. C. 1925–1928.
GELATIN SILVER PRINT, 8.8 x 13.3 CM.,
ARCHIVE AND MUSEUM OF THE
SOCIALIST LABOUR MOVEMENT
(AMSAB), GHENT

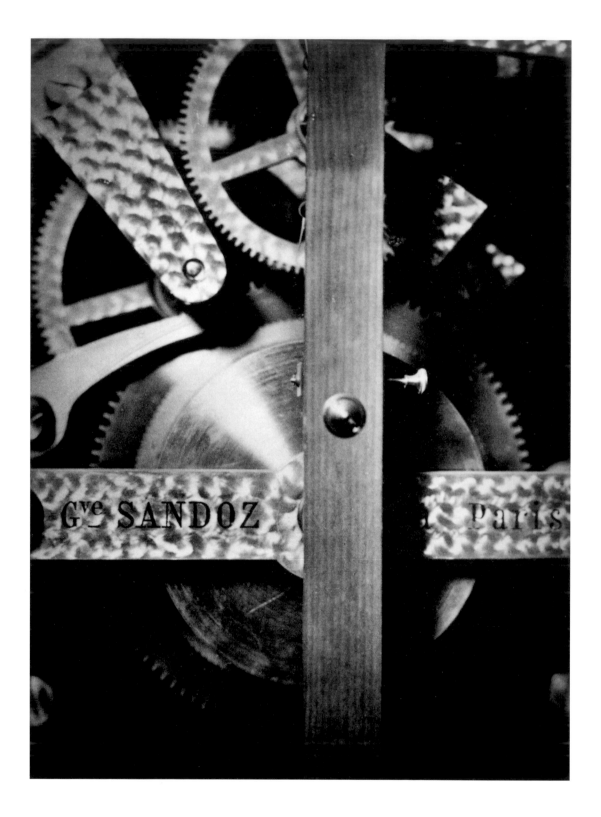

PLATE 4.15
UNTITLED. [*MÉTAL*, PLATE 47],
1928. COLLOTYPE. 23.5 x 17.1 CM.,
GERMAINE KRULL NACHLASS.
MUSEUM FOLKWANG, ESSEN

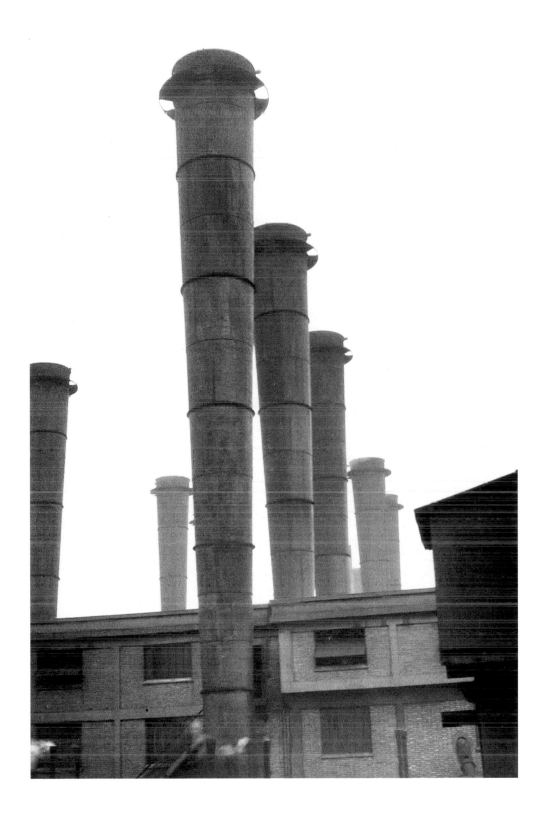

144.145

PLATE 4.16
UNTITLED. [*MÉTAL*. PLATE 8].
C. 1925–1928.
GELATIN SILVER PRINT. 22.1 x 14.8 CM..
COLLECTION A. JAMMES. PARIS

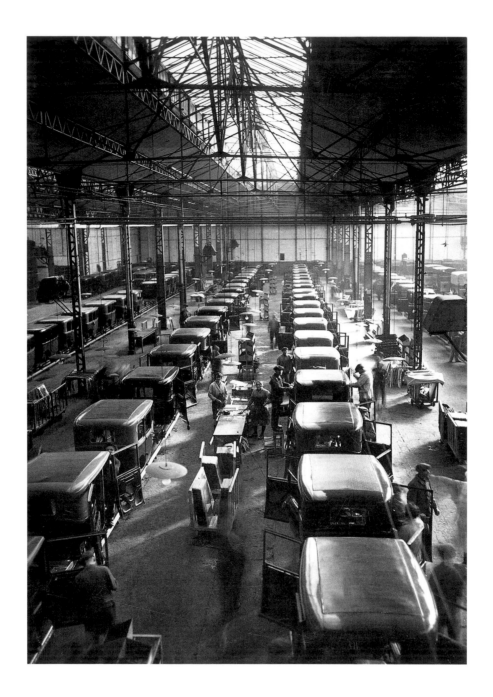

PLATE 4.17
AUTOMOBILE ASSEMBLY LINE, N.D.,
GELATIN SILVER PRINT, 16.1 x 11.1 CM.,
COLLECTION A. JAMMES, PARIS

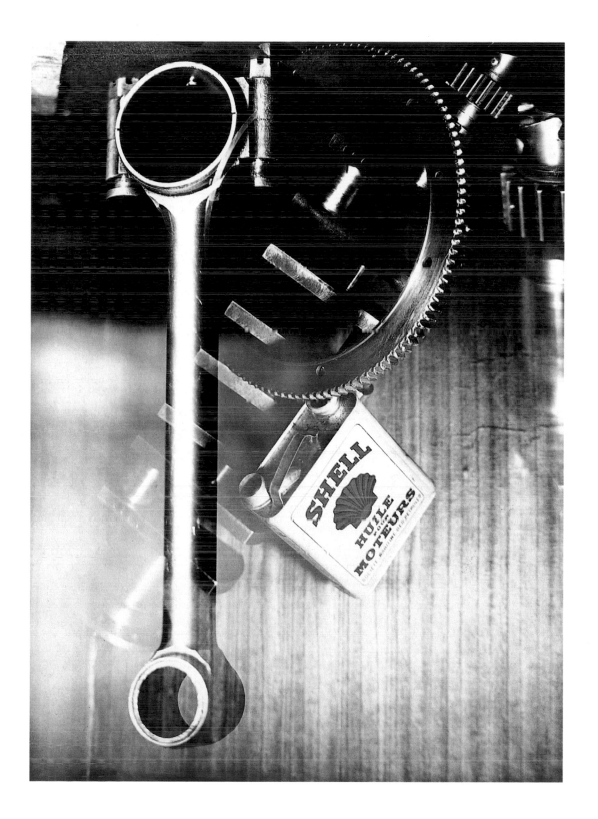

PLATE 4.18
SHELL OIL ADVERTISEMENT, N.D.,
GELATIN SILVER PRINT, 23.1 x 16.9 CM.,
PRIVATE COLLECTION, NEW YORK

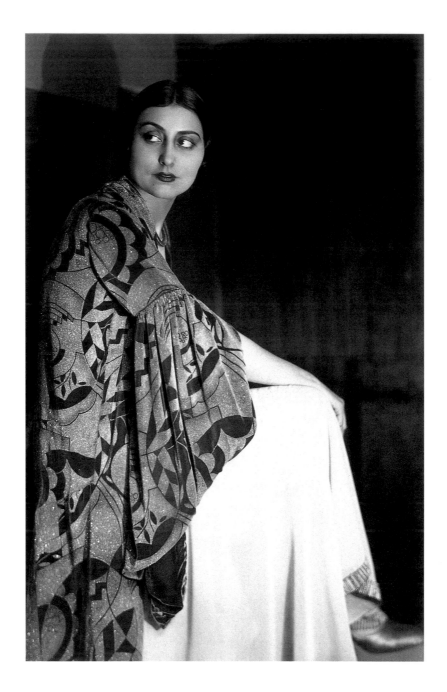

PLATE 5.1
DEMARIA, MODÈLE SONIA DELAUNAY,
LA DANSEUSE RUSSE VIOLETTE
NAPIERSKA, 1926,
GELATIN SILVER PRINT, 21.3 x 13.6 CM.,
PRIVATE COLLECTION, NEW YORK

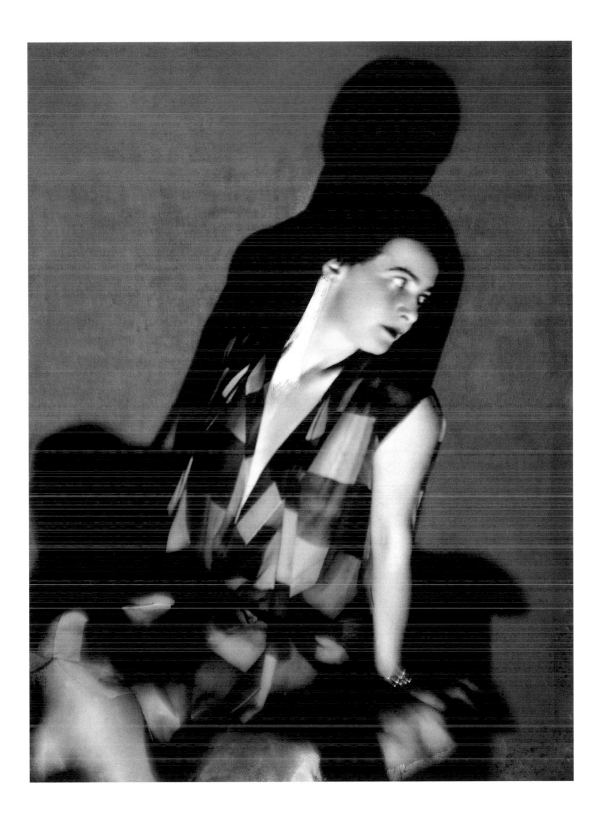

PLATE 5.2
MODEL IN SONIA DELAUNAY
DRESS, C. 1926, NEW GELATIN
SILVER PRINT (1995) FROM GLASS
NEGATIVE, 23.3 x 17.5 CM.,
GERMAINE KRULL NACHLASS,
MUSEUM FOLKWANG, ESSEN

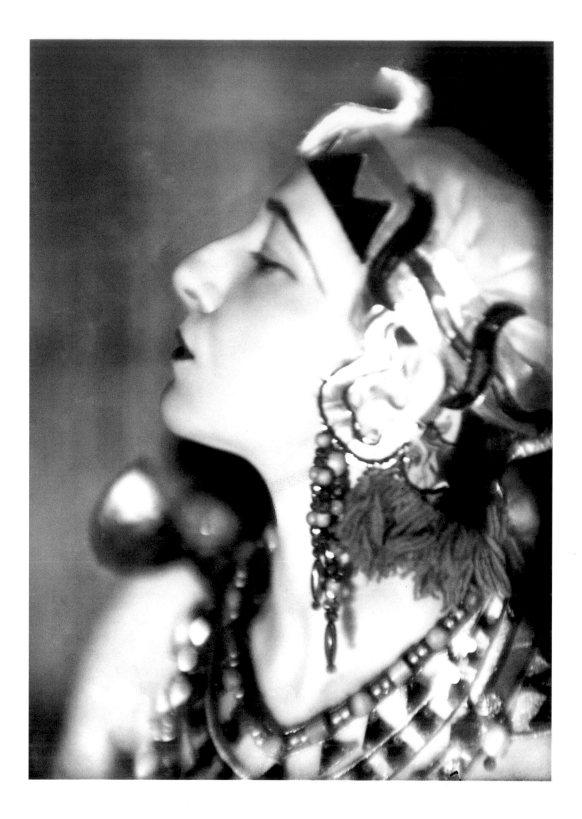

PLATE 5.3
JAVANESE DANCER (PRINCE MAS
MADJA-DJAVA), C. 1930,
NEW GELATIN SILVER PRINT, 1995,
23.7 x 17.2 CM.,
NACHLASS GERMAINE KRULL,
MUSEUM FOLKWANG, ESSEN

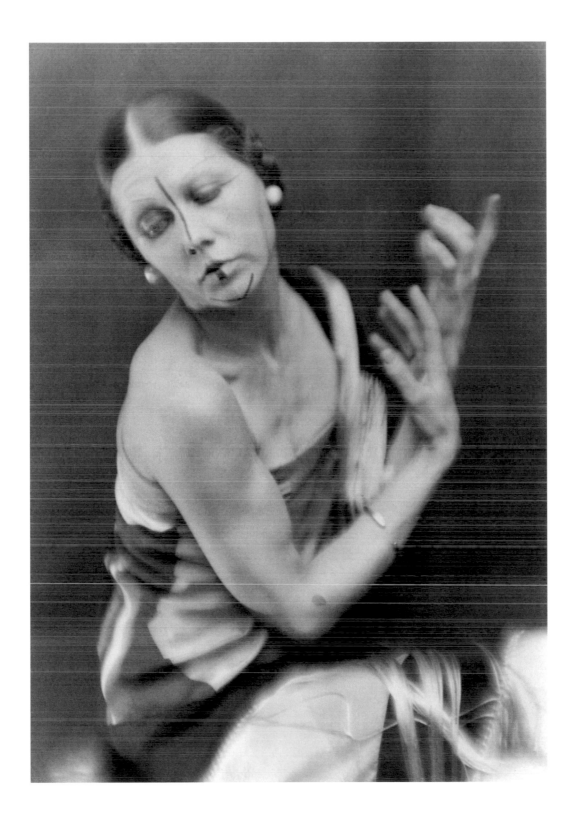

PLATE 5.4
*LIZICA CODRIANO IN A SONIA
DELAUNAY DRESS*, 1926,
GELATIN SILVER PRINT, 22 x 15.3 CM.,
DONATION SONIA DELAUNAY,
BIBLIOTHÈQUE NATIONALE DE
FRANCE, PARIS

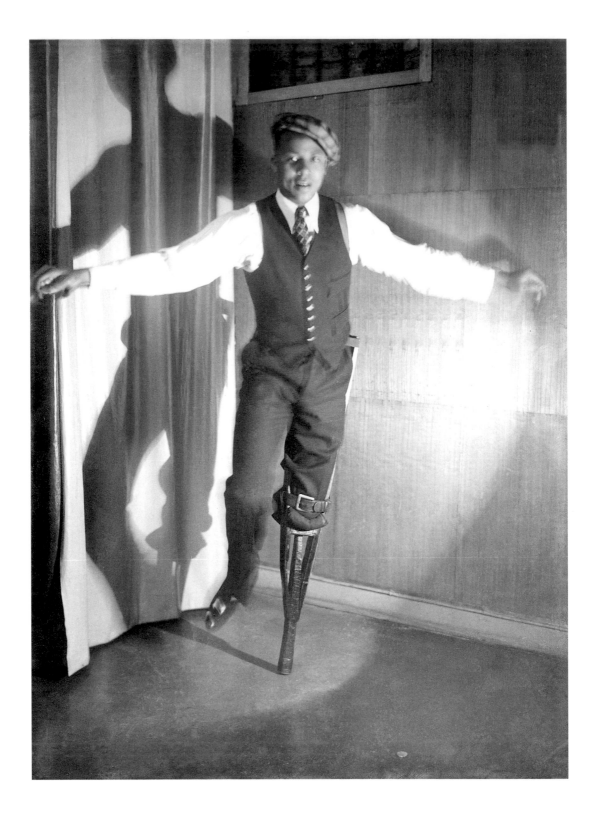

PLATE 5.5
BLACKBIRD DANCER. C. 1929.
NEW GELATIN SILVER PRINT. 1995. 24 x 17.7 CM.
GERMAINE KRULL NACHLASS.
MUSEUM FOLKWANG, ESSEN

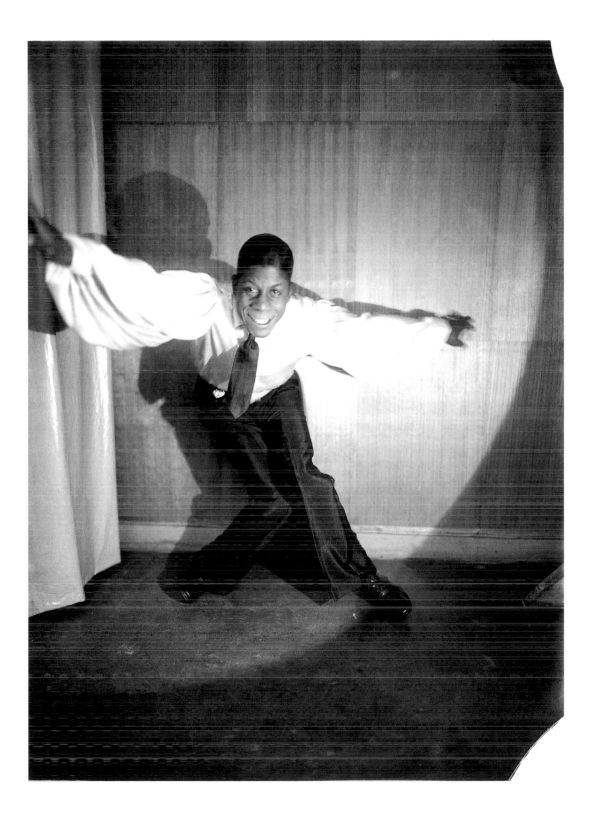

PLATE 5.6
EARL TUCKER, C. 1929,
NEW GELATIN SILVER PRINT, 1995,
24 x 17.7 CM.,
GERMAINE KRULL NACHLASS,
MUSEUM FOLKWANG, ESSEN

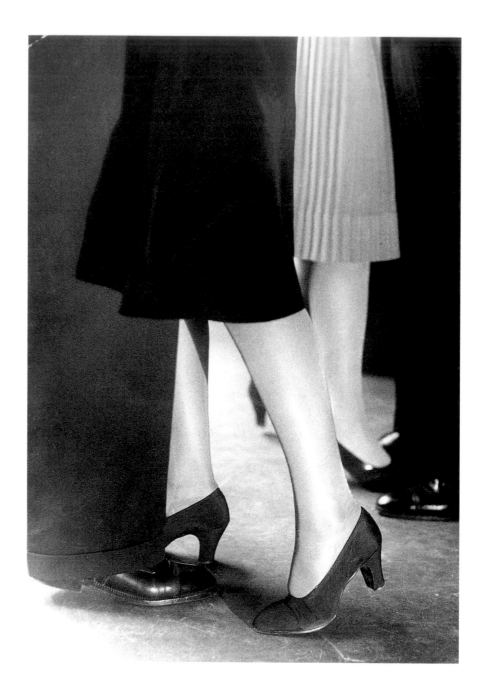

PLATE 5.7
DANCING COUPLE, N.D.,
GELATIN SILVER PRINT, 15.3 x 10.6 CM.,
COLLECTION GALERIE 1900, PARIS

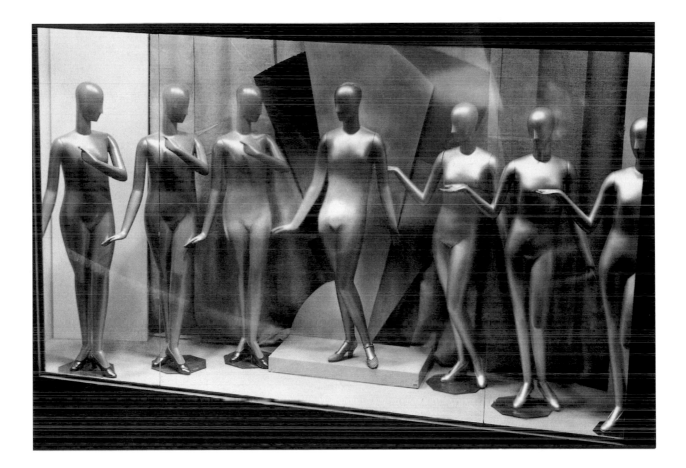

154.155

PLATE 5.8
MANNEQUINS, N.D.,
GELATIN SILVER PRINT, 10.9 x 15.8 CM.,
ARCHIVE AND MUSEUM OF THE
SOCIALIST LABOUR MOVEMENT
(AMSAB), GHENT

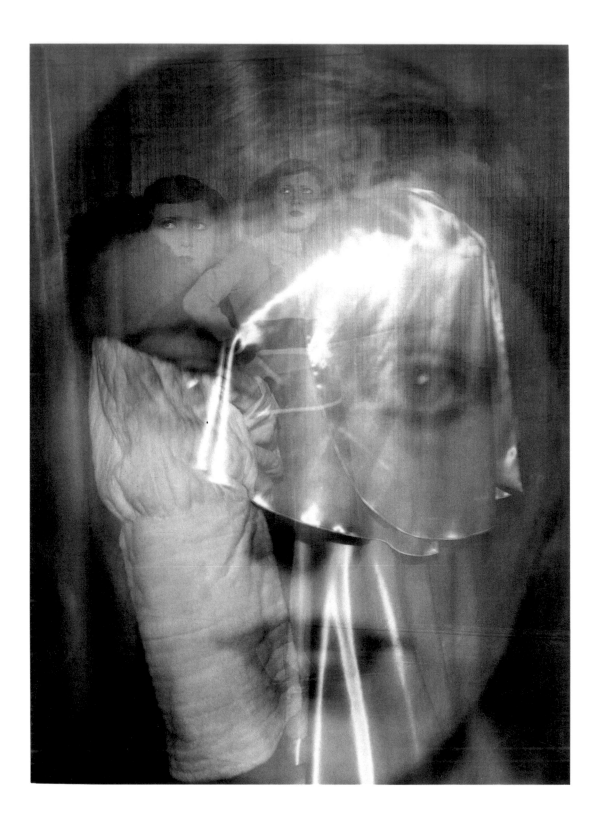

PLATE 5.9
ETUDE, N.D.,
GELATIN SILVER PRINT, 22.6 x 16.7 CM.,
COLLECTION A. JAMMES, PARIS

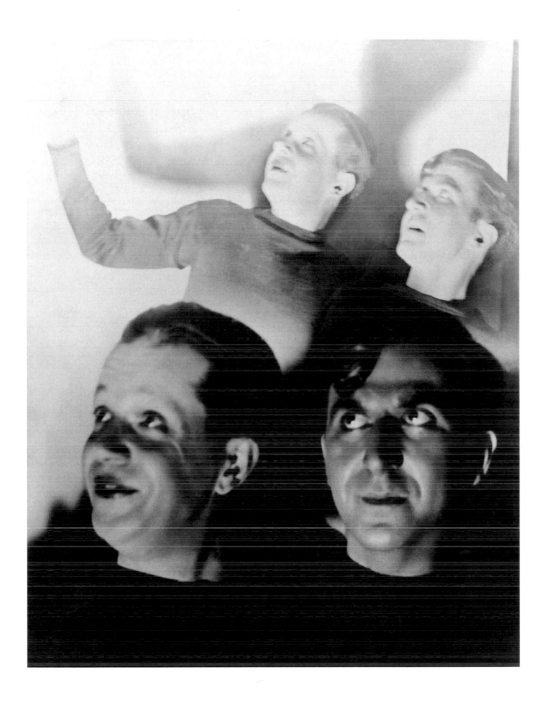

PLATE 5.10
JULES AND JULIEN,
GELATIN SILVER PRINT, 30.1 x 24.0 CM.,
GERMAINE KRULL NACHLASS,
MUSEUM FOLKWANG, ESSEN

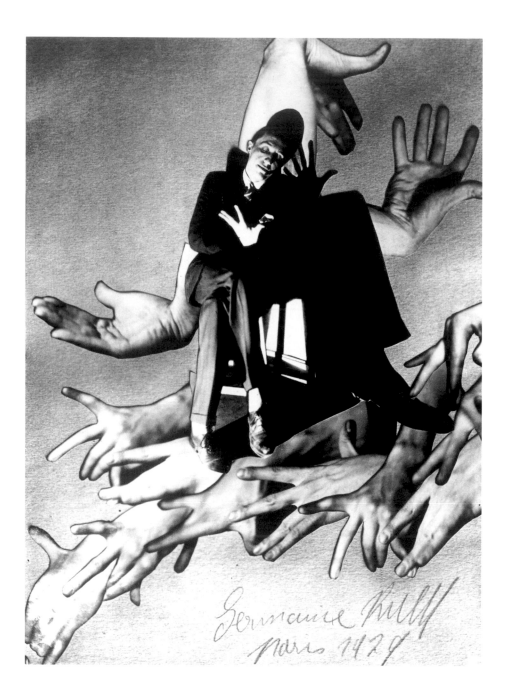

PLATE 5.11
PAL RAB, 1929
GELATIN SILVER PRINT, 16 x 12.2 CM.,
ARCHIVE AND MUSEUM OF THE
SOCIALIST LABOUR MOVEMENT
(AMSAB), GHENT

PLATE 5.12
L'ÉCRIVAIN RUDOLF LEONHARD, BERLIN,
N. D., GELATIN SILVER PRINT, 21.1 x 16 CM.,
ARCHIVE AND MUSEUM OF THE
SOCILAIST LABOUR MOVEMENT (AMSAB),
GHENT

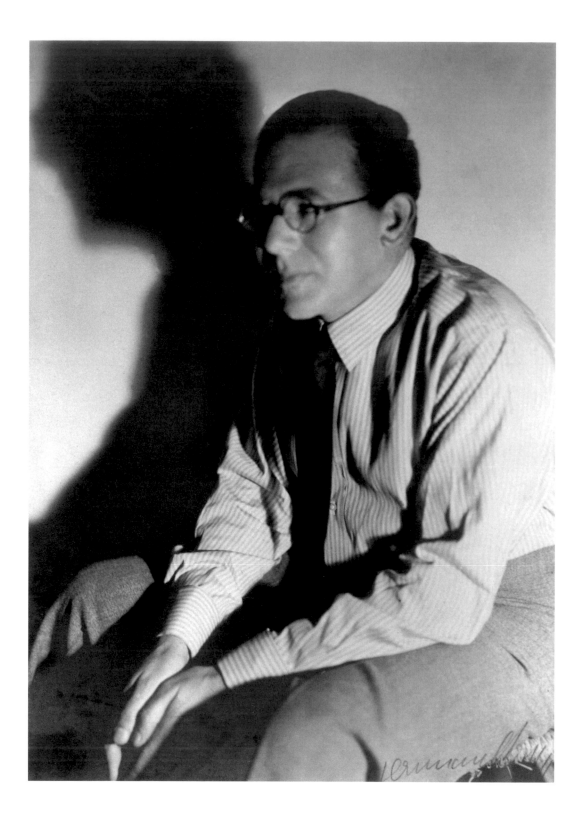

PLATE 5.13
FRIEDRICH POLLOCK, 1923,
GELATIN SILVER PRINT, 16.0 x 22.5 CM.,
MAX-HORKHEIMER-ARCHIV,
STADT- UND UNIVERSITÄTSBIBLIOTHEK,
FRANKFURT

PLATE 5.14
WALTER BENJAMIN. 1926
GELATIN SILVER PRINT. 16.5 x 12.1 CM..
COURTESY OF THE LEO BAECK
INSTITUTE. NEW YORK AND ANOTHER
PRINT, COLLECTION GARY SMITH,
BERLIN

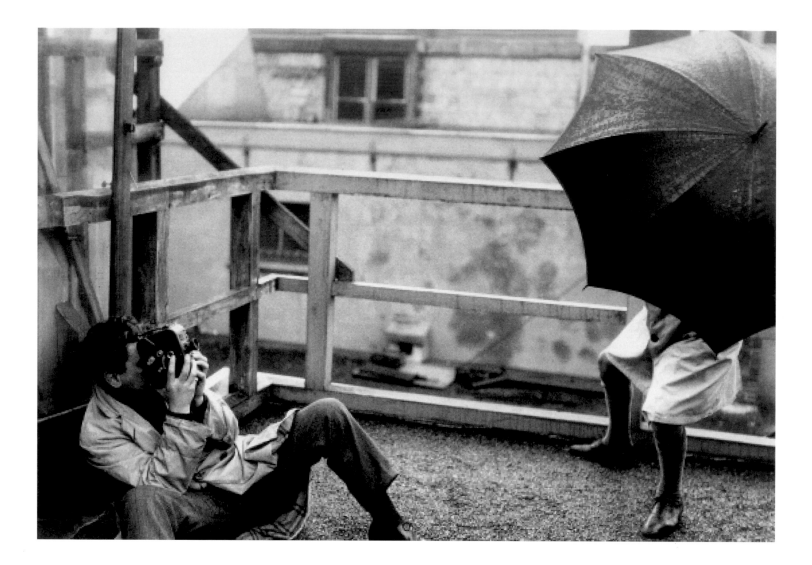

PLATE 5.15
JORIS IVENS FILMING *REGEN*, 1928.
GELATIN SILVER PRINT, 15.8 x 22.8 CM.,
PRIVATE COLLECTION, NEW YORK

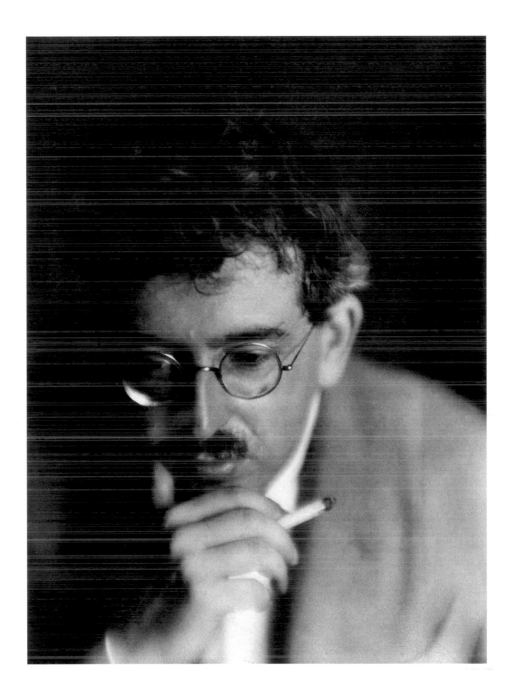

PLATE 5.14
WALTER BENJAMIN, 1926.
GELATIN SILVER PRINT, 16.5 x 12.1 CM.,
COURTESY OF THE LEO BAECK
INSTITUTE, NEW YORK AND ANOTHER
PRINT, COLLECTION GARY SMITH,
BERLIN

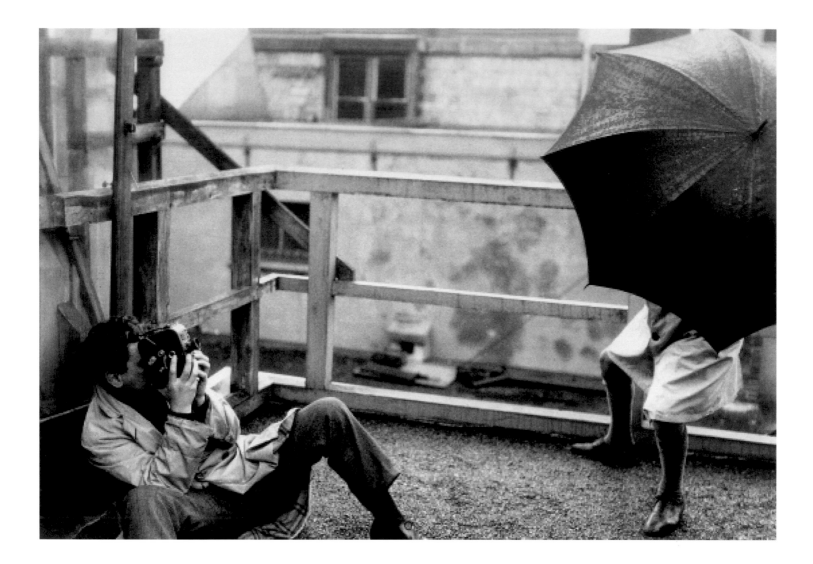

PLATE 5.15
JORIS IVENS FILMING *REGEN*, 1928.
GELATIN SILVER PRINT, 15.8 x 22.8 CM.,
PRIVATE COLLECTION, NEW YORK

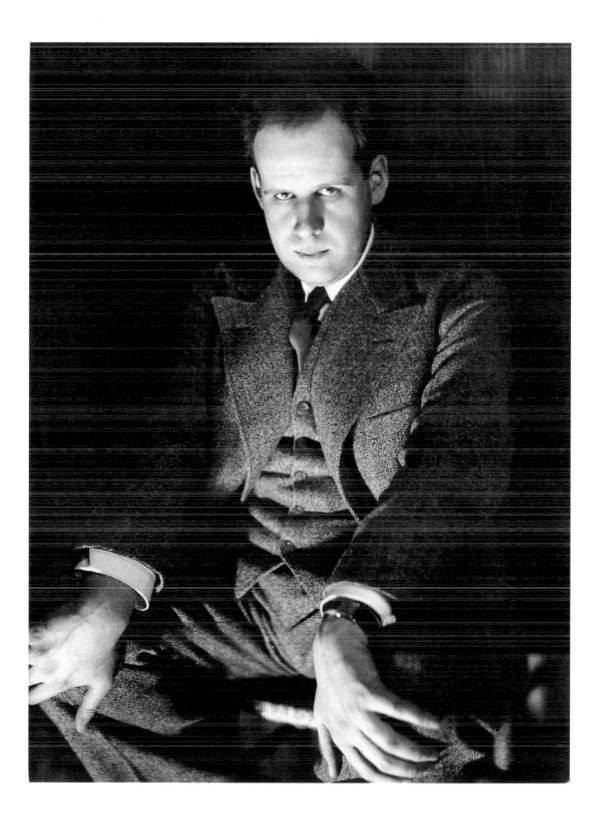

PLATE 5.16
S. M. EISENSTEIN. C. 1926.
GELATIN SILVER PRINT, 21.9 x 16.9 CM.,
COLLECTION DR. CHRISTIAN
BRANDSTÄTTER, VIENNA

PLATE 5.17
S. M. EISENSTEIN, 1930.
GELATIN SILVER PRINT, 16.8 x 22.9 CM.,
PRIVATE COLLECTION, NEW YORK

PLATE 5.18
ETUDE. [MRS. HUBBELL]. 1931.
GELATIN SILVER PRINT. 23.1 x 17.3 CM.,
PRIVATE COLLECTION. NEW YORK

PLATE 5.19
JEAN COCTEAU, C. 1930
GELATIN SILVER PRINT, 23.8 x 16.8 CM.,
GERMAINE KRULL NACHLASS,
MUSEUM FOLKWANG, ESSEN

PLATE 5.20
JEAN COCTEAU, C. 1929,
GELATIN SILVER PRINT, 22.3 x 16.6 CM.,
COLLECTION THOMAS WALTHER,
NEW YORK

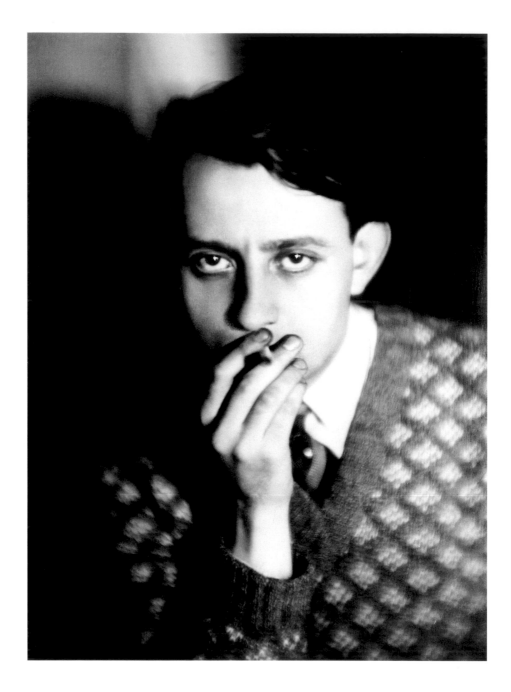

PLATE 5.21
ANDRÉ MALRAUX, 1930,
GELATIN SILVER PRINT, 17.0 x 12.8 CM.,
GERMAINE KRULL NACHLASS, MUSEUM
FOLKWANG, ESSEN

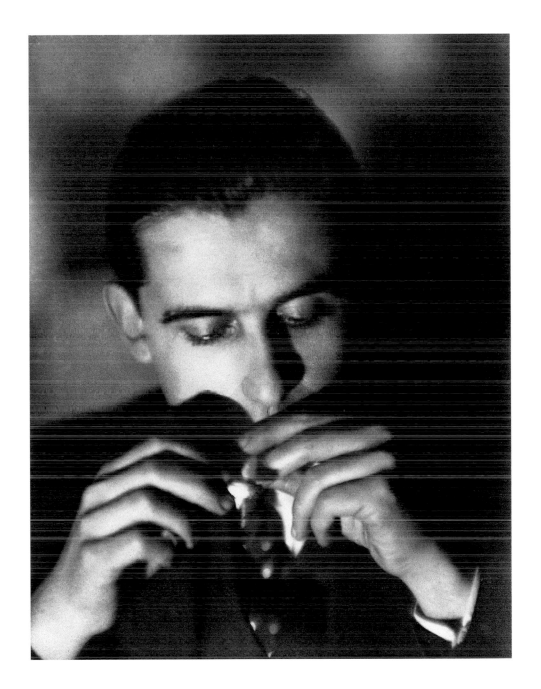

PLATE 5.22

JACQUES HAUMONT, C. 1930.

GELATIN SILVER PRINT, 20.9 x 16.4 CM.,

COLLECTION A. JAMMES, PARIS

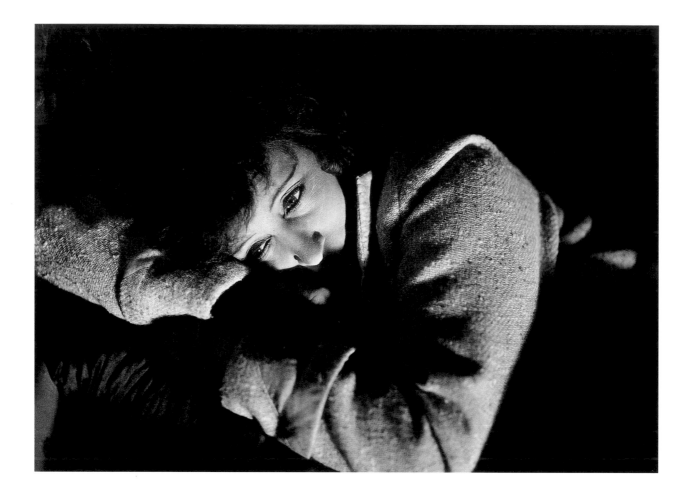

PLATE 5.23
COLETTE, 1930.
GELATIN SILVER PRINT, 12.7 x 17.6 CM.,
GERMAINE KRULL NACHLASS,
MUSEUM FOLKWANG, ESSEN

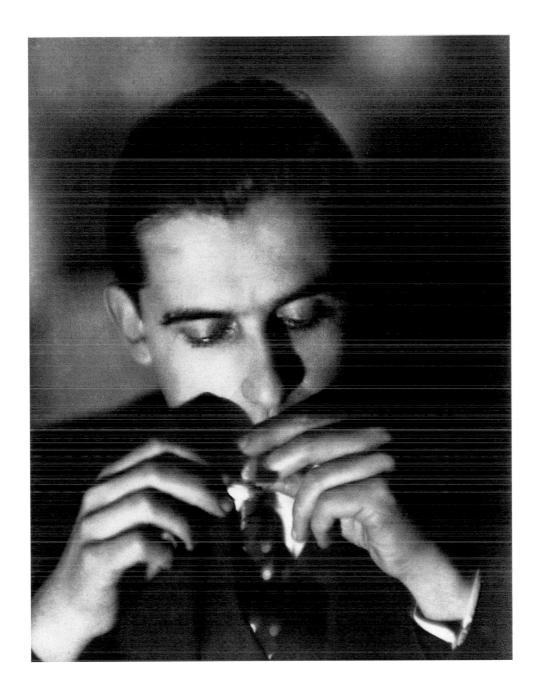

PLATE 5.22
JACQUES HAUMONT, C. 1930.
GELATIN SILVER PRINT, 20.8 x 16.4 CM.,
COLLECTION A. JAMMES, PARIS

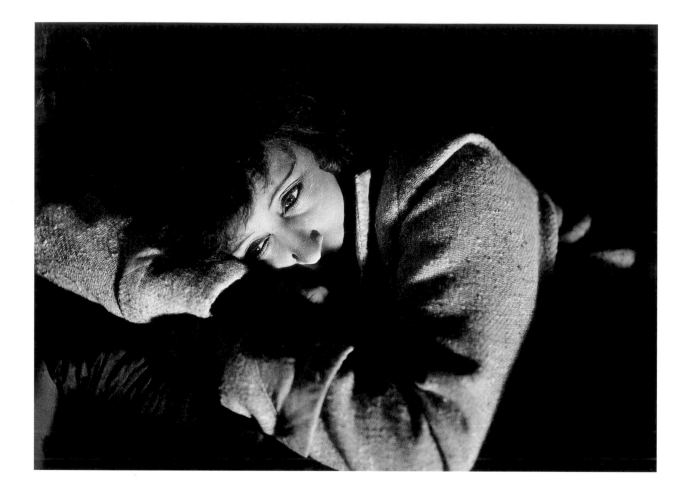

PLATE 5.23
COLETTE, 1930.
GELATIN SILVER PRINT, 12.7 x 17.6 CM.,
GERMAINE KRULL NACHLASS,
MUSEUM FOLKWANG, ESSEN

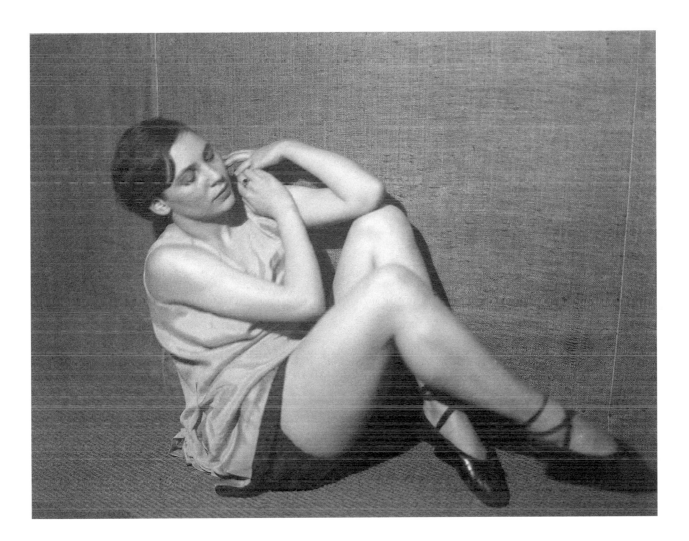

PLATE 5.24
BERTHE KRULL. 1928.
GELATIN SILVER PRINT. 15.6 x 20.1 CM.,
GALERIE BODO NIEMANN. BERLIN

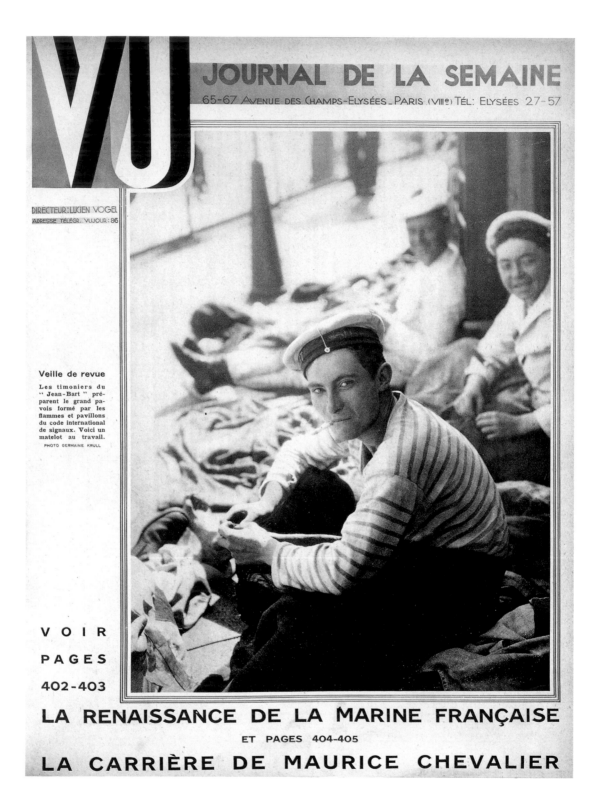

VU

JOURNAL DE LA SEMAINE

65-67 Avenue des Champs-Elysées _ Paris (VIIIᵉ) Tél: Elysées 27-57

DIRECTEUR: LUCIEN VOGEL
ADRESSE TÉLÉGR. VUJOUR: 86

Veille de revue

Les timoniers du "Jean-Bart" préparent le grand pavois formé par les flammes et pavillons du code international de signaux. Voici un matelot au travail.

PHOTO GERMAINE KRULL

VOIR
PAGES
402-403

LA RENAISSANCE DE LA MARINE FRANÇAISE

ET PAGES 404-405

LA CARRIÈRE DE MAURICE CHEVALIER

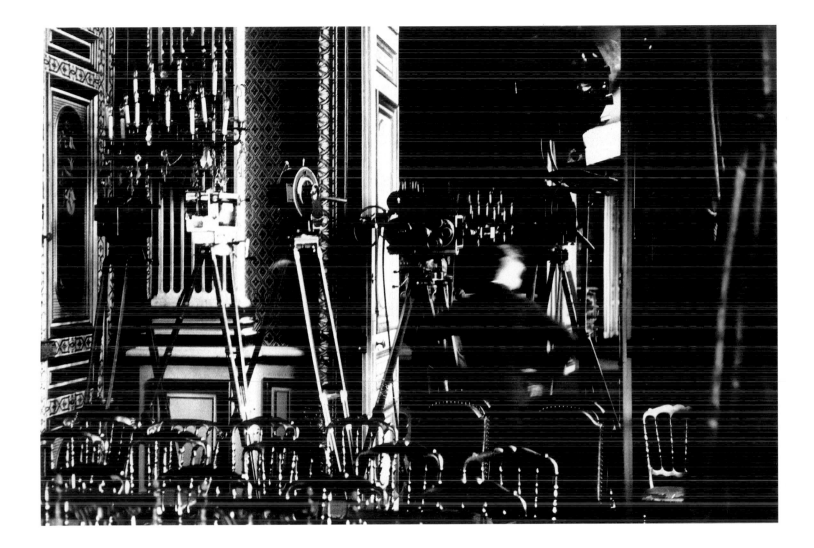

PLATE 6.2
CAMERAMEN'S PREPARATIONS
BEFORE THE SIGNING OF THE
KELLOGG-BRIAND PACT, AUGUST 1928,
GELATIN SILVER PRINT, 14.7 x 21.2 CM.,
PRIVATE COLLECTION, NEW YORK

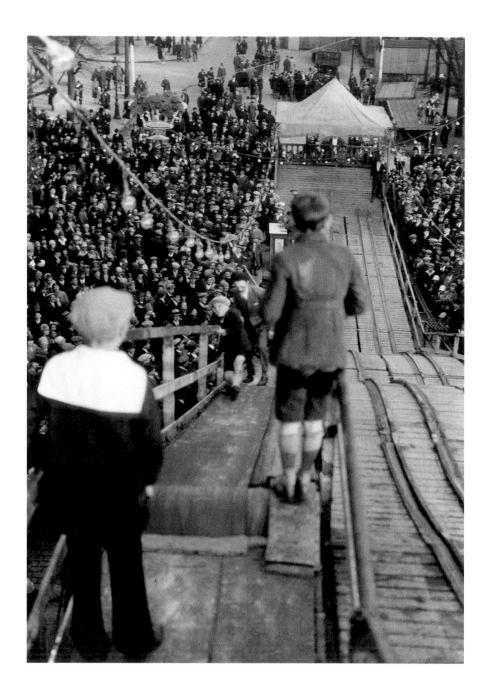

PLATE 6.3
STREET FAIR, THE SLIDE, N.D.,
GELATIN SILVER PRINT, 20.0 x 14.9 CM.,
MUSEUM FOLKWANG, ESSEN

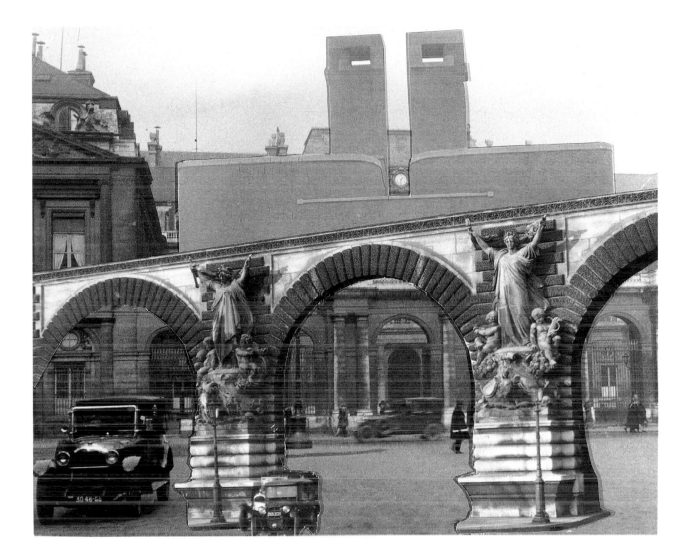

PLATE 6.4
PARIS. N.D..
PHOTOMONTAGE 11 9 x 18 2 CM .
COLLECTION LE CLÉZIO, PARIS

Dans toute sa force

PHOTOS
GERMAINE
KRULL

L A Tour. Clocher des ondes. Sa monstruosité incongrue a surpris et irrité. Maintenant, à trois cents mètres du sol, les amoureux y donnent des rendez-vous aux oiseaux. Et les poètes, du' douanier Rousseau à Jean Cocteau, prétendent que les beaux soirs de printemps, des fées jouent au toboggan sur ses élytres. La Tour demeure l'ultime symbole des temps nouveaux. En quittant New-York et ses palais couronnés de fumées, c'est la Tour Eiffel, balise aérienne, que Lindbergh visait, pour atteindre Paris, au cœur sentimental du monde.

Elle a les pieds dans la Seine qui, jusqu'à Rouen, traîne derrière les remorqueurs la France calculée en tonnes. Il manquait à cette géante une chevelure d'étoiles : on la lui a donnée. L'industrie inscrit maintenant son progrès lumineux sur l'échine nocturne de la Tour. FLORENT FELS.

Poutres, poutrelles, rivets sont ici comme le vers, les mots et la rime. On ne pense plus à la merveille mécanique, au labeur, à la forge, à la mine. On oublie l'ingénieur, l'ouvrier, le manœuvre, pour ne songer qu'au poète inouï, incomparable : EIFFEL.

L'ascenseur, la roue qui entraîne quelques humains jusqu'au royaume des oiseaux, change soudain jusqu'à notre naturel élément. (A gauche.)

En haut, il semble que l'on se détache un peu des contingences terrestres. On glisse en pensée tout le long, le long de la Tour, jusqu'à la pointe de sa sœur d'ombre, qui gît comme l'aiguille d'un cadran solaire. (A droite.)

PLATE 6.6
FLORENT FELS. "DANS TOUTE SA FORCE." *VU* 11 (31 MAY 1928): 284.
PHOTOGRAPHS BY GERMAINE KRULL

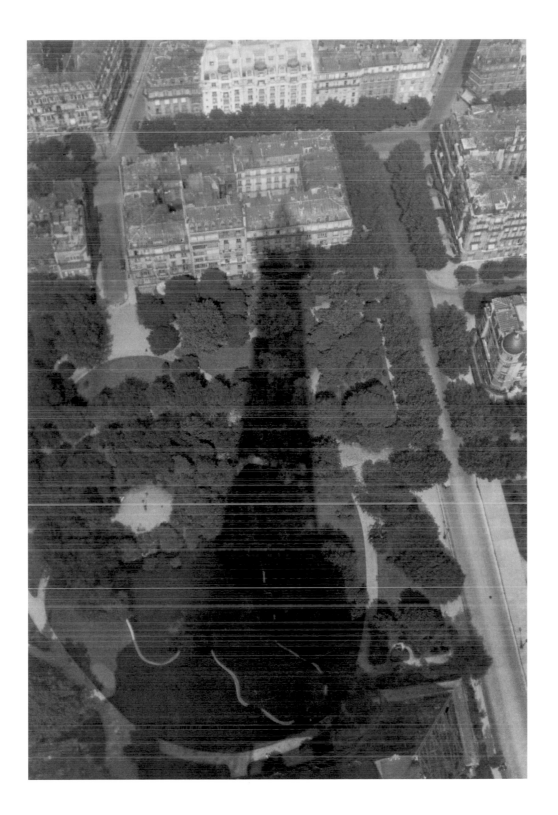

PLATE 6.7
GERMAINE KRULL. GERMAN BORN
IN POLAND 1897–1985.
SHADOW OF THE EIFFEL TOWER, PARIS.
SILVER GELATIN PRINT. 1925–1930. 22.2 x 15.3 CM..
PHOTOGRAPHY PURCHASE ACCOUNT, 1984. 1202.
PHOTOGRAPH © 1997, THE ART INSTITUTE OF CHICAGO

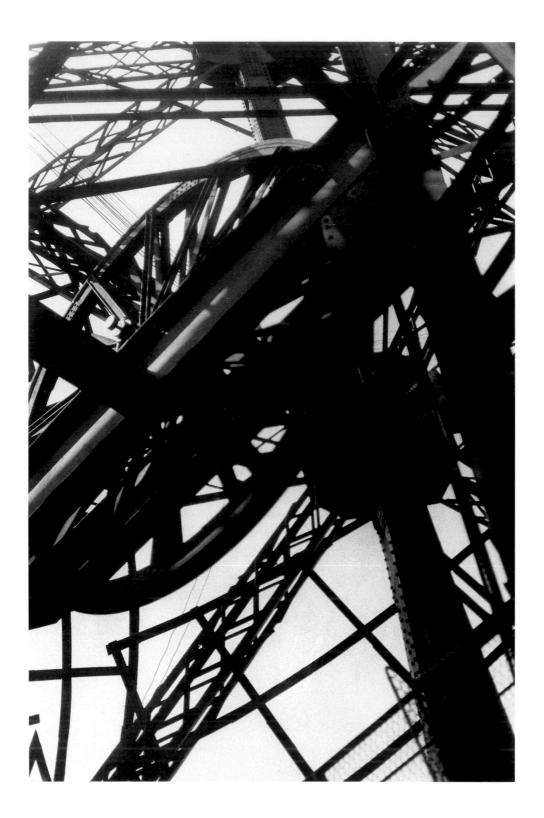

PLATE 6.8

EIFFEL TOWER, C. 1928,

GELATIN SILVER PRINT, 22 x 14.5 CM.,

PRIVATE COLLECTION, PARIS

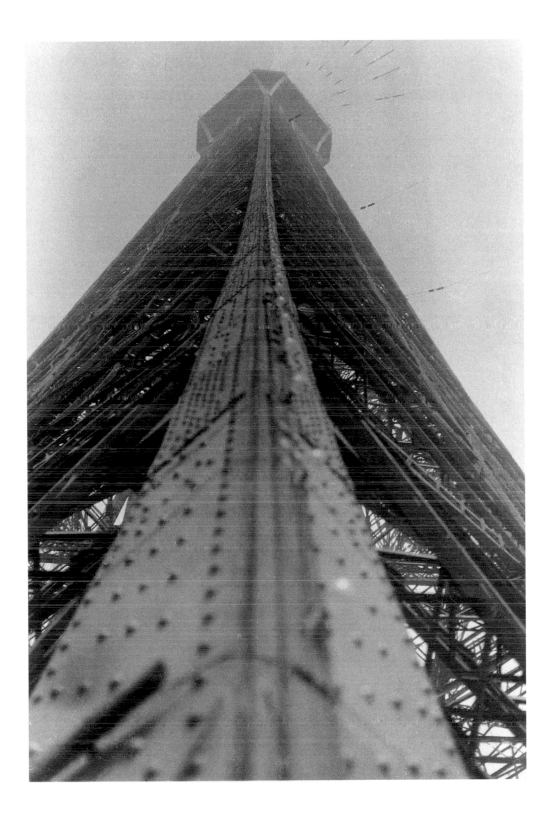

PLATE 6.9
LA TOUR, 1928.
GELATIN SILVER PRINT, 22.0 x 16.2 CM.,
MUSEUM FOLKWANG, ESSEN

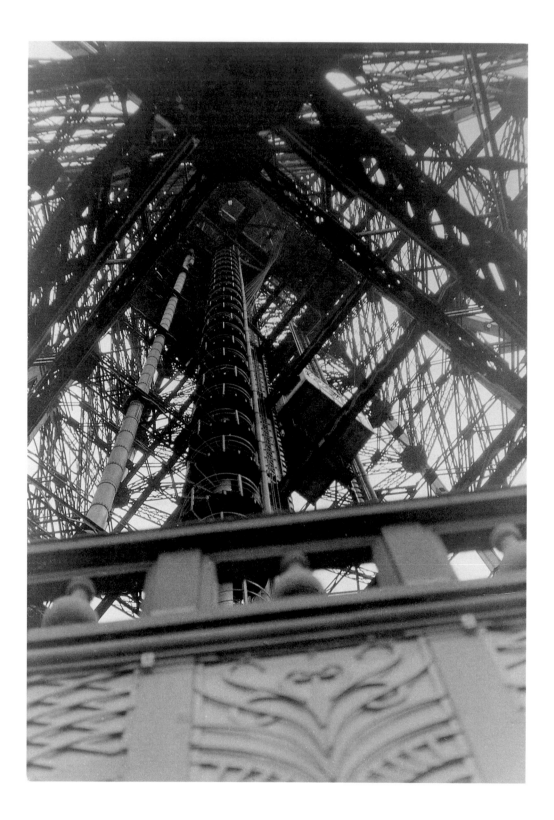

PLATE 6.10
EIFFEL TOWER
[*MÉTAL*. PLATE 50]. C. 1928.
GELATIN SILVER PRINT. 22.8 x 15.5 CM..
MUSEUM FOLKWANG. ESSEN

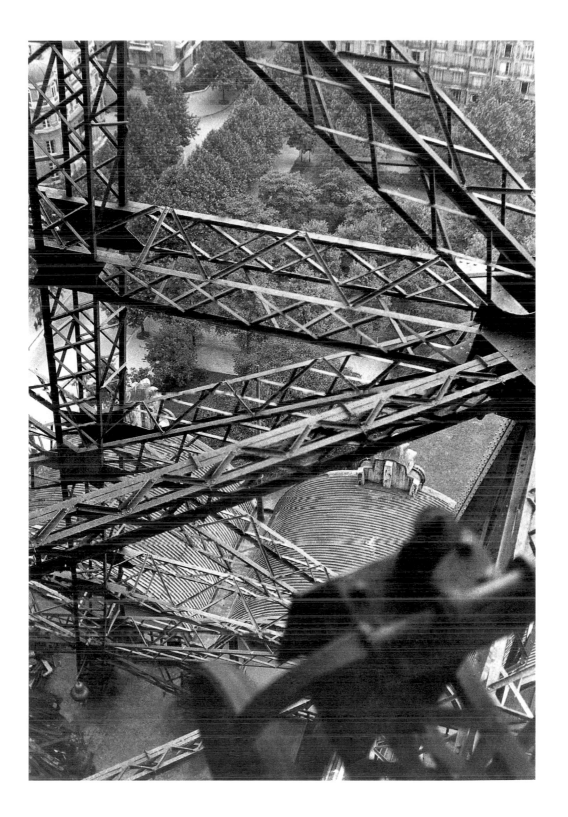

PLATE 6.11
LA TOUR EIFFEL—PARIS. PRISE DE VUE
DU 1ER ÉTAGE.
[*MÉTAL*, PLATE 64]. C. 1928.
GELATIN SILVER PRINT, 22.3 x 15.5 CM.,
MUSEUM FOLKWANG, ESSEN

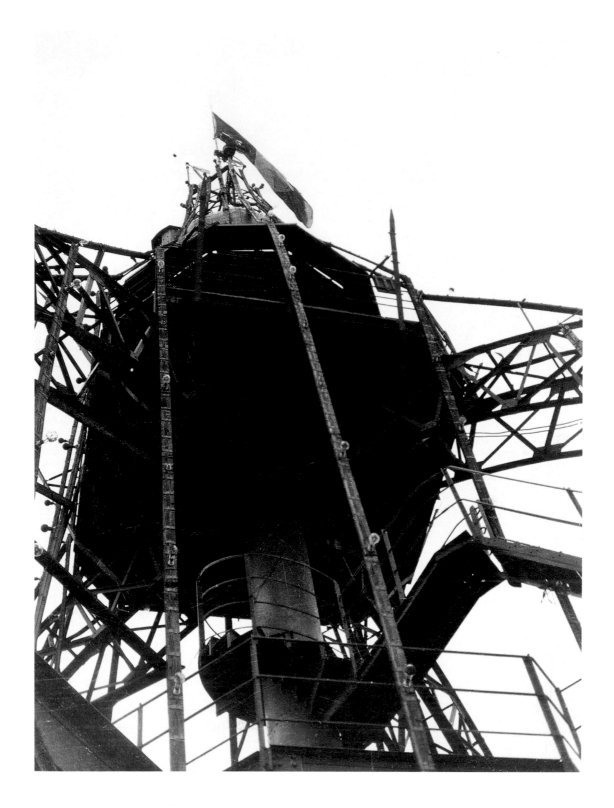

PLATE 6.12
TOUR, C. 1928.
GELATIN SILVER PRINT, 20.2 x 15.2 CM.,
MUSEUM FOLKWANG, ESSEN

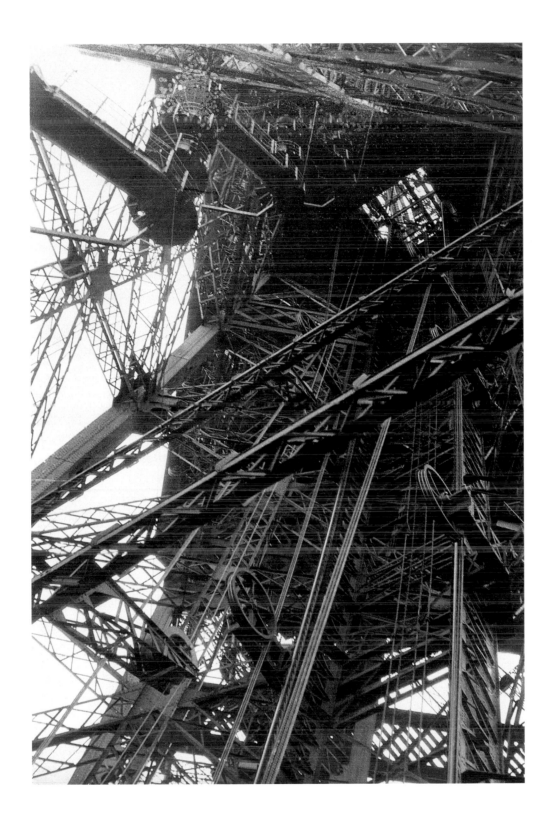

PLATE 6.13
EIFFEL TOWER
[*MÉTAL*, PLATE 2], C. 1928,
GELATIN SILVER PRINT, 22.6 x 15.2 CM.,
MUSEUM FOLKWANG, ESSEN

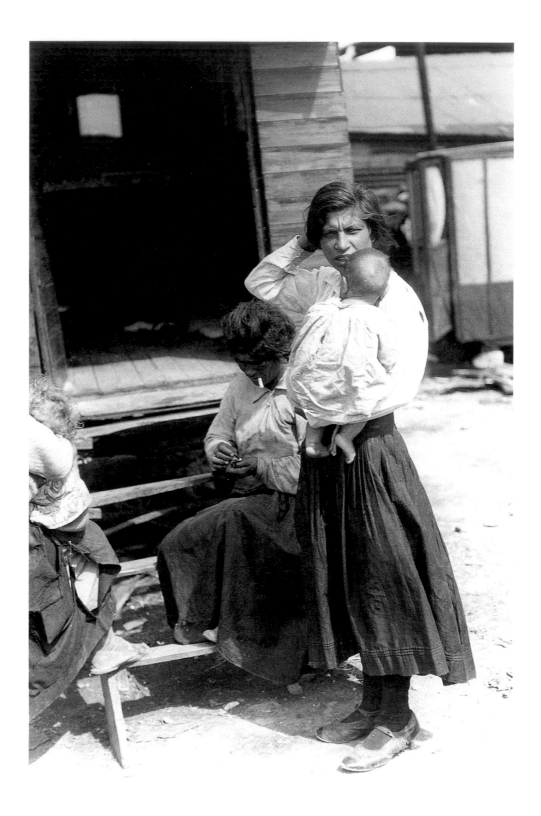

PLATE 6.14

GITANES, 1929.

GELATIN SILVER PRINT, 21.7 x 14.4 CM.,

COLLECTION A. JAMMES, PARIS

PLATE 6.15
LA REFUGE, 1929.
GELATIN SILVER PRINT, 18.4 x 13.3 CM.,
COLLECTION A. JAMMES, PARIS

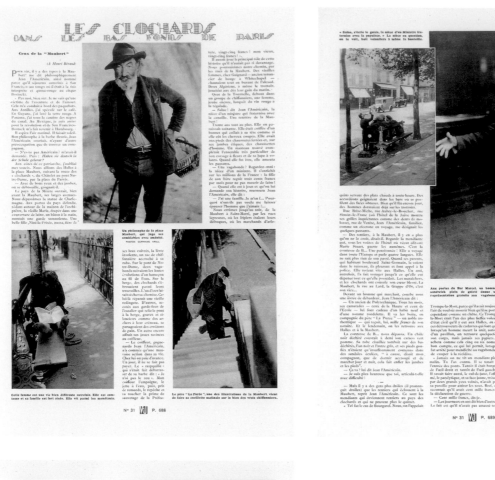

PLATE 6.16
HENRI DANJOU. "LES CLOCHARDS
DANS LES BAS-FONDS DE
PARIS—CEUX DE LA 'MAUBERT.'"
VU 31 (17 OCTOBER 1928): 688.
PHOTOGRAPHS BY GERMAINE KRULL

PLATE 6.17
HENRI DANJOU. "LES CLOCHARDS
DANS LES BAS-FONDS DE
PARIS—CEUX DE LA 'MAUBERT.'"
VU 31 (17 OCTOBER 1928): 689.
PHOTOGRAPHS BY GERMAINE KRULL

PLATE 6.18
HENRI DANJOU. "LES CLOCHARDS
DANS LES BAS-FONDS DE
PARIS—CEUX DE LA 'MAUBERT.'"
VU 31 (17 OCTOBER 1928): 690.
PHOTOGRAPHS BY GERMAINE KRULL

PLATE 6.19
CLOCHARDE. 1928.
GELATIN SILVER PRINT. 21.5 x 15 CM.
COLLECTION SYLVIO PERLSTEIN.
ANTWERP

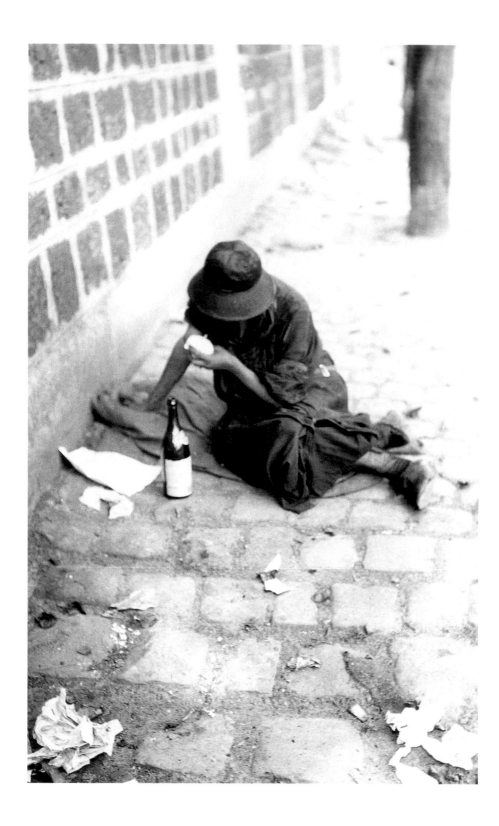

PLATE 6.20
CLOCHARDE, 1928,
GELATIN SILVER PRINT, 20.2 x 12.5 CM.,
COLLECTION A. JAMMES, PARIS

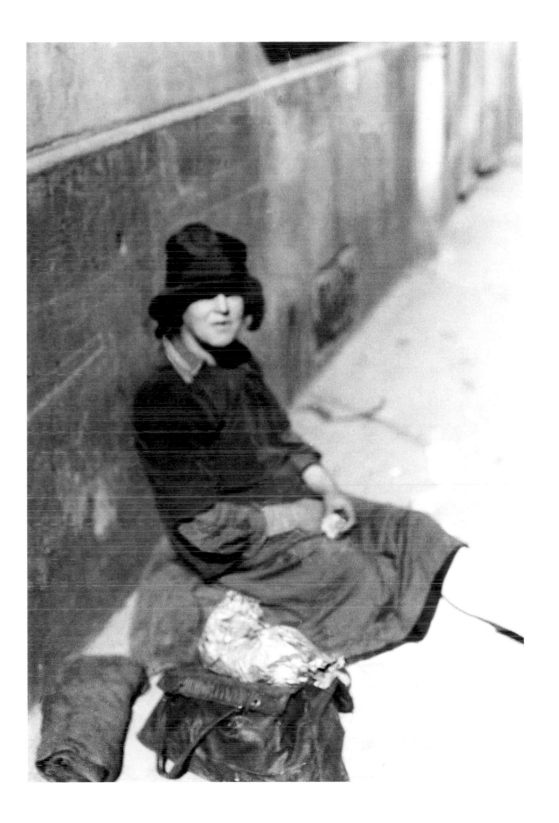

PLATE 6.21
CLOCHARDE, C. 1928.
GELATIN SILVER PRINT, 21.9 x 14.8 CM.,
MUSEUM FOLKWANG, ESSEN

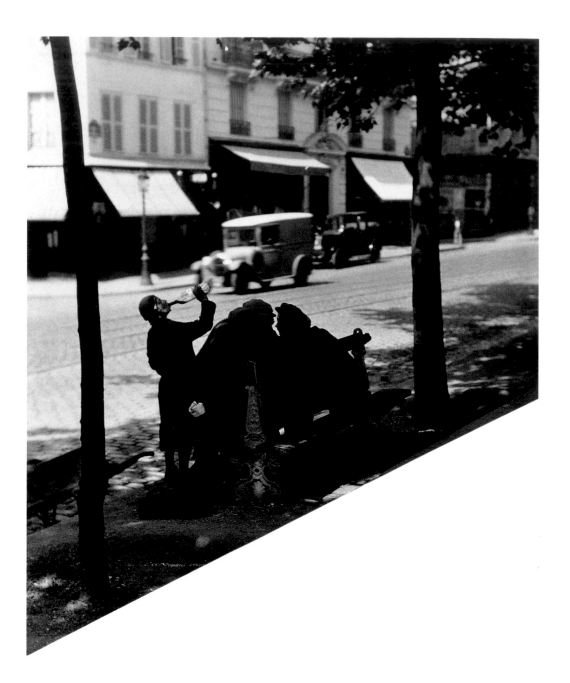

PLATE 6.22
CLOCHARDS, 1928.
GELATIN SILVER PRINT, 15.0 x 10.1 CM.,
ARCHIVE AND MUSEUM OF THE
SOCIALIST LABOUR MOVEMENT
(AMSAB), GHENT

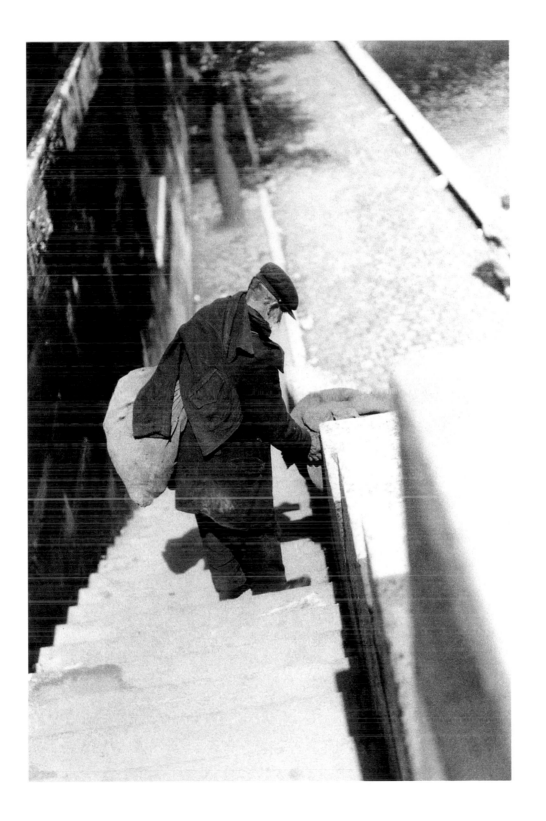

PLATE 6.23
CLOCHARD, [PÈRE LA PURÉE], 1928,
GELATIN SILVER PRINT, 21.7 x 14.4 CM.,
MUSEUM FOLKWANG, ESSEN

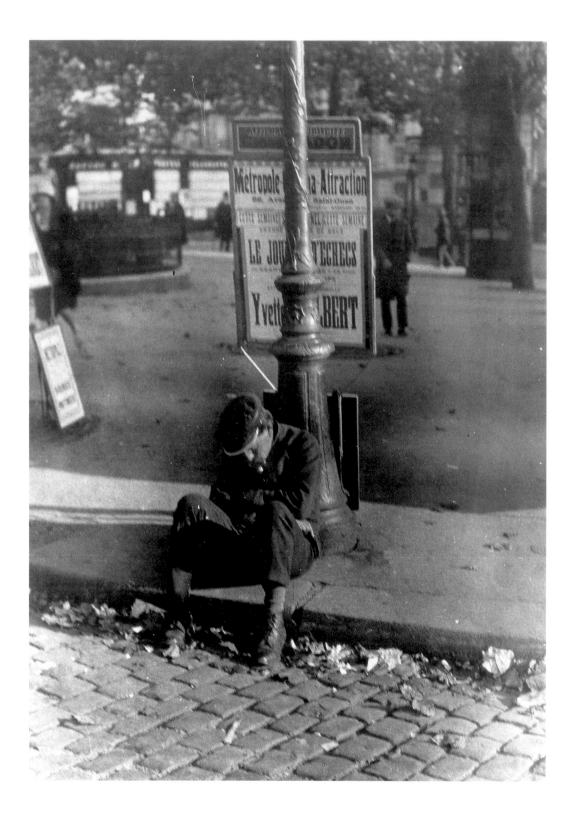

PLATE 6.24

CLOCHARD. N.D..

GELATIN SILVER PRINT. 20.1 x 14.2 CM..

COLLECTION SYLVIO PERLSTEIN.

ANTWERP

194.195

PLATE 6.25
SANS ABRI (SOUS LES PONTS), 1928,
GELATIN SILVER PRINT, 21.0 x 14.3 CM.,
MUSEUM FOLKWANG, ESSEN

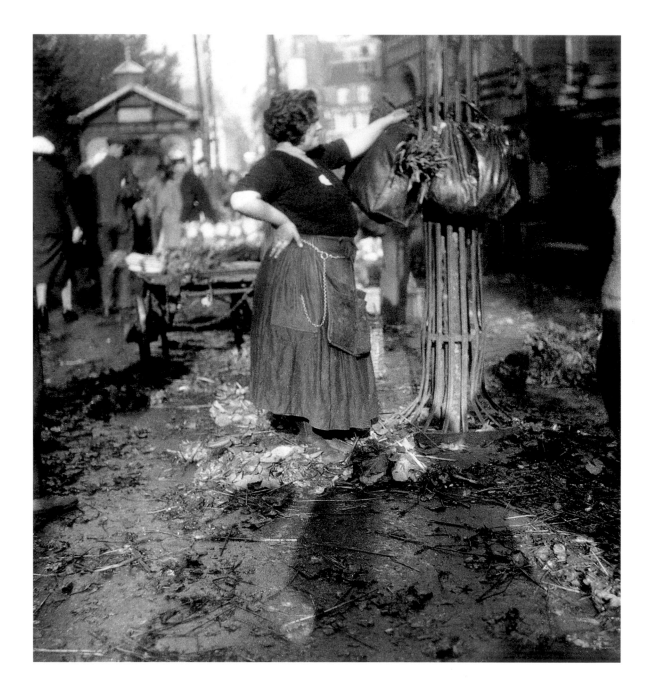

PLATE 6.26

LES HALLES, PARIS, C. 1928,

GELATIN SILVER PRINT, 18.1 x 17.2 CM.,

MUSEUM FOLKWANG, ESSEN

PLATE 6.27
LES HALLES, 9$^1/_2$, RUE DE RIVOLI
ET RUE ST. DENIS, C. 1928,
GELATIN SILVER PRINT, 18.1 x 15.1 CM.,
MUSEUM FOLKWANG, ESSEN

PLATE 6.28
RUE DE RIVOLI—RUE DES HALLES,
À 10$^1/_2$ DU MATIN, C. 1928,
GELATIN SILVER PRINT, 14.6 x 17.5 CM.,
MUSEUM FOLKWANG, ESSEN

PLATE 6.29
RUE DE RIVOLI À 10 H., C. 1928.
GELATIN SILVER PRINT, 18.1 x 17.6 CM.,
MUSEUM FOLKWANG, ESSEN

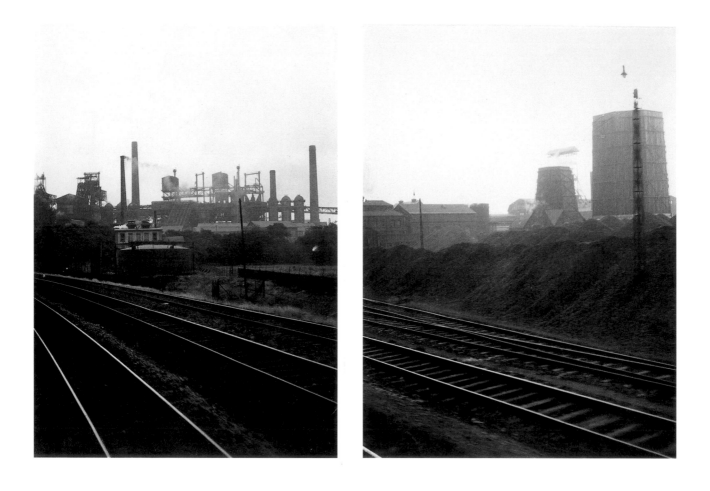

PLATE 7.1
ALLEMAGNE, 1930,
GELATIN SILVER PRINT, 19.9 x 14.3 CM.,
MUSEUM FOLKWANG, ESSEN

PLATE 7.2
ALLEMAGNE, 1930,
GELATIN SILVER PRINT, 19.9 x 14.7 CM.,
MUSEUM FOLKWANG, ESSEN

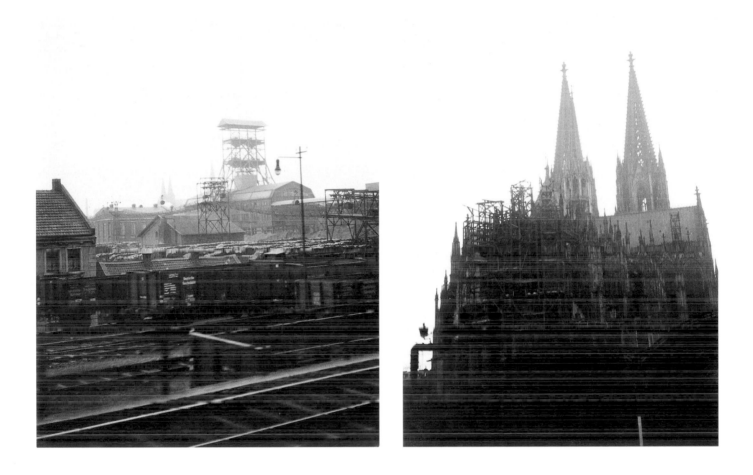

PLATE 7.3
ALLEMAGNE, 1930.
GELATIN SILVER PRINT, 19.0 x 14.9 CM.,
MUSEUM FOLKWANG, ESSEN

PLATE 7.4
ALLEMAGNE, 1930.
GELATIN SILVER PRINT, 19.8 x 14.6 CM.,
MUSEUM FOLKWANG, ESSEN

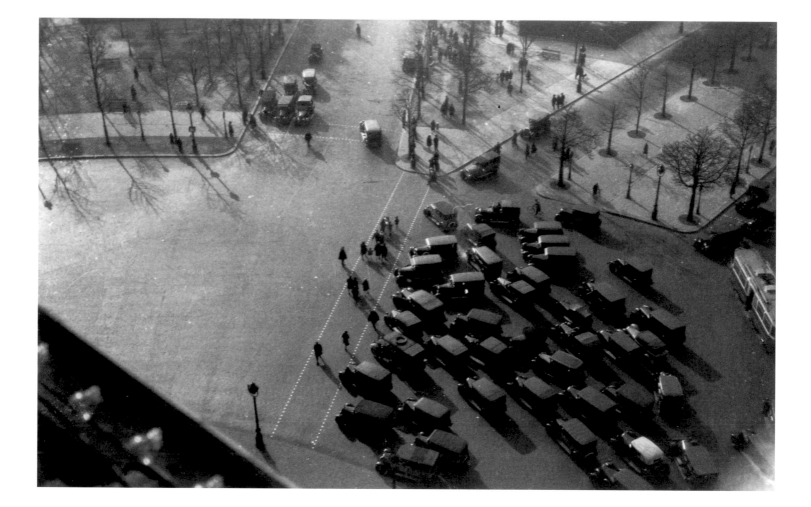

PLATE 7.5
PLACE DE L'ETOILE, AVENUE DE
LA GRANDE ARMÉE, AVENUE DU
BOIS DE BOULOGNE, 1926,
GELATIN SILVER PRINT, 14.3 x 22 CM.,
MUSÉE NATIONAL D'ART MODERNE,
ACHAT DU CNAC GP, 1990, 1991.5,
CENTRE GEORGES POMPIDOU.
© C. G. POMPIDOU, 1986

PLATE 7.6
BOULEVARD DES MARÉCHAUX, PARIS, 1930,
GELATIN SILVER PRINT, 16 x 18.3 CM.,
PRIVATE COLLECTION, PARIS

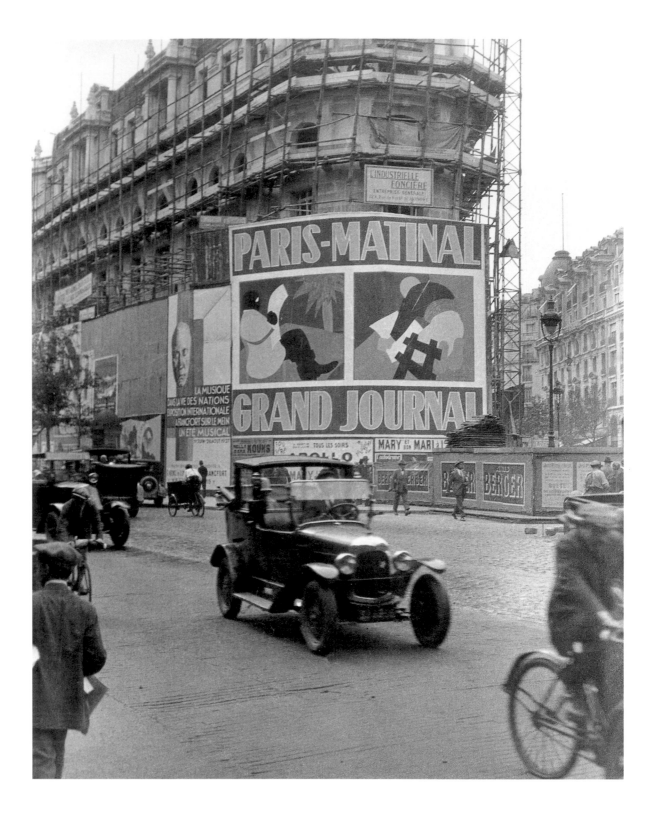

PLATE 7.7
PARIS-MATINAL BILLBOARD.
PARIS. 1927.
NEW GELATIN SILVER PRINT BY
JÜRGEN WILDE (1992) FROM
GLASS NEGATIVE. 30.0 x 24.1 CM..
GERMAINE KRULL NACHLASS.
MUSEUM FOLKWANG. ESSEN

PLATE 7.8
PILLOT SHOES, N.D.,
NEW GELATIN SILVER
PRINT BY JÜRGEN WILDE (1992)
FROM GLASS NEGATIVE, 23.7 x 19.4 CM
GERMAINE KRULL NACHLASS,
MUSEUM FOLKWANG, ESSEN

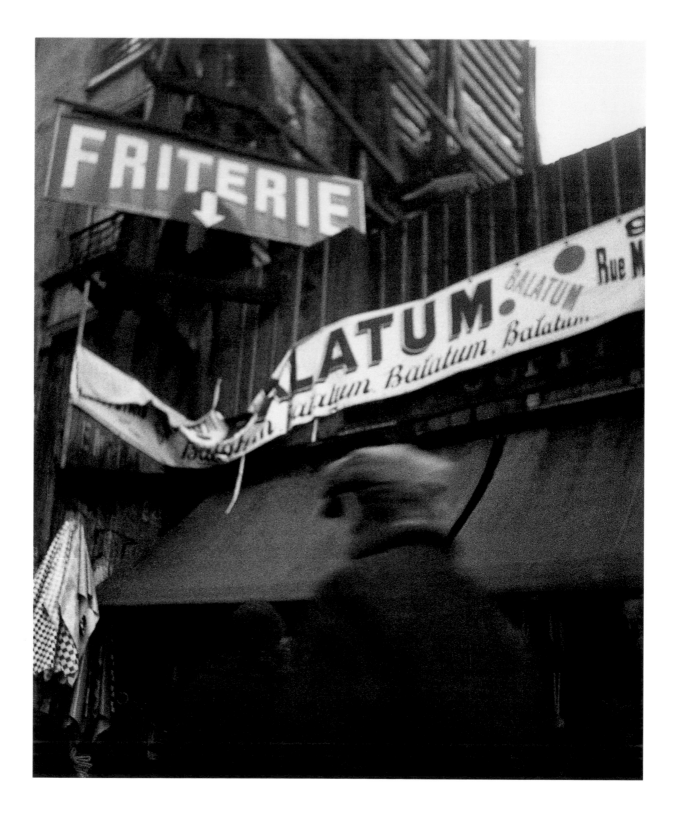

PLATE 7.9
FRITERIE, N.D.,
NEW GELATIN SILVER
PRINT BY JÜRGEN WILDE (1992)
FROM GLASS NEGATIVE, 28.9 x 24.0 CM.,
GERMAINE KRULL NACHLASS,
MUSEUM FOLKWANG, ESSEN

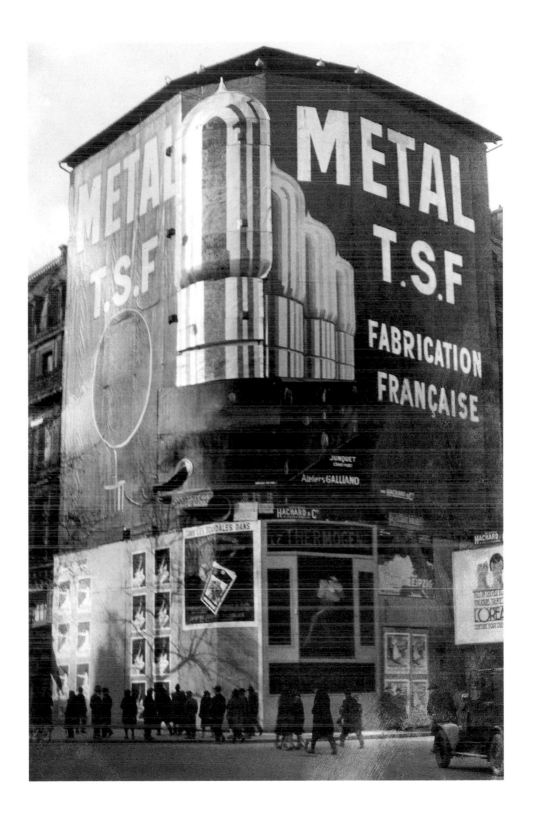

PLATE 7.10
MÉTAL BILLBOARDS, PARIS, 1926.
NEW GELATIN SILVER
PRINT BY JÜRGEN WILDE (1992)
FROM GLASS NEGATIVE, 30.1 x 19.5 CM.,
GERMAINE KRULL NACHLASS.
MUSEUM FOLKWANG, ESSEN

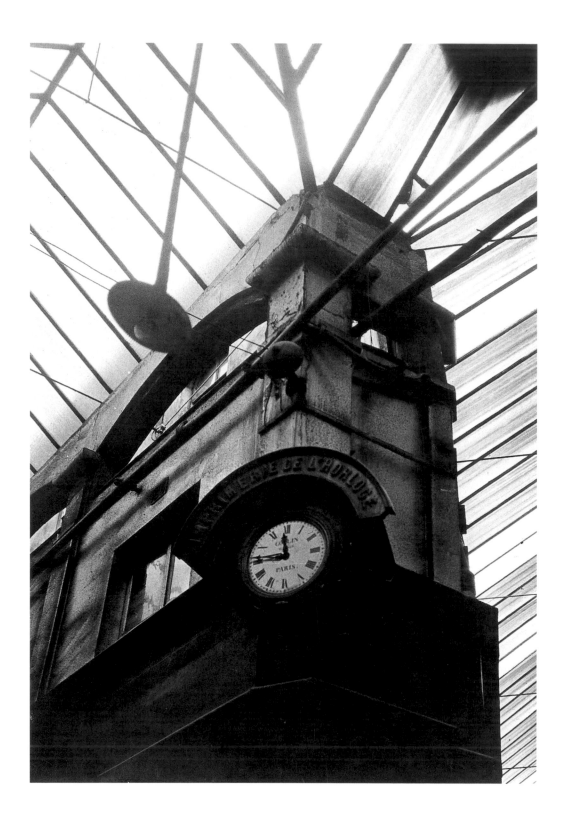

PLATE 7.11
IMPRIMERIE DE L'HORLOGE,
PASSAGE DES DEUX SOEURS, C. 1928,
GELATIN SILVER PRINT, 21.8 x 15 CM.,
THEODOR W. ADORNO ARCHIV,
FRANKFURT

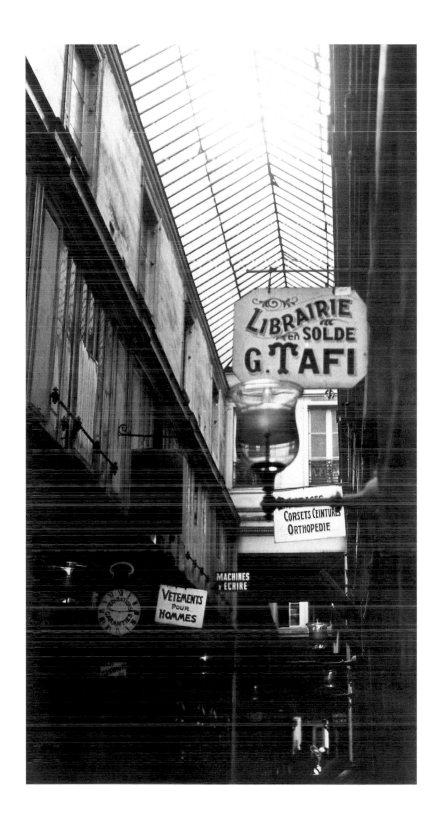

PLATE 7.12
PASSAGE DU PONCEAU. N.D.,
GELATIN SILVER PRINT, 21.8 x 11.6 CM.,
THEODOR W. ADORNO ARCHIV.
FRANKFURT

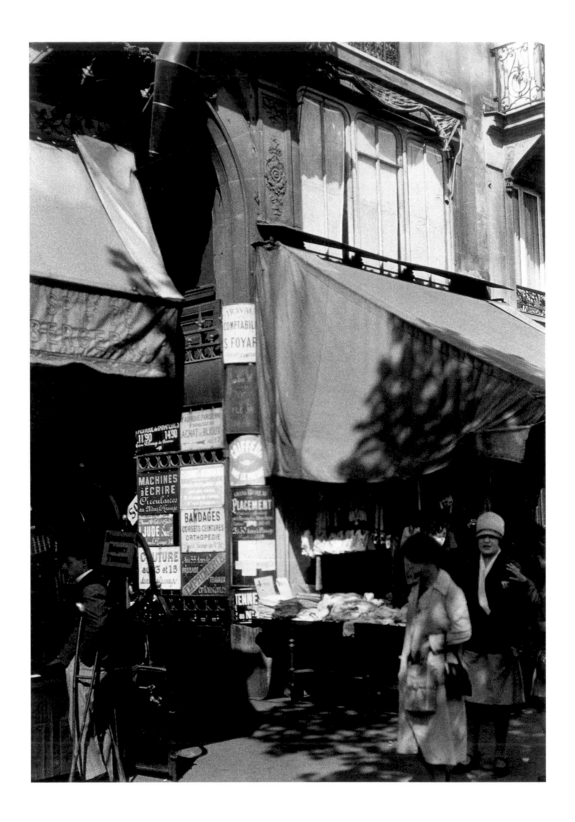

PLATE 7.13.
PASSAGE, N.D.,
GELATIN SILVER PRINT, 21.8 x 15.1 CM.,
THEODOR W. ADORNO ARCHIV,
FRANKFURT

PLATE 7.14
PASSAGE, N.D.,
GELATIN SILVER PRINT, 19.4 x 14.8 CM.,
THEODOR W. ADORNO ARCHIV,
FRANKFURT

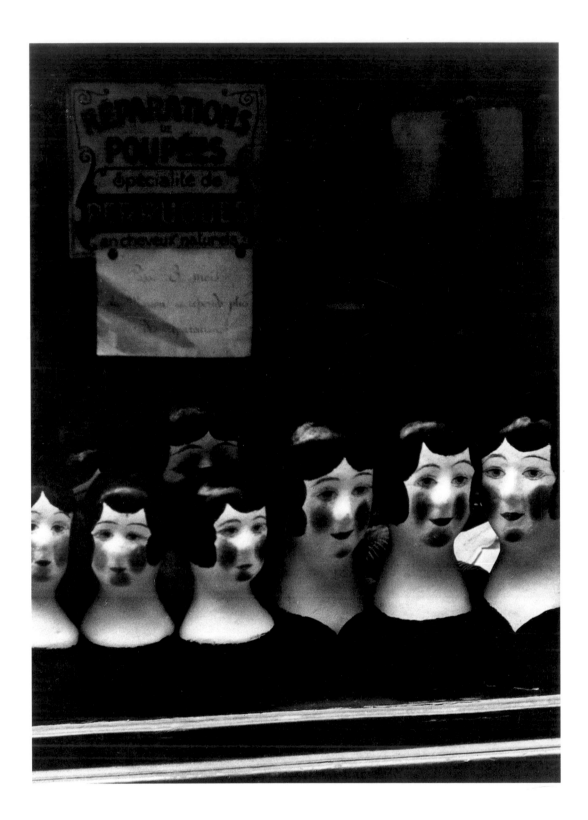

PLATE 7.15
PASSAGE, N.D.,
GELATIN SILVER PRINT, 21.4 x 15.6 CM.,
THEODOR W. ADORNO ARCHIV,
FRANKFURT

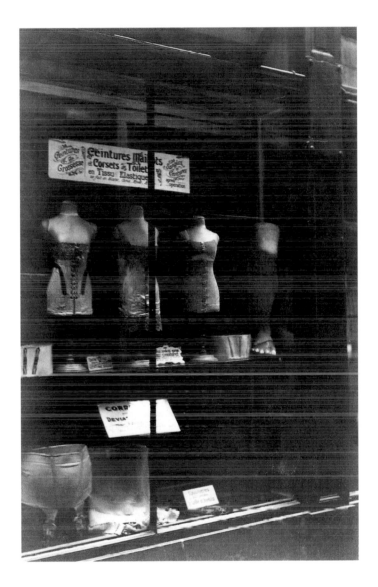

PLATE 7.16
PASSAGE, N.D.,
GELATIN SILVER PRINT, 13.7 x 8.8 CM.,
THEODOR W. ADORNO ARCHIV,
FRANKFURT

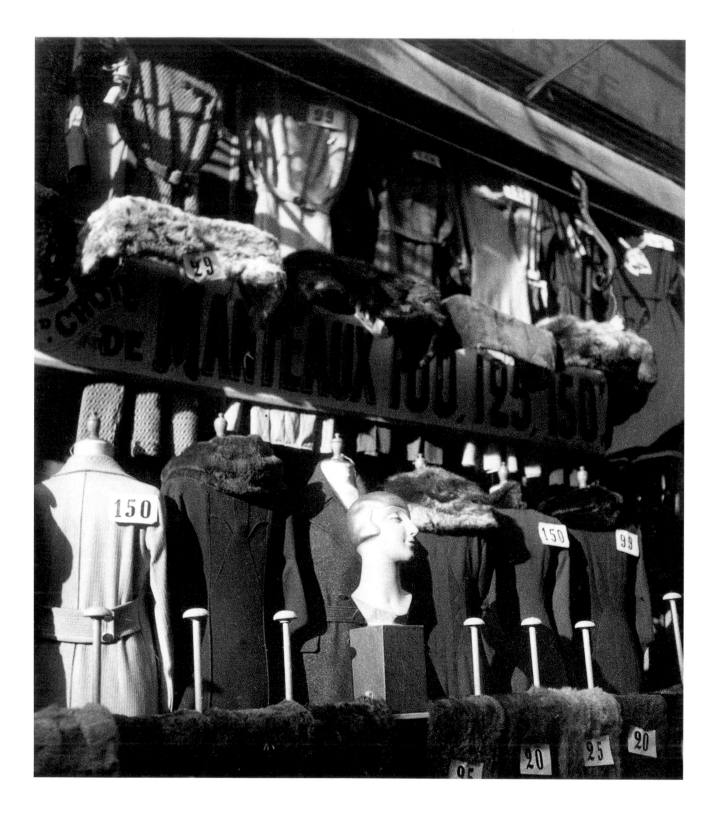

PLATE 7.17
MANTEAUX. C. 1928–1929.
NEW GELATIN SILVER
PRINT BY JÜRGEN WILDE (1992)
FROM GLASS NEGATIVE. 27.2 x 24.0 CM..
GERMAINE KRULL NACHLASS.
MUSEUM FOLKWANG. ESSEN

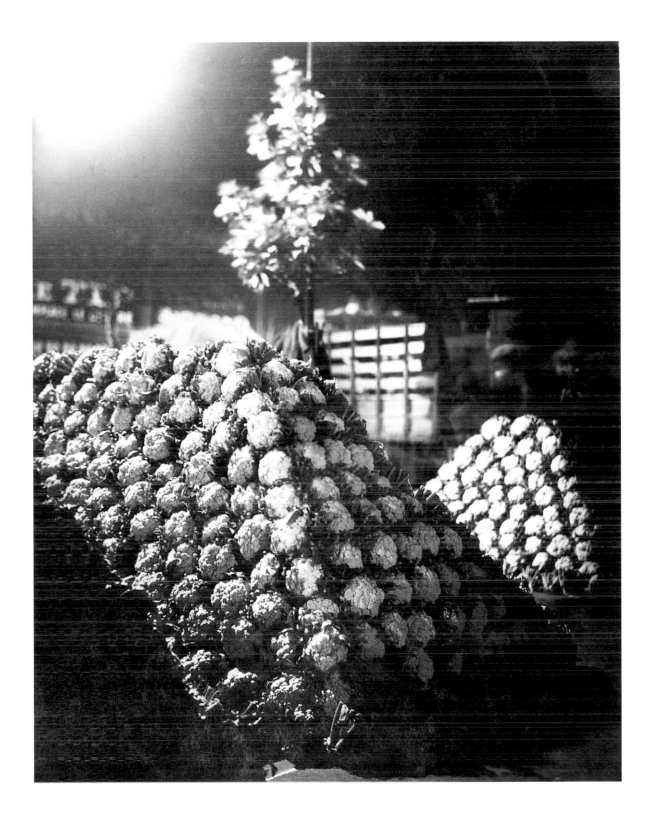

PLATE 7.18

LES CHOUX-FLEURS, 1930,

GELATIN SILVER PRINT, 20.6 x 16.5 CM.,

COLLECTION A. JAMMES, PARIS

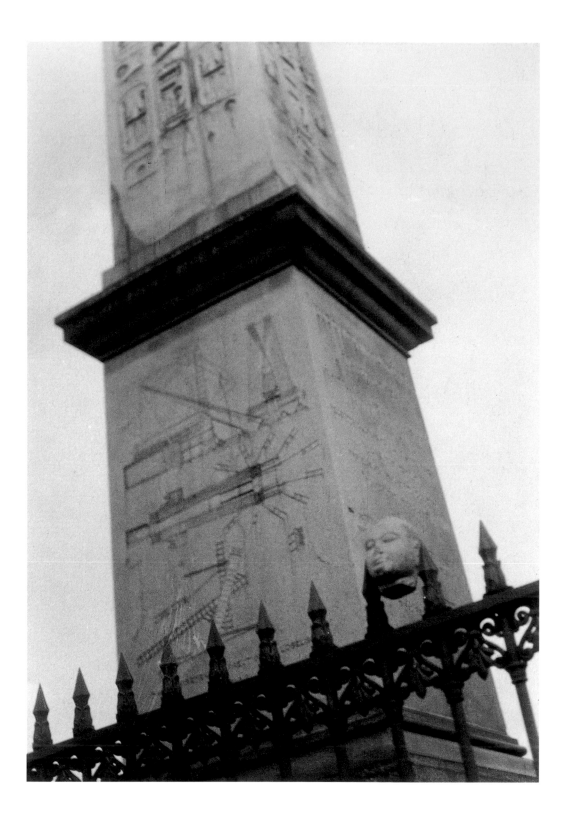

PLATE 7.19
OBELISQUE.
[PLACE DE LA CONCORDE]. 1928.
GELATIN SILVER PRINT. 22.9 x 15.5 CM.,
COLLECTION GILLES DELATRONCHETTE.
PARIS

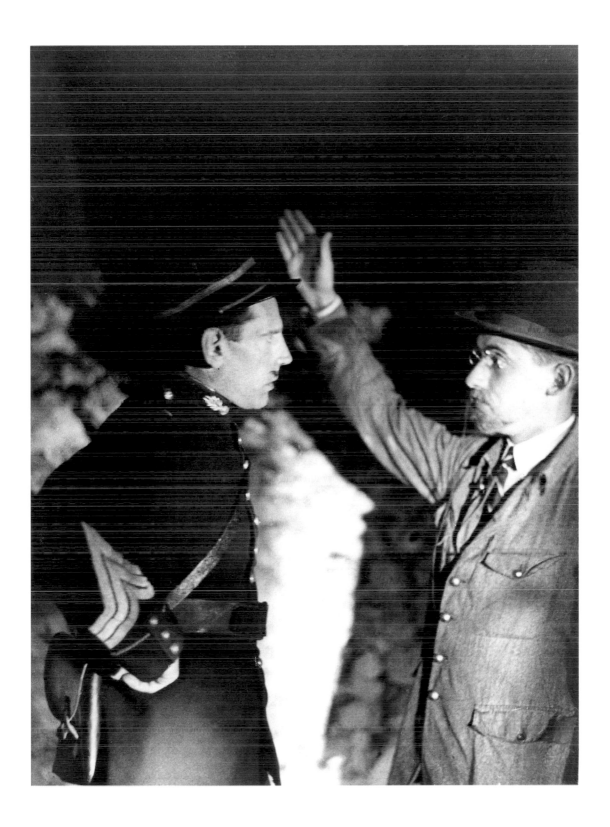

PLATE 7.20

DETECTIVE AND POSTMAN

[JACQUES HAUMONT]. 1931.

GELATIN SILVER PRINT. 15.4 x 11.6 CM..

COLLECTION A. JAMMES PARIS

(EX. COLL. JACQUES HAUMONT)

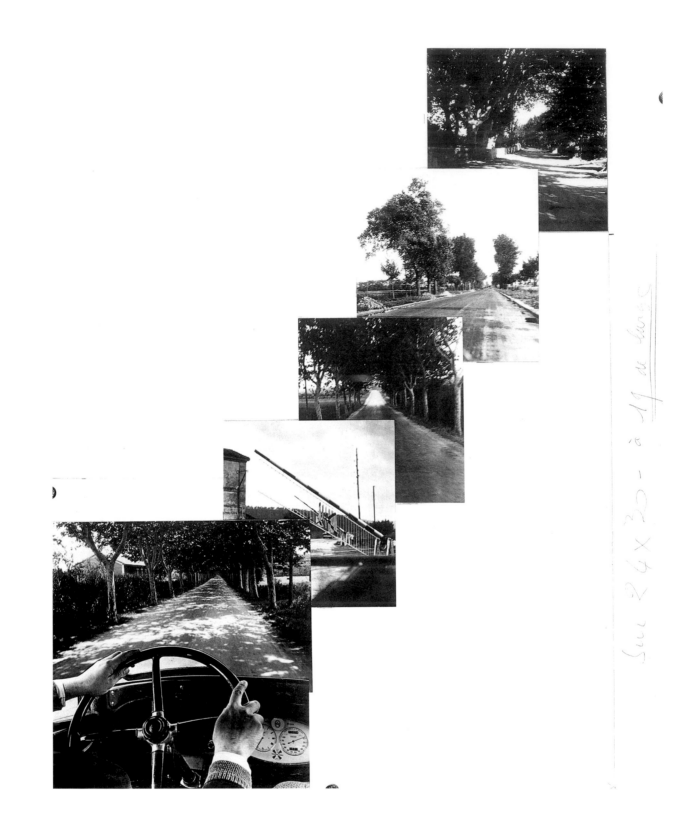

PLATE 7.21
POSTER FOR *LA ROUTE DE PARIS*
À LA MEDITERRANÉE, 1931,
PHOTOMONTAGE, 25.0 x 21.0 CM.,
COLLECTION A. JAMMES, PARIS

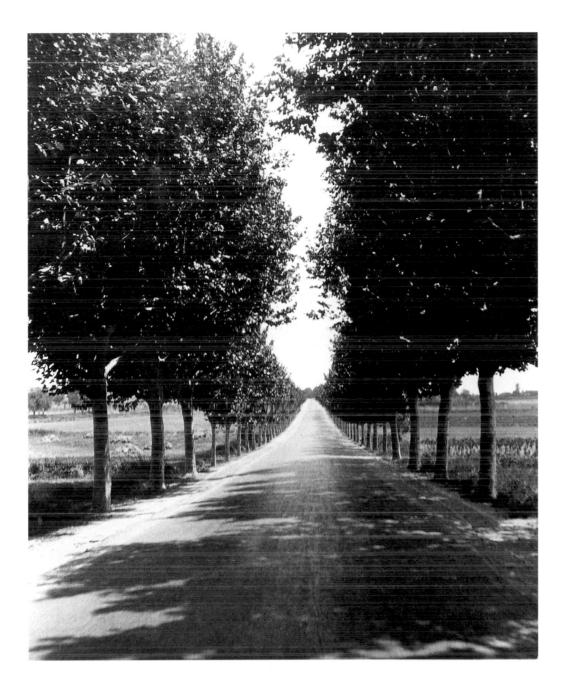

PLATE 7.22
ROAD.
GELATIN SILVER PRINT. 18.1 x 15.0 CM..
COLLECTION A. JAMMES. PARIS

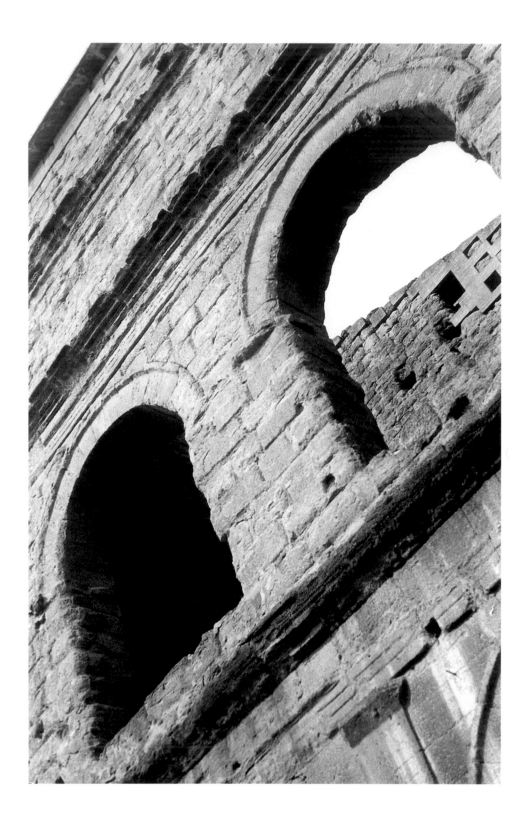

PLATE 7.23

ORANGE.

GELATIN SILVER PRINT. 20.1 x 14.2 CM..

COLLECTION A. JAMMES, PARIS

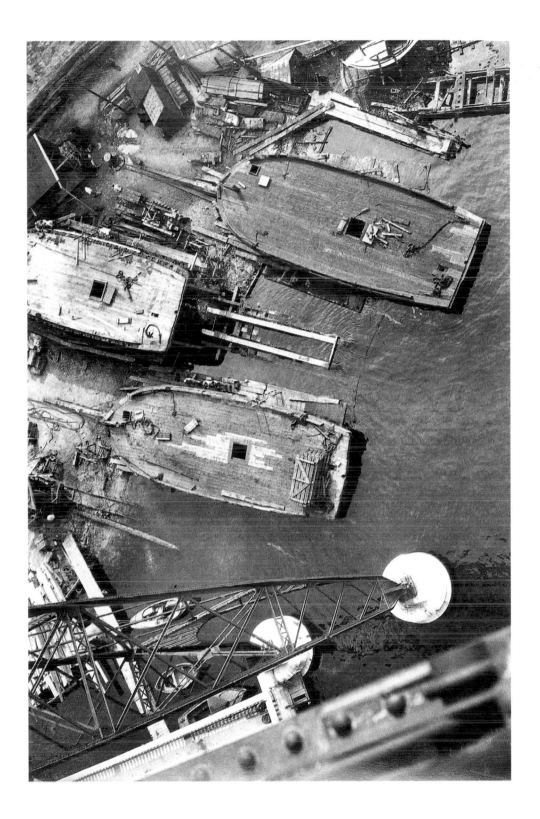

PLATE 7.24
PONT TRANSBORDEUR, 1926.
NEW GELATIN SILVER PRINT
BY CLAUDINE SUDRE, 30.0 x 19.5 CM.,
COLLECTION A. JAMMES, PARIS

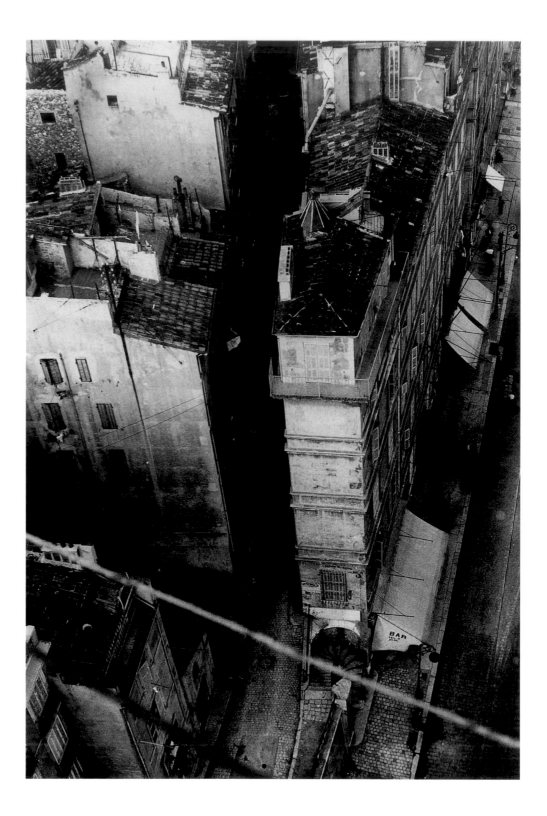

PLATE 7.25

MARSEILLE. C. 1927.

GELATIN SILVER PRINT. 21.8 x 14.8 CM..

COLLECTION THOMAS WALTHER.

NEW YORK

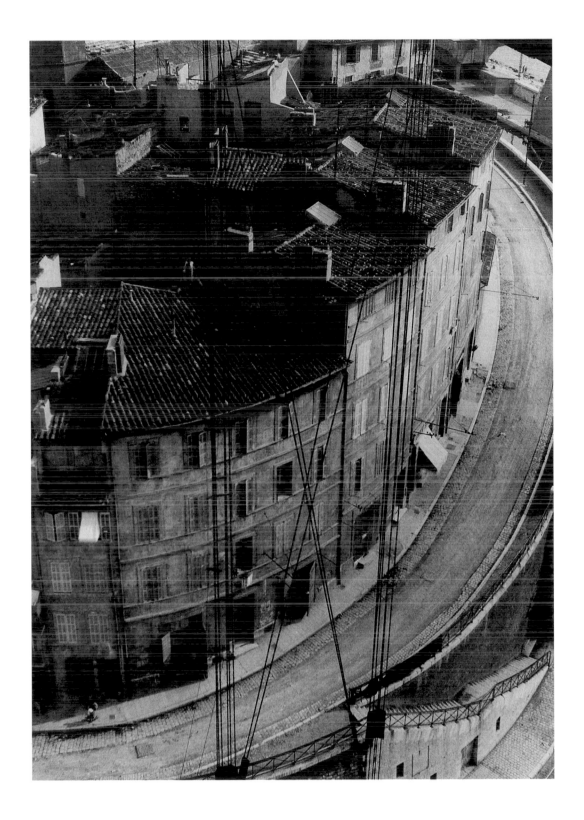

PLATE 7.26
MARSEILLE. C. 1927.
GELATIN SILVER PRINT, 21.2 x 15.2 CM..
COLLECTION THOMAS WALTHER.
NEW YORK

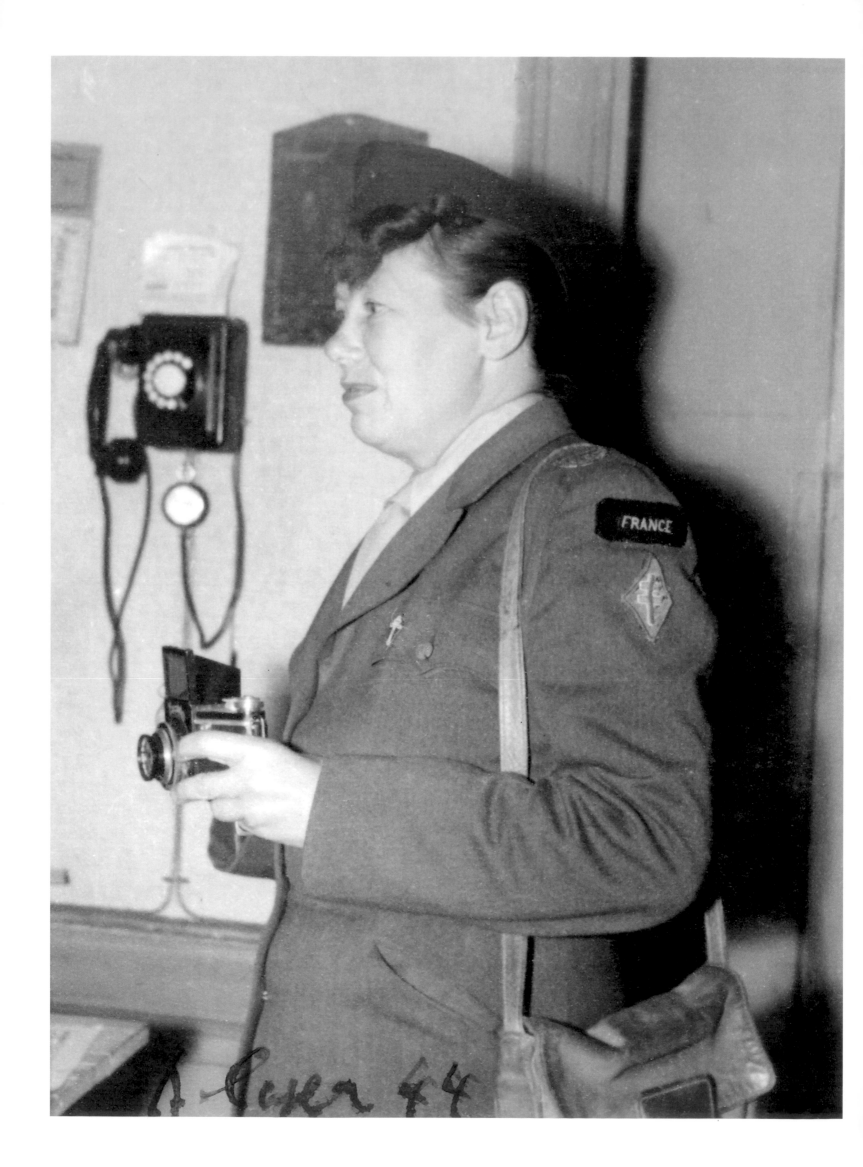

Chapter 8

Fighting with Photographs

KRULL AND THE FREE FRENCH IN AFRICA, 1942–1945

"London. General de Gaulle is speaking." . . .
That voice that had taken hold of my heart, of
my chest, of my stomach, that voice that had led
me to leave France and that had brought me to
the heart of Africa. The voice seized me again in
the same way. I do not know the words it spoke,
but my whole body trembled and cried, and at
the same time I was full of joy.[1]
— *8 November 1942, the day Americans*
disembarked in Algeria

The sight of Germaine Krull in an army uniform of any
kind marks a long journey for the young revolutionary
who had marched with Kurt Eisner in the streets of
Munich in 1918. During her first period of political ac-
tivity and during her successful European avant-garde
career, she had avoided rules, conventions, and confor-
mity with great passion. She appears here in 1944 in a
new guise, a member of Charles de Gaulle's Free French
forces operating in tandem with the Allied forces in
Africa (fig. 8.1). Her military costume signals several
changes. In her army hat, jacket, and tie, she has once
again donned a masculine costume, yet this one re-
mains within the newly revised definition of accepted
women's roles as one of the adjunct military figures
who assumed a particularly important role in this war.
Krull's most heartfelt belief, the abhorrence of totali-
tarianism, had become a global concern by World War
II. In fighting fascism, she had become part of the ma-
jority rather than the minority.

Krull stands next to a telephone, her camera's
angles echoing the square and round forms of the other
communication device in the image; both machines
disseminated war information to the outside world.
Their juxtaposition signifies the importance of her role
within a global and highly political information net-
work. Krull did not tote a gun during the war; her cam-
era became her weapon, and it was widely accepted as
a powerful antifascist tool. Her photographs were no

PRECEDING SPREAD:

FIGURE 8.1

ALGIER, 1944, GELATIN SILVER

PRINT, 9.1 x 6.2 CM.,

GERMAINE KRULL NACHLASS,

MUSEUM FOLKWANG, ESSEN

longer a subtle critique of their society; now they were to serve as part of the war machinery itself.

Krull first heard Charles de Gaulle's voice on 18 June 1940 when she had fled to a southern French village after Paris was evacuated. His famous speech from London declaring that "France has lost a battle, but France has not lost the war!" inspired her then and pitted her against her Pétainist friends Maurice and Flechette Privat.[2] De Gaulle ended a second speech that day by stating, "No matter what happens, the flame of French resistance should not be extinguished and will not be extinguished."[3] From these words were born the internal French resistance movement and de Gaulle's Free French government in exile, headquartered first in London and eventually, in 1943, in Algiers. Krull's visceral reaction to de Gaulle equaled her violent hatred for the compromises of the Vichy government led by Marshall Pétain that brokered a compromise with Hitler's Germany, ceding to German control two-thirds of France. Krull's response echoed several patterns in her earlier political experiences. Krull was adamantly antifascist, like her Frankfurt school colleagues Max Horkheimer and Friedrich Pollock and her Paris avant-garde friends.[4] Furthermore, she abhorred the collaboration of Pétain's government with Hitler as fully as she hated Hitler himself; it threatened her belief in the French intellectual world she had adopted as her own after years of wandering. Most European artists and intellectuals fought fascism during these years, but Krull carried her distaste for totalitarianism past the end of the war and throughout her life.

In the early years of World War II, working from an expatriate base in London and calling on the forces of freedom around the world, Charles de Gaulle must have seemed to Krull like a reincarnation of Kurt Eisner. Like her belief in Eisner's socialist government and worker's councils in Munich, she believed that de Gaulle represented "the people." The stakes were, if anything, higher now than in 1918. Then, Krull had seen the collapse of a government she believed in and the Soviet and German answer in the form of totalitarian repression, beginning with the White terror in Germany and the first steps of a Soviet turn toward a more authoritarian regime at Moscow's 1921 Congress of the Third International. Although the photographer herself drew no overt parallels between the two political crises, it is telling that she had been writing her fictionalized memoirs of the 1918 German events, "Chien-fou," as the Nazis gained power during the 1930s. In watching Hitler assume power, she must have been reminded of the right-wing reactions against the Bavarian revolutions. Thus, the invasion of Paris by the Germans probably held for Krull an even greater symbolic meaning than for those Europeans who had not directly participated in the political events of 1918 through 1921. Then, she had been a student activist, a political foot soldier who put aside photographic craft for more activist behavior. Now, her photography was her weapon. The passive stance of the Vichy government—which ceded Paris without a fight and handed over the majority of France's territory to the Germans—appalled her. In choosing to serve de Gaulle—who eventually reunited the Free French government in exile with the internal underground movements (joined together under Jean Moulin to form the National Resistance Council) and went on to become the first leader of postwar France—she could cast her vote for freedom as part of a fighting force.

From that first moment in June 1940, she resolved to fight for her adopted country, France, rather than accept the Vichy government. Although she carried a Dutch passport, Krull felt strong cultural and emotional ties to France, where she had been living for almost fifteen years when the war broke out. She emigrated from France six months later, bound for Brazil because that was the only country for which she could obtain a visa, and arrived in French Equatorial Africa in the autumn of 1942. Its capital, Brazzaville, was the main center for the transmission of de Gaulle's press from Free French soil and served as an important symbolic center for the continued freedom of speech during the war. Here Krull's most potent political tool, her photography, was urgently needed to fight fascism. Oddly, she was much less critical of another power-hungry institution of the modern world, colonialism. Her memoirs of these years, "Ceux de Brazzaville," seem quite oblivious of the patronizing attitude she took toward the native African populations all around her. Her photographs, too, display a conventional colonizing attitude, in presenting Africans as different from Europeans. For this she used a wide variety of formal ploys common to colonialist imagery—ranging from titillating images to distancing yet heroizing compositions. African figures are monumentalized—made heroic, static, and beautiful. In short,

they are mute, rather than active, in her compositions. These images served the Press Service as journalistic images for international publication, to convey a variety of messages about the French African colonies to a European audience, yet Krull seemed conscious only of their antiauthoritarian message and not the implicit colonialist lessons the photographs embodied. Her African work displays a conventional colonializing attitude, conforming to the European-based attitudes toward the native inhabitants.

Once Germaine Krull left France for Africa, her relationship to European culture changed irrevocably. For the rest of her life, Krull would participate in European politics, economics, and intellectual life from outside the continent, reshaping Africa (and later Thailand and India) for European consumption through her photographs and increasingly through her writing. Krull wrote frequently and fervently of her growing disillusionment with Europe; she never returned permanently, choosing instead to make her home outside the Anglo-French-German homelands. She remained a European observer, however, and in her various activities during and after the war she provides a compelling case study for the complexities of colonializing views of the third world from the 1940s through the 1970s. Despite her frequently fantastical adventures, Krull remained a member of the monied, politically powerful, and ruling European elite.

Certain key projects executed from 1941 to 1945 demonstrate the intersection of Krull's politics and evolving photographic form during the war years. In Brazil, she published a book called *Uma Cidade antiga do Brasil: Ouro Preto* (1943), that demonstrates the continuation of the conventional travelogue form of her French work of the late 1930s. Krull also produced press photos, exhibitions, and films for the Service de l'Information de la France Combattante (Radio Brazzaville) in Brazzaville in the French Congo. Commissioned and published as war information press photographs, some of her African photographs follow the picture story format of *Vu* and yet serve a military cause. In addition, Krull conflated the exhibition and ethnographic worlds when she mounted a show of some of her most monumentalizing photographs of the African peoples and landscapes she observed. She also assisted director François Villiers in the making of two propaganda films, *L'Amitié noire* (1943, released in France in 1946) and *Autour de Brazzaville* (1943). Finally, on her return to the European theater of battle, Krull documented the Battle

of Alsace in November and December of 1944. The military press service used her photographs, but she also published a volume authored by Roger Vailland, *La Bataille d'Alsace (Novembre–Décembre, 1944)* (1945), with her old friend Jacques Haumont.

Krull's role in World War II was both more conventional and more unusual than that of many women photographers of her era. Of the women who had opened studios and operated successful businesses as press photographers or studio photographers in Berlin and Paris, almost none joined the Free French. Many Germans, like Ellen Auerbach, Ilse Bing, and Gisèle Freund, were Jewish and fled Europe for safer territories. Of the French photographers, women like Laure Albin-Guillot remained in France. In choosing to fight fascism directly, in a military context, Krull adopted a more masculine persona, closer to that of Robert Capa and other photojournalists who became war photographers. She shared what Susan Moeller, in her book *Shooting War*, calls a kind of optimism: "war photojournalists often persist in believing the best about humanity."[5] In departing from France and battling fascism from abroad rather than remaining to work in the Resistance or to quietly survive the war, Krull took an activist role. It would be false, however, to label her unique in this. Few other women photographers may have entered the Free French forces (and there may be more whom we have not yet discovered), but many women used their professions to contribute to the war effort, in ways both large and small.

Paula Schwartz has begun to resurrect the nameless Resistance activism of French women who remained on French soil.[6] She summarizes the work to date on women Resistance workers during the war and then broadens the categories to include the women who have remained nameless and unacknowledged until now. Many women remaining in France assumed new identities and went underground (*illégals*), and others remained in their places and operated "above ground" (*légals*). As Schwartz writes, many women belonged to no group but helped the movement in incidental ways: "Strict adherence to a military definition of resistance made women's contribution invisible."[7] But Krull did join a military group, although not on French soil, and many other members of her Radio Brazzaville unit were wom-

en. She was not alone, and in her memoirs of her African adventures, "Ceux de Brazzaville," she created pseudonyms for her colleagues: "Gene," the Englishwoman who wrote the English bulletin; "Anna," the Alsacian refugee in London who followed de Gaulle to French Equatorial Africa and translated the German radio transmissions into French; "Nelly," a typist; and "Hilda," the English editor. Krull was in fact part of a group of international women who used their professional skills in the service of the war effort.

Although many of her working patterns continued from her New Vision work of the 1920s and 1930s, the photojournalistic style of Krull's photographic activity during these years differed markedly. She continued to make photographic essays for the photographic service of the Free French in Brazzaville; these expressed both her belief in work (now indigenous African industry instead of European factory machinery) and an interest in individual people. In a general sense, she became interested for the first time in straight documentary photography, using a transparent style to convince viewers of the force of the arguments her pictures presented. This presents a shift from the more overtly avant-garde compositions of her work for *Vu*, although she sometimes used dramatic angles and close-up views for effect. She photographed relatively few overtly military activities, even when she documented mining and other war-related industries in the African colonies. These essays were published in war magazines and newspapers throughout the war.

Krull continued to explore the narrative possibilities of photography, and she produced several books and films in Brazil, Africa, and the battlefields of France. Krull's interest in narrating her own story also continued during these years, and working on her war memoir reinforced her use of writing to validate her political life. Although she tried for many years, Krull was not successful in publishing "Ceux de Brazzaville," and she eventually deposited a copy of the African manuscript with the Fondation Charles de Gaulle in 1971, through the efforts of André Malraux.[8]

Brazil

Krull's road to Africa was a circuitous one, due to the difficulty of obtaining visas and contacting the forces she wished to serve. It began in early 1941, when she departed from Marseilles on a boat she variously re-

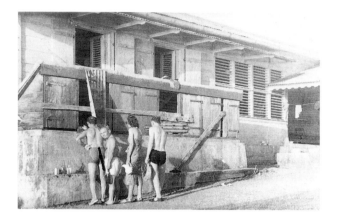

called as the *Emile Lemerle* and the *Paul Lemerle*, foreseeing a voyage of three weeks. Among her shipmates, she recounted, were many Jewish refugees. Also aboard were André Breton, his wife and daughter, as well as Victor Serge, a Franco-Russian writer, and his family.[9] Krull reported that they landed in Martinique and that she and Serge remained for two weeks while the others continued to other destinations. These weeks of waiting were Krull's closest experience of refugee camp life, and she described them in a short essay entitled "Concentration Camps in Martinique." Krull's archives in Essen include a number of photographs she took in Martinique to accompany her unpublished article. Centered in Lazared, a former leper camp where the emigrants waited for their next ship, these documentary photographs continue the tradition of the *Vu* photo stories. Captions related the shortage of water and the long lines, and Krull's photographs document both the lines and the dilapidated shanties they lived in during these weeks. In one image, for example (fig. 8.2), men and women clad in bathing gear and sundresses stand with their water containers in front of a bleak shuttered building whose overhanging veranda seems to intensify rather than reduce the glaring sunlight. The photographs capture the bleak quality of the location despite its brilliant light. From Martinique, she took a mail boat to Belem, the first port in Brazil, and stopped at St. Laurent-les-Marronniers, a French penal colony.[10] Krull then traveled to Belem and on to Rio de Janeiro. A Brazilian document lists the date of her disembarkation at Belem as 25 May 1941.[11]

Krull stayed in Brazil for little more than a year. Most of her time there was devoted to two tasks, finding

FIGURE 8.2

GERMAINE KRULL. MARTINIQUE. REFUGEE CAMP. 1942. GELATIN SILVER PRINT. 11 x 16.8 CM.. GERMAINE KRULL NACHLASS. MUSEUM FOLKWANG. ESSEN

her way to the Free French in Africa and making a living along the way. Financial independence, as always, was hard to achieve, although she briefly opened a studio in Rio de Janeiro. Her commercial work includes portraits and city views. Krull existed almost entirely in the European community; few photographs document the varied and rich Brazilian cultures outside the capital. She did mount one exhibition in Rio, at the Livraria Geral Franco-Brasileira, but she displayed her French photographs rather than any Brazilian imagery.[12] Her other surviving photographs document Rio at carnival time and in the night, its beaches, and other city landmarks, and they lack the passion and the stylistic innovation of much of her other work.[13]

Krull's relatively cool reaction to Brazil may have reflected the difficulties she encountered there as a woman traveling and working alone. In her memoirs, she often describes Brazil as a land for men, not women: "For me, Rio stays in my memories as a city of contrasts. . . . European habits and values had no importance; one had to set them aside. I had to learn this with quite a few blows to my vanity and my pride."[14] In Brazil, Krull depended on help from friends to survive, much as she did in her last years in Monte Carlo. Several letters from Joris Ivens, now in the United States, prove that he was continuing to support her with U.S. $60 or $80 each month, for at least a six-month period. "I promised to send you [money] for six months, and I've done that. I will send more the moment I have money once again."[15] One of Ivens's letters asks whether she could survive two or three months without his help, as he had no cash to send her. Their friendship continued although they had initiated divorce proceedings in the late 1930s in France, and Ivens finalized the divorce in August of 1943 in a Mexican court.[16]

Before Krull's departure from Brazil, she obtained a more substantial commission—a photographic travelogue of Ouro Preto, the center of the historically richest gold mine in South America.[17] Ouro Preto, which means "black gold" in Portuguese, became the main town of its region when gold was discovered in 1698, triggering a gold rush that lasted until well past 1710. Gold mines were most active from 1725 to 1733, and an extraordinary town was built in the second half of the eighteenth century. It was distant from most urban centers, but with almost fifty rococo churches, its architectural and sculptural treasures rendered it a national cultural center.[18] Brazil's greatest sculptor, Aleijadinho (Antonio Francisco Lisboa, 1739–1844), decorated many

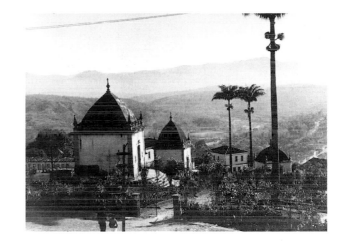

of these churches with transcendent works.[19] Krull's book, *Uma Cidade antiga do Brasil: Ouro Preto*, was published in 1943 with introductions by Raul Lino and Ribeiro Couto.[20] In this book, Krull continued the travelogue format that she had perfected in France and that would evolve into effective war propaganda in Africa. She also concentrated on the European accomplishments of Brazil rather than on indigenous culture for its own sake, a pattern that would be repeated in her colonialist views in Africa.

The first photographs show the city's rooftop panorama from above, in dramatic views. The rest of the book presents the town's crosses, individual churches, and the extraordinary rococo ornamentation of the interior decorative programs. The sculpture of Antonio Francisco ("Aleijadinho") and his school appear prominently. In views like one of Nossa Senhora do Carmo (fig. 8.3), the intricately carved and painted architectural decoration and religious statues take on a life of their own, as Krull frames them in a diagonal composition in a similar manner to her treatment to the Pont du Gard in Orange for her *Marseille* book.

Africa: War Photographs

On 29 July 1942, Krull joined the Information Service of the Fighting Forces of Free French Africa, finally becoming an active soldier in the battle against Hitler. Her declaration, signed in Rio and stamped by the Comité de France Libre du Brésil, reads as follows:

FIGURE 8.3
GERMAINE KRULL. NOSSA SENHORA DO CAMPO. *OURO PRETO*. 1942.
GELATIN SILVER PRINT. 24.0 x 17.5 CM
GERMAINE KRULL NACHLASS. MUSEUM FOLKWANG. ESSEN

I swear before those present and confirm by my signature that I put myself at the disposition of the FORCES FRANÇAISES COMBATTANTES and that I desire to be attached to the army of the FRANÇAISES COMBATTANTES wherever my professional skills can be used. I declare that I will assume my obligations as soon as I am called and that I will go wherever I am sent and will serve in whatever professional mission I am given.[21]

She left Brazil in August 1942, landing in the Belgian Congo after a voyage of about three weeks with a stop in South Africa.[22] After her arrival on 4 September, she stayed in Brazzaville for about a year and a half, until at least January of 1944, before moving on to Casablanca and Algiers in preparation for the August 1944 invasion of southern France.[23]

In her book *Shooting War*, Susan Moeller offers a useful definition of war photography:

Images of war are defined by the moral position of the individual photographer, the institutional structure of the media, the official censorship of the military, the propaganda needs of the government, and the technological advances of both the photographer's equipment and the armed forces' weaponry.[24]

Moeller's multileveled view of how war photographs are made and, more important, used, contributes to an understanding of Krull's complicated activities within the Free French war effort. In the autumn of 1942, when she arrived, Brazzaville was a pivotal site in the African campaigns. De Gaulle was visiting Brazzaville on the day she arrived, and the Americans invaded French Morocco and Algeria that autumn. Radio Brazzaville was building a new radio transmitting station and was itself the subject of much media coverage. Krull's photographic projects for Radio Brazzaville may have been among her more pedestrian productions, but they resonated with the power of liberty.

The political situation in French colonial Africa during World War II was quite complicated, including Free French–controlled zones, Vichy-controlled zones, and areas that changed allegiance or manifested no clear loyalty to one side or the other. Krull became embroiled in the Free French view of these affairs, as well as in the task of broadcasting radio transmissions and publishing

texts and pictures to send across Europe and America. A bastion of Free France, French Equatorial Africa offered a much more solid Gaullist base than the territory of then-Vichy French West Africa.[25]

As the capital of French Equatorial Africa, therefore, Brazzaville was important not only for its strategic site as a Free French communications and military base[26] but for a much more symbolic series of reasons, close to Krull's own heart. French Equatorial Africa was and had consistently been Free French, not Vichy, territory. Its leaders had declared allegiance to de Gaulle from the beginning of the Vichy government, and Krull was a lifelong admirer of its governor, Félix Eboué, to whom she dedicated one version of her war memoirs.[27] Moreover, in October of 1940, de Gaulle had established a Free French Radio information service in Brazzaville, whose purpose was to globally broadcast Free French news from Free French soil.[28] News was broadcast as of December 1940, and daily programs went out to England, South Africa, the United States, and Canada in February 1941.

In the autumn of 1942, Lieutenant Pierre Desjardins, the director of the information service, planned a photo service to augment the radio transmissions and recruited Krull to create images of African war efforts to be used in the Allied war press.[29] Krull ran the photographic service for Radio Brazzaville from the moment it was formalized in 1942 and was a central contributor to the message of independent speech. De Gaulle's propaganda was probably no less skewed than any other war information, but to Krull and many others it symbolized the expression of freedom against the voice of fascism. Krull recounts what she perceived to be Desjardin's aims in "Ceux de Brazzaville":

To show everyone that . . . [French Equatorial Africa] is actively part of the war effort, economically. To show landscapes, indigenous people, schools, constructions, plantations, customs, all that can make this part of Free France better known. All that can validate the participation of Free France on French soil.[30]

Krull arrived in Africa just before the Americans landed in North Africa and soon before West Africa, which pre-

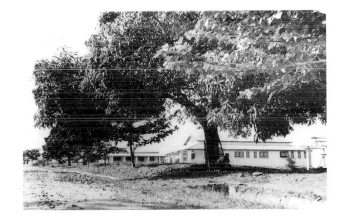

viously had been allied with Vichy France, rejoined the Allied fold. On her arrival, and for several years after, the tensions between Vichy French and Gaullist French were high. In addition, Brazzaville was next door to the notoriously profascist Belgian Congo. Her patriotic work for de Gaulle was simultaneously a struggle for the purity of the Radio Brazzaville forces against the compromises that occurred when Algiers became the information center for French Africa in 1944. Krull's opinions were uncompromising; she writes that "for the Free French of Brazzaville or those of the 'first hour' of London, Algiers was a basketful of crabs."[31]

Krull formed part of a small group of war photographers in Africa and was, as far as is known, the only woman photographer working there.[32] She may have been excluded from battle reportage because of her gender, although this restriction did not hold true for the European campaigns she later recorded. For whatever reason, her African work seldom documents battlefields and instead concentrates on culture and industry for the war effort. In contrast, Bernard Lefebvre, otherwise known as Ellebé, made industrial reportages and more military images. Ellebé also worked for de Gaulle in Africa and photographed many of the same places as Krull.[33] Ellebé recounts that the archives of the Service Photographique of the Information Service in Brazzaville contained photographs by Robert Carmet, Jean Costa, Germaine Krull, and himself.[34] Ellebé photographed more military gatherings than Krull, although he, too, photographed indigenous industry and culture in French Equatorial Africa and accompanied Germaine Krull and Robert Carmet on a trip to Messabé to photograph the Tchikombi people and their material culture.[35]

Military Portraits

Krull's photographs were published in a variety of official Allied and illegal resistance war magazines and newspapers, including *Les Cahiers français, Les Documents, Free France, Rafales,* and *Libération.*[36] *Les Cahiers français,* for instance, reproduced imagery documenting the buildings of the Service de l'Information (fig. 8.4) and the new offices of Radio Brazzaville in a three-page magazine spread about "Radio Brazzaville."[37] At least two of the sixteen photographs in this picture story can be found in Krull's archives, and the entire suite is probably her work. Many of the staff members are shown, although not named, and the view of the photographic section of the Information Service depicts a

capable-looking young African, who is probably Krull's assistant Malonga, working at the enlarger. Despite her reliance on his hard work and her clear affection for him, her stories of Malonga echoed conventional European attitudes toward African workers in assuming their ignorance and primitivism. In "Ceux de Brazzaville" she describes his arrival in a kind of pidgin dialogue, recalling that he arrived from a colleague in the Cairo Photographic service, saying, "Me not a jerk. Know how to make lunch. Know white habits. Me know how to muddle through [*démerder*]. Me called MALONGA."[38] The success of her African work, however, probably owed a great deal to Malonga's knowledge of local materials and conditions and his ability to improvise darkroom conditions in underequipped spaces and tropical climates.

During Krull's tenure in Brazzaville and Algiers, she photographed visiting dignitaries like General Leclerc and General de Gaulle (plate 8.2). She photographed Eboué while reading the many newspapers that came to his office each day. While she was in Africa, Krull had several opportunities to photograph General de Gaulle. She photographed him the month she arrived in Brazzaville, in September 1942. Photographs from February 1944 include views of General Leclerc, Governor-General Eboué, de Gaulle, and André Diethelm. In Algiers in early 1944, she made a series of formal portraits of de Gaulle, which have been often reproduced (plate 8.1). In this portrait, the general sits before a window, his face lit dramatically from one side as he looks upward with a concerned expression. The curtains of de Gaulle's Algiers office windows are visible behind him. The humanity and immediacy of this portrait create a

232.233

FIGURE 8.4

GERMAINE KRULL. *CASES D'HABITATION DU SERVICE DE L'INFORMATION.*

1943. GELATIN SILVER PRINT. 10.8 x 16.0 CM..

GERMAINE KRULL NACHLASS. MUSEUM FOLKWANG. ESSEN

psychological as well as a propaganda image, and it appeared widely in the press. Krull relates in her memoirs that she was quite moved to be taking his photograph and that the general unbent only when she asked him if he had received the photographs she had sent him from Brazzaville.[39] In the autumn of 1943, Krull sent copies of her field photographs to de Gaulle, and a personal letter from de Gaulle to Krull acknowledged their receipt on 25 October 1943. In thanking her, de Gaulle wrote, "It was a pleasure for me to see in your photographs a concrete vision of the many aspects of your active devotion to France. I thank you for them."[40]

Industry and the War Effort

Although she herself acknowledged no ambivalence about the military work she did, Krull's photographs of French Equatorial African industry and its war production mirror the complexity and problematic nature of the French war effort. From November 1942 onward, the colonies had been cut off from France. The Free French needed materials and supplies for the African war effort, and Eboué did not hesitate to use extreme measures to ensure their production. Rubber, cotton, wood, coffee, and gold were squeezed out of previously underperforming or exhausted plantations and mines, and the toll on workers was enormous. Many of these industries were staffed by forced labor, and Krull's assignments tended to whitewash their hardships, although she mentions them briefly in her memoirs. These photographs served a dual propaganda purpose— to ensure continued funding for mining and industry and to convince French resistance fighters and Allied troops to respect and honor the black African troops who were fighting the African campaigns.

Krull's travel in Africa is difficult to map, but she traveled widely and frequently. Her official documents showed that she traveled to Pointe Noire in October 1942 to photograph the port and to Gabon and Cameroon in 1943.[41] According to her memoirs, Krull was sent on three excursions around the colonial territories to photograph industrial activities and produce pictorial records of the ways in which Africans were aiding the war effort (for example, cotton bales in plate 8.3).[42] She describes her trips into the jungle to document rubber plantations in Cameroon and the sisal harvests in Ubangi-Chari.[43] Krull's other travel assignments were to photograph gold mining and wood harvesting for the war effort. She herself had no political arguments with this task, writing in her memoirs, "It was

important to show the war efforts of [French Equatorial Africa]."[44] The pictures that resulted from her field work were sometimes uneven, as Krull was a relative newcomer to straight reportage photography in the jungle; their immediacy comes from their snapshot quality rather than the consistent quality of their technique or structure.

On her first trip in 1943, Krull traveled through Lambaréné, the site of Albert Schweitzer's famous hospital in the jungle. She fell ill there with either sleeping sickness or dysentery and was forced to spend ten days recuperating.[45] Although she was allowed to photograph only the outside of the buildings, Krull's memoirs record the doctor's physical appearance: "He is an impressive old man, tall, with square shoulders on which is planted a wild beast's head crowned with white hair."[46] She paints a less than flattering image of Schweitzer's personality, however, describing him as a despotic and exacting man.

The photographs from these excursions were published as military propaganda in various Allied war magazines. For example, one view of the Cameroon coffee plantations appeared in *Free France* (plate 8.4).[47] In views like this coffee reportage, traces of Krull's photojournalistic style survive. Three sacks are prominently arranged in the foreground, a figure stands behind the central sack, and the graphic pattern of the cattle heads adorning the sacks seems to move slightly as the three sacks sag differently. The background consists of the irregular, geometric pattern of stacks of sacks rising above the worker's head. Yet the photographic author had no trace of a voice or a byline in its publication, unlike in *Vu*, where the authors and photographers often collaborated and published personal comments on their projects within the articles. Krull's coffee photograph was published, oddly enough, as an illustration to the listings of the 125 tons of merchandise and products imported from the United States and Britain by December 1943. It is unclear why an image of sacks of coffee at the native coffee production center illustrates a list of imports. Such war industry photographs, for the first time in years, lacked Krull's credit line; they are credited to the Office française d'information cinématographique (OFIC), the military press information service for the Free French. Dozens of OFIC photographs illustrate the

war publications; many are probably by Krull but similarly lack a credit. Only images documented to her are discussed here, but we can assume that the few photographs labeled as being by Krull are but a small fraction of the total work she produced in Africa.

Among other industries, Krull recorded gold mining in M'Vouti, halfway between Pointe Noire and Brazzaville in Middle Congo. She documented the various stages of the process, and nine photographs from August 1943 survive in her archives. These compelling photographs document the mining process, illustrating the gold-washing table that separates gold from dirt. One closely framed image (plate 8.6) shows the massive quantities of water and dirt to be washed and the sluicing tables manned by the workers. Although the caption typed and attached to the back of the photograph adopts an impersonal tone, Krull's composition suggests the overwhelming difficulty of this work. Dirt pours out of all four frames of the photographs, and although the work looks backbreaking, the men are not represented as heroes. They squat or sit above the sluices, surrounded by the gold-laden dirt, occupying no visible space other than their sea of sand. A second photograph in this series is even more grim (plate 8.5). Here, Krull shows the workers in a closer view; they shovel ceaselessly while water pours down from above their heads. Three workers are depicted, their bodies emaciated and their muscles straining. Although Krull frames and lights the workers heroically in the photographs, the glistening light on their skin only serves to highlight their emaciated limbs.

Krull's memoirs reinforce the impression of hardship: she recalls that "the work was hard and long," remarking that workers got only two meager meals a day, were recruited by force from their village, and were not allowed to have women living at the mines.[48] Yet none of the ambivalence of her recollections enters the captions or the photographs in their primary usage. Nonetheless, Krull was aware that the war production occurred at enormous cost to the African workers and recounts that Eboué wrote, "In order to produce gold for the war, that requires reducing the blacks to slavery; the alternative is not forcing them and not obtaining the gold."[49] Here she exhibits an awareness of the human toll of labor in the war effort, faintly reflecting her earlier interest in workers' rights.

Krull also recorded the military subjugation of African bodies. The building of the roads and the huge amount of industrial work done in French Equatorial Africa required brute force. As the least modernized of the French colonized areas, with no industrial base, many of these indigenous industries were built on the backs of workers coerced into labor. Krull emphasizes this in a beautiful but disturbing image that highlights the glistening backs of the doubled-over workers, contrasted to the neat rows of logs that form the road's surface (plate 8.8). She frames the dark backs and cloth loincloths as isolated elements that contrast with the grain of the log roadbed, allowing no faces, no expressions, and no personalities to emerge. The upright figures are cropped to appear headless, and the ones bent double are framed so their faces are invisible; this is a picture of brute labor, not of laborers.

Picks and shovels were the only available tools, and Krull's captions emphasize the primitive level of the building industry. In another photograph, she heroizes the humble picks and shovels in a close-up detail that masses them into a classical triangular composition (plate 8.7). An undated photograph from Gabon records the human labor that traveled on Krull's route from Lebamba to the Etéké gold mines. In this view (fig. 8.5), ten porters stand prepared for departure, loaded with building materials and provisions on their backs. This looks like brutal work, but Krull's composition lends these workers an elegance by framing their bodies in a gradually receding diagonal line, to suggest an activity closer to dance. By framing the laborers so elegantly, Krull participates in the military message denying the injustice of their working conditions and heroizing the African industrial activity.

Ethnographic Portraits

Besides the industrial imagery, there are many portraits of women and children, indicating that Krull adhered to a popular subject for Europeans documenting the African peoples in the territories they controlled. Photographers from the nineteenth century onward had been fascinated with the images of black women.[50] As a single European woman upholding what might be called the Anglo-French colonial position, she can on one level be understood in a role not dissimilar to the colonial wife. She operated not in subordination to a husband but in obeisance (and in rare cases disobedience) to orders from male military commanders.

234.235

In these partnerships, she participated in the colonial packaging of information and economic endeavors to the benefit of European ideals and projects. Krull's indefatigable independence, however, put her slightly at odds with the colonializing status quo, and her informal snapshots of African labor were less thoughtful than the most efficient propaganda and reportage imagery of the war. The pictures bear enough of an argumentative voice to suggest a language of their own—a reshaping of colonial culture according to her own views. Her primary variance from military aims was the large number of portraits she made of African men and women at work in their villages. These images had no direct war utility, but her compelling vision of their strength would soon be used by François Villiers in a film planned to educate French viewers about their African compatriots.

Krull's portraits embody her subjects with dignity and poise, and she often frames them from below to monumentalize them. These were accepted ploys in the colonializing views of African women, and European photographers like Marie-Pauline Thorbecke in Cameroon (1911–1912) and Anna Wuhrmann in Bamum (1913) provide just two of many examples of this colonialist photographic tradition. In writing about the images from the kingdom of Bamum in then-German Cameroon, Christraud M. Geary explores how "European photographers in Africa reinforced and perpetuated stereotypes of Africa and Africans."[51] (Cameroon came under French rule in 1916). A few photographers, like Anna Wuhrmann, came to know their subjects well and photographed them more personally, but most, like Krull, remained formal and distant, emphasizing beauty and strangeness alike.

In most respects, Krull's photographs of women conform to the stereotypes of her other European colleagues. Many of her predecessors, male and female, were either missionaries or anthropologists. Krull's military assignments differed in that her European audience had more immediate and practical needs to be met by her African images. Therefore, she concentrated less on the fiction of dangerous sexuality that prevailed in images from pornographic postcards to serious documentaries but shared the European fascination with black seminude bodies and differing standards of beauty.[52] Although she was a woman traveling among women, there are few signs of personal interactions between the photographer and her subjects. For example, one of her portraits presents a Banda woman whom

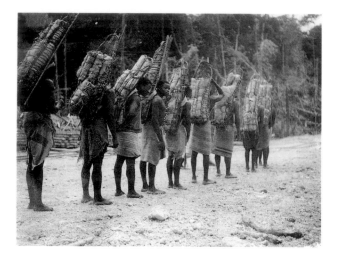

Krull photographed in Fort Archambault, Chad, in August 1943 (plate 8.12). Krull frames this woman from the thighs up, and shows her closely enough to identify her plate lips and other ornaments. She gestures in a natural way but does not look directly at the camera. Krull recounts her first experiences with these women in her memoirs, with a strange mixture of pity and fascination, describing the process by which a small wooden object was placed into the incision of a child's lip and exchanged for ever larger wood plates as she grew. She recalls that "the result [was] that a beauty of sixteen years had a lip that supported a wooden plate the size of a saucer. A girl adorned with colored glass beads in her hair, in her ears, and on her arms, carrying before her a plate, is quite strange to see, but still sometimes of a certain beauty."[53] Unlike more empathetic photographers such as Thurmann, she employed photographs to highlight deviance from European customs and to package the subjects for her European audience.

Similar portraits depict different groups with different customs. In an April 1943 portrait of a betrothed Tchikombi woman in Pointe Noire, Krull documents the dozens of bracelets and necklaces worn in the customs of this group (plate 8.11). Various captions describe the custom among the Bavilis-Loanges of isolating their young women, shaving their heads, painting them with a special red paint, and adorning them with heavy bracelets. They danced in village after village searching for husbands the first year and being permitted to see them the second year. One woman's photograph, in the archives of the Information Service, bears the label "Pointe Noire, une Tchikombi déjà promise." In this frontal view, this woman looks directly at us, her head

FIGURE 8.5

GERMAINE KRULL. *GABON. SUR LA ROUTE DE LEBAMBA À LA MINE D'ETÉKÉ. AU TERMINUS DE LA ROUTE. LE TRANSPORT DE MATÉRIEL ET RAVIAITAILLEMENT DE LA MINE SE FAIT AU DOS D'HOMMES. LE DÉPART DES PORTEURS.* 1943. GELATIN SILVER PRINT. 14.5 x 16.4 CM.. GERMAINE KRULL NACHLASS. MUSEUM FOLKWANG. ESSEN

framed by the hanging straw of her hut and her upper torso encased in beads and jewelry. Yet another photograph presents a mounted Bororo horseman, in Ubangi-Chari (plate 8.16), photographed in August 1943. Sitting on a rearing horse, with his white turban and garments silhouetted against a dramatic cloudy sky, this man is a romantic representation of the ceremonies of these nomadic people.

Exhibition Images

In her photographs that were not directly targeted for the war information office, Krull adopted another kind of idealizing tone. In March of 1943, Krull printed a series of very large views of some of her favorite African photographs and mounted an exhibition of pictures for sale. The exhibition opened in Brazzaville on 16 March with invitations issued in the name of the director of the Information Service of "la France Combattante en [Afrique Equatoriale Française]," under the patronage of Governor-General Eboué.[54] It was held in the offices of the Information Service, and the invitation card states that the show's purpose was to raise funds to support the Fighting French. Krull felt that some of the photos, which included many landscapes and close-up portraits of different African women and men, were among her best work.[55] Their presentation was effected with the help of Krull's friend Margaret Nairn, the wife of the British consul Bryce Nairn.[56] Instead of typing labels and gluing them onto the back of creased five-by-seven-inch press photographs, Krull printed eleven-by-fourteen-inch exhibition prints made on fine paper she had brought from Brazil. She signed and dated the images, and she and Nairn then mounted them onto cardboard with simple labels like "Gabon," "Brazzaville," or "Cameroun," inked in calligraphic lettering beneath.

This exhibition combined the accepted uses of war imagery and exoticizing images made by Europeans with a different venue—the gallery space. Presentation photographs of native African people had a long history in the European international expositions, and not only photographs but often people themselves were put on display in Paris and London.[57] In her book *Reinventing Africa: Museums, Material Culture and Popular Imagination in Late Victorian and Edwardian England*, Annie Coombes analyzes colonial exhibitions like the Franco-British exhibition of 1908 and argues that ethnographic collections and material culture were known much more

widely than by a narrow scientific community. This exhibition, held in London to cement the *entente cordiale* between the two countries, combined nationalistic and colonialist concerns in a manner not so very distanced from the issues Krull was addressing during the Allied efforts in World War II.[58] Krull's exhibition was confined to a Brazzaville audience made up of those who had first-hand knowledge of the region, but it embodied a similar nationalistic purpose. Although Krull stopped short of putting African people on view, she reprinted her images and framed them in large, compelling exhibition prints. She consciously had a plan to fund and display what she considered to be her best African work, but the subconscious agenda of the exhibition transformed the native population of this colony into a photographic commodity with no power, a series of images whose purpose was to satisfy European notions of exotic beauty while raising funds for the European war effort.

Krull included in this show some images that she had made during her travels on assignment in 1943, especially images of village women, but she chose different negatives and cropping from those reproduced as war propaganda. The exhibition images are, if anything, more idealizing than her war information work. For instance, she included a close-up view of one of the Gabonese road porters (plate 8.9, variation of fig. 8.5). Instead of framing them from the back and at a distance, as she had in the group shots for the army, this photograph isolates one man and frames him from the thighs up. His straw backpack soars out of the photographic frame, creating an impression of a monumentally strong and heroic figure who seems to be carrying the world. The print highlights the sheen of his skin and the angle of his posture, turned partly to one side so that we see his features but not his expression, and also reinforces the impression of the noble or heroic worker. Krull never heroized her Paris workers in such a fashion; she was more likely to photograph them head on or to show a quirky quality of their personalities. In this photograph, we are presented with a foreign yet monumental figure but given no clues to his individual personality; instead, Krull adheres to the dramatic commercial documentary style shared by Margaret Bourke-White, for instance. Krull was not alone in highlighting the sheen of black skin and physical strength; despite

the differing characteristics that Europeans bestowed on African peoples, strength was always a part of the myth.[59]

The exhibition included many romanticized landscapes of the African jungle and rivers, like a river view from Gabon with dramatic dark clouds scudding across the grasses and water (plate 8.15). In fact, Krull gleefully recounts that one of her Brazzaville buddies (named Dédé in "Ceux de Brazzaville") reportedly told her that "maybe French Equatorial Africa is not so bad, according to your photographs. Only in your pictures one can't feel the mosquitoes and the other charming beasts."[60] The landscapes are grand, peaceful, and heroic, suggesting little of the difficult living conditions in this part of central Africa. They are more elegiac than Krull's French landscapes, and one can sense that this powerful world struck an emotional chord for the photographer that she had not found in the French views she took with Jacques Haumont in the mid-1930s.

Krull's portraits for the exhibition are framed more closely than her work for the wartime press; Krull depicts her subjects to emphasize the beauty of their skin, their ornaments, and their postures and yet remains formal in her presentation so that no details of disease or poverty dilute the classic beauty of the compositions. These beautifully printed photographs contain a peculiar mix of intimacy and convention. In a view of a mother and child from Brazzaville, for instance (plate 8.10), we see the expressions of both and their relationship to each other. Krull documents the details of costume and posture but captures the mother at a particularly relaxed moment, when both her body and her son's seem loose and free. The mother regards the photographer with an expression that could be suspicion or scorn, while her son looks out of the frame at an event clearly more interesting than the photographer. This photograph, like many of Krull's portraits of women, cannot be identified as a psychological portrait, a casual snapshot, or a reifying classification document. These are individuals, but Krull does not engage them directly. We see the details of their tribal costumes and their individual personalities, but Krull records no intimacy with her subjects. Nonetheless, they are much more individualized than portraits in some of her press work and less exaggerated than similar portraits by Ellebé, who tended to shoot women from such a low vantage point that they loom out of the frame like giants.

These photographs both reveal the attraction Krull felt for this part of the world and show the essentially conventional and colonial attitudes that she adopted,

perhaps unknowingly. On the one hand, she was sympathetic to different groups and the people she met on her travels; on the other hand, even in her memoirs of three decades later, she still clearly differentiated herself from them, presenting them as "the other." This sympathetic yet patronizing attitude had begun in Brazil: "It was necessary to accept different values. In Brazil, I had encountered customs so different from ours that I learned that fundamental values do not exist. This helped me enormously in Africa, later on. One must never forget that we are so different [autres que] from the Africans."[61]

In the remaining photographs of African people from her 1943 exhibition, Krull adopted certain conventions of ethnographic photography but chose to avoid others, preferring a vocabulary of art portraiture to a catalogue of scarification or tribal custom. She did not create an impersonal and demeaning classification of different scars, adornments, and ethnic costumes. Yet she did classify her subjects by group and shows their most characteristic costumes and customs. Her subjects include a wide compendium of people—the Tchikombi women, the Pygmies of Gabon, the plate-lipped women of the Banda in Chad, and the mounted Bororo horsemen of Ubangi-Chari.[62]

These images served a propagandistic purpose in a subtler forum than the press pictures. Many of the men of this region were forced by their chiefs into backbreaking and often fatal labor in the gold mines, rubber plantations, and road-building projects of the war effort. In monumentalizing the Africans and depicting them as serene and strong, Krull tacitly aided in the war effort's to whitewash the miserable living and working conditions that the European battles imposed in French Equatorial Africa. By the end of the war, the previously underdeveloped colonies had moved forward in industrial production but at great human cost. Krull, Desjardins, and General Eboué, from their varying points of view, shared in the public presentation of the colonizing European control of the lives, the work, and even the depiction of these people.

There is a long history, dating back to the nineteenth century, of Europeans who use photography to classify non-Europeans according to anthropological or other ethnographic categories. The French fascination

with African sexuality dates back to the beginnings of colonialism.[63] Krull's portrait of the Tchikombi woman differs very little visually from, for example, a Samoan woman photographed around 1890, whose portrait is in the Royal Anthropological Institute in London, sharing the conventional topless pose, ornamentation, frontal gaze, and accessoried backdrop of the earlier document.[64] By embracing the formal tools of anthropological photography, Krull adopted its unspoken colonialist message as well as its style.

Much of the shift in Krull's work can be attributed to the very different demands of the Information Service and to the effort to convince the Allies of the worth of French Equatorial Africans' war work. This was no time for geometric experiments. Krull's work here, like much of her earlier work, was a collaboration, and the patron was working with a specific end in mind. The goals of the press offices during the war can be even better understood in another collaboration—the work Krull did with film director François Villiers to create two films about Africa for the war information office. In the second half of 1943, relatively soon before Krull was transferred to Casablanca and Algiers, she was asked to collaborate on a film project that would result in two short films—*Autour de Brazzaville* and *L'Amitié noire.*

Films

L'Amitié noire would not be released in France until 1946, but the government commissioned the production of these two films in 1943 for very urgent reasons. One hundred thousand Africans would fight in the Free French armies before the war's end, and the colonies of French Equatorial Africa and Cameroon, as well as French West Africa, were asked to supply exports at great cost to the populations there.[65] As the war ended, this film was meant to foster gratitude for the African war effort and to continue, amid growing pressure, the dialogue about progress in the colonies toward autonomous management, which would lead to independence in the coming years. In this context, Villiers and Krull received orders to leave Brazzaville on 1 October 1943, heading to Dolisie, Mouila, Lambaréné, Port Gentil, Libreville, Douala, Yaoundé, Garoua, Maroua, Fort Lamy, and supposedly to Cairo by plane after the project ended.[66]

Autour de Brazzaville, produced by the Office Français d'Information–de Gaulle in 1943, is a twenty-two-minute film narrated by Richard Francoeur and shot by François Villiers, "realized with the collaboration of Germaine Krull."[67] The exact nature of her involvement is unknown, although she is clearly and prominently credited. It is described as a short film on the effort of the Free French in Africa, describing their military and economic aid to the Allies. From the available documentation, *Autour de Brazzaville* seems to be a straightforward war documentary.

L'Amitié noire, however, belongs in another category. *L'Amitié noire* is described in the French distribution catalogues as an excellent film on the life and customs of indigenous blacks of French Africa, with very beautiful dance scenes. Jean Cocteau's commentary, which is cited as "remarkable," catapulted it into an entirely new realm.[68] Cocteau is credited for writing as well as delivering the commentary, Villiers receives credit for photography and montage, and Krull and fellow photographer Pierre Bernard are cited as "collaborators."

L'Amitié noire, which is seventeen minutes long, opens with a shot of the Radio Brazzaville post itself, revealing men at the editing desk and Germaine Krull herself reflected in the mirror. Cocteau's extraordinary voice intones, "A new monster has been born in Africa. . . . It is Radio Brazzaville."[69] The film thus begins with the June 1943 opening of the new post of Radio Brazzaville, with close-up shots of machinery, the workshop, the tickertape machine, and various offices. In a flight of oratory that increases during the film, Cocteau declares, as the tickertape appears, "Here is the ribbon that France sends to her lovers to remind them that she is beautiful."[70] Patriotism and the language of love permeate the film from its opening moments, and the unfolding views continue to build a song of praise for French loyalty in Africa by combining nude bodies, gyrating dancing, and patriotic talk. War information and ethnographic fact take a decided back seat to romantic patriotism and nude imagery.

The film shows views almost identical to the romantically moody riverscapes that Krull showed in her exhibition (plate 8.15), the same Tchikombi and Banda women (plates 8.11, 8.12) that she documented, and the same Bororo horsemen (plate 8.16). As the music increases in volume, and the movie camera moves closer

and closer in to the women's breasts, we realize that this is a different genre. We do not know whether Villiers edited the film to increase its sexual content or whether Krull and Villiers shot these scenes together. But this footage has a different audience from the tamer press and exhibition photos. Krull might frame a nude woman with bare breasts to show her scars or her jewelry, but the film's narration equates their flesh with the birth of civilization. For instance, as the camera closes in on a woman weaving, in a sensual shot, Cocteau booms, "This woman who weaves resumes the trace of her profound race. Her arm is a miracle of beauty."[71]

Cocteau's narration refers explicitly to classical literature, equating these peoples with the birth of civilization. For instance, he intones, "We reenter the legends of Apollo" as we see goat herders and women crushing grain. In the footage of the Tchikombi women with their bracelets, Cocteau labels one the "woman with the bracelet" and whispers "Venus de bronze" as the camera zooms in on gyrating hips and bouncing breasts. He equates dancing men and women with the Ballets Russes and Scheherazade. Cocteau comments on the basic rites of birth, marriage, and death, and the film ends with a marriage, celebrated by a horse race across the desert, as Bororo mounted men (in a shot almost identical to plate 8.16) race toward the camera in a deafening roar, accompanied by the music recorded on site. The drama of thundering horsemen had a clear precedent in the enactments like the 1890 performance at the French Exhibition at Earls Court, when Arabs on horseback created a "life picture" that supposedly provided a riveting experience and proved that "things seen are mightier than things heard."[72] Cocteau's last words in the film reveal the same belief—this time in the name of patriotism—as he dramatically proclaims: "For centuries these great races, Muslim and animist, have been massacring each other. They have united to undertake a long voyage, to defend France. Let us salute them!"[73] The film ends as the horsemen raise their swords and stop before a man in a white robe; the gesture of swords raised before the white-clad man intertwine with the sonorous words, "Let us salute them! [*Saluons-les!*]." The marriage of Africans and French warriors, and of European and indigenous cultures, is encased in the resonating tones of Cocteau's unforgettable voice. Under the rhetoric, however, is an attempt to whitewash the sacrifices imposed on Africans during the war and to frame the populations of French Equatorial Africa so that they can be admired by Frenchmen. This involves

using classicizing European cultural language to cast these Africans in the conventional orientalizing roles of subjugated women and soldiers for their white masters.

The exact meaning of the film's credit "with the collaboration of Germaine Krull" is somewhat unclear, although the shots are uncannily close to her still photographs. She may have been the photographic scout and tour guide for the filmmakers, or she may have participated directly in the composition of the film. In any case, she condoned the framing of these people as primitive servants to the "civilized" French. This film goes further than the photographs that Krull printed herself to cast French Equatorial Africa in terms easily swallowed by the European imperialist audience. *L'Amitié noire* seems to present a complex colonialism, comprising many stereotypes of non-European imagery, rather than a static or fixed ideological construction of otherness.[74] Krull's complicity with this complex imperialism seems at odds with her supposed love for independence, and although she acknowledged the compromises Eboué and others made in the last years of colonial French Africa, she did not fight them. She adopted a similarly conventional European attitude in her next years in Thailand and in India, although she had a greater sympathy for their culture than for African culture. Despite her love of adventure and her eventual renunciation of European culture, she remained a European viewer of the "Oriental world" throughout her life.

European Campaigns

Krull refused to compromise in the more internally European political conflicts of the war. She stood firmly behind her belief in the initial goals of the Free French and abhorred the compromises that began to occur in 1944 as the Allies began to turn the tide of the battle. The photographer left Brazzaville in late December 1943 or January 1944, traveling on assignment to Casablanca and eventually moving to Algiers to join the Office français d'information cinématographique.[75] Here she made the previously discussed photograph of de Gaulle, among other assignments (plate 8.1). At this time all the French colonies, previously split between Free French

and Vichy allegiances, merged into one large colonial government under the control of Algiers, all supposedly in support of the Free French. After this point, Krull received her instructions from the provisional government of the French Republic in Algiers, most often from the Commissariat of Information rather than from Radio Brazzaville and the Information Service. This move necessitated certain compromises, as Algeria had been pro-Vichy under General Giraud before the Anglo-American invasions. Leaders' allegiances changed, but the French Equatorial African colonies continued to see them as traitors or at least as turncoats. Krull describes the situation vividly in her memoirs:

> *Politics had required that General de Gaulle, at the moment of the American disembarkation in North Africa, had to accept the submission of General Giraud, chief of the French Forces who had more or less escaped from Nazi control in accepting the Vichy government. For us others, Algiers represented the beginning of a compromise that we accepted badly, and the pains and grindings of teeth of the "pure" ones were difficult and painful.[76]*

The nature of Krull's work for this government agency for the first seven months of 1944 is unclear. She landed in Saint Tropez with the August 1944 southern invasion that followed the 6 June Normandy invasion. Her itinerary can be reconstituted from the various "Ordres de Mission" that survive.[77] She left Algiers on 29 July by plane to rejoin the French army in Naples, where her orders were to make reportages for the weekly Algerian newspaper *Rafales* and to take further orders from the Service de Presse aux Armées. Her task was to document the work of the French Resistance where she found it and "the demographic, sanitary, and moral conditions" of the French population. On 15 August she landed with the southern forces in Saint Tropez. Her photographic record (fig. 8.6) presents all the factuality of the landing and none of the romance of Robert Capa's damaged images of the Omaha Beach landing. She received a Peugeot 202 to travel through the territory controlled by the Forces Françaises de l'Intérieur (French Interior Forces) in Vaucluse. She left from Avignon and must have arrived in Paris in time to record its liberation in late August. She traveled from Paris to Besançon-Belfort after 5 October 1944 and documented the Battle of Alsace in the last two months of 1944.

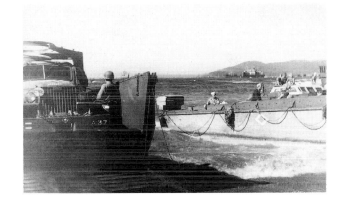

In France she reencountered André Malraux, who had been working in the French resistance under the code name of Berger. Here she joined up with the American Seventh Army and French First Army and worked in northern France and Paris for the next months. Her path in the wake of the Allies was shared by other photographers, notably Constance Stuart Larrabee, a South African photographer who also documented the war.

Krull's documentation of the Battle of Alsace served two audiences—military and commercial. She was working for the government as a war correspondent, and her images were used by the army. In addition, she sent copies of these images, and of her book on Alsace, to Charles de Gaulle, whose thank-you letters she carefully saved in her archives. De Gaulle wrote: "In these decisive days where Alsace, so close to our hearts, was definitively returned to France, the beautiful photographs you have taken have, in addition to their documentary merit, a special value."[78]

Back on French soil, Krull lost no time returning to one of her great interests, the entrepreneurial possibilities of making photographic narratives in book form. Despite her uncomfortable parting from Jacques Haumont, she signed a new book deal with him on 15 December 1944, immediately after recording the battles in northern France.[79] Haumont also planned to publish her African photographs and memoirs, although this last project never saw the light of day.[80] For *La Bataille d'Alsace*, Roger Vailland, a war correspondent accredited by the Grand Quartier Général du Corps Expéditionnaire Allié (SHAEF), was cosigner as author of the text.

As a wartime chronicle, not an art book, *La Bataille d'Alsace* suffers from its grainy offset lithographic repro-

FIGURE 8.6
GERMAINE KRULL. LANDING IN PROVENCE, 15 AUGUST 1944.
GELATIN SILVER PRINT, 11.3 x 17.5 CM.,
GERMAINE KRULL NACHLASS, MUSEUM FOLKWANG, ESSEN

ductions printed on inexpensive newsprint. The images impress on the reader the immediacy of the events, using the grainy newspaper format of battlefield and camp reportage to create a sense that the events have just occurred. Its format reproduces the kind of work that Vailland did as the correspondent for the French paper *Libération*. Krull published at least one photograph in *Libération* as a special photographic correspondent. It depicts Seppois, the first Alsatian village liberated by the French.[81] Vailland's narrative tells the story of the two-month campaign to retake Alsace in November and December of 1944.[82] Captions and labels accompany Krull's forty-page photographic story, and her images depict humorous moments among the troops and various villages and cities along the battle route. The various leaders included the generals, as well as members of the Resistance now fighting alongside the French army. These include Krull's friend André Malraux, who fought under the name of Colonel Berger,[83] and Henri d'Astier de la Vigerie (fig. 8.7), a major figure in the resistance movement who was instrumental in unifying the various factions and making them loyal to de Gaulle.[84] The anecdotal note that author and photographer attempt to strike follows the general tradition of the picture magazine story but seems much less convincing. Krull seems to have noticed the details of army camp life and of the towns they passed through, but her heart was not in these photographs as it is in her French and African material. As war propaganda, *L'Amitié noire* is far more powerful, although problematic.

Krull wrote several short essays on the daily life she observed while traveling north toward Belfort, including "L'Haut du Fang" (3 November 1944) and "Entre Marseille et Avignon" (9 October 1944).[85] She also recalls having photographed a Nazi concentration camp near Stuttgart, at the time when Allied troops began to help the survivors.[86] She describes the shocking moment when a German prisoner was brought through the camp and was torn limb from limb as the survivors recognized him as the camp's director. She writes that these photographs appeared in a Resistance illustrated magazine, but they have not been recovered.

Krull's ambivalence about her role as army photographer emerges from her prose and her pictures. She was joyful at the August 1944 liberation of Paris, which she photographed (fig. 8.8), and at the retaking of French territory from Provence to Alsace in 1944. Nevertheless, Krull's zest for the fight was waning—not

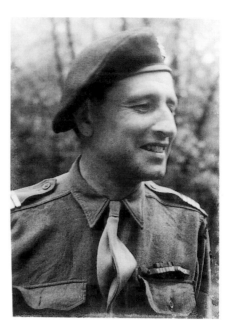

because the Allies were winning but because she was forced to participate in a huge military and photographic machinery that ran contrary to her beliefs. Gone was the thrill of politically supporting the underdog, and army restrictions continued to frustrate her professional belief in independence. Particularly galling to Krull was the fact that all the French now claimed to have been Gaullists and Resistance fighters from the beginning, while she had been in the African mud fighting for them all along. Krull had not been happy at the compromises required for her service in Algiers. In "Ceux de Brazzaville," she describes her confusion at the new government in Algiers run by Giraud. In the dialogue she constructs in the memoir, Krull's friend "Jane" attempts to explain to her the compromises necessary in war, telling her, "Politics is not always clean, as James [her husband] would say. General de Gaulle cannot rebuild France without the French. And the French are not only the 'Free French;' there are also the others, and de Gaulle knows it."[87] Back on European soil, the photographer was very blunt about her intolerance for this point, later writing: "I had to escape from this path. I did not want to stay in Europe any longer; Europe disgusted me."[88]

Krull was still based in Paris and northern France on 8 May—V-E Day, the end of World War II in Europe. She continued her military war correspondence work beyond the liberation of Europe, but she found a way to remain a pioneer, both in her professional assignments and in her political involvement. Her reportage for the First French Army completed, she was ordered to Paris on 12 May 1945. She then traveled to London on 25 June 1945 and by late July was preparing to travel to

FIGURE 8.7
GERMAINE KRULL. HENRI D'ASTIER DE LA VIGERIE. 1944.
SILVER GELATIN PRINT. 18.0 x 13.0 CM..
GERMAINE KRULL NACHLASS. MUSEUM FOLKWANG. ESSEN

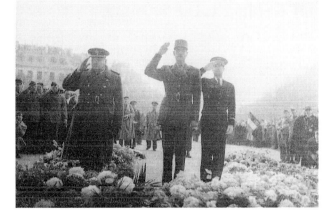

Asia as a war correspondent. The Japanese surrendered on 2 September 1945, after the atomic bombs of 6 August and 9 August. A week after these events, Krull received a letter from the Agence d'Edition et de Presse, dated 16 August 1945, which exclusively engaged her as an Asian photographic reporter at a point when the war was clearly about to end. Almost immediately, Krull embarked for Ceylon.[89] Krull was forty-eight years old at this point, and most other women her age would not have left Europe, let alone embarked on a solitary assignment to document Indochina, Laos, and Siam. However, her actions were quite consistent with her beliefs in forging new worlds where she could feel passionate and with her lifelong urge for a life of adventure.

Krull's official papers include a permit issued in London on 27 August 1945, granting her a one-year permit for the South East Asia Operational Area. It is stamped "Valid for Ceylon in direct transit to S. E. Asia." She received a permit as "an accredited Woman War Correspondent" on behalf of the Agence d'Edition et de la Presse on 4 September 1945.[90] Krull left for Asia sometime in late August or early September, and a further letter from Agence d'Edition et de Presse dated 21 September 1945 acknowledged receipt of her first negatives from Asia. The agency informed her that they had published two views of General Leclerc. Her correspondent than asked her for any original information she had, as well as "small stories or other curiosities that you encounter on your journeys."[91] Writing that he preferred texts and captions of twenty-five to thirty lines rather than longer essays, he added that he was impatiently awaiting information on Saigon. Krull's departure for Ceylon marked her transfer from the African and European theaters of political operations to the Far East. The travels in a new continent would prove very fulfilling, replacing the loss of country and family with a new environment. She would now adopt Asia as her home and return permanently to Europe only at the very end of her life after four more decades away.

242.243

Chapter 9

Flight

*Like a movie montage, the intervening years
flashed through my mind. . . . And now after all
those wonderful, mad, sad, exciting, depressing
and thrilling days and years, I found myself in
an oasis of peace. The lush, fast growing
vegetation had covered the scars of bombard-
ments and fires in Bangkok and there was
nothing to show which crack and hole in the
pavements came from bomb splinters and which
from erosion, or which vacant lot had always
been vacant or had formerly been occupied by a
building.[1]*

Germaine Krull landed in Ceylon (now Sri Lanka) in
late August or early September of 1945 and spent the
next few months as a war and photographic corre-
spondent in Saigon, Singapore, Phnom Penh, and
Bangkok. Krull settled in Bangkok definitively by the
beginning of 1946. In the spring of 1947, she became
the manager and part owner of an old hotel that would
soon become Bangkok's most famous postwar interna-
tional hotel, the Oriental. Krull would spend almost
twenty years running the Oriental Hotel, resigning as
director only in 1965.[2] Nearing retirement age in her
late sixties, she sold her shares in the hotel and moved
to Paris for a year in April of 1966.

For the first twenty years after the end of World
War II, Krull exchanged the photography world for the
business world. In restructuring her life as an entre-
preneur yet again, she took the unlikely path of adopt-
ing her mother's profession of running a boarding
house but on a much larger scale. Instead of being a
single woman taking in boarders, Krull and her hotel
were famous throughout Asia; older international
business travelers still speak of "the Oriental" with awe
today, and it continues to be Bangkok's most romantic
hotel.

From this powerful position, Krull participated in
and helped to shape many events in Asia, including the

vitalization of the independent Thai state, the modernization of Bangkok, and its establishment as an international business center in Asia. She also made a myriad of political and international contacts. Her enthusiastic involvement with a booming capitalist culture in Bangkok might seem an inexplicable choice for a woman whose life had been so politically activist and seemingly antiestablishment. Krull's lifelong individualism led her to value this new culture she encountered, and her pragmatic streak allowed her to craft her newest professional career as an entrepreneur. It did not, however, seal her from racism or myopia in her political opinions, and her views in Africa and Asia remained those of a European woman. Krull's independence, pragmatism, and European values carried her through the events of the second half of her life as firmly as they had guided her first half-century, and this chapter studies her activities as a European entrepreneur, political commentator, and artist utilizing Asia as a testing ground.[3] Her activities tell us far more about European reactions to Asia than about Asian culture on its own terms and form a powerful case study for a postwar imperialist view that frames the East for Western consumption.

In the last decades of her life, Krull's long-standing friendship with André Malraux assumed an increasing importance and helps to explain her particular position as a modernist cultural and political European observer of Asia. The intense young man whom she had photographed in the 1920s had become a resistance hero. Krull had reencountered "Berger," as he was called in the Resistance, during the Battle of Alsace. Malraux joined de Gaulle's government as minister of information in 1945, and Krull addressed her political correspondence on Indochinese issues to Malraux. He became minister of cultural affairs when de Gaulle returned to power in 1958 and remained a staunch friend to the photographer in the 1960s, obtaining for her a contract to document Buddhist monuments for the Gallimard series of books "Univers de formes," part of an enormous French effort to cast all the world's monuments in a single trajectory that privileged the Graeco-Roman origins of culture over any other. Finally, when she contemplated a return to Europe in the mid-1960s, Malraux arranged a 1967 retrospective exhibition of her work in Paris, becoming her most important advocate for reinsertion into the modernist artistic canon. Their friendship examined freely both politics and art.

During Krull's last years, photography played a very different role from what it played in the first half of her life: in effect, she ceased to be a professional photographer, which she had been throughout her adult life until then. Krull herself recognized this split, and in November 1976 published a letter in the *Gazette des beaux-arts* stating that during these years, her photography was no more than a touristic record of the sites she visited: "I had little time left to make photographs; besides, my camera was not what most excited me; it had become a game for souvenirs rather than of artistic research."[4] She did, however, continue to make thousands of photographs, sending her film back to Europe to be printed by Jean Privat, the son of her friends in Monte Carlo. Certain projects and publications continued to connect her occasionally with professional photographic life. In her first two years in Asia, she made photographic reportages as well as written records of political events and daily life in Asia, although these were rarely published. During her busiest years at the Oriental Hotel, she almost never had time for photography.

During her years in Thailand, Krull wrote two more books—*Bangkok: Siam's City of Angels* and *Tales from Siam*.[5] Krull's books, which stylistically combine the drama of the African photographs with the calm of her French travel books, echo her stance as a European woman who wielded enormous power in Bangkok. The narratives present Thailand as an unspoiled new world that she and her colleagues could reshape and redefine as they wished, with little attention to indigenous wishes. These books occupy an intangible region that writer Mary Louise Pratt calls "contact zones," areas where Europeans and non-Europeans interact. Pratt distinguishes the inherent inequality of relationships in contact zones, describing "peoples geographically and historically separated [who] come into contact with each other and establish ongoing relations, usually involving conditions of coercion, radical inequality, and intractable conflict."[6]

The Thai books continued a pattern begun in Africa—a series of books where Krull commented on foreign and non-Western cultures as a European outside her homeland. In titling these books *Bangkok: Siam's City of Angels* (1964) and *Tales from Siam* (1966)—that is,

choosing Thailand's outdated historical name rather than its current political title—Krull framed Southeast Asia through a nostalgic lens that disempowered Thailand and reduced it to mythical status. The Thai books, unlike their predecessors, were actually published and join a long history of lighthearted travel memoirs by Europeans in foreign places. Rather than a view of Thai culture, these books clearly form part of the postwar imperialist construction of Asia as a place for European development and domination. In fact, Krull's political reportages, her memoirs, and her photographs for Malraux can also be seen through Mary Louise Pratt's lens of "contact zones." All three package Asia for a European audience and tell us more about Krull and the postwar experiences of her fellow Europeans in controlling Thailand than about indigenous 1950s Thai culture.

Southeast Asian War Correspondent

Krull arrived in Asia as a war correspondent; political events in Southeast Asia absorbed her for her first year there. Her activities at this time illuminate her progression in several ways. They show a path she might have preferred to hotel management and her dependence on Malraux. She abandoned her political career only reluctantly, largely because de Gaulle's government and her patron there, Malraux, fell from power. In addition, the memoirs demonstrate her antiauthoritarian beliefs while revealing her more conventional racist or European attitudes toward third world cultures. Finally, Krull's actions prove that at forty-eight she had no lack of energy or passion for an entirely new and foreign world and that no family or personal contacts held her back.

On 24 August 1945, she wrote to Friedrich Pollock, sending him her new address in Kandy, Ceylon.[7] After a quick tour of Indochina, Krull returned to Singapore on 11 November and seems to have been in Bangkok in December of 1945.[8] She settled permanently in Bangkok by March of the next year. Although her letters to Pollock do not survive, his responses to them suggest that she was sick at heart at the events accompanying the war's end in Europe. In response to her despair, his letter expresses optimism for France in the long run:

> I firmly believe that after many a detour and
> quite a few false starts, the French people will
> rebuild their shattered social and economic home

into something beautiful and solid. . . . I admit
this is hard for those who are no longer young
enough to participate in this better life. But that
is man's fate, and those are to be considered
happy who have been privileged to contribute
their share.[9]

Moreover, he urges her not to lose hope: "I want you to be a little more courageous. The world is moving, and you have a right to be proud that you have contributed whatever your abilities permitted you to do and perhaps a little more."[10]

Whereas Pollock expresses his hopes for the postwar rebuilding of Europe, Krull clearly continued to have doubts. There are no signs that she considered returning to Europe during these years; she found it corrupt. When she writes in 1946 that her contract with the French press agency had ended, she has no wish to return to Europe.[11]

The photographer clearly landed in a hotbed of activity; despite her apparent gloom, Krull was extremely active in Asia and wrote several reports and articles during her first months as a correspondent. The autumn and early winter months of 1945 were full of turmoil in the Asian countries she visited. The Japanese surrender was signed on 2 September in Tokyo Bay, just about the time Krull was arriving in Ceylon.[12] In her first few days there, she photographed General Leclerc, who was in Kandy, and her photographs were reportedly published in France, although no evidence of their existence has yet surfaced. By 4 October, she was already a visible presence in the Southeast Asian international community, and the Bangkok newspaper *Liberty* included a small notice entitled "Lady War Correspondent Arrives in Bangkok," explaining, "Madam Krule [sic] Ivens, a French lady war correspondent, arrived in Bangkok by plane yesterday from Saigon and was expected to leave today by plane for Singpore [sic]. She covered the incidents in Siagon [sic] for a Paris newspaper."[13]

In September 1945, Krull filed the first in a series of reports on the Indochinese Federation.[14] This essay, and the others she wrote, exist only as unpublished typescripts in the archives of the Institut Charles de Gaulle.[15] We do not know whether they were originally sent to the Agence d'Edition et de la Presse that hired

her in the summer of 1945 or whether she wrote them directly for André Malraux, while he was a cabinet minister in de Gaulle's provisional French government in the autumn of 1945. During this period Malraux and Krull corresponded regularly about the political events she was witnessing; he evidently valued her opinion highly. Her writings in the fall of 1945 and winter of 1946 clarified her political support for the Indochinese rebellion of Ho Chi Minh, a support that ran counter to popular French colonial policy and even to Malraux's ideas.[16] She agreed to write André Malraux on behalf of the proindependence Annamites, asking for his help. In her later memoirs, she writes plainly, "I was for the Annamites anyway."[17] We know that Krull sent her first report, from September 1945, to Malraux, for his letter of 8 October 1945 acknowledges its receipt. He replied:

> On the whole, what you write to me corresponds more or less to the official information that is given here. The relevance of your letter is that we are a bit suspicious of official information, which risks being too unilateral, and it is very interesting for us to know—for me, in particular—that in this case it was correct.[18]

Soon after that, facing anger from the colonial government for her contacts with the rebels, Krull was asked to leave Saigon. Although the details of her reports are too lengthy for full discussion here, they reveal her antifascist stance.[19] With a nostalgic wish for a continued Francophile culture, she concluded her reports by plaintively wondering why the Indochinese needed to abandon French culture and why friendship could not be sustained between the French and the Indochinese. In realizing that the French would be forced to leave Indochina, Krull foresaw the events of the terrible years to follow.[20]

Krull followed these events closely, and her reaction highlighted her unwavering support for de Gaulle and dislike of other French political parties. She consistently sent reports and letters to André Malraux about the events that upset her,[21] and once again found, as she had discovered so often earlier in her life, that her passionate though narrow political beliefs were not necessarily shared by others. In a letter of 15 November 1947, Malraux writes to her, somewhat impatiently, "I don't have to tell you that unfortunately France's destiny will not be resolved through the Indochinese question. The problem is excessively simple: it is a matter of knowing

whether or not one wants Stalin in Paris."[22] In this matter, at least, Malraux, who had become a staunch anti-Communist, found her too idealistic, although her reports were often useful to him.[23] A letter from Malraux suggests that perhaps she would have wanted to continue her political career. In a letter of 24 April 1946, he writes, "The arrangements I would have been able to make for you have become impossible, for the simple reason of my departure from the government."[24] This suggests that Krull would otherwise have begun a diplomatic career of some sort if Malraux's government had remained in power, but de Gaulle had resigned on 20 January 1946 due to continued leftist opposition.

Krull's views on Laos found a wider audience. In June of 1947, *Far Eastern Survey*, the journal of the American Institute of Pacific Relations, published her article "Error in Laos."[25] Krull essentially blamed the French for the resumption of hostilities in Laos. Her archives at the Institut Charles de Gaulle also contain a letter dated 9 February 1947 from Thao-Oun, minister of state, to Son Altesse le Chef Effectif du Gouvernement Lao,[26] proving that she continued for several years to try to intervene in the diplomatic jostling between the French and the Free Laotians.

If Indochina and Laos provided a replay of the reality of compromise politics that she had so disliked in 1945 France, they did force Krull to confront the issue of colonialism openly for the first time. In her later memoirs, she writes that after she left Saigon for a brief trip to Singapore and then Indonesia, she began to struggle with the concept of colonialism. Her statement also reinforces her racist attitude toward her African coworkers during the war. Even as she awoke to the colonial domination in Asia and Africa, she made—even in 1980 when she penned "La vie mène la danse"—a personal distinction between the Annamites, whom she perceived as a historically educated people, and the African Congolese, whom she continued to perceive as "primitive":

> I had never, in principal, thought about the colonial question. But now I had to. In Africa, the problem had not arisen for me. My memories were good, and my boy Malonga served me well. I had nothing to reproach him with, and also I did

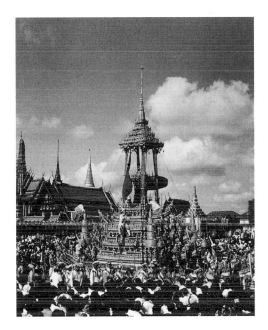

not see Frenchmen who maltreated blacks in Africa. Everything was so simple, and there was no question of liberty. The Annamites were something else. There were a race with a long history behind them. They had the right, after all.[27]

In privileging cultures with a rich written history, she shared the classic framework of European colonialism. Nonetheless, Krull's reactions to these issues were idiosyncratic. Her reaction to her surroundings continued to be personal and adventurous rather than reasoned or analytical, which explains why her writings remain memoiristic rather than philosophical contributions of the caliber of her friends Horkheimer and Malraux, whose grasp of history was far more sophisticated.

Bangkok and the Oriental Hotel

Independent Siam, which adopted the name of Thailand in 1949, had a history of alliances with Britain.[28] It was a more peaceful and prosperous country than the French Indochinese states, and furthermore, it was free from the colonialist battles of French Indochina. Despite its independent status, two factions had developed within Thailand during the war. Thailand had been technically allied to Japan during World War II (through its rightist leader, Marshal Luang Phibun Songgram), although the United States diplomatically ignored Thailand's declaration of war against the Allies.[29] The pro-Allied Free Thais were represented by Nai Pridi Panomyang, who facilitated Allied espionage in Thailand during the war.[30] With their underground wartime relationship to build on, the United States and Britain resumed diplomatic relations with Thailand in January of 1946, and international business grew quickly.

Krull thus arrived in Bangkok at the moment when diplomatic relations with the former Allied nations were resuming. Despite her intensive attempts to support the Vietnamese liberation efforts in French Indochina, she seems to have happily maintained friendships with partners and friends at both ends of the political spectrum in Bangkok, enjoying government aid for her hotel under both the Songgram and Pridi regimes of the postwar years.[31] Krull's acceptance of a government that had collaborated, however superficially, with the Japanese may seem puzzling. In her published memoirs,

she offers a clue to this mystery when she comments on Thailand's independence: "The atmosphere of freedom and equality in Thailand struck me forcibly. It was and is a happy country, the only one in this part of the world that has never been a colony."[32] After her dislike for colonial governments in Indochina and Laos, and her distrust of external control of France in World War II, Thailand's tradition of fiercely independent nationhood must have been very compelling, and the prospect of rebuilding the nation very exciting.

Krull was in Bangkok in December of 1945 when King Ananda Mahidol (Rama VIII) returned from his studies in Switzerland, and she was in Bangkok at the time of his sudden violent death on 9 June 1946. In a style reminiscent of her late work for *Vu*, she created a picture story of King Ananda's funeral, his cremation, and the subsequent coronation of his brother Phumiphon Aduldet as King Rama IX (fig. 9.1). These are some of her earliest surviving postwar photographs, and the images of crowds, the cremation structure, and the streets jammed with people seem to be among the few street photographs she took in Asia. She moved away from action photography after the war, although the reasons for the shift are unclear. The next years would be occupied with hotel management rather than art or street photography.

In the spring of 1946, Krull and an American businessman named Jim Thompson decided to take over the Oriental Hotel and restore the great international hotel. Thompson, her closest friend in Bangkok, was an American who had served with the Office of Strategic Services (OSS) in Thailand during the war, settled in Bangkok, and single-handedly developed the interna-

FIGURE 9.1

GERMAINE KRULL. CREMATION OF KING ANANDA. SIAM. JUNE 1946. SILVER GELATIN PRINT. 25.2 x 20.0 CM.. GERMAINE KRULL NACHLASS. MUSEUM FOLKWANG. ESSEN

tional silk industry in Thailand from the 1940s to the 1960s.[33] As the hotel stood on crown property, the support of Pridi, the wartime pro-Allied representative, was essential to their success.[34] Thompson conducted the negotiations with Pridi, and they obtained its purchase. At this time, Krull first rented her house at 3 Convent Road.

Legal and practical arrangements took months, but on 9 May 1947, the Bangkok newspaper *Liberty* ran a front-page article with the headline, "War Correspondent Now Hotel Manager":

> *Madame Germaine Krull, former French war correspondent, is now managing the Oriental Hotel. One of the first improvements to be installed by her will be a much-needed bar. The bar will be set going in about a fortnight. During the war, Madame Krull worked with the Free French Forces in Africa. She came to Bangkok at the termination of the war as a correspondent for a French news agency.*[35]

The Oriental Hotel had a long and distinguished history. It was founded in 1869 by two Danish sea captains soon after the country was opened to world trade. A new building was added to the original structure in 1876. The Oriental had hosted writers like Joseph Conrad, Somerset Maugham, and Noel Coward. Maugham's 1929 novel *The Gentleman in the Parlor* includes a famous scene set at the Oriental, in which the narrator suffers from a bad bout of malaria and almost dies. Maugham describes Krull's prewar predecessor, a Swiss manager named Madame Mayer:

> *I lay there, panting and sleepless, and shapes of monstrous pagodas thronged my brain, and great gilded Buddhas bore down on me. Those wooden rooms with their verandas made every sound frightfully audible to my tortured ears, and one morning I heard the manageress of the hotel, an amiable creature but a good woman of business, in her guttural German voice say to the doctor: "I can't have him die here, you know. You must take him to the hospital."*[36]

This account is interesting for its revelation of a previous woman manager who was, like Krull, a Germanic European. Although Maugham wrote decades earlier, the essential challenges of hotel management remained

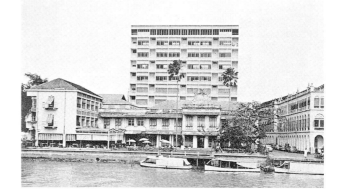

unchanged. Another great hotel in postwar Bangkok, the Princess, was also owned by two women, but Krull's long tenure as a female manager was unusual for Asia. During World War II, the Oriental Hotel was occupied by Japanese and American troops, and when Krull and her partners took over, it was little more than a decrepit army barracks. By the early 1950s it was once again a great luxury hotel, largely due to her efforts.

Krull's friends and colleagues in the Oriental Hotel venture spanned the spectrum of Thai politics, from those previously allied with the Japanese to those who had engaged in resistance work in Thailand during the war. The Oriental soon became the most important and luxurious hotel in Bangkok, housing foreign diplomats, writers, businessmen, and celebrities. During the 1950s, Krull raised money for and supervised the construction of a new tower wing of the hotel in 1958 (fig. 9.2).[37] She writes that she argued with Jim Thompson during the building project, and Thompson was bought out of the partnership.[38]

Krull writes vividly about her hotel adventures in the two books that she coauthored with Dorothea Melchers and illustrated with her tourist photographs. Dorothea Melchers had long written a column in the Sunday *Bangkok Post* and was a longtime friend, along with her husband Karl Melchers, one of the cofounders of the *Bangkok Post*.[39] Germaine Krull published *Bangkok: Siam's City of Angels* in 1964. She and Melchers collaborated on a second book two years later, *Tales from Siam*.

Krull begins the first book, *Bangkok: Siam's City of Angels* in her persona as a photographer. She begins her tale with a highly colored and romanticized word picture:

FIGURE 9.2
ORIENTAL HOTEL. WITH TOWER. POSTCARD. 9 x 14 CM..
GERMAINE KRULL NACHLASS. MUSEUM FOLKWANG. ESSEN

Siam conjures up visions of sleek, aristocratic blue-eyed cats; glittering gold spires rising above fabulous red and green tiled curved temple and palace roofs; barefooted dancers with top-heavy ornate pointed headdresses, unnaturally posed with up-curled jeweled fingers and a raised angularly turned foot displaying a heavy gold anklet; white elephants; and all the pageantry of a centuries old Royal Court. What more could an artistically minded photographer and journalist desire on this somber old earth?[40]

She writes of wanting to create beautiful picture books like those she had made in Brazil and France, and the book, in fact, includes both words and pictures:

I was thinking about the beautiful pictures I could take, the beautiful albums and books I could illustrate, with thousands of temples to choose from, the exotic flowers, and the graceful girls. I had dreamed of putting out beautiful picture books, as I had in Brazil and France before the war.[41]

The pictures in this book, however, serve as tourist illustrations, and the bulk of the book is a text devoted to her full and fascinating life as a hotel manager and to her role at the center of European and Asian business and political events. In her lighthearted account, the early days at the hotel were more of a camping excursion than hotel management: sheets, mosquito nets, and cutlery had either been stolen or belonged to the American Army, which was occupying the hotel. She describes in humorous detail how procuring items such as silverware, often found in the street markets, and cleaning, repairing, and refurbishing the hotel occupied her for several months. The Thai method of cleaning, for instance, is comically and patronizingly described:

First you tie a dirty rag from an old rice sack on a broom, dip it in a pail of dirty water and languidly swish it around the floor leaving it wet and muddy—and that's about all that happens. If there are any odd pieces of rubbish, such as bits of wood or paper, you dampen them too and push them in a little heap. Then you pick them up in your hands and put them in a corner.[42]

Few political, social, or anecdotal stories of postwar Thailand can be found in *Bangkok: Siam's City of Angels.*

Instead, Krull spins an engaging and conversational yarn of her perceptions of the adventures and troubles of hotel life.[43] Liberally sprinkled with anecdotes concluding with the Thai phrase *mai pen arai* (never mind), the book paints a vivid picture of her experiences as a powerful outsider living in Thailand.

Except for the first and last pages, almost none of the narrative concerned art or Krull's artistic career. Tales of photographic activity were completely absent from the memoirs of this period. *Bangkok: Siam's City of Angels* is illustrated with fourteen of Krull's photographs, but they record Bangkok's most famous sites, like Wat Phra Keo (Temple of the Emerald Buddha), Wat Po (Temple of the Reclining Buddha), and Wat Arun (Temple of Dawn). The "glittering spire of Wat Arun," photographed at a slight angle, bears a slight resemblance to Krull's slanted views of the spire of the Eiffel Tower, but this is almost the sole reference to the abstracted style in the corpus of her Asian photography.[44] The remaining photographs are little more than postcard or snapshot views.

During Krull's early years in Bangkok, Friedrich Pollock, who always played the role of family supporter for Krull, put her back into contact with her sister Berthe, who was then living with a friend, Elsie Leitz, in Wetzlar, Germany. Albertine Krull, their mother, had recently died, on 13 February 1948, and the two sisters began corresponding in the fall of 1948. Krull's first letter to her sister offers insight into their differing politics but close affections. She writes to Berthe that Max Horkheimer would inform Berthe about Krull's activities during the war, adding that she had seen quite a bit of Germany on her travels as a war correspondent in 1944 and 1945.[45] In this 1948 letter, she refers to the differences between her expatriate view of the world and her sister's German lifestyle:

Life here is as good as it could be. I have become the manager of the biggest hotel here, and I like this life of work and activity. I fled Europe after my brief return of several months, and I came here because I don't like all that is happening in Europe, and you know my views well enough to know that I don't want to live over the same things with the same people. I suppose that we

250.251

are quite far from each other in our feelings and aspirations. Me, I like the wisdom of the Orient, and I am content here.[46]

Krull's account of the uneasy yet affectionate relationship between the sisters demonstrates the great differences between the siblings. There seemed to be an almost inseparable gulf between Krull's Resistance war work and her later international travels and Berthe's much narrower experiences: the younger sister had survived the war in Berlin, spent several years in Berlin's Russian zone, and now ran a small ballet school in Wetzlar. The sisters corresponded sporadically.

During the dozen years from the end of the war until the late 1950s, Krull did not return to France.[47] After a trip to Japan, she returned to Europe in the late 1950s to visit Horkheimer, Pollock, Lotar, Ivens, and the Privats. On this first trip back to Europe, she actually saw Berthe again for the first time since the late 1930s, writing: "I loved my sister; she was my only kin and I found myself suddenly with a family! It was quite surprising. Returning to Bangkok, my life changed a bit because there was someone to think about and care for."[48] Berthe soon visited her in Bangkok, where the two sisters enjoyed each other's company while grating on each other's nerves. During one of her stays in France, Krull saw André Malraux again, and they planned their photographic project to record the Buddhist monuments and architecture of Thailand, Indochina, and Burma.[49]

Photographic Projects

When Krull began to slow down her hotel activities in the early 1960s, she embarked on an enormous documentation project in collaboration with Malraux. Together they planned to record sculptures and architecture of Thailand and Indochina. Although she wrote that these images were only records of sites, they do reveal her interest in Buddhist culture and its monuments throughout Southeast Asia and form part of a long tradition, which Donald S. Lopez, Jr., terms "the academic study of Buddhism in Europe and America within the context of the ideologies of empire."[50] She also published a small book of pictures about the region of her vacation home, Chieng Mai, in northern Thailand. The Krull archives at the Museum Folkwang in Essen contain several thousand photographs of Burma,

Thailand, and other Southeast Asian countries, with beautifully framed records of Buddhas, temples, and other art objects. An in-depth study of these photographs would require an additional book, but highlighting of her projects will demonstrate the stylistic choices she made for her own records and for André Malraux. These projects are neither scholarly examinations of the cultural artifacts Krull visited nor photojournalistic essays like her studies of the French landscape or the Congolese tribesman. With single views of a multitude of monuments, they record her travels with documentary images but fall short of a systematic study of the subject.

Chiengmai

Chieng Mai, the site of Krull's vacation home during her years in Thailand, is a city in northern Thailand, dating from the thirteenth century.[51] Since Krull's day, its surrounding hills have included retirement and vacation communities, built there because of the agreeable climate. Krull's records of temples such as that at the sacred mountain of Doi Suthep demonstrate her fascination with the architecture of these structures. She also built a small wooden vacation house on the mountain of Doi Suthep.[52] In *Tales from Siam*, her second book of conversational anecdotes about her Thai years, she writes, "I had had the small comfortable wooden house built just below the Temple of Doi Suthep by kind permission of the abbot."[53] During her stays there, she became very friendly with the monks of Doi Suthep, whose abbot is photographed in *Tales from Siam*. This book contains only eleven of Krull's photographs, and aside from a single portrait of the abbot, they record her house, the temple and white elephant at Doi Suthep, and a handful of other well-known sites.

Krull's travels to Chieng Mai began at the latest in 1951, for a 1951 newspaper article accompanied by excerpts from her journals and by her photographs of the journey in her Citroën recounts her hazardous car trip from Bangkok to Chieng Mai.[54] Perhaps in this essay Krull was attempting to reproduce the format of her 1930s books, which recount automobile trips across France. Krull's monograph, which she titled *Chiengmai*, is undated but was probably produced around this time, and she most likely published it privately.[55] *Chiengmai*

is clearly a photographic tour book in the tradition of *Ouro Preto* and *La Route Paris-Biarritz*, with photos of architectural monuments, temples, and one or two landscapes. The sketchy text by an author named Lotus consists of no more than a touristic paragraph or two introducing the main historical and tourist facts of the city. Krull's photographs are in the same vein but are more effective and dramatic than the illustrations for *Tales from Siam*. For instance, Krull recorded such well-known sites as the temple of Wat Phra Thart (That) Suthep, which houses a relic of Buddha found in the fourteenth century, on the 3,300-foot mountain of Doi Suthep near Chieng Mai. One of her photographs records the *naga* (serpent or snake) staircase, built in 1557, with 290 steps leading to the *wat* (plate 9.1). Krull's view emphasizes shadows and light to draw a dramatic contrast between two enormous, dragon-size snakes, devotees and protectors of the historical Buddha. She highlights both the drama and the superb craftsmanship of this extraordinary site. As opposed to her colorful explanations in *Tales from Siam*, the introduction to the Doi Suthep section of this book is standard tourist prose, explaining merely that "the temple is of great sanctity and is visited each year by thousands of pilgrims from every part of the Buddhist world."[56] In *Tales from Siam*, on the other hand, she relates more anecdotal details of the nagas:

> *Their long, undulating bodies covered with glittering tiles, simulating scales, form the balustrades of the wide comfortable steps, lined by pink and white blooming frangipani, firs and casurinas. Blessed water is supposed to spurt from their jaws to spray the passing pilgrims but in all the years I spent on the Doi I only saw this happen once, since there was seldom sufficient water pressure.*[57]

Her records of Buddhist temples are partly a touristic and architectural record, but they are also a reflection of her growing Buddhist beliefs. These years in Thailand were spiritually important for her. As Krull succinctly phrases it: "I did not become Buddhist [in Thailand]; that had already happened."[58]

Krull's other photographs often document similarly famous sites. Another Chieng Mai view in her book about the region records Wat Suan Dok (fig. 9.3). This photograph is accompanied by a caption reading, "The existing temple is modern but is built on the site of a very ancient temple."[59] The book also includes

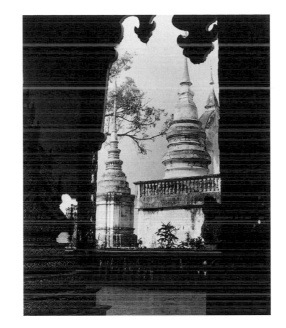

occasional landscapes, such as a spectacular view of the Mae Klang waterfall (plate 9.2). The framing and drama of this image hark back to her pictorialist photographs of the early 1920s, resembling the soft focus effect of Impressionist painting more than any other of her late photographs.

Malraux's *Univers des formes*

Krull's trips to Europe in this period temporarily revived her photographic career. In the early 1960s, Krull returned to her camera, amassing several thousand images of Burmese and Thai architecture and monumental sculpture in a series of trips around Southeast Asia. These images, like her political writings and memoirs, frame Asia for Western consumption. Krull traveled widely, documenting the drama and beauty of the sites but not their spiritual symbolism or their contextual historical importance. Instead, she framed them as classical and timeless art objects, both referring to the European classical tradition rather than the indigenous meaning and also removing any of the fervent religious meanings of the sculptures and buildings that might disconcert a French audience.

This project was intimately connected to André Malraux. After seeing Malraux on her trips to France, Krull signed a contract with Editions Gallimard on 29 January 1962 to provide the photographic documentation for a book on Indochina for the collection "Univers des formes," which she sometimes called "Connaissance des formes," under the direction of Malraux and Georges Salles.[60] The published series,

252.253

FIGURE 9.3
GERMAINE KRULL. WAT SUAN DOK. CHIENGMAI. LATE 1950S.
SILVER GELATIN PRINT. 26.5 x 21.8 CM..
GERMAINE KRULL NACHLASS. MUSEUM FOLKWANG. ESSEN

however, concentrates more on European monuments and the European ancient world than on Asia; the few non-European volumes seldom stray as far out of the European intellectual mainstream as Burma, so that Malraux's intentions may not have been as clear as Krull would have us believe in her memoirs. Nevertheless, in the spring of 1961, while still enmeshed in the affairs of the Oriental Hotel, she wrote to Malraux, describing her intention to provide him with documentation for a planned 1962 exhibition on Thailand as well as the project for Gallimard.[61] In her letters to the French scholar-diplomat, she asks for some direction for her photographic work, explaining that she intended to photograph sculpture in private collections and museums and in the north of Thailand, but needed some additional indications—which were never received. Although the projects never saw completion, Krull and Malraux shared the specific Asian vision of their interwar generation in France, and their joint passion for politics and art continued throughout their lives. Their shared interest in Buddhist sculpture is reinforced by Krull's gift of a Buddha head to Madeleine Malraux.

Krull's interest in Buddhist artifacts and in Asian culture had begun in the late 1920s, when she photographed a stolen Buddha head from Angkor for *Vu*. Krull's unforgettable photograph (plate 7.19), discussed in chapter 7, displays the Buddha head wedged between two spikes of the grille surrounding the obelisk of the Place de la Concorde. Titaÿna's narrative is framed as an action adventure, and it is modeled on the tradition of André and Clara Malraux's escapades in Indochina in 1923.

Malraux's interests in Asian and Buddhist culture, and his involvement with stolen artifacts, had begun, in fact, with his 1923 voyage to Indochina in search of lost Khmer temples on the Buddhist pilgrimage routes. He was arrested then for stealing sculptures from the temple at Bantai Rey and briefly edited an anticolonial Communist newspaper, *L'Indochine*, in Saigon.[62] Oddly enough, his early political beliefs for Indochina were closer to Krull's anticolonial and pro-Communist sentiments than he would readily admit in the years after 1945. Nevertheless, his love for Asia and for archaeology continued throughout his life and was further explored in his writings on "museums without walls" in the late 1950s.

Krull and Malraux were both fascinated with Burma and with the numerous shrines at Pagan built in this central Burmese plain between the eleventh and thirteenth centuries, during and after the reign of King Anawrahta. Between Anawrahta's conquest of Thaton and Kublai Kahn's overrunning of Pagan in 1287, this enormous religious city was the site of close to 13,000 temples, pagodas, and other religious structures.[63] More than two thousand remained as she began photographing. Krull's images include the great monuments like the Ananda Temple and Shwezigon Pagoda and the extraordinary sculpture of these sites. For example, plate 9.7 documents the golden figures that adorn the Shmaniyan Pagoda, in a powerfully angled composition whose serene and neatly spaced sculptural figures mount calmly through an open doorway into an invisible interior that seems to promise an eternal peace. In plate 9.5, a different but equally dramatic composition highlights Pagan's architectural monuments.

In the late 1950s, Krull had already traveled widely in Thailand and Cambodia, photographing such temples as Wat Pra Ken in Kampangpet (plate 9.3). Among her most haunting images are photographs of Buddha statues overgrown with jungle vines and greenery, as in her view of a weather-worn Buddha in the forest in Chiengsen, in northern Thailand (plate 9.4). In this image, vines and tree branches almost obscure the head of the Buddha, creating a headdress of leaves to adorn the carvings around the features of flaking stone. These figures seem to be fading back into the forest, and Krull frames them almost wistfully, perhaps suggesting her growing interest in finding a more quiet life than hers at the Oriental. She also photographed the extraordinary Cambodian monuments at Angkor (plates 9.6 and 9.8).

Krull wrote to Malraux in April of 1962 that she returned from Burma and Pagan with many images of their pagodas and sculptures, despite miserable photographic conditions.[64] She acknowledged his letter from Rangoon and said she planned to photograph Ratanakosin for him. In this letter, the vague nature of their project is still evident: "Tell me something if there is some kind of plan for the photos that I am making."[65] Malraux replied that she was free to do as she pleased, and that he would expedite her payment from Gallimard.[66] She later left about fifteen hundred photographs with Malraux, for him to make a choice. In her memoirs she writes, "They are there still!"[67]

No publication from Gallimard came to fruition, and Krull blamed Malraux: "Malraux had a bit of bad conscience. He had promised me things that he could not deliver."[68] The French minister probably had more pressing needs than helping Krull, but he remained a loyal friend. For instance, he supported her 1967 exhibition in Paris, and by that time she had accepted the book's delay more gracefully. In one 1967 interview, Krull discusses the fact that her book on Buddhist art with André Malraux was still not published. To the interviewer, she remarks that Malraux was marvelous but always busy: "It is he who must choose the photographs. I have confidence. I hope that one day or another he will find a bit of time and the book will finally be printed."[69]

Bangkok: Siam's City of Angels, published in 1964, ends with her wish to do more than run the hotel. She recounts that she sold her shares in the hotel to Jim Wester and turned over the day-to-day management to someone she names only as Bill.[70] In the last pages of the book, she writes of her wish to return to photography and uses a bit of creative license to make Malraux's offer to publish pictures of Asian monuments the reason for her departure from the hotel:

> *The postman brought the perfect ending a few days later—really fifteen years later. It was a letter from a great French publisher asking me to take pictures of Thai art, especially sculpture, for the great collection of art books being sponsored by the French minister of culture. It was just what I had dreamed of doing when I first arrived here, and I wanted to do it as much now as ever. So off I went to buy film and ask Hiran to get the Mercedes in travelling order. The rains were about to start and we had far to go.*[71]

The practical reasons for her shift away from hotel management and back to photography are less clear than Krull's book made them. She was photographing for Malraux four or five years before she left the Oriental Hotel, and there was probably not a clear choice between her entrepreneurial life in the hotel and her creative life as a photographer. Both existed simultaneously in the 1960s, and both became proof of Krull's love for and proselytizing for her newest adopted country. She left Thailand only in 1966, when she retired from the hotel.

A Final Resting Place

BUDDHISM IN INDIA, 1968–1983

*I had the sensation of a birth, and I felt young.
The spirit came to rest. I abandoned all the little
affairs of my personal luxuries. All that had
been important in my life departed. I wanted
nothing more for myself, and as in a spell, I
turned toward the interior. My life changed, and
since then I have been simpler and more
detached.*[1]

The mid-1960s marked another definitive shift in
Germaine Krull's life, one that changed her politics, her
religious beliefs, and her geographical choices.

After leaving the Oriental Hotel in April of 1966,
Krull settled in Europe for a year, renting an apartment
in Poissy, near Paris.[2] During her short stay in Europe
and in the decade and a half thereafter, several impor-
tant events occurred. First, Krull began to exhibit her
photography in museums. With the help of André
Malraux, now a minister in de Gaulle's government,
she mounted her first major retrospective exhibition in
1967, and other exhibitions followed. However, Krull
soon came to believe that she was no longer a European
in a geographical or a cultural sense and decided to
move back to Asia. She settled in northern India in
1968, living first in Mussoorie and then, from 1970 on-
ward, in a small northern village, Rajpur, near Dehra
Dun, in the province of Uttar Pradesh. Originally
drawn there to document the plight of exiled Tibetan
Buddhists, she settled there for the rest of her active life
as a devout Buddhist. Her last twenty years, therefore,
witnessed her conversion to Buddhism, her movement
away from the teeming crowds of Bangkok and Paris
alike to the peaceful northern Indian mountains, and
her passionate involvement in the lives and causes of
the Sakya order of Tibetan Buddhism. Her monetary as-
sistance was one entrée to the circle, and her belief the
second. The boy monks she helped at the monastery
became a surrogate family, affording her the structure
of a supportive group while satisfying her spiritual

needs. While living quietly in India, the photographer began to work on two long autobiographical memoirs. Unlike her earlier memoirs of Germany, Africa, or Thailand, these autobiographies addressed her political and artistic lives as intertwined and interdependent but also foregrounded her photographic career in a more sustained manner than any earlier memoir. She wrote "Click entre deux guerres," concentrating on the interwar years, in preparation for her 1977 retrospective at the Rheinisches Landesmuseum in Bonn. Her last autobiographical memoir, "La vie mène la danse," was completed in India in 1981 and was published in Italian as *La vita conduce la danza* in 1992.

During these fifteen years, Krull simultaneously distanced herself physically from what she viewed as the corruption of Europe and recreated herself in writing as a Eurocentric artist and political activist. Although these two activities may seem at odds with each other, they are in fact dependent on each other. Krull never became Asian; she remained a European observer even in her conversion to Buddhism. However, she also refused to fit comfortably into European norms for a modernist artist or a political activist. Her growing recognition in the West as a major European artist developed in conjunction with her conscious choice to leave its culture behind her. Krull's rehabilitation as a key photographer in the development of modernism is illuminated by her distance from the center of its market and cultural centers. She remained an outsider as much by her own devices as by the accidents of history, and her outsider status allows us to redefine not only the role she played as a tastemaker in twentieth-century photography but the development of photographic modernism on a larger scale.

Furthermore, Krull's conversion to Buddhism, which, on the one hand, can be read as a rejection of European culture, in fact was shaped by the same colonialism that influenced her war photography in Africa and her entrepreneurial activities in Thailand. Her adherence to Buddhism remained within the frame of how the West saw the religion and saw Tibetan Buddhism in particular. Donald S. Lopez, Jr., in his book *Curators of the Buddha*, catalogues the most prevalent European stereotypes about Buddhism, including the common but extremely skewed ideas "that Tibetan Buddhism is polluted, or that it is pristine; that the Buddha image is of Greek, or Roman, origin; . . . that the classical source supersedes the vernacular."[3] Although Krull genuinely derived comfort from her religion, her photographs of Buddhist monuments throughout Southeast Asia and her depiction of this particular Tibetan Buddhist order share many of these conventions. Her experience of Tibetan Buddhism, in particular, should be read as a product of a particular historical period in the late 1960s and 1970s. This followed the 1959 exile of the Dalai Lama after the final Tibetan takeover by a hostile Chinese communist government and the arrival of fifty thousand Tibetans in India alone.[4] At this time, many foreign scholars traveled to India to try to preserve a disappearing Tibetan culture, an oral tradition in danger of political and temporal extinction.[5]

Exhibitions

In the mid-1960s, Krull began to exhibit her earlier work. This was much later than colleagues like Man Ray (who presented himself as a modern European artist) and André Kertész (whose photography became well known in the United States in the 1960s), who were well known in the museum and gallery worlds. Her first retrospective exhibition in Europe, in 1967, was arranged by André Malraux at the Cinemathèque Française in Paris,[6] and a show of her Asian photographs followed at the Alliance Française in New Delhi in 1968.[7] A second retrospective ten years later, in 1977, at the Rheinisches Landesmuseum in Bonn, was the occasion for the publication of "Click entre deux guerres" in German.[8] An exhibition at the Musée Réattu in Arles, France, in 1988, was the first, albeit brief, posthumous look at her career.[9]

Housed at the Palais de Chaillot's Musée du Cinéma, the 1967 exhibition at the Cinémathèque Française was a large show. Her 1920s work was shown in large-scale reproduction prints of *Métal* photographs and a series of Paris street scenes such as the flea market, accompanied by photographs from Burma, Thailand, and Africa, as well as three nudes and portraits from the 1920s. These enlarged prints, however, were a deliberate choice of their era and not a response to the lack of vintage prints—a term that meant little to the photographic world of the 1950s and 1960s. Instead, the large prints fit aesthetically into the exhibition practices of their decade, where photographs

were perceived as mass communications tools in international exhibitions like the *Family of Man* show. The retrospective included one hundred photographs and received significant attention in the press, a marked success at a time when photography was not yet the popular exhibition subject that it is today.[10]

The exhibition also contained a series of thirteen very recent color photographs. Krull's sole experiments with color, which she called "silpagrammes," involved a process she developed that year in Paris at Kodak. For the silpagrammes, Krull moved the camera up and down while turning it quickly.[11] These photographs had been made as a series of experiments in Kodak's Paris labs, with the help once again of André Malraux, who obtained funding and laboratory assistance for her. The result was a series of semiabstract views of French forests, buildings, and landscapes whose colors seem to rotate and oscillate before the eye. Although these are Krull's most abstract photographs since the 1920s, they lack the keen focus of her black and white photography.

The reviews of this exhibition revealed more than the public reaction to her work. They also highlighted her struggle with her feelings about Europe. In an interview with Anne Manson, Krull explains that she had been back in Europe for only six months and had not yet decided her permanent plans. Likewise, a hint of ambivalence similarly colors her explanation of why she had left Europe in 1945:

> It's Strindberg, I think, who wrote: "I found the house of my childhood, and I was disappointed because in my memory the garden door was painted green and now I discovered it painted in blue." That is what happened to me. I no longer loved this continent, the values had changed, and so I asked to be sent to the Far East.[12]

Krull made new friends on this trip to Europe, among them Henri Langlois and Mary Merson of the Cinémathèque Française. She saw old friends like Max Horkheimer, Eli Lotar, André Malraux, Friedrich Pollock, Jean Privat, and others.

André Malraux may or may not have had a bad conscience about the delay in their Asian book, but he was a good friend in other ways. In addition to facilitating Krull's color experiments and sponsoring her exhibition, he also introduced her to the Indian ambassador and his wife.[13] Krull recalled that Madame Dayal was

the first person to tell her about exiled Tibetans living in India and about the Dalai Lama. After her exhibition ended, Krull decided to return to Asia to work on a book about Tibetans in India. She hoped that Malraux could obtain French government support for her project, but the fact that she was a Dutch citizen created problems in obtaining funding for her book. In her memoirs, Krull relates that Malraux paid for her trip because he felt at fault for not sponsoring the project and that she still did not understand why it was not possible.[14] Arriving in New Delhi, Krull encountered an old Bangkok friend, Jean Daridan, who had been the first French ambassador to postwar Thailand and who was now the French ambassador to India.

Buddhism

The Tibetans in India provided more than a book project for Krull. Buddhist beliefs offered her a peace that had eluded her in Bangkok and Paris. She soon settled in Dehra Dun, a northern Indian village, living in severely simplified conditions. She would spend the next twenty years there, supporting a community and school of Tibetan Buddhist monks under the leadership of the Sakya Trizin. She considered this community her family, giving major financial support to the monastery's leadership and lavishing attention on the children who attended school there. Her attachments to the sect waned only in the last three or four years of her life, when after a severe illness in 1983 she returned to Wetzlar, Germany, where her sister Berthe lived. She died there in 1985.

Krull's spiritual conversion to Buddhism was completed during her years in India, but it was no sudden decision. She had turned away from Christianity in her childhood, but during her adult life, other spiritual beliefs occasionally interested her. As early as 1929, she published photographs in *Vu* that dealt with religions outside the mainstream of European conventions. In the article, "Religions inconnus," Krull provided photographs of Quaker practices, Theosophist temples, Antoinist cult temples, and the liberal Catholic church, with services conducted by lay priests.[15] In her work in this article and in other photo-essays in *Variétés* and

elsewhere, Krull did not adopt the beliefs she documented but clearly was interested in them.[16]

Buddhist art and religion alike had an early impact on Krull. In earlier years, she had repeatedly referred to Buddhism, both in personal comments and in her commercial work. The Buddhist religion and its art had fascinated her in Thailand and before. As early as 1937, she had thought of Tibet, a devoutly Buddhist country, as a kind of refuge. She writes of it in passing, in a letter to Walter Benjamin, in closing a long diatribe against European politics with the phrase, "As long as we cannot go to Tibet and do as the wise men of the mountains do, we must simply support and be more intelligent in our choice the next time that we come onto this earth."[17] Although Krull was clearly not contemplating a Buddhist life of meditation in this letter, it is a clue that Buddhist beliefs in reincarnation and the simplicity of Tibetan Buddhist monasticism held deep appeal for her, even before she knew much about the religion. It would take her thirty years from this letter's passing reference to actually travel to the mountains that sheltered Tibetan Buddhism in India, but once she did, she stayed.

Krull's first mention of Tibet, in 1937, predated by more than twenty years the political events that would drive the Dalai Lama into exile. In 1949, one month after the People's Republic of China was declared, the new Communist government invaded Tibet. In 1951, the Chinese government and the Dalai Lama signed an agreement giving Tibet internal autonomy but granting China control of defense and foreign affairs. After fighting recurred between the native population and occupying forces, China dissolved the Dalai Lama's government in 1959, and on 31 March he sought asylum in India. During the following years, he and his followers established Tibetan Buddhist centers in India to keep alive the tradition of Buddhism that the Chinese were systematically trying to destroy in Tibet. Krull became intimately involved with this struggle on personal, political, and spiritual levels.

On her arrival in India, Krull expected to work on a book about the Tibetans, but their refugee cause soon consumed her life much more fully than a mere book project might have. After long and adventurous travels, Krull joined a woman whom she names Frida Bedi in her memoirs, traveling to northern India in order to visit Tibetan settlements there.[18] Although she was seventy years old, she climbed mountains on horseback, recounting, "It had been many years since I had ridden a horse; I lost my balance. . . . I got down from my horse, but my legs would not hold me. . . . It took me a long time to get balanced again. It is not easy to ride a horse at my age."[19] Frida Bedi introduced her to His Holiness Sakya Trizin, the head of the Sakya order of Tibetan Buddhism. The Sakya order, founded in 1073, is one of the four Tibetan Buddhist orders in India, and this order is named after Tibet's head monastery.[20] Krull describes the sense of recognition she felt on meeting Sakya Trizin: "He took a step forward and we both knew that it was not the first time that we had met."[21] She left the meeting dazed: "It was as if I was in a dream. I had certainly never seen him before, but he seemed very close to me. That evening, Peter [a friend] told me that it was karma, that I must have had a close relationship with him in another life."[22] Krull's encounter with Sakya Trizin was an intense spiritual experience, and she eventually moved to the village where the religious leader resided. The Sakya Trizin clearly fulfilled another need as well; despite her friends across the globe, Krull, now seventy-one years old, had little family, and she welcomed her close relations with the religious leader and his wife and brought many gifts and support to his family.

Tibetans in India
Shortly thereafter, Krull was granted an audience with the Dalai Lama and explained to him that she wished to produce a book about the Tibetans. She recounts, "Meeting the Dalai Lama was a revelation for me. A force above the normal, a force of God was in him."[23] With his permission, in 1968 she published her book *Tibetans in India*, the last major photographic project she undertook in her career. She mourned the abysmal reproduction of the photographs: "The printing of the book was quite bad; it betrayed my photographs, but I could do nothing. It was necessary to use paper that was made in India."[24] Krull donated the proceeds of the book to the Dalai Lama.[25]

Krull's final photographic project—recording the Tibetans in India—moved away from the drama of the 1920s, the pseudoethnography of the war work, or even the Thai monumental format. It presented a simple life and her new belief system in a style plainer than any she had used earlier in her career. It is tempting to think

that Krull adapted her style to suit her cause, but the extreme simplicity of these photographs follows logically from her European vision of Tibetan Buddhism rather than a complex understanding of the religion and its art. Tibetan Buddhist images, which were used as objects of meditation, were often brightly colored, complex mandalas, sometimes representing multiheaded, multilimbed male and female figures in explicit sexual union. As Robert A. F. Thurman explains in his recent catalogue on Tibetan Buddhist art, these did not represent the animistic primitive Buddhism that Europeans saw in Tibetan art. Instead, "the father-mother union is a manifestation of the Buddha's highest spiritual essence, of enlightenment as the union of wisdom and compassion."[26] The female-mother represented wisdom; the male-father symbolized compassion. Krull, however, censored these colorful and energetic images from her book, restructuring it instead to depict monks and buildings that suggested a safer, single-form Buddha more easily accessible to Europeans. Her book deals more with the daily life of the monks and Tibetans, but it is striking that no images in the book depict the ornate objects that her simply clad monks study; instead, they consistently look out of the frame at their objects of worship.

Despite the beauty of their religious art, the Tibetans lived in poverty, and Krull attempted to better their circumstances by advertising their plight. In her preface to *Tibetans in India*, which is written in English and clearly intended for an international audience, Krull asks and answers the question, "Why have I made this book?" Her tone as a European commentator on Tibet is oddly similar to the tone of the actor Richard Gere in the most recent exhibition catalogue of Tibetan Buddhist art; both explain their own conversion to the faith and attempt to frame it for the West.[27] She explains that at a reception in 1962 she first saw a group of Tibetan monks and "felt that, with their entrance, the atmosphere had somehow changed, as if the vibrations of a higher spiritual world had entered the room."[28] She explains her continuing dedication to the cause and her need to try to help:

> Although a few years have now passed, my idea has remained unchanged, and so I have returned to India to take the photographs for this book. I hope that many will see the faces of these people, and that this small contribution may be regarded as an homage to the wisdom of Tibet. May it help

> to wake the conscience of the world to save all that is left from the destruction of Tibetan culture and literature, and to preserve the treasure which was guarded well for so long in the Land of Snow—the timeless spirituality of mankind.[29]

Tibetans in India contains a text on the Tibetans in exile by Gyatsho Tshering and a description of the various settlements in India, as well as an essay on the continuation of Tibetan culture outside of Tibet. These texts are straightforward historical overviews of the events that led the Dalai Lama from Tibet to India, with a description of the six agricultural settlements that in 1968 housed fifteen thousand Tibetans in India. Tshering writes, "Freedom is the very breath of Tibetan life, and Tibetans value it more than anything else." This sentiment is so similar to Krull's own credo that her commitment to the cause can be judged as a manner of fitting into her new surroundings.

The photographs in the book are badly reproduced, and the pictures themselves are not as monumental as many of Krull's African images or as flashy as some of her Thai photographs. European interactions with these cultures celebrated monumentality and power, and Krull's photographic style could reflect her impressions of their imposing physical presence to craft a symbol of their force. Tibetan Buddhist culture posed a very different problem for her. In deciding to eschew formal innovations and to make plain pictures, Krull equated her photographic style with the beliefs she was trying to communicate. She found this order compelling because of its simple lifestyle and adapted her photographic style to convey her impressions of Tibetan Buddhism to her largely European audience. But she whitewashed precisely the colorful and sexual qualities that marked the images of this faith as unique, perhaps because she thought the images might alienate Europeans. Her own sexual adventures throughout much of her adult life make it difficult to suggest that the erotic imagery scandalized her; she probably had a more political motive in presenting such a partial and particular view. The cheap paper and plain style could be read as modest and therefore acted to promote the message Krull believed Europeans would accept and the message she wanted them to accept. Whether or not this accurately reflected

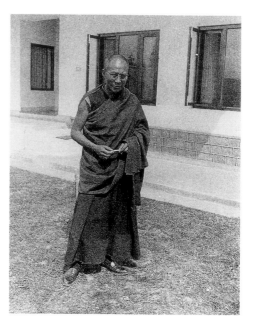

the Sakya order is less important than its effect on its audience, and Krull, as a European expatriate turned Buddhist, was a successful salesperson for her cause. Therefore, although *Tibetans in India* is formally Krull's least interesting book, it conforms to her lifelong pattern of creating books with a political agenda that serve the cultures she observed. This book demonstrates her comfort with the concept of changing styles to serve her perceptions of the cultures around her.

The book's illustrations begin with a portrait of the Dalai Lama in very unrealistic color, one of Krull's many views of the religious leader (fig. 10.1). Bodh Gaya, the site of the historical Buddha's enlightenment in the sixth century b.c.e., follows. The story of the Tibetans is told in captions that accompany the photographs of Tibetan people. Unlike her African portraits, which are more distanced and formal, for an image of a Tibetan dancer (plate 10.3) Krull has moved to a few inches from the dancer and aimed her camera upward to monumentalize his standing figure. Many similar portraits feature the elderly, the women, and the children in the community. Some are striking. Interspersed with views of the Dalai Lama and the landscapes around the settlements are views of characteristic Tibetan costumes, schoolchildren, and monks. The monks are shot in their robes seated in rows; they may be praying, chanting, or studying. In one dramatically receding diagonal composition (plate 10.5), Krull reflects the poses of the gilded Buddhas at Pagan (plate 9.7). The monks sit cross-legged in a line, their dark robes and heads forming a diagonal path across the page, their lips moving in prayer. His Holiness Sakya Trizin, Krull's personal contact in the Tibetan Buddhist movement, makes only a brief appearance in the book, clad in costume during a ceremony (plate 10.1). The children of the Sakya Center at Rajpur, who would be a major focus for Krull over the next ten years, are also present only occasionally. In one photograph (plate 10.6), a young monk sits reading a book whose flipped page reveals a child's line drawings of cars, drawing a contrast between the rigor of religious study and the life of childhood. Other groups are included in these photographs as well, as in an extraordinary photograph of six women in tribal dress, seen from the back so that their elaborate hair and headdresses can be admired by the viewer (plate 10.4).

The book appeared in 1968, and in the same year, Krull had another exhibition, at the Alliance Française in New Delhi, organized with the assistance of French Ambassador Daridan. The printing of the images at the labs of Mahatta and Company in New Delhi marked the last time Krull worked in a photographic laboratory. The exhibition included a small pamphlet, with an introduction by Henri Langlois and testimonials by Brassaï, Henri Cartier-Bresson, and Jean Cocteau, all reprinted and translated into English from the 1967 Paris exhibition catalogue.[30] Krull showed only Indian works; the brochure explained, "In the last five years Germaine Krull has made four trips to India. This exhibition shows some of the photographs taken during these visits." The show included twenty-one images of Indian sites in Sarnath, Benares, and Delhi, among others. The works included sculptural monuments similar to the Buddhist temples in her Thai photographs, as well as some views of pilgrims, monks, and children. Krull recounts, "This was the exhibition that gave me the greatest pleasure."[31]

After these projects, Krull returned to Mussoorie to live near Sakya Trizin, whom she described as "her lama." She lived first in Mussoorie; then, in about 1970, she followed Sakya Trizin to Dehra Dun, near Rajpur.[32] The monastery and village of Dehra Dun, with its school for young monks, would occupy her fully during the subsequent years. Under the sponsorship of Sakya Trizin, she participated in a ceremony called "taking refuge," which she explained as being equivalent to baptism.[33] During this time, she began studying Buddhism seriously and participated in an "initiation" under the tutelage of Sakya Trizin.

Krull's unpublished account of her lama's life and the history of the Sakya order are housed at the Museum Folkwang in Essen.[34] In this unofficial history, she relates the most important myths of the sect. She

FIGURE 10.1

GERMAINE KRULL. HIS HOLINESS THE DALAI LAMA. N.D..

SILVER GELATIN PRINT. 27.8 x 21.4 CM..

GERMAINE KRULL NACHLASS. MUSEUM FOLKWANG. ESSEN

describes a Tibetan Himalayan mountain with a white patch of earth, named Ponpo-ri, which was shaped like an elephant. This holy place housed the first monastery of the Sakya order of Buddhism, and Krull explains that the name *Sakya* meant "white earth" in Tibetan. She also outlines the order's recent history and that of Sakya Trizin himself.[35] Soon after the Dalai Lama left for India, Sakya Trizin had moved his family to Mussoorie, in India, in 1959. He founded the small school for monks in Dehra Dun and began a noodle-making project to earn money.[36] In 1970, Sakya Trizin went to Dehra Dun permanently, and Krull followed, as she relates in her text.

In the mid-1970s, Krull also wrote and illustrated a pamphlet about the Sakya Centre in the small village of Rajpur. In her introduction, she succinctly explains its purpose:

> *Although the Sakya Centre in Rajpur was*
> *originally established for quite a different*
> *purpose, it is not surprising that over the past ten*
> *years it should have become the de facto*
> *headquarters of the Sakya Order itself.*
> *Geographically convenient to the three*
> *settlements in Himachal—Puruwala, Kamrao,*
> *and Bir—and to New Delhi and Dharamsala, the*
> *centre has now become the natural focus of Sakya*
> *affairs, both religious and rehabilitative.*[37]

The school housed sixty-five students between six and eighteen years old and taught Tibetan language and literature, philosophy, English, and art. After their education, students were free to join the order as adults or to leave. Krull lived in the Doon Guest House, a simple pension near the monks' school. This arrangement evidently suited her, for she cared for the boys, writing, "There were some who were only five years old. They were alone with no woman to help them."[38]

Krull found spiritual fulfillment in her years in Dehra Dun and also worked actively to support the Tibetan Buddhist cause. Never one to sit quietly when political agitation might accomplish something, she attempted to improve the relations between the Indian government and the Tibetan Sakya order, striving to raise funds for a Sakya school and acting as a mediator between the government and the order. When the settlement and school for child monks was first established in Dehra Dun, Krull traveled back to Thailand to find sponsors for "her" small monks. About $100 a year

would feed and clothe a child at that time. She recounted that she mounted a press campaign there and that her friends in Bangkok, even if they knew nothing of the Vajrayana or Tantric Buddhism specific to Tibet, understood the needs of children and gave generously.[39] A 1970 article in the *Bangkok World* captures her enthusiasm while publishing her photographs of the monks and a portrait of her. In this article, Krull writes, "I went there myself and saw these little monks. I became very much attached to them because they are such bright, happy children. Being myself a Buddhist for many years, I feel concerned and responsible for helping them."[40] The author of the article describes Krull as a resident of the Indian community during the previous two years and a strong supporter of the beliefs and schooling of these little monks.

This austere life seems to have suited Krull, then well into her seventies. She found in Buddhism a rationale for her life's adventures and sums it up in the last pages of her memoir:

> *Everything that happens is due to something that*
> *you did in another life. All that you have done in*
> *this life follows you into the next. I felt very good*
> *about this religion. I had always thought that it*
> *was my fault if I found myself in bad situations.*
> *I had created them by my faults in another life.*
> *This was much more sensible than the original*
> *sin of Christianity.*[41]

Although there is no way of knowing whether she found the multiple lives of the Buddhist belief appealing because they seemed to mirror the reincarnations within her own life, she remained a devout Buddhist. Continuing to live in the simple Doon Guest House, Krull remained with Sakya Trizin through his marriage and the birth of his two children, and a later prostate illness, and she accompanied him on his trips throughout Europe, the United States, and Canada in the 1970s.

Autobiographies

The plainness of her late photographs does not suggest that Krull distanced herself from the most innovative

stylistic work she had done earlier in her career. Instead, as Krull increasingly became aware of the importance of her own work in the interwar years, she began to try to promote it. Her career patterns at this time were atypical, an alternative to the professional and artistic choices of many well-known modernist photographers who continued to work as photographers. By the 1970s, many of them had shows, sold work in galleries, and remained active in the European and American cultural world for both marketing and creative reasons. From her Asian viewpoint, the marketplace issues that drove contemporaries to promote their work in American galleries and museums in the 1970s seemed very distant. Furthermore, she had sold her shares in the Oriental Hotel to fund her retirement, and for the first time in her life, she was a relatively wealthy woman and did not depend on her photography to support herself.

Instead, Krull resurrected her creative life largely through the written word. She wrote her artistic and intellectual autobiographical manuscripts "Click entre deux guerres" and "La vie mène la danse" in late 1976 and early 1981, respectively, when she began to reconstruct her own interwar career. Despite her involvement with the Sakya Centre and with her spiritual life, she did not abandon Western friends or travel. She traveled to New Delhi about once a month, and stayed with her friends Carl and Lucy Frucht or with the Dutch ambassador.[42] Her intellectual life remained lively as well: Pollock's letters from the late 1960s and early 1970s refer to an ongoing dialogue on Einstein, Marx, Malraux, and Schopenhauer, as well as on the political events in France, Germany, and India. She clearly discussed her Buddhist writings and beliefs with Pollock as well. Her letters from Max Horkheimer express their common despair at political events in the West. For instance, he writes, "Your reactions to this dubious world are very similar. . . . We have so many things in common, and it would be so good to talk of our thoughts and our feelings."[43]

Krull's external contacts reached further than her visits to Delhi and letters to old friends. In fact, these years marked her growing awareness of the importance of her own life and work. In 1971, she was already writing to Horkheimer and to Malraux about trying to publish a manuscript, probably a revision of "Chien-fou," that Horkheimer sent to his agent in New York and Malraux tried to place with Doubleday.[44] In the same summer of 1971, Malraux promised to give the Brazzaville text to the Institut Charles de Gaulle in Paris. In

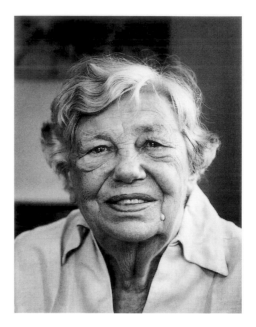

1977, Krull wrote her memoir about her years in Paris, "Click entre deux guerres." Lucy Frucht, a friend from India who frequently visited Europe as well, recalls that Krull dictated the memoirs to her, and she typed them as the photographer spoke.[45] They worked together intensively for about six weeks in Zurich in June and July of 1976, creating a freeform overview of the intellectual and artistic highlights of Krull's German, Dutch, and French career. In "Click entre deux guerres," politics take a distinct back seat to accounts of fellow artists and, above all, writers.

Five years later, Krull wrote her most extensive memoir, "La vie mène la danse," completed on 28 October 1980 and revised by 30 October 1981 (fig. 10.2). This volume of reminiscences encompasses her entire life—from her student days in Munich, through the difficult years in Moscow and Berlin, all the way to her most recent experiences with the Tibetans. A reading of these late memoirs is both rewarding and frustrating; they are full of information and lively detail, but, as with all autobiographies, fact is indistinguishable from fiction. In these accounts, we can learn that Krull clearly enjoyed the personalities she met and valued her own resilience in rebounding from adversity. She continually praised her own brand of stubborn independence and almost never wallowed in self-pity. The most important insight that she gives us is that she valued integrating politics and art into a seamless whole and living an unorthodox life. By 1981, when "La vie mène la danse" was completed, Krull realized that her life's accomplishments were important and reassembled the fragments of her experiences in yet another reinvention of herself—this time as an artist. Unlike many of her peers, she

FIGURE 10.2

MADAN MAHATTA. GERMAINE KRULL. NEW DELHI. 1980.

GELATIN SILVER PRINT, 28.3 x 20.8 CM.,

GERMAINE KRULL NACHLASS. MUSEUM FOLKWANG. ESSEN

never framed herself as "the great artist." On the other hand, she perceived herself as a photographer above all, despite the fact that she had not supported herself as a photographer since 1945.

At the very end of this memoir, written at the age of eighty-four, Krull writes of her disillusionment with the Sakya Centre. In fact, when Krull fell ill in 1983, she found no support from the monks and was forced to return to friends in New Delhi for help. She would return to Europe at the end of her life. It is clear that she sought to leave India after her health failed in 1983 and that the monks still unexplained neglect of her during her severe stroke and long recuperation had horrified her. Friends such as John Tate, who knew her well in India, recall that she "rightly or wrongly believed that they had simply left her to die."[46] It is painfully clear that she lost sympathy for the Sakya order. She had named the order as the beneficiary of her will but rewrote her will to exclude them.[47] Krull's Buddhist faith remained strong, but her political involvement with Dehra Dun and the Sakya order ultimately disappointed her. Her memoir ends with the thought, "I think that for me all that is finished and I will stay with photography, which, after all, has been my life."[48] John Tate writes that even at the end of her life, Krull had the pride and courage to "start again, from scratch, in her 84th year."[49] Photography was becoming popular in the European and American art world, and the interest of dealers and museums at the very end of her life gave her another impetus to begin yet another project—her own reinvention as an artist. Krull's reexamination of her own photographic life was her last adventure and the final, successful example of her adaptation to the changes in her world. It was at this point that she decided to create a foundation to promote and preserve her photographic legacy.

In 1982, Krull tried to plan a return to France, contacting Joris Ivens, with whom she remained friendly, Guy Mandery (a critic), and other old friends to try to arrange for a retirement home there. Her Dutch passport seems to have stood in her way. Further, the lack of vintage prints made it difficult to broker an arrangement with the French government to give her and her archives a home together. When Krull fell ill, in the autumn of 1982, she left Dehra Dun for a brief stay in New Delhi, returning once but leaving the village again before Christmas of that year. She then stayed with friends in New Delhi and Thailand. When arrangements in France could not be made, she moved to Wetzlar, Germany, where her sister lived, an eloquent statement of the support of her sister despite their different life histories. No longer a healthy woman, she lived in a nursing home in Wetzlar and died there on 31 July 1985.

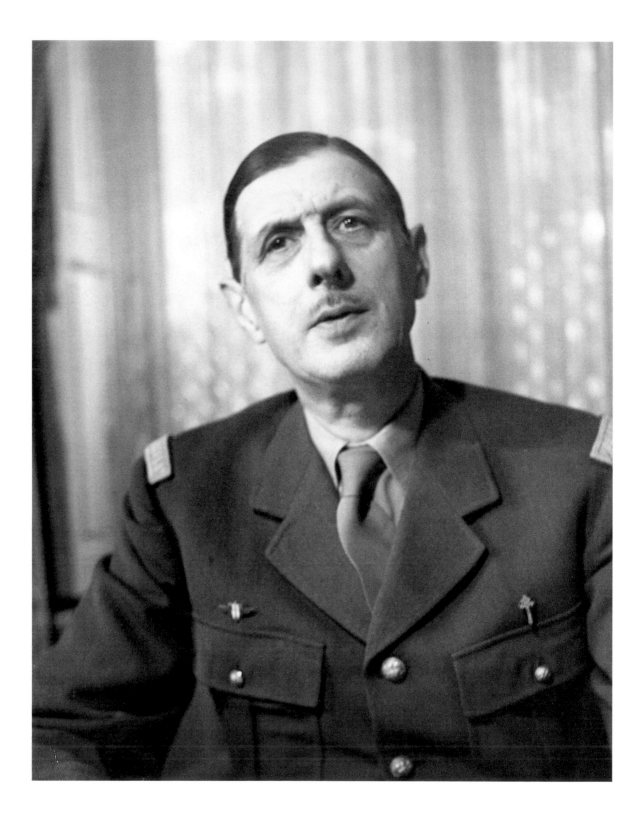

PLATE 8.1
GENERAL DE GAULLE, ALGIERS, 1944,
GELATIN SILVER PRINT, 24.5 x 19.5 CM.,
GERMAINE KRULL NACHLASS,
MUSEUM FOLKWANG, ESSEN

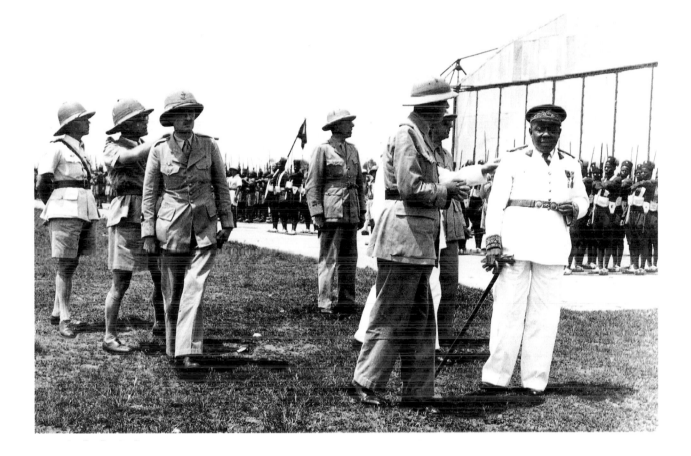

266.267

PLATE 0.2
AEF BRAZZAVILLE, LES GÉNÉRAUX
DE GAULLE ET LE CLERC ET LE
GOUVERNEUR GÉNÉRAL EBOUÉ SUR
L'AÉRODROME. 1943.
GELATIN SILVER PRINT, 11.5 x 17.0 CM.,
GERMAINE KRULL NACHLASS,
MUSEUM FOLKWANG, ESSEN

PLATE 8.3

OUBANGUI-CHARI. BANGASSOU,

USINE DE COTON COMOUNA,

LES BALLES DE COTON PRÊTES À

ÉXPEDIER. AUGUST 1943,

GELATIN SILVER PRINT, 11.8 x 17.5 CM.,

GERMAINE KRULL NACHLASS,

MUSEUM FOLKWANG, ESSEN

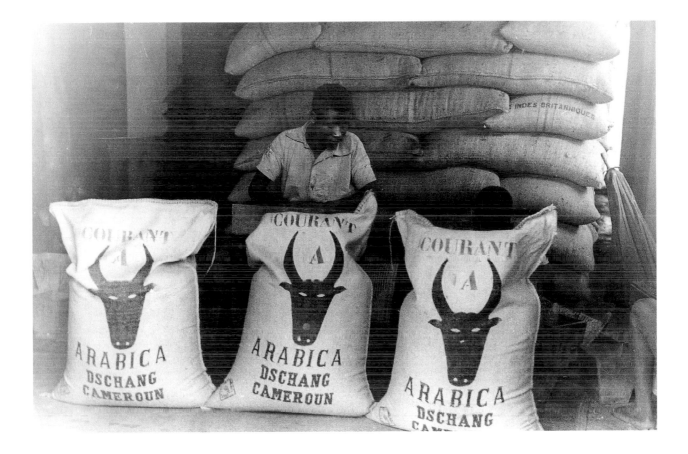

PLATE 8.4
CAMEROUN. DSCHANG. COOPÉRATIVE
INDIGÈNE DU CAFÉ. CES SACS SONT
PRETS À PARTIR. JUNE 1943.
GELATIN SILVER PRINT, 12.0 x 18.0 CM.,
GERMAINE KRULL NACHLASS.
MUSEUM FOLKWANG, ESSEN

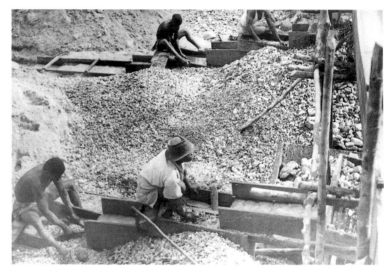

PLATE 8.5
M'VOUTI, EXPLOITATION MINIÈRE
DE M. VIGOUREUX, LA TERRE QUI
CONTIENT L'OR EST EMENÉE PRÈS
D'UNE 'TABLE' POUR ÊTRE LAVEÉ.
APRIL 1943.
GELATIN SILVER PRINT, 17 x 11.8 CM.,
GERMAINE KRULL NACHLASS,
MUSEUM FOLKWANG, ESSEN

PLATE 8.6
M'VOUTI, EXPLOITATION MINIÈRE
DE M. VIGOUREUX, TRAVAIL À UNE
'TABLE.' APRIL 1943.
GELATIN SILVER PRINT, 11.4 x 17.7 CM.,
GERMAINE KRULL NACHLASS,
MUSEUM FOLKWANG, ESSEN

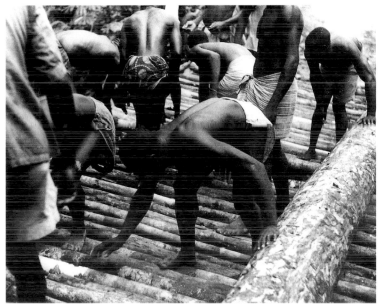

PLATE 8.7

GABON. SUR LA ROUTE DE
MOUILA À L'ONOI. PELLES ET
PIOCHES, LE SEUL MATÉRIEL QUE
L'ADMINISTRATION A POUR CONSTRUIRE
LA ROUTE. GABON. 1943.
GELATIN SILVER PRINT, 16.4 x 13.8 CM.,
GERMAINE KRULL NACHLASS.
MUSEUM FOLKWANG, ESSEN

PLATE 8.8

GABON. DÉBLAYAGE SUR LA ROUTE
APRÈS UNE PLUIE. MOUILA-ONOI, 1943.
GELATIN SILVER PRINT, 11.8 x 14.9 CM.,
GERMAINE KRULL NACHLASS.
MUSEUM FOLKWANG, ESSEN

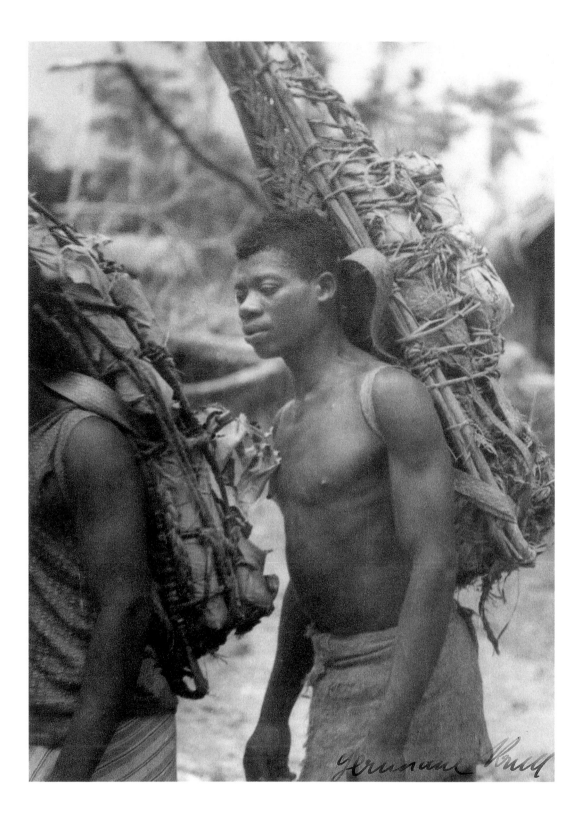

PLATE 8.9
GABON. PORTER. 1943.
GELATIN SILVER PRINT. 23.5 x 17.0 CM..
GERMAINE KRULL NACHLASS.
MUSEUM FOLKWANG. ESSEN

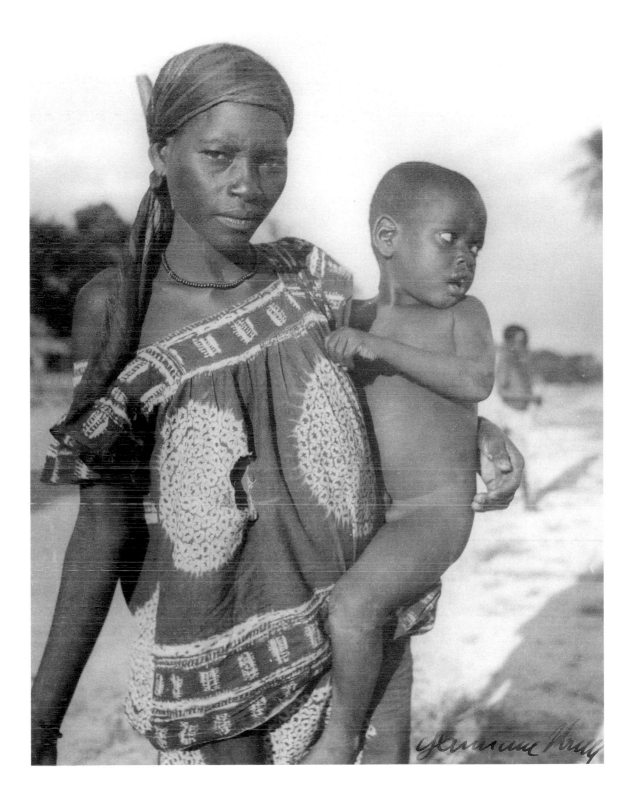

272.273

PLATE 8.10
MOTHER AND CHILD, BRAZZAVILLE, 1943.
GELATIN SILVER PRINT, 22.0 x 17.6 CM
GERMAINE KRULL NACHLASS,
MUSEUM FOLKWANG, ESSEN

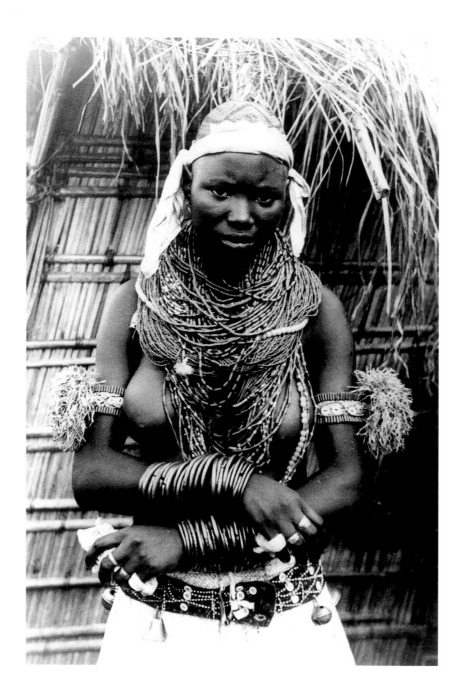

PLATE 8.11

UNE TCHIKOMBI DÉJÀ PROMISE.

POINTE NOIRE. APRIL 1943.

GELATIN SILVER PRINT. 17.3 x 11.9 CM..

GERMAINE KRULL NACHLASS.

MUSEUM FOLKWANG, ESSEN

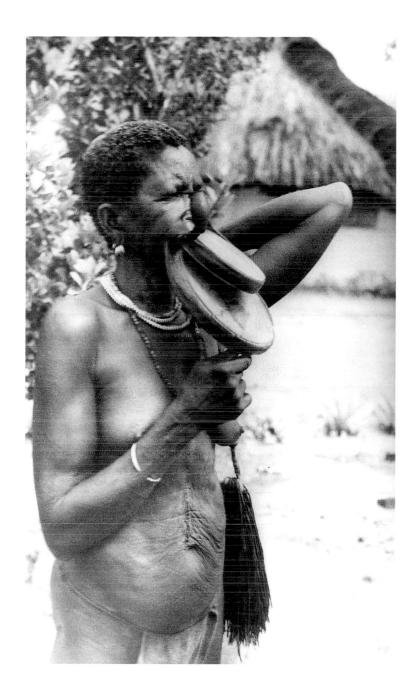

274.275

PLATE 8.12
TCHAD, FORT ARCHAMBAULT. LES
NÉGRESSES À PLATEAU. UNE
TRIBUE DE LA RACE BANDA QUI
ENCORE AUJOURD'HUI PRATIQUE
CETTE CURIEUSE COUTOUME.
AUGUST 1943.
GELATIN SILVER PRINT. 18.5 x 11.2 CM..
GERMAINE KRULL NACHLASS.
MUSEUM FOLKWANG, ESSEN

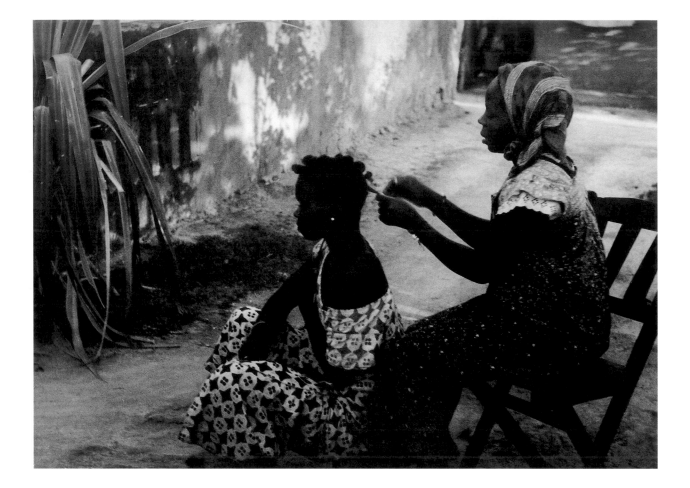

PLATE 8.13
BRAZZAVILLE. POTO-POTO.
SÉANCE DE COIFFEUR, N.D.,
GELATIN SILVER PRINT, 11.9 x 16.8 CM.,
GERMAINE KRULL NACHLASS,
MUSEUM FOLKWANG, ESSEN

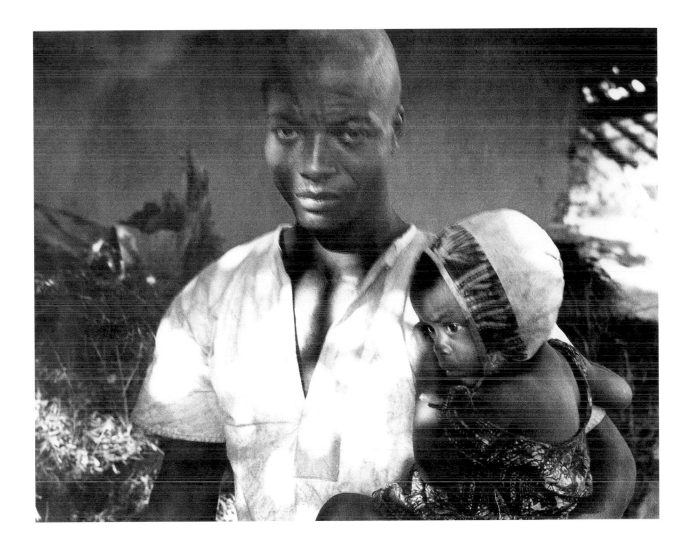

276.277

PLATE 0.14
MAN AND CHILD. N.D..
GELATIN SILVER PRINT. 13.1 x 16.9 CM..
GERMAINE KRULL NACHLASS.
MUSEUM FOLKWANG. ESSEN

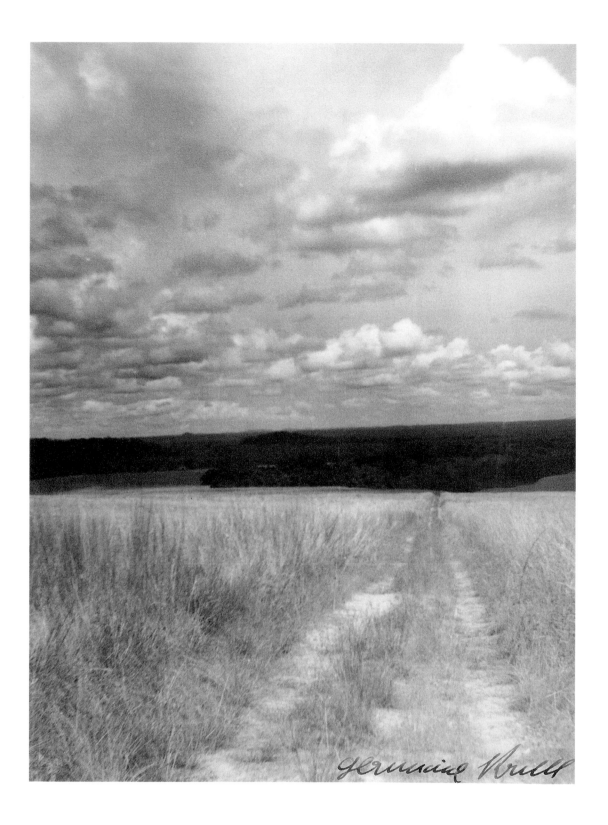

PLATE 8.15
LANDSCAPE, GABON, 1943.
GELATIN SILVER PRINT, 22.5 x 16.8 CM.,
GERMAINE KRULL NACHLASS,
MUSEUM FOLKWANG, ESSEN

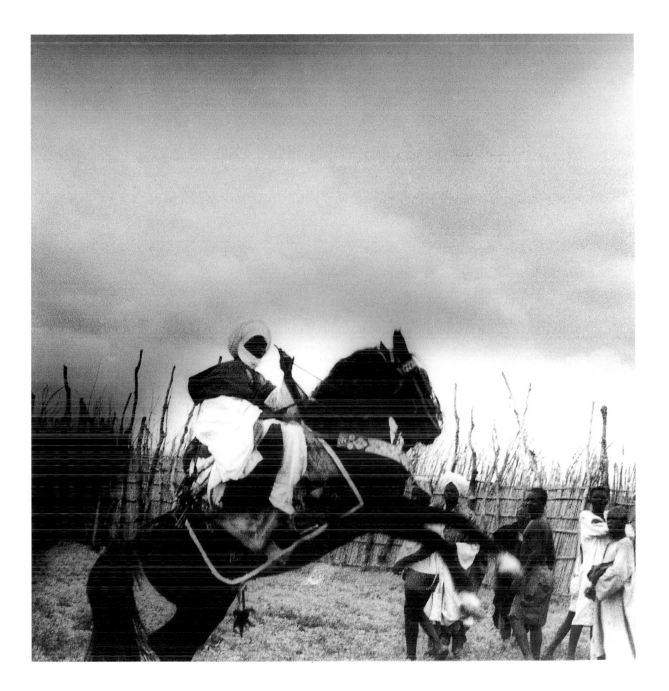

278.279

PLATE 8.16
OUBANGUI-CHARI. BAMBARI.
CAVALIER DORORO. AUGUST 1943.
GELATIN SILVER PRINT. 14.0 x 13.5 CM.,
BAMBARI, UBANGI-CHARI,
GERMAINE KRULL NACHLASS,
MUSEUM FOLKWANG, ESSEN

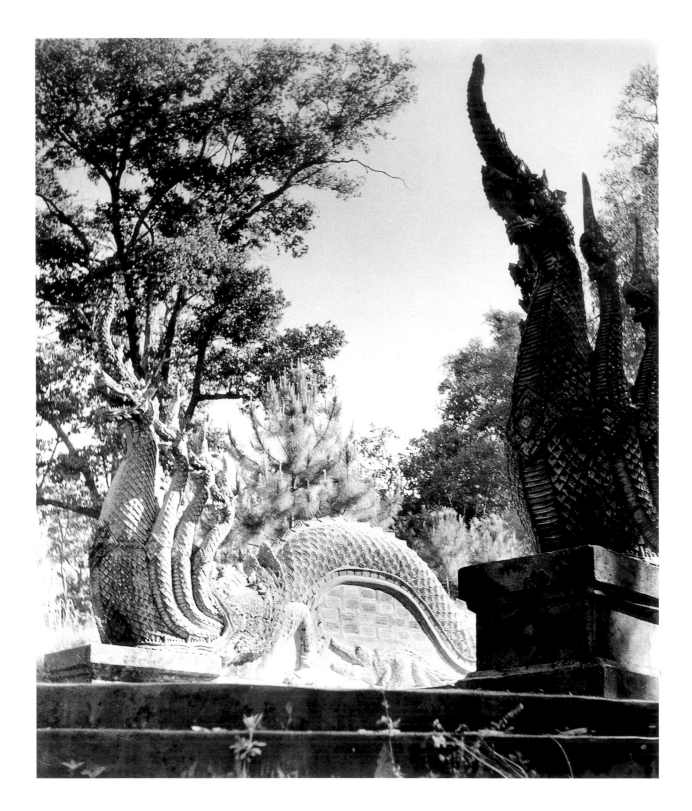

PLATE 9.1
SIAM NORD CHIENGMAI, DOI SUTHEP,
GELATIN SILVER PRINT, 26.0 x 22 CM.,
GERMAINE KRULL NACHLASS,
MUSEUM FOLKWANG, ESSEN

PLATE 9.2
CHUTE D'EAU MÉKONG NORD.
LATE 1950S.
GELATIN SILVER PRINT, 14.4 x 13.9 CM..
GERMAINE KRULL NACHLASS.
MUSEUM FOLKWANG. ESSEN

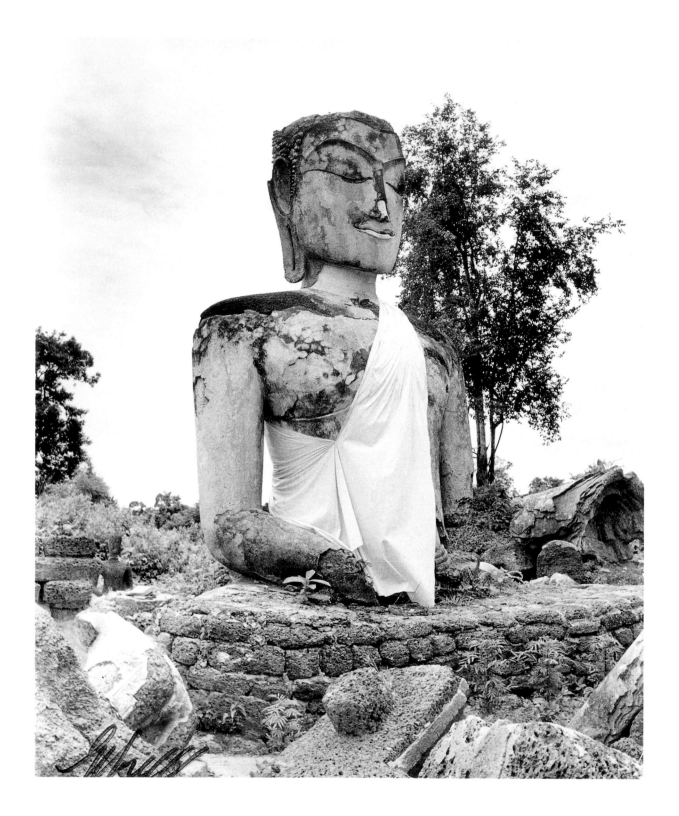

PLATE 9.3
SIAM NORD KAMPANGPET WAT PRA
KEN 61, 1961,
GELATIN SILVER PRINT, 29.2 x 24.3 CM.,
GERMAINE KRULL NACHLASS,
MUSEUM FOLKWANG, ESSEN

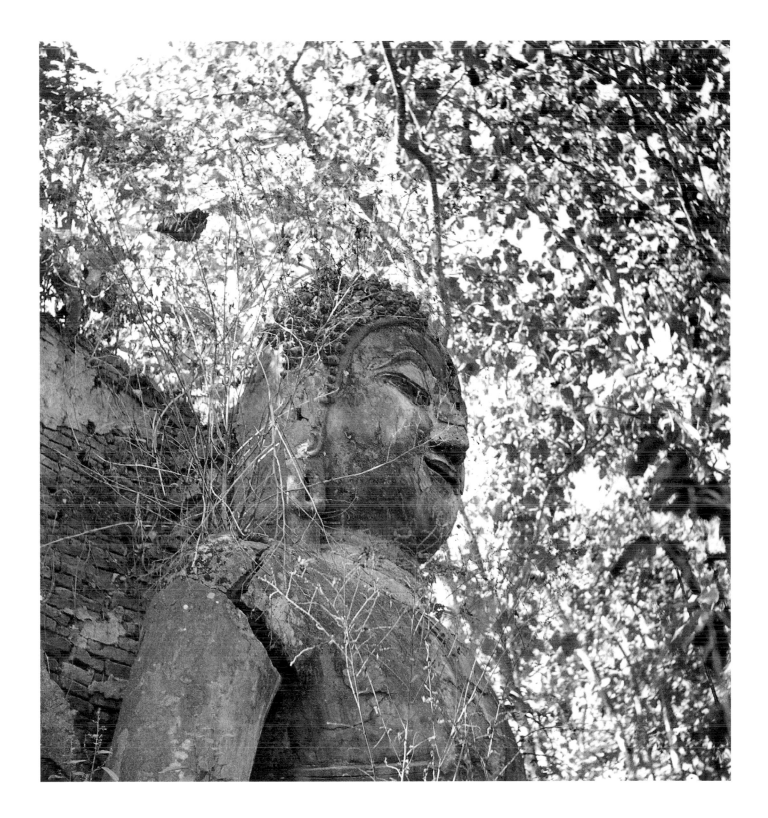

282.283

PLATE 9.4
SIAM NORD 58. STATUE DE
BUDDAH DANS LA FORET (XIIème)
À CHIENGSEN. 1958.
GELATIN SILVER PRINT, 23.8 x 22.0 CM.,
GERMAINE KRULL NACHLASS,
MUSEUM FOLKWANG, ESSEN

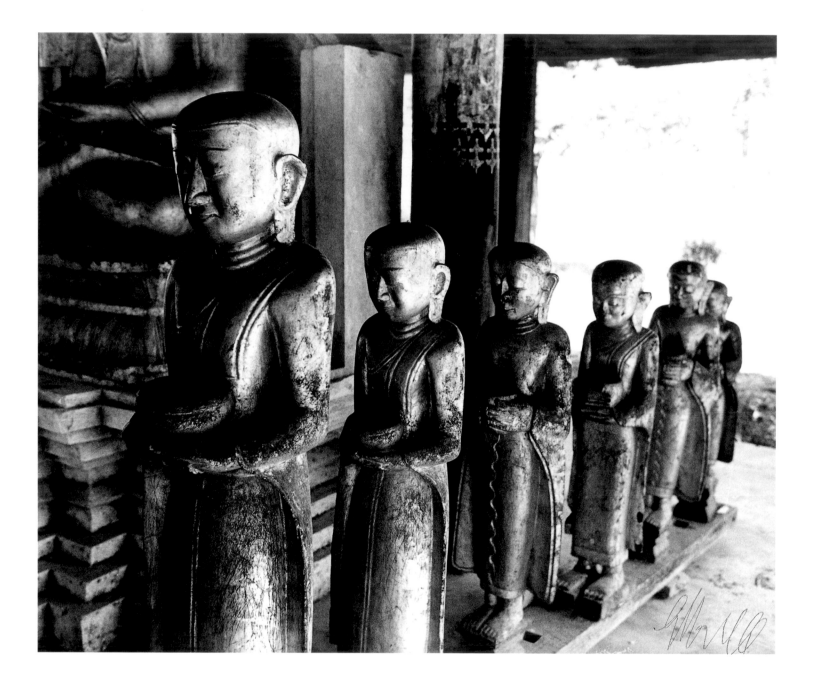

PLATE 9.7
PAGAN SHMANIYAN PAGODA,
BURMA, 1959,
GELATIN SILVER PRINT, 24.5 x 29.5 CM.,
GERMAINE KRULL NACHLASS,
MUSEUM FOLKWANG, ESSEN

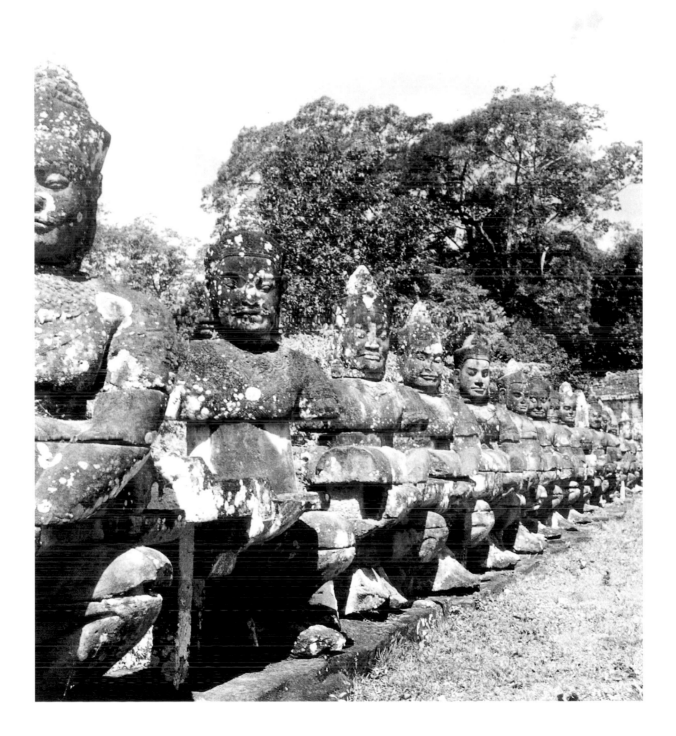

286.287

PLATE 9.8
ANKOR.
GELATIN SILVER PRINT, 20.3 x 16.7 CM.,
GERMAINE KRULL NACHLASS,
MUSEUM FOLKWANG, ESSEN

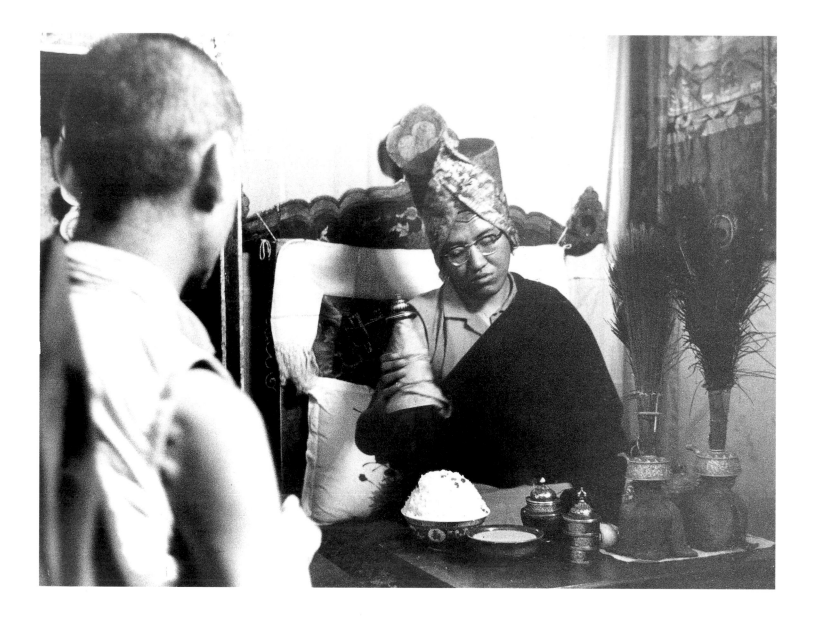

PLATE 10.1
HIS HOLINESS SAKYA TRIZIN, C. 1968,
GELATIN SILVER PRINT, 18.3 x 24.0 CM.,
GERMAINE KRULL NACHLASS.
MUSEUM FOLKWANG, ESSEN

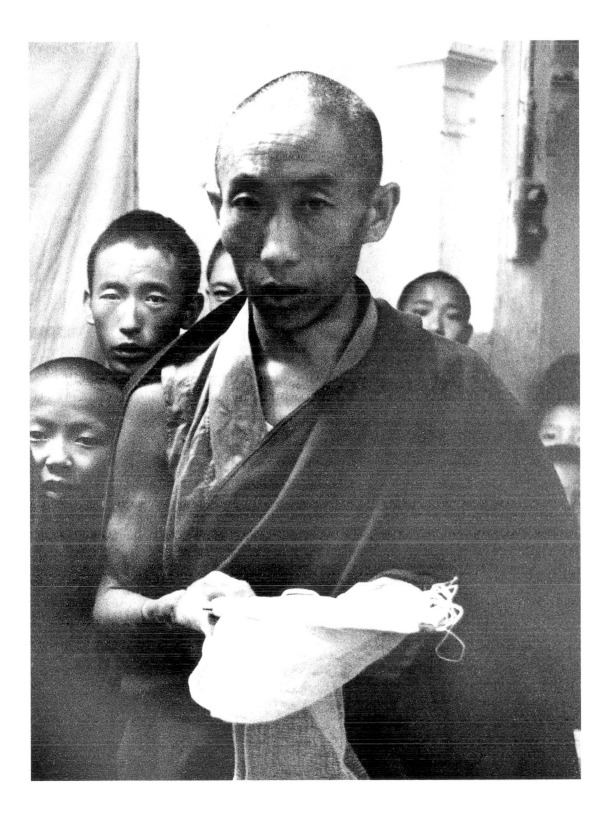

PLATE 10.2
TIBETAN RELIGIOUS CEREMONY.
OFFERING OF THE WHITE SCARF
TO THE ABBOT. N.D.,
GELATIN SILVER PRINT, 24.1 x 18.4 CM.,
GERMAINE KRULL NACHLASS,
MUSEUM FOLKWANG, ESSEN

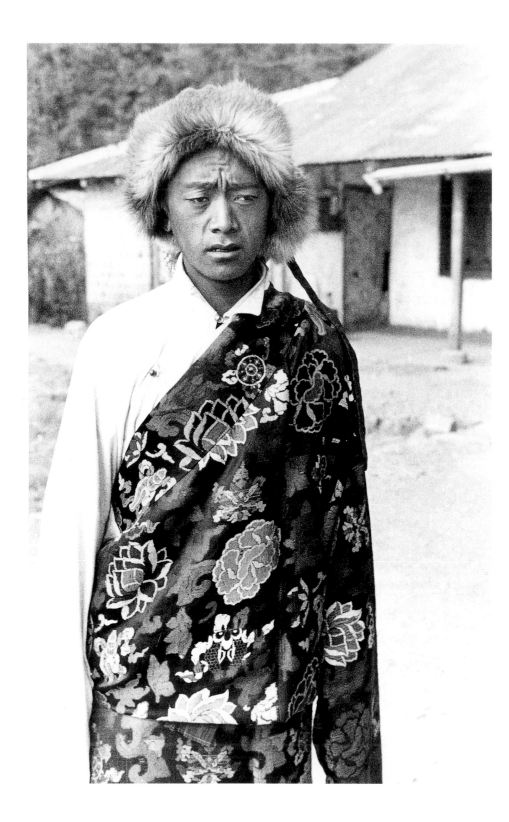

PLATE 10.3
TIBETAN DANCE GROUP, N.D.,
GELATIN SILVER PRINT, 24.1 x 15.6 CM.,
GERMAINE KRULL NACHLASS,
MUSEUM FOLKWANG, ESSEN

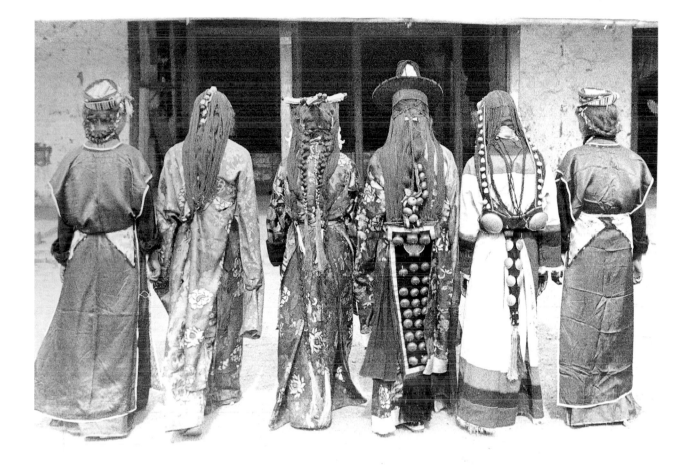

PLATE 10.4
A GROUP OF TIBETAN DANCERS, C. 1968,
SILVER GELATIN PRINT, 12.8 x 17.8 CM.,
GERMAINE KRULL NACHLASS,
MUSEUM FOLKWANG, ESSEN

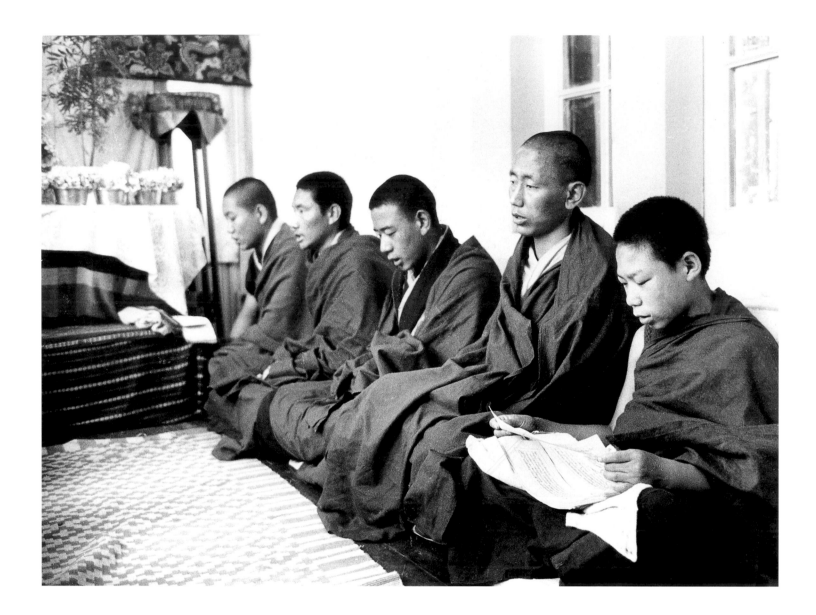

PLATE 10.5
DURING PRAYERS IN THE TEMPLE, C. 1968,
SILVER GELATIN PRINT, 18.5 x 24.0 CM.,
GERMAINE KRULL NACHLASS,
MUSEUM FOLKWANG, ESSEN, ESSEN

292.293

PLATE 10.6

YOUNG MONK, C. 1968.

SILVER GELATIN PRINT, 11.6 x 16.8 CM.,

GERMAINE KRULL NACHLASS,

MUSEUM FOLKWANG, ESSEN

Any understanding of Germaine Krull's photographic production must take into account her fiercely individualistic political and professional beliefs. Her work and life were inextricably intertwined, and photography both afforded her a pragmatic tool for surviving in a variety of places and allowed her to respond to the cultures she moved through. Krull was one of the most influential modern photographers of the interwar years, but she was remarkably unaware of the impact of her work on others. Indeed, her own definition of stylistic innovation was not limited to the New Vision and to abstraction, nor was it limited to a divisive distinction between avant-garde practice and commercial practice. Her broad photographic activities were no exception; rather, they constituted a normal pattern for photographers of her time and reflect her pragmatic approach to her career. Her unconventional activities in the years after World War II insulated her from the reconstruction of her work as purely modernist, a reconstruction to which her colleagues in Europe and America alike, influenced by the formalism of Clement Greenberg's decade, succumbed. Against the background of her varied and eclectic choices, a much richer vision of the modern artist emerges.

Krull followed no single formal path or stylistic fashion; she created her own. Jean Cocteau's description of Krull as a "reforming mirror" is a powerful one. Even as she responded to the stylistic dictates of each decade of her career, she made individual choices by reacting intuitively and positively to the cultural forces around her. Always aware of her surroundings, she absorbed the best from them, and as she responded to the cultures she participated in, she eventually both reflected and reformed them. As a young woman, she adopted the prevailing style of pictorialism but used it as a tool for reform in portraits of political leaders like Kurt Eisner. In Berlin, she adopted the *Freikörperkultur* of carefree Weimar society, but her nudes mocked as well as frolicked within the frames of the photographs. Krull's *Métal* series of industrial details abstracted and celebrated industrial form in the manner of the best of her avant-garde contemporaries. Yet her organization of images into disjunctive patterns was an uneasy dance with industry and not simply an adulation, and abstract modernism was but one of her experiments, not—in her eyes—the height of her career. Similarly, her magazine street photographs in Paris both celebrated and criticized the city, reflecting popular Parisian culture even while subtly reshaping it.

Krull's reactions to her era were her strength; her deep involvement with her various milieus allowed her to interpret them for her viewers. The photographer utilized the diagonal style she helped to develop in interwar Europe and both mirrored conventionally judgmental attitudes toward poverty and heroized it. Simultaneously, she participated in the broad re-creation of a pastoral and timeless European landscape in her travel books.

During and after World War II, Krull's style shifted from an avant-garde aesthetic to a more documentary style. Instead of abandoning avant-garde modernist style, she adapted it to her own purposes. Before the war, as a European, she was an insider, distorting European subjects in a sympathetic yet mildly critical series of images. Once she moved outside Europe, she framed her images more simply so that Europeans could visually begin to possess new cultures. In short, intuitively responding to the globalization of her century, she moved from a critique of European culture to a complex and colonialist selling of non-European values to Westerners. In the decades of the 1947 founding of Magnum as a forum for photographers who believed in "concerned photography" and of the establishment of the Museum of Modern Art's international education agenda, Krull documented wartime Africa in a style that encapsulated the African culture and made it comprehensible to the European audience. Then she packaged little-known Thai monuments and religious sculptures as grandly as any nineteenth-century view of the Athenian Parthenon. In India, she abandoned grandiose European monumentalism for a self-consciously austere style whose poverty chastised its well-fed viewers while eliciting support for the Tibetan Buddhist cause.

This view of Krull's life's work does not pretend that all her work was equal in quality; she herself preferred her industrial images to all others and admitted that the Thai pictures were merely tourist records. But the diversity of her work does not lessen the importance of the entire oeuvre. Unequal quality was a necessary by-product of a lifelong commitment to the medium, and fluctuations in aesthetic worth, shared by Kertész, Brassaï, and other contemporaries, do not lessen the historical and cultural importance of her pictures. Krull valued her various kinds of photographic practice equally, and her own position about her work is essential for a complete understanding of her life's work.

Krull's dogged individualism is evident in all of the decisions she made during her long and varied life, and it was equally strong in her political choices. Although her political causes varied widely, Krull abhorred totalitarianism in whatever form she found it. Her support for the independent rights of others often paralleled her own struggle to remain free of external constraints in her own life. She broke from the mainstream German Communist Party in late 1919 when it became too dogmatic; and she disagreed with Lenin's speeches at the Third World Congress in 1921 for being too authoritarian. Several years later, she left Berlin in

1925 due to her dislike of German cultural rigidity. The more fluid French culture of the interwar years suited her better, until World War II broke out and ideals gave way to pragmatism there, too. Krull left France in 1940 because of the double tragedies of the Hitler regime and the Vichy government's capitulation to Germany. She followed a difficult and tortuous path to join up with the Free French in Africa, detouring through Brazil and forcing herself into active service by her letter to London. She left Europe again in 1945 at least in part because she was disillusioned with what she percieved as compromise and dishonesty on all sides, even in victory.

Her actions in Asia followed the same pattern. Krull's few articles and war correspondent essays in 1945 and 1946 reveal her continuing beliefs in individual and antitotalitarian rights. She decided to remain in Thailand, in a culture little-known in Europe, for similar reasons; she wrote admiringly of its long tradition of fierce independence. Her support for the Dalai Lama and exiled Tibetan Buddhists in India forms part of the same political pattern. Krull's last resolution, to eschew the comforts of a wealthy existence in the Far East and Europe for the monastic life she chose in India, was her most courageous independent act.

Krull's career choices were equally independent and essentially practical. She valued professional autonomy as highly as political independence. Yet for all her sympathy for workers, she was too feisty to be a salaried worker herself. She was always an entrepreneur. Throughout her life, she never worked for any other person. Even at the brink of starvation, Krull operated her own studios in Munich and Berlin, when she might have worked profitably for another photographer or studio. She occasionally worked with a partner, like Kurt Hübschmann in Berlin or Luigi Diaz or Eli Lotar in Paris, but these business pairings never lasted. In Paris, and in the south of France, Krull worked on her own and not for any of the large agencies. During the war, although she was in a military operation, she had autonomy as the head of her branch of the Photographic Service. When Europe disappointed her in 1945, she carved out a new niche as an Asian war correspondent working on commission from an agency.

With this background in mind, Krull's decision to take advantage of the opportunity to restore a hotel in Bangkok rather than work for anyone else is quite logical, both for its independence and pragmatism. After her work for the Agence d'Edition et de la Presse ended in 1946, the Oriental Hotel must have seemed a welcome, suitably autonomous undertaking. If becoming a hotel manager was the way to stay in Asia as her own boss, then she followed her priorities. Although she had partners in this project, she ran the day-to-day operations. She essentially gave up this wealthy and cosmopolitan existence when it became less challenging to her. India and monasticism afforded a new adventure, reflecting her responses to new challenges throughout her life.

Krull's moral beliefs during these last forty years of her life also fit into a clear pattern established from her earlier experiences. Her free-thinking stance dated back to her childhood and the idiosyncratic education she received from her father. Although she had no specific religion and her father taught her to distrust Catholicism, she sought a kind of moral honesty throughout her life, always acting in accordance with her own conscience. Krull did not consciously seek to be a feminist, but she managed to find a path of emancipation from standard feminine roles without great effort, seizing opportunity for unconventional paths more for adventure than to be militant. She was fortunate in her choices and her friends. Although she followed no conventional pattern of love affairs or marriage, she remained close to and supportive of her most serious lovers even after their romantic involvement ended—as in her lifelong support of Lotar and her friendship with Ivens. Her loyalty to other friends is reflected in her correspondence; she actively and consistently maintained relationships with Max Horkheimer, Friedrich Pollock, André Malraux, Sakya Trizin, and other friends. Krull's hatred of dictatorships and her belief in individual rights form no small part of this moral stance, and her friends respected her dogged morality while trying to counsel her to accept reality on occasion. Krull believed that no one should make decisions for anyone else. In her last years, she found in Buddhism many of the elements of independence and personal responsibility that had attracted her throughout her life. The fact that her sect of Tibetan Buddhists was in exile and struggling against injustice only strengthened her devotion to the cause.

Krull could succeed in these efforts because she genuinely believed in the myths she was creating, which lends a moral force to the pictures she framed. She also had a finely honed sense of adventure. The power of her credos and her joie de vivre allowed her to transcend the marketplace pressures of an artist's career and to carve a particularly clear path through the issues that have sometimes clouded other artist's careers in the twentieth century. All artists incorporate their ideologies into their work, but few express them so clearly, write about them so consistently, or so consciously convert their artistic practices to serve either their own lives or their larger societal concerns. Krull's work and her experiences of many political and cultural segments of the twentieth century may be geographically and politically broader than the work and experiences of most other Euro-American artists, but the underlying patterns of her life echo those that all modernist artists followed during these tempestuous years. Her belief in the power of the photographic image and the written word was clear throughout her life, and she had no illusions about their factuality. Krull remained relatively uncritical about the quality of her work, choosing instead to harness it to her life's experiences. In reading her biased, passionate, and engaged words and images through a career of seventy years, we are able to reconstruct a multidisciplinary

memoir of the twentieth century—a personal view that witnessed wars in Germany, Africa, Europe, and Southeast Asia as well as the cultural highlights of Weimar Berlin, interwar Paris, and postwar Bangkok. Krull's writing and pictures remain engaged, and their immediacy offers one revealing window onto the twentieth century.

In citing works in the notes, works frequently cited have been identified by the following abbreviations:

"Vie"
Germaine Krull, "La vie mène la danse," 1981 (Germaine Krull Nachlass, Fotografische Sammlung im Museum Folkwang, Essen)

Vita
Germaine Krull, *La vita conduce la danza,* trans. Giovanna Chiti (Florence: Giunti Gruppo Editoriale, 1992)

"Click"
Germaine Krull, "Click entre deux guerres," 1976 (Germaine Krull Nachlass, Fotografische Sammlung im Museum Folkwang, Essen)

"Einstellungen"
Germaine Krull, "Einstellungen," in *Germaine Krull: Fotografien 1922–1966* (Bonn: Rheinisches Landesmuseum Bonn, 1977)

GKN
Germaine Krull Nachlass, Fotografische Sammlung im Museum Folkwang, Essen

Krull wrote her memoirs in French. Unless otherwise noted, all translations are by the author. Only the Thai books were written in English.

Introduction

1. Modernism has often been defined through the writings of Clement Greenberg and Michael Fried, although many scholars now read the movement in much more inclusionary terms.

2. Literature on the image of the New Woman in photography has been vastly enriched by Ute Eskildsen's groundbreaking exhibition and catalogue, *Fotografieren hieß teilnehmen: Fotografinnen der Weimarer Republik* (Essen: Museum Folkwang and Düsseldorf: Richter, 1994), which both introduces dozens of women photographers and examines the complex issues with which they grappled.

3. David Harvey, *The Condition of Postmodernity: An Enquiry into the Origins of Cultural Change* (London: Basil Blackwell, 1989), 24.

4. Germaine Krull wrote six memoirs or autobiographies; only three were published before her death. They include: (1) "Chien-fou" (unpublished novelized memoir, c. 1934, GKN); "Ceux de Brazzaville" (unpublished war memoir, c. 1940s, with an English version "Hello Hello Brazzaville!" translated by Margaret Nairn, a British colleague in Africa, GKN); (3) *Bangkok: Siam's City of Angels* (written with Dorothea Melchers, London: Robert Hale, 1964); (4) *Tales from Siam* (written with Dorothea Melchers, London: Robert Hale, 1966); "Click entre deux guerres" (unpublished memoir, 1976, GKN), translated by Klaus Honnef and published as "Einstellungen," in *Germaine Krull: Fotografien 1922–1966* (Bonn: Rudolf Habelt Verlag, Rheinisches Landesmuseum Bonn, 1977); and (6) "La vie mène la danse" (unpublished memoir, 1981, GKN), translated by

Giovanna Chiti and published posthumously as *La vita conduce la danza* (Florence: Giunti Gruppo Editoriale, 1992). This final, most comprehensive memoir, "La vie mène la danse," was completed in 1981, four years before the photographer's death. In this manuscript, not published during her lifetime, Krull created the most complex version of her life, spanning the years from her childhood at the turn of the century to her life in the Indian village of Dehra Dun in the 1970s. At this point she valued her political experiences as highly as her photographic career, and she assessed her career as an independent entrepreneur and celebrated her independence of political thought. Except for the two Thai memoirs, published in English, she always wrote in French, the language of the culture to which she felt closest.

5. Germaine Krull recounted the genesis of "Chien-fou" in a letter to Walter Benjamin: "I have written a very long novel that is about my life up to the moment when I left for the USSR, with all the era of Munich and the revolution, and above all the first hints of Stalinist treason. The book is very well written. I worked with the man who writes under the name of Gaston Cohen in *La Fleche* and who writes the "Trusts" page there. I worked with him for two years, and it was a close and successful collaboration. The book was finished three years ago, and here it is." Germaine Krull to Walter Benjamin, 21 November 1937, Monte Carlo (Walter-Benjamin-Archiv, Akademie der Kunst, Berlin).

6. Recent literature on the New Woman includes Atina

Grossmann's seminal articles, "Girlkultur or Thoroughly Rationalized Female: A New Woman in Weimar Germany?" in Judith Friedlander, Blanche Wiesen Cook, and Alice Kessler-Harris, eds., *Women in Culture and Politics: A Century of Change* (Bloomington: Indiana University Press, 1983), 62–80; and "The New Woman and the Rationalization of Sexuality in Weimar Germany," in Ann Snitow, Christine Stansell, and Sharon Thompson, eds., *Powers of Desire: The Politics of Sexuality* (New York: Monthly Review Press, 1983), 153–171; as well as her book *Reforming Sex: The German Movement for Birth Control and Abortion Reform* (New York: Oxford University Press, 1995). Patrice Petro's *Joyless Streets: Women and Melodramatic Representation in Weimar Germany* (Princeton: Princeton University Press, 1989) addresses the issue of popular imagery and the New Woman. Also see Renate Bridenthal, Atina Grossmann, and Marion Kaplan, eds., *When Biology Became Destiny: Women in Weimar and Nazi Germany* (New York: Monthly Review Press, 1984). A recent anthology edited by Katharina von Ankum, *Women in the Metropolis: Gender and Modernity in Weimar Culture* (Berkeley: University of California Press, 1997) directly addresses the cultural and representational discourses as a separate subject. For a compelling analysis of these issues in France, see Mary Louise Roberts, *Civilization without Sexes: Reconstructing Gender in Postwar France, 1917–1927* (Chicago: University of Chicago Press, 1994).

7. For a demographic view, see Tim Mason, "Women in Germany, 1925–1940: Family, Welfare and

Work," *History Workshop: A Journal of Socialist Historians* 1 (1976): 74–113. Seminal contemporary essays on these issues include Walter Benjamin's "The Work of Art in the Age of Mechanical Reproduction," in Hannah Arendt, ed., *Illuminations,* trans. Harry Zohn (New York: Harcourt, Brace and World, 1968), 217–252, and "On Some Motifs in Baudelaire," ibid., 155–200; Max Horkheimer, "Art and Mass Culture," *Studies in Philosophy and Social Science* 9 (2) (1941), reprinted in Horkheimer, *Critical Theory: Selected Essays* (New York: Seabury Press, 1972); Siegfried Kracauer's writings in Thomas Y. Levin, ed., *The Mass Ornament: Weimar Essays* (Cambridge: Harvard University Press, 1995). An early view of anxiety in Weimar culture is that of Peter Gay, *Weimar Culture: The Outsider as Insider* (New York: Harper & Row, 1970). An important gendered view of the problem has been written by Andreas Huyssen, "Mass Culture as Woman: Modernism's Other," in *After the Great Divide: Modernism, Mass Culture, Postmodernism* (Bloomington: Indiana University Press, 1986), 44–64.

8. The theory of the male gaze stems from Laura Mulvey's seminal article, "Visual Pleasure and Narrative Cinema," *Screen* 16 (3) (Autumn 1975): 6–18, reprinted in *Visual and Other Pleasures* (Bloomington: Indiana University Press, 1989). Recent scholars who address the gender divisions include Susan Buck-Morss, "The Flâneur, the Sandwichman and the Whore: The Politics of Loitering," *New German Critique* 39 (1986): 99–141 (Buck-Morss allows women a position of power in the street but only as prostitutes); Mary Ann

Doane, "Film and Masquerade: Theorising the Female Spectator," *Screen* 23 (September-October 1982): 80–82; Anke Gleber, "Female Flanerie and the *Symphony of the City*," in von Ankum, *Women in the Metropolis;* Miriam Hansen, "Pleasure, Ambivalence, Identification: Valentino and Female Spectatorship," *Cinema Journal* (Summer 1986): 6–32; and Patrice Petro, "Perceptions of Difference: Woman as Spectator and Spectacle," in von Ankum, *Women in the Metropolis.* Scholars such as Susan Buck-Morss attempt to place women in an active street role by symbolically empowering them as prostitutes, and Anke Gleber specifically tries to find "the traces of an alternate form of flanerie, one that might eventually inscribe the presence and potential of a female flaneur in the history of perception," although she finds them only in films that represent women (Gleber, 69).

9. For an insightful overview of androgyny in Weimar culture, see Maud Lavin, "Androgyny and Spectatorship," in *Cut with the Kitchen Knife: The Weimar Photomontages of Hannah Höch* (New Haven: Yale University Press, 1993), 185–204.

10. László Moholy-Nagy first formulated this term as a modern way of seeing, but in American scholarship it has recently come to broadly signify any interwar photography that experimented with form and technical innovation. See Eleanor Hight, *Picturing Modernism: Moholy-Nagy and Photography in Weimar Germany* (Cambridge: MIT Press, 1995), 3–4.

11. Siegfried Giedion, *Mechanization Takes Command* (New York: Norton, 1969), 5. Giedion

places the machine's moment of glory between the two world wars.

12. Post–World War II commentators on the Machine Age have included Reyner Banham, *Theory and Design in the First Machine Age* (New York: Praeger, 1960); Thomas Crow, "Modernism and Mass Culture in the Visual Arts," in S. Guilbaut and D. Solkin, eds., *Modernism and Modernity* (Halifax, N.S.: Press of the Nova Scotia College of Art and Design, 1983); Andreas Huyssen, Teresa de Lauretis, and Kathleen Woodward, eds., *The Technological Imagination* (Madison, Wis.: Coda Press, 1980); Karen Lucic, *Charles Sheeler and the Cult of the Machine* (Cambridge: Harvard University Press, 1991); Stephen Mansbach, *Visions of Totality: László Moholy-Nagy, Theo van Doesberg, and El Lissitsky* (Ann Arbor, Mich.: UMI Press, 1980); Leo Marx, *The Machine in the Garden: Technology and the Pastoral Ideal in America* (Oxford: Oxford University Press, 1964); and Terry Smith, *Making the Modern: Industry, Art and Design in America* (Chicago: University of Chicago Press, 1993).

13. For overviews of photography in the Machine Age, see Maria Morris Hambourg and Christopher Phillips, *The New Vision: Photography between the World Wars: The Ford Motor Company Collection at the Metropolitan Museum of Art, New York* (New York: Metropolitan Museum of Art/Harry N. Abrams, 1989); Christopher Phillips, ed., *Photography in the Modern Era: European Documents and Critical Writings, 1913–1940* (New York: Metropolitan Museum of Art/Aperture, 1989); and Matthew Teitelbaum, ed., *Montage and Modern Life, 1919–1942* (Cambridge: MIT Press, 1992). On

the connections between modernism and industry, see Kim Sichel, *From Icon to Irony: German and American Industrial Photography* (Seattle: University of Washington Press and Boston University Art Gallery, 1995).

14. Huyssen, *After the Great Divide,* vii.

15. Ibid., viii. Huyssen takes his definition of the historical avant-garde from Peter Bürger, *Theory of the Avant-Garde,* trans. Michael Shaw (Minneapolis: University of Minnesota Press, 1984).

16. Most overviews of the current discourse of postcolonial theory stem from Edward Said's *Orientalism* (New York: Vintage Books, 1979). For more recent studies, see Malek Alloula, *The Colonial Harem,* trans. Myrna Godzich and Wlad Godzich (Minneapolis: University of Minnesota Press, 1986); Homi K. Bhaba, *The Location of Culture* (London: Routledge, 1994), Mary Louise Pratt, *Imperial Eyes: Travel Writing and Transculturation* (London and New York: Routledge, 1992); Gayitri Chakravorty Spivak, *In Other Worlds: Essays in Cultural Politics* (New York: Methuen, 1987); and Patrick Williams and Laura Chrisman, eds., *Colonial Discourse and Post-colonial Theory: A Reader* (New York: Columbia University Press, 1994). More regionally specific postcolonial texts of relevance to Krull are Annie E. Coombes, *Reinventing Africa: Museums, Material Culture and Popular Imagination in Late Victorian and Edwardian England* (New Haven: Yale University Press, 1994); Elizabeth Edwards, ed., *Anthropology and Photography, 1860–1920* (New Haven: Yale University Press and the Royal

Anthropological Institute, 1992) and Donald S. Lopez, Jr., *Curators of the Buddha: The Study of Buddhism under Colonialism* (Chicago: University of Chicago Press, 1995).

17. Said, *Orientalism*, 1.

18. Ibid., 3.

19. Gayitri Spivak remains self-conscious about the absurdity of speaking of one non-European world, which she terms "the Asian absurdity with Israel and Japan on either end." Comment, "Modern Culture and Modernity Today" conference, Brown University, 15 March 1997.

20. Fredric Jameson, "Periodizing the 60s," in Sohnya Sayres, Anders Stephanson, Stanley Aronowitz, and Fredric Jameson, eds., *The 60s without Apology* (Minneapolis: University of Minnesota Press, 1984), 184.

Chapter 1

1. "Vie," 40–41; *Vita*, 41. Some references appear only in the unpublished version, "Vie." Krull wrote in French, English, and German, and in no language did she master spelling or grammar. In my translations of her French memoirs and early German correspondence, I have used conventional grammar.

2. I am grateful to Caroline A. Jones for reminding me of the gendered implications of Krull's translation.

3. What we know of her early years comes from two of her autobiographical manuscripts—"La vie mène la danse" and "Chien-fou."

4. Berthe Krull had a different biological father, although she was brought up as Friedrich Krull's daughter.

5. "Vie," 12; *Vita*, 10–11.

6. "Vie," 16; *Vita*, 15.

7. "Vie," 27; *Vita*, 26.

8. Ibid.

9. "Chien-fou," 5.

10. "Vie," 5–6. *Vita*, 5–6.

11. "Chien-fou," 4.

12. "Vie," 11.

13. Ibid.

14. "Vie," 30.

15. "Vie," 33; *Vita*, 32.

16. "Vie," 38; *Vita*, 38.

17. "Chien-fou," 64; similar comment in "Vie," 39; and *Vita*, 39.

18. Abortion itself, although largely still illegal in Germany, was not unusual during these years. Estimates range from 100,000 to 300,000 abortions annually before World War I and half a million after the war. James Woycke, *Birth Control in Germany 1871–1933* (New York: Routledge, 1988), 68. The number rose as the 1920s progressed, and, in fact, Atina Grossmann writes that "by 1931, at the height of the Depression . . . there were one million [illegal] abortions annually with about 10,000 to 12,000 fatalities. This averages out to at least two abortions for every woman in Germany." Grossmann, "The New Woman," 157. Krull was unusual only in her youth.

19. "Vie," 40; *Vita*, 39–40.

20. "Vie," 40; *Vita*, 39–40. In "Chien-fou," Krull recounted this period through the eyes of a ceramics student rather than a photography student, but the episodes, friends, and contacts described there are identical to her own.

21. References to Krull's enrollment in photography school appeared in the *Jahrbuch der Lehr- und Versuchsanstalt für Photographie, Chemigraphie, Lichtdruck und Gravüre zu München 1915–1916* (Munich, 1916), 32, listing her in

residence for the winter and summer semesters. The yearbook lists her as a Hamburg citizen, daughter of an engineer, and someone who had been privately tutored. Her name also appears in the *Jahrbuch der Lehr- und Versuchsanstalt für Photographie* for 1916–1918 (Munich, 1918), 52, as the tenth of twenty-seven students who took exams in July of 1917. Promotional literature for the school lists her as a student from 1916 to 1918. "Die Geschichte der Photoschule," *Das Lichtblick: Informationsblatt der Freunde und Förderer der Bayerischen Staatslehranstalt für Photographie München* (Munich: February 1988), n.p. However, Christian Bouqueret has found records listing her in Hans Spörl's class as student 15 in 1918, with a grade of II out of the three possible marks.

22. "Vie," 40. *Vita*, 40.

23. "Vie," 42.

24. The 1916 to 1918 *Jahrbuch der Lehr- und Versuchsanstalt für Photographie* lists Käthi Lux, born in 1896 in Wilmersdorf and a citizen of Prussia, and Erna Messerschmitt, born in 1897 in Zürich and a citizen of Bavaria. Katja's father was an engineer, and Erna's was a professor (32, 52). Max Horkheimer, too, was a friend of Katja and continued to correspond with her in the 1930s. Max Horkheimer to Katja Walch-Lux, Kopenhagen, 26 September 1934, 31 January 1935; Katja Walch-Lux to Max Horkheimer and Friedrich Pollock, 24 February 1937; in Max Horkheimer, *Gesammelte Schriften*, Alfred Schmidt and Gunzelin Schmid Noerr, eds., 16 vols. (Frankfurt: S. Fischer Verlag, 1995), 15: 233–34, 314–15; 16: 54–55.

25. In "Chien-fou," Germaine credited Katja's boyfriend Marc

with the invention of the nick-name: "What an odd mess of a hairdo you have! Is that you, Maria? Who gave you that ridiculous name? I baptize you *Chien-fou*." "Chien-fou," 83. Regardless of which friend invented the nick-name, it clearly stemmed from her inner circle of student friends during these years.

26. Interview with Ilse Siebert, 7 November 1993, quoted in Suzanne Baumann, "Der Weg über die Schulen," *Fotografieren hieß teilnehmen*, 34.

27. Berliner Photo-Adressbuch, 1931, cited in Ute Eskildsen, "Die Kamera als Instrument der Selbsbestimmung," in *Fotografieren hieß teilnehmen*, 19.

28. Of these economically active women, 4.133 million worked noncontractually as "family assistants" in family businesses (3.57 million on family farms), and almost 5 million more worked for regular weekly wages. Even among the wage earners, more than 1 million worked on the land; 1.3 million worked as domestic servants; and 2.2 million worked as manual workers, largely in clothing, textile, and food-processing industries. Figures reported by Tim Mason, "Women in Germany, 1925–1940," 78–80.

29. Ibid., 81. In 1925 there were several thousand doctors, almost 100,000 teachers, and 130,000 nurses. Also see Renate Bridenthal, "Beyond *Kinder, Kirche, Küche*: Weimar Women at Work," in *When Biology Became Destiny*, 33–65.

30. Eskildsen, "Die Kamera als Instrument der Selbsbestimmung," 17.

31. For a discussion of photographic schools in Germany, see Baumann, "Der Weg über die

Schulen," 34–40.

32. Eskildsen, "Die Kamera als Instrument der Selbsbestimmung," 16.

33. Baumann, "Der Weg über die Schulen," 35.

34. Ibid.

35. Ulrich Pohlmann, "'Beauty Is Soul': The Life and Work of the Photographer Frank Eugene Smith," in Ulrich Pohlmann, ed., *Frank Eugene: The Dream of Beauty* (Munich: Nazraeli Press, Fotomuseum im Münchner Stadtmuseum, 1995), 67.

36. *Jahrbuch der Lehr- und Versuchsanstalt für Photographie in München, 1905*, 1, cited in Baumann, "Der Weg über die Schulen," 36.

37. Ibid.

38. See Hans Spörl, "Die Neuordnung an der Höheren Fachschule für Phototechnik in München," *Photographische Chronik* 29 (16) (1922): 142, cited in Baumann, "Der Weg über die Schulen," 36.

39. Pohlmann, *Frank Eugene*, 285.

40. Ibid., 113.

41. Ibid., 133.

42. K. W. Wolf Czapek, "Die Münchener Lehr- und Versuchs-Anstalt für Photographie," *Deutscher Camera-Almanach* 10 (1914): 172–91.

43. Pohlmann, *Frank Eugene*, 117.

44. In addition to Krull, other graduates who achieved major recognition in their time were Frantisek Drtikol (1901–1903), Werner Mantz (1920–1921), Hanna Seewald (1922–1925), Willy Zielke (1924–1926), and Lotte Jacobi (1925–1927). "Die Geschichte der Photoschule," n.p. The international exhibition *Das Lichtbild* in 1930

included five graduates of the school—Germaine Krull, Wanda von Debschitz-Kunowski, Elfriede Reichelt, Lotte Reichman, Hedda Reidt, and Aenne Valentin. Cited in Baumann, "Der Weg über die Schulen," 37.

45. "Vie," 43; *Vita*, 43.

46. Berthe Krull corroborates their differing religious upbringings in a letter to the author, writing that Friedrich Krull was raised as a Catholic but had a "very disagreeable experience in his high school or college, which was directed by priests." She writes, "Later, he wanted me educated in the Catholic faith, he loved me dearly. G., on the other side, got all his atheistic ideas, she had never a religious training." Berthe Krull, letter to author, 10 March 1995.

47. Berthe Krull, letter to author, 10 March 1995.

48. Krull's 1921 deposition to the authorities in Moscow gave her 1919 home address as 53 Adalbertstrasse. Protokoll no. 1897, Kominterm-Archiv, Moscow.

49. Cited in Waggi Herz, "Heinrich Hoffmann und die Revolution: zur Genese faschistischer Fotografie," in *München 1919: Bildende Kunst/Fotografie der Revolutions- und Rätezeit* (Munich: Ein Seminarbericht der Akademie der Bildenden Künste, 1979), 135. Herz has published enormously important early research on Krull's Munich years, both here and in Rudolf Herz and Dirk Halfbrodt, *Fotografie und Revolution: München 1918/19* (Munich: Nishen, 1988).

50. Pohlmann, *Frank Eugene*, 133.

51. "Vie," 45; *Vita*, 46.

52. The Deutsches Tanzarchiv in Cologne owns three portraits by Krull of Hilde Brumof, a dancer

who trained privately in the Staatstheater in Munich and with the Berlin balletmaster Blanvaalet in Berlin.

53. Pohlmann, *Frank Eugene,* 69, 71.

54. Ibid.

55. Germaine Krull, Wanda von Debschitz-Kunowski, and Josef Pécsi, *Der Akt: Zwanzig photographische Aufnahme wiblicher Körper nach Natur* (Dachau: Einhorn-Verlag, 1918). An advertisement for the book appeared in *Der Bücherwurm: Eine Monatszeitschrift* 1 (1919).

56. "Biography: Wanda von Debschitz-Kunowski," *Fotografieren hieß teilnehman,* 313. She must have studied independently at the school, since it did not open officially to women until 1905.

57. Krull's recollections, related to Françoise Denoyelle in the late 1970s in Paris. Conversation between author and Françoise Denoyelle, 18 March 1995. I am very grateful to Françoise Denoyelle for sharing her memories of conversations with Krull, as well as showing me the portfolio, *Der Akt.*

58. For a full discussion of the *HAWE* portfolio, see Pohlmann, *Frank Eugene,* 183–193.

59. See Kim Sichel, *Turn of the Century Photographs by Robert Demachy* (New Haven: Yale University Art Gallery, 1983).

60. Richard Grunberger, *Red Rising in Bavaria* (New York: St. Martin's Press, 1973), 23.

61. "Vie," 41–42; *Vita,* 42.

62. "Chien-fou," 114. Similar passage in "Vie," 46.

63. John Willett, *Art and Politics in the Weimar Period: The New Sobriety, 1917–1933* (New York: Pantheon Books, 1978), 47.

64. "The armistice was signed on November 11, and it was Rainer Maria Rilke who telephoned to tell me the news, in the middle of the night." "Vie," 49. *Vita,* 56.

65. "Vie," 46; *Vita,* 49–50.

66. "Vie," 48; *Vita,* 53.

67. Pollock was born in 1894 to an assimilated Jewish businessman. He studied business, served in the war, and afterward became a student of economics and politics. During these months in 1919 he studied in Munich (he received an economics doctorate in 1923 from the University of Frankfurt). Pollock had been friends with Max Horkheimer since 1911. Horkheimer, born in 1895 in Stuttgart to a Jewish businessman, also began his career in commercial training. He and Pollock traveled to Brussels and London in 1913 to 1914 to learn French and English; then, like Pollock, Horkheimer began to study after the war's end in 1918. He fought briefly in 1917, was invalided out of the army, received his Abitur in 1919 in Munich, and then continued university studies in Munich, Freiburg, and ultimately Frankfurt, where he received his doctorate in 1922 in philosophy.

68. See Herz and Halfbrodt, *Fotografie und Revolution,* 71, for research on Ernst's last name. Krull, in "Vie," 42, lists him as a war-wounded son of a friend of her mother's.

69. "Vie," 43; *Vita,* 43.

70. "Vie," 43; *Vita,* 43 (partial).

71. Franz Blei, *Erzählung eines Lebens* (Leipzig, 1930), 350–51, cited in Pohlmann, *Frank Eugene,* 63.

72. "Vie," 48.

Chapter 2

1. "Vie," 48–49. *Vita,* 54. The revolt of Munich occurred on 7 November 1918, and the Bavarian republic was declared that night.

2. "Vie," 49; *Vita,* 54.

3. Demographics show that 300,000 civilians died during the war years for war-related reasons. For a comprehensive overview of wartime demographics, see Jay Winter, "Some Paradoxes of the First World War," in Richard Wall and Jay Winter, eds., *The Upheaval of War: Family, Work and Welfare in Europe 1914–1918* (Cambridge: Cambridge University Press, 1988), 9–42.

4. Bavaria did not act in isolation. In the two years following the successful Russian Revolution of 1917, German, Italian, Hungarian, and Austrian uprisings took place as well, culminating in short-lived new soviet states in Bavaria, Berlin, and Budapest. These were crushed by counterrevolutionary forces within a matter of weeks or months, but when Krull and her student friends participated in the events occurring all around them, no one was sure of the outcome. Only the month before, Lenin had stated a willingness to help Germany, saying, "The time is approaching when circumstances may demand from us help for the German people to liberate itself from its own imperialism against Anglo-French imperialism." Sebastian Haffner, *Failure of a Revolution: Germany 1918–1919,* trans. Georg Rapp (Chicago: Banner Press, 1986), x.

5. Allan Mitchell, *Revolution in Bavaria 1918–1919: The Eisner Regime and the Soviet Republic* (Princeton: Princeton University Press, 1965), 5. Mitchell concludes that, although many historians blame the revolution's chaos for easing the rise of National

Socialism, the "eventual result of the revolution . . . was to fulfill the major demands of the reform movement prior to 1918 and to realize its republican implications." In other words, Bavaria adopted a unicameral parliamentary system (Mitchell, 335).

6. Ibid., 33.

7. Max Horkheimer, "Foreword," (1971), in Martin Jay, *The Dialectical Imagination: A History of the Frankfurt School and the Institute of Social Research 1923–1950* (Boston: Little, Brown, 1973), xi.

8. For histories of the Bavarian revolutions, see Grunberger, *Red Rising in Bavaria*; Haffner, *Failure of a Revolution*; and Mitchell, *Revolution in Bavaria 1918–1919*. The Social Democratic Party of Germany (SPD) first became a presence in Bavarian politics in 1893 and advocated a parliamentary system based on universal suffrage (Mitchell, 14). In April 1917, the socialist SPD was abandoned by antiwar members of the SPD, who formed the Independent Socialist Party of Germany (USPD).

9. Grunberger, *Red Rising in Bavaria*, 27.

10. A. J. Ryder, *The German Revolution of 1918: A Study of German Socialism in War and Revolt* (Cambridge: Cambridge University Press, 1967), 143–44.

11. Grunberger, *Red Rising in Bavaria,* 33 ff.

12. Krull met Toller through her friends Katja Lux and Rainer Maria Rilke. In his autobiography, Toller describes Eisner poignantly, emphasizing the qualities that must have attracted Krull: "In him was embodied all that is finest in Nordic austerity and Latin rationalism. His political ideal was the

complete democracy. . . . The thing which differentiated him from all the other Republican ministers was his will to action." Ernst Toller, *I Was a German: The Autobiography of Ernst Toller* (New York: William Morrow, 1934), 144, 149.

13. In *Vita*, Ernst's father is named Wallach, 48; in "Vie," no surname is given, 45. Rudolf Herz writes that Ernst Joske, a childhood friend of Krull's, was Eisner's secretary and a member of the USPD. Herz and Halfbrodt, *Fotografie und Revolution*, 71, 323. Berthe Krull, however, has no recollection of a family friend named Ernst Wallach or Joske.

14. "Vie," 45; *Vita*, 47.

15. They were to use an old theater revolver belonging to Erich Mühsam, a revolutionary friend of his who was an expressionist poet and a member of Eisner's circle at the Golden Anchor.

16. Krull adopts a similar tone in her account of rape by her Berlin abortionist during the war; clearly, the loss of the fetus affected her more directly than either act of rape, although the distanced tone in her memoirs remains a disturbing puzzle.

17. "Vie," 45–46; *Vita*, 48–49; "Chien-fou," 142–45.

18. Herz and Halfbrodt, *Fotografie und Revolution*, 71, 323.

19. Toller, *I Was a German*, 144.

20. Reproduced in Waggi Herz, "Heinrich Hoffmann und die Revolution: zur Genese faschistischer Fotografie," in *München 1919*, 134.

21. Kurt Eisner, *Die neue Zeit* (Munich: Georg Müller Verlag, 1919).

22. Count Arco-Valley, acting for the monarchists, shot him in the street. Arco was a former mem-

ber of the Thule Club, which was the nucleus of the Nazi movement. He had been expelled because of his Jewish heritage.

23. See Herz and Halfbrodt, *Fotografie und Revolution*, for an extensive overview of Hoffmann's photography.

24. Ibid.

25. *Neue Zeitung* 1 (52) (22 February 1919). Reproduced in Herz and Halfbrodt, *Fotografie und Revolution*, 116.

26. "Vie," 50; *Vita*, 58.

27. Munich events paralleled the better-known communist attempts in Berlin. The January 1919 Spartakist revolt (KPD) was crushed in Berlin, and its leaders Rosa Luxemburg and Karl Liebknecht were killed while under arrest. See Ruth Fischer, *Stalin and German Communism: A Study in the Origins of the State Party* (Cambridge: Harvard University Press, 1948), 102 ff., for an overview.

28. Haffner, *Failure of a Revolution*, 175.

29. Grunberger, *Red Rising in Bavaria*, 145.

30. For a clear vision of the Bavarian events and their dubious reception by the Cominterm in Moscow, see Fischer, *Stalin and German Communism*, 102 ff., and Günter Nollau, *International Communism and World Revolution: History and Methods* (New York: Praeger, 1961), 46 ff.

31. Mühsam held a post as advisor to Russia and Hungary and was sentenced to fifteen years in prison. Toller, one of the council republic leaders, had gone into hiding on 1 May and was not captured until 5 June, which probably saved his life. With his literary renown as a playwright, Toller found figures such as Thomas Mann to support a

reduction of his sentence to five years.

32. "Chien-fou," 156.

33. Jay, *The Dialectical Imagination*, 3.

34. Ibid., 14.

35. "Vie," 50.

36. Ibid. Cited as "follia di Toller" without mention of Pollock, in *Vita*, 59. In "Chien-fou" (155), the Horkheimer and Pollock characters (Franz and Paul) warned what a mess this would become.

37. In "Chien-fou," 149 ff.

38. "Vie," 52 ff.; *Vita*, 60 ff.

39. Axelrod headed the Soviet government news bureau in Moscow until 1918 and then came to Germany as a representative of the Rosta press agency. Bruno Lazitch, ed., "L. Tobias Axelrod," *Biographical Dictionary of the Cominterm* (Stanford: Hoover Institution Press, Stanford University, 1986), 13.

40. Herz and Halfbrodt, *Fotografie und Revolution*, 71.

41. Archival sources in Moscow include a deposition from Krull in the Kominterm-Archiv (no. 1897, dated 29 and 30 March 1921, recorded by Comrade Popper of the ZKRKP and Comrade Molt of the Communist International), which relates many details of these years.

42. Herz and Halfbrodt, *Fotografie und Revolution*, 71. This information is corroborated in Krull's statement in Protokoll no. 1897 (Kominterm-Archiv, Moscow).

43. Grunberger, *Red Rising in Bavaria*, 157–58.

44. "Vie," 56; *Vita*, 66.

45. She was released through the assistance of Dr. Mathiesen. Krull's memoirs suggest one possible reason: she had destroyed Dr. Mathiesen's papers by shredding them and tossing them out of the train window. She thus removed the evidence that could convict him of revolutionary complicity, and he repaid the favor by arranging her release ("Vie," 57; *Vita*, 67). The Kominterm-Archiv statement credits Mathiesen with her release but gives no further clarification of his reasons for doing so.

46. "Vie," 58; *Vita*, 68.

47. Protokoll no. 1897 (Kominterm-Archiv, Moscow).

48. "Vie," 61; *Vita*, 71.

49. "Vie," 62; *Vita*, 74.

50. "Vie," 61–62; *Vita*, 71–73.

51. "Vie," 68; *Vita*, 80–81; Protokoll No. 1897 (Kominterm-Archiv, Moscow).

52. When she traveled to Berlin, Horkheimer accompanied her and assisted in the negotiations that resulted in a letter from Berlin authorities in support of Axelrod. Horkheimer then carried the letter to Munich. Statement (Kominterm-Archiv, Moscow).

53. Protokoll no. 1897 (Kominterm-Archiv, Moscow). In her statement she claims that on a trip to Berlin after Leviné's shooting she met Levit, through Franz Pfemfert, the editor of *Aktion*, in a village in the Harz mountains. She seems to have been married by November 1920, since Krull said that at the Party conference that month in Berlin Levit was under suspicion due to the supposed spying activities of his wife.

54. Samuel Levit refers to "meine Braut Krull" in a police statement of 19 November 1919. For a detailed overview of Krull's political adventures in Munich in 1918 and 1919, see Herz and Halfbrodt, *Fotografie und Revolution*, 68–72, 297 n. 184.

55. The photographer's sister Berthe recalls that Germaine told her they were married in Moscow before a magistrate, in an informal way: "Germaine was married to Mila in Moscow. At that moment, the couple went to the office of a magistrate and declared that they wanted to be married. I guess that they gave their names on a document but there were [sic] no formality at all. And when a couple told the magistrate they wanted to be divorced, it was O.K. too. Germaine and Mila told the official that they wanted to be divorced and that was it. Germaine decided then that they could all the same say that they were not married, because it all seemed stupid for German ways, or how a marriage was looked upon in relation to Western ideas. So Germaine told me." Berthe Krull, letter to author, 22 January 1995.

56. Ibid. An elliptical letter from Krull to Max Horkheimer in early 1922 bemoaned the fact that her relationship with him was a mistake but that she carried his name (the letter bore the name "Frau Germ. Levit-Krull" in her hand).

57. Krull to Horkheimer and Pollock, Riga, 12 January 1922, in Horkheimer, *Gesammelte Schriften*, 15: 80–81.

58. Berthe Krull, letter to the author, 22 January 1995.

59. I am grateful to Margarita Tupitsyn and to Renny Harrigan for their thoughts on the informal unions popular in Germany and Russia at this time.

60. According to Krull's memoirs, Pollock took an instant dislike to Levit, and in "Chien-fou," Krull recreates a passage where he tells Levit, "You're anarchists, you and *Chien-fou*. She must be crazy to be attracted by a type like you."

("Chien-fou," 224).

61. "Vie," 72; *Vita*, 86. Krull's Kominterm-Archiv statement relates that "the break" occurred in Frankfurt and that in Stuttgart their delegation was not admitted on the grounds that Munich was a spy organization.

62. Herz and Halfbrodt, *Fotografie und Revolution*, 72, 297 n. 187. Germaine Krull is mentioned in police records of Karl Römer's trial.

63. In "Chien-fou," Krull vividly describes her jail cell: "The wall of the cell went further than the wildest drawings of George Grosz. What artist could have had the idea of mixing communism and prostitution on the same wall?" ("Chien-fou," 276).

64. Police records document that Mila was sentenced to one year and three months. Herz and Halfbrodt, *Fotografie und Revolution*, 297 n. 187. Count Anton Graf von Pestalozza, the lawyer for Räterepublik leader Eugen Leviné, defended Levit and by some accounts served as Krull's lawyer too, although she herself cites a Dr. Stepacher as her lawyer. Berthe Krull lists Pestalozza as her sister's lawyer in a letter, written in Wetzlar, 31 October 1989, clarifying characters in "La vie mène la danse." Krull herself names Stepacher as her attorney in "Vie," 75–76; *Vita*, 89–90. Dates and prison times vary in Krull's writings. For instance, in "Vie," Krull writes that the prosecutor at her own trial demanded two years but cites five years as the demand in "Chien-fou."

65. "Vie," 75–76; *Vita*, 89–90, Protokoll no. 1897 (Kominterm Archiv, Moscow).

66. *Bayerische Kurier* (26

February 1920). Cited in Herz and Halfbrodt, *Fotografie und Revolution*, 72, 297 n. 189.

67. Ibid.

68. "Vie," 79. *Vita*, 93–94. The original document in the Stadtarchiv München is cited in Herz and Halfbrodt, *Fotografie und Revolution*, 297 n. 190.

69. "Chien-fou," 296.

70. Document 3473, by Paul Frölich (Kominterm-Archiv, Moscow). Frölich was one of the two leaders of the German delegation to the Third World Congress, along with August Thalheimer. Frölich was a right-wing leader of the Communist Party, with a particular dislike for the Bavarian Soviet council republic as an "adventurist folly." Fischer, *Stalin and German Communism*, 102 n. 18, 176.

71. Berthe Krull recalled that Levit's was an orthodox Jewish family from Russia. Letter to author, 22 January 1995.

72. "Vie," 85; *Vita*, 99–100.

73. "Vie," 84; *Vita*, 99.

74. "Through the intrigues of Mila's mother I sat for half a year as a counterrevolutionary. . . . If Mila finds that I'm here, I fear further interference from his parents." Unpublished letter, Germaine Krull to Max Horkheimer, 21 January 1922 (Max-Horkheimer-Archiv, Stadt- und Universitätsbibliothek, Frankfurt).

75. Beginning and end dates of her Russian sojourn are clarified in Krull's letters to Horkheimer and Pollock, 12 January 1922 and 21 January 1922 (Max-Horkheimer-Archiv).

76. "Vie," 87; *Vita*, 102.

77. Lazitch, "L. Tobias Axelrod," 13.

78. "Vie," 87; *Vita*, 102.

79. Protokoll no. 1897

(Kominterm-Archiv, Moscow).

80. "Vie," 88; *Vita*, 103.

81. "Vie," 88; *Vita*, 103.

82. Nollau, *International Communism*, 66–70.

83. "Vie," 90; in *Vita*, 105–06. She wrote nothing of the abortive strikes concurrently occurring in Germany, which would so incense the Cominterm leadership and soon lead to the excommunication of Paul Levi, the head of the German Communist Party.

84. Leon Trotsky, *The Third International after Lenin*, trans. John G. Wright (New York: Pioneer Publisher, 1936), 90–91, cited in Nollau, *International Communism*, 72.

85. Overview of "The Third Congress of the Communist International," in Jane Degras, ed., *The Communist International, Documents 1919–1922*, (London: Oxford University Press, 1956), 1: 224.

86. Ibid., 225.

87. Nollau, *International Communism*, 53.

88. Ibid., 66.

89. "Vie," 91–92; *Vita*, 106. *Tcheka* was the abbreviation for the Soviet commission against counterrevolution and sabotage, which existed between December 1917 and January 1922. Horkheimer, *Gesammelte Schriften*, 15: 81 n. 2.

90. "Vie," 93; *Vita*, 108.

91. "Vie," 95; *Vita*, 111.

92. "Vie," 96; *Vita*, 111.

93. Krull to Horkheimer and Pollock, 12 January 1922, Horkheimer, *Gesammelte Schriften*, 15: 80–81.

94. "Arrested and condemned to death by a revolutionary committee, she succeeded in escaping death, and escaping altogether. But the dramatic moment when she

was pushed against the execution wall, then released, left an ineradicable impression; she considered herself someone whose death sentence had been stayed." Joris Ivens and Robert Destanque, *Joris Ivens ou la mémoire d'un regard* (Paris: Editions BFB, 1982), 45–46. According to Berthe Krull, "Germaine told me many things about her time in the Tkeka. Once a group of soldiers and an officer took her out of her cell and said they take her to her execution. She had to stand against a wall with her face. She awaited her death, but after awhile the officer laughed and they took her back to her cell. It was a sadistic way to frighten her. . . . This event haunted her always in some way many years later, her whole life. . . . She told me about these events in Berlin when I visited her, but also in Monte Carlo when I visited her in 1937." Letter to the author, 22 January 1995.

95. Letter from Krull to Horkheimer and Pollock, 21 January 1922 (Max-Horkheimer-Archiv).

96. "Vie," 98; *Vita,* 114.

97. Latvia had been an independent state since 11 August 1921.

98. Berthe Krull, letter to the author, 22 January 1995.

99. Originally written as *My Two Years in Russia,* the text was abridged and appeared in 1923 as *My Disillusionment in Russia.* Emma Goldman, *Living My Life,* (New York: Dover, 1970), 2: 953.

100. Goldman, *Living My Life,* 2: 927.

101. Krull to Horkheimer and Pollock, 12 January 1922, in Horkheimer, *Gesammelte Schriften,* 15: 80–81.

102. Letters to "Maidon," whom he would soon marry, are

less than enthusiastic at the prospect of potentially having to house Krull when she left the hospital. Max Horkheimer to Rosa Riekher (Maidon), 25 January 1922, in Horkheimer, *Gesammelte Schriften,* 15: 85.

103. Horkheimer to Krull, 24 January 1922, in Horkheimer, *Gesammelte Schriften,* 15: 82–84.

Chapter 3

1. "Vie," 109; *Vita,* 129.

2. There is some discrepancy about where she convalesced. In her memoirs, Krull wrote of her convalescence with Else Eisner, whereas her sister Berthe suggests that she was in a clinic.

3. "Vie," 101; *Vita,* 118.

4. Berthe Krull recalls visiting her sister with her mother and Freidrich Pollock at this time: "I remember that one day my mother told me: 'This afternoon we will go and visit Germaine.' I was overjoyed. We met Germaine in the garden of a modern clinic. It was springtime. We were sitting together on chairs put on nice green grass with many little flowers. A very sympathetic ambiance. Germaine looked still sickly and very pale, very thin. It was when she had returned to Bavaria after the Russian horrors. My mother spoke with Germaine. I was 'out' of their conversation, I should say, but they were nice to me." Berthe Krull to the author, 22 January 1995.

5. The formal details of their marriage and divorce remain unclear.

6. See *Fotografieren hieß teilnehmen* for information on these photographers.

7. For demographic details, see Bridenthal, "Beyond *Kinder, Kirche, Küche,*" 148–66; and Grossmann,

"*Girlkultur* or Thoroughly Rationalized Female," 62–80.

8. For further discussions of the New Woman, see Bridenthal, Grossmann, and Kaplan, eds., *When Biology Became Destiny,* 1–29.

9. Grossmann, "The New Woman and the Rationalization of Sexuality in Weimar Germany," 156.

10. She had a similar relationship in Munich with Rudi, the older painter who helped her set up her first studio and whose conventional academic marine paintings were the scorn of her intellectual friends.

11. "Vie," 103, 104; *Vita,* 122, 123.

12. Krull's liaison with Basler is recounted in "Vie," 102–08; and *Vita,* 121–28.

13. Soon after Krull's arrival, Walther Rathenau, a Jewish industrialist and foreign minister, was assassinated on 24 June 1922. The 1922 Rapallo treaty between Germany and Soviet Russia heightened tensions between Germany and its western neighbors. Less than a year later, the French occupied the Ruhr on 11 January 1923, triggering great tensions between Germany and France. Riveting political events like these are hardly acknowledged in Krull's memoirs, in marked contrast to her accounts of the previous four years.

14. The German government owed 269 billion gold marks, and although this amount was reduced to 132 billion marks in 1921, the debt indirectly caused the enormous inflation of the German mark. The mark rose from a level of 550 marks per U.S. dollar in July 1922 to 4 billion marks per U.S. dollar in October 1923. By 20 November 1923, the mark reached

levels of 4,200 billion marks per dollar. On this day the Rentenmark was introduced, and Germans could exchange 1 billion old marks for one new Rentenmark, beginning the halt to the ruinous slide of the mark.

15. Malcolm Cowley, *Exile's Return: A Literary Odyssey of the 1920s* (New York: Viking, 1951), quoted in Otto Friedrich, *Before the Deluge: A Portrait of Berlin in the 1920s* (New York: Harper & Row, 1972), 125.

16. "Vie," 104; *Vita*, 123.

17. "Vie," 103; *Vita*, 122.

18. "Vie," 107; *Vita*, 126. The Weimar sex reform movement allowed some legal abortions but only when necessary, and "the number of illegal abortions rose throughout the decade to a height of 1931 of about one million illegal abortions (with 10,000 to 12,000 fatalities)." Grossmann, "The New Woman and the Rationalization of Sexuality in Weimar Germany," 157.

19. The first was a natural miscarriage when she still lived with her mother in Munich; the second ended in an illegal abortion in Berlin in 1915 or 1916 when she was pregnant by Peters.

20. Wolf von Eckhardt and Sander L. Gilman, *Bertolt Brecht's Berlin: A Scrapbook of the Twenties* (New York: Anchor Press/Doubleday, 1975), 130–31.

21. "On 'Naked Day,' German families, spanning three generations, could be seen sitting or swimming, naked as the day they were born. The peculiar atmosphere of the place was compounded by the fact that its waiters were fully and formally dressed." Alex de Jonge, *The Weimar Chronicle: Prelude to Hitler* (New York:

Paddington Press, 1978), 175.

22. For a fuller discussion of the *Freikörperkultur* milieu, see Ulf Erdmann Ziegler, *Nackt unter Nackten: Utopien der Nacktkultur 1906–1942* (Berlin: Nishen, 1990).

23. For more background the history and ideology of the movement, see Michael Kohler and Gisela Barche, eds., *Das Aktfoto: Ansichten vom Körper im fotografischen Zeitalter* (Munich: Münchner Stadtmuseum, 1985), 289–310.

24. The caption on the back of the double image (plate 3.4) tells us, in Freia's hand, that Krull needed a model at the Roma household but couldn't afford to pay, so Freia posed for free. Krull may have been a member of Berlin's lesbian circles, despite the lack of documented evidence. Ulrike Boehmer has conducted research on the actress and author Maximiliane Ackers, who in 1923 published a popular lesbian novel, *Freundinnen* (Hanover: Paul Steegeman, 1923), and suggests that Freia, Ackers, and Krull moved in the same artistic circles in Berlin.

25. See Elizabeth Anne McCauley, *Industrial Madness: Commercial Photography in Paris 1848–1871* (New Haven: Yale University Press, 1994).

26. "Vie," 115; *Vita*, 136.

27. "Vie," 112; *Vita*, 132–33.

28. See, for example, Kuhn's portfolio of bromoil prints, *Weiblicher Akt* (1906).

29. See *Das deutsche Aktwerk* (Berlin: Bruno Schultz Verlag, 1938), which includes images by Grainer, Bruno Schultz, Willy Zielke, and others. Although this was published sixteen years later, the convention of nudes silhouetted against the sky (Bruno Schwartz), kneeling or crouching dramatically (Trude Fleischmann),

and posed against patterned cloth (Franz Grainer) were still popular.

30. "Vie," 106; *Vita*, 125.

31. "Akte," Collection Dietmar Siegert, Munich. Another portfolio of nudes is listed in Frank Heidtmann, *Bibliographie der Photographie deutschsprachige Publikationen der Jahre 1839–1984: Technik, Theorie, Bild/Bibliography of German-Language Photography Publications 1839–1984* (Munich: K. G. Saur, 1989). This portfolio is listed on page 383 as a 1923 publication (#11141): "Kara Mappe (Aufn.) von Germaine Krull," *Körperbildungsgruppen Adolf Koch, Aktkunstmappe*, vol. 1, preface by Max Hodann (Leipzig: Ernst Oldenburg-Verlag o. j., 1923). This portfolio, however, is listed as including men and women.

32. I am grateful to Susan Ehrens for sharing this portfolio and its history with me.

33. Among the many studies of nude and pornographic photography in the nineteenth and twentieth centuries, see McCauley, "Braquehais and the Photographic Nude," *Industrial Madness*, 149–94.

34. Lavin, *Cut with the Kitchen Knife*, 1.

35. Ibid., 2.

36. For a comprehensive overview of German photography and newspaper illustration, see Peter de Mendelsohn, *Zeitungsstadt Berlin: Menschen und Mächte der Geschichte der deutschen Presse* (Berlin: Ullstein, 1959, 1982); Ute Eskildsen, ed., *Fotografie in deutschen Zeitschriften 1924–1933* (Stuttgart: Institut für Auslandsbeziehungen, 1982); Tim N. Gidal, *Modern Photojournalism: Origin and Evolution, 1910–1933*, trans. Maureen Oberli-Turner (New York: Macmillan, 1973), and

Diethart Kerbs, Walter Uka, and Brigitte Walz-Richter, eds., *Zur Geschichte der Pressefotografie 1930–1936* (Berlin: Frölich & Kaufmann, 1983).

37. There were numerous other colleagues. Elsbeth Heddenhausen, a Lette-Verein student, directed the photography studio at the Ullstein publishing house from 1924 on. Hannah Höch also worked for Ullstein in Berlin from 1915 to 1926. Florence Henri worked with Johannes Walter-Kurau in a studio in Berlin in 1922 and 1923. Irene Bayer (Irene Hecht) married the Bauhaus photographer and artist in 1923. Stephanie Brandl opened a Berlin portrait studio in 1926. For a comprehensive look at women photographers working in Weimar Germany, and biographical information on all the figures mentioned in this paragraph, see Eskildsen, *Fotografieren hieß teilnehmen,* especially biographies of artists, 312–19.

38. Atina Grossmann, "Berufswahl—ein Privileg der bürgerlichen Frauen," in Eskildsen, *Fotografieren hieß teilnehmen,* 8.

39. See Petro, *Joyless Streets.*

40. See Siegfried Kracauer, *From Caligari to Hitler: A Psychological History of the German Film* (Princeton: Princeton University Press, 1947); and Gay, *Weimar Culture.*

41. Petro, *Joyless Streets,* xix–xxiii.

42. Petro, *Joyless Streets,* 119.

43. "The agreement was signed and Basler signed without saying a word . . . and this sum would not be returned to him if we were not in agreement in six months." "Vie," 105; *Vita,* 124.

44. "Vie," 105; *Vita,* 124.

45. Felix Man, cited in Gidal,

Modern Photojournalism, 91.

46. Gidal, *Modern Photojournalism,* 21, 26.

47. Hübschmann (Hutton) worked for the *Münchner Illustrierte Presse,* and photographic essays include "Goethe's House" and "Charlie Chaplin at a Children's Dance in Berlin." Ibid., 22, 25.

48. "Vie," 105–06; *Vita,* 125.

49. The Deutsches Tanzarchiv owns fourteen of these photographs, and they are signed with a joint signature reading "G. Krull/Hübschmann." A series of notes by Berthe, added in later years, informs us that this series may or may not have been published as a portfolio.

50. Handwritten notes by Berthe Krull on the backs of the photographs (Deutsches Tanzarchiv, Cologne).

51. These photographs exist today in a battered cardboard folio, with the word "Akte" hand lettered on the cover, suggesting a less professional presentation than the Munich portfolio.

52. Siegfried Kracauer, "Reise und Tanz" (*Frankfurter Zeitung,* 1925), trans. as "Travel and Dance," in Thomas K. Levin, trans. and ed., *The Mass Ornament: Weimar Essays* (Cambridge: Harvard University Press, 1995), 65–73.

53. Mary Wigman, *Die Musik* 35 (December 1932).

54. Terpis made a guest appearance in Berlin in 1923 and became ballet master for the Berlin State Opera from 1924 to 1930. Von Horst Koegler and Hellmut Günther, eds., *Reklams Balletlexica* (Stuttgart: Philipp-Reklam, 1980), 448.

55. For information on German dance in Berlin and on these figures, I am grateful to Frank-Manuel

Peter of the Deutsches Tanzarchiv, Cologne.

56. Ibid.

57. de Jonge, *The Weimar Chronicle,* 128.

58. J. Chancellor, *How to Be Happy in Berlin* (London, 1929), 114–15, quoted in de Jonge, *The Weimar Chronicle,* 140.

59. "Vie," 105; *Vita,* 124 (partial). Seven of Krull's dance images, including plates 3.13 and 3.14, were published in *Körperbildung Nacktkultur: Blätter freier Menschen* 1 (July 1923): 1 ff. Krull's photographs of the Kroll-Redoute masked ball were published in 1926, the same year that industrial photographs were first published in Dutch magazines, and her Sonia Delaunay photographs appeared in the French and German press.

60. In fact, the earliest dated Krull photographs in the Berlin press that I have been able to find are in *UHU* in February 1926, illustrating an article on headhunters in the Indonesian island of Nias. Illustrations for Dr. A. Ponsel, "Unter Kopfjägern," *UHU* (February 1926): 69–75. It is not clear whether she traveled to Nias, for which there is no other documentation, or reproduced another photograph.

61. For a discussion of Mauritius and of German photographic magazine practices, see C. Zoe Smith, "Emigré Photography in America: Contributions of German Photojournalism from Black Star Picture Agency to *Life* Magazine, 1933–1938," Ph.D. dissertation, University of Iowa, 1983, 109 ff. Krull was supplying Mayer with images as early as December 1928. Letter from Ernst Mayer to Berenice Abbott, 14 December 1928 (Berenice Abbott Archives, Commerce Graphics Ltd. Inc.,

E. Rutherford, N.J.).

62. "Vie," 107; *Vita*, 127.

63. Toke van Helmond, "Politique et culture: Quelques notes biographiques sur Arthur Lehning, fondateur et rédacteur en chef de *i10*," *i10 et son époque* (Paris: Institut Néerlandais, 1989), 17.

64. Ivens and Destanque, *Joris Ivens ou la mémoire d'un regard*, 37.

65. van Helmond, "Politique et culture," 19.

66. Ibid., 19–20.

67. Van Helmond, "Portraits et biographies des collaborateurs de *i10*: Hendrik Marsman," *i10 et son époque*, 66. Lehning wrote about his friendship with Marsman as a collaboration: "Not in the sense that we exerted a dominant influence on each other, but rather that we respectively ignited each others ideas." Arthur Lehning, *De vriend van mijn jeugd (herinneringen aan H. Marsman)* (The Hague: W. Van Hoeve, 1954), cited in van Helmond, "Politique et culture," 15.

68. Twenty or more letters from Krull to Marsman are in the Hendrik Marsman Archiv, Koninklijke Bibliotheek (Royal Library), The Hague. For a fuller discussion, see Ida Boelema, "Een nooit geschreven roman: Brieven van Germaine Krull an Hendrik Marsman," *Jong Holland* 6 (4) (1990): 2–11. An English summary, "A Novel Never Written: Letters from Germaine Krull to Hendrik Marsman," appears on page 38.

69. "Vie," 107–08; *Vita*, 127–28.

70. Ivens and Destanque, *Joris Ivens ou la mémoire d'un regard*, 36–42.

71. Ivens worked at the companies of Ica and Ernemann in Dresden and at Carl Zeiss in Jena

and studied at the Technische Hochschule in Charlottenburg. Ivens and Destanque, *Joris Ivens ou la mémoire d'un regard*, 35.

72. van Helmond, "Politique et culture," 17.

73. Ivens and Destanque, *Joris Ivens ou la mémoire d'un regard*, 44–45.

74. Ibid., 45.

75. Ibid., 46.

76. "Vie," 109; *Vita*, 129.

77. "Vie," 110; *Vita*, 130.

78. Ivens and Destanque, *Joris Ivens ou la mémoire d'un regard*, 47.

79. In his new biography of Ivens, Hans Schoots suggests that Ivens's communist sympathies throughout his life were often more allied with totalitarian regimes such as those of Stalin and Mao rather than with the most leftist movements. Hans Schoots, *Gevaarlijk leven: Een biografie van Joris Ivens* (Amsterdam: Uitgeverij Jan Mets, 1995).

80. Ivens and Destanque, *Joris Ivens ou la mémoire d'un regard*, 48.

81. I am grateful to Percy Lehning for numerous discussions about his father's political positions and affiliations.

82. Roberts, *Civilization without Sexes*, 46.

83. Ibid., 11. Roberts reports that *La Garçonne* sold a million copies in France before 1929 and that from 12 to 25 percent of the population read the novel. Victor Margueritte, *La Garçonne* (Paris: Flammarion, 1922).

84. Ibid.

Chapter 4

1. "Vie," 113–14; *Vita*, 133.

2. For discussions of the meanings of self-portraits in photography, see Erika Billeter, *L'Autoportrait*

à l'age de la photographie: peintres et photographes en dialogue avec leur propre image (Lausanne: Musée cantonale des beaux-arts Lausanne, 1985) and Susan Butler, "So How Do I Look? Women before and behind the Camera," *Staging the Self: Self-Portrait Photography 1840–1980s* (London: National Portrait Gallery, 1986), 51 ff. For self-portraits in the Weimar period, see Monika Faber, "Selbstfoto," *Fotografieren hieß teilnehmen*, 280–87. Faber sees Krull as one of the first photographers to place the camera directly in front of her face, reading her control of the camera that traditionally subjugated women as a positive aggressive act. She also sees a loss of movement in the frontal pose, however, whereas I see Krull's hands as clearly controlling all aspects of her world, in tandem with her eyes, both human and mechanical. Other Weimar women who made self-portraits of themselves include Ilse Bing, Marianne Brandt, Gisèle Freund, Florence Henri, Lotte Jacobi, and Ergy Landau. Krull's is the earliest of this group of images and the most frontally powerful, unashamedly conflating eye and machine.

3. László Moholy-Nagy, *The New Vision: Fundamentals of Design, Painting, Sculpture, and Architecture* (New York: Brewer, Warren, and Putnam, 1930); originally published as *Von Material zu Architektur Bauhausbücher* 14 (Munich: Albert Langen Verlag, 1929). Although Moholy's book was not published until 1929, this term gained wide acceptance in current English scholarship as a general label for European experimental photography with the publication of Hambourg and Phillips, *The New Vision: Photography between the*

World Wars.

4. De Jonge, *The Weimar Chronicle*, 132.

5. Hight, *Picturing Modernism*, 3.

6. *Capi* is an acronym for the name of Ivens's father, Cornelieus Adrian Peter Ivens. In an April 1928 advertisement at the back of *Filmliga*, the company is listed as "Foto-, Projectie- en Kino-Handel" (handling photography, film, and cinema), with addresses at Kalverstraat 115, Amsterdam; Noordeinde 124, Den Haag; Kl. Pelsterstraat 3, Groningen; and v. Berchenstraat 15–17, Nijmegen. *Filmliga* 10 (April 1928): 16. Cited in *Filmliga 1927–1931* (Nijmegen: Socialistiese Uitgeverij Nijmegen, 1982), 238.

7. Ivens and Destanque, *Joris Ivens, ou la mémoire d'un regard*, 67 ff.

8. For interpretations of Hendrik Marsman's letters to and from Krull and their information about dates of her residence in Amsterdam, see Ida Boelema, "Een nooit geschreven roman: Brieven van Germaine Krull aan Hendrik Marsman," *Jong Holland* 6 (4) (1990): 2–11; and the Hendrik Marsman Archive, Koninklijke Bibliotheek, The Hague.

9. "Extrait du Registre d'Immatriculation," no. 7167, Feuillet 92, Prefecture de Police, Paris, 2 May 1927 (GKN). Through the Treaty of Versailles, Krull's hometown, Wilda, had become Polish territory, which left her with no legal papers at all; hence the *mariage blanc.*

10. Ivens obtained the divorce on 2 August 1943 in Chihuahua, Mexico, in the middle of World War II (GKN). The reasons and methods for the divorce were a bone of contention between Krull and Ivens for years afterward, but their relationship had merely been a deep friendship since 1927.

11. In her study of gender roles in France between the wars, Mary Louise Roberts isolates three types—"the modern woman," the French equivalent of the New Woman, "independent and sexually free"; "the mother," representing "continuity and tradition"; and "the single woman," an unsuccessful attempt to find a middle ground between the first two, "economically independent but . . . celibate." Catherine R. Stimpson, "Foreword," Roberts, *Civilization without Sexes*, ix–x.

12. "Vie," 128; *Vita*, 152.

13. Marriage certificate no. 552, Mairie du Dix-huitième Arrondissement, Paris, 2 April 1927 (GKN).

14. "Contrat de mariage," 10 March 1927, translated and witnessed by Maitre Johannes Hermanus Franciscus Maria de Hoog, Notary of Amsterdam (GKN).

15. Boelema, "Een nooit geschreven roman," 211. For further discussions of Ivens's and Krull's relationship, see Ida Boelema, "'La vie mène la danse': De vroege jaren van Germaine Krull volgens haar memoires," *Jong Holland* 3 (September 1995): 31–40, 63–64.

16. Jan Havermans, "Maske zu Strawinskis 'l'Histoire d'un soldat,'" photograph by Germaine Krull, in *Der Querschnitt* 6 (12) (December 1926): facing 918. Prints of these photographs can be found in the collections of the Cabinet des Estampes, Bibothèque Nationale, Paris.

17. Ivens and Destanque, *Joris Ivens, ou la mémoire d'un regard*, 68.

18. "Vie," 113; *Vita*, 133–34. For a fuller description of the artists who befriended Ivens and Krull in Amsterdam, see Schoots, *Gevarlijk leven*, 41–46.

19. First published in *Rynbende's blijmoedig manndblad* 1 (4) (1928): 11–13. See Boelema, "Een nooit geschreven roman," 5.

20. Joris Ivens, "Apprentice to Films, I," *Theatre Arts* 3 (3) (March 1946): 186. Schoots suggests that this episode took place in the Rotterdam Lightship Bar when Ivens, Krull, and Marsman visited there. Schoots, *Gevaarlijk leven,* 54.

21. Ivens, "Apprentice to Films, I," 186. Walther Ruttmann was an early German abstract experimental filmmaker whom Krull also photographed.

22. "Vie," 113; *Vita*, 134.

23. Another view survives in reproduction with the caption, "Buveurs de bière au cabaret, à Amsterdam," in *Variétés* 1 (12) (15 April 1929): 656 ff. These may be early or later views.

24. "Vie," 117.

25. This photograph was published in Germaine Krull, *Métal*, edited by A. Calavas (Paris: Librairie des arts décoritifs, 1928), plate 9. Also reproduced as "Mats metalliques à Amsterdam" in "Aspects de Hollande," in *Variétés* 1 (12) (15 April 1929): 688 ff.

26. See Boelema, "Een nooit geschreven roman," 8–9, for a discussion of the contacts with the magazine and its editors and for a reproduction of the photograph.

27. Published in *Métal* (plate 30) and also reproduced as "Hambourg" in "Panorama des ports," *Variétés* 2 (1) (15 May 1929): 284.

28. Krull, "Click," 6; "Einstellungen," 120.

29. For an overview of

Lehning's biography, see van Helmond, "Politique et culture," 14–20.

30. See Lehning's memories of the review in Arthur Lehning, "*i10*: trent-cinq ans après," *i10 et son époque*, 21–26.

31. I am indebted to Ida Boelema for this information. Boelema writes that the Krull photographs carry an Ivens credit line and that other Krull photographs appeared in Holland in the literary magazine *De Gemeenschap* (October 1926, May–June 1927, and October–November 1927) and in a weekly illustrated magazine called *Wij* in the 1930s. Letter from Ida Boelema to the author, 29 November 1994. One of the earliest times Krull's name appeared as a credit is in "Unter Kopfjägern," by Dr. A. Ponsel, *UHU* (February 1926): 69–75. Krull sold Ullstein several photos of Nias near Sumatra (probably postcards that she purchased or found in Paris: no Krull stamp adorns the vero of the remaining print in the Ullstein archive).

32. For a full discussion of German and American industrial imagery in the 1920s and its cultural meaning, see Sichel, *From Icon to Irony*.

33. For discussions of photography and the Dutch avant-garde, see Flip Bool and Kees Broos, eds., *Fotografie in Nederland 1920–1940* (The Hague: Staatsuitgeverij, 1979); Piet Zwart, *Piet Zwart: L'Opera tipografica 1923–1933* (Bologna: CIP-IA, 1987); and Paul Schuitema, *Paul Schuitema: Ein Pionier der holländischen Avantgarde* (Zurich: Kunstgewerbemuseum, 1967).

34. For a discussion of Bauhaus photography activities and theory, see Jeannine Fiedler, ed., *Photography at the Bauhaus*

(Cambridge: MIT Press, 1990). Hight's book *Picturing Modernism* clearly places Moholy-Nagy into his context.

35. Andreas Haus, "László Moholy-Nagy," in Fiedler, ed., *Photography at the Bauhaus*, 16.

36. László Moholy-Nagy, "Die beispiellos Fotografie," *i10* 1 (1) (1927): 114–17. Also published in *Das Deutsche Lichtbild* (Berlin, 1927), x–xi. Translated by Joel Agee as "Unprecedented Photography" in Phillips, *Photography in the Modern Era*, 83–85.

37. She met both around 1927 when Ivens visited her in Paris.

38. For a description in English of the Filmliga's formation, see Ivens, "Apprentice to Films, I": 179–86, and Ivens, "Apprentice to Films, II," *Theatre Arts* 30 (4) (April 1946): 245–50.

39. "Trappenhuis," with text, "Het Clair-Obscur in de Beeldvlak-Techniek." The photograph accompanies an article by Fritz Rosenfeld, "Film, Bild und Rhythmus," *Filmliga* 1 (10) (April 1928): 7–9, illustration on 9, reproduced in *Filmliga 1927–1931*, 231. This view was also reproduced, with the caption "Escalier en spirale," in *Variétés* 1 (9) (15 January 1929): 488 ff.

40. *Filmliga* 1 (10) (April 1928): 9, reproduced in *Filmliga 1927–1931*, 231. She also contributed a cover to the journal depicting a closely cropped view of a filmmaker's hands holding a strip of film over a splicing machine. *Filmliga* 2 (5) (February 1929): cover, reproduced in *Filmliga 1927–1931*, 349.

41. Ivens, "Apprentice to Films, II," 245; Portrait of S. M. Eisenstein, *Filmliga* 3 (7) (April 1930): 86, reproduced in *Filmliga 1927–1931*, 560.

42. For a full discussion of the making and critical reception of *De Brug*, see Schoots, *Gevaarlijk leven*, 56 ff.

43. Eisenstein and Pudovkin had a long and heated series of debates over this issue. See Sergei Eisenstein, "The Cinematographic Principle and the Ideogram," in Jay Leyda, ed. and trans., *Film Form: Essays in Film Theory* (New York: Harcourt, Brace, 1949), 28–44.

44. There is an extensive literature on these films. In particular, see Annette Michelson, "Dr. Crase and Mr. Clair," *October* 11 (Winter 1979): 29–53.

45. Schoots, *Gevaarlijk leven*, 56.

46. The Rotterdam bridge appears in *Métal* in plates 6, 13, 25, 32, 41, and 46 and possibly in other plates as well.

47. Ivens, "Apprentice to Films, II," 246.

48. Carlos Boker, *Joris Ivens, Filmmaker: Facing Reality* (Ann Arbor: UMI Research Press, 1981), 24.

49. László Moholy-Nagy, cited in Lucic, *Charles Sheeler and the Cult of the Machine*, 11.

50. Cited in Donald Kuspit, "Albert Renger-Patzsch: A Critical-Biographical Profile," in *Albert Renger-Patzsch: Joy before the Object* (Millerton, N.Y.: Aperture. 1993), 5.

51. The critical debate between the two sides can be best seen in the excerpts published in Phillips, *Photography in the Modern Era*, 105.

52. *Métal* has been dated 1927 in Krull's autobiography and in much of the published secondary literature. It was probably published the following year, since the first reviews date from early 1929. See Pierre Bost, "Les Livres: *Métal*," *Jazz* 2 (15 January 1929): 90, 92.

53. Reviews include Marcelle

Auclair, "Tour Eiffel, soeur aînée des avions," *L'Art vivant* (1 October 1928): 743–44; Pierre Bost, "Les Livres: *Métal*," *Jazz* 2 (15 January 1929): 90, 92; Florent Fels, "Acier," *Jazz* 5 (15 April 1929): 232–34; Jean Gallotti, "La photographie est-elle un art? Germaine Krull: *Métal*," *L'Art vivant* (1 July 1929): 526–27, 530; Daniel Rops, "Review of *Métal*," *Europe* (27 November 1929), reprinted in Pierre Mac Orlan, *Germaine Krull* (Paris: Librairie Gallimard, 1931), 15; Charles Saunier, "Le Métal: Inspirateur d'art," *L'Art vivant* (1 May 1929): 361, 368–69; Unsigned, "*Métal* par Germaine Krull," *Variétés* 1 (9) (15 January 1929): 509–10. See David Travis, "In and of the Eiffel Tower," *The Art Institute of Chicago Museum Studies* 13 (1) (1987): 21, for more discussion.

54. *Variétés* 2 (2) (15 June 1929): 128.

55. Albert Renger-Patzsch, *Eisen und Stahl*, introduction by Dr. Albert Vögler (Berlin: Verlag Hermann Reckendorf, 1931).

56. Albert Renger-Patzsch, *Die Welt ist Schön*, introduction by Carl Georg Heise (Munich: Kurt Wolff Verlag, 1928).

57. The Rotterdam bridge is present in several plates (see note 46).

58. "Vie," 117.

59. Eisenstein, "A Dialectic Approach to Film Form," 52–54.

60. Ibid., 60.

61. Eisenstein, "The Cinematographic Principle and the Ideogram," in Leyda, *Film Form*, 37.

62. Sergei Eisenstein, "A Dialectic Approach to Film Form," in Leyda, *Film Form*, 49.

63. One recent biography of Walter Benjamin dates this portrait to 1927, Bernd Witte, *Walter*

Benjamin: An Intellectual Biography, trans. James Rolleston (Detroit: Wayne State University Press, 1991), 93. Another, noting that Benjamin was in Paris from March 1926 for over six months, gives a 1926 date. Momme Brodersen, *Walter Benjamin: A Biography*, trans. Malcolm R. Green and Ingrida Ligers (London: Verso, 1996), 158, 167. The year 1926 seems plausible since both the writer and photographer were in Paris at that time.

64. Walter Benjamin, "The Author as Producer," *Reflections: Essays, Aphorisms, Autobiographical Writings*, ed. with introduction by Peter Demetz, trans. Edmund Jephcott (New York: Schocken Books, 1986), 234–35.

65. Ibid., 230.

66. Walter Benjamin, "A Small History of Photography" (1931) in *One Way Street and Other Writings*, trans. Edmund Jephcott and Kingsley Shorter (London: NLB, 1979), 254–55. Originally published as "Kleine Geschichte der Photographie," *Literarische Welt* (18 and 25 September, 2 October 1931).

67. Benjamin, "The Author as Producer," 237–38.

68. Christopher Phillips, "Introduction," in Teitelbaum, *Montage and Modern Life*, 22.

69. Rosalind Delmar, *Joris Ivens: Fifty Years of Filmmaking* (London: BFI, 1979), 20.

70. Citroën and Louis Renault, of course, were what Susan Pedersen calls "the arch-enemies of the leftist union movement," but this bothered Krull not at all.

71. Christian Bouqueret, *Germaine Krull 1924–1936* (Arles: Musée d'Arles, Rencontres Internationales de la Photographie, 1988), 146 ff. Krull's curriculum vita from Monte Carlo also includes as

clients Columbia, CDPE, Galeries Lafayette, Institut de Beauté Marceline Sebalt, Les Magasins Reunis, Montres VOG, Citroën, and Peugeot.

72. I am very grateful to M. André Jammes for sharing this rare volume with me.

73. For discussions of André Citroën's politics, see Patrick Fridenson, "L'Idéologie des grands constructeurs dans l'entre-deux-guerres," *Mouvement Social* 81 (October–December 1972): 51–68. For a more general discussion, see Charles S. Maier, "Between Taylorism and Technocracy: European Ideology and the Vision of Industrial Productivity in the 1920s," *Journal of Contemporary History* 5 (1970): 27–61.

Chapter 5

1. Germaine Krull, "Pensées sur l'art," in Mac Orlan, *Germaine Krull*, 12.

2. "Vie," 124; *Vita*, 147.

3. Ibid.

4. Krull to Marsman, 31 October 1926 (Hendrik Marsman Archives, Koninklijke Bibliotheek, The Hague).

5. "Vie," 117. In "Click," however, Krull stated that Sonia Delaunay introduced her to Luigi. "Click," 3; "Einstellungen," 118.

6. "Vie," 118; *Vita*, 141.

7. Krull's correspondence lists many addresses in Paris, and the exact dating of her studio addresses is uncertain. See letters in the Hendrik Marsman Archive, Koninklijke Bibliotheek, The Hague. At various times, she lived at the following addresses: 78 bis, rue de Maistre, Paris (Krull to Hendrik Marsman, n.d.); 19, boulevard Malesherbes, Paris 8 (Krull to

Marsman, 21 September 1927; also "Vie," 118; *Vita*, 141); 16 place Emile Goudeau, Paris 18 (studio with Eli Lotar; Krull to Marsman, 21 September, n. d.); 6, avenue Daubigny, Paris 17 (with Luigi Diaz, "Photos Presse Paris" letterhead); 11, avenue Junot, Paris 18 (with Diaz, "Photos Presse Paris" letterhead; Krull to Marsman, 31 July 1926 and 31 October 1926); 4, rue Becquerel (Krull to Marsman, 11 July 1927); 61, rue Damrémont, Paris 18 (FIFO Catalogue, 18 May to 7 July 1929); 95, boulevard St. Michel, Paris 5 (Krull to Marsman, 26 February 1933). (Hendrik Marsman Archive, Koninklijke Bibliotheek, The Hague).

8. "Click," 20; "Einstellungen," 129.

9. "'Mais Mademoiselle, votre appareil n'était pas d'aplomb!'" "Vie," 119; *Vita*, 142.

10. Tudor Arghez was born Ion Teodoresco in 1880. His works include *Mots ajustés* (1927), *Icones de bois* (1930), *Fleurs de moissisures* (1931), *Le Livre des jouets* (1932), and *Petit Livre du soir* (1935). For a discussion of Tudor Arghezi and his relationship with his son, see Annick Lionel-Marie, "Essai biographique: Le coeur meurtri par de mortes chimères," in *Eli Lotar* (Paris: Musée national d'art moderne, Centre Georges Pompidou, 1993), 10–11.

11. "Vie," 121; *Vita*, 144.

12. "Vie," 128; *Vita*, 152.

13. Lotar became very interested in film and worked on Ivens's films *Nous bâtissons* (*Wij Bouwen*, 1929–1930), *Zuiderzee* (*Zuyderzee*, 1930–1933), and *Nouvelle Terre* (*Nieuwe Gronden*, 1934).

14. Jean Gallotti, "La photographie est-elle un art? Eli Lotar," *L'Art vivant* (1 August 1929): 605, 609–10.

15. Studios unis operated at 59 rue Froidevaux and was financed by Charles de Noailles and Georges-Henri Rivière. Rivière was codirector of Georges Bataille's journal, *Documents*, which published Lotar's slaughterhouse photographs, as well as Boiffard's images of "Le gros orteil," or the big toe. Lotar was no more successful with Boiffard than with Lotar, and the studio closed by 1932. Lionel-Marie, "Essai biographique," 17–18.

16. "Vie," 129; *Vita*, 152.

17. As late as 1959, Lotar wrote Krull, then in Bangkok, a long letter encapsulating his last fifteen years of activities, financial troubles, emotional ties, and breakup with Lala, who had become his wife. Lotar to Krull, 29 December 1959 (GKN).

18. Letter from Germaine Krull to Hendrik Marsman, 31 October 1926 (Hendrik Marsman Archives, Koninklijke Bibliotheek, The Hague).

19. "Vie," 119; *Vita*, 141; "Click," 4; "Einstellungen," 119.

20. Letters from the Koninklijke Bibliotheek, Hendrik Marsman Archives, The Hague, and discussion in Boelema, "Een nooit geschreven roman," 7–9.

21. In a letter to Marsman at the end of 1926 or beginning of 1927, Krull wrote, "I'm practically the photographic correspondent for the *Frankfurter Zeitung*," and complained that Luigi had not been very nice. Letter from Germaine Krull to Hendrik Marsman (Hendrik Marsman Archives, Koninklijke Bibliotheek, The Hague), reprinted in Boelema, "Een nooit geschreven roman": 9.

22. For example, see Krull's relatively straightforward image of a Champcommunal design in *Für die*

Frau 3 (1) (January 1928): 10. My study of the scattered issues available in the United States reveals no Diaz or Photos-Presse Paris photographs.

23. See Luigi Diaz's photograph, "Interessanter Nachmittags-Mantel aus schwarzem Tuch mit reichstem Galjac-Besatz. Kleines Cape," designed by Heim, in Paris. This photograph is reproduced in *Die Dame* 2 (October 1929): 11. The compositions of these photographs reflect Krull's dramatic use of shadows and geometric backdrops similar to those in the Sonia Delaunay design photographs.

24. "Click," 3; "Einstellungen," 118.

25. *Variétés* published five photographs of Norine designs. *Variétés* 2 (7) (15 November 1929): 534 ff. The Bouqueret collection owns two views of Davia. Krull discussed commissions for Lanvin, Lelong, and Poiret, often on the recommendations of Sonia Delaunay. "Click," 4; "Einstellungen," 119.

26. Two views (Collection Ann und Jürgen Wilde, Zülpich, on loan to the Sprengel Museum, Hanover).

27. Seventeen views were in the collection of the Schostal Agency, Vienna.

28. I am grateful to Sherry Buckberrough for many conversations about the Delaunays and their Paris circles.

29. "Vie," 118; abbreviated translation in *Vita*, 141.

30. For a clear discussion of Delaunay's textile and clothing work, see Sherry Buckberrough, "Delaunay Design: Aesthetics, Immigration, and the New Woman," *Art Journal* 54 (1) (Spring 1995): 51–55.

31. "Der Delaunay-Stil—die kommende Mode," *Illustrierte*

Beilage zum Berlin Börsen-Courier (14 March 1926), clipped and inserted in *Sonia Delaunay Albums de Presse, 1926* (Fonds Delaunay, Bibliothèque Nationale, Paris).

32. These photographs of Sonia Delaunay models, with Krull's signature in the negative, can be found in the Fonds Delaunay, Bibliothèque Nationale, Paris. The press clippings with photographs that allow us to date them are from the Delaunay Press notebooks for 1925 and 1926 to 1927, in the Bibliothèque Nationale, Paris.

33. These photographs can be found in the photographic collection "Photos de la mode" in the Fonds Delaunay, Bibliothèque Nationale, Paris. I am grateful to Sherry Buckberrough, whose tireless work in the Delaunay archives allowed these images to be identified and included in this study of Krull's work.

34. Receipt from Sonia Delaunay to Mme. Krull, 21 September 1927, for 875 francs: 425 francs paid, 450 francs balance (Hendrik Marsman Archives, Koninklijke Bibliotheek, The Hague).

35. Buckberrough, "Delaunay Design," 54.

36. The photograph bears the stamp "Photo Germaine Krull" and a note by Sonia Delaunay stating, "L. Codriano, artiste roumaine, danseuse dans le P'tit Parigot" (photograph #153, Fonds Delaunay, Bibliothèque Nationale, Paris). Another uncredited photograph of the same dress and model is a full-length view of Codriano, in her shawl and identically painted face, suggesting that many more of these photographs may have been Krull's even if they are not stamped with her name or "Photos Presse Paris."

37. "Ein javanischer Prinz tanzt," *Die Dame* 14 (April 1930): 18–19. Krull's photographs in this article are credited "Aufnahme: Germaine Krull (Mauritius)."

38. Germaine Krull, *Etudes de nu,* text by Gerard de Nerval, ed. A. Calavas, 24 plates (Paris: Librairie des arts décoratifs, 1930).

39. Krull, "Preface," *Etudes de nu,* n.p.

40. Krull included a newer portrait of Ivens in the Salon de l'Escalier.

41. A Benjamin portrait appeared in the Galerie l'Epoque exhibition in Brussels (October 1928).

42. Soon after this Paris trip, Eisenstein invited Ivens to come to Moscow. Ivens was thrilled, but Krull cautioned him that she was still disliked by the Soviets as a leftist counterrevolutionary. She explains in her memoirs that they kept their marriage secret to safeguard Ivens during his many travels in the Soviet Union. Her references to Ivens's fascination with Soviet culture and her reaction that he was naive to be so optimistic are almost the only political comments in her memoirs of the Parisian years. "Vie," 132; *Vita,* 154–55.

43. Carlo Rim, Interview with Christian Bouqueret, 20 March 1988. I am grateful to Christian Bouqueret for showing me this material.

44. "Click," 37; "Einstellungen," 139.

45. Letter from Jean Cocteau to Germaine Krull, April 1930, reprinted in Mac Orlan, *Germaine Krull,* 16.

46. *Variétés* 1 (9) (15 January 1929): 464 ff.

47. "Click," 30–31; "Einstellungen," 135–36; "Vie," 136–37; *Vita,* 157–58.

48. Krull also added a view of Colette's hands to her growing collection of hand photographs.

49. "Vie," 134; *Vita,* 156.

50. Malraux's career included dozens of books and different travels, and only those that intersect with Krull are noted here. With his wife, Malraux traveled to Indochina in 1923 to rediscover Buddhist temples but was arrested for the theft of sculpture from the temple at Bantai Srey. He also went on other archaeological expeditions. His leftist contacts in Indochina led to three famous novels on revolutionary themes—*Les Conquérants* (1928), *La Condition humaine* (1933), and *L'Espoir* (1937). Antifascist activities include his participation in the Republican air force in the Spanish Civil War. In World War II, he was imprisoned by the Germans and later worked in the Resistance, first unifying the disparate groups in Southwest France and then commanding the Alsace-Lorraine brigade. After the war, he wrote *Les voix du silence* (1951) and argued long and hard for a museum without walls. He worked in de Gaulle's government, becoming minister of culture in 1958. Bédé Edgarton, ed., *Columbia Dictionary of Modern European Literature,* 2d ed. (New York: Columbia University Press, 1980), 503.

51. See Mac Orlan, *Germaine Krull.*

52. Krull, "Pensées sur l'art," 12.

53. Ivens did the same, even in the formal experimentation of *The Bridge.* He rejected Ruttmann's circles and squares and sought his abstract new vision in the industrial world of the port.

54. The exhibition Neue Wege

der Fotografie had taken place in 1927 in Jena, but this was the first French exhibition and one of the most important early events in the development of modern photography.

55. See László Moholy-Nagy, "La photographie ce qu'elle était, ce qu'elle devra être," *Cahiers d'art* 4 (1929): 29–30.

56. Krull, "Pensées sur l'art," 12.

57. In fact, Cartier-Bresson cites Krull as an important photographer.

58. Maria Morris Hambourg has discovered that Clair was apparently not involved in the exhibition. Phillips, *Photography in the Modern Era,* 26 n. 1.

59. "Click," 21; "Einstellungen," 130.

60. Krull had a particular connection with this theater because of her friendship and work history with its director Louis Jouvet, whose productions of plays by Jean Giraudoux and others she photographed for *Vu.* Vogel, as *Vu's* editor, presumably had the same connections. Giraudoux's *Siegfried* was, in fact, being performed during the time of the Salon de l'Escalier exhibition.

61. "Its purpose is to show that, far from being a mechanical art, photography is becoming more and more of an art with its own laws. It depends neither on reality nor on pictorial art. The choice of works will therefore be strictly aesthetic." *Catalogue, Salon de l'Escalier* (Paris, 1928), 11 (translation by the author).

62. For a clear discussion of this event and its importance, see Maria Morris Hambourg, "Atget: Precursor of Modern Documentary Photography," in *Observations*

(Carmel, Calif.: Friends of Photography, 1984), 24–39; and Hambourg and Phillips, "Resurrecting Vision: The New Photography in Europe between the Wars," in *The New Vision*, 102.

63. Albin-Guillot contributed only nudes and still life images, and Hoyningen-Huené showed mostly portraits. Man Ray and Outerbridge exhibited still lifes and formal compositions with only a few portraits. The Atget retrospective listed only landscapes, although it is impossible to know whether these were park scenes or cityscapes.

64. Photographers working in France who followed Krull's lead into constructivist and city imagery include Ilse Bing, Pierre Boucher, Brassaï, Henri Cartier-Bresson, Réné Jacques, Pierre Jahan, François Kollar, Roger Parry, Roger Schall, Maurice Tabard, and Réné Zuber.

65. From an interview with Berenice Abbott, by James McQuaid and David Tait, July 1975, on deposit at the Library of the George Eastman House, Rochester.

66. Brassaï, "Germaine Krull vue par . . . Brassaï," *Germaine Krull* (Paris: Cinémathèque Française et Musée du Cinéma, 1967): n.p.

67. F.L., "L'exposition de la photographie à la Galerie 'l'Epoque,'" *Variétés* 1 (7) (15 November 1928): 401. Another anonymous review of the exhibition appeared in *Cahiers d'Art* 8 (1979): n.p.

68. For a comprehensive discussion of German modern photography exhibitions in the 1920s, see Ute Eskildsen and Jan-Christopher Horak, eds., *Film und Foto der zwanziger Jahre: Eine Betrachtung der International Werkbundausstellung "Film und Foto" 1929* (Stuttgart:

Württembergischer Kunstverein, 1979).

69. Letter from Berenice Abbott to Museum Folkwang, 20 December 1928 (Berenice Abbott Archives, Commerce Graphics). Krull also helped Abbott to begin working with the German picture agency Mauritius.

70. The catalogue has been reprinted as Gustaf Stotz et al., *Film und Foto* (New York: Arno Press, 1979), and includes artists' addresses and titles of works (Krull is listed as living at 61, rue Damrémont). Various other books were published in conjunction with this exhibition, although the others make no mention of Krull. They are Franz Roh and Jan Tschichold, *Foto-Auge* (Stuttgart: Akademischer Verlag/Dr. Fritz Wedekind, 1929), and Werner Gräff, *Es kommt der neue Fotograf* (Berlin: Hermann Reckendorf, 1929). A concise overview in English of the exhibition can be found in Hight, *Picturing Modernism.* For a complete discussion of this exhibition, see Eskildsen and Horak, *Film und foto der zwanziger Jahre.* Contemporary press clippings are reprinted on pages 167 ff.

71. Krull exhibited in Das Lichtbild (Munich, 1930); Photographes d'aujourd'hui (Galérie à la Plume d'or, Paris, 1931–1932); Constitution des artistes photographes (Galerie Saint-Jacques, Paris, 1932); Exposition Internationale de la Photographie (Palais des Beaux-Arts, Brussels, 1932); L'image photographique en France de Daguerre à nos jours (Galerie d'Art Braun, Paris, 1933); Deuxième Exposition Internationale de la Photographie et du Cinéma (Palais des Beaux Arts, Brussels, 1933); Groupe an-

nuel des photographes (Galerie de la Pléiade, Paris, 1933 and 1934); Exposition de la Société des artistes photographes (S.A.P., Studio Saint-Jacques, Paris, 1934); and the Documents de la Vie Sociale Section de l'Association des Ecrivains et des Artistes Révolutionnaires (Galerie de la Pléiade, Paris, 1936). For many of these citations, I am indebted to Christian Bouqueret, "Expositions de groupe et personelle," *Germaine Krull: Photographie 1924–1936*, 152–54.

72. Benjamin, "A Small History of Photography," 199–216.

73. Romy Golan, *Modernity and Nostalgia: Art and Politics in France between the Wars* (New Haven: Yale University Press, 1995), ix.

74. *L'Art vivant* was cofounded by Georges Charensol, Roger Martin du Gard, Florent Fels, and Jacques Guenne and ran from 1925 to 1929. For further discussions of the journal's impact, see Golan, *Modernity and Nostalgia*, 6.

75. Fels wrote numerous monographs on artists like Ensor, Pascin, Van Gogh, and Vlaminck. Fels was also involved with the bar and gallery Le Boeuf sur le Toit, along with Paul Morand, Léon-Paul Fargue, and others. For details of his colorful life, see Florent Fels, *Voilà* (Paris: Librairie Arthème Fayard, 1957); Fels, *L'Art vivant de 1900 à nos jours* (Geneva: P. Cailler, 1950); and Fels, *L'Art et amour* (Paris: Editions Arc-en-ciel, 1952–1953). For an informative contemporary profile, see Princess Lucien Murat, "Florent Fels," *Les Nouvelles Littéraires* (28 July 1928): 2.

76. "Vie," 128.

77. Florent Fels, "Le Premier Salon Indépendant de la Photographie," *L'Art vivant* (1 June 1928): 445, trans. Robert Erich Wolf and reprinted in Phillips, *Photography in the Modern Era*, 23–26. In her memoirs, Krull also cites Eugène Merle, editor of *Le Merle blanc*, as the source for a similar nickname, "The Iron Walkyrie." "Click," 44; "Einstellungen," 144.

78. Florent Fels, "Introduction," Krull, *Métal*. Marceline Desbordes-Valmore (1786–1859) was a French poet and actress.

79. Fels, "Introduction," n.p.

80. Ibid.

81. Ibid.

82. See *L'Art vivant* No. 135 (1 August 1930): cover. Krull and Lotar also collaborated on three collages in Charles Fegdal, "Anticipations Parisiennes," *L'Art vivant* 127 (1 April 1930): 289, 293. These views conflate metro bridges, the Arc de Triomphe, and other Parisian monuments to confuse the normal perception of city monuments.

83. Saunier, "Le Métal, Inspirateur d'art," 361, 368–69.

84. Anonymous, "Les expositions" [Salon de l'escalier], *L'Art vivant* (15 June 1928): 486. Reprinted in Dominique Baqué, ed., *Les Documents de la modernité: Anthologie de textes sur la photographie de 1919 à 1939* (Paris: Editions Jacqueline Chambon, 1993), 456–57.

85. Louis Emié, "Renaissance de la photo," *La Petite Gironde* (6 June 1929), n.p. Reprinted in Mac Orlan, *Germaine Krull*, 15.

86. Towinez, "Review," *La Revue hebdomadaire* (16 June 1928): 358–59.

87. Dominique Baqué, "La photographie dans *L'Art vivant*," in *Les Documents de la modernité*, 373–78.

88. Jean Gallotti, "La photographie est-elle un art? Germaine Krull," *L'Art vivant* (1 July 1929): 526–27. Reprinted in Baqué, *Les Documents de la modernité*, 384–87.

89. Pierre Mac Orlan (1883–1970), wrote numerous books, poems, and songs, including *A bord de l'Etoile matutine* (1920), *La Cavalière Elsa* (1921), *Le Quai des brumes* (1927), *Chansons pour accordéon* (1953), and his memoirs, *La Petite cloche de Sorbonne* (1959). His complete works comprise at least twenty-five volumes. (*Oeuvres complètes*. Geneva: Edito-Service, 1971).

90. Pierre Mac Orlan, "Graphismes," *Arts et métiers graphiques* 11 (1928–1929): 645–49. Reprinted in Baqué, *Les Documents de la modernité*, 39–41.

91. For example, Pierre Mac Orlan, "La Photographie et le Fantastique Social," *Les Annales politiques et littéraires* (1 November 1928): 413–14; Mac Orlan, "L'Art littéraire d'imagination et la photographie," *Les Nouvelles littéraires* (22 September 1928); and Mac Orlan, "Eléments de fantastique social," *Le Crapouillet* (March 1929): 33. The latter two articles are translated by Robert Erich Wolf and reprinted in Phillips, *Photography in the Modern Era*, 27 and 31, respectively.

92. Pierre Mac Orlan, "Les sentiments de la rue et ses accessoires," *L'Art vivant* 144 (1 January 1931): 20–21.

93. Mac Orlan, *Germaine Krull*, 6. Also published in *L'Art vivant* 145 (February 1931): 21.

94. Mac Orlan, *Germaine Krull*, 7.

95. Cocteau had collaborated on the wartime magazine *Le Mot*, which attempted to rescue "modernism and imaginative creative endeavor from the accusations of

Germanic affiliation." Following this, Cocteau's friendship with Picasso placed him in the center of the Montparnasse circles, while his collaboration with Picasso and Erik Satie on *Parade* at the Ballets Russe in 1917 combined Left Bank and Right Bank culture as well as politics. Cocteau's theatrical successes continued with *Le Boeuf sur le toit* in 1920 and *Les Mariés de la Tour Eiffel* in 1921. Kenneth Silver, *Esprit de Corps: The Art of the Parisian Avant-Garde and the First World War, 1914–1925* (Princeton: Princeton University Press, 1989), 125–26.

96. "Vie," 137; *Vita,* 159.

97. Letter from Jean Cocteau to Germaine Krull, April 1930, reprinted in Mac Orlan, *Germaine Krull,* 16.

98. Krull, "Pensées sur l'art," 12.

Chapter 6

1. "Click," 12; "Einstellungen," 123.

2. For a further discussion of the role of foreigners in interwar France, see Kim Sichel, "Les photographes étrangers à Paris durant l'entre-deux-guerres," in André Kaspi and Antoine Marès, eds., *Le Paris des étrangers depuis un siècle* (Paris: Imprimerie Nationale/Institut d'histoire des relations internationales contemporaines, 1989), 257–70.

3. Maren Stange forms a useful definition of documentary photography, recognizing the importance of the interactions between a picture, a caption, a text, and a presenting agency. *Vu,* and the writers and photographers who produced work for it, represent one of the first groups to produce this kind of multileveled imagery in the post-

war period. See Maren Stange, *Symbols of Ideal Life: Social Documentary Photography in America 1890–1950* (New York: Cambridge University Press, 1989). For a discussion of the political meanings of documentary photography, see John Tagg, *The Burden of Representation: Essays on Photographies and Histories* (Amherst: University of Massachusetts Press, 1988).

4. Jean-Jacques Becker and Serge Berstein, *Victoire et frustrations, 1914–1929,* vol. 12, *Nouvelle histoire de la France contemporaine* (Paris: Editions du Seuil, 1990), 12: 178.

5. Golan inserts Kertész into her discourse about nostalgia and the appropriation of types but overlooks the distinction between the more disjunctive works of the late 1920s and the more traditionalist ones of the mid 1930s. Golan, *Modernity and Nostalgia,* 148–49. Also see Silver, *Esprit de Corps.*

6. "Vu cette semaine," *Vu* 1 (21 March 1928): 4.

7. *Vu* 4 (4 April 1928): 92–93 (text by Edmond Gréville).

8. Krull published photographic essays or single images in the following issues of *Vu:* in 1928, nos. 1, 2, 4, 6, 10, 11, 12, 17 (cover, sailor photo), 19, 24, 31, 33, 38; in 1929, nos. 42, 44, 47, 49, 56, 62, 64, 69, 70, 71, 77 (cover, Blackbird dancers), 81, 87, 93; in 1930, nos. 94, 101, 103, 120 (cover chiropractor), 143; in 1931, nos. 247, 248, 249, 250, 252, 298, 331. She almost certainly also published in other issues, but it is nearly impossible to locate all issues of the journal, and different libraries own different series of months and volumes. The covers include "Veille de revue: Les timoniers du 'Jean-Bart' préparent

le grand pavois formé par les flammes et pavillons du code international de signaux. Voici un matelot au travail," *Vu* 17 (11 July 1928); and "Au Revoir Black Birds! [Portrait of Adélaïde Hall]," *Vu* 77 (4 September 1929).

9. For a profile of Vogel, see Georges Charensol, "Un Grand éditor d'art: Lucien Vogel," *Les Nouvelles littéraires* (2 May 1925): 5.

10. See Fels, *Voilà,* for an anecdotal history.

11. Krull had been publishing single fashion photographs in the Munich paper since at least January 1928. For more on the German picture press, see Gidal, *Modern Photojournalism*; John Four, "The *Berliner Illustrirte* and Photojournalism in Germany, 1929–1935," in *Picture Magazines before* Life (Woodstock, N.Y.: Catskill Center for Photography, 1982); Smith, "Emigré Photography in America; Kerbs, Uka and Walz-Richter, *Zur Geschichte der Pressefotografie 1930–1936*; and de Mendelssohn, *Zeitungsstadt Berlin.*

12. Lorant became Berlin editor of the Munich paper only in August 1928, several months after *Vu* began picture stories. Gidal notes that Lorant "underlined the 'essay' character of the photo reportage and identified himself with the photos as if they were his own. He emphasized graphic presentation and arrangement instead of showing a mere succession of photos, text, and captions." Gidal, *Modern Photojournalism,* 18.

13. *Vu* published photographs by Berenice Abbott, Laure Albin-Guillot, Ilse Bing, Brassaï, d'Ora, Man Ray, and Maurice Tabard, among many others.

14. For a fuller discussion of *Vu,* see Sandra Phillips, "The

French Picture Magazine *Vu*," in *Picture Magazines before Life*, 1–4.

15. *Vu* 1 (21 March 1928): 12.

16. Ibid., 11.

17. Ibid., 12.

18. Brassaï, *Paris de nuit*, text by Paul Morand (Paris: Arts et Métiers Graphiques, 1932); Germaine Krull, *100 x Paris*, text by Florent Fels (Berlin: Verlag der Reihe, 1929); André Kertész, *Paris vu par André Kertész* (Paris: Société des Editions d'Histoire et d'Art, Librairie Plon, 1934).

19. *Vu*'s last issue was 472 (5 May 1937). *Vu et lu* began publication on 12 May 1937, with 479.

20. "Photojournalism in the 1920s: A Conversation between Felix H. Man, Photographer, and Stefan Lorant, Picture Editor (1970)," in Beaumont Newhall, ed., *Photography: Essays and Images* (New York: Museum of Modern Art, 1980), 271.

21. In an interview with Christian Bouqueret on 20 March 1988, Carlo Rim described the photographs in *Jazz*, noting that he worked with four or five photographers (including Kertész, Krull, and Ergy Landau) whom he knew well.

22. For example, during the two-year existence of *Variétés*, Krull published 118 photographs, more than any other photographer. Lotar, for instance, published thirty-seven images. Krull's subjects ran the gamut from industrial and Eiffel Tower landscapes, to mannequins, flea markets, Les Halles, *clochards*, hands, mystical "ectoplasm" images, beauty salons, Amsterdam, Rotterdam, various city ports, various mystical religions, cityscapes, "melancholic cityscapes," Brittany, portraits of architects and poets, and foodstuffs.

23. For a fuller discussion of

Mayer and Black Star, see Smith, "Emigré Photography in America," 109 ff.

24. Letter from Ernst Mayer to Berenice Abbott, 14 December 1928 (Berenice Abbott Archives, Commerce Graphics Ltd. Inc., East Rutherford, N.J.). I am grateful to Peter Barr for sharing this correspondence with me.

25. "Ein javanischer Prinz tanzt," *Die Dame* 14 (April 1930): 18–19. One Krull photograph depicts the Javanese prince Mas Madja-Djava, who danced in Paris, and the second shows the mask of the Hindu-Javanese "Helden Ardjuna."

26. A. G. Schostal, Paris (81, rue Blanche), Vienna (Starhemberggasse, 26), Milan (Via Vaviao 24).

27. Thanks are due to Dr. Christian Brandstätter for sharing his knowledge of this archive.

28. Three Krull photographs of the signing of the Pact appear in *Vu* 24 (30 August 1928): 542–45, 559.

29. For examples of additional urban and abstract cityscapes, see L. Léontin, "Un Port Moderne: Une Ville d'Art—Anvers," *Vu* 38 (6 December 1928): 834–35 (five Krull photographs); Marc d'Aubrive, "Le Pardon des Terre-Neuvats," *Vu* 49 (20 February 1929): 130–31 (six Krull photos); Louis Cheronnet, "Eden de Banlieue," *Vu* 331 (18 July 1934): 902–03 (five Krull photographs).

30. She also contributed essays on the Salvation Army, La Goulue, Punch and Judy puppet shows, suburbs, Paris "types," and the women workers of Paris. A partial list includes the following articles: Stella Croissant, "Les Sauvetages de l'armée du Salut," *Vu* 44 (16 January 1929): 38–39 (Krull and Lotar pho-

tos); Henri Danjou, "Le Dernier interview de la Goulue—un million à retrouver," *Vu* 47 (6 February 1929): 84–85 (two Krull photographs); Jean Gallotti, "Guignol: A propos du Congrès des Marionettes," *Vu* 87 (13 November 1929): 939–41 (Krull and Kertész photographs); Jean Gallotti, "Permanence du type populaire—les modèles des frères Le Nain," *Vu* no. 331 (18 July 1934): 912–14; and Emmanuel Berl, "Les Ouvrières de Paris," with many Krull photographs in all but one of the six issues where this series appeared: *Vu* 247 (7 December 1932): 1925–28; 248 (14 December 1932): 2011–14; 249 (21 December 1932), 2047–50; 250 (28 December 1932): 2079–82; 251 (4 January 1933): 12–15; and 252 (11 January 1933): 43–47.

31. These essays will be discussed in Chapter 9. Similar travel portfolios of photographs appeared in *Jazz* and *Variétés*.

32. For example, Jean d'Erleich, "La Perle," *Vu* 33 (31 October 1928): 728–30 (Krull and Lotar photographs); and Sylviac, "Superstition," *Vu* 143 (10 December 1930): 1343–45 (four Krull and nine Kertész photographs).

33. "Click," 54; "Einstellungen," 149.

34. Thanks are due to Christian Bouqueret for sharing this typescript and the photographs.

35. "Nr. 5. Vorbereitungen der Filmoperateure vor Zeichnung." Typescript notes to photographs in the Collection Christian Bouqueret, Paris.

36. "Du Bureau à la chambre à coucher de Mr. Herriot à Lyon," *Vu* 9 (17 May 1928): 222–24 (cover image and six photographs by Lotar); Edmond Wellhof, "Les heures de

Son Eminence le Cardinal Dubois," *Vu* 11 (31 May 1928): 270–72 (ten Lotar photos); "Les Obsèques nationales du vainqueur de la guerre," *Vu* 55 (3 April 1929): 257 (Maréchal Foch)."

37. Some Eiffel Tower pictures were also included in *Métal* and in Jean Prévost's 1929 monograph on Gustav Eiffel. They were one of the first homages to the tower as it approached its fortieth birthday in 1929 and an earlier publication of images by Krull appeared in L. Emners, Ingenieur, "Protest gegen ein unmögliches Bauwerk: ein interessante prophezeiung aus dem Jahre 1889," *UHU* (December 1927): 106–111. Other popular articles included one illustrated with photographs by André Kertész in May of 1929: Jean d'Erleich, "La Tour à quarante ans," *Vu* 63 (29 May 1929): 433; and "40 Jahre Eiffelturm," *Münchner Illustrierte Presse* 19 (12 May 1929): 637. Kertész made this reporting excursion in the company of Brassaï. Sandra S. Phillips, David Travis, and Weston Naef, *André Kertész: Of Paris and New York* (Chicago: Art Institute of Chicago, New York: Metropolitan Museum of Art, and London: Thames and Hudson, 1985), 268.

38. Lucien Vogel was a leading force in the development of Paris photography. Magazine editors in general wielded great power with their suggestions, assignments, editing, and layout of images, and Vogel, as the first editor of *Vu* and an extremely charismatic character, influenced many projects. A profile, "Un Grand Editeur d'Art: Lucien Vogel," *Les Nouvelles littéraires* (2 May 1925): 5, gives a few details of his previous activities before the 1928 publication of *Vu*'s first number. He studied architecture at the Ecole des Beaux Arts and began his editing career at Hachette, soon working specifically on *La Vie heureuse* and learning commercial and industrial practices. He then moved to *Art et Décoration* to work with Emile Levy, where he learned about art book layouts and editing as well as magazine work. He worked at *La Gazette du Bon Ton* from 1910 until after 1919 and then moved to *Vogue*, where he was art director before coming to *Vu*.

39. "Click," 12; "Einstellungen," 123.

40. "Click," 12; "Einstellungen," 123. Krull recounts a slightly different version of this story in "Vie": "Faites-moi la Tour Eiffel dans la même manière. . . . Après demain, on verra un nouveau Paris, la Tour!" "Vie," 125; *Vita*, 147–48.

41. "Protest gegen ein unmögliches Bauwerk," *UHU* (December 1927): 106–11.

42. Jean Prévost, *Eiffel* (Paris: Les Editions Rieder, 1929).

43. Marcelle Auclair, "Tour Eiffel, soeur ainée des avions," *L'Art vivant* (1 October 1928): 743.

44. For information on Philippe Lamour, *Entretiens sous la Tour Eiffel* (1929) and *Grand'Route* (March–July 1930), I am indebted to Mark Antliff. Krull's Eiffel Tower images are discussed in Eric Hurel, "La Confusion des arts," *Grand'Route* (May 1930): 71–74.

45. "Vie," 125; *Vita*, 148. "Click," 12; "Einstellungen," 123.

46. They were exhibited in the 1928 Salon de l'Escalier at the Théâtre des Champs Elysées and at the 1929 Stuttgart exhibition Film und Foto. They were published in Prévost's book on Eiffel, in *L'Art vivant*, in *Métal*, and in a Swedish Paris album by Aldolf Hallmann, *Paris under 4 Årstider* (Stockholm: Albert Bonniers Förlag, 1930), 146.

47. Florent Fels, "Dans toute sa force," *Vu* no. 11 (31 May 1928): 284. Vogel and his staff may have written the captions, or Fels may have written them himself; no archives survive from the magazine and the authorship of the captions remains in doubt, although their tone is in keeping with Fels's text.

48. Ibid.

49. This photograph also seems related to an aerial photograph of the tower and its environs by the Compagnie Aérienne de Paris, in the collection of Robert Delaunay. This older photograph, in Delaunay's scrapbook in the Cabinet des Estampes at the Bibliothèque Nationale, Paris, clearly served as a model for several of Delaunay's *Tour Eiffel* paintings.

50. *Métal*, 1928, cover; Mac Orlan, *Germaine Krull*, 17, plate 37.

51. Moholy-Nagy was the major voice of this German style, but the "diagonal style" of photography had become common by this time in France and in Germany.

52. David Travis disagrees, seeing all three as pure formal explorations (David Travis, "Kertész and His Contemporaries in Germany and France," in Phillips, Travis, and Naef, *André Kertész*, 65. Both Krull and Kertész, unlike Moholy-Nagy, photographed the tower for Lucien Vogel at *Vu* and published the pictures in the popular press, in articles about the fortieth birthday of the tower. Yet it is impossible to ignore the different captions and the ways they inform the images, and there are distinct formal as well as contextual differences.

53. Fels, "Dans toute sa force," 284. Portions of Fels's text are re-

published in *Métal* and elsewhere.

54. Ibid.

55. Ibid.

56. Several of the *Métal* images depict the Eiffel Tower. Other Krull tower images depict the Citroën ads lit up at night. She also published images in Jean Prévost's *Eiffel* monograph, and in many other books and articles.

57. Jacopozzi proposed his lighted advertisements on the tower to André Citröen in 1925 but was turned down. Henry Ford, in Detroit, learned of the project and expressed an interest in ads for the Ford Motor Company. When Citroën learned this, he capitulated. The nationalistic symbol of the tower remained purely French. "There can be no question" said Citroën, "of lending the tower to a foreign company." The tower was lit with a 120 watt generator and 250,000 bulbs on 2l July 1925 and could be seen for forty kilometers, advertising French cars. Citroën's ads continued for several years, featuring lit fountains on the tower in 1926, a clock in 1933, and a thermometer in 1934.

58. She certainly knew the work of Réné Clair. "Vie," 129; *Vita*, 152. Clair's 1924 film *Paris qui dort* used the Eiffel Tower as its centerpiece, and his specific shots of the tower resemble Krull's rendition of it.

59. Plates 6.8, 6.13, and 6.14 refer, respectively, to plates 2, 54, and 50 in *Métal*.

60. Frédéric Lefèvre, "La photographie est-elle un art?" *République* (30 September 1930), reprinted in Mac Orlan, *Germaine Krull*, 13–14.

61. Published in Nico Rost, "Le Congrès des vagabonds," *Variétés* 2 (2) (15 June 1929): 160 ff.

62. Edmond Gréville, "Fêtes foraines," *Vu* 4 (4 April 1928): 92–93 (six Krull photographs); Florent Fels, "Dans toute sa force," *Vu* 11 (31 May 1928): 284 (three Krull photographs); Florent Fels, "Les Mystères de la foire aux Puces," *Vu* 12 (6 June 1928): 306–307 (seven Krull photographs); Henri Danjou, "Les Clochards dans les bas-fonds de Paris—ceux de la 'Maubert,'" *Vu* 31 (17 October 1928): 688–90 (ten Krull photographs).

63. Danjou, "Les clochards dans les bas-fonds de Paris," 688–90. For a comparable article in the German press, also illustrated by Krull, see "Anbeter der Freiheit," *Das Illustrierte Blatt (Frankfurter Illustrierte)* 19 (12 May 1928): 515-16, 520 (with ten Krull photographs). Thanks are due to David Travis for this information.

64. Henri Danjou, *Place Maubert (Dans les bas-fonds de Paris)* (Paris: Albin-Michel), 1928.

65. The term *clochard*, with its very particular meaning, did not appear until the very end of the nineteenth century. The *Grande Larousse de la langue française* (1971–1978) cites its first usage in 1895; cf. Gaston Esnault, *Dictionnaire historique des argots françaises* (Paris: Larousse, 1965). The word is defined in Larousse as follows: "Man, woman without home, who refuses to integrate into social life and resorts to expedients to subsist." *Grande Larousse*, 1972, 2: 767). The root is derived from *clocher* (to limp) and suggests an abnormal path of existence. The representation of poor, homeless, and hungry figures dates back to the seventeenth century, when the *mendiant* (beggar) appears in the *petits métiers* (small trades) print cycles. A late nineteenth-century example of this tradition is *Paris qui crie—petits métiers*, drawings by Pierre Vidal (Paris: Les Amis des Livres, Georges Chamerot, 1890), n.p.

66. A sampling of such articles, in various journals, includes the following: Henri Danjou, "Le dernier interview de la Goulue—un million à retrouver?" *Vu* 47 (6 February 1929): 84–85 (photographs by Krull); Marchot, "La Vie pour rien—comment en 24 heures un gueux devint gentleman," *Vu* 164 (6 May 1931): 633–35 (photographs by Universal Agency); Janine Delpech, "Sur les bancs de Paris," *Vu* 396 (16 October 1935): 1354–55 (photographs by Kitrosser); and Emmanuel Astier, "Quelques philosophes du pavé de Paris," *Vu* 525 (6 April 1938): 426–27. Gypsies were a comparable and popular subject, as in Charles Fegdal, "Les 'Mannousch' de Bagnolet," *L'Art vivant* (1 March 1930): 201, 204–05 (photographs by Krull and Atget). Articles on *clochards* in other journals included Nico Rost, "Le Congrès des vagabonds," *Variétés* 2 (3) (15 June 1929): 158–65; Armand Souriguère, "Les Vagabonds de Paris," *Scandale* 8 (March 1934): 20–25 (photographs by Kertész); Marc Réal, "Noel chez les clochards," *Voilà* 353 (24 December 1937): 7; and "The Kingdom of the Beggars," *Picture Post* 2 (1) (7 January 1939): 15–17. Some of these personae, of course were adapted from nineteenth-century precedents.

67. In the 1930s, Lucien Vogel edited special editions of *Vu* on Soviet Russia, the Spanish Civil War, and the Front Populaire, in addition to his normal news policies.

68. This is not a denial of the

strong political right wing in Paris during these years but Vogel and these photographers tended to lean toward the left. In the later 1930s, photographs that advocated a more conservative political stance gained favor in the popular magazines, after Vogel left *Vu* in 1937.

69. "Vie," 126; *Vita*, 149–50.

70. "Vie," 126; *Vita*, 150.

71. Brassaï, for instance, considered her in the same light as Man Ray and Kertész: "The photographers named Kertész, Man Ray, Brassaï, Germaine Krull . . . knew how to render with magnificence the desolate and bare atmosphere of certain corners of the banlieue," France Bequette, "Rencontre avec Brassaï," *Culture et communication* no. 27 (1 May 1980): 12.

72. "Un philosophe de la place Maubert, qui juge ses semblables avec aménité." Danjou, "Les clochards dans les Bas Fonds de Paris," 688–90.

73. See, for example, Emmanuel Astier, "Quelques philosophes du pavé de Paris," *Vu* 525 (6 April 1938): 426–27, citing various *clochards*: Bijou, who was also photographed by Brassaï, a figure parading in the guise of Napoleon, and a Jesus Christ figure.

74. For instance, to merit entry into Danjou's full-length book on vagrants, *Place Maubert (Dans les bas-fonds de Paris)*, indigents needed to be exceptional characters. Of the fourteen people he interviewed, several were deemed too uninteresting to write about. Of the remaining nine, their stories ranged from the improbable to the extreme—a man who had testified in the Dreyfuss case, a former actor with a smashed head, a ninety-year-old man who had seen the emperor, a former lawyer and writ-

er, and a *mort-vivant* who had had amnesia and whose wife had identified another corpse as his so that he had no more civil identity. Danjou's is only one of many similar tales of *clochard* life in Paris. Others include Boni, Marquis de Castellane, *L'Art d'être pauvre, mémoires* (Paris: G. Crès, c. 1925); Roland Coudon, *Clochards* (Paris: Editions G. Girard, 1939); and Aïda Louppe, *Marché aux puces (Mes amis les cloches)* (Paris: Julliard, 1953). For a journalistic account of a vagrant's gathering, see Nico Rost, "Le Congrès des vagabonds," 160 ff; (photographs by Krull, Lotar, and Atget, although Atget had died in 1927).

75. Danjou, "Les clochards dans les bas-fonds de Paris—ceux de la 'Maubert,'" 688–90.

76. Ibid.

77. For an insightful discussion of these subjects in the work of Eugène Atget, see Molly Nesbit, *Atget's Seven Albums* (New Haven: Yale University Press, 1992).

78. "*Clochards*, par Germaine Krull," *Variétés* 1 (8) (15 December 1928): 422 ff.

79. Ibid.

80. André Warnod, *Visages de Paris* (Paris: Firmin-Didot, 1930). Warnod's tone is moralistic and nostalgic, although Krull's photographs, many of them the same ones as in *Vu* and *Variétés*, deny the morality of the text. His reproduction of the first *clochard* from the *Vu* article exemplifies the use of a photograph for a purpose contrary to its original purpose. Where the "philosopher" was seen as a strong, independent centerpiece in *Vu*, Warnod described him in terms closer to the older definition of the vagrant—pitiful, menacing, and unappetizing.

81. The image of the *clochard* created by the middle class in order to critique its own values is also common in film. Charlie Chaplin's Little Tramp is the most widely known cinematic example. A *clochard* is also penetratingly represented in Jean Renoir's film of 1932, *Boudu sauvé des eaux*. Played by Michel Simon, the hero of this film is a *clochard* rescued from the Seine by a Parisian rare-book dealer, Lestingois, who had just been admiring his unkempt splendor (a perfect example of the generalized "type") when he jumped.

82. Typescript accompanying Les Halles photographs, from Schostal Agency, Vienna, courtesy of Dr. Christian Brandstätter, Vienna.

83. This photograph was reproduced as "Marraicher," in "Les Halles de Paris," *Variétés* 1 (6) (15 October 1928): 414 ff.

84. Letter from Ilse Bing to Sandra Phillips, 3 February 1982, cited in Phillips, "The French Picture Magazine *Vu*," *Picture Magazines before Life*, 4.

85. *Vu* 331 (18 July 1934): 912 14 (five Le Nain figures and five Krull photographs of "types").

86. These perceptions extended beyond French borders. *World's Work*, an American business journail, published three Krull images, including a machine view and a *clochard*, to illustrate French independence and resilience in the face of the Depression. Freeman Tilden, "Why France is Top-Dog," *World's Work* (January 1931): 37–41.

Chapter 7

1. Pierre Mac Orlan, "Les Sentiments de la rue et ses accessoires," *L'Art vivant* 145 (February

1931): 21. Reproduced in Baqué, *Les Documents de la modernité,* 169–71.

2. "Vie," 132; *Vita,* 155.

3. "Vie," 139; *Vita,* 160.

4. "Vie," 131; *Vita,* 155.

5. A document from the Commissariat de Police, Monte Carlo, Principauté de Monaco, dated 16 August 1940, certifies that "Mme Ivens-Krull née Krull, Germaine, née le 29 novembre 1897 à Wilda (Pologne), de nationalité hollondaise, exerçant la profession de reporter-photographe, demeurant 4, rue des Violettes—Monte Carlo, réside dans notre circonscription depuis novembre 1935" (GKN).

6. Krull, *100 x Paris.*

7. For similar books, see Mario Bucovich, *Paris,* preface by Paul Morand (Berlin: Albertus Verlag, 1928); *Paris: 285 photographies* (Paris: Flammarion, 1931); André Warnod, *Visages de Paris* (Paris: Firmin-Didot, 1930). For an excellent overview of urban photography in the nineteenth century, in Europe and America, see Eve Blau, "Patterns of Fact: Photography and the Transformation of the Early Industrial City," in *Architecture and Its Image: Four Centuries of Architectural Representation—Works from the Collection of the Canadian Centre for Architecture* (Montreal: Canadian Centre for Architecture/MIT Press, 1989), 36–57.

8. Florent Fels, "Introduction," *100 x Paris,* xxiv. The text is published in French, German, and English.

9. Ibid., xxv.

10. Published in *100 x Paris,* plate 37.

11. Charensol, "Les Livres d'art: *Paris,* par Germaine Krull," *Les Nouvelles littéraires* 8 (357) (17

August 1929): 7; Paul Fierens, "Des rues et des carrefours: '100 x Paris,'" *Variétés* 2 (7) (15 November 1929): 507–09. Other reviews of the book include M.B., "100 x Paris (Germaine Krull)," *Variétés* 2 (2) (15 June 1929): 142–43.

12. Paul Fierens, review of *100 x Paris,* "Des rues et des carrefours: '100 x Paris,'" 507–09. Reprinted in Baqué, *Les Documents de la modernité,* 167–68.

13. Ibid., 168.

14. For a fuller discussion of Kertész's book, see Kim Sichel, "*Paris vu par André Kertész*: An Urban Diary," *History of Photography* 16 (2) (Summer 1992): 105–14.

15. "Mélancolie des villes," *Variétés* 2 (8) (15 December 1929): 582 ff.

16. Pierre Mac Orlan, "Hambourg," *Jazz* 4 (15 March 1929): 151–56.

17. "La Nourriture," *Variétés* 2 (12) (15 April 1930): 836 ff.

18. Krull's image was published in "Nourritures," *Variétés* 2 (12) (15 April 1930): 836 ff. For a fuller discussion of nocturnal imagery in the work of Brassaï, see Kim Sichel, *Brassai: Paris le jour Paris la nuit* (Paris: Musée Carnavalet, 1988); and Kim Sichel, "On Reading Photographic Books," *Views* (Autumn 1989): 3, 22.

19. Krull's mannequins were also reproduced in *Variétés,* as were Atget's, sometimes side by side.

20. Walter Benjamin, *Das Passagen-Werk,* vol. 1, ed., Rolf Tiedemann (Frankfurt: Suhrkamp Verlag, 1982), plate 1, "Passage du Ponceau"; plate 2, "Passage du Caire"; plate 3, "Passage des Deux-Soeurs."

21. See "L'Imprimerie de l'Horloge," in "Pignons de Paris," *Variétés* 1 (8) (15 December 1928):

439 ff.

22. Walter Benjamin, "A Small History of Photography," *One-Way Street and Other Writings,* 250–51.

23. Krull, "L'Imprimerie de l'horloge," 439.

24. André Breton, *Nadja* (Paris: Editions des cahiers libres, Gallimard, 1928), *Les Vases communicants* (Paris: Gallimard, 1932), *L'Amour fou* (Paris: Gallimard, 1937). For recent discussions of these issues in photographic images, see Hal Foster, *Compulsive Beauty* (Cambridge: MIT Press, 1995), and Rosalind Krauss and Dawn Ades, *L'Amour Fou: Photography and Surrealism* (New York: Abbeville Press, 1985).

25. R. Thomazeau, "Chasseurs d'images," *Voilà* 33 (7 November 1931): 8–9.

26. Ibid.

27. Letter from Jean Cocteau to Germaine Krull, April 1930, reprinted in Mac Orlan, *Germaine Krull,* 16.

28. Jean Cocteau, "La Voix humaine," *Vu* 102 (18 February 1930): 170–71 (photographs by Georges Marant).

29. "Berthe Bovy dans la pièce de Jean Cocteau: 'La voix humaine,'" *Variétés* 2 (12) (15 April 1930): 872 ff.

30. See Mac Orlan, *Germaine Krull,* 7.

31. Krull's circle of literary friends was far larger than her group of artist friends. In addition to Jean Cocteau, Colette, André Malraux, and Georges Simenon, her archives contain the single autographed title pages torn out of her books by the writers Jean Bazin, Emmanuel Bove, Eugène Dabit, Henri Danjou, Henri de Monfreid, Pierre Mac Orlan, André Masson, Maurice Privat, Willie Seebrook,

and Serge. She clearly valued these highly and carried them with her until her last years in India.

32. See Jean Portail, "Chez les marchands d'avenir," *Vu* 129 (4 September 1930): 868–69, and follow-up article in *Vu* 130, illustrated with Kertész photographs.

33. *Vu* 143 (10 December 1930): 1343–45.

34. "Les prédictions de la voyante," *Variétés* 1 (9) (15 January 1929): 472 ff.

35. See Henri Danjou, "Religions inconnues" *Vu* 42 (2 January 1929): 908–10, and "Croyances et pratiques" (one Lotar and four Krull photographs), *Variétés* 2 (6) (15 October 1929): 416 ff.

36. Titaÿna, "Comment j'ai volé la tête d'un bouddha d'Angkor," *Vu* 5 (11 April 1928): 122–23 (cover photograph by Man Ray); cont'd. in *Vu* 6 (22 April 1928): 165 (four Krull photographs).

37. Ibid. (11 April and 22 April).

38. André and Clara Malraux traveled to French Indochina in 1923, hoping to rediscover Khmer Buddhist temples in the jungles of Laos and Cambodia. Malraux was arrested for stealing sculpture from the temple of Bantai Srey, tried, and sentenced to three years in prison. His sentence was set aside, but the press in Paris followed the case closely, and Malraux became notorious for his actions.

39. Pierre Mac Orlan, "La Vie moderne: L'art littéraire d'imagination et la photographie," *Les Nouvelles littéraires* (22 September 1928): 1; and "Les Nuits dans la littérature," *Les Nouvelles littéraires* (9 February 1929): 1.

40. Mac Orlan, "La Vie moderne: L'art littéraire d'imagination et la photographie," 1

41. "Au Pays de 'L'Hôtel du Nord' et de 'Petit Louis,'" photographic reportage by Germaine Krull, *Les Nouvelles littéraires* (27 December 1930): 8.

42. Josef Kessel, "Paris la nuit," *Détective* 1 (3) (15 November 1928): 3 (four photographs by "Germaine Krühl" [sic]).

43. For example, see Paul Bringuière, "Mystère des gares," *Détective* 1 (34) (20 June 1929): 3; and Henri Danjou, "Au son de l'accordéon," *Détective* 1 (47) (19 September 1929): 12.

44. Pierre Mac Orlan, "Ombre de Paris," *Détective* 3 (70) (27 February 1930): 7, and following issues until 3 (86) (15 May 1930): 7.

45. Thomas Narcejac, *Esthétique du roman policier* (Paris: Le Portulan, 1947).

46. Régis Messac, *Le 'détective novel' et l'influence de la pensée scientifique* (Paris: Librairie Ancienne Honoré Champion, 1929), 9. A popularized version of the scientific attitude toward detective fiction is serialized in *Vu* by Dr. H. Ashton Wolfe, "La détection scientifique du crime" (pts. 1–5), *Vu* 78 (11 September 1929): 732–33; 84 (23 October 1929): 877–78; 93 (25 December 1929): 1091–92; 99 (11 February 1930): 115–16; 124 (30 July 1930): 772–73; and 138 (5 November 1930): 1163–64. The history of scientific method in the work of the modern detective harks back to the first French detective, Vidocq, in the mid-nineteenth century.

47. This viewpoint is shared by Roger Caillois, *Le roman policier; ou, Comment l'intelligence se retire du monde pour se consacrer à ses jeux et comment la société introduit ses problèmes dans ceux-ci* (Buenos Aires: Editions des lettres françaises: SUR,

1941); Richard Cobb, *Promenades: A Historian's Appreciation of Modern French Literature* (Oxford: Oxford University Press, 1980), Hugh Eames, *Sleuths, Inc.: Studies of Problem Solvers—Doyle, Simenon, Hammett, Ambler, Chandler* (Philadelphia: Lippincott, 1978); and Fereydown Hoveyda, *Histoire du roman policier* (Paris: Editions du Pavillon, 1965).

48. Georges Simenon and Germaine Krull, *La Folle d'Itteville* (Paris: Editions Jacques Haumont, 1931), and *L'Affaire des sept* (Paris: Editions Jacques Haumont, 1931).

49. "Click," 68; "Einstellungen," 156.

50. Haumont's first book was on voodoo, written by an American, Willie Seebrook. In her memoirs, Krull recounts the book's genesis and Seebrook's voodoo curse, which seems to either alienate or kill his women friends. "Click," 61–63; "Einstellungen," 152–54.

51. Georges Simenon, *Quand j'étais vieux* (Paris: Presses de la Cité, 1970), 321.

52. Mrs. Hubbell posed for a series of photographers, and an extraordinary suite of her portraits, by Alban, Laure Albin-Guillot, Hoyningen-Huené, André Kertész, Germaine Krull, Lorelle, Lee Miller, Man Ray, Maurice Tabard, and André Vigneau is published in *Photographies* (1931), an annual publication of *Arts et métiers graphiques* highlighting the best photographs of the year.

53. André Breton, "Preface to new edition," *Nadja* (Paris: Gallimard, 1964), 6.

54. "Click," 36; "Einstellungen," 139.

55. According to Krull's memoirs, Renaud was the son of

Jouvenel and Countess Ina de Comminges, who was married to someone else. Jouvenel had been married to Colette and had a daughter, also Colette, with the novelist. The writer divorced Jouvenel when she learned of Ina de Comminges. Renaud de Jouvenel and the young Colette were born one day apart and became very close. Krull seems to have been friendly with all factions of this complicated family and in fact stayed with Ina de Comminges in the South of France. "Vie," 135; *Vita*, 157.

56. "Vie," 141–42; *Vita*, 162. Gladyne was an actor whom she met through Louis Jouvet and Jean Cocteau.

57. Original music was by Jean Marcillac, the photographer's role was acted by FINET, and the music was by Jean Marcillac.

58. "Click," 71; "Einstellungen," 158.

59. Ibid.

60. Information on these films is from inventory files of the Centre national de la cinématographie, Bois d'Arcy, France. I am grateful to Sylvie Boucher for her assistance in unearthing this documentation.

61. "Vie," 129; *Vita*, 152.

62. Travel photography essays in *Vu* include "A Carcassonne, Le mirage des fêtes du bimillénaire," *Vu* 19 (25 July 1928): 449–51 (nine Krull photographs); L.-M. Chauffier, "Revolution Arméricaine: L'autonomisme breton et ses joies," *Vu* 24 (30 August 1928): 543–45 (ten Krull photographs); L. Léontin, "Un Port Moderne: Une Ville d'art—Anvers," *Vu* 38 (5 December 1928): 834–35 (six Krull photographs); Marc d'Aubrive, "Le Pardon des Terre-

Neuvas," *Vu* 49 (20 February 1929): 130–31 (six Krull photographs); and Henri Danjou, "La Porte du monde: Marseille," *Vu* 56 (10 April 1929): 276–78 (five Krull photographs, one Herbert Bayer photo, four Vereenigde Fotobureaux Amsterdam photos).

63. For an insightful discussion of the automobile as the plaything of the modern world, see Roberts, *Civilization without Sexes*.

64. "Vie," 132.

65. Krull recalls this episode in "Vie," 132; *Vita*, 155.

66. "Vie," 132; *Vita*, 154.

67. Paul Morand, *La Route de Paris à la Mediterranée* (Paris: Firmin-Didot, 1931).

68. Ibid., plate 12.

69. Mark Antliff has studied the politics and publications of Philippe Lamour in depth, for his forthcoming book *The Advent of Fascism: Myth, Art, and Ideology in France*, and I am grateful to him for sharing his research with me.

70. I am grateful to André Jammes for sharing his knowledge of this book.

71. Germaine Krull, *Le Valois*, text by Gerard de Nerval (Paris: Firmin-Didot, 1930).

72. "Click," 58; "Einstellungen," 151.

73. "Vie," 139; *Vita*, 160.

74. Germaine Krull, *Marseille*, text by André Suarès (Paris: Plon, 1935), n.p.

75. Many photographers were fascinated by this bridge. See Robert P. Vigouroux and Christian Poitevin, eds., *Le Pont Transbordeur et la vision moderniste* (Marseille: Musées de Marseille/Réunion des Musées Nationaux/Musée Cantini, 1992).

76. André Jammes, for example, recalls that Haumont seldom had

funds of his own to invest, and Georges Simenon shared the perception that Haumont was a bad businessman.

77. "Vie," 144; *Vita*, 165.

78. "Click," 75; "Einstellungen," 160.

79. "Vie," 145; *Vita*, 166–67.

80. "Click," 69; "Einstellungen," 157.

81. "Click," 70; "Einstellungen," 157.

82. Letter from J. H. Berenguier (Commissaire Général Adjoint de l'Exposition Internationale de Paris 1937) to Germaine Krull, 27 September 1937 (GKN).

83. "Click," 76; "Einstellungen," 160.

84. Gisèle Freund, "La photographie à l'Exposition," *Arts et métiers graphiques* 62 (1938): 37–38, 41. Reprinted in Baqué, *Les Documents de la modernité*, 485–89.

85. Germaine Krull, *Ballets de Monte-Carlo*, with a drawing by Henri Matisse (Monte Carlo: Marcel Roche, 1937).

86. Letters between Louis Jouvet and Germaine Krull, dated 20 June 1939 to 9 October 1939 (Collection Louis Jouvet, courtesy of the Department des Arts du Spectacle of the Bibliothèque Nationale, Paris and Pierre Jouvet).

87. GKN.

88. GKN.

89. Krull to Horkheimer, 31 August 1937 (Max-Horkheimer-Archiv, Stadt- und Universitätsbibliothek, Frankfurt).

90. Krull's Black Star connection must have come through Ernst Mayer of Mauritius Verlag, through whom she had sold prints in Germany in the late 1920s. Mayer emigrated to New York, founding Black Star in 1935. Black Star records in New York reveal that she

was connected with the agency from 1935 to 1940, but no negatives or records of her activity remain, and no prints have surfaced among the million photographs at Black Star. Ben Chapnick, the director of Black Star, has no memory of her presence at the agency in the forty years that he has been there.

91. Horkheimer to Krull, 6 September 1937 (Max-Horkheimer-Archiv, Stadt- und Universitätsbibliothek, Frankfurt).

92. Krull to Marsman, 26 February 1933 (Hendrik Marsman Archives, Koninklijke Bibliotheek, The Hague).

93. Krull to Benjamin, 21 November 1937 (Walter-Benjamin-Archiv, Archiv der Akademie der Künste, Berlin).

94. Thanks are due to Elizabeth Davis for her research on this journal.

95. Krull to Benjamin, 21 November 1937 (Walter-Benjamin-Archiv).

96. Krull to Benjamin, 19 May 1938 and 8 October 1938 (Walter-Benjamin-Archiv).

97. Krull to Horkheimer, 31 August 1937 (Max-Horkheimer-Archiv).

98. Krull to Benjamin, 19 May 1938 (Walter-Benjamin-Archiv).

99. In 1925, Maurice Privat founded the *Journal Parlé à la Radio* broadcast from the Eiffel Tower. He lived in Monte Carlo in the late 1930s.

100. Krull to Jouvet, 2 October 1939 (Collection Louis Jouvet, courtesy of the Departement des Arts du Spectacle de la Bibliothèque Nationale, Paris).

101. "Vie," 148; *Vita*, 169.

102. "Vie," 149; *Vita*, 171.

103. "Click," 80; "Einstellungen," 162.

104. Visa-requirement documents from the Brazilian embassy in Vichy (dated 6 December 1940) and from the Commissariat de Police in Monte Carlo, Monaco (dated 16 August 1940) both bear stamps from the Brazilian consulate in Marseille from 23 December 1940. In her essay on the camps in Martinique, she stated that she had a visa valid until 24 March 1941 and barely two months to arrange transport, so that early 1941 seems a logical deduction for a departure date (GKN). Although the embarkation papers themselves do not survive, we can assume that she left shortly after these permissions were obtained.

Chapter 8

1. "Ceux de Brazzaville," 59 (GKN). Partly based on a handwritten diary from 1942 (GKN).

2. Krull cited de Gaulle's 1940 speech in her memoirs, recalling that she and Jean Privat supported de Gaulle, whereas his parents Maurice and Flechette Privat opted for Marshall Pétain. "Vie," 148; *Vita*, 169–70.

3. Charles de Gaulle, *La France n'a pas perdu la guerre* (New York: Didier, 1944), 1 (frontispiece). De Gaulle combined several traits that must have attracted Krull personally—"a fervent patriotism, a touch of mysticism, an austere and mainly humorless integrity, and a serene conviction of destiny." Gordon Wright, *France in Modern Times* (New York: Norton, 1981), 413.

4. In their original introduction to *Dialectic of Enlightenment*, written in 1944 while the Frankfurt School for Social Research was in exile in New York, Max Horkheimer and Theodor Adorno asserted their

principal point that "social freedom is inseparable from enlightened thought." They placed their study within history, musing in a new introduction in 1969 that "the work was written when the end of the Nazi terror was in sight." Max Horkheimer and Theodor Adorno, *Dialectic of Enlightenment*, trans. John Cumming (New York: Herder and Herder, 1972), xiii, ix.

5. Susan Moeller, *Shooting War: Photography and the American Experience of Combat* (New York: Basic Books, 1989), xiv.

6. Paula Schwartz, "Redefining Resistance: Women's Activism in Wartime France," *Behind the Lines: Gender and the Two World Wars*, Margaret Higonnet, ed., (New Haven: Yale University Press, 1987), 141–53.

7. Ibid., 143.

8. Pierre Lefranc (Institut Charles de Gaulle) to André Malraux, 30 August 1971 (GKN). LeFranc thanked Malraux for the Krull manuscript and comments, "It is clear that a document of this nature will be very useful for those who want to write on this period."

9. "Vie," 150; *Vita*, 173.

10. In her record of St. Laurent-les-Marronniers, she discussed the *bagnards* (penal servitors) and *relegués* (more serious criminals who had been transported after repeated crimes). Krull believed such penal colonies were immoral and made a photographic record of them. Yet in an indication of her adherence to her political cause, she discarded the images, unwilling to indict France during its battle for its life: "I took photographs that I destroyed because such a terrible shame should not stay with a country. France was wrong, and she abolished penal servitude after the

war." "Vie," 154; *Vita*, 178.

11. Brazilian temporary residence card #118.784 (GKN).

12. The invitation card from Livraria Geral Franco-Brasileira, Ltda. lists Krull's French photographs as the topic of the show (GKN).

13. In her memoirs, Krull relates the progression of political events during her stay in Rio de Janeiro but gives little attention to her commercial photographic efforts. She contacted a M. Soulier, a representative of the Free French, and a poet named Augusto Frederico Schmidt, who put her in contact with Lorival Fontes, wife of Brazil's propaganda chief. Fontes gave her a certain amount of work preparing tourist brochures. Krull's attempts to convince Soulier to send her to Africa bore little fruit until she saw a letter in a newspaper from André Diethelm, a commissioner of Finance, Economy, and the Merchant Marine on General de Gaulle's London-based Comité nationale de la France libre in London. Diethelm's letter asked: "When the war ends and you are asked what you did during the war, what will you say?" Outraged, she wrote directly to London to offer her services and to chide the central office for moralizing and yet not accepting all volunteers, such as herself.

The only European friend Krull encountered in Rio was theater director Louis Jouvet, whose main star, Madeleine Ozeray, had refused to continue performing under the Vichy government. Jouvet's theater troupe was then in Brazil. Jouvet himself had a more neutral attitude and tried to dissuade Krull from joining the Free French, believing that the military could not use a

woman's skills intelligently and that she would end up peeling potatoes rather than processing photographs. She cites Jouvet's comments in both "Ceux de Brazzaville" and "La vie mène la danse," but she was determined to serve.

14. "Vie," 159; *Vita*, 183.

15. Ivens to Krull, 20 January 1942 (GKN).

16. Final Divorce Decree, *Joris Ivens v. Germaine Krull Ivens*, filed 2 August 1943 and granted 27 August 1943, in the City of Juarez, Chihuahua, Mexico (GKN). The details of this divorce seem to have troubled her in some manner, and a September 1945 letter from Friedrich Pollock informed her that nothing could be done in the United States to "force Joris to make an adjustment" (GKN).

17. Her dedication, on the first page, is inscribed "Brazzaville, Março de 1943." Krull declared that these photographs were an homage of gratitude to the country that had been so hospitable during her stay, and she also credited her many Brazilian friends.

18. Its most famous churches included Nossa Senhora do Monte do Carmo and Nossa Senhora do Pilar.

19. *Aleijadinho* is the diminutive of the Portuguese word *aleijado*, which means "crippled." Aleijadinho suffered from a disfiguring disease, which was probably leprosy, and carved many of his greatest works after losing his toes and later his hands to the disease ("he had his hammer and chisel strapped to the stumps" of his arms). Jean Cau and Jacques Bost, *Brazil*, trans. James Emmons (Geneva: Nagel, 1953), 151.

20. *Uma Cidade antiga do Brasil:*

Ouro Preto, photographs by Germaine Krull, preface by Raul Lino and Ribeiro Couto (Lisbon: Edições "Atlantico," Secção Brasileira do Secretariado da Propaganda Nacional, 1943).

21. Document signed by Germaine Krull-Ivens 28 July 1942 and stamped by the Comité National Français on 29 July 1942 (GKN).

22. Handwritten journal notes dated from 3 July 1942 to 4 September 1942 document her voyage from South America to Africa (GKN).

23. A formal attestation from D. Schlumberger, chief editor of the Information Service in Brazzaville, certifies that she directed the photographic section of the Service from September 1942 to September 1943 and beyond. D. Schlumberger, "Attestation," Service de L'Information de la France Combattante de l'Afrique Française Libre, Brazzaville, 23 Septembre 1943 (GKN).

24. Moeller, *Shooting War*, 4.

25. The major French colonies in Africa encompassed three distinct territories—Equatorial French Africa, French West Africa, and French North Africa. The territory of French North Africa included Algeria, Tunisia, and Morocco. French West Africa included Senegal, Mauritania, (French) Sudan, Guinea, Ivory Coast, Dahomey, and Niger. The French Equatorial African (FEA) Federation, where Krull worked, comprised four provinces—Middle Congo, Gabon, Ubangi-Chari, and Chad. Brazzaville served both as the capital of Middle Congo and of the whole federation from its inception in 1910.

26. Soon after declaring the

Free French cause in June of 1940, when Paris fell, General de Gaulle suffered a major defeat in Dakar, the capital of Senegal in French West Africa, which was in the hands of the Vichy government. Immediately after this September 1940 setback, de Gaulle turned to French Equatorial Africa, where three cities—Fort Lamy, Douala, and Brazzaville—had declared themselves loyal to the Free French. Félix Eboué, the Guyanan-born governor of Chad, was rewarded by de Gaulle with the governorship-general of the French Equatorial African Federation in 1941. With a firm base of Free French soil beneath his feet, de Gaulle established in Brazzaville the Council for Defense of the Empire. In November of 1942, soon after Krull's arrival, General Eisenhower disembarked in Algeria. By June of 1943, anti-Vichyism was declared in French West Africa. Although French West Africa now changed allegiance, its leaders had previously supported the Vichy government, and only French Equatorial Africa had remained steadfastly in support of de Gaulle. For an account of de Gaulle's African campaigns, see Jean Lacouture, *De Gaulle* (London: Hutchinson, 1970).

27. Although he died in May 1944, Eboué was also a major contributor to formulating the ideas that would propel the French African colonies to freedom in the years after World War II. He was a prime organizer of the Brazzaville conference of January 1944. Shortly after, all African colonies were reorganized under a central government in Algiers that spearheaded these concepts. See "French Colonial Policy in Africa," *Free France* 2 (Special Issue, September 1944).

28. When General de Gaulle arrived in Free French Africa in October 1940, he created the Service de l'Information, an information base and radio transmitting center for the Free French at Brazzaville. He believed it necessary to have a broadcast each day from Free French soil to French citizens struggling all over the world. Fresh from his defeat in Dakar and soon after the declaration of allegiance by the French Equatorial African governors, he appointed two brothers, Lieutenant Pierre Desjardins and his older brother Captain François Desjardins, to run the information service.

In order to capture the Morse code transmissions of the Allied services, the Desjardins brothers trained thirty Africans who spoke no English or French to transcribe on typewriters the dots and dashes they heard. The European staff then translated the information, and Radio Brazzaville sent out its news to Europe and America. Radio Brazzaville operated under unbelievably primitive conditions, which became the stuff of myth in many popular press articles of the time. (For a discussion of the early history of Radio Brazzaville, see "Le nouveau Poste de Radio—Brazzaville," *Les Cahiers français* 47 (August 1943): 46–50; and Gordon Galskill, "Voice of Victory," *American Magazine: In the Service of the Nation* 1 (December 1942): 35, 106–08. The general tone of such articles was to praise the spunky determination of the Desjardins brothers and their engineers and editors, who produced news directly from the source for the worldwide community. The spirit of adventure and heroic work was evi-

dent in the press coverage. A Free French article in *Les Cahiers français*, for example, proclaimed: "All, men and women, young and old, shared the same spirit of sacrifice, went to work with a remarkable willingness under the rigorous work discipline that was imposed by the circumstances. They accepted, despite the unhealthy climate, working daily for a minimum of ten to twelve hours, without a single day of rest." ("Le nouveau Poste de Radio-Brazzaville," 48.)

On 18 June 1943, a far more powerful short-wave transmitter was installed to replace the smaller transmitters. Later, Italian, Spanish, and Portuguese transmissions were added. The new transmitting post, capable of transmitting 50,000 watts, and a building to house it were completed in the summer of 1943. A typical transmission program might include a French commentary for Canada at 3:00 A.M., an English one for the United States at 3:45 A.M., French news at 6:00 A.M., more French news at 1:30 P.M., a commentary in French at 6:45 P.M., news to French families at 7:30 P.M., an English broadcast for Great Britain at 7:45 P.M., Spanish news at 8:00, and further French news at 9:00 P.M. (*Les Cahiers français* 57 (July 1944): 36.)

29. André Diethelm, to whom Krull had written from Rio, had personally contacted Desjardins about Krull. "Ceux de Brazzaville," 50–51; "Vie," 164; *Vita*, 188.

30. "Ceux de Brazzaville," 48.

31. "Vie," 184; *Vita*, 240.

32. Constance Stuart Larrabee, a South African photographer, followed the African campaigns and also photographed ethnic peoples in her part of Africa. Her travels took her with the South African

Sixth Division through Egypt to Italy in 1944 and on to St. Tropez, Paris, and Strasbourg with the Allied advances—a path similar to Krull's. I am grateful to Brenda Danilowitz for sharing her extensive knowledge of Larrabee with me.

33. He worked directly for the Forces Aériennes Françaises Libres from June 1940, photographing for them until 1944 in Douala, Fort-Lamy, Bangui, Brazzaville, Pointe-Noire, and Algeria. He was briefly posted at Radio Brazzaville in July 1941 and from time to time thereafter, although he was based at Pointe Noire from June 1942 to November of 1943, during the bulk of the time Krull was in Africa. See Bernard Lefebvre ("Ellebé"), *Album de mes photographies avec de Gaulle en Afrique* (Luneray: Editions Bertout, 1990).

34. Ibid., 124.

35. Ibid., 198.

36. Due to the confusion of re-assembling Gaullist French archives from the period when the Free French government was in exile, only fragmentary evidence of Krull's work remains in contemporary French government archives. The Photothèque of the Documentation Française in Paris owns a few Krull photographs of military personnel, events in Brazzaville, and portraits of General Eboué. All bear the stamp "Photographie du Service de l'Information de la France Combattante en Afrique Française Libre," and some are credited to Krull. I am grateful to Madame Genevieve Dieuzeide and Madame Anne Zourabischvili at the Documentation Française for their patient help with my searches. The "Photothèque Afrique," also under

the jurisdiction of the "Documentation Française," probably has many more, as their catalogue lists many industrial images from Cameroon, Gabon, and Congo whose subjects seem very close to Krull's. Since this archive is frozen for lack of staff, it is impossible at this time to research the specific images, but they undoubtedly resemble the few that remain in Krull's archive in Essen.

37. "Le nouveau poste de Radio-Brazzaville," 46–50.

38. In her memoirs, Krull discussed her "boy" Malonga and his tremendous help to her during her stay in Brazzaville. "Ceux de Brazzaville," 38–39.

39. "Vie," 184–85; *Vita*, 240 (incomplete translation).

40. Charles de Gaulle to Germaine Krull-Ivens (Service de l'Information, Brazzaville), 25 October 1943 (GKN).

41. Félix Eboué to Germaine Krull, "Ordre de Mission," 6 July 1943. Krull's official travel documents from Afrique Equatoriale Française and the Service de l'Information de la France combattante en Afrique française libre (GKN).

42. She was sent to Ubangi-Chari and to Chad (GKN).

43. The rubber industry was one of the major war efforts of French Equatorial Africa. French Equatorial Africa was expected to produce a target amount of 4,000 tons of rubber for sale to British Rubber Control during the years from 1943 to 1945, although they often fell short of their quotas: 2,505 tons were produced in 1943, closer to 4,000 in 1944, and only 2,725 in 1945. Jean Suret-Canale, *French Colonialism in Tropical Africa 1900–1945*, trans. Till Gottheiner

(New York: Pica Press, 1971), 481. Krull recounted her voyage of June 1943 when she documented the rubber industry at Dizangue, which housed the only rubber plantation (Sanaga) in Cameroon. The eighty-five Cameroon photographs from the Krull archive include the various stages of the industry, with matter-of-fact descriptive captions. Although the photographs included all the necessary industrial details, and the captions are purely descriptive, the photographs were composed to capture the geometric shapes of this industry. Krull documented many other industries in French Equatorial Africa, including the hemp and sisal harvests in Bakouma, Ubangi-Chari. These photographs satisfied the need of the war information services and operated as effective propaganda advertising the indigenous African materials contributing to the war effort.

44. "Vie," 182.

45. "Ceux de Brazzaville," 85.

46. Ibid.

47. *Free France* 6 (4) (15 August 1944): 143.

48. "Vie," 182.

49. Ibid.

50. For historical overviews, see Melissa Banta and Curtis M. Hinsley, *From Site to Sight: Anthropology, Photography, and the Power of Imagery* (Cambridge, Mass.: Peabody Museum Press, 1986), and Edwards, *Anthropology and Photography, 1860–1920*. This volume contains a useful series of theoretical essays on anthropological photography and a group of case studies.

51. Christraud M. Geary, *Images from Bamum: German Colonial Photography at the Court of King Njoya, Cameroon, West Africa,*

1902–1915 (Washington: Smithsonian Institution Press, 1988), 11. Also see Christraud M. Geary, "'On the Savannah': Mary Pauline Thorbecke's Images from Cameroon, West Africa (1911–1912)," *Art Journal* 49 (2) (Summer 1990): 150–58.

52. Alloula has explored these fantasies in *The Colonial Harem,* and others have followed his lead.

53. "Vie," 184.

54. Invitation to Krull Exhibition, 16 March 1943, Service de l'Information de la France Combattante en A.E.F. (GKN).

55. "Vie," 182.

56. In "Ceux de Brazzaville," Krull renamed Margaret Nairn "Jane Barnes," as she renamed Philippe Desjardins "George Desmaisons."

57. For an insightful account of the multiple purposes and uses of these exhibitions, see Coombes, *Reinventing Africa.* Chapter 9, on the Franco-British Exhibition of 1908, is particularly useful, as it differentiates between British and French uses of similar kinds of imagery.

58. Ibid., 188 ff.

59. Eugenic theory tied physical features to racial characteristics in the late nineteenth century and onward. Annie Coombes summarizes that the British, for instance, saw Sudanese as courteous, Zulus as chivalrous, and Ahanti as childlike; but all are depicted as strong. Coombes, *Reinventing Africa,* 97.

60. "Ceux de Brazzaville," 133.

61. "Vie," 170; *Vita,* 193–94.

62. Although Krull's photographs for OFIC and other wartime agencies have not been fully recovered, the photographs that remain in Krull's archive concentrate on a series of subjects, centered in Gabon, Cameroon, Middle Congo, Ubangi-Chari, and Chad.

63. Coombes, *Reinventing Africa,* 201, 206.

64. See figure 4 in Edwards, "Introduction," *Anthropology and Photography, 1860–1920,* 11.

65. For a history of French colonial policies in Africa, see Edward Mortimer, *France and the Africans, 1944–1960: A Political History* (London: Faber and Faber, 1969); and Suret-Canale, *French Colonialism in Tropical Africa 1900–1945.*

66. Félix Eboué to Germaine Krull, "Ordre de Mission," Brazzaville, 27 September 1943 (GKN).

67. "Autour de Brazzaville," *Index de la cinématographie française* (Paris: La Cinématographie Française, 1954), 586. This film is housed at the Centre national cinématographique, Bois d'Arcy, France.

68. "L'Amitié noire," *Index de la cinématographie française* (Paris: La Cinématographie Française, 1949–1950), 349.

69. *L'Amitié noire* (film).

70. Ibid.

71. Ibid.

72. Coombes, *Reinventing Africa,* 85–87.

73. *L'Amitié noire* (film).

74. Homi K. Bhaba defines the categories of fixed and complex otherness in "The Other Question: Stereotype, Discrimination and the Discourse of Colonialism," in *The Location of Culture,* 66.

75. Commissaire Résident Géneral to Germaine Krull, "Ordre de Mission No. 268," Rabat, Maroc, 28 January 1944 (GKN). Her "Feuille de route" lists her arrival in Dakar on 22 December 1943, her arrival in Rabat on 9 January 1944, and her landing in Casablanca on 11 January. Germaine Krull-Ivens, "Feuille de Route, No. 16, 1944," issued by Service Colonial du Port de Casablanca Secrétariat d'Etat aux Colonies, A.E.F. (GKN).

76. "Vie," 184; *Vita,* 240 (partial).

77. Ordres de Mission (GKN).

78. Charles de Gaulle to Germaine Krull, Paris, 8 February 1945. In a second similar letter, dated 2 February 1945, the director of de Gaulle's cabinet thanked Krull for her book (GKN).

79. The contract gave the editor rights to determine the number of books, the price, and the publication date. Krull was to receive 5 percent of the sales price, and Vailland would get another 5 percent. Each of the coauthors also received 5,000 francs. Haumont to Germaine Krull and Roger Vailland, Paris, 15 December 1944 (GKN).

80. "Do I intend to publish Africa? Certainly, but not before next year." Haumont to Krull, 11 September 1947 (GKN).

81. "Seppois, premier village d'Alsace repris par les Français, photo de notre envoyée spéciale Germaine KRULL," accompanying an article by Roger Vailland, "Je suis en Alsace," *Libération* (21 November 1944): 1.

82. The narrative and the photographs begin in Belfort, where the Seventh American army and the First French Army began pushing north under the leadership of Generals de Lattre, Devers, and Leclerc. Maps and a day-by-day narrative dominate the text. Vailland ends his twenty-page text by lauding the army where the first French Gaullists—the Free French in Africa—and Allies fought together.

83. Caption: "Le colonel Berger, commandant la brigade Alsace-

Lorraine est en réalité le romancier André Malraux." Germaine Krull, *La Bataille d'Alsace (Novembre-Décembre, 1944)*, text by Roger Vailland (Paris: Jacques Haumont, 1945), n.p.

84. D'Astier de la Vigerie founded Libération-Sud in 1940, and it merged with two other groups, Combat and Franc-Tireur in March 1943, forming the Southern Zone's Mouvements Unis de Résistance (MUR). In 1944, the MUR joined the Northern Zone's resistance movements and came under de Gaulle's leadership in the Mouvement de Libération Nationale (MLN). Le Robert, *Dictionnaire universel des noms propres alphabetique et analogique* (Paris: Robert, 1974), 187.

85. Manuscripts (GKN). Additional unpublished war writings have been found in the archives of the Institut Charles de Gaulle, including the essays, "Le Débarquement Américain en Afrique du Nord Française le 8 novembre 1942" (8 November 1942); "Ceux de Vercors" (Summer 1944); "Le Crime de la grotte de la Luire" (August–September 1944); "Pont d'Ain," (September 1944); "Besançon," (Autumn 1944); "Entre Marseille et Avignon" (9 October 1944); "Une Journée avec les commandos de France" (10 October 1944); "Ici on soigne" (13 October 1944); "Dortan" (24 October 1944); and "Le Haut du Faing," (3 November 1944).

86. "Vie," 185–86; *Vita*, 241.

87. "Ceux de Brazzaville," 133. "James" is the pseudonym for Bryce Nairn, the British consul in Brazzaville, and "Jane" is Margaret Nairn, his wife. Both were good friends of Krull, and it is interesting that in reconstructing her memoirs

Krull put the voice of reason into her memories but made sure that it came from another mouth. She clearly knew what she had to do as a war correspondent, but it did not sit well with her.

88. "Vie," 187.

89. Her pay was to be 15,000 francs a month, and the contract was written for six months, with a renewal clause for a further period of up to two years. Yvon Morandat (Political Director, Agence d'Edition et de Presse, Paris) to Germaine Krull-Ivens, 16 August 1945 (GKN).

90. Travel permit, 1945. (GKN).

91. Agence d'Edition et de Press to Germaine Krull, Paris, 21 September 1945 (GKN).

Chapter 9

1. Krull and Melchers, *Bangkok: Siam's City of Angels*, 10.

2. The dates of Krull's departure from the hotel remain murky; she probably sold her shares in late 1965 or early 1966. Perhaps the best indication of her departure date is a letter that Friedrich Pollock wrote to await her arrival in Paris in April of 1966. Pollock to Krull, 12 April 1966 (GKN). Her obituary in the *Bangkok Post* lists her as director of the Oriental Hotel from 1947 to 1965. "Died in Germany," *Bangkok Post*, 17 August 1985. A 1975 article in *Bangkok World* states that she left the hotel in 1967 (Krull Scrapbook, GKN).

3. Much work remains to be done on Krull's Asian archives. This discussion attempts only to place Krull's Asian photographs in the context of her European training and lacks the advantages of primary research in Thailand and India.

4. Germaine Krull, "Une Lettre de la célèbre photographe

Germaine Krull: *Métal* (1925 [*sic*]) et la suite," *Gazette des beaux-arts* no. 1294 (November 1976): 35.

5. Krull and Melchers, *Bangkok: Siam's City of Angels*; and Krull and Melchers, *Tales from Siam*.

6. Mary Louise Pratt, "Introduction: Criticism in the Contact Zone," *Imperial Eyes: Travel Writing and Transculturation* (London: Routledge, 1992), 6–7.

7. It is not clear whether she sent this shortly before her departure from London or on her arrival in Ceylon.

8. She wrote again on 7 September from Colombo, Ceylon; on 7 October from Singapore; and on 14 October on her way to Java. For verification of her dates of passage, see letters from Pollock to Krull (GKN). Pollock was still writing to her address in Kandy in mid-December but acknowledged her letters from Bangkok on 6, 7, and 12 January 1946. Additional dating of her movements can be gleaned from Krull's biography byline in her article, "Error in Laos," trans. Elizabeth Converse, *Far Eastern Survey* 16 (11) (4 June 1947): 121.

9. Pollock to Krull, 19 September 1945 (GKN).

10. Pollock to Krull, 27 October 1945 (GKN).

11. "Vie," 196.

12. Ceylon was the base for Mountbatten's Fourteenth British Imperial Army, which, with American and Chinese support, had crushed much of the Japanese army the previous spring.

13. "Lady War Correspondent Arrives in Bangkok," *Liberty* 1 (15) (4 October 1945): 4.

14. Krull defined the Indochinese Federation as Tonkin and Annam (Republic of Viet Minh), Cochinchina (the French

colonial Republic of Cochinchina), the Kingdom of Cambodia, and the Kingdom of Laos. Ivens, "Error in Laos," 121. The Indochinese states had remained under French governance until just before the end of the war, although Japan had assumed military control. Japan had been content with this arrangement as long as France was Vichy and thus a supposed ally; but when France was liberated, the Japanese disarmed and interned all the French soldiers there.

15. In the 1970s, she mailed the typescripts from her own files to her Brazzaville superior and friend, Philippe Desjardins: "Dearest Philip, In organizing papers, I found these. They have a certain importance and I send them to you to do with whatever you wish." Krull to Philippe Desjardins, 25 October 1975, Dossier Krull FAA10 (Archives de l'Institut Charles de Gaulle, Paris).

16. Krull traveled to Saigon with the first Allied (British) troops to enter Indochina, Major-General Douglas D. Gracey's Indian troops from Rangoon. For a comprehensive history of Indochina and Thailand during these years, see Lea E. Willams, *Southeast Asia: A History* (New York: Oxford University Press, 1976), 199–200. For details on these days in Saigon, see "Report to the Combined Chiefs of Staff by the Supreme Allied Commander, South East Asia [Extracts]," in Allan W. Cameron, ed., *Viet-Nam Crisis: A Documentary History*, vol. 1, 1940–1956 (Ithaca: Cornell University Press, 1971), 55–63.

In Krull's first essay, "Les Dix jours qui ont décidé du sort de l'Indochine Française," she writes that on "2 September 1945, Ho Chi Minh, the Nationalist Communist leader of the native resistance to Japan in Tonkin, proclaimed the independence of the Vietnam Republic." Her account of the subsequent ten days recounts the events around the beginning of the Vietnam battles that would last for decades. Her diaristic account covers the events of 15 to 25 September and she writes that she was the only woman present and one of only three war correspondents.

In her essay, she describes the huge numbers of war correspondents pouring into Saigon and the distressed colonial French reaction to Ho Chi Minh's Annamite demonstrations. She also encountered anti-French demonstrations in Saigon and came face to face for the first time with the Vichyist French government in Indochina, which disliked de Gaulle. Her distaste for the Vichy government may have had something to do with her sympathy for their adversaries. She also describes dramatic beatings and her outrage at the atrocities committed by the French. Germaine Krull, "Les Dix jours qui ont décidé du sort de l'Indochine Française [September 1945]," (Archives de l'Institut Charles de Gaulle, Paris). Also see "Vie," 191; *Vita*, 245.

17. "Vie," 192.

18. Malraux to Krull, 8 October 1945 (GKN).

19. Her report states quite bluntly: "In their colonial pride these fanatical [Vichyist] people, ignorant of the facts of the world, were responsible for what is and will happen. They are the ones who provoked what can be called the 'Saigon microbe,' which is extremely contagious. If the [Gaullist] men of France—with a sane and impartial soul—were here, this would never have happened. Liberty is a right that is not reserved to the Metropolis. The Europeans fought for this liberty; that was not in order to apply the principle of submission onto other people, no matter what color their skin. The Annamites will have their independence no matter what because they fight for their liberty. We will be obliged to talk to them one day. . . . Why kill when one can talk?" Krull, "Les Dix jours."

20. In March of 1946, the French officially recognized Vietnam as a free state within the French Union but still clashed with Ho Chi Minh. France declared an "autonomous Republic of Cochin China" at Saigon on 1 June 1946. The struggle between Communist northern Vietnam and French- (subsequently American-) sponsored southern Vietnam began at this time. On 23 November 1946, the French bombed Haiphong, killing six thousand, the beginning of a long French struggle to maintain Indochina. By 1950 the "conflict" looked more like a war between France and Ho Chi Minh's forces.

21. In the spring of 1946, she wrote a follow-up essay called "S.O.S. France." In it she asks, "Where are the soldiers of de Gaulle?" and wonders how General Leclerc, who had led the European liberation forces in Fezzan and Strasbourg, could now be burning Annamite villages. "S.O.S. France," 27 May 1946, Dossier Krull FAA10 B, Indochine 1945–1947 (Archives de l'Institut Charles de Gaulle, Paris). As late as January 1947 she was writing another report, "S.O.S. Indochine." That June, she wrote a

third report, "Jeunesse de Vietnam: Le Parti Viet-Minh, Batisseur de l'Indochine Nouvelle," 2 June 1946, Dossier Krull FAA10 B, Indochine 1945–1947 (Archives de l'Institut Charles de Gaulle, Paris).

22. Malraux to Krull-Ivens, 15 November 1947 (GKN).

23. Krull also wrote reports on the political situations in Cambodia and Laos. On 2 January 1946 she filed a report on Cambodia, "Voyage au Cambodge," 2 January 1946, Dossier Krull FAA10 B, Indochine 1945–1947 (Archives de l'Institut Charles de Gaulle, Paris). In Malraux's response to her commentary, he expresses his regret that it arrived too late to be of any effective use. Malraux to Krull-Ivens, 24 April 1946 (GKN).

24. Malraux to Krull-Ivens, 24 April 1946 (GKN).

25. Krull, "Error in Laos." Laos, she believed, was more peaceful and closer to French culture than the other Southeast Asian colonies, and she quotes the Lao-Issara (Free Laotians) who wrote: "We want our independence. We love France, but she must make us free. . . . Let her help us to stay as we are—a country that is French in thought and culture." (121–22). She believed that the French colonials, in contrast to her own tone of respect, treated the Laotians like children.

26. Thao-Oun to Son Altesse le Chef Effectif du Gouvernement Lao, 9 February 1947, with document on "Gouvernement provisoire d'Indépendance," Dossier Krull FAA10 B, Indochine 1945–1947 (Archives de l'Institut Charles de Gaulle, Paris).

27. "Vie," 194.

28. Siam became known once again by its older name of Thailand on 11 May 1949, three years after Krull's arrival. The country is referred to as Thailand in this text.

29. Thailand had declared war on England and the United States on 25 January 1942, but the United States never formally acknowledged the act of aggression. Williams, *Southeast Asia*, 193, 198.

30. Ibid., 198.

31. On 8 November 1947, in a bloodless coup d'état, an army group under Marshal Luang Pibul Songram overthrew the government in the first of a series of non-violent coups during the next years. On 17 September 1957, another coup gave control to Thanarat, and on 21 September 1957 Pote Sarasin was elected premier.

32. Krull and Melchers, *Bangkok,* 10.

33. Thompson employed thousands of weavers and transformed a cottage industry into an international business, reviving the Thai economy along the way. He became one of postwar Thailand's most celebrated business people and art collectors. His house, full of Southeast Asian treasure, has become a museum. Thompson mysteriously disappeared in the Cameron Highlands in Malaysia in 1967, and the case of his death has never been resolved. For information on the Thompson home and art collection, see William Warren, *The House on the Klong: The Bangkok Home and Asian Art Collection of James Thompson*, photographs by Brian Blake (Tokyo: privately printed, 1968). For James Thompson's life, see William Warren, *Jim Thompson: The Legendary American of Thailand* (Bangkok: Jim Thompson Thai Silk Co., 1989).

34. Another of their partners was General Chai Pratipasen, who had been second in command to Field Marshal Pibul under Japanese control but who had resigned from the army when the Allies arrived. The other partners were H.R.H. Prince Bhanupan Yukol, a lawyer (who became premier in 1957) named Pote Sarasin, and another American businessman named John Wester. All six partners contributed $250 to launch the business. Warren, *Jim Thompson*, 46.

35. "War Correspondent Now Hotel Manager," *Liberty*, 9 May 1947, p. 1.

36. W. Somerset Maugham, *The Gentleman in the Parlour: A Record of a Journey from Rangoon to Haiphong* (Garden City, N.Y.: Doubleday, 1930), 182.

37. Another tower was built in 1976.

38. "Vie," 217; *Vita*, 265. Thompson's biographer, on the other hand, ascribes their quarrel to "the simple fact that both he and Miss Krull were strong personalities, with very definite ideas about what should be done with the hotel and how, and they were probably bound to clash in time." Warren, *Jim Thompson*, 53.

39. Krull and Melchers signed a joint agreement of authorship before writing the book, on 15 March 1961, agreeing to divide the income equally and to support the other partner if one were for some reason unable to complete the project. "Joint agreement of authorship between Germaine Krull and Dorothea Melchers," 15 March 1961, for "a book about Germaine Krull's experiences in postwar Bangkok" (GKN).

40. Krull and Melchers, *Bangkok,* 9.

41. Ibid., 21.

42. Ibid., 45.

43. She chronicled her friendships with Josie Stanton, the wife of the U.S. Ambassador Edwin F. Stanton, with Jim Thompson, and with General Chai. She also described her staff and her negotiations with the political parties in order to get what she needed for the hotel.

44. Krull and Melchers, *Bangkok*, 65.

45. "He kept in touch during all the period of battle and war, and I saw quite a bit of Germany again between 1944 and 1945 with the troops; you know that I was a war correspondent." Germaine Krull to Berthe Krull, 20 November 1948 (GKN).

46. Germaine Krull to Berthe Krull, 20 November 1948 (GKN).

47. "Vie," 230; *Vita*, 271.

48. The two sisters traveled together, voyaging to Chiang Mai, Hong Kong, Angkor Wat, and throughout India; they also took other voyages to Greece, Italy, the south of France, and elsewhere in Europe. They sometimes clashed. Krull recalls: "Berthe was always my little sister, but she was also very stubborn, and we had quite a few battles." "Vie," 232; *Vita*, 273.

49. At one point she almost bought property in the south of France. During these early trips back to Europe, Krull also took along with her Leck, the daughter of one of her servants. Their complicated relationship later turned sour, as Leck believed herself an adopted daughter and Krull saw her as an unpaid companion. Their relationship is an example of Krull's unresolved perceptions of her Asian experiences. Krull writes: "If she called me Mummy or Aunty, there seemed to be no difference. I should not have accepted, as I saw

later on." "Vie," 242; *Vita*, 279.

50. Lopez, *Curators of the Buddha*, 2. I am grateful to Elizabeth ten Grotenhuis for sharing her vast knowledge of Buddhist scholarship with me.

51. Chiang Mai is the capital of Lan Na Thao ("Kingdom of one million rice fields") and was the first independent Thai state. Chiang Mai is home to many hill tribes, including the Akha, Karen, Lahu, Lisu, Homong, and Yao. The region houses the descendants of the Mon-Khmer people. Now it is the second largest Thai city after Bangkok. Krull spelled the city as *Chiengmai*, but it is more often listed in current English books as *Chiang Mai*. Such transpositions of letters are common in the anglicization of Thai sites and temples.

52. "Vie," 226.

53. Krull and Melchers, *Tales from Siam*, 13.

54. Germaine Krull, photographs, "The Road to Chiengmai," *Standard*, 17 February 1951, p. 11 (GKN).

55. Germaine Krull, *Chiengmai*, commentary by Lotus (Bangkok: Oriental Hotel, undated).

56. Krull, *Chiengmai*, n.p.

57. Krull, *Tales from Siam*, 18–19.

58. "Vie," 228.

59. Krull, *Chiengmai*, n.p.

60. Albert Beuret (Secrétaire Général, L'Univers des Formes, Editions Gallimard), to Germaine Krull, 29 January 1962 and 1 March 1962 (GKN). This series, which includes more than forty titles, is still being produced today, with texts by well-known scholars such as André Chastel, Oleg Grabar, and Michel Leiris. Subjects include the Renaissance, classical Greece, classical Rome, Celtic art, Sumerian art,

medieval Byzantium, and the Andes.

61. Krull to Malraux, 1 May 1961 (GKN).

62. In another parallel to Krull's interest, this paper evinced an early interest in Communism, although Malraux abandoned Communism after the Spanish Civil War in 1936. For an account of André and Clara Malraux's adventures in Southeast Asia, see Axel Madsen, *Silk Roads: The Asian Adventures of Clara and André Malraux* (New York: Pharos Books, 1989).

63. Wilhelm Klein, *Burma* (Hong Kong: APA Productions/Insight Guides), 1981), 213.

64. Krull to Malraux, 30 April 1962 (GKN).

65. "Tell me a little bit; is there some sort of plan concerning the photographs that I am making?" Krull to Malraux, 30 April 1962 (GKN).

66. Malraux to Krull, 18 June 1962 (GKN).

67. "Vie," 242; *Vita*, 279.

68. "Vie," 243; *Vita*, 280.

69. "Le bouddha de M. Malraux en panne depuis cinq ans," *Le Figaro*, 8 February 1967.

70. Krull and Melchers, *Bangkok*, 186. This may be Alois X. Fassbind, who is listed as general manager of the Oriental Hotel in 1967. "The Oriental Hotel: A Bangkok World Special Supplement," *Bangkok World*, 14 November 1967, pp. 4 (list), 10–11 (excerpts).

71. Krull and Melchers, *Bangkok*, 191.

Chapter 10

1. "Vie," 257.

2. Friedrich Pollock wrote her on 12 April 1966, so that his letter would greet her arrival in Paris. Pollock to Krull, 12 April 1966 (GKN).

3. Lopez, "Introduction," *Curators of the Buddha*, 1.

4. Krull provided the political dateline and the demographic settlements *Tibetans in India*. See Gyatsho Tshering, "Tibetans in Exile," in *Tibetans in India* (New Delhi: Allied, 1968), 2.

5. See Lopez, "Foreigner at the Lama's Feet," *Curators of the Buddha*, 251–96, for a discussion of the four historical moments when Tibetan Buddhism was studied. He places himself as a scholar at this last moment in the late 1960s and 1970s, and we can place Krull there as well. Both worked "with a native scholar who was made to serve as informant and guru" (18).

6. *Germaine Krull*, Cinémathèque Française/Musée du Cinéma/Palais de Chaillot, Paris, 1967.

7. *Germaine Krull*, Alliance Française, New Delhi, 1968.

8. "Einstellungen"; Klaus Honnef, "Introduction," in *Germaine Krull: Fotografien 1922–1966*.

9. Bouqueret, *Germaine Krull: Photographie 1924–1936*.

10. For a sampling of responses to the exhibition, see "Le bouddha de M. Malraux en panne depuis cinq ans," *Le Figaro*, 8 February 1967; B. Girod de l'Ain, "La Photographie: Le chant de l'acier," *Le Monde*, 24 February 1967; M. G. de Ray, "Cinémathèque consacre une exposition à Germaine KRULL," *Combat*, 31 January 1967 (Krull clipping files, GKN); Anne Manson, "Au Musée du Cinéma, une exposition va révéler l'extraordinaire Germaine KRULL," *L'Aurore* (8 February 1967): 17a; "Photographe des années folles, Germaine Krull expose les images de sa vie aventureuse," *France-Soir*, 10 February 1967; "La (Wo)man Ray," *Le Nouvel Observateur*, 15 February 1967.

11. "Vie," 244; *Vita*, 280.

12. Manson, "Au Musée du Cinéma," p. 17a.

13. "Vie," 243.

14. "Vie," 244.

15. The Antoinist cult was founded by a Belgian miner. Henri Danjou, "Religions inconnus," *Vu* 42 (2 January 1929): 908–10.

16. Germaine Krull, Eli Lotar, et al., "Croyances et pratiques," *Variétés* 2 (6) (15 October 1929): 416 ff. This essay includes Krull photographs of the Divinist chapel (with its founder, M. Fortin), the temple of the Antoinist cult, the Theosophist temple, Quakeresses, and others, as well as a view of Trappist monks by Eli Lotar.

17. Krull to Benjamin, 21 November 1937 (Walter-Benjamin-Archiv).

18. She described Frida Bedi (spelled *Frieda* in the typescript and *Frida* in *Vita*) as an Englishwoman married to a Sikh, who was a friend of Nehru's and had been imprisoned fighting for India's independence. "Vie," 245; *Vita*, 285.

19. "Vie," 247; *Vita*, 285.

20. The four orders are the Nyingma (the ancient), founded c. A.D. 810; Sakya, founded c. A.D. 1034; Kagyu (oral tradition), founded c. A.D. 1012; and Geluk (virtue tradition), founded c. A.D. 1357. Girija Saklani, *The Uprooted Tibetans in India: A Sociological Study of Continuity and Change* (New Delhi: Cosmo, 1984), 63. For more information on Tibetans in India, see Institute of National Affairs, *Dalai Lama and India* (New Delhi: Hind Book House, 1959); and Information Office of His Holiness the Dalai Lama, *Tibetans in Exile, 1959–1980* (Dharamsala: Information Office, Central Tibetan Secretariat, 1981). The best study of the interaction of Tibetan Buddhism and its artworks in Western literature is Marylin M. Rhie and Robert A. F. Thurman, *Wisdom and Compassion: The Sacred Art of Tibet* (New York: Harry N. Abrams, Asian Art Museum of San Francisco, and Tibet House, 1991). I have followed Robert Thurman's lead in discussing the four areas of Tibetan Buddhism as orders, rather than sects—which imply a Christianized version of a splinter group (26).

21. "Vie," 249; *Vita*, 286.

22. Ibid.

23. "Vie," 251; *Vita*, 286.

24. Ibid.

25. "Vie," 251; *Vita*, 287.

26. Robert A. F. Thurman, "Wisdom and Compassion: The Heart of Tibetan Culture," in Rhie and Thurman, *Wisdom and Compassion*, 17.

27. Statement by Richard Gere, founder, Tibet House, in Rhie and Thurman, *Wisdom and Compassion*, 8.

28. Germaine Krull, "Preface," *Tibetans in India* (New Delhi: Allied, 1968), n.p.

29. Ibid.

30. *Germaine Krull*, Alliance Française, New Delhi, 1968. The show traveled to Bombay, Calcutta, Madras, and Pondicherry.

31. "Vie," 254.

32. Pollock's letter of 26 March 1970, addressed to Germaine Krull

at Camelsback Road in Mussoorie, offers condolences for the "young Lama friends [who] became the victim of a car accident." A subsequent letter, dated 30 April 1970, relates, "It was a pleasure to read about the new organization of your life. This will give you an opportunity to spend part of your seemingly inexhaustible energy for productive work." Pollock to Krull (GKN).

33. "Vie," 255; *Vita*, 288.

34. Germaine Krull, "The Founding of the Sakya Sect and the History of His Holiness Sakya Trizin," untitled and unpublished manuscript, n.d. (GKN).

35. In 1951, the Dalai Lama appointed a six-year-old boy named Aayu Vajra as the head of the order, and he took the name Sakya Trizin, meaning "holder of the throne." The group stayed in Tibet until 1959, when the Chinese government assumed power soon after his coronation in the Tantric temple.

36. A lama named Chiwang Rinpoche set up the children's center, while Thutob Rinpoche began the settlement in Mussoorie. All soon moved to Dehra Dun, where Chiwang Rinpoche supervised the building of schoolrooms and dormitories.

37. Germaine Krull, *The Sakya Centre: A Monastic School for Tibetan Refugees* (Rajpur: no publication information).

38. "Vie," 260; *Vita*, 290.

39. "Vie," 259.

40. Jana, "Little Monks," *Bangkok World*, 16 February 1970, p. 1.

41. "Vie," 262.

42. Lucy Frucht, interviewed by the author, 25 February 1995, Riverdale, N.Y.

43. Horkheimer to Krull, 17 May 1970 (GKN).

44. Dr. H. Dembitzer [Horkheimer's secretary] to Krull, 28 July 1971 (GKN); and Malraux to Krull, 24 August 1971 (GKN). As early as 1961, Krull had returned to "Chien-fou" and given the manuscript to friends to reedit. Germaine Krull to unknown correspondent on Oriental Avenue, Bangkok, 1 May 1961 (GKN).

45. Lucy Frucht, interviewed by the author, 24 February 1995, Riverdale, N.Y. Carl and Lucy Frucht met Krull in Delhi when they lived there between 1965 and 1972, and Krull regularly stayed with them in Switzerland on her subsequent trips to Europe.

46. John Tate, statement about Krull's late years, in letter to the author, 10 March 1997.

47. Christel Klose, conversation with the author, October 1994.

48. "Vie," 272; *Vita*, 291.

49. John Tate, letter to the author, 10 March 1997.

at Camelsback Road in Mussoorie, offers condolences for the "young Lama friends [who] became the victim of a car accident." A subsequent letter, dated 30 April 1970, relates, "It was a pleasure to read about the new organization of your life. This will give you an opportunity to spend part of your seemingly inexhaustible energy for productive work." Pollock to Krull (GKN).

33. "Vie," 255; *Vita*, 288.

34. Germaine Krull, "The Founding of the Sakya Sect and the History of His Holiness Sakya Trizin," untitled and unpublished manuscript, n.d. (GKN).

35. In 1951, the Dalai Lama appointed a six-year-old boy named Aayu Vajra as the head of the order, and he took the name Sakya Trizin, meaning "holder of the throne." The group stayed in Tibet until 1959, when the Chinese government assumed power soon after his coronation in the Tantric temple.

36. A lama named Chiwang Rinpoche set up the children's center, while Thutob Rinpoche began the settlement in Mussoorie. All soon moved to Dehra Dun, where Chiwang Rinpoche supervised the building of schoolrooms and dormitories.

37. Germaine Krull, *The Sakya Centre: A Monastic School for Tibetan Refugees* (Rajpur: no publication information).

38. "Vie," 260; *Vita*, 290.

39. "Vie," 259.

40. Jana, "Little Monks," *Bangkok World*, 16 February 1970, p. 1.

41. "Vie," 262.

42. Lucy Frucht, interviewed by the author, 25 February 1995, Riverdale, N.Y.

43. Horkheimer to Krull, 17 May 1970 (GKN).

44. Dr. H. Dembitzer [Horkheimer's secretary] to Krull, 28 July 1971 (GKN); and Malraux to Krull, 24 August 1971 (GKN). As early as 1961, Krull had returned to "Chien-fou" and given the manuscript to friends to reedit. Germaine Krull to unknown correspondent on Oriental Avenue, Bangkok, 1 May 1961 (GKN).

45. Lucy Frucht, interviewed by the author, 24 February 1995, Riverdale, N.Y. Carl and Lucy Frucht met Krull in Delhi when they lived there between 1965 and 1972, and Krull regularly stayed with them in Switzerland on her subsequent trips to Europe.

46. John Tate, statement about Krull's late years, in letter to the author, 10 March 1997.

47. Christel Klose, conversation with the author, October 1994.

48. "Vie," 272; *Vita*, 291.

49. John Tate, letter to the author, 10 March 1997.

ARCHIVES

Berenice Abbott Archives, Commerce Graphics Ltd. Inc., E. Rutherford, N.J.

Archief en Museum ven de Socialistische Arbeiderbewegung, Ghent

Walter Benjamin-Archiv, Archiv der Akademie der Kunst, Berlin

Archives de l'Institut Charles de Gaulle, Paris

Fonds Delaunay, Bibliothèque Nationale, Paris

Deutsches Tanzarchiv, Cologne

Documentation Française, Paris

Max-Horkheimer-Archiv, Stadt- und Universitätsbibliothek, Frankfurt

Collection Louis Jouvet, Department des Arts du Spectacle de la Bibliothèque Nationale, Paris

Berthe Krull, Wetzlar, Germany

Germaine Krull documents, Cabinet d'Estampes, Bibliothèque Nationale, Paris

Germaine Krull documents, Kominterm-Archiv, Moscow

Germaine Krull Nachlass, Fotografische Sammlung im Museum Folkwang, Essen

Eli Lotar Archives, Musée national d'art moderne, Centre national d'art et de culture Georges Pompidou, Paris

Hendrik Marsman Archives, Koninklijke Bibliotheek (Royal Library), The Hague

Letters to the author

Collection Ann and Jürgen Wilde, Zülpich, on loan to the Sprengel Museum, Hannover

WRITINGS BY AND ABOUT GERMAINE KRULL

Books by Germaine Krull

100 x Paris. Text by Florent Fels. Berlin: Verlag der Reihe, 1929.

L'Affaire des Sept. Text by Georges Simenon. Paris: Editions Jacques Haumont, 1931.

The Afghan Stuccos of the N.R.F. Collection. Text by J. Strzygowsky. Paris: N.R.F., n.d.

Der Akt: Zwanzig photograpische Aufnahmen weiblicher Körper nach Natur. With Wanda von Debschitz-Kunowski and Josef Pésci. Dachau: Einhorn-Verlag, 1918.

Ballets de Monte Carlo. With a drawing by Henri Matisse. Monte Carlo: Marcel Roche, 1937.

Bangkok: Siam's City of Angels. With Dorothea Melchers. London: Robert Hale, 1964.

La Bataille d'Alsace (Novembre–Décembre, 1944). Text by Roger Vailland. Paris: Jacques Haumont, 1945.

Chiengmai. Commentary by Lotus. Bangkok: Oriental Hotel, n.d.

Uma Cidade antiga do Brasil: Ouro Preto. Preface by Raul Lino and Ribeiro Couto. Lisbon: Edições Atlantico, Secção Brasileira do Secretariado da Propaganda Nacional, 1943.

Etudes de nu. Text by Gerard de Nerval, ed. A. Calavas. Paris: Librairie des arts décoratifs, 1930.

La Folle d'Itteville. Text by George Simenon. Paris: Editions Jacques Haumont, 1931.

Kara-Mappe (Aufnahmen) von Germaine Krull. Preface by Max Hodann. Leipzig: Ernst Oldenburg-Verlag, 1923.

Marseille. Text by André Suarès. Paris: Editions d'art et d'histoire, distributed by Plon, 1935.

Métal. Ed. A. Calavas; preface

by Florent Fels. Paris: Librairie des arts décoratifs, 1928.

La route Paris-Biarritz. Text by Claude Farrère. Paris: Jacques Haumont, 1931.

The Sakya Centre: A Monastic School for Tibetan Refugees. Rajpur: no publication information.

Tales from Siam. With Dorothea Melchers. London: Robert Hale, 1966.

Tibetans in India. New Delhi: Allied, 1968.

Le Valois. Text by Gérard de Nerval. Paris: Firmin-Didot, 1930.

La vita conduce la danza. Translated by Giovanna Chiti. Florence: Giunti Gruppo Editoriale, 1992.

Books with Photographs by Germaine Krull

Bucovich, Marius von. *Paris.* Foreword by Paul Morand. Berlin: Albertus-Verlag, 1928.

Colette. *La Chatte.* Paris: Grasset, 1930.

Hallmann, Adolf. *Paris under 4 Årstider.* Stockholm: Albert Bonniers Förlag, 1930.

Morand, Paul. *La Route de Paris à la Mediterranée.* Paris: Firmin-Didot, 1931.

Warnod, André. *Visages de Paris.* Paris: Firmin-Didot, 1930.

Unpublished Books and Memoirs by Germaine Krull

Krull, Germaine. "The Blue Orchid." Unpublished novel, n.d., Germaine Krull Nachlass, Fotografische Sammlung im Museum Folkwang, Essen (GKN).

Krull, Germaine. "Ceux de Brazzaville." Unpublished war memoir, c. 1940s. GKN.

Krull, Germaine. "Chien-fou."

Unpublished novelized memoir, 1934. GKN.

Krull, Germaine. "Hello! Hello! Brazzaville." English version of "Ceux de Brazzaville," translated by Margaret Nairn, n.d. GKN.

Krull, Germaine. "Click entre deux guerres." Unpublished manuscript, 1976. GKN.

Krull, Germaine. "La vie mène la danse." Dehra Dun, India: unpublished memoir, 1980–81. GKN.

Krull, Germaine. "The Founding of the Sakya Sect and the History of His Holiness Sakya Trizin." Untitled and unpublished manuscript, n.d. GKN.

Krull, Germaine. Handwritten journal notes dated from 3 July 1942 to 4 September 1942 documenting her voyage from South America to Africa. GKN.

Selected Articles with Photographs by Germaine Krull

"A Carcassonne, Le mirage des fêtes du bimillénaire." *Vu* 19 (25 July 1929): 449–51.

"Anbeiter der Freiheit." *Das illustrierte Blatt (Frankfurter illustrierte)* 19 (12 May 1928): 515–16, 520.

Berl, Emmanuel. "Les Ouvrières de Paris." *Vu* 247 (7 December 1932): 1925–1928; 248 (14 December 1932): 2011–14; 249 (21 December 1932): 2047–50; 250 (28 December 1932): 2079–82; 251 (4 January 1933): 12–15; 252 (11 January 1933): 43–47.

Chauffier, L.-M. "Revolution Armoricaine: L'autonomisme breton et ses joies." *Vu* 24 (30 August 1928): 543–45.

Cheronnet, Louis. "Eden de Banlieue." *Vu* 331 (18 July 1934): 902–03.

"Clochards, par Germaine Krull." *Variétés* 1 (8) (15 December

1928): 422 ff.

"Le Congrès des vagabonds." *Variétés* 2 (15 June 1929): 160 ff.

Croissant, Stella. "Les Sauvetages de l'armée du Salut." *Vu* 44 (16 February 1929): 38–39.

Cover, *Filmliga* 2 (5) (February 1929).

"Croyances et pratiques." *Variétés* 2 (6) (15 October 1929): 416 ff.

Danjou, Henri. "Les Clochards dans les bas-fonds de Paris—ceux de la 'Maubert.'" *Vu* 31 (17 October 1928): 688–90.

Danjou, Henri. "Le Dernier interview de la Goulue—un million à retrouver?" *Vu* 47 (6 February 1929): 84–85.

Danjou, Henri. "La Porte du monde: Marseille." *Vu* 56 (10 April 1929): 276–78.

Danjou, Henri. "Religions inconnus." *Vu* 42 (2 January 1929): 908–10.

d'Aubrive, Marc. "Le Pardon des Terre-Neuvas." *Vu* 49 (20 February 1929): 130–31.

"Der Delaunay-Stil—die kommende Mode." *Illustrierte Beilage zum Berlin Börsen-Courier.* 14 March 1926.

d'Erleich, Jean. "La Perle." *Vu* 33 (31 October 1928): 728–30.

Fegdal, Charles. "Les 'Mannousch' de Bagnolet." *L'Art vivant* (1 March 1930): 201, 204–05.

Fels, Florent. "Dans toute sa force." *Vu* 11 (31 May 1928): 284.

Fels, Florent. "Les Mystéres de la foire aux puces." *Vu* 12 (6 June 1928): 306–07.

Gallotti, Jean. "Guignol: A propos du Congrès des Marionnettes." *Vu* 87 (13 November 1929): 939–41.

Gallotti, Jean. "Permanence du type populaire—les modèles des frères Le Nain." *Vu* 331 (18 July 1934): 912–14.

Gréville, Edmond. "Fêtes foraines." *Vu* 4 (4 April 1928): 92–93.

"Imprimerie de l'Horloge." In "Pignons de Paris." *Variétés* 1 (8) (15 December 1928): 439 ff.

"Ein javanischer Prinz tanzt." *Die Dame* 14 (April 1930): 18–19

Kessel, Josef. "Paris la nuit." *Détective* 1 (3) (15 November 1928): 3.

Léontin, L. "Un Port Moderne: Une Ville d'art—Anvers." *Vu* 38 (5 December 1928): 834–35.

Mac Orlan, Pierre. "Hambourg." *Jazz* 4 (15 March 1929): 151–56.

"Maske zu Strawinskis 'l'Histoire d'un soldat.'" *Der Querschnitt* 6 (12) (December 1926): facing 918.

"Melancholie des villes." *Variétés* 2 (8) (15 December 1929): 582 ff.

"La Nourriture." *Variétés* 2 (12) (15 April 1930): 836 ff.

Niel, Ada. "Pariser Kolonial-Ausstellung." *Die Dame* 21 (July 1931): 4–7.

Ponsel, Dr. A. "Unter Kopfjägern." *UHU* (February 1926): 69–75.

"Les Predictions de la voyante." *Variétés* 1 (9) (15 January 1929): 472 ff.

"The Road to Chiengmai." *Standard*. 17 February 1951, p. 11.

Rosenfeld, Fritz. "Film, Bild und Rhythmus." *Filmliga* 1 (10) (April 1928): 7–9.

Rost, Nico. "Le Congrès des vagabonds." *Variétés* 2 (2) (15 June 1929): 158–65.

Sylviac. "Superstition." *Vu* 143 (10 December 1930): 1343–45.

Tilden, Freeman. "Why France is Top Dog." *World's Work* (January 1931): 37–41.

Titaÿna. "Comment j'ai volé la tête d'un bouddha d'Angkor." *Vu* 5 (11 April 1928): 122–23 and *Vu* 6 (22 April 1928): 165–66.

Vailland, Roger. "Je suis en Alsace." *Libération* (21 November 1944): 1.

Cover. "Veille de revue: Les timoniers du 'Jean-Bart'" *Vu* 17 (11 July 1928).

Cover. "Au revoir Black Birds!" *Vu* 77 (4 September 1929).

Published Essays

Krull, Germaine. "Einstellungen." In Klaus Honnef, *Germaine Krull: Fotografien 1922–1966*. Bonn: Rudolf Habelt Verlag, Rheinisches Landesmuseum Bonn, 1977.

Krull, Germaine. "Une Lettre de la célèbre photographe Germaine Krull: *Métal* (1925 [sic]) et la suite." *Gazette des Beaux-Arts* 1294 (November 1976): 35.

Krull, Germaine. "Pensées sur l'art." In Pierre Mac Orlan, *Germaine Krull*. Paris: Librairie Gallimard, 1931, 12.

Krull, Germaine. "Preface." *Tibetans in Laos*. New Delhi: Allied, 1968.

Krull Ivens, Germaine. "Error in Laos." *Far Eastern Survey* 16 (11) (4 June 1947): 121–124. Translated by Elizabeth Converse.

Unpublished Essays by Germaine Krull

"Besançon." Autumn 1944. Archives de l'Institut Charles de Gaulle, Paris.

"Camps de Concentration à la Martinique." n.d. GKN.

"Ceux de Vercors." Summer 1944. Archives de l'Institut Charles de Gaulle, Paris.

"Le Crime de la grotte de la Luire." August-September 1944. Archives de l'Institut Charles de Gaulle, Paris.

"Le Débarquement Américain en Afrique du Nord Française le 8 novembre 1942." 8 November 1942. Archives de l'Institut Charles de Gaulle, Paris.

"Les Dix jours qui ont decidé du sort de l'Indochine Française [September 1945]." Archives de l'Institut Charles de Gaulle, Paris.

"Dortan." 24 October 1944. Archives de l'Institut Charles de Gaulle, Paris.

"Entre Marseille et Avignon." 9 October 1944. GKN and Archives de l'Institut Charles de Gaulle, Paris.

"L'Haut du Fang." 3 November 1944. GKN and Archives de l'Institut Charles de Gaulle, Paris.

"Ici on soigne." 13 October 1944. Archives de l'Institut Charles de Gaulle, Paris.

"Jeunesse de Vietnam: Le Parti Viet-Minh, Batisseur de l'Indochine Nouvelle." 2 June 1946. Dossier Krull FAA10 B, Indochine 1945–1947. Archives de l'Institut Charles de Gaulle, Paris.

"Une Journée avec les Commandos de France." 10 October 1944. Archives de l'Institut Charles de Gaulle, Paris.

"Le Long du Mékong au Siam." 15 January 1947. Archives de l'Institut Charles de Gaulle, Paris.

"Palabres." 26 January 1947. Archives de l'Institut Charles de Gaulle, Paris.

"Pont d'Ain." September 1944. Archives de l'Institut Charles de Gaulle, Paris.

"S.O.S. France." 27 May 1946. Dossier Krull FAA10 B, Indochine 1945–1947. Archives de l'Institut Charles de Gaulle, Paris.

"S.O.S. Indochine." 14 January 1947. Archives de l'Institut Charles

de Gaulle, Paris.

"Voyage au Cambodge." 2 January 1946. Dossier Krull FAA10 B, Indochine 1945–1947. Archives de l'Institut Charles de Gaulle, Paris.

Films by Germaine Krull

L'Amitié noire (1943, released 1946). Written and narrated by Jean Cocteau, directed, shot, and edited by François Villiers, with the collaboration of Germaine Krull and Pierre Bernard.

Autour de Brazzaville (1943). Narrated by Richard Francoeur, directed and shot by François Villiers, with the collaboration of Germaine Krull.

Il partit pour un long voyage (1932). Germaine Krull and Georges Patin.

La Route Paris–Nice (n.d.). Germaine Krull.

La Seine (1931). Germaine Krull.

Six pour dix francs (1925). Germaine Krull and Georges Patin. Music by Jean Marcillac.

Books and Articles on Germaine Krull

Anonymous. "Died in Germany." *Bangkok Post.* 17 August 1985.

Anonymous. "The Oriental Hotel: A Bangkok World Special Supplement." *Bangkok World.* 14 November 1967.

Anonymous review. "*Métal* par Germaine Krull." *Variétés* 1 (9)(15 January 1929): 509–10.

Auclair, Marcelle. "Tour Eiffel, soeur aînée des avions." *L'Art vivant* (1 October 1928): 743–44.

B., M. "*100 x Paris* (Germaine Krull)." *Variétés* 2 (2) (15 June 1929): 142–43.

Bayerische Kurier (26 February 1920).

Boelema, Ida. "Een nooit geschreven roman: Brieven van Germaine Krull aan Hendrik Marsman." *Jong Holland* 6 (4) (1990): 2–11, 38.

Boelema, Ida. "'La vie mène la danse': De vroege jaren van Germaine Krulls volgens haar memoires." *Jong Holland* 3 (1995): 31–40.

Bost, Pierre. "Les Livres: *Métal*." *Jazz* 2 (15 January 1929): 90, 92.

"Le bouddha de M. Malraux en panne depuis cinq ans," *Le Figaro*, 8 February 1967.

Bouqueret, Christian. *Germaine Krull: Photographie 1924–1936*. Arles: Musées d'Arles, Rencontres Internationales de la Photographie, 1988.

Brassaï. "Germaine Krull vue par . . . Brassaï." *Germaine Krull*. Paris: Cinémathèque Française et Musée du Cinéma, 1967, n.p.

Charensol. "Les livres d'art: *Paris*, par Germaine Krull." *Les Nouvelles littéraires* 8 (357) (August 17, 1929): 7.

Fels, Florent. "Acier," *Jazz* 5 (15 April 1929): 232–34.

Fierens, Paul. "Des rues et des carrefours: *100 x Paris*," *Variétés* 2 (7) (15 November 1929): 507–09.

Gallotti, Jean. "La photographie est-elle un art? Germaine Krull." *L'Art vivant* (1 July 1929): 526–27, 530. Reprinted in Dominique Boqué, ed., *Les Documents de la modernité: Anthologie de textes sur la photographie de 1919 à 1939*. Paris: Editions Jacqueline Chambor, 1993.

Gallotti, Jean. "La photographie est-elle un art? Germaine Krull: *Métal*." *L'Art vivant* (1 July 1929): 526–27, 530.

Germaine Krull. Paris: Cinémathèque Française/Musée du cinéma/Palais de Chaillot, 1967.

Germaine Krull. Delhi: Alliance Française, 1968.

Girod de l'Ain, B. "La Photographie: Le chant de l'acier," *Le Monde*, 24 February 1967.

Herz, Rudolf, and Dirk Halfbrodt. "Germaine Krull." In *Revolution und Fotografie: München 1918/19*. Berlin: Nishen, 1988.

Honnef, Klaus. *Germaine Krull: Fotografien 1922–1966*. Bonn: Rudolf Habelt Verlag, Rheinisches Landesmuseum Bonn, 1977. Includes Germaine Krull, "Einstellungen" (German translation of "Click entre deux guerres").

Jana. "Little Monks." *Bangkok World*. 16 February 1970, p. 1.

"Lady War Correspondent Arrives in Bangkok." *Liberty* 1 (15) (4 October 1945): 4.

Lefebvre, Frederic. "La Photographie est-elle un art?" *République* (30 September 1930). Reprinted in Pierre Mac Orlan, *Germaine Krull*. Paris: Librarie Gallimard/Les photographes nouveaux, 1931.

Mac Orlan, Pierre. *Germaine Krull*. Paris: Librairie Gallimard/Les photographes nouveaux, 1931.

Manson, Anne. "Au Musée du Cinéma, une exposition va révéler l'extraordinaire Germaine KRULL," *L'Aurore*, 8 February 1967, p. 17a.

"*Métal* par Germaine Krull," *Variétés* 1 (9) (15 January 1929): 509–10.

"Photographe des années folles, Germaine Krull expose les images de sa vie aventureuse," *France-Soir*, 10 February 1967.

Ray, M. G. de. "Cinémathèque consacre une exposition à Germaine Krull," *Combat*, 31 January 1967.

Rops, Daniel. "Review of *Métal*." *Europe* (27 November 1929).

Reprinted in Pierre Mac Orlan, *Germaine Krull*. Paris: Librarie Gallimard, 1931.

Saunier, Charles. "Le Métal: Inspirateur d'art," *L'Art vivant* (1 May 1929): 361, 368–69.

Sichel, Kim. *From Icon to Irony: German and American Industrial Photography*. Seattle and Boston: University of Washington Press and Boston University Art Gallery, 1995.

Travis, David. "In and of the Eiffel Tower." *Art Institute of Chicago Museum Studies* 13 (1) (1987): 21.

"War Correspondent Now Hotel Manager." *Liberty*, 9 May 1947, p. 1.

"La (Wo)man Ray." *Le Nouvel Observateur*, 15 February 1967.

GENERAL REFERENCES
BOOKS

Ackers, Maximiliane. *Freundinnen*. Hanover: Paul Steegeman, 1923.

Aglion, Raoul. *The Fighting French*. New York: Henry Holt, 1943.

Alloula, Malek. *The Colonial Harem*. Translated by Myrna Godzich and Wlad Godzich. Minneapolis: University of Minnesota Press, 1986.

Banham, Reyner. *Theory and Design in the First Machine Age*. New York: Praeger, 1960.

Banta, Melissa, and Curtis M. Hinsley. *From Site to Sight: Anthropology, Photography, and the Power of Imagery*. Cambridge, Mass.: Peabody Museum Press, 1986.

Baqué, Dominique, ed. *Les Documents de la modernité: Anthologie de textes sur la photographie de 1919 à 1939*. Paris: Editions Jacqueline Chambon, 1993.

Barrett, Nancy C. *Ilse Bing: Three Decades of Photography*. New

Orleans: New Orleans Musem of Art, 1985.

Becker, Jean Jacques, and Serge Berstein. *Victoire et frustrations, 1914–1929*. Vol. 12, *Nouvelle histoire de la France contemporaine*. Paris: Editions du Seuil, 1990.

Benjamin, Walter. "A Small History of Photography." In *One-Way Street and Other Writings*. Translated by Edmund Jephcott and Kingsley Shorter. London: NLB, 1979.

Benjamin, Walter. *Charles Baudelaire: A Lyric Poet in the Era of High Capitalism*. Translated by Harry Zohn. London: Verso Edition, 1973.

Benjamin, Walter. *Das Passagen-Werk*. Vol. 1. Edited by Rolf Tiedemann. Frankfurt: Suhrkamp Verlag, 1982.

Berkman, Alexander. *The Russian Tragedy*, Edited by William G. Nowlin, Jr. Sanday: Cienfuegos Press, 1976.

Bhaba, Homi K. *The Location of Culture*. London: Routledge, 1994.

Billeter, Erika. *L'Autoportrait à l'age de la photographie*. Lausanne: Musée Cantonale des Beaux-Arts, 1985.

Boker, Carlos. *Joris Ivens, Filmmaker: Facing Reality*. Ann Arbor: UMI Research Press, 1981.

Bool, Flip, and Kees Boos, eds. *Fotografie in Nederland 1920–1940*. The Hague: Staatsuitgeverij, 1979.

Brassaï. *Paris de nuit*. Text by Paul Morand. Paris: Arts et Métiers Graphiques, 1932.

Breton, André. *L'Amour fou*. Paris: Gallimard, 1937.

Breton, André. *Les Vases communicants*. Paris: Editions des cahiers libres, 1932.

Breton, André. *Nadja*. Paris: Gallimard, 1928. Edition entièrement revue par l'auteur, 1964.

Reprint 1972.

Bridenthal, Renate, Atine Grossmann, and Marion Kaplan, eds. *When Biology Became Destiny: Women in Weimar and Nazi Germany*. New York: Monthly Review Press, 1984.

Brodersen, Momme. *Walter Benjamin: A Biography*. Translated by Malcolm R. Green and Ingrida Ligers. London: Verso, 1996.

Brunel, Claude. *Joris Ivens: Conception et réalisation*. Paris: Cinémathèque Française, 1983.

Bürger, Peter. *Theory of the Avant-Garde*. Translated by Michael Shaw. Minneapolis: University of Minnesota Press, 1984.

Busch, Noel F. *Thailand: An Introduction to Modern Siam*. Princeton: Van Nostrand, 1959.

Caillois, Roger. *Le roman policier, ou, Comment l'intelligence se retire du monde pour se consacrer à ses jeux et comment la société introduit ses problèmes dans ceux-ci*. Buenos Aires: Editions des lettres Françaises: SUR, 1941.

Cameron, Allan W., ed. *Viet-Nam Crisis: A Documentary History, vol. 1, 1940–56*. Ithaca: Cornell University Press, 1971.

Castellane, Boni, Marquis de. *L'art d'être pauvre: mémoires*. Paris: G. Crès, c. 1925.

Cau, Jean, and Jacques Bost. *Brazil*. Translated by James Emmons. Geneva: Nagel, 1953.

Chancellor, J. *How to Be Happy in Berlin*. London: 1929.

Charensol, Georges. *D'une rive à l'autre*. Paris: Mercure de France, 1973.

Chipman, John. *The French in Africa*. Oxford: Basil Blackwell, 1989.

La Cinématographie française. *Index de la cinématographie française*. Paris: La Cinématographie

française, 1949–1950.

Cobb, Richard. *Promenades: A Historian's Appreciation of Modern French Literature.* Oxford: Oxford University Press, 1980.

Coke, Van Deren, et al., eds. *Avant-Garde Photography in Germany, 1919–1939.* San Francisco: San Francisco Museum of Modern Art, 1980.

Conte, Arthur. *La Tour Eiffel.* Paris: Editions Lacroix, 1980.

Coombes, Annie E. *Reinventing Africa: Museums, Material Culture and Popular Imagination in Late Victorian and Edwardian England.* New Haven: Yale University Press, 1994.

Coudon, Roland. *Clochards.* Paris: Editions G. Girard, 1939.

Cowley, Malcolm. *Exile's Return: A Literary Odyssey of the 1920s.* New York: Viking, 1951.

Crozier, Brian. *De Gaulle: The Warrior.* London: Eyre Methuen, 1973.

Danjou, Henri. *Place Maubert (Dans les bas fonds de Paris).* Paris: Albin-Michel, 1928.

Das deutsche Aktwerk. Berlin: Bruno Schultz Verlag, 1938.

de Gaulle, Charles. *La France n'a pas perdu la guerre.* New York: Didier, 1944.

de Jonge, Alex. *The Weimar Chronicle: Prelude to Hitler.* New York: Paddington Press, 1978.

Degras, Jane, ed. *The Communist International, Documents 1919–1922.* Vol. 1. London: Oxford University Press, 1956.

Delmar, Rosalind. *Joris Ivens: Fifty Years of Filmmaking.* London: BFI, 1979.

de Mendelssohn, Peter. *Zeitungsstadt Berlin: Menschen und Mächte in der Geschichte der deutschen Presse.* Berlin: Ullstein, 1959, 1982.

Dinan, Desmond. *The Politics of Persuasion: British Policy and French African Neutrality, 1940–1942.* Lanham: University Press of America, 1988.

Eagleton, Terry, Fredric Jameson, and Edward Said. *Nationalism, Colonialism, and Literature.* Minneapolis: University of Minnesota Press, 1990.

Eames, Hugh. *Sleuths, Inc.: Studies of Problem Solvers—Doyle, Simenon, Hammett, Ambler, Chandler.* Philadelphia: Lippincott, 1978.

Edwards, Elizabeth, ed. *Anthropology and Photography, 1860–1920.* New Haven: Yale University Press and the Royal Anthropological Institute, 1992.

Ehrenburg, Ilya. *Memoires, 1921–1941.* Translated by Tatiana Shebbunina and Yvonne Capp. Cleveland: World Publishing, 1963.

Eisner, Kurt. *Die neue Zeit.* Munich: Georg Müller Verlag, 1919.

Erdmann Ziegler, Ulf. *Nackt unter Nackten: Utopien der Nacktkultur 1906–1942.* Berlin: Nishen, 1990.

Eskildsen, Ute, ed. *Fotografieren hieß teilnehmen: Fotografinnen der Weimarer Republik.* Essen: Museum Folkwang and Düsseldorf: Richter, 1994.

Eskildsen, Ute. *Fotographie in deutschen Zeitschriften 1924–1933.* Stuttgart: Institut für Auslandsbeziehungen, 1982.

Eskildsen, Ute, and Jan-Christopher Horak, eds. *Film und Foto der zwanziger Jahre: Eine Betrachtung der Internationalen Werkbundausstellung Film und Foto 1929.* Stuttgart: Württembergischer Kunstverein, 1979.

Esnault, Gaston. *Dictionnaire historique des argots françaises.* Paris: Larousse, 1965.

Evans, John Lewis. *The Communist International, 1919–1943.* Brooklyn: Pageant-Poseidon, 1973.

Fels, Florent. *L'Art et amour.* Paris: Editions Arc-en-Ciel, 1952–53.

Fels, Florent. *L'Art vivant de 1900 à nos jours.* Geneva: P. Cailler, 1950.

Fels, Florent. *Voilà.* Paris: Librairie Arthème Fayard, 1957.

Ferber, Christian, ed. *UHU: Das Monatsmagazin Berlin Oktober 1924 bis Oktober 1934.* Berlin: Ullstein, 1979.

Fiedler, Jeannine, ed. *Photography at the Bauhaus.* Cambridge: MIT Press, 1990.

Fischer, Ruth. *Stalin and German Communism: A Study in the Origins of the State Party.* Cambridge: Harvard University Press, 1948.

Foster, Hal. *Compulsive Beauty.* Cambridge: MIT Press, 1993.

Freund, Gisèle. *Photography and Society.* Boston: Godine, 1980.

Freund, Gisèle. *The World in My Camera.* Translated by June Guicharnaud. New York: Dial Press, 1974.

Friedrich, Otto. *Before the Deluge: A Portrait of Berlin in the 1920s.* New York: Harper & Row, 1972.

Gay, Peter. *Weimar Culture: The Outsider as Insider.* New York: Harper & Row, 1970.

Geary, Christraud M. *Images from Bamum: German Colonial Photography at the Court of King Njoya, Cameroon, West Africa, 1902–1915.* Washington: Smithsonian Institution Press, 1988.

Gidal, Tim N. *Modern Photojournalism: Origin and Evolution, 1910–1933.* Translated by Maureen Oberli-Turner. New York:

Macmillan, 1973.

Giedion, Siegfried. *Mechanization Takes Command*. New York: Norton, 1969.

Golan, Romy. *Modernity and Nostalgia: Art and Politics in France between the Wars*. New Haven: Yale University Press, 1995.

Goldman, Emma. *Living My Life*. Vol. 2. New York: Dover Publications, 1970.

Gräff, Werner. *Es kommt der neue Fotograf*. Berlin: Hermann Reckendorf, 1929.

Grossmann, Atina. *Reforming Sex: The German Movement for Birth Control and Abortion Reform*. New York: Oxford University Press, 1995.

Grunberger, Richard. *Red Rising in Bavaria*. New York: St. Martin's Press, 1973.

Haffner, Sebastian. *Failure of a Revolution: Germany 1918–1919*. Translated by Georg Rapp. Chicago: Banner Press, 1986.

Hambourg, Maria Morris, and Christopher Phillips. *The New Vision: Photography between the World Wars: The Ford Motor Company Collection at the Metropolitian Museum of Art, New York*. New York: The Metropolitan Museum of Art/Harry N. Abrams, 1989.

Hardt, Hanno. *Social Theories of the Press: Early German and American Perspectives*. Beverly Hills: Sage, 1979.

Harris, Geoffrey T. *De l'Indochine au R.P.F., une continuité politique: les romans d'André Malraux*. Toronto: Editions Paratexte, 1990.

Harvey, David. *The Condition of Postmodernity: An Enquiry into the Origins of Cultural Changes*. London: Basil Blackwell, 1989.

Hebey, Pierre. *L'esprit N.R.F., 1908–1940*. Paris: Editions Gallimard, 1990.

Heidtmann, Frank. *Bibliographie der Photographie deutschsprachige Publikationen der Jahre 1839–1984: Technik, Theorie, Bild/Bibliography of German-Language Photography Publications 1839–1984*. Munich: K. G. Saur, 1989.

Heijs, Jan, ed. *Filmliga, 1927–1931*. Nijmegen: Socialistiese Uitgeverij Nijmegen, 1982.

Herz, Rudolf, and Dirk Halfbrodt. *Fotografie und Revolution: München 1918/19*. Munich: Nishen, 1988.

Hight, Eleanor M. *Picturing Modernism: Moholy-Nagy and Photography in Weimar Germany*. Cambridge: MIT Press, 1995.

Hoefer, Hans Johannes. *Burma*. Hong Kong: Apa Productions, 1981.

Horkheimer, Max. *Gesammelte Schriften*, Vol. 15, 1913–1936. Edited by Alfred Schmidt and Gunzelin Schmid Noerr. Frankfurt: S. Fischer Verlag, 1995.

Horkheimer, Max, and Theodor Adorno. *Dialectic of Enlightenment*. Translated by John Cumming. New York: Herder and Herder, 1972.

Hoveyda, Fereydoun. *Histoire du roman policier*. Paris: Editions du Pavillon, 1965.

Hulten, Pontus, general commissioner. *Rapports et contrastes France-Allemagne, 1900–1933*. Paris: Centre Georges Pompidou, 1978.

Huyssen, Andreas. *After the Great Divide: Modernism, Mass Culture, Postmodernism*. Bloomington: Indiana University Press, 1986.

Huyssen, Andreas, Teresa de Lauretis, and Kathleen Woodward, eds. *The Technological Imagination*. Madison, Wis.: Coda Press, 1980.

Information Office of His Holiness the Dalai Lama. *Tibetans in Exile, 1959–1980*. Dharamsala: Information Office, Central Tibetan Secretariat, 1981.

Institute of National Affairs. *Dalai Lama and India*. New Delhi: Hind Book House, 1959.

Ivens, Joris, and Robert Destanque. *Joris Ivens ou la mémoire d'un regard*. Paris: Editions BFB, 1982.

Jahrbuch der Lehr- und Versuchsanstalt für Photographie, Chemigraphie, Lichtdruck und Gravüre zu München 1915–1916 [and] *1916–1918*. Munich: 1916, 1918.

Jay, Martin. *The Dialectical Imagination: A History of the Frankfurt School and the Institute of Social Research 1923–1950*. Boston: Little, Brown, 1973.

Johnson, Douglas, and Madeleine Johnson. *The Age of Illusion: Art and Politics in France, 1918–1940*. New York: Rizzoli International, 1987.

Johnson, William. *Aigner's Paris*. Stockholm: Fotografiska Museet, 1982.

Kerbs, Diethart, Walter Uka, and Brigitte Walz-Richter, eds. *Zur Geschichte der Pressefotografie, 1930–1936*. Berlin: Verlag Frölich & Kaufmann, 1983.

Kertész, André. *Paris vu par André Kertész*. Paris: Société des éditions d'histoire et d'art, Librairie Plon, 1934.

Klein, Wilhelm. *Burma*. Hong Kong: APA Productions/Insight Guides, 1981.

Koegler, Von Horst, and Hellmut Günther, eds. *Reklams Balletlexica*. Stuttgart: Philipp-Reklam, 1980.

Kohler, Michael, and Gisela Barche, eds. *Das Aktfoto: Ansichten vom Körper im fotografischen Zeitalter*. Munich: Münchner

Stadtmuseum, 1985, 289–310.

Koonz, Claudia. *Mothers in the Fatherland: Women, the Family, and Nazi Politics.* New York: St. Martin's Press, 1987.

Kracauer, Siegfried. *From Caligari to Hitler: A Psychological History of the German Film.* Princeton: Princeton University Press, 1947.

Kracauer, Siegfried. *The Mass Ornament: Weimar Essays.* Translated and edited by Thomas Y. Levin. Cambridge: Harvard University Press, 1995.

Krauss, Rosalind, and Dawn Ades. *L'Amour Fou: Photography and Surrealism.* New York: Abbeville Press, 1985.

Krens, Thomas, et al., eds. *The Great Utopia: The Russian and Soviet Avant-Garde, 1915–1932.* New York: Guggenheim Museum/Rizzoli, 1992.

Lacouture, Jean. *De Gaulle.* Translated by Francis K. Price. London: Hutchison, 1970.

Langer, William L., ed. *An Encyclopedia of World History: Ancient, Medieval, and Modern,* 4th ed. Boston: Houghton Mifflin, 1968.

Lavin, Maud. *Cut with the Kitchen Knife: The Weimar Photomontages of Hannah Höch.* New Haven: Yale University Press, 1993.

Lazitch, Branko. *Lénine et la Troisième Internationale.* Paris: L'Evolution du monde et des idées/Editions de la Baconnière, Neuchatel, 1951.

Lefebvre, Bernard ("Ellebé"). *Album de mes photographies avec de Gaulle en Afrique.* Luneray: Editions Bertout, 1990.

Lehning, Arthur. *De vriend van mijn jeugd (herinneringen aan H. Marsman).* The Hague: W. van Hoeve, 1954.

Lehning, Arthur. *From Buonarroti to Bakunin: Studies in International Socialism.* Leiden: E. J. Brill, 1970.

Lehning, Arthur. *Marsman en Het Expressionisme.* The Hague: L.J.C. Boucher, 1969.

Lenin, Vladimir Ilich. *Selected Works of V. I. Lenin.* New York: International, 1971.

Lopez, Donald S., Jr., ed. *Curators of the Buddha: The Study of Buddhism under Colonialism.* Chicago: University of Chicago Press, 1995.

Louppe, Aïda. *Marché aux puces (Mes amis les cloches).* Paris: Julliard, 1953.

Lucic, Karen. *Charles Sheeler and the Cult of the Machine.* Cambridge: Harvard University Press, 1991.

Luft, Friedrich, and Alexander von Baeyer. *Facsimile Quershnitt durch die Berliner Illustrirte.* Munich: Scherz Verlag, 1965.

Mac Orlan, Pierre. *Oeuvres complètes.* Geneva: Edito-Service, 1971.

Madsen, Axel. *Silk Roads: The Asian Adventures of Clara and André Malraux.* New York: Pharos Books, 1989.

Malraux, André. *L'Espoir.* Paris: Gallimard, 1937.

Malraux, André. *La Condition humaine.* Paris: Grasset, 1928.

Malraux, André. *Les Conquerants.* Paris: Gallimard, 1933.

Mansbach, Steven. *Visions of Totality: László Moholy-Nagy, Theo van Doesburg, and El Lissitsky.* Ann Arbor, Mich.: UMI Press, 1980.

Margueritte, Victor. *La garçonne.* Paris: Flammarion, 1922.

Marx, Leo. *The Machine in the Garden: Technology and the Pastoral Ideal in America.* Oxford: Oxford University Press, 1964.

Maugham, W. Somerset. *The Gentleman in the Parlour: A Record of a Journey from Rangoon to Haiphon.* Garden City, N.Y.: Doubleday, 1930.

McCauley, Elizabeth Anne. *Industrial Madness: Commercial Photography in Paris 1848–1871.* New Haven: Yale University Press, 1994.

McClintock, Anne. *Imperial Leather: Race, Gender and Sexuality in the Colonial Contest.* New York and London: Routledge, 1995.

McDonald, Gordon C., et al. *Area Handbook for People's Republic of the Congo (Congo-Brazzaville).* Washington: U.S. Government Printing Office, 1971.

Mercadet, Leon. *La brigade Alsace-Lorraine.* Paris: Bernard Grasset, 1984.

Messac, Régis. *Le detective novel et l'influence de la pensée scientifique.* Paris: H. Champion, 1929.

Mett, Ida. *The Kronstadt Uprising, 1921.* Montreal: Black Rose Books/Our Generation Press, 1971.

Mitchell, Allan. *Revolution in Bavaria 1918–1919: The Eisner Regime and the Soviet Republic.* Princeton: Princeton University Press, 1965.

Moeller, Susan. *Shooting War: Photography and the American Experience of Combat.* New York: Basic Books, 1989.

Moholy-Nagy, László. *The New Vision: Fundamentals of Design, Painting, Sculpture, and Architecture.* New York: Brewer, Warren, and Putnam, 1930. Originally published as *Von Material zu Architectur,* Bauhausbücher 14. Munich: Albert Langen Verlag, 1929.

Moholy-Nagy, László. *Painting, Photography, Film.* Translated by Janet Seligmann. Cambridge: MIT Press, 1969. Originally published as *Malerie, Photographie, Film,*

Bauhausbücher 8. Munich: Albert Langen, 1927.

Mortimer, Edward. *France and the Africans, 1944–1960: A Political History.* London: Faber and Faber, 1969.

Mulvey, Laura. *Visual and Other Pleasures.* Bloomington: Indiana University Press, 1989.

Narcejac, Thomas. *Esthétique du roman policier.* Paris: Le Portulan, 1947.

Nesbit, Molly. *Atget's Seven Albums.* New Haven: Yale University Press, 1992.

Newhall, Beaumont, ed. *Photography, Essays and Images: Illustrated Readings in the History of Photography.* New York: Museum of Modern Art and Boston: New York Graphic Society, 1980.

Neyer, Hans Joachim. *Gisèle Freund.* Berlin: Argon, 1988.

Nollau, Günter. *International Communism and World Revolution: History and Methods.* New York: Praeger, 1961.

Novack, George, Dave Frankel, and Fred Feldman. *The First Three Internationals: Their History and Lessons.* New York: Pathfinder Press, 1974.

O'Brien, Justin. *From the N.R.F.* New York: Farrar, Straus and Cudahy, 1958.

Paris: 285 photographies. Paris: Flammarion, 1931.

Petro, Patrice. *Joyless Streets: Women and Melodramatic Representation in Weimar Germany.* Princeton: Princeton University Press, 1989.

Pfemfert, Franz. *Die Revolutions G.m.b.H.: Agitation und politische Satire in der ,Aktion.'* Wissmar: Anabas Verlag Günter Kämpf, 1973.

Phillips, Christopher, ed. *Photography in the Modern Era: European Documents and Critical Writings, 1913–1940.* New York: Metropolitan Museum of Art/Aperture, 1989.

Phillips, Sandra S. "The Photographic Work of André Kertész in France, 1925–1936: A Critical Essay and Catalogue." Ph.D. dissertation, City University of New York, 1985.

Phillips, Sandra S., David Travis, and Weston Naef, eds. *André Kertész: Of Paris and New York.* Chicago: Art Institute of Chicago; New York: Metropolitan Museum of Art; and London: Thames and Hudson, 1985.

Pohlmann, Ulrich, ed. *Frank Eugene: The Dream of Beauty.* Munich: Nazraeli Press, Fotomuseum in Münchner Stadtmuseum, 1995.

Porter, Dennis. *The Pursuit of Crime: Art and Ideology In Detective Fiction.* New Haven: Yale University Press, 1981.

Pratt, Mary Louise. *Imperial Eyes: Travel Writing and Transculturation.* London: Routledge, 1992.

Prentenboek, Schrijvers. *H. Marsman.* The Hague: Nederlands Letterkundig Museum en Documentatiecentrum, 1960.

Prévost, Jean. *Eiffel.* Paris: Les Editions Rieder, 1929.

Renger-Patzsch, Albert. *Die Welt ist schön.* Introduction by Carl Georg Heise. Munich: Kurt Wolff Verlag, 1928.

Renger-Patzsch, Albert. *Eisen und Stahl.* Introduction by Dr. Albert Vögler. Berlin: Verlag Hermann Reckendorf, 1931.

Rhie, Marylin M., and Robert A. F. Thurman. *Wisdom and Compassion: The Sacred Art of Tibet.* New York: Harry N. Abrams, in association with Asian Art Museum of San Francisco, and Tibet House, New York, 1991.

Roberts, Mary Louise. *Civilization without Sexes: Reconstructing Gender in Postwar France, 1917–1927.* Chicago: University of Chicago Press, 1994.

Roh, Franz, and Jan Tschichold. *Foto-Auge.* Stuttgart: Akademischer Verlag/Dr. Fritz Wedekind, 1929.

Ryder, A. J. *The German Revolution of 1918: A Study of German Socialism in War and Revolt.* Cambridge: Cambridge University Press, 1967.

Said, Edward. *Orientalism.* New York: Vintage Books, 1979.

Saklani, Girija. *The Uprooted Tibetans in India: A Sociological Study of Continuity and Change.* New Delhi: Cosmo, 1984.

Schoots, Hans. *Gevaarlijk leven: Een biografie van Joris Ivens.* Amsterdam: Uitgeverij Jan Mets, 1995.

Schuitema, Paul. *Paul Schuitema: Ein Pionier der holländischen Avantgarde.* Zurich: Kunstgewerbemuseum, 1967.

Sichel, Kim. *Brassaï: Paris le jour Paris la nuit.* Paris: Musée Carnavalet, 1988.

Sichel, Kim. "Pictures of Paris 1928–1934: Brassaï, André Kertész, Germaine Krull and Man Ray," Ph.D. dissertation, Yale University, 1986, UMI microfilm.

Sichel, Kim. *Turn of the Century Photographs by Robert Demachy.* New Haven: Yale University Art Gallery, 1983.

Silver, Kenneth. *Esprit de Corps: The Art of the Parisian Avant-Garde and the First World War, 1914–1925.* Princeton: Princeton University Press, 1989.

Simenon, Georges. *Quand j'étais vieux.* Paris: Presses de la Cité, 1970.

Siripant, Sakda. *King and Camera: Evolution of Photography in*

Thailand, 1845–1992. Bangkok: Darnsutha Press, 1992.

Smith, Sidonie, and Julia Watson, eds. *De/colonizing the Subject: A Poetics of Women's Autobiography*. Minneapolis: University of Minnesota Press, 1992.

Smith, Terry. *Making the Modern: Industry, Art, and Design in America*. Chicago: University of Chicago Press, 1993.

Smith, C. Zoe. "Emigré Photography in America: Contributions of German Photojournalism from Black Star Picture Agency to *Life* Magazine, 1933–1938." Ph.D. dissertation, University of Iowa, 1983.

Spivak, Gayitri Chakravorty. *In Other Worlds: Essays in Cultural Politics*. New York: Methuen, 1987.

Stange, Maren. *Symbols of Ideal Life: Social Documentary Photography in America 1890–1950*. New York: Cambridge University Press, 1989.

Stotz, Gustav. *Film und Foto*. New York: Arno Press, 1979.

Strasser, George, ed. *i10 et son époque*. Paris: Institut Neéderlandais, 1989.

Suret-Canale, Jean. *French Colonialism in Tropical Africa, 1900–1945*. Translated by Till Gottheiner. New York: Pica Press, 1971.

Tagg, John. *Burdens of Representation: Essays in Photographies and Histories*. Amherst: University of Massachusetts Press, 1988.

Teitelbaum, Matthew, ed. *Montage and Modern Life, 1919–1942*. Cambridge: MIT Press, 1992.

Thebaud, Françoise, ed. *A History of Women in the West*. Vol. 5, *Toward a Cultural Identity in the Twentieth Century*. Cambridge:

Belknap Press of Harvard University Press, 1994.

Thompson, Virginia, and Richard Adloff. *Historical Dictionary of the People's Republic of the Congo (Congo-Brazzaville)*. African Historical Dictionaries, No. 2. Metuchen, N.J.: Scarecrow Press, 1974.

Toller, Ernst. *I Was a German: The Autobiography of Ernst Toller*. New York: William Morrow, 1934.

Trachtenberg, Alan, ed. *Classic Essays on Photography*. New Haven: Leete's Island Books, 1980.

Trotsky, Leon. *The Third International after Lenin*. Translated by John G. Wright. New York: Pioneer Publishers, 1936.

Vidal, Pierre. *Paris qui crie—petits métiers*. Drawings. Paris: Les Amis des Livres/George Chamerot, 1890.

Vigouroux, Robert P., and Christian Poitevin, eds. *Le Pont Transbordeur et la vision moderniste*. Marseille: Musées de Marseille, Réunion des Musées Nationaux, Musée Contini, 1991.

von Ankum, Katharina. *Women in the Metropolis: Gender and Modernity in Weimar Culture*. Berkeley: University of California Press, 1997.

von Eckardt, Wolf, and Sander L. Gilman. *Bertolt Brecht's Berlin: A Scrapbook of the Twenties*. New York: Anchor Press/Doubleday, 1975.

Warren, William. *The House on the Klong: The Bangkok Home and Asian Art Collection of James Thompson*. Photographs by Brian Brake. Tokyo: private printing, 1968.

Warren, William. *Jim Thompson: The Legendary American of Thailand*. Bangkok: Jim Thompson Thai Silk Co., 1989.

Waugh, Alec. *Bangkok: The Story*

of a City. Boston: Little, Brown, 1971.

Wheeler, Kenneth W., and Virginia Lee Lussier, eds. *Women, the Arts, and the 1920s in Paris and New York*. New Brunswick: Transaction Books, 1982.

White, Dorothy Shipley. *Black Africa and de Gaulle: From the French Empire to Independence*. University Park: Pennsylvania State University Press, 1979.

Willett, John. *Art and Politics in the Weimar Period: The New Sobriety, 1917–1933*. New York: Pantheon Books, 1978.

Williams, Lea E. *Southeast Asia: A History*. New York: Oxford University Press, 1976.

Williams, Patrick, and Laura Chrisman, eds. *Colonial Discourse and Post-colonial Theory: A Reader*. New York: Columbia University Press, 1994.

Wispelaere, Paul de. *Hendrik Marsman*. Ontmoetingen: Desclée de Brouwer, 1963.

Witte, Bernd. *Walter Benjamin: An Intellectual Biography*. Translated by James Rolleston. Detroit: Wayne State University Press, 1991.

Woyke, James. *Birth Control in Germany 1871–1933*. New York: Routledge, 1988.

Wright, Gordon. *France in Modern Times*. New York: Norton, 1981.

Wright, Gwendolyn. *The Politics of Design in French Colonial Urbanism*. Chicago: University of Chicago Press, 1991.

Wright, Joseph J., Jr. *The Balancing Act: A History of Modern Thailand*. Bangkok: Asia Books, 1991.

Ziegler, Ulf Erdmann. *Nackt unter Nackten: Utopien der Nacktkultur 1906–1942*. Berlin: Nishen, 1990.

Zwart, Piet. *Piet Zwart: L'Opera tipografica 1923–33*. Bologna: CIP-IA, 1987.

Magazines/Journals

"40 Jahre Eiffelturm." *Münchner Illustrierte Presse* 19 (12 May 1929): 736.

Anonymous. "Les expositions" [Salon de l'escalier]. *L'Art vivant* (15 June 1928): 486. Reprinted in Dominique Baqué, ed., *Les Documents de la Modernité: Anthologie de textes sur la photographie de 1919 à 1939*. Paris: Editions Jacqueline Chambon, 1993.

Anonymous. "Oldest and Newest in Photographs Contrasted in Unique Exhibit." *Chicago Tribune*, 26 May 1928.

Anonymous. "Salon to Be Held by Photographers." *New York Herald*, 12 May 1928.

Astier, Emmanuel. "Quelques philosophes du pavé de Paris." *Vu* 525 (6 April 1938): 426–27.

Baumann, Suzanne. "Der Weg uber die Schulen." In Ute Eskildsen, ed., *Fotografieren hieß teilnehmen: Fotografinnen der Weimarer Republik*. Essen: Folkwang Museum and Düsseldorf: Richter, 1994.

Benjamin, Walter. "The Author as Producer." In Peter Demetz, ed., *Reflections: Essays, Aphorisms, Autobiographical Writings*. Introduction by Peter Demetz. Translated by Edmund Jephcott. New York: Schocken Books, 1978.

Benjamin, Walter. "A Small History of Photography" (1931). *One Way Street and Other Writings*. Translated by Edmund Jephcott and Kingsley Porter. London: NLB, 1974. Originally published as "Kleine geschichte der Photographie," *Literarische Welt* (18 and 25 September, 2 October 1931).

Benjamin, Walter. "On Some Motifs in Baudelaire." In Hannah Arendt, ed. *Illuminations*. Translated by Harry Zohn. New York: Harcourt, Brace and World, 1968, 155–200.

Benjamin, Walter. "The Work of Art in the Age of Mechanical Reproduction." Written in German and first published in French in *Zeitschrift fur Sozialforschung* 5 (1) (1936). In Hannah Arendt, ed. *Illuminations*. Translated by Harry Zohn. New York: Harcourt, Brace and World, 1968, 217–52.

Bequette, France. "Rencontre avec Brassaï." *Culture et communication* 27 (1 May 1980): 12.

Blau, Eve. "Patterns of Fact: Photography and the Transformation of the Early Industrial City." In *Architecture and Its Image: Four Centuries of Architectural Representation—Works from the Collection of the Canadian Centre for Architecture*. Montreal: Canadian Center for Architecture/MIT Press, 1989.

Bridenthal, Renate. "Beyond Kinder, Kirche, Küche: Weimar Women at Work." *Central European History* 6 (1)(1973): 148–66.

Bringuière, Paul. "Mystère des gares." *Détective* 1 (34) (20 June 1929): 3.

Buckberrough, Sherry. "Delaunay Design: Aesthetics, Immigration, and the New Woman." *Art Journal* 54 (1) (Spring 1995): 51–55.

Buck-Morss, Susan. "The Flâneur, the Sandwichman and the Whore: The Politics of Loitering." *New German Critique* 39 (1986): 99–141.

Butler, Susan. "So How Do I Look? Women before and behind the Camera." In *Staging the Self: Self-Portrait Photography 1840s–*

1980s. London: National Portrait Gallery, 1986, 51 ff.

Cameron, Allan W., ed. "Report to the Combined Chiefs of Staff by Supreme Allied Commander, South East Asia" [Extracts]. In *Viet-Nam Crisis: A Documentary History*. Vol. 1, 1940–1956. Ithaca: Cornell University Press, 1971, 55–63.

Charensol. "Un Grand éditeur d'art: Lucien Vogel." *Les Nouvelles littéraires* (2 May 1925): 5.

Cocteau, Jean. "La Voix humaine." *Vu* 102 (18 February 1930): 170–71.

Crow, Thomas. "Modernism and Mass Culture in the Visual Arts." In Serge Guilbaut and D. Solkin, eds., *Modernism and Modernity*. Halifax, N.S.: Press of the Nova Scotia College of Art and Design, 1983.

Danjou, Henri. "Au son de l'accordéon." *Détective* 1 (47) (19 September 1929): 12.

Delpech, Janine. "Sur les bancs de Paris." *Vu* 396 (16 October 1935): 1354–55.

d'Erleich, Jean. "La Tour à quarante ans." *Vu* 63 (29 May 1929): 433.

Doane, Mary Ann. "Film and Masquerade: Theorising the Female Spectator." *Screen* 23 (September–October 1982): 80–82.

"Du Bureau à la chambre à coucher de Mr. Herriot à Lyon." *Vu* 9 (17 May 1928): 222–24.

Eisenstein, Sergei. "The Cinematographic Principle and the Ideogram, and A Dialectic Approach to Film Form." In Jay Leyda, ed. *Film Form: Essays in Film Theory*. Translated by Jay Leyda. New York: Harcourt, Brace, 1949.

Emié, Louis. "Renaissance de la photo." *La Petite Gironde* (6 June 1929): n.p. Reprinted in Pierre Mac Orlan, *Germaine Krull*. Paris:

Librarie Gallimard/Les Photographes nouveaux, 1931.

Eskildsen, Ute. "Photography and the Neue Sachlichkeit Movement." In *Neue Sachlichkeit and German Realism of the 1920s*. Exhibition catalogue, 1978, pp. 85–97. Reprinted in David Mellor, ed., *Germany: The New Photography 1927–1933*. London: Art Council of Great Britain, 1978, 100–12.

Faber, Monika. "Selbstfoto." In Ute Eskildsen, ed., *Fotografieren hieß teilnehmen: Fotografinnen der Weimarer Republik*. Essen: Folkwang Museum and Düsseldorf: Richter, 1994, 280–87.

Fels, Florent. "Le Premier Salon Indépendant de la Photographie." *L'Art vivant* (1 June 1928): 445. Translated by Robert Erich Wolf and reprinted in Christopher Phillips. *Photography in the Modern Era: European Documents and Critical Writings, 1913–1940. New York: Metropolitan Museum of Art/Aperture, 1984.*

Filmliga 1927–1931. Nijmegen: Socialistiese Uitgeverij Nijmegen, 1982.

Four, John. "The *Berliner Illustrirte* and Photojournalism in Germany 1929–1935." In *Picture Magazines before* Life. Woodstock, N.Y.: Catskill Center for Photography, 1982, 1–4.

"French Colonial Policy in Africa." *Free France* 2 (Special Issue, September 1944).

Freund, Gisèle. "La photographie à l'Exposition." *Arts et métiers graphiques* 62 (1938): 37–38, 41. Reprinted in Dominique Baqué, ed. *Les Documents de la Modernité: Anthologie de textes sur la photographie de 1919 à 1939*. Paris: Editions Jacqueline Chambon, 1993.

Fridenson, Patrick. "L'Idéologie des grands constructeurs dans l'en-tre-deux-guerres." In *Mouvement Social* 81 (October-December 1972): 51–68.

Gallotti, Jean. "La photographie est-elle un art? Atget." *L'Art vivant* (1 January 1929): 20–21, 24.

Gallotti, Jean. "La photographie est-elle un art? Laure Guyot [sic]." *L'Art vivant* (1 February 1929): 138–39.

Gallotti, Jean. "La photographie est-elle un art? Kertész." *L'Art vivant* (1 March 1929): 208–09, 211.

Gallotti, Jean. "La photographie est-elle un art? Man Ray." *L'Art vivant* (1 April 1929): 282–83.

Gallotti, Jean. "La photographie est-elle un art? Eli Lotar." *L'Art vivant* (1 August 1929): 605, 609–10.

Gallotti, Jean. "La photographie est-elle un art? Alban." *L'Art vivant* (15 August 1929): 654–55.

Galskill, Gordon. "Voice of Victory." *American Magazine: In the Service of the Nation* 1 (December 1942): 35, 106–08.

Geary, Christraud M. "'On the Savannah': Mary Pauline Thorbecke's Images from Cameroon, West Africa (1911–1912)." *Art Journal* 49 (2) (Summer 1990): 150–58.

"Die Geschichte der Photoschule." In *Das Lichtblick: Informationsblatt der Freunde und Förderer der Bayerischen Staatslehranstalt für Photographie München*. Munich: February 1988.

"Un Grand éditeur d'Art: Lucien Vogel." *Les Nouvelles lit-téraires* (2 May 1925): 5.

Grossmann, Atina. "Berufswahl—ein Privileg der bürgerlichen Frauen." In *Fotografieren hieß teilnehmen: Fotografinnen der Weimarer Republik*. Essen: Folkwang Museum and Düsseldorf: Richter, 1994.

Grossmann, Atina. "Girlkultur or Thoroughly Rationalized Female: A New Woman in Weimar Germany?" In Judith Friedlander, Blanche Wiesen Cook, and Alice Kessler-Harris, eds., *Women in Culture and Politics: A Century of Change*. Bloomington: Indiana University Press, 1983, 62–80.

Grossmann, Atina. "The New Woman and the Rationalization of Sexuality in Weimar Germany." In Ann Snitow, Christine Stansell, and Sharon Thompson, eds., *Powers of Desire: The Politics of Sexuality*. New York: Monthly Review Press, 1983, 1953–71.

Hambourg, Maria Morris. "Atget: Precursor of Modern Documentary Photography." In *Observations*. Carmel, Calif.: Friends of Photography, 1984, 24–39.

Hansen, Miriam. "Pleasure, Ambivalence, Indentification: Valentino and Female Spectatorship." *Cinema Journal* (Summer 1986): 6–32.

Haus, Andreas. "László Moholy-Nagy." In Jeanine Ziegler, ed. *Photography at the Bauhaus*. Cambridge, Mass.: MIT Press, 1990, 15–23.

Herz, Waggi. "Heinrich Hoffmann und die Revolution: zur Genese faschistischer Fotografie." In *München 1919: Bildende Kunst/Fotografie der Revolutions- und Rätezeit*. Munich: Ein Seminarbericht der Akademie der Bildenden Künste, 1979.

Horkheimer, Max. "Art and Mass Culture." *Studies in Philosophy and Social Science* 9 (2) (1941). Reprinted in Max Horkheimer, *Critical Theory: Selected Essays*. New York: Seabury Press, 1972.

Huyssen, Andreas. "Paris/Childhood: The Fragmented Body in Rilke's *Notebooks of Malte Laurids Brigge*." In Andreas Huyssen

and David Bathrick, eds., *Modernity and the Text: Revisions of German Modernism*. New York: Columbia University Press, 1989.

Ivens, Joris. "Apprentice to Films, I." In *Theatre Arts* 30 (1) (1946): 179–186.

Ivens, Joris. "Apprentice to Films, II." In *Theatre Arts* 30 (3) (April 1946): 245–50.

Jameson, Fredric. "Periodizing the 60s." In Sohnya Sayres, Anders Stephanson, Stanley Aronowitz, and Fredric Jameson, eds., *The 60s without Apology*. Minneapolis: University of Minnesota Press, 1984, 178–209.

"The Kingdom of the Beggars." *Picture Post* 2 (1) (7 January 1939): 15–17.

Körperbildung Nacktkultur: Blätter freier Menschen 1 (July 1925).

Kuspit, Donald. "Albert Renger-Patzsch: A Critical-Biographical Profile." In *Albert Renger-Patzsch: Joy before the Object*. Millerton, N.Y.: Aperture, 1993, 4–7, 66–75.

L., F. "L'exposition de la photographie à la Galerie 'l'Epoque.'" *Variétés* 1 (7) (15 November 1928): 401.

Lionel-Marie, Annick. "Essai biographique: Le coeur meurtri par de mortes chimères." In *Eli Lotar*. Paris: Musée national d'art moderne, Centre Georges Pompidou, 1993.

Mac Orlan, Pierre. "L'Art littéraire d'imagination et la photographie." *Les Nouvelles littéraires* (22 September 1928). Translated by Robert Erich Wolf, reprinted in Christopher Phillips, ed., *Photography in the Modern Era: European Documents and Critical Writings, 1913–1940*. New York: Metropolitan Museum of Art/Aperture, 1989.

Mac Orlan, Pierre. "Elements

de fantastique social." *Le Crapouillet* (March 1929): 33. Translated by Robert Erich Wolf and reprinted in Christopher Phillips, ed. *Photography in the Modern Era: European Documents and Critical Writings 1913–1940*. New York: The Metropolitan Museum of Art/Aperture, 1989, 31–33.

Mac Orlan, Pierre. "Graphismes." *Arts et métiers graphiques* 11 (1928–29): 645–49. Reprinted in Dominique Baqué, ed. *Les Documents de la modernité: Anthologie de textes sur la photographie de 1919 à 1939*. Paris: Editions Jacqueline Chambon, 1993, 39–41.

Mac Orlan, Pierre. "Les Nuits dans la littérature." *Les Nouvelles littéraires* (9 February 1929): 1.

Mac Orlan, Pierre. "Ombre de Paris." *Détective* 3 (70) (27 February 1930): 7 and following issues until *Détective* 3 (86) (15 May 1930): 7.

Mac Orlan, Pierre. "La Photographie et le fantastique social." *Les Annales politiques et littéraires* (1 November 1928): 413–14.

Mac Orlan, Pierre. "Les Sentiments de la rue et ses accessoires." *L'Art vivant* 145 (1 January 1931): 20–21.

Mac Orlan, Pierre. "La Vie moderne: L'art littéraire d'imagination et la photographie." *Les Nouvelles littéraires* (22 September 1928): 1.

Maier, Charles. "Between Taylorism and Technocracy: European Ideology and the Vision of Productivity in the 1920s." *Journal of Contemporary History* 5 (1970): 27–61.

Marchot. "La Vie pour rien—comment en 24 heures un gueux devint gentleman." *Vu* 164 (6 May 1931): 633–35.

Mason, Tim. "Women in Germany, 1925–1940: Family,

Welfare and Work." *History Workshop: A Journal of Socialist Historians* 1 (1976): 74–113.

Michelson, Annette. "Dr. Crase and Mr. Clair." *October* 11 (Winter 1979): 29–53.

Moholy-Nagy, László. "Die beispiellos Fotografie." *i10* 1 (1)(1927): 114–17. Also published in *Das Deutsche Lichtbild*. Berlin, 1927, x–xi. Translated by Joel Agee as "Unprecedented Photography," in Christopher Phillips, ed., *Photography in the Modern Era: European Documents and Critical Writings, 1913–1940*. New York: Metropolitan Museum of Art/Aperture, 1989, 83–85.

Moholy-Nagy, László. "La Photographie ce qu'elle était, ce qu'elle devra être." *Cahiers d'art* 4 (1929): 29–30.

Murat, Princess Lucien. "Florent Fels." *Les Nouvelles littéraires* (28 July 1928): 2.

"Le nouveau Poste de Radio-Brazzaville." *Les Cahiers français* 47 (August 1943): 46–50.

"Les Obsèques nationales du vainqueur de la guerre, (Maréchal Foch)." *Vu* 55 (3 April 1929): 257.

Phillips, Christopher. "Introduction." In Matthew Teitelbaum, ed., *Montage and Modern Life, 1919–1942*. Cambridge: MIT Press/Institute of Contemporary Art, 1992.

Phillips, Sandra S. "The French Picture Magazine *Vu.*" In *Picture Magazines before* Life. Woodstock, N.Y.: Catskill Center for Photography, 1982.

"Photojournalism in the 1920s: A Conversation between Felix H. Man, Photographer, and Stefan Lorant, Picture Editor (1970)." In Beaumont Newhall, ed. *Photography: Essays and Images*. New York: Museum of Modern Art, 1980,

271–75.

Portail, Jean. "Chez les marchands d'avenir." *Vu* 129 (4 September 1930): 868–69.

Réal, Marc. "Noel chez les clochards." *Voilà* 353 (24 December 1937): 7.

Schwartz, Paula. "Redefining Resistance: Women's Activism in Wartime France." In Margaret Higonnet, ed., *Behind the Lines: Gender and the Two World Wars.* New Haven: Yale University Press, 1987, 141–53.

Sichel, Kim. "On Reading Photographic Books." *Views* (Autumn 1988): 3, 22.

Sichel, Kim. *"Paris vu par André Kertész:* An Urban Diary." *History of Photography* 16 (2) (Summer 1992): 105–14.

Sichel, Kim. "Les photographes étrangers à Paris durant l'entre-deux-guerres." In André Kaspi and Antoine Marès, eds., *Les Paris des étrangers depuis un siècle.* Paris: Imprimerie Nationale/Institut d'histoire des relations internationales contemporaines, 1989, 256–67.

Souriguère, Armand. "Les Vagabonds de Paris." *Scandale* 8 (March 1934): 20–25.

Spörl, Hans. "Die Neuordnung an der Höheren Fachschule für Phototechnik in München." In *Photographische Chronik* 29 (16) (1922): 142.

Thomazeau, R. "Chasseurs d'images." *Voilà* 33 (7 November 1931): 8–9.

Towinez. "Review." In *La Revue hebdomadaire* (16 June 1982): 358–59.

van Helmond, Toke. "Politique et culture: quelques notes bi-ographiques sur Arthur Lehning, fondateur et rédacteur en chef de *i10"* and "Portraits et biographies des collaborateurs de *i10."* In *i10 et son époque.* Paris: Institut Néerlandais, 1989.

Wellhof, Edmond de. "Les Heures de Son Eminence le Cardinal Dubois." *Vu* 11 (31 May 1928): 270–72.

Winter, Jay. "Some Paradoxes of the First World War." In Richard Wall and Jay Winter, eds. *The Upheaval of War: Family, Work and Welfare in Europe 1914–1918.* Cambridge: Cambridge University Press, 1988, 9–42.

Wolf-Czapek, K. W. "Die Münchener Lehr- und Versuchs-Anstalt für Photographie." *Deutscher Camera-Almanach* 10 (1914): 172–91.

Wolfe, Dr. H. Ashton. "La détéction scientifique du crime" (pts. 1–5). *Vu* 78 (11 September 1929): 732–33; 84 (23 October 1929): 877–78; 93 (25 December 1929): 1091–92; 99 (11 February 1930): 115–16; 124 (30 July 1930): 772–73; 138 (5 November 1930): 1163–64.

Theodor W. Adorno Archiv, Frankfurt: plates 7.11, 7.12, 7.13, 7.14, 7.15, 7.16

Archief en Museum van de Socialistische Arbeidersbeweging, Ghent: plates 3.15, 4.1, 4.9, 4.10, 4.14, 5.8, 5.11, 5.12, 6.22

The Art Institute of Chicago. All rights reserved. Photograph © 1977: fig. 6.2; plate 6.7

Leo Baeck Institute: plate 5.14

Bibliothèque Nationale, Paris: plate 5.4

Boston Public Library: figs. 6.1, 6.5; plate 6.1

Boston University Photo Services: figs. 6.1, 7.1, 7.5; plates 6.6, 6.16, 6.17, 6.18

Christian Bouqueret, Paris: figs. 4.2; plates 3.1, 3.2, 3.16, 4.18, 5.1, 5.15, 5.17, 5.18, 6.2, 6.3, 6.4, 6.5, 6.8, 7.6, 7.19

Dr. Christian Brandstätter, Vienna: figs. 1.6, 5.4, 6.4; plates 5.7, 5.16

Françoise Denoyelle/Guy Hersant, Paris: fig. 1.8; plates 1.4, 1.5

Deutsches Tanzarchiv Köln/Fotografie und Druckvorlagen GMBH, Cologne: fig. 3.3; plates 1.3, 3.3, 3.4, 3.11

Susan Ehrens, San Francisco: plates 3.7, 3.8, 3.9, 3.10

Museum Folkwang, Essen: figs. 1.1, 1.2, 1.3, 1.4, 1.5, 3.2, 7.6, 8.1, 8.2, 8.3, 8.4, 8.5, 8.6, 8.7, 8.8, 9.1, 9.2, 9.3, 10.1, 10.2; plates 4.2, 4.4, 4.7, 4.11, 4.13, 4.15, 5.2, 5.3, 5.5, 5.6, 5.10, 5.19, 5.21, 5.23, 6.3, 6.9, 6.10, 6.11, 6.12, 6.13, 6.21, 6.23, 6.25, 6.26, 6.27, 6.28, 6.29, 7.1, 7.2, 7.3, 7.4, 7.7, 7.8, 7.9, 7.10, 7.17, 8.1, 8.2, 8.3, 8.4, 8.5, 8.6, 8.7, 8.8, 8.9, 8.10, 8.11, 8.12, 8.13, 8.14, 8.15, 8.16, 9.1, 9.2, 9.3, 9.4, 9.5, 9.6, 9.7, 9.8, 10.1, 10.2, 10.3, 10.4, 10.5, 10.6

Fotomuseum im Münchner Stadtmuseum, Munich/Wolfgang Pulfer Fotografie: plate 1.1

Harvard College Library: figs. 4.4, 5.1, 5.2, 7.2. 7.3, 7.4

Hattula Hug-Moholy-Nagy, Ann Arbor: fig. 6.3

Rudolf Herz/Hans Döring, Munich: fig. 1.7; plate 1.2

Max-Horkheimer-Archiv, Stadt- und Universitätsbibliothek, Frankfurt: plate 5.13

Houk Friedman, New York/Robert Klein Gallery, Boston: plate 3.12

Institut für Zeitungsforschung, Dortmund: fig. 3.1

André Jammes, Paris: plates 4.5, 4.8, 4.12, 4.16, 4.17, 5.9, 5.22, 6.14, 6.15, 6.20, 7.18, 7.20, 7.21, 7.22, 7.23, 7.24

Ministère de la Culture (AFDDP)–France: fig. 6.2

Musée National d'Art Moderne, Paris/Photo Philippe Migeat © Centre G. Pompidou: fig. 5.3; plates 4.3, 4.6, 6.5, 7.5

Museum of Fine Arts, Houston: fig. 6.3

Museum of Modern Art, New York: fig. 4.3

Galerie Bodo Niemann, Berlin: plates 3.13, 3.14, 5.24

Sylvio Perlstein, New York: plate 6.19, 6.24

Dietmar Siegert, Munich: plates 3.5, 3.6

Thomas Walther, New York: plates 5.20, 7.25, 7.26

Jürgen Wilde: fig. 4.1